CEZANNE
PAINTINGS

Götz Adriani

CÉZANNE

PAINTINGS

Including an Essay by Walter Feilchenfeldt
on the Early Reception of Cézanne's Work

Translated from the German by Russell Stockman

DUMONT Buchverlag, Cologne
Harry N. Abrams, Inc., Publishers

This edition is an edited translation of the catalogue originally published in German for the Cézanne exhibition held at the Kunsthalle Tübingen, from January 16 to May 2, 1993.

Library of Congress Cataloging-in-Publication Data

Adriani, Götz, 1940 –
[Cézanne. English]
Cézanne paintings / Götz Adriani.
p. cm.
"Edited translation of the catalogue originally published in German for the Cézanne exhibition
held at the Kunsthalle Tübingen from January 16 to May 2, 1993" – CIP foreword.
Includes bibliographical references and index.
ISBN 0-8109-4026-4
1. Cézanne, Paul, 1839–1906 — Exhibitions. I. Cézanne, Paul, 1839–1906. II. Kunsthalle Tübingen.
III. Title.
ND553.C33A4 1995
759.4 — dc20 94–20396

Editor: Karin Thomas
Editor, English-language edition: Robbie Capp
Designed by Winfried Konnertz
Production: Peter Dreesen and Matias Möller

Copyright © 1993 DUMONT Buchverlag, Cologne

Distributed in 1995 by Harry N. Abrams, Incorporated, New York
A Times Mirror Company
Reproductions by Ringbahnlitho, Neuss; Litho Köcher, Cologne
C. Müller & H. Daiber, Sigmaringendorf
Typeset by Fotosatz Harten, Cologne
Printed in Germany by Rasch, Bramsche
Bound in Germany by Bramscher Buchbinder Betriebe, Bramsche

Contents

Foreword
8

Lenders
10

Götz Adriani
"A sort of great god of painting"
14

Catalogue
37

Selected Bibliography
282

Exhibitions and Catalogues
286

Chronology
289

Walter Feilchenfeldt
The Early Reception of Cézanne's Work,
with Emphasis on Its History in Germany
293

Index
313

Photograph Credits
316

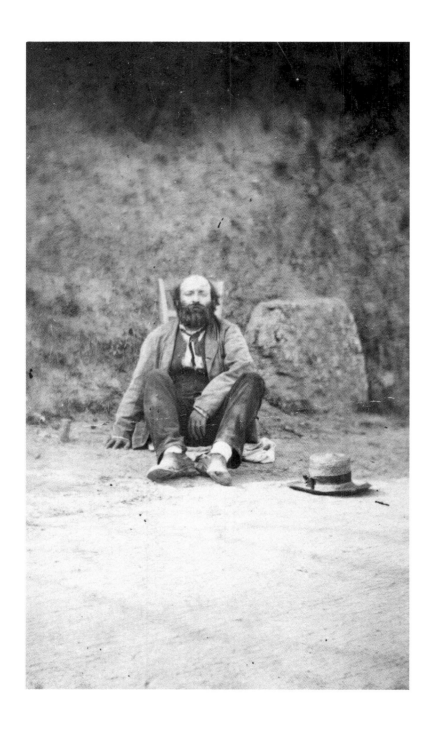

Paul Cézanne, photograph circa 1874

Foreword

This exhibition of Cézanne's paintings in the Kunsthalle Tübingen is the third in a series. The first, in 1978, presented an extensive selection of the artist's drawings, while the second, in 1982, focused attention on his watercolors. This final showing of ninety-seven paintings is larger than any previous Cézanne exhibition, with the exception of the Paris retrospective of 1936. The three Cézanne shows in Tübingen – of his drawings, his watercolors, and now his paintings – are the only retrospectives ever originally mounted in Germany; the one shown in Munich and Cologne in 1956 was taken over from The Hague and Zurich. This is surprising, in that Germany's warm reception of Cézanne, thanks to a few courageous museum directors, dealers, and collectors, began very early. One need only remember that the first museum to purchase a Cézanne painting for its collections was the Nationalgalerie in Berlin. That was in 1897. Beginning with the turn of the century, the Berlin art dealer Paul Cassirer devoted himself to the French artist with considerable success, and 1910 saw the publication in Munich of the first Cézanne monograph, written by Julius Meier-Graefe.

Apart from the fact that Cézanne's painting seems as topical as ever, there was no particular reason – no anniversary to be commemorated – behind our conception and organization of this exhibition. In recent decades, shows in the United States, England, and Switzerland have presented important aspects of the Cézanne œuvre. The late work was featured in New York in 1977, that of his early years shown in London in 1988. Meritorious as such undertakings were, they tended to ignore the grandiose unity of his work, and concentrated instead on discrete periods or even subjects. As such, they somewhat obscured a larger view of Cézanne's long career with its many twistings and turnings spanning more than four decades. Thus, in mounting the Tübingen exhibition, our intention was to retrace a development, from 1866 to 1906, that essentially determined modernist views of art, using major works and significant sequences of paintings that for the most part had never before been seen in Germany.

When compiling our list of works to be borrowed, we were guided not only by quality but by quantity within each subject, for we wished the exhibition to reflect the relative importance of different pictorial genres – landscape, portrait, still life, and figural scenes – within the total œuvre. We managed to do so quite accurately, for landscapes make up slightly over 40 percent of the selection; portraits and still lifes, 20 percent each; figural scenes and depictions of bathers, an even 10 percent each.

The Tübingen exhibition and this volume will have accomplished our objective if they succeed, at nearly the close of our century, in calling attention to the formidable standard that Cézanne's painting represented in the opening years of our century. Indeed, his example was first acknowledged by his own notable colleagues – these pages include paintings once owned by Monet, Renoir, Liebermann, Matisse, Picasso, and Zola – and left its imprint on our era like no other. Matisse, Braque, Picasso, Duchamp, Mondrian, Kandinsky, Klee, Beckmann, Giacometti, and Jasper Johns are but a few of the artists of our century who have avowed their great indebtedness to Cézanne.

Our efforts, which seemed audacious at first, were crowned with a degree of success we would not have dared hope for, and it is due to countless friends and colleagues who so willingly granted our requests for loans that we are able to raise the issue of Cézanne's modernity once again in such exemplary form. We thank them all for acceding to virtually all of our requests. Such willingness to oblige one's colleagues is especially valuable now that it has become increasingly difficult, for many reasons, to put together retrospectives of this sort with scholarly catalogues – especially when they are initiated by an institute that cannot reciprocate, when asked, with loans from its own collections.

The contents of the exhibition and the catalogue are identical. We resisted expanding the latter into a compendium promising more than the exhibition holds. Many of the works are here reproduced in large size and extensively discussed for the first time. This has been made possible thanks to the commitment brought to the project by our friends at DuMont publishers. We also express thanks to our team in Tübingen, whose remarkable energy helped to make the organization and realization of the exhibition possible.

Götz Adriani Walter Feilchenfeldt

Lenders

Aix-en-Provence	Musée Granet, Denis Coutagne
Basel	Sammlung Beyeler, Ernst Beyeler
Berlin	Staatlich Museen zu Berlin, Nationalgalerie, Wolf-Dieter Dube, Dieter Honisch, Peter-Klaus Schuster
Boston	Museum of Fine Arts, Allan Shestack, Peter C. Sutton
Bremen	Kunsthalle Bremen, Siegfried Salzmann
Brooklyn	The Brooklyn Museum, Robert T. Buck, Elisabeth W. Easton
Buffalo	Albright-Knox Art Gallery, Douglas G. Schultz
Cambridge	The Provost and Fellows of King's College, Fitzwilliam Museum, Cambridge, Simon Jervis, David E. Scrase
Canberra	Australian National Gallery, Betty Churcher, Michael Lloyd
Chicago	The Art Institute of Chicago, James N. Wood, Douglas Druick
Cleveland	The Cleveland Museum of Art, Evan H. Turner
Cologne	Wallraf-Richartz-Museum, Hiltrud Kier, Rainer Budde
Columbus	Columbus Museum of Art, Roger D. Clisby
Detroit	The Detroit Institute of Arts, Samuel Sachs II, J. Patrice Marandel
Edinburgh	National Gallery of Scotland, Timothy Clifford, Michael Clarke
Frankfurt am Main	Städtische Galerie im Städelschen Kunstinstitut, Klaus Gallwitz
Helsinki	Art Museum Ateneum, Helmiritta Sariola
Houston	The Museum of Fine Arts, Peter C. Marzio, George T. M. Shackelford
Kansas City	The Nelson-Atkins Museum of Art, Marc F. Wilson
Karlsruhe	Staatliche Kunsthalle Karlsruhe, Horst Vey
Liverpool	The Trustees of the National Museums and Galleries on Merseyside, Walker Art Gallery, Julian Treuherz
London	Courtauld Institute Galleries, Michael Kauffmann, Dennis Farr
	Thomas Gibson Fine Art Ltd., Thomas H. Gibson
	The Trustees of the National Gallery, Neil MacGregor, Christopher Brown, John Leighton
	Berggruen Collection, National Gallery, Heinz Berggruen
	The Trustees of the Tate Gallery, Nicholas Serota

Los Angeles	Los Angeles County Museum of Art, Philip Conisbee
Malibu	Collection of the J. Paul Getty Museum, John Walsh
Miami Beach	Mr. and Mrs. Thomas Kramer
Montreal	The Montreal Museum of Fine Arts, John R. Porter
Munich	Bayerische Staatsgemäldesammlungen, Neue Pinakothek, Johann Georg Prinz von Hohenzollern, Christian Lenz
New York	Acquavella Modern Art, William Acquavella Stephen Hahn Collection, Stephen Hahn The Metropolitan Museum of Art, Philippe de Montebello, Gary Tinterow The Museum of Modern Art, Kirk Varnedoe
Northampton	Smith College Museum of Art, Linda Muehlig
Oslo	Nasjonalgalleriet, Tone Skedsmo
Ottawa	National Gallery of Canada, Shirley L. Thomson
Paris	Musée d'Orsay, Françoise Cachin Musée Picasso, Gérard Regnier
Philadelphia	Philadelphia Museum of Art, Anne d'Harnoncourt, Joseph J. Rishel
Pittsburgh	The Carnegie Museum of Art, Phillip M. Johnston
Prague	Národní Galerie v Praze, Lubomír Slavíček
Rome	Galleria Nazionale d'Arte Moderna, Augusta Monferini
St. Petersburg	State Hermitage Museum, Michael Pjotrowski
São Paulo	Museu de Arte, Fabbio Magalhães
Solothurn	Kunstmuseum, André Kamber
Stockholm	Nationalmuseum, Olle Granath, Görel Cavalli-Björkman
Stuttgart	Staatsgalerie Stuttgart, Peter Beye
Tokyo	Bridgestone Museum of Art, Ishibashi Foundation, Yasuo Kamon, Nobuo Abe Galerie Yoshii, Chozo Yoshii
Wuppertal	Von der Heydt-Museum, Sabine Fehlemann
Yokohama	Museum of Art, Heihachiro Tsuruta
Zurich	Stiftung Sammlung E. G. Bührle, Hortense Anda-Bührle Werner and Gabrielle Merzbacher Fondation Rau pour le Tiers-Monde

and numerous lenders who do not wish to be identified.

"I don't paint anything I don't see."
Paul Cézanne

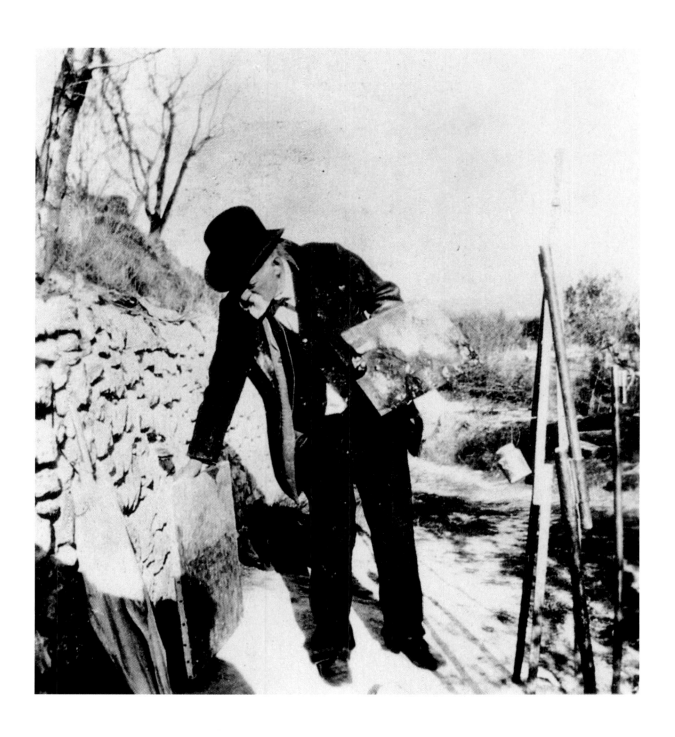

Paul Cézanne at work on the Chemin des Lauves,
photograph by Ker-Xavier Roussel, 1906

"A sort of great god of painting"
Matisse

"Proving something to Cézanne is like trying to persuade the towers of Notre Dame to dance a quadrille.... He is all of a piece, stiff and hard to reach; nothing makes him bend, nothing can make him give in.... And there he is, thrown into life, bringing to it certain notions, and unwilling to change unless he himself sees fit." Thus did the twenty-one-year-old Emile Zola characterize his closest friend, a year older than he, in 1861. The two had been schoolmates together in Aix-en-Provence, but this did not prevent Zola from making the prediction: "Paul may possess the genius of a great painter, he'll never have the genius to become one."[1]

Admittedly, no one was in a better position than Zola to describe Cézanne's difficult personality, one plagued with self-doubt. For over three decades, he would continue to be the painter's closest friend and an objective observer of his career. It was not until 1886, and the publication of Zola's novel *L'Œuvre*, that their friendship ceased. In that work about an artist, the novelist, long accustomed to his own success, voiced his reservations and disappointment in the painter – a character based on Cézanne – who had failed to match that success. By then, Cézanne had been spurned by the fickle Parisian public. To the more robust Zola, who had so brilliantly achieved his early ambitions, Cézanne ultimately represented an "abortive genius, without complete realization."[2]

Zola may have been utterly sincere in his judgment of his friend as a man, but his comments do not really tell us much about Cézanne the artist. Having rapidly become the most popular writer in France, Zola seemed unable to appreciate how much time and effort might be required of his friend in the development of such a probing and original artistic intelligence. Cézanne, at least, maintained a faith in his own abilities despite all his self-doubts. Filled with conflicting desires, and fully conscious of his shortcomings and general awkwardness, his spirit was more akin to Flaubert's than to Zola's – Monet even went so far as to refer to him as a Flaubert of painting.[3] He also had to struggle against his volatile and hypersensitive temperament. It was only toward the end of his career that he had a vague sense that he was on the right path. It is difficult to think of any other artist so convinced of what he wished to do, and yet so uncertain of himself. He tended toward exaggeration when expressing himself, yet was intent on factual exactness. He longed for approval, but feared that he could never gain acceptance as he perceived it. He was absolutely uncompromising, but at the same time highly indecisive. With incredible will-power he managed to impose on himself a rigid self-discipline, yet he was deeply emotional, withdrawn, and shy, and suffered from frequent working blocks. If he projected a cool composure, it was in part because he was so skilled at suppressing his feelings.

At the start of his career he craved recognition, but because of his extraordinary rebelliousness, it eluded him. Rebellion and reaction defined his early art. Though he was ruthless in his refusal to compromise, he nonetheless imposed on himself a strict self-discipline in an effort to embrace established artistic traditions, to develop out of what had come before a new art for the future. A stranger in his own time and a social misfit, Cézanne eventually curbed the more revolutionary side of his nature and chose instead a life of monotonous dedication. Largely withdrawn from society and aloof from its concerns, he found fulfillment in his ongoing struggle.

Paradoxical as it sounds, the man claimed by all manner of artists as a precursor, one whose breakthrough approach gave legitimacy to many of the innovative movements of twentieth-century art, was himself dependent on authority figures throughout his life. In order to pursue his own torturous way, he was forced to rely on the autocratic patronage of his father, on the ingenuity of Zola, on the advice of the older Pissarro, on museum masterpieces, and finally, on his own son, Paul.[4] He was determined to paint only what he saw, and had no interest in topical subjects like those of a Courbet or a Manet, yet nothing was further from his thoughts than

creating works that would change the course of art forever. He would scarcely have approved of the conclusions the modernists drew from his work, their decreasing reliance on direct observation of nature. To him it would have seemed that they were confusing being true to nature with being dependent on it. In any case, the real Cézanne was soon enough displaced by a mythical one. Critics seized upon and sentimentalized the artist in his isolation, scorned by his Provençal compatriots. They presented a distorted image of a recluse whose contemplative withdrawal somehow presaged large revelations in the offing.

But once he had put the rebelliousness of his youth behind him, Cézanne showed no interest in creating new avenues of expression. Indeed, in his adherence to the basic forms that had dominated painting for centuries – the landscape, the portrait, the still life, the figural composition – he appears less innovative than many of his contemporaries. Out of step with his time, he would become timeless. These traditional forms offered him the greatest scope for his new way of seeing. Unlike Degas, Seurat, Gauguin, or Van Gogh, all of whom developed new ways of painting, Cézanne stuck to the tried-and-true. What distinguishes him, and what prevented him from falling into the routine that characterizes much Impressionist work, was his uncommonly intense way of looking at things. He would gaze at his subject as though transfixed, constantly rechecking his perceptions; it would not have occurred to him to piece out one work with solutions he had worked out in another. Although claiming to follow in his footsteps, the modernists failed to appreciate that it was precisely Cézanne's way of looking, his ability to analyze what he was seeing, that allowed him to create.

Cézanne confined his looking to nature, specific people, and the simple objects he permitted into the private world of his still lifes. He avoided any involvement in social concerns, for that would have led him too far away from his essential aim, a life true to nature, not the historical moment. He had no interest in active men of affairs either from the past or in his own time. He admired Daumier and Courbet, but he was as blind to their social criticism as he was to the touch of urbanity in Manet and Degas or the untroubled concentration on moment in Pissarro and Monet. So as to keep his own world free of any of the political or societal concerns of his century, Cézanne largely avoided contemporary references. And just as he turned his back on his own time, he had no use for all the clichéd, historicizing trumpery of the past. The spare, motionless world of his pictures presents a reality unaffected by the evanescent.

Just as his landscapes rarely evoke a specific season of the year, his portraits rarely include any of the sitter's identifying personal effects, and in his still lifes, everyday objects appear to have been relieved of any particular function. The artist projected his own isolation into a nature unencumbered by man and his doings. The tightly closed structures of his pictures seem forbidding, like himself. While he succeeded in creating his own compelling view of nature out of landscapes, unique bodies out of figures, fresh still lifes out of mundane objects, and noble portraits out of unimposing faces, in every case it was the motif itself that attracted him. He very deliberately stripped his subjects of the dimension of time; in their transmutation into painting, much of what made them unique – their momentary appearance or their specific condition – necessarily fell by the wayside. While he never went so far as to espouse the radical doctrine of *l'art-pour-l'art*, in which art becomes its own subject, the painter did think of each subject primarily as an occasion for his intensive analysis of color forms.

Some have insisted that Cézanne's carefully regulated life in Aix-en-Provence had but little to do with the only thing that mattered to him, namely his art. In fact, nothing could be further from the truth. The tedium of his living conditions, largely devoid of social contacts – although in his later years, the artist shared many of the prejudices of the small-town bourgeois – explains an iconography that differs greatly from the subject matter being pursued by artists elsewhere, whether in Paris, Arles, or Tahiti. Cézanne derived all of his strength from the landscapes, the people, and objects

of his day-to-day existence. His deepest insights into the essences of things were based on the scenes most familiar to him. In the Provençal landscapes he had known since childhood, in the homely objects near at hand in his studio, and in sitters he was well acquainted with, he found the subjects on which to imprint his artistry. Motifs he was unable to study for long periods of time gave him trouble. This was one of the reasons why he chose not to portray, like the Impressionists – intent on investing everyday life with the radiance of an eternal Sunday – anonymous people pursuing their daily pleasures on the boulevards, at the beach, in parks, or at the racetrack.

In the 1870s, under the gentle guidance of Pissarro, Cézanne managed to put behind him the excessive energy of his earlier pictures, their active figures caught up in dramatic action, and devote himself to the more passive experience of nature derived wholly from observation. But his sense of nature has virtually nothing in common with that of the Impressionists, for whom all was atmosphere. While he was in close contact with those painters from 1872 to 1877, he countered their people-oriented *joie de vivre* with a far more earnest expression. He was determined to translate the things they were content to leave suspended in the moment into durable images freed from the vicissitudes of time. Although he acknowledged the achievements of plein-air painting, he could not resist investing his canvases with an almost idealized notion of formal stability. In order to capture their fleeting images of life, almost all of his contemporaries – Manet, the Impressionists, Degas, Toulouse-Lautrec – invented shorthand techniques employing a free, sketchy style and breaking up the picture view into fragments. Cézanne chose the very opposite approach. To be true to nature as he saw it, he needed a more substantial style rooted in permanence. Time in its passing, the signs of fluctuation or development immanent in nature, were not his concern. What mattered to him was the solidity of things, their stability, not chance lighting effects that made them seem weightless or incidental details that help to clarify their nature. According to Maurice Denis, Cézanne once explained that he wanted to "make of Impressionism something solid and lasting, like the art in museums."[5] While the Impressionists left objects largely undefined and suffused in atmosphere, Cézanne gave them concrete shape through the organizing force of his color forms. He may have borrowed something from Impressionist techniques, but to get past the superficial appearance of reality and arrive at its fundamentals, he needed to tie down his picture relationships, to make them clearer, more comprehensive, more meaningful than the Impressionists did. His colleagues found in shimmering-light phenomena the vital distillate of nature that gives objects a transitory validity. For Cézanne, by contrast, light is not the mere dappling of surfaces but a radiant component of color itself, color's form-giving energy. The Impressionists used patches of color to give their paintings a vibrant sense of life. Cézanne's colors were placed in such a way as to develop definite contrasts with an eye to the structure of the picture as a whole. Applied with either a palette knife or brushes in differing thicknesses, his colors, as a plastic medium, become structural elements themselves.

Although arrived at in conformity to nature, Cézanne's pictorial ideas are autonomous. Exhibiting no particular desire for originality, they are simply based on the forms he saw before him. Sufficient unto themselves, they do not imply anything they are not. The meaning lies exclusively in the pictures – in their complex insights, their clear structures, their logical arrangements, their monumental effects. Any inclusion of textural abundance or charming details would have run counter to Cézanne's notion of painting as an elemental entity, one that derives its substance from color. Although his choices of subjects were personal decisions, the pictures that resulted, placid and untouched by time, appear impersonal and unfamiliar. The artist did all he could to prevent any sense of intimacy with his subjects from creeping into his pictures. He banished everything that might have aroused curiosity or evoked particular emotions. His landscapes, for example, have to make do without a distance fading into infinity, identifiable detail, or informative staffage. In only a very few still

lifes do we find objects associated with an artist's studio or occupation. The ponderous figural scenes with which the young painter shattered the traditions of acceptability like no one before him are distinguished by their alienation; isolation characterizes the later portraits in which externals became a kind of interior monologue. In contrast to the several types of pictures he created *sur le motif*, however, his figural scenes were wholly products of his imagination. Only in his paintings of unhurried, languorous bathers blissfully ensconced in the lap of nature does he make up for the lack of people in his landscapes, and the absence of nature from his early dramas.

<p style="text-align:center">II</p>

In his last years, pressed by a circle of young friends interested in art theory, Cézanne tirelessly emphasized, both in his letters and in conversation, the importance of nature study: "I have little to tell you," he confessed to the budding painter Charles Camoin, "more, indeed, can be said about painting, and perhaps, more pertinently, by stressing the subject than by devising purely speculative theories - in which one often gets lost." After recommending that the young man "make studies of the great decorative masters, Veronese and Rubens, but as though you were working from nature," Cézanne summed up his thinking in the 1903 credo: "Everything, above all in art, is a question of theory developed and applied to contact with nature."[6] In the nine fascinating letters he wrote to Emile Bernard, he also spoke repeatedly of his chief concern: "The artist must disdain all opinion that is not based upon intelligent observation of character. He must be wary of the literary mind, which so often leads the painter out of his true path - the concrete study of nature - and to waste time in abstract speculations. The Louvre is a fine place to study, but it must be only a means. The real, the great study is the endless variety of the natural scene."[7] Cézanne's theories were by no means seamlessly thought out, even though he was perfectly capable of expressing them convincingly in his painting. There, he could demonstrate what he meant, both to himself and to those who wished to learn from him. He left no doubt but that art was "the most intimate manifestation" of himself, and work his sole vindication in the eyes of the public and of history. "I was a painter of your generation more than my own.... I won't have the time to express myself ... we must work.... The reading of a model and its realization are sometimes very slow in coming."[8]

"Realization," which for him consisted of carefully observing, analyzing, and perfecting one's painterly response, became a key concept in Cézanne's thinking and his work. "I feel I am getting closer every day, albeit somewhat painfully. For if a strong feeling for nature - and mine is certainly intense - is the necessary basis for any artistic concept, and upon which rest the grandeur and beauty of future work, a knowledge of the means of expressing our emotion is no less essential, and can only be gained through long experience." Only a strong feeling for nature, in connection with awareness "in the face of nature" of the means at one's disposal, can lead to the realization "of that part of nature that, falling under our eyes, yields up the picture to us."[9] This is how the painter might have summed up the complex process of working *sur le motif* to create a picture that can stand on its own, one whose reality is equivalent to the reality of nature.

From Cézanne's various comments it is clear that for him, "contact with nature," whether a landscape, a figure, or a simple object, was what mattered most in the making of a picture. Over the years, a profound understanding of nature had become for him at once his inspiration, his point of departure, and his goal. He was not one to invent things on his own. His originality lay in his ability to make us see even the most banal objects in a new way, and endow them with a life of their own. In many of the late works, one has the impression that painterly considerations have become more important to him than the depiction of the given motif, but in fact, his color forms

never cease to reflect the reality he saw before him. "I have nothing to hide when it comes to art,"[10] he insisted, and indeed it is possible, given the way he worked, to see how he responded to every visual impression he received. Many critics have dismissed his working method as an end in itself, arguing that the original image tends to get lost in his increasing tendency toward abstraction. In doing so they cast the artist, after the fact, as it were, in the role of a precursor, but one that has nothing to do with what makes him a true pioneer. For it was not his tendency toward abstraction that set the tone for painting in the twentieth century, but rather the consistency with which he reached the countless decisions required in the creation of a picture structure that could stand as an independent entity – and his constant questioning of the correctness of those decisions. His abstraction does not draw away from the subject. On the contrary, it was his way of presenting the subject more palpably on the picture surface, utilizing multiple points of view, and incorporating it, mindful of its actual appearance, into a harmonious system of color. If one compares his paintings with the actual subjects he worked from – very few survive in the state he found them in – one discovers that forms at first thought to be unrelated to the subject and wholly enmeshed in increasingly independent sequences of color suddenly take on a definite meaning, reflecting some feature of the reality before him. For Cézanne, painting was a matter of "realizing" through color the objects presented him with a constant view to the integrity of the picture as such. The Cubists who followed him paid increasingly less attention to actual objects, intent on investigating, with their disintegrated forms and minimal use of color, independent pictorial configurations.

Cézanne's reality-based paintings document his tireless, at times discouraging, search by way of constant "study of nature" for insight into the essential nature of art. At the beginning, he vehemently challenged accepted stylistic conventions; in the end, he had become aware of the need to create art as an independent phenomenon "parallel to nature."[11] The mature painter rejected naturalistic verisimilitude just as decisively as he had in his youth. What he sought instead was a reflection in artistic terms of nature's creative force and intensity. His idea of what constitutes a picture was something uniquely his own. Working in accord with nature, not copying it, he strove to create pictorial structures with a logic of their own. Thanks to the empathy he brought to his observation of nature and his profound knowledge of artistic traditions, he was able to reconstruct nature's forms and configurations, and thereby create a pictorial reality equivalent to that of nature. His inspiration came from his contemplation *sur le motif,* and in the course of it, he constantly developed new ideas about how to accomplish what he wanted. No matter how often he stationed himself in front of a particular view, drawn back to it not so much by its specific charm as by its immutability, each of his paintings of it was different from the one before, each representing a new painterly solution. In a letter written to his son on September 8, 1906, he alludes to this: "Anyhow, I must tell you that as a painter I am becoming more lucid with regard to nature, but in my own mind the realization of my feelings is still very difficult. I can't manage to achieve the intensity my senses feel, I don't have that magnificent richness of color that livens nature. Here, on the riverbank, there are so many motifs, the same subject seen from another angle offers a subject of the most compelling interest, and so varied that I believe I could work away for months without changing position but just by leaning a little to the right and then a little to the left."[12]

Everything in a Cézanne picture seems artificial: its color structure, the odd distortions of its forms, the way nearness and distance behave in defiance of perspective conventions, the way light is used to define form. Even so, one has the impression that when creating it he worked precisely as his way of seeing told him to, following a process analogous to the working of nature. Each of his pictures has a truth of its own, one that the painter developed through observation, in harmony with nature, and fully conscious of what a painting can and cannot do. Each represents a solid structure derived from painstaking analysis of nature's processes, one that depicts

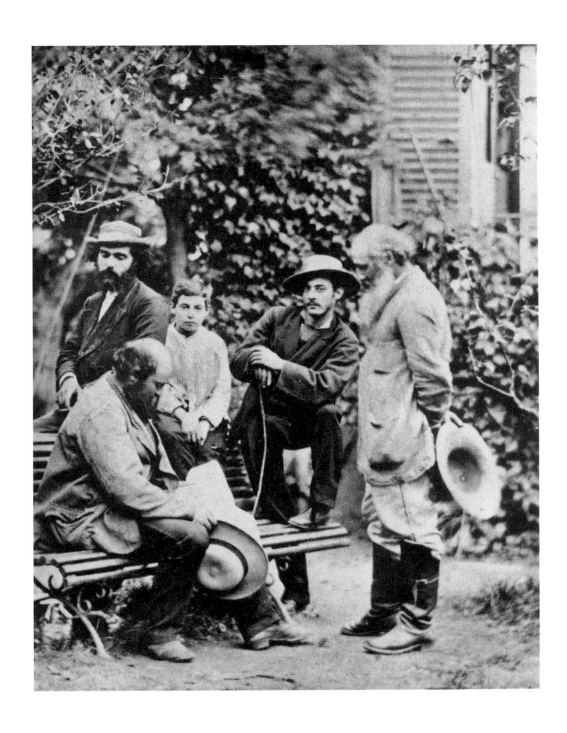

Paul Cézanne (seated) and Camille Pissarro (standing, right),
1877 photograph taken in Pissarro's garden in Pontoise

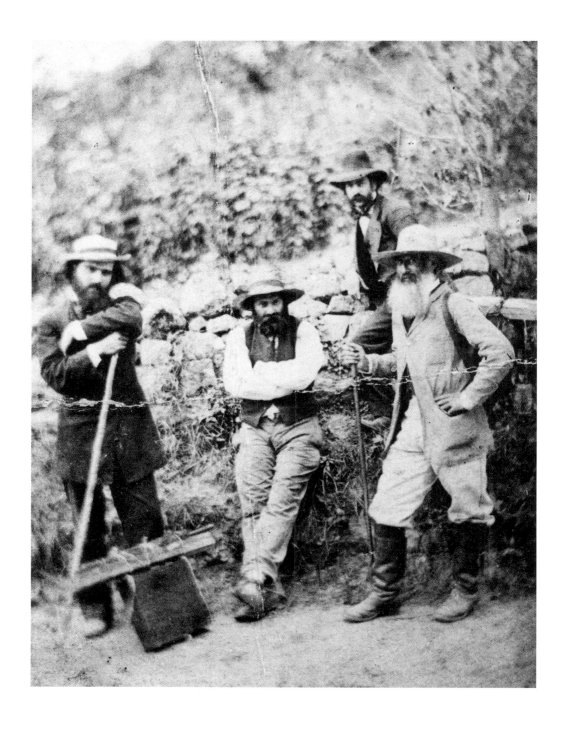

Paul Cézanne (center) with Camille Pissarro (right) in the vicinity of Auvers.
photograph circa 1877

but does not imitate. Again, in those places where it is still possible to see the view that Cézanne had before him, one can only be disappointed at how indistinct the reality appears. Unavoidably, it is the artist's picture that one envisions instead of the actual scene. With almost no hint of either partiality or antipathy, Cézanne translated the mutable substance of reality into images of absolute durability. He may have imposed seemingly illogical distortions on the simple objects in a still life, but in the finished picture, they appear to have stood in just such a relationship to one another for all eternity.

Cézanne was convinced that the painter's primary task was to "render the image of what we see … forgetting everything that appeared before us."[13] Although he admitted that "feelings [are] at the bottom of what I'm doing," he stressed that "optics, which we develop through study, teaches us to see."[14] This was his way of explaining that unprejudiced observation takes precedence over our knowledge of the forms, substance, and functions of things. All that matters is selecting the visually relevant data and relating them to the picture as a whole. Looking a second time at what first appears to be only a pattern of light and dark colors, one discovers the motif, almost unexpectedly, in *statu nascendi*, and recognizes these *sensations colorantes* as primary visual impressions. Only an unprejudiced eye can identify the colors actually seen, and once these are established, the remaining details fall naturally into place.

Cézanne, like his revered Delacroix, believed that color alone creates structure. To him, it was the most important element in painting, the focus of all his deliberations. By differentiating more and more precisely between the color actually seen and what his knowledge of his subject told him he ought to see, he developed a way of looking that registered color impressions he could trust, unprejudiced by his knowledge of how things should look. Straining his formidable powers of concentration to their fullest, he would keep studying that reality, initially consisting only of arbitrary colors and forms, while placing his first balanced colors on the canvas. Then, gradually, he would develop out of this still-nonobjective vision a picture structure in which objects and spaces might interact in a convincing way with the picture surface. The picture space and the actual objects it contained only took shape as the result of a logical sequence of color decisions affecting the structure as a whole. Strokes of color represented the painterly equivalents of observed forms, but at the same time, they were part of an overriding pattern that assured the picture's integrity and gave it a consistent intensity across the entire spectrum of color.

In one of the remarkable letters about Cézanne written in 1907 by Rainer Maria Rilke to his wife, the poet insisted that it had "never been so clear how much painting proceeds beneath the colors, how one must leave them completely alone so that they can come to terms with each other. Their dealings among themselves; that is what painting is all about. Anyone who interrupts, who attempts to regulate, who allows his human responses, his intellect, his role as intermediary, his mental agility to intrude in any way, only disrupts and muddies their interaction." In another passage he remarks: "I feel that in Cézanne the two processes, that of observing and correctly perceiving, and that of appropriating and making his own use of what has been perceived, worked against each other, perhaps owing to his awareness of them, that they began speaking simultaneously as it were, interrupting each other constantly, incessantly quarreling. And the old man put up with their discord…."[15]

The objects in Cézanne's early paintings were highly simplified, formed with crude strokes of impasto colors. In the 1870s and 1880s, when the painter developed his method of covering his canvas with uniform strokes of precisely calculated color, his objects became more clearly defined. Then, in his late period, he again drew back from the object, favoring a close-knit fabric of relatively short color forms placed next to each other, either vertically or diagonally, with a broad brush. These colorful patterns, different in character depending on how he held the brush, the pressure he applied, and the angle of his stroke, coalesce into larger structures that fix the given

spaces or solid forms onto the picture surface. The objects are left to reveal themselves in the same way they do in nature, emerging out of nonobjective patterns of color. The texture of color is the essential substance of the painting, and as such, it guarantees the stability of the pictorial structure. It represents a kind of foundation, out of which the subject rises in varying degrees of clarity. It also draws the front and back of the picture space more closely together. With no regard for our habit of seeing things in perspective and our expectation of a uniform spatial continuum, the artist seems to want to push away objects lying near at hand while drawing the background closer. It is as though he wished to deny his intimate knowledge of the closer objects while at the same time defining those in the background more clearly, refusing to allow them to be drawn back into arbitrary vanishing points. Even the most distant objects become structural elements, and are required to fit into color coordinates of the picture surface.

As a painting progressed, its color references became increasingly complex, and the objects represented only revealed themselves as reference points woven into the texture of color. Rilke explained that it was as though Cézanne had weighed them on a scale: "Here the thing, and there the color; never more, never less than what is required for equilibrium. It can be a lot or a little, it depends; but it is precisely what befits the object."[16] At the same time, it was necessary to treat all parts of a picture equally. The painter could not allow the larger forms and most extreme colors set down in the beginning to dominate his painting. He had to bring the entire structure into balance. All that was then left to do was to see that each detail was given precisely the prominence it deserved, and to refine the whole in such a way as to pull together the picture surface, the objects, and the space within a seamless network of color. Each new addition had to be a logical response to what was already there. No individual color could be permitted to call attention to itself at the expense of the others, and thereby destroy the integrity of the entire structure. It is as though the tiniest thread was required to know its place in the fabric of the whole.

On September 21, 1906, only a few weeks before he died, Cézanne managed to sum up in a letter to Bernard much of what he had only recently tried to express in terms of theory but had been practicing for decades. At the end, he still questioned his understanding of nature and the appropriateness of his painterly response to it:

> It seems to me now that I can see more clearly and am thinking more correctly in forming my studies. Will I ever achieve the goal I have sought so fervently and pursued so long? I hope so, but as long as I haven't reached it, I have this vague unrest that will not disappear until I have reached port, or until I have achieved something better developed than in the past, and thereby proving theories, which for that matter are always easy; it's only giving proof of what one thinks that presents serious obstacles. So I'm pursuing my studies.... I'm still painting from nature, and it seems to me I'm making some slow progress.... I believe in the logical unfolding of what we see and feel by studying nature, never mind bothering about the ensuing processes, those being only mere means for us to manage to make the public feel what we ourselves feel and to accept us. The great men we admire must have done no differently.[17]

III

Anyone attempting to organize Cézanne's artistic output, the work of over forty years and comprising some twenty-seven hundred paintings, watercolors, and drawings, is confronted with enormous difficulty.[18] There is no possible way to arrange it in a clear chronological sequence. Even stylistic analysis is problematical, for he often worked in various styles at the same time, and it is not uncommon to find him going back to one

he had abandoned long before. Of the 839 paintings listed in the catalogue raisonné, only six from the early period carry definite dates.[19] The situation is much the same for the 1,223 drawings and 645 watercolors.[20] Although it is possible to date about a hundred of the paintings with some degree of certainty from external evidence, one cannot pin down an equal percentage, small though it is, of the drawings and watercolors. In most cases, one is thus forced to deal with only approximate datings, representing large spans of time and distinct changes in style. In each medium there are reminiscences, overlappings, and prefigurings, so that one must exercise caution when assigning works to more specific dates. Even obvious close connections between paintings, watercolors, and drawings prove misleading, for Cézanne favored specific landscape views or still life subjects for years at a time, and for want of models for his late figural compositions, it is clear that he referred back to early academy studies. Stylistic advances are by no means reflected equally in all picture genres, and works in fact produced at the same time can differ radically. On the one hand, the artist tended to maintain certain basic stylistic traits – with interruptions – for a long time, but on the other, he might introduce a specific innovation and immediately abandon it, only to take it up and explore it further years later, possibly in a different context. Ideas once worked out he carried with him always. It made no difference that in his later work he tended to be much more objective, putting the emotionalism of his early years behind him; much of what informs the exciting work of his late period was prefigured in his early work, born of conflict and controversy. Only one thing is certain: There is no simple approach to the Cézanne œuvre, whose incredible breadth, seriousness, and beauty defy easy categorization.

In his letters, as we have seen, Cézanne stressed again and again that a painter must devote himself above all to the study of nature, and it is clear from his large number of landscapes, representing his major interest, that he never ceased to do so himself. Yet, there does not appear to be any type of landscape that he particularly favored; he was obviously challenged by all kinds. He was just as likely to select some unprepossessing, restricted close-up view as an expansive panorama or a complex configuration of angled rooftops. There is a constant alternation between confinement and spaciousness, between more modest views constricted by trees and open prospects of the sea or distant mountains. He was drawn to the panorama of the ring of hills surrounding Aix, to Mont Sainte-Victoire, to the bay at L'Estaque, but also to the tumbled rocks at the Bibémus quarry, which encouraged him to experiment with sharply angled views from above or below. Parks with allées, steep-hill towns, and woodland interiors were just as much a part of his repertoire as were isolated stands of trees, brooks, and overgrown riverbanks. One does note the absence of typical urban motifs. There are no street scenes or views of the industrial complexes found in Paris, Aix, or Marseilles. Doubtless the painter found that traffic and crowds of people distracted him from his work. Moreover, in his old age he came to deplore all technical advances and the so-called progress they unleashed.[21] When cities or villages do appear in his pictures, they are usually found in the distance, viewed from a "safe" vantage point, with no sign of people in their streets and houses.

As noted earlier, roughly 40 percent of Cézanne's paintings are landscapes; still lifes and portraits account for 20 percent each; figural scenes and bathers, 10 percent each. The ratios are somewhat similar for his watercolors, though there, the percentage of landscapes is even higher, and watercolor portraits are quite rare. In the drawings, landscapes are by no means as plentiful as figure sketches and portraits, and studies done after the works of other artists clearly predominate. Cézanne initiated this dialogue with works of art from the past in about 1865, and it is represented in nearly four hundred studies based on more than one hundred and sixty different works, or in roughly a third of his total number of drawings. Oddly, there are no signs of others' work in his canvases. Doubtless his study in museums was intended primarily to increase his repertoire of forms. It is also likely that he would have felt uncomfortable

working with easel and canvas, brushes, tubes of paint, and palette in front of inquisitive museum visitors eager to compare his work with the originals.[22] It was easy for him to carry along his sketching block, but transporting all of his painting paraphernalia would have been a considerable bother.

The papers he used for drawing and for watercolors have the most common standard dimensions of the day, and his canvases likewise tend to be the stock medium sizes readily available. The dimensions of fully half of his paintings fall within a range between approximately 18 x 21 inches (46 x 55 cm) and 28 x 36 inches (73 x 92 cm).[23] These were the formats easiest to handle out of doors. Smaller canvases turn up mainly in the 1860s and 1870s, while larger formats were employed only for a few portraits and figural paintings in his early years and again after 1890.

When laying out the basic structure of a painting, Cézanne tended to use either pencil or crayon, or – beginning in the mid-eighties – a deep ultramarine blue heavily diluted with turpentine. On his half-finished canvases one can occasionally see that such preliminary sketching was done in a dark gray or brown. It was only meant to be approximate, a temporary orientation on the bright ground of the canvas. At first, nothing is clearly defined. the network of lines merely marks the main contours of the picture and suggests how they relate to each other. One might compare it to the scaffolding used in construction, which gives an indication of the shape of the building to be erected and reveals its function only as the work progresses, only to disappear once it is no longer needed. The painter was now ready to begin applying colors, one by one, at first in seemingly arbitrary patches, a few small dots or larger shapes reinforcing the intersecting lines already there. In time, the preliminary drawing came to be replaced by an increasingly diverse texture of color forms, the deepest tones overlaid by progressively lighter ones. Once these first colors began to join together in calculated "modulations" from darkest to brightest, the theme of the picture gradually emerged, its shapes rising up into visibility out of the shadows.

The painter Emile Bernard was in Aix-en-Provence in February 1904 and again briefly at the end of March 1905. During those visits, he had various opportunities to accompany Cézanne on his way to his painting site. Thanks to him, we know something of how the painter worked – at least in his late years – and how he arranged his palette. According to Bernard, Cézanne avoided mixing his colors when painting. He kept "full ranges of all gradations of the various colors on his palette, which he then applied in succession."[24] Cézanne's palette was exceptionally rich. It was made up of five values of yellow, six of red, three each of green and blue, and peach black.[25] Bernard recalled that Cézanne worked extremely slowly, and would stop what he was doing the moment his concentration lagged. He frequently left pictures unfinished.

"For example, in a small storeroom next to his studio on the top floor in the rue Boulegon, I saw numerous landscapes that were neither sketches nor studies, but only initial scales, which had not been developed any further on account of the weather. A number of motifs were there in which the canvas had not even been fully covered with pigment. People have made the mistake of judging Cézanne on the basis of works like these that he had started, but then abandoned himself."[26] Today's viewer, accustomed to looking at all styles of contemporary painting, may be prepared to find these unfinished works fully conceived, with their free distribution of color rhythms and interspersed patches of bare canvas. To Cézanne, however, they were simply proof of his inability to create what he wanted. He would hardly have approved had he heard Pissarro calling special attention to the beauty of his unfinished still lifes, or known that Denis, in 1907, would go into raptures over the mystique of works never completed. It is therefore a mistake to mention starts of paintings in the same breath with watercolors, despite their similar feeling. Such paintings were simply abandoned because the artist found himself faced with insoluble problems, and therefore chose to avoid the endless new decisions required to carry on. In the watercolors, the empty

spaces are part of the artist's conception; there, he would stop painting the minute any additional application of color threatened to muddy the overall structure.[27]

There are indeed certain similarities between Cézanne's oils and watercolors, but this is not the place in which to inquire to what extent his watercolor technique influenced his work in oil. Admittedly, it would appear that in a considerable number of paintings the artist did incorporate artistic solutions that would have been available to him in watercolor. One might also argue that something of the compactness of the early paintings executed with a palette knife carried over into his work in watercolors, and conversely, many of the late paintings reveal an attempt at the open feeling provided by watercolor's white ground. Yet, neither this openness nor his relatively thin application of pigments constitutes adequate proof to support these claims. Close comparison of the watercolors with fully worked oil paintings reveals how little the two techniques have in common. The painter left no doubt about their separate natures.

IV

Cézanne's thinking, at times ingeniously misunderstood, has provided legitimacy to broad reaches of modern art. Were one to name all of the artists who have espoused his ideas with differing degrees of understanding and appropriated specific pronouncements of his to justify their own brand of painting, one would have an almost complete survey of art in the twentieth century. As the painter André Masson snidely remarked: "They have divided Cézanne's apple into four pieces so as to eat it better."[28]

His fellow artists could appreciate the import of his work even before he died. Some of the most important of his contemporaries, Pissarro, Monet, Renoir, Degas, and Gauguin, were among the first to buy his paintings. The younger artists of the time – Van Gogh and Toulouse-Lautrec, for example – became aware of the eccentric old painter in Aix through Emile Bernard and Gauguin. It was difficult to know just what he was up to, for between 1863, when a still life of his had occasioned an outcry at the Salon des Refusés, and 1895, fewer than two dozen of Cézanne's works had been exhibited publicly in Paris. Among these were the three paintings shown at the first Impressionist exhibition in 1874 and the fourteen paintings and three watercolors included in the third in 1877. The only place one could see his paintings was in Montmartre, in the shop belonging to Tanguy, where Cézanne sometimes stocked up on painting supplies. The artist had left them there in payment, for until his father's death in 1886, he was wholly dependent on a modest monthly allowance from home and sporadic advances from Zola. It was at Tanguy's that the young Paris art dealer Ambroise Vollard saw his first Cézannes in 1892. As he later recalled:

> One rarely entered the rue Clauzel, since at that time it was not yet the fashion to pay high prices for these "atrocities," for that matter not even low ones.
> If some admirer did show up looking for a Cézanne, Tanguy would lead him to the painter's studio, to which he had a key, and there he could choose from the various stacks of pictures at the fixed price of forty francs for the small ones and a hundred francs for the large. Cézanne had painted over some of the pictures with small sketches of various subjects. He left it to Tanguy to cut them up. They were meant for those buyers who were unable to pay either forty or a hundred francs. Thus one would see Tanguy selling small "motifs" with his scissors, while some Maecenas or other handed him a louis and made off with "Three Apples" by Cézanne.[29]

It was Vollard, at the urging of Pissarro, Monet, and Renoir, who mounted the first exhibition devoted exclusively to Cézanne at his gallery in the rue Laffitte in late

1895. After almost two decades of near obscurity, Cézanne was thus suddenly thrust back into the public eye.[30] Heretofore he had been known to only a small circle of cognoscenti, among them the collector Victor Chocquet and Dr. Gachet, but the Vollard exhibition served to stimulate broader discussion of his work. Earlier critics had either expressed utter bafflement or aligned the painter with the Impressionists, as had Théodore Duret in 1878, Zola in 1880, and Joris Carl Huysmans in 1883 – though the last named would later revise his thinking. The first enthusiastic review of the show was penned by the critic Gustave Geffroy: "In the rue Laffitte, passersby can step into the Galerie Vollard and be confronted by some fifty pictures – figures, landscapes, fruits, flowers. On seeing them, one can at last form an opinion about one of the greatest and most appealing personalities of our time.... He is a great fanatic for truth, fiery and naive, caustic and nuanced. He will one day be hung in the Louvre."[31]

Even after the exhibition, Cézanne's two closest friends from earlier years, Zola and Pissarro, continued to represent opposing viewpoints. Zola's only previous published comments about the artist had appeared in 1867 and 1880; he still considered him an "unrealized genius." The writer had had no contact with Cézanne since the latter had broken off their relations in 1886. In a review of the Salon in *Le Figaro* on May 2, 1896, one in which Zola took to task the painters who were then only aping the onetime Refusés, he recalled his boyhood friend: "I had grown up virtually in the same cradle as Paul Cézanne; one is only now beginning to discover the touches of genius in this abortive great painter." Pissarro, on the other hand, whose Cézanne collection numbered at least fifteen paintings either given him by the artist or bought from Tanguy and later Vollard, finally felt vindicated in his championship of his onetime protégé. He wrote about the exhibition in several letters to his son Lucien:

> I also thought of Cézanne's show, in which there are exquisite things, still lifes of irreproachable perfection, others, *much worked on* and yet unfinished, of even greater beauty, landscapes, nudes, and heads that are unfinished but yet grandiose, and so *painted*, so supple.... Curiously enough, while I was admiring this strange, disconcerting aspect of Cézanne, familiar to me for many years, Renoir arrived. But my enthusiasm was nothing compared to Renoir's. Degas himself is seduced by the charm of this refined savage. Monet, all of us.... Are we mistaken? I don't think so. The only ones who are not subject to the charm of Cézanne are precisely those artists or collectors who have shown by their errors that their sensibilities are defective. They properly point out the faults we all see, which leap to the eye, but the charm – that they do not see. As Renoir said so well, these paintings have – I do not know what quality, like the frescoes of Pompeii.... Degas and Monet have bought some marvelous Cézannes; I exchanged a poor sketch of Louveciennes for an admirable small canvas of bathers and one of his self-portraits.

In a letter from December 4, 1895, Pissarro again wrote about the enthusiasm shown by his artist friends:

> You can imagine how difficult it is for me at times to make certain collectors, friends of the Impressionists, recognize all of Cézanne's great, rare qualities. I feel that centuries will have to pass before they are properly appreciated. Degas and Renoir are full of enthusiasm for Cézanne's works. Vollard showed me a drawing with a few pieces of fruit; to determine its lucky owner, they drew lots. Degas was so excited by Cézanne sketches! What do you say to that? Was my eye not correct in 1861 when Oller [a friend of Pissarro's] and I visited the strange Provençal in the Atelier Suisse, where Cézanne was doing drawings of nudes that were the laughingstock of all of the school's muddlers?[32]

Renoir owned but four Cézannes (see cat. no. 30); however, Monet, with thirteen (see cat. nos. 27, 95), had a group that put all the other artists' collections in the shade in terms of quality. Pissarro, Renoir, and Monet had mostly landscapes, but not so Degas, who had only slight interest in the genre. His purchases from Vollard included three portraits, two still lifes, a mythological scene, and the standing figure of a bather, which now belongs to Jasper Johns.

Beginning at the turn of the century, Cézanne became, as Pissarro remarked, "greatly *en vogue*, which is quite astonishing."[33] He took part in the exhibitions of the Salon des Indépendants in Paris in 1899, 1901, 1902, and 1905. He showed thirty pictures in the Salon d'Automne in 1904, ten each in 1905 and 1906. After his death in October 1906, two retrospectives were held that served especially to acquaint younger artists with his work. The Galerie Bernheim-Jeune showed seventy-nine watercolors in an exhibition that ran from June 17 to 29, 1907, and in October of that year, within the framework of the fifth Salon d'Automne in the Grand Palais, mainly devoted to Belgian art, two galleries were given over to a Cézanne memorial exhibition with forty-nine paintings and seven watercolors.

Of the younger artists, Matisse was the first to share an enthusiasm for Cézanne and demonstrate how much he was inspired by him. At the age of eighty, in 1949, he stressed that in all of modern art it was Cézanne to whom he owed the most.[34] Fifty years earlier, in 1899, he had bought a small Cézanne painting of bathers at Vollard's for twelve hundred francs. It accompanied him wherever he went for the next thirty-seven years, until he finally donated it to the Musée du Petit Palais in Paris. On November 10, 1936, he wrote to the curator of the museum from Nice: "In the thirty-seven years it belonged to me, I came to know this picture very well, and yet not completely, I would hope. In critical moments of my artistic adventure it gave me courage; from it I drew my faith and my perseverance. Therefore, permit me the request that you give it the location it requires for full effect. For that it needs both light and distance. It is exquisite in color and in design; in the distance it reveals the vigorous energy of its lines and the extraordinary calm of its relationships."[35]

In 1907, Matisse had painted his famous *Blue Nude: Memory of Biskra* (illus. 1), a work in which he attempted to combine African influences with Cézanne's precepts and one that served as a challenge to both Picasso and Braque. He may have patterned his painting after Cézanne's larger-than-life-size *Reclining Nude*, created for the Salon exhibition in 1870. The work has long since disappeared, and our only indication of what it looked like is provided by a caricature of Cézanne produced at the time (illus. 2). This large-format painting from his early period once belonged, together with four other Cézanne paintings, to Gauguin, but for financial reasons Gauguin was forced to give it back to Tanguy. In the early 1890s, then, it was again possible to see the *Reclining Nude* at Tanguy's in the rue Clauzel.[36] Matisse could have come upon the Cézanne nude somewhat later at Vollard's. The Fauvist Matisse would have been particularly drawn to the early Cézanne's revolutionary attitude, his imposing challenges to the Salon. Even as late as 1870, Cézanne had mocked its conventions with his "savage" pictures. It would have been logical, then, for Matisse, in the first important picture he produced after Cézanne's death, to refer back to one of that artist's major early works. The deliberate ugliness, crudity, and primitivism of his homage to Cézanne may well have been intended as an affront, like the earlier work that inspired it, to the Salon's notions of what constituted beauty.

Throughout his life Matisse continued to be influenced by the "master of Aix." In time, he acquired five of the artist's earlier paintings (see cat. no. 40). He gave some indication of how much Cézanne meant to him in his thoughtful comments to an interviewer in 1925:

If only you knew how much moral strength, how much encouragement his wonderful example has given me all my life! In moments of wavering, when

28

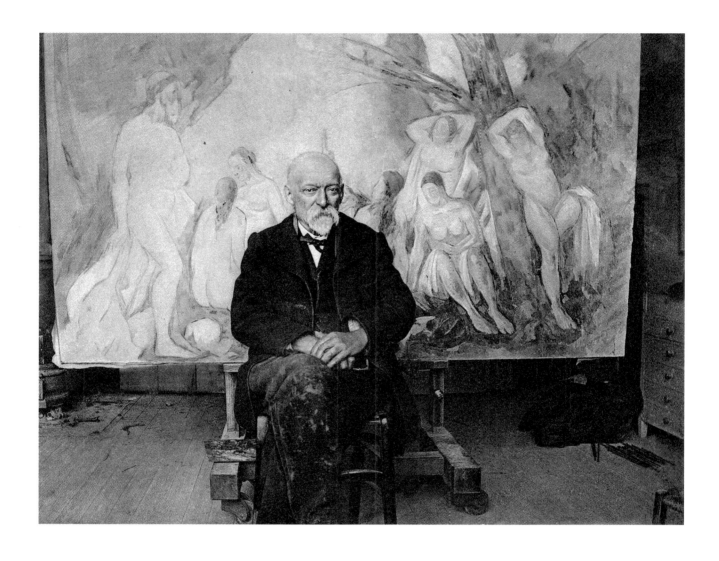

Paul Cézanne in front of the unfinished painting *The Large Bathers* (The Barnes Foundation, Merion), photograph by Emile Bernard, 1904

I was still trying to find myself, I would sometimes be alarmed at my discoveries, then I would think: "If Cézanne is right, I am right too," and I knew that Cézanne had not been mistaken. In Cézanne's work, you see, there are structural laws that are very useful to a young painter. He thought of his painting profession as a great mission, and among his other remarkable virtues he had a desire to allow the colors to work as forces in a picture. It should thus come as no surprise that Cézanne wavered so long and so constantly. For my part, whenever I step up to my canvas I always feel that I am painting for the first time. Cézanne was blessed with so much potential, that he more than another needed to order his thoughts. Cézanne, you see, is probably a sort of great god of painting. Is he dangerous, his influence? And if he is? All the worse for those who haven't the strength to endure him! Not being robust enough to endure someone's influence without growing weak is a sign of ineptitude.[37]

The Cubists, from Braque and Picasso to Duchamp and Mondrian, arbitrarily acknowledged Cézanne without troubling to discover precisely what he was about, notably his relationship to nature. As for that relationship, the master's often-quoted recommendation that one "deal with nature as cylinders, spheres, cones," first published by Bernard in 1907, was widely misinterpreted. A striking example of this appears in Malevich's tract *On the New Systems in Art*, issued in Vitebsk in 1919: "Cézanne had become aware of the basis of geometrizations, and very deliberately singled out for us the cone, the cube, and the sphere as characteristic varieties on the principles of which nature is to be constructed."[38]

Braque literally followed in Cézanne's footsteps, finding inspiration in the very spots where the older painter had often worked. He went to L'Estaque for the first time in October 1906 – the month in which Cézanne died – and stayed until February 1907. He returned in the fall of that year, and it was there that he developed his pre-Cubist style *sur le motif*. Then, as a Cubist, he painted in June 1909 in La Roche-Guyon, in the valley of the Seine, where Cézanne had also worked twenty-four years earlier. In 1961, Braque spoke of Cézanne's importance for him, both in his pre-Cubist and early Cubist periods: "It was more than influence, it was an initiation. Cézanne was the first one to turn away from scholarly, mechanical perspective. …"[39] A similar enthusiasm was expressed by Picasso in 1943: "He was my one and only master! … he was like our father. It was he who protected us.…"[40] Picasso had begun to be fascinated with

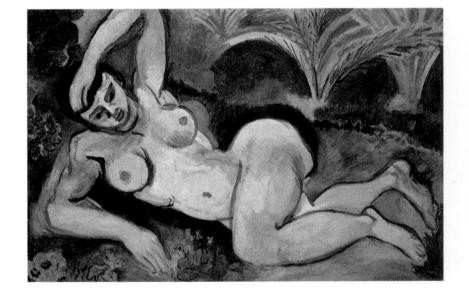

Cézanne's figural pictures in 1905–6, and would continue to study them up until his late years. Having bought two large Cézanne landscapes in the 1930s and 1940s (see cat. nos. 23, 96), he added yet another composition with bathers to his collection in 1957. Already in the winter of 1908–9, he had created an amusing monument to the master in his *Still Life with Cézanne's Hat* (private collection), featuring a hat of the type Cézanne wore that Braque had bought as a memento. In the following year, in a review of two exhibitions in the Bernheim and Vollard galleries, Apollinaire also praised the genius of Cézanne, whose daring, he insisted, was sometimes alarming: "Yet above all, his painting attests to his struggles, his insecurities, and his sufferings. No one is more reminiscent of Pascal than Cézanne. The literary genius of the former was of the same stature as the painterly genius of the latter. Both artists depicted in their works a grandeur at times exceeding our understanding."[41]

Until only very recently, French museums managed to maintain a haughty reserve with respect to Cézanne. It was only thanks to private donations and bequests that his works found their way into state collections. By contrast, the Nationalgalerie in Berlin, under its director Hugo von Tschudi, bought its first Cézanne in 1897, thereby becoming the first museum to add one of his works to its collections. Following that acquisition, a landscape (cat. no. 25), the same institution added two still lifes in 1904 and 1906 (cat. no. 55). Thanks to Tschudi, the Berlin collection was particularly receptive to various French art movements of the period. Max Liebermann was also partly responsible, as he, together with Tschudi, had gone to Paris in 1896 for the express purpose of examining the Impressionists' work. His own collection, studded with many important paintings by Manet and Degas, included two by Cézanne (see cat. no. 16).

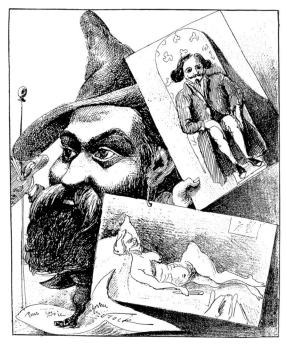

Illus. 2
Le Salon par Stock, caricature of Cézanne with the two paintings rejected by the Salon jury in 1870, lithograph

Rainer Maria Rilke's letters to his wife about Cézanne from 1907 are among the most profound tributes to the artist ever written. Rilke had encountered his first Cézannes at Paul Cassirer's gallery in Berlin, confessing that they then left him feeling "amazed and unsure." No one has ever revealed such insight into the artist's attempt at "objective expression" as did this poet who found in Cézanne his "strongest model," one whom he "followed in all his tracks."[42] Alerted to the memorial exhibitions at Bernheim-Jeune's and the Salon d'Automne by painter Paula Modersohn-Becker, he reported back: "Today I was once again with his pictures; it is remarkable what an ambience they create. Without looking at any specific one, standing in the middle between the two galleries, one feels their presence coalesce into a single, colossal reality. As though these colors relieved one of indecision once and for all."[43]

The artists known as *Der Blaue Reiter* were especially insistent that in their new explorations Cézanne was their guide. Paul Klee had noted in his diary as early as 1909: "Volition and discipline are everything. Discipline with respect to the entire work, volition with respect to its parts ... for me, Cézanne is a master par excellence."[44] In the *Blaue Reiter* almanac published by Wassily Kandinsky and Franz Marc in 1912 – dedicated to the memory of Hugo von Tschudi – Marc wrote of the spiritual affinity between Cézanne and El Greco, whose respective works ushered in new epochs in painting. August Macke's article in the same publication also emphasizes the similarity between the two artists.[45] Kandinsky voiced his ideas about Cézanne in his *On the Spiritual in Art*, also published in 1912. There, he emphasized the "constructive aspirations in the painting of Cézanne" and a "strong resonance of the abstract."[46]

Representing a different viewpoint, Max Beckmann also expressed his great admiration for Cézanne in his "Thoughts on Timely and Untimely Art." His essay was prompted by the important "International Art Exhibition of the Sonderbund" in Cologne in 1912, which included a total of twenty-four Cézanne paintings. While he was at it, Beckmann took Franz Marc to task for an article on the new painting and its patron saint that Marc had published in the journal *Pan*:

I myself revere Cézanne as a genius. With his pictures he was able to express in a new way the sense of the world's mystery that informed Signorelli, Tintoretto,

El Greco, Goya, Géricault, and Delacroix before him. He only managed to do so by taking pains to match his coloristic visions to the artistic realities and to the sense of space, these two fundamental principles of creative art. That alone is how he succeeded in keeping his wonderful pictures from falling into the superficiality of applied art.... In him a tree is not merely a tasteful arabesque or, to use perhaps a fancier term, a structural idea; it is also an organism in itself, one whose bark you can feel, as you feel the air surrounding it and the earth in which it is rooted. It is so silly in general to talk so much of cubism or structural ideas. As though there were not a structural idea behind every good picture, old or new, for all I care one chosen for its cubic effects. Great art is precisely a matter of concealing this to some extent fundamental compositional idea in such a way that the composition once again strikes one as perfectly natural, yet rhythmical and balanced, constructed in the best sense.[47]

In 1909, Aristide Maillol began working on a Cézanne monument for Aix-en-Provence, one that was to take the form of a seated female nude. Among the project's supporters were Monet, Renoir, Liebermann, Bonnard, Matisse, and Picasso. The city fathers put up a strong resistance, however, and the idea had to be dropped in 1920. There was also talk of a monument to him in Russia, but again, nothing came of it. Cézanne had been a known quantity in Russia since 1904, largely because works of his hung in the collections of Sergei Shchukin and Ivan Morosov, and in some of its phases, the Russian avant-garde had been greatly indebted to him. In early 1918, Lenin urged that Russia's cities erect monuments to the heroes of the world revolution, and on the list of notables to be so honored, the name Cézanne stood next to that of the Communard Courbet. In about 1923, El Lissitzky emphasized the Frenchman's influence on the development of Russian modernism in a lecture on the new Russian art: "Cézanne approached his canvas like a field the painter works, plowing, sowing, and growing new fruits of nature on it ... with his work he shattered the endless passivity of museum art. Cézanne still painted objects, still lifes, landscapes, but this was for him only the scaffolding, for his sky blooms in the same colors as his trees, his people, his earth."[48]

After Matisse, the one artist who grappled with Cézanne most intensely was Alberto Giacometti. His drawings and sculptures maintain something of the distance found in Cézanne's pictures, holding back so strangely from our gaze. Giacometti's descriptions of the Provençal artist clearly reveal his own experience. He spent the war years in Switzerland studying Cézanne's ideas and objectives, and concluded among other things that the painter's sole concern was to depict "things – an apple, a head, the mountain ... on his canvas ... just as he saw them, to paint them as precisely, as faithfully as possible ... he freed himself from all fixed ideas, wanting only to reproduce his visual impression, and as precisely as possible.... Cézanne was almost a scientist.... For him the apple on the table always eluded any possible representation. He could only approximate it."[49] Giacometti's own understanding of objects also led him to make the following comment:

Cézanne exploded a bomb by painting a head like an object. He said: "I paint a head the way I do a door, like anything else." By tying the left ear more closely to the background than to the right ear, by linking the color of the hair more closely to the color of the sweater than to the structure of the skull, he demolished the previous concept of the head as an integral whole – and yet, in spite of everything, he too wished to arrive at the integrity of a head. He demolished a whole system; he demolished it so utterly that people began insisting that the head was only pretext, and accordingly, ended up at abstract painting. Now, any depiction that tried to return to the earlier way of seeing ... would no longer be believable. A head whose integrity is preserved is no longer

a head. It belongs in a museum. People don't believe it any longer, because Cézanne came along....[50]

Cézanne continues to serve as a model for any number of artists of our own time. Jasper Johns has acknowledged his indebtedness to him,[51] as has A. R. Penck, who finds inspiration in Cézanne's conceptual achievements, so opposite from the objectives of Pop Art: "Cézanne talked about realization; his pictures can be thought of as models of such realization; seen from our vantage point today, they already have a conceptual character. In the abstract, his is a model that represents a kind of antithesis of Pop Art. What we now speak of as Underground also begins with Cézanne. The insistence on a space of your own and your own idea of what you're after despite the dominant trend of the time."[52] In conclusion, Per Kirkeby accurately summed up all of this in the opening sentence of his most enlightening recent Cézanne article: "Cézanne is a crisis in the life of a painter that comes and goes." He then speaks of the formidable challenge that these small, matter-of-fact canvases represent, and of their creator, who gave his "artist's life in pawn ... for something that makes most of what we normally concern ourselves with look like anxious clamoring for originality and utter superficiality."[53]

For the works cited here in abbreviated form, see the Bibliography, page 282 ff.

1 Cézanne 1984, 95, 97.
2 The painter Emile Bernard visited Cézanne in Aix-en-Provence in 1904 and 1905. In his "Souvenirs sur Paul Cézanne et lettres inédites," published in the *Mercure de France* in 1907, Bernard includes some comments by the painter about the traitorous Zola: "He was a very mediocre intellect and an execrable friend. He only saw himself. Thus it happened that his novel *L'Œuvre*, in which he claimed he was portraying me, is only an outrageous distortion and altogether puts the lie to his fame.... He had been my classmate, we had played together on the banks of the Arc ... Zola became unbearable, the more famous he became, and it seemed to me that he only continued to receive me out of condescending courtesy. It got so bad that I stopped wanting to see him. I have not visited him now for years. One fine day I received *L'Œuvre*. It was a blow for me. I then saw how he really felt about us. In short, it is a very poor book and utterly false." Bernard 1982, 77 f.
3 Monet characterized Cézanne as a "Flaubert of painting, a little clumsy, stubborn, hardworking, sometimes hesitant like a genius struggling to assert itself." Marc Elder, *A Giverny chez Claude Monet,* Paris 1924, 49.
4 Ample proofs of this assertion are scattered through his letters. See Cézanne 1984, passim.
5 Denis 1982, 207.
6 Cézanne 1984, 277-78, 290.
7 Ibid., 297.
8 Ibid., 279, 255.
9 Ibid. 294, 313.
10 Ibid., 290. Picasso described this method very clearly: "Cézanne is Cézanne for the following reason: When he stands in front of a tree, he studies carefully what he sees before him; he fixes on it like a hunter sighting the animal he hopes to kill. Once he has taken hold of a leaf, he does not let it out of his sight. If he has the leaf, he has the branch, and the tree will not escape him. Even if he only has the leaf, that's something. A picture is often nothing but that ... one has to give one's whole attention to all of it at the same time." Jaime Sabartes, *Picasso, Documents iconographiques,* Geneva 1954, 72.
11 In a letter of September 26, 1897, he wrote: "Art is a harmony parallel to nature – what can those imbeciles be thinking who keep saying that the artist always falls short of nature?" Cézanne 1984, 261.
12 Ibid., 322. In an interview published in 1925, Matisse also stressed the necessity of working from nature impressions: "I managed to discover the secret of my art only gradually. It consists of a meditation after nature, of the expression of a dream always inspired by reality.... When you think about it, the classical painters created the same picture over and over again, and always in a different way. From a certain point on, Cézanne kept painting the same picture of the *Baigneuses*. Does one not approach a new Cézanne with the keenest curiosity nevertheless, although the master of Aix painted the same picture again and again?" Matisse 1982, 104.
13 Cézanne 1984, 313. In 1902, the painter told Jules Borély that he wished he could see "like a person who was just born." Borély 1982, 39.
14 Cézanne 1984, 328, 313.
15 Rilke 1977, 37, 21.
16 Ibid., 26.
17 Cézanne 1984, 324.
18 Cézanne's few attempts at graphics, five engravings produced in 1873 at the urging of Dr. Gachet and three lithographs created in 1896-97 for the art dealer Vollard, are unimportant both in terms of quality and quantity. The artist destroyed many paintings and works on paper in 1899, when forced to clear out the studio in his parents' house that he had used for decades.
19 Venturi 1936, nos. 22, 59, 101 (cat. no. 1), 104, 138, 139.
20 Adrien Chappuis published a catalogue raisonné of the drawings in 1973, John Rewald one of the watercolors in 1983.
21 To his niece, Paule Conil, Cézanne wrote on September 1, 1902: "Unfortunately, what we call progress is nothing other than the invasion of bipeds, who won't stop until they have transformed the whole thing into odious quays with gas lamp standards and – even worse – electric light. What kind of times are we living in!" Cézanne 1984, 285.
22 Emile Bernard confirms this in his *Souvenirs* from 1907: "When he led me into his studio one afternoon, I noticed that after he had placed the canvas on his easel and prepared his palette, he waited for me to leave. When I asked, 'Surely I am disturbing you?' he replied, 'I have never been able to stand having anyone watch me at work; I can't do anything when someone else is looking.'" Bernard 1982, 82.
23 These were the French canvas sizes Toile 10, 20, 25, 30; see Cézanne 1984, 115, 197, 228.
24 Bernard 1982, 83.
25 Bernard lists specifically for yellow: brilliant yellow, Naples yellow, chrome yellow, yellow ocher; for red: raw Sienna, vermilion, red ocher, burnt Sienna, madder lake, carmine lake, burnt lake; for green: Veronese green, viridian, green earth; for blue: cobalt blue, ultramarine, Prussian blue. Ibid., 96f. [Rewald 1986, 230].
26 Ibid., 84.
27 Picasso made an apt observation in this connection: "The main thing in modern painting is this: a painter – Tintoretto, for example – worked step by step on a canvas, and only when he had finally covered the canvas with paint and perfected it was it finished. Now, if you take a painting by Cézanne (and you can see this much more clearly in the watercolors), the painting is already there the moment he applies the first brushstroke." Hélène Parmelin, *Picasso: The Artist and His Model, and Other Recent Works,* New York 1965, 150.

28 Discussing an exhibition in 1910, Apollinaire had already observed that it was "indeed probably sufficiently well known that most of the new painters claim to be followers of this serious painter who was solely interested in art." Apollinaire 1989, 106.

29 Vollard 1960, 30.

30 From Aix-en-Provence, Cézanne had shipped some one hundred fifty pictures for the exhibition, of which, owing to space limitations, only about fifty could be shown at once.

31 Gustave Geffroy, *Le Journal*, November 16, 1895. Earlier, an exceptionally farsighted appraisal of Cézanne was written by Georges Rivière in the second of five issues of the journal *L'Impressioniste*, published in 1877. In it, the "artist most set-upon, most poorly treated by the press and the public for fifteen years" was for the first time given his due, in that Rivière did not hesitate to compare the serenity and heroic daring of his pictures with the paintings and terra cottas of antiquity. It would then be another eleven years until Huysmans, in early August 1888, attempted to present an objective appraisal of Cézanne in the journal *La Cravache*.

32 Pissarro 1963, 322, 325; see also 320.

33 Ibid., 392.

34 Matisse 1982, 218.

35 Ibid., 141; this was the painting *Trois baigneuses*, Venturi no. 381.

36 Merete Bodelsen, "Gauguin's Cézannes," in *The Burlington Magazine* CIV, 710 (May 1962), 208f. Bernard spoke of this early nude in his "Souvenirs sur Paul Cézanne": "At the shop of old Tanguy, the paint dealer in the rue Clauzel, I once saw a *Femme nue couchée* that, although very ugly, was a masterful work; for its very ugliness was of the sort of inconceivable, impressive grandeur that prompted Baudelaire to remark: 'Les charmes de l'horreur n'enivrent que les forts.'" Bernard 1982, 91.

37 Matisse 1982, 104f.

38 Cézanne 1984, 296. Kasimir Malevich, *Écrits*, edited by A. B. Nakov, Paris 1975, 289ff.

39 Jacques Lassaigne, *Les Cubistes*, Bordeaux 1973, XVI.

40 Gyula H. Brassai, *Picasso and Co.*, New York 1966, 79.

41 Apollinaire 1989, 92.

42 Rilke 1977, 83.

43 Ibid., 27.

44 *Tagebücher von Paul Klee 1898–1918*, edited by Felix Klee, Cologne 1957, 247f.

45 *Der Blaue Reiter. Dokumentarische Neuausgabe*, edited by Klaus Lankheit, Munich 1979, 23, 56.

46 Wassily Kandinsky, *Über das Geistige in der Kunst, insbesondere in der Malerei*, Munich 1912, 50.

47 Max Beckmann, *Die Realität der Träume in den Bildern. Aufsätze und Vorträge, aus Tagebüchern, Briefen, Gesprächen 1903–1950*, edited by Rudolf Pillep, Leipzig 1984, 39.

48 Sophie Lissitzky-Küppers, *El Lissitzky*, Dresden 1975, 335f. A paean to the "master of Aix" by the Russian poet Ossip Mandelstam began with the lines: "Greetings, Cézanne! Glorious grandfather! Great, inexhaustible worker. Best acorn of the French forests," then continued: "His painting has been certified on the oak table at the village notary's. He is as sound as a testament drawn up by a sound mind and unfailing memory." Frank 1986, 228.

49 James Lord, *Giacometti*, New York 1985, 229. At that time, he also did countless drawings based on Cézanne work; see Alberto Giacometti, *Begegnungen mit der Vergangenheit. Kopien nach alter Kunst*, Zurich n.d., 276ff.

50 Georges Charbonnier, "Entretien avec Alberto Giacometti," in *Le Monologue du Peintre*, Paris 1959, 159ff.

51 In the catalogue of the exhibition *Sixteen Americans* in the Museum of Modern Art, New York 1959, Jasper Johns attests that Cézanne is one of his most important models, along with Duchamp and Leonardo.

52 Stefan Szczesny, *Maler über Malerei*, Cologne 1989 261.

53 Per Kirkeby, "Das Vorhaben Normalität," in *du* (1989), 86, 88.

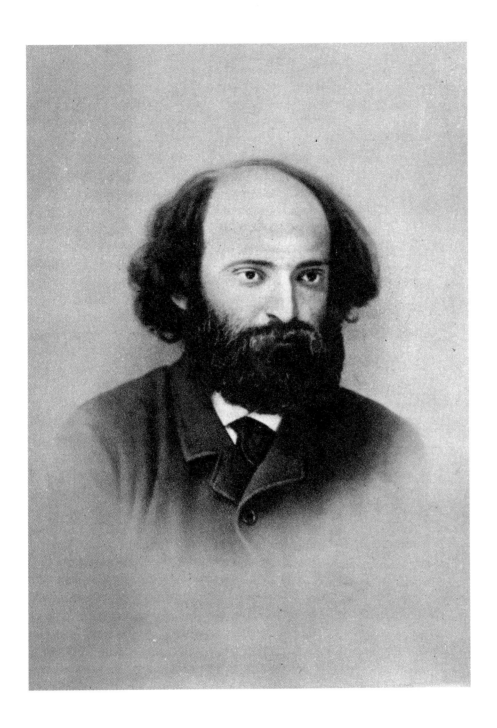

Paul Cézanne, photograph circa 1875

Catalogue

Preface to the Catalogue

The Venturi numbers cited are taken from Lionello Venturi's catalogue raisonné, *Cézanne, son art, son œuvre*, Paris 1936. When a dating indicates a span of several years, any one of the years within that span might be considered as the painting's possible date.

Thanks to the assistance of Jayne Warman, longtime associate of the late John Rewald, I am able to establish consistency between picture titles used in this edition and those that will appear in the forthcoming Cézanne catalogue raisonné.

For this catalogue, almost all of the paintings were photographed unframed, so that the entire canvas is reproduced. Dimensions provided are in inches and centimeters, height before width; small discrepancies may be noted in those few instances where we were prevented from removing the painting from its frame and could not determine precise dimensions.

For full listings of sources and exhibitions cited in abbreviated form in the notes and in other supporting data, see pp. 282 ff. Page numbers in boldface in Bibliography listings indicate an illustration.

1 The Abduction, 1867
 L'enlèvement
 Venturi no. 101 (1867)
 Oil on canvas, 35 1/4 x 45 1/2″ (89.5 x 115.5 cm).
 Dated and signed, lower left
 The Provost & Fellows of King's College (Keynes Collection), on permanent loan
 to the Fitzwilliam Museum, Cambridge

This powerful composition is one of Cézanne's few signed and dated paintings.
The uncommon size of the picture and its signature, added to the fact that the artist
made various preparatory drawings for it as well as a watercolor, also signed,[1] suggest
how much this subject meant to him. It is certain that he intended the mannered
composition for his friend Emile Zola, and he probably even painted it in Zola's Paris
residence in the rue la Condamine. Zola had spoken up for the artist in *Le Figaro* on
April 12, 1867, and it is possible that Cézanne wished to show his gratitude with this
painting (see cat. no. 11).
 Only in his late years, after 1895, did the artist again combine nude figures and
landscape on such a large scale in three oversized canvases with bathers.[2] The central
pair of figures, whose ancestral line runs from Pollaiuolo by way of Tintoretto to
Daumier, has been placed in front of a dark landscape that includes a lake or river.
Beyond the trees on the shore and the two women bathers in the background we can
see in the blue distance a mountain massif that may represent the painter's first
depiction of the Mont Sainte-Victoire (see cat. nos. 89–92). The two large nudes,
probably based on life studies, have been rendered in contrasting flesh tones, the color
applied so as to suggest modeling, while the heroic landscape that serves as a
backdrop is executed in short strokes of the brush.
 One could interpret this abduction as a scene from mythology, possibly inspired
by Ovid's *Metamorphoses* – as the rape of Proserpina by Hades, for example, following
the example of Niccolò dell'Abbate (illus. 1). More likely, however, it is only another
instance of the artist's compelling need to give form to images haunting his own

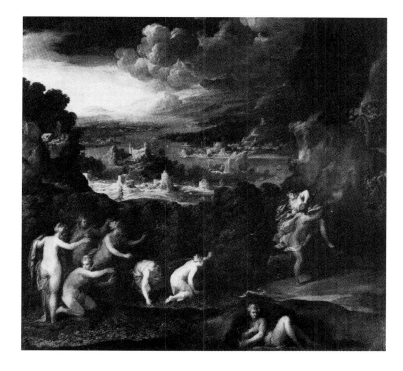

Illus. 1
Niccolò dell'Abate,
The Rape of Proserpina, circa
1560. Musée du Louvre, Paris

39

psyche, with the result that a large part of his early work is dominated by a violent sensuality and eroticism. It is as though by parading such images Cézanne, described by a friend in 1858 as "poetic, fantastic, bacchic, erotic, antique, physical, geometrical,"[3] hoped to compensate for years of submission to paternal authority and provincial conventions.

The Abduction is the first of a series of figural paintings, stretching well into the 1870s, on the basic theme of the confrontation between the sexes (see cat. nos. 2, 10–12). Having chosen to be an artist, Cézanne was left entirely to his own devices; his family never stopped patronizing him, and even in his old age, in his hometown of Aix-en-Provence, he had to endure his sister's bigoted condescension. With utter candor, these paintings give vent to his inner feelings, his hidden compulsions. In this period he delighted in presenting extreme situations at the climax of the action, with jarring forms and colors. Out of his subconscious he dredged up symbols of his own aggressive passions, depictions of atrocities and sexual excess. He gave expression to his physical urges in a formal idiom that flew in the face of all standards of propriety. His urgent need to air what had long been suppressed is what gives these violent scenes their authenticity. They expose with startling clarity extremes of sublimated feeling.

NOTES

1 Rewald 1983, no. 30, see also no. 28; Chappuis 1973, nos. 199, 200.
2 *Les grandes baigneuses*, Venturi 1936, nos. 719–21.
3 Cézanne 1984, 24.

PROVENANCE: Emile Zola, Paris-Médan; Zola auction, Hôtel Drouot, Paris, March 9–13, 1903, no. 115; Ambroise Vollard, Paris; Durand-Ruel, Paris-New York; H. O. Havemeyer, New York; Havemeyer auction, American-Anderson Galleries, New York, April 10, 1930; Etienne Bignou, Paris; Société La Peinture Contemporaine, Lucerne; Galerie Charpentier auction, Paris, June 26, 1934, no. 4; Maynard Keynes, London; Lady Keynes, London.
BIBLIOGRAPHY: Meier-Graefe 1904, **62**; Meier-Graefe 1910, **9**, 50f.; Burger 1913, illus. 45; Vollard 1914, 31; Meier-Graefe 1918, **86**; Coquiot 1919, 244; Meier-Graefe 1922, **92**; Rivière 1923, 46, 198, 234; Rewald 1936, illus. 14; Venturi 1936, 23, 88f., no. 101, **239**; Mack 1938, 127, 247; Barnes, Mazia 1939, 8, 10, 403; Rewald 1939, **24**; Dorival 1949, 28, 31, 105, illus. 11, 148f.; Schmidt 1952, 13; Cooper 1954, 346; Raynal 1954, 25; Badt 1956, 88; Cooper 1956, 449; Gowing 1956, 186f.; Berthold 1958, 35, 45f., illus. 72; Reff 1958, 153; Ratcliffe 1960, 7; Vollard 1960, 20; Wayne V. Andersen, "Cézanne's Sketchbook in the Art Institute of Chicago," *The Burlington Magazine* CIV, 710 (May 1962), 196; Chappuis 1962, 83; Reff 1962, 113f.; Reff 1963, 151; Lichtenstein 1964, 57, 60, illus. 3; Murphy 1971, 42, 165; Brion 1973, 22; Chappuis 1973, 84, no. 167, 93, no. 199, 94, no. 200; Elgar 1974, 26, illus. 9, 29, 31, 42, 45; Lichtenstein 1975, 127; Rewald 1975, 159; Wadley 1975, 91, illus. 81; Adriani 1978, 76, 308; Krumrine 1980, 121; Arrouye 1982, 104; Philadelphia 1983, XVI, 2; Rewald 1983, 89, no. 28, 90, no. 30, 93, no. 39; Coutagne 1984, **184**; Rewald 1986, **50**, 79, 93, 212; Frances Weitzenhoffer, *The Havemeyers: Impressionism Comes to America*, New York 1986, 147, illus. 116; Geist 1988, 225ff., illus. 183; Lewis 1989, 151, 155f., 159, 161ff., 169f., 173, illus. X; Rewald 1989, 43f., illus. 16, 51, 99, 124, 128, 306f.; Krumrine 1992, 588, 594.
EXHIBITIONS: Paris 1930, no. 26; London 1933, no. 3, illus.; *French Art*, Museum of Art, Cleveland, 1934, no. 3; Art Association, Montreal 1934; *French Painting of the 19th Century*, National Gallery of Canada, Ottawa, 1934, no. 10, illus.; Art Gallery of Ontario, Toronto, 1934; London 1935, no. 1, illus.; Paris 1935; Chicago 1952, no. 6, illus.; London 1954, no. 4, illus. 2; London 1988, 11f., 22, 42, 55, 61f., 64f., 80, 126, 128, 130, 132f., no. 31, illus.; Basel 1989, 39, 41, illus. 18, 43f., 58, 83, 85, 100, 263, 266, 311, no. 2; Aix-en-Provence 1990, 80, illus. 27, 175, illus. 159, no. 24.

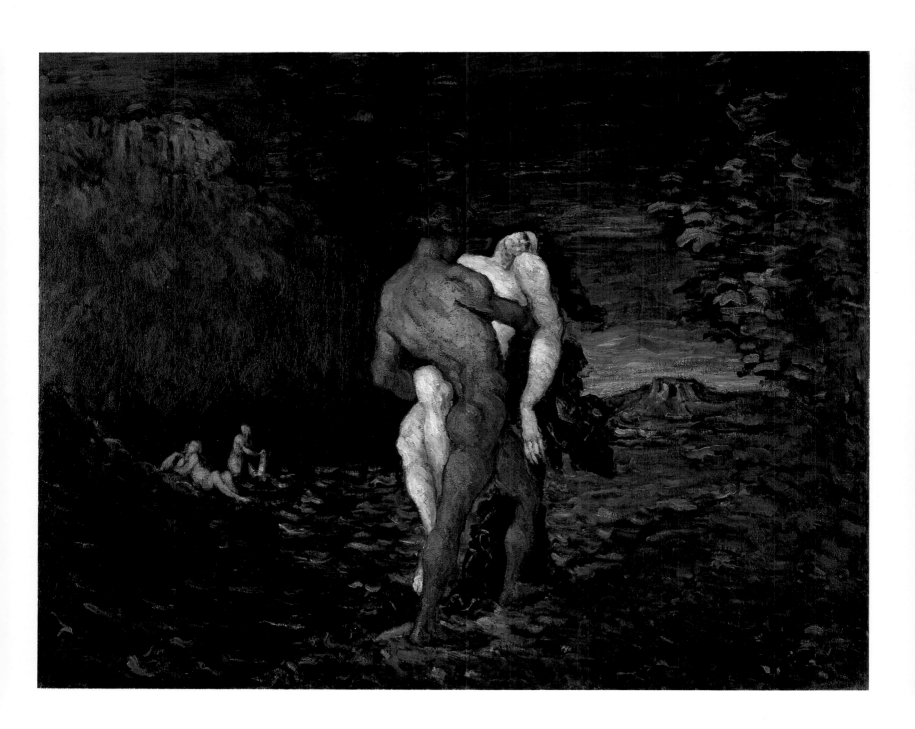

2 The Murder, 1867–69
Le meurtre

Venturi no. 121 (1867–70)
Oil on canvas, 25 3/4 x 31 1/2″ (65.5 x 80.5 cm).
Trustees of the National Museums and Galleries on Merseyside,
Walker Art Gallery (inv. no. WAG 6242), Liverpool

Cézanne's picture of a murder is the first in a long line of paintings illustrating Picasso's dictum that gruesome subject matter calls for repellent forms. The young painter's extreme self-confidence is evident in his willful distortions of colors and shapes. Cézanne had lived in Paris more or less permanently since 1861, and with paintings like this one, he deliberately set out to challenge the prevailing artistic tastes of the city's so-called Salon. He despised the insipid trifles of the painters who had monopolized that annual exhibition since 1863, and sought to replace those "artistic" prettifications of reality with "artless" works of genuine expressive force. On March 15, 1865, he told Pissarro that this time he intended to submit to the Salon pictures which will "make the Institute blush with fury and despair."[1] He perceived the clamoring for effect in the Salon, even the gifted brilliance of a Manet, as a direct challenge. To distance himself from all of this and demonstrate his own originality, he was determined to produce paintings as different as possible. His rejection of virtuosity in favor of violent expression was wholly appropriate to his passionate temperament, and constituted a reaction rarely matched in the history of art (see cat. no. 4).

With its air of menace approaching that of Goya,[2] *The Murder* is a striking example of how utterly uncompromising the painter could be in trying something new. At this point, he still measured his success by the degree of scandal he provoked. For this depiction of a subject that was clearly taboo he created forms so crude as to be nearly unrecognizable. The exaggerated gestures and provocative colors, at once descriptive and expressive, are altogether suited to the painting's horrifying content. Cézanne deliberately eschewed the flat application of color and exquisite forms of traditional painting. Dissonances are left unresolved; formal and tonal discrepancies flaunted. With a total lack of concern for correct proportions, the painter has placed his color highlights on top of a crude drawing that seems to snatch the figures out of a landscape veiled with ominous clouds.

Cézanne's public, incapable of accommodating such extreme subjectivity in their received notions of style, could only be affronted by it; the work was neither a historical painting nor a genre scene in the traditional sense. A number of commentators described the artist's desire to display his own emotional response to his subject as "Baroque," but their use of that term was hardly appropriate. Baroque artists had no use for this kind of raw savagery; in their works, passion of any kind was portrayed with extreme composure. In this connection it is interesting to note that Cézanne apparently based his figural arrangement on an altarpiece by Caravaggio (illus. 1) – he was given permission to copy paintings in the Louvre in 1868 – the spirit of which is altogether different.

The graphic horror of the scene may have been inspired in part by popular prints of the day, but it owes its particular coarseness to the artist's knowledge of the early writings of Zola, who had become editor of the Parisian daily *L'Evénement* in the spring of 1866, and encouraged Cézanne in his antiauthoritarian stance. In a stinging review of the Salon on May 4, he spelled out the demands he would impose on the artist as creator of individual values: "I want him to be full of life, to create something new, unlike anything else, according to his own eyes and his own temperament."[3] The well-known writer had dealt with distasteful subjects in some depth in his early novels and novellas (see cat. no. 6). His second novel, for example, *Thérèse Raquin,* first

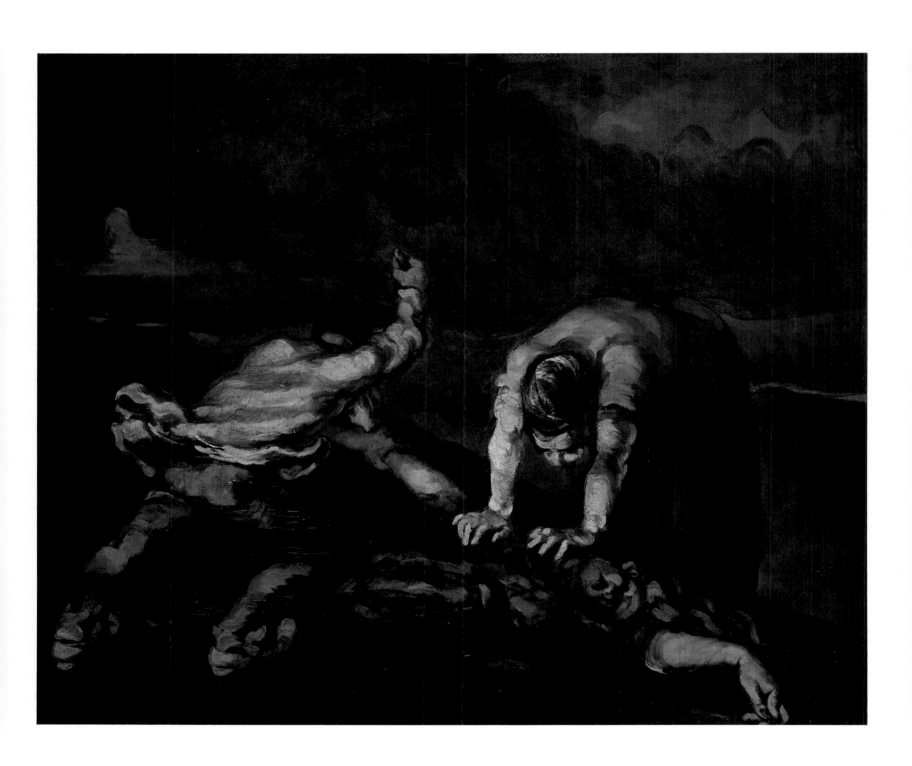

published in December 1867, has to do with an adulterous couple's murder of the woman's husband. With his scenes of abduction, murder, rape, and prostitution, Cézanne took that same twilight world as his own, to the extent that the critic Louis Ulbach raged in *Le Figaro* against the "pools of blood and filth" inspired by Zola. Conversely, it is probable that Zola had Cézanne's work in mind when in *Thérèse Raquin* he described a painter whose studies were executed with genuine force and vitality: "every part of the picture was accentuated with grandiose brushstrokes.... These studies were clumsy, but they had a strangeness and character so powerful that they proclaimed a highly developed artistic sense. It might be called painting that had been lived."[4]

NOTES

1 Cézanne 1984, 107.
2 He took up the subject once again in modified form in the mid 1870s with his *La femme étranglée*, Venturi 1936, no. 123; see also the garish watercolor Rewald 1983, no. 39, as well as the sketches Chappuis 1973, nos. 162, 254.
3 Emile Zola, *Malerei*, Berlin 1903, 50.
4 Rewald 1956, p. 78.

PROVENANCE: Ambroise Vollard, Paris; Paul Cassirer, Berlin; Sally Falk, Mannheim; Paul Cassirer, Berlin; Julius Elias, Berlin; Wildenstein, Paris-London-New York.
BIBLIOGRAPHY: Meier-Graefe 1918, 74, **92**; Meier-Graefe 1922, 74, **104**; Rivière 1923, 199; Pfister 1927, illus. 21; Javorskaia 1935, illus. 10; Rewald 1936, 46; Venturi 1936, 94, no. 121, illus.; Mack 1938, 127, 129, 156; Barnes, Mazia 1939, 8, 73, **161**, 404; Schmidt 1952, 13; Badt 1956, 226, 232; Reff 1958, 153; Reff 1962, 113f.; Reff 1962 (*Stroke*), 222; Feist 1963, illus. 6; Lichtenstein 1964, 65; Schapiro 1968, 52; Murphy 1971, **24f.**, 42; Brion 1973, **74**; Chappuis 1973, 83, no. 162, 105, no. 254; Elgar 1974, 31f.; Schapiro 1974, **21**; Sutton 1974, **99f.**; Barskaya 1975, 12, **19**; Wadley 1975, 93, illus. 83; Adriani 1978, 308; Venturi 1978, **48f.**; Adriani 1980, illus. 12, 57; *Foreign Catalogue*, Walker Art Gallery, Liverpool 1980, 44; Krumrine 1980, 121; Adriani 1981, p. 20; Rewald 1983, 93, no. 39; Coutagne 1984, 186, illus. 4; Rewald 1986, **52**; Erpel 1988, no. 2, illus.; Geist 1988, 99ff., illus. 81; Basel 1989, 39, 42ff., illus. 19, 83, 214; Fry 1989, 4, 13; Lewis 1989, 151, **154**, 156.
EXHIBITIONS: *XXVI. Ausstellung der Berliner Sezession*, Berlin 1913, no. 24a, illus.; *Eröffnungsausstellung des Kunstvereins Köln*, Cologne 1913, no. 8; *Französische Malerei des XIX. Jahrhunderts*, Galerie Ernst Arnold, Dresden 1914, no. 8; *Sommerausstellung*, Galerie Paul Cassirer, Berlin 1914, no. 8, illus.; *XVIII. Jahrgang. II. Ausstellung*, Galerie Paul Cassirer, Berlin 1915, no. 54; Berlin 1921, no. 1, illus.; Basel 1936, no. 6; Chicago 1952, no. 2, illus.; Aix-en-Provence 1953, no. 2, illus.; Zurich 1956, no. 5, illus. 2; Munich 1956, no. 2, illus.; Vienna 1961, no. 4, illus. 2; Tokyo 1974, no. 7, illus.; Liège 1982, no. 2, illus.; Madrid 1984, no. 6. illus.; London 1988, 13, 27, 42, 65, 138f., no. 34, 140, illus.

Illus. 1
Caravaggio, *The Dormition of Mary*, 1605–6.
Musée du Louvre, Paris

3 Skull and Kettle, circa 1865
 Crâne et bouilloire
 Venturi no. 68 (1865–66)
 Oil on canvas, 23 1/2 x 18 7/8″ (59.5 x 48 cm).
 Private collection

This painting, which formerly belonged to Alfred Flechtheim, the impassioned dealer
in Post-Impressionist and Cubist art in Germany, is one of two compositions from
Cézanne's early years incorporating a skull.[1] The other is the still life that follows
(cat. no. 4). The death symbol, alluded to frequently enough in his somewhat sarcastic
and macabre youthful poems, only reappears as a subject in the works of his old age
(cat. nos. 86, 87). In Joachim Gasquet's discussion of Cézanne's early years (see cat.
no. 68), there is a mention of *Skull and Kettle*: "Long before this he had painted a skull
in a picture full of warm, rich colors, one that was as *pastos* [impastoed] and solemn as
a painting by Rembrandt. It lay on a draped tablecloth next to a milk pitcher, glowing
out of the depths of who knows what grave, out of who knows what cavern of
nothingness. In his last days this idea of death coalesced into the vision of a pile of
skulls whose blue eye sockets seemed shadowed with thought. I can still hear him
reciting one evening beside the Arc the quatrain by Verlaine: 'For in this frozen
world/forever tortured by pangs of conscience/the only comprehensible laughter/is
the sneer of the skulls of the dead.'"[2]

Gasquet, who had known the painter since 1896, clearly had had only a fleeting
glimpse of the early work still preserved in the atelier in Aix. The pitcher (*bouilloire*, or
kettle in this work's title) he refers to and what he took to be a "serviette rugueuse"
(rough cloth) belong to compositions totally different from the death's head he
described. The unfinished painting blends different pictorial ideas in various stages of
completion. If one rotates the canvas ninety degrees to the right, one can see that it
first served as a horizontal format. To the left of the skull on the flat surface of a table
one can make out a muscular figure sketched in light colors, half kneeling, half seated.
The so-called *écorché* (flayed man) was a familiar feature in artists' studios in the

Illus. 1
Plaster cast of an *écorché*, formerly
attributed to Michelangelo

Illus. 2
Paul Cézanne,
Portrait of an Old Man,
circa 1865. Musée d'Orsay, Paris

nineteenth century, a useful object in the study of anatomy. Cézanne himself owned a cast of the statuette – formerly attributed to Michelangelo – about eight inches tall. So as to display the various muscle groups to maximum effect, the figure is portrayed in an extremely uncomfortable-looking pose (illus. 1). The majority of the nineteen drawings and the two paintings he made of the *écorché* were executed only in the late 1870s or even later,[3] yet we may assume that his cast, still visible in the artist's atelier in Aix, had accompanied him from his start.

Returning the canvas to its original position, it becomes apparent how Gasquet might have mistaken the statuette, with indistinct outlines and partially obscured by the overlay of brown serving as a background for the skull, for the folds of a white tablecloth. But the pitcher standing atop a light-colored pedestal could hardly have been part of the same picture as the skull. It too represents an earlier layer of the painting. In the further evolution of the work, it would have been sacrificed to a darker overpainting appropriate to the death's head just like the statuette of the *écorché* and the sky blue on the left or the light yellows and green tones of the background on the right. Similar overpainting can be seen in the *Portrait of an Old Man*, from circa 1865 (illus. 2). In the lower right corner of that work one can still make out portions of a procession of flagellants wearing death's-head masks. Such processions, following an ancient tradition, were an annual event in Aix-en-Provence. That portrait and the present still life reveal how the young painter, very possibly for reasons of economy, tried out various ideas on a given canvas just as he might have on a piece of drawing paper filled with sketches. Having abandoned various starts, he ultimately preserved the whole "collage" as a fascinating picture fragment (see cat. no. 35).

NOTES

1 Compare the drawing Chappuis 1973, no. 125.
2 Gasquet 1930, 17f.
3 Chappuis 1973, nos. 185, 418, 565–74, 980, 1086–89; Rewald 1983, no. 559; Venturi 1936, nos. 706, 709.

PROVENANCE: Alfred Flechtheim, Düsseldorf-Berlin; Gottlieb Friedrich Reber, Barmen-Lausanne; Robert von Hirsch, Basel; Hirsch auction, Sotheby's, London, June 26, 1978, no. 720.
BIBLIOGRAPHY: Gasquet 1921, 18f.; Meier-Graefe 1922, 96; Rivière 1923, 198; Gasquet 1930, 17; Ors 1936, illus. 24; Raynal 1936, illus. 81; Venturi 1936, 81, no. 68, illus.; Mack 1938, 128; Dorival 1949, 30, illus. 16, 149; Guerry 1950, 34; Chappuis 1962, 114; Reff 1962, 114; Chappuis 1973, 77, no. 125B; Adriani 1978, 84, 338; Adriani 1981, 280; Reff 1983, 90, illus. 6; Rewald 1983, 228, no. 559; illus.; Gasquet 1991, 50; Kosinski 1991, 521.
EXHIBITIONS: *Kunstwerke des 19. Jahrhunderts aus Basler Privatbesitz*, Kunsthalle, Basel 1943, no. 311; Zurich 1956, no. 4; London 1988, 160f., no. 45, illus.

4 Still Life, Skull and Candlestick, 1866–67
 Nature morte, crâne et chandelier

Venturi no. 61 (1865–67)
Oil on canvas, 18 3/4 x 24 5/8″ (47.5 x 62.5 cm).
Private collection, Switzerland

This still-life memento mori (see cat. no. 3) was painted for Heinrich Morstatt, the son of an apothecary from Bad Cannstatt, near Stuttgart. Morstatt, who later studied music in Stuttgart, found himself in Marseilles from 1864 to the end of 1866, where he was completing a business apprenticeship. While there, he became acquainted with the young scientist Antoine Fortuné Marion, an amateur painter, from Aix-en-Provence and friend of both Zola and Cézanne. Marion was convinced of Cézanne's artistic gifts from the beginning. Morstatt frequently left Marseilles to stay with his friends in Aix, where he introduced them not only to German literature, but also to German music from Beethoven to Wagner, whom they all admired as an avant-gardist. Only selections from Marion's letters to Morstatt have been published. The earliest were written while Morstatt was still in Marseilles, the later ones after he had returned to Stuttgart. The many extracts presented here contain fascinating glimpses into the lives of the circle of friends in Aix between August 1865 and the fall of 1868.[1] One's first impression on reading them is how greatly the young artists were infected with a kind of *Weltschmerz*, a chronic melancholy. On August 18, 1866, for example, Marion wrote about Cézanne: "But he, dear friend, is becoming more and more impressive. I truly believe that he is an uncommonly passionate and vigorous spirit. Hopelessly depressed, of course." By May 1867, little seems to have changed: "Do write to Paul in Paris. You have his address: 22, rue Beautreillis. Tell him everything. He will surely reply, especially if he is in a gloomy frame of mind." Finally, early in 1868, Marion spoke directly of their mutual affliction: "What a generation of sufferers, my poor old man. Zola, the two of us, and so many others. And some of us who are suffering but with fewer troubles are just as unhappy as we – Cézanne, for example, with his life assured and his dismal attacks of spiritual despair."

Given such moods, it was fitting that the painter should have shown an interest in symbols of mortality common in Italian, Spanish, and Netherlandish still lifes since the Baroque. Disturbed at the all too superficial reflection of reality provided by Naturalism and Impressionism, he preferred to return to motifs of seventeenth-century artists from Caravaggio to Ribera and Zurbarán.[2] His adoption of the Baroque notion of *vanitas* was quite deliberate, and he was content to embellish it with the traditional symbols. The skull, around which the shadows of the background form a sort of nimbus, the wilted flowers, the candle that has been snuffed out – with these he creates his own affirmation of the frailty of all that is earthly. The objects that might appear in the still lifes of Courbet or Manet solely for their formal or color interest Cézanne enriches with a freight of feeling. Along with his figural compositions, he draws the emotion-laden still life into his struggle for self-expression.

It is above all the drama of Cézanne's compositions that distinguishes them from the exquisite painting of the Baroque masters or the still lifes of his contemporaries. Instead of imitating their deft craftsmanship, he was content with heavy forms in colors of extreme thickness. Texture was virtually ignored in favor of an overall pattern made up of Baroque contrasts between light and shadow. In the years 1866 to 1868, he frequently laid on the pigments with a palette knife so as to prevent them from becoming too closely tied to the objects depicted, piling layer upon layer until they almost take on the look of relief. While Rembrandt had used a palette knife in his late work in an attempt to attain the highest expression of color as spiritual substance, Cézanne, in imitation of Courbet, another frequent wielder of the knife,

used it to "construct" his objects on the surface of the picture out of the thick paste of his pigments.

Cézanne first submitted his work for inclusion in the annual Salon exhibition in 1864 (see cat. no. 2). But every year he was rejected; his painting was much too remote from what was considered "good art." His reaction was to treat the jury's refusals as proof of his originality. Marion wrote in this vein to Morstatt on March 28, 1866: "I just received a letter from our friends in Paris. Cézanne is hoping to be refused by the exhibition, and his painter friends are preparing an ovation for him." On April 12, 1866, Marion quoted from a letter from their mutual friend Antony Valabrègue, in which, along with other news from Paris, he mentioned that Manet had shown an interest in Cézanne's still lifes:

> "Paul will doubtless be rejected at the exhibition. When one of the philistines on the jury saw his portrait of me, he exclaimed that the thing looked like it had been painted not only with a spatula, but with a shotgun.[3] A number of articles have appeared. Daubigny said some words in his defense. It was his contention that he would rather see pictures full of daring than the timid nothings that find their way into each Salon. But nobody paid any attention to him." Meanwhile, I have also had other news: the whole realistic school was rejected. Cézanne, Guillemet, and the rest. They are only taking the canvases of Courbet, who is apparently losing his touch, and a *Fifer* by Manet, a new and truly first-rank talent. Cézanne has met this master, and they appear to get along quite well; here's what Valabrègue has to say about it: "Cézanne has already written you about his visit with Manet. But he did not write you that Manet saw his still lifes at Guillemet's. He felt that they were powerfully executed. Cézanne was extremely pleased. But he doesn't parade his delight, and does not allow it to show, just as is his habit. Manet will have to call on him. They have similar personalities, and will surely find they have much in common."

Since this last statement was in fact quite untrue, it is doubtful that Manet ever paid such a call. According to Marion, the Salon jury was no less dismissive two years later:

> This naturally brings me to tell you about Cézanne and the present fate of realistic painting. It is, my dear fellow, further than ever from finding favor with those elements of society that matter, and it is certain Cézanne will not be permitted to show his work in the exhibition of officially sanctioned and favored art for a long time yet. His name is already too well known, and too many revolutionary artistic ideas are associated with him for the painters who make up the jury to weaken even for a moment. And I admire the persistence and equanimity with which Paul writes me: "So what! One will simply place such works before them with even greater persistence in eternity." Even so, he doubtless wishes people would talk about him in a different and more positive way. He has truly attained an astonishing ability now. His excessive barbarity has been tamed, and I now feel that it is high time that external circumstances make it possible for him to work as an artist full-time. I gather that he is soon returning to Provence. Then we will both write you.

Just when Cézanne painted this still life for Morstatt is unclear. In terms of style, it would appear to have been around 1866–67, when he used his palette knife in numerous portraits – and one could also think of the still life as the transitory form of a portrait. In Marion's letters there is frequent mention of pictures by Cézanne being sent to Morstatt in Stuttgart. In June 1867, they were apparently landscapes: "Paul … will be returning to us in Provence in two weeks at the latest. We will get drunk on the beauty and the sunlight of our homeland with its dazzling colors.... We will both send

you sketches, if we have spent a day painting with Paul. I am counting on it, especially if we have enough money for the postage." In January 1868, Marion again noted that Morstatt would be getting something from Cézanne as soon as he was back from Paris. And in one of his last letters, one from July 17 of that year, he held out the prospect of the still life, which a German by the name of Katz would be bringing from Aix to Stuttgart:

> Keep playing the piano with passion and endurance, and making music. It seems to me that you could then find a good post in France, somewhere where Paul and I could come, too. That is no simple daydream, and I am hoping that this plan will soon be realized. We three, a painter, a musician, and a scientist, what a splendid team we would make. The writers from our circle could also join us from time to time. To Zola and Valabrègue, to be sure, Paris is the be-all and end-all, while for the three of us, Provence would be perfectly fine. The day Katz left I was unable to write to you. He is bringing along a small picture of mine that turned out quite well.... You are also getting a still life of Paul's. We will send you still other pictures later.

NOTES

1 Excerpts from Marion's letters to Morstatt were published by Alfred Barr: "Cézanne d'après les lettres de Marion à Morstatt 1865–1868," *Gazette des Beaux-Arts* XVII, 79 (1937), 37ff. The thirty-eight surviving letters, in the collection of the author, are here quoted from the originals, drawing from portions previously unpublished.

2 In the journal *Mémorial d'Aix* for December 3, 1865, the budding artist was introduced as an admirer of Ribera and Zurbarán.

3 *Portrait de Valabrègue*, Venturi 1936, no. 126.

PROVENANCE: Heinrich Morstatt, Stuttgart; Heinrich Thannhauser, Munich-Berlin-Lucerne; Bernhard Mayer, Zurich.

BIBLIOGRAPHY: Pfister 1927, illus. 18; Venturi 1936, 23f., 79, no. 61, illus.; Alfred H. Barr, "Cézanne d'après les lettres de Marion à Morstatt 1865–1868," *Gazette des Beaux-Arts* 6, XVII, 79 (1937), 42, 50, illus. 6; Schmidt 1952, 12; Ratcliffe 1960, 8; Reff 1962, 114; Schapiro 1968, 52f.; Brion 1973, **18**; Chappuis 1973, 77, no. 125B; New York 1977, **33**, 396; Adriani 1978, 84, 338; Venturi 1978, **9**; Adriani 1981, 280; Arrouye 1982, 55; Reff 1983, 91, illus. 7; Rewald 1983, 140, no. 232; Frank 1986, illus.; Lewis 1989, 37, illus. 1; *du* 1989, **16**.

EXHIBITIONS: Berlin 1927, no. 10, illus.; Basel 1936, no. 3; The Hague 1956, no. 1; Zurich 1956, no. 1, illus. 3; *Chefs-d'œuvre des collections suisses, de Manet à Picasso*, Palais de Beaulieu, Lausanne 1963, no. 84, illus.; Basel 1983, no. 3, illus.; London 1988, 55, 92f., no. 12, illus., 128.

5 Paul Alexis Reading to Zola, 1869–70
Paul Alexis lisant à Zola

Venturi no. 118 (1869–70)
Oil on canvas, 20 1/2 x 22″ (52 x 56 cm).
Private collection, Switzerland

The writer and journalist Paul Alexis (1847–1901) was an admirer and friend of Zola's (1840–1902), whose biography of him, *Emile Zola, notes d'un ami*, was published in 1882.[1] The first mentions of the budding poet from Aix-en-Provence in Cézanne's letters date from July and late November of 1868. The first reads: "Alexis was good enough to read to me a poem that I found really good, then he recited to me from memory a few verses from another one, entitled *Symphonie en l'A mineur* [Symphony in A-minor]. I found those few lines more special, more original, and I complimented him on them." The second: "Monsieur Paul Alexis, a fellow of another and better sort altogether and not at all proud, lives on poems *et alia*. I saw him a few times when the weather was good. I saw him again just recently.... He's dying to be off to Paris, without parental consent; he's trying to borrow some money, mortgaging his father's skull to take off to other climes."[2]

As it happened, Alexis did not manage to move to Paris until September 1869, almost a year later. There he became closely associated with Zola, serving as the latter's secretary. Zola had need of him, as he had by then begun work on his vast cycle of novels *Les Rougon-Macquart*. Cézanne also spent most of 1869 in Paris, only returning to the South after the outbreak of the Franco-Prussian War on July 18, 1870. It would appear, then, that this depiction of the two writer friends in Zola's apartment in the rue la Condamine was painted between the fall of 1869 and the summer of 1870 (see cat. no. 6). It has been argued on stylistic grounds that it must date somewhat earlier.[3] But aside from the fact that a reunion in Paris of the three friends from Aix could only have taken place at the earliest in the fall of 1869, paintings dating from around 1870 (see cat. nos. 8–10) display a similarly effective use of color, the same simplification of forms, and equally great contrasts between light and dark. In all of them the colors represent extreme contrasts, and thereby contribute a distinct tension to the composition.

To suggest something of the depth of the scantily furnished room, Cézanne made use of an artistic device perfected in the seventeenth and eighteenth centuries, a draped curtain like those found in Netherlandish interiors from the Baroque period (see cat. nos. 11, 35, 41, 45, 62), and portrays his figures as seen from above and as though on a stage under bright lights. Each of the seated men is defined within a rectangular field of color. Zola, in the foreground with his back to the viewer, wears a red coat and is seated at a table, identified as a writer by the quill pen he holds in his hand. Alexis sits reading, farther back. On a shelf in the background stands a black clock – somewhat obscured by Zola's profile – that would play a prominent role in a still life painted about this same time.[4] Bearing in mind that a picture within a picture usually has a special significance, the depiction of a reclining nude on white sheets, somewhat unclear but set off by a gold frame and light gray wall, may refer to Zola's wedding, which took place in Paris on May 31, 1870, with Cézanne serving as one of the witnesses.

Of the numerous portraits that Cézanne created in the course of his life, there is a small group in which he highlights friendship between two people. In this group are the two paintings of his poet friends (cat. nos. 5, 6) that were given to Zola and remained in his possession[5]; the double portrait of his son Paul with Louis Guillaume as Harlequin and Pierrot, called *Mardi gras*[6]; and finally the grandiose compositions titled *Two Card Players* (cat. nos. 65, 66).

52

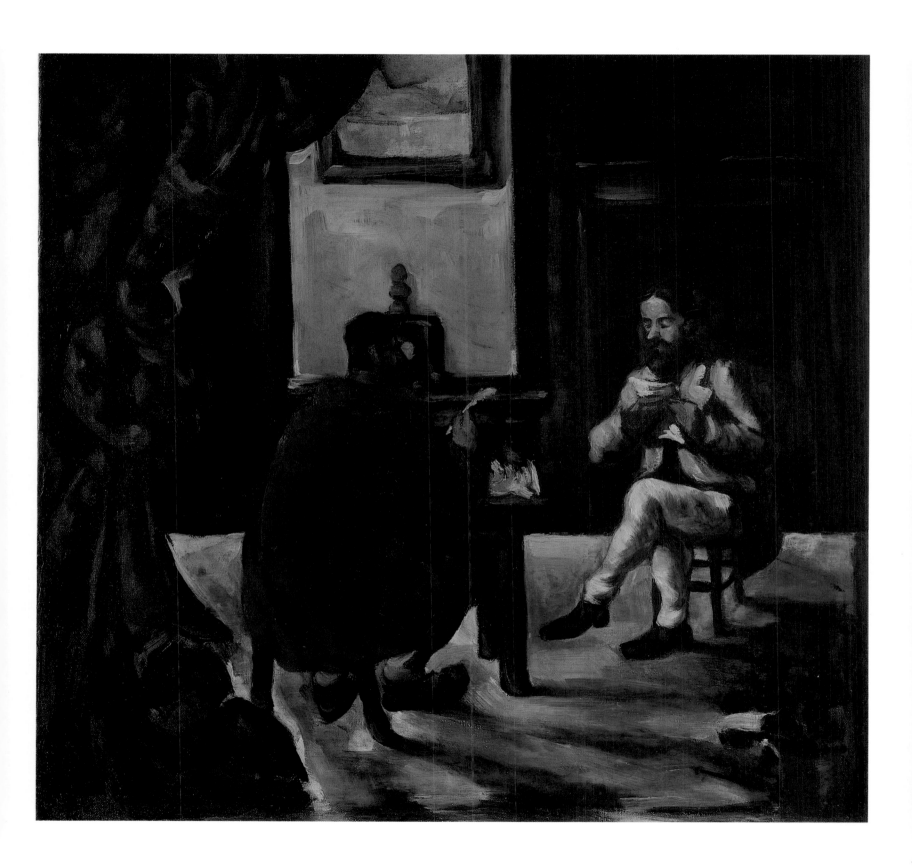

NOTES

1 Alexis sent a copy of the book to Cézanne in Aix, and on February 15, 1882, the painter sent him a touching letter of thanks. Cézanne 1984, 203.
2 Ibid., 127, 128.
3 Chappuis 1973 dates the preparatory drawings, nos. 220-22, to 1866-69.
4 *La pendule noire*, Venturi 1936, no. 69.
5 In addition to the two double portraits, Zola owned the early Cézanne paintings Venturi 1936, nos. 22, 55, 64, 69, 81, and 101 (cat. no. 1).
6 Venturi 1936, no. 552. Cézanne's intention to produce large-figured group portraits was never realized. On November 2, 1866, he wrote to Zola that "as you had feared, my large picture of Valab[règue] and Marion [see the sketch Venturi 1936, no. 96] has not worked out and that, having attempted a 'family evening,' that didn't even get started. Nevertheless, I shall persevere, and perhaps on another try it will." (Cezanne 1984, 121.) A projected outdoor group picture of his friends also never got beyond the preliminary stage. All that we know of it is a trio of sketches, Chappuis 1936, nos. 223, 224, and 224 bis, and a letter of Marion's to Morstatt dated May 24, 1868: "Cézanne plans to paint a picture soon using portraits of his friends. One of us will be shown speaking in a landscape while the rest listen to him. I have a photograph of you, and you will be included. To crown the project, Paul wants to present the picture beautifully framed, if it turns out, to the museum in Marseilles, which will thus be forced to exhibit realistic painting and contribute to our fame." (See cat. no. 4, note 1.)

PROVENANCE: Emile Zola, Paris-Médan; Zola auction, Hôtel Drouot, Paris, March 9-13, 1903, no. 113; Josse Hessel, Paris; Auguste Pellerin, Paris; Jean-Victor Pellerin, Paris; Wildenstein, Paris-London-New York.
BIBLIOGRAPHY: Lehel 1923, illus.; Rivière 1923, 198, 229, 234; Fry 1927, 24, illus. 12; Gasquet 1930, illus.; Ors 1936, illus. 41; Raynal 1936, illus. 8; Rewald 1936, illus. 20; Venturi 1936, 92f., no. 118 illus.; Novotny 1937, 14, 16, 19, illus. 9; Mack 1938, 247; Barnes, Mazia 1939, 8, 19, 40, **154**, 308f., 404; Rewald 1939, illus. 23; Guerry 1950, 30ff., 163; Badt 1956, 117, 223, illus. 25; Reff 1958, 20, 75; Adhémar 1960, 289, illus. 6; Ratcliffe 1960, 8; Chappuis 1962, **56**; Theodore Reff, "Cézanne Drawings," *The Burlington Magazine* CV, 725 (August 1963), 375; Andersen 1970, 5, 7, 37, 41, **223ff.**; Chappuis 1973, 82, no. 158, 98, nos. 219, 220, 99, nos. 221, 222; Newcastle 1973, 152; Rewald 1986, **49**, 212; Lewis 1989, 138f., illus. VIII; Krumrine 1992, 589.
EXHIBITIONS: Paris 1907, no. 7; *Cent ans de théâtre, music-hall et cirque*, Galerie Bernheim-Jeune, Paris 1936, no. 12, illus.; *Emile Zola*, Bibliothèque Nationale, Paris 1952, no. 53; *Faces from the World of Impressionism and Post-Impressionism*, Wildenstein Galleries, New York 1972, no. 12; Tokyo 1974, no. 5, illus.; London 1988, 30, 60, 64f., 156f., no. 43, illus., 164; Basel 1989, 66, illus. 38, 257, 262, 311, no. 3.

6 Paul Alexis Reading to Zola, 1869–70
Paul Alexis lisant à Zola

Venturi no. 117 (1869–70)
Oil on canvas, 51 5/8 x 63″ (131 x 160 cm).
Museu de Arte de São Paulo

It would be difficult to imagine two paintings more unlike each other than Cézanne's two portrayals of his friends Zola and Alexis (see cat. no. 5). Even in format they are very different. In this version the two subjects are much weightier than in the previous, smaller one. There, they were portrayed in an interior space, while here, they are seated outside the house, with no suggestion of an ambience appropriate to them, no indication of their tastes and interests. The two works are altogether different in style and even in the degree to which they have been finished. The coloring, thickness of pigments, relative proximity of subjects to the viewer, and the portrayal of the moods of the two men are altogether dissimilar. The two compositions appear to be worlds apart from each other, yet both of them were produced in Paris in the brief period between the fall of 1869 and the summer of 1870. To understand how Cézanne could have created such profoundly different works, one has to look to the painters who exercised the greatest influence on him in this period, namely, Courbet and Manet.

From various reports that Marion dispatched to Heinrich Morstatt in Stuttgart in 1867, we learn how greatly the friends from Aix-en-Provence were interested in both of these controversial artists: "Paul and I are thinking of going to Paris for a week in the middle of August.... Actually all we want to do there is visit the Manet and Courbet exhibitions; one of those pleasure trains that take the Provençals to Paris and back for 30 frs. offers us the opportunity to do so." Then, on August 15 he reported from Paris:

> The special Courbet exhibition is truly wonderful. 300 [?] outstanding paintings are in the show, all of them remarkable and most executed to supreme perfection. This is an artist whose strength is undiminished, unbroken. The exhibition of Manet is quite remarkable in another respect. Just imagine, I was absolutely stunned by his painting and it took me some time to get used to it! Ultimately, these pictures are very beautiful; it is their sure sense of color that strikes one. But his work has not yet attained its full ripeness, I feel; he will continue to perfect himself and gain more strength.

Nonetheless, in summing up on September 6, 1867, Marion ventured the bold conclusion: "Paul is truly far better than all of them."[1]

While the glowing colors and compact, heavy forms of the small-format work (cat. no. 5) are more reminiscent of Delacroix and Courbet, the large double portrait, possibly intended for the Salon exhibition of 1870 but left unfinished on the outbreak of war in Paris, is wholly indebted to Manet. Indeed, one could even argue that the work was intended as an homage to Zola for his courage in championing Manet in a brief biography of the artist he published in January 1867. Manet had shown his gratitude by painting his famous portrait of Zola (illus. 1) in the following year, including in it a depiction of the article in question as both dedication and signature. That portrait had created a sensation at the 1868 Salon exhibition, and once Cézanne had an opportunity to study it more carefully in Zola's Paris apartment, he could not resist responding to it with an imposing portrait of his friend of his own composition, one that would go beyond traditional portrait form employed by Manet. Although horizontal in format, and even larger than the Manet, the similarities between the two works are unmistakable. In Cézanne's picture, Alexis assumes the position taken by Zola in the earlier work, while the latter lounges on a sketchily drawn divan. Alluding

to the close understanding between Manet and his courageous champion Zola, Cézanne placed the writer in the spot where his signature appears in the Manet portrait. Further indications that Cézanne was willing to learn from the seven-years-senior artist are the way he frames Zola's head with a dark window opening, similar to the one in Manet's *The Balcony* (illus. 2), shown at the Salon in 1869, and his use of a palette inspired by his colleague. Even so, he failed to impress Zola with his work. While Manet's painting was always prominently in the writer's various elegant residences, Cézanne's gift was forgotten, and only turned up in 1927, after the death of Madame Zola, in the storeroom at the Zolas' summer house in Médan.

Still in his twenties and immortalized by Manet and Cézanne as a prince of writers, Zola had already made a name for himself by the end of the 1860s. He had barely put behind him the difficult period that Marion spoke of to Morstatt as late as October 9, 1867:

> Zola came south for a week. Why weren't you here? We would have spent some pleasant hours, he, Cézanne, you, and I. A play of his (*Les Mystères de Marseille*) was being presented in the gymnasium at Marseilles, hence his trip. Said play is not altogether bad, even though Zola himself says it is abominable. There are certain spots that are quite risqué and artificial, and less than pleasing. For example, a theft is depicted onstage, an employee steals from his merchant boss, and delivers a passionate monologue in front of the cashbox. In this play there is a mother who becomes a whore so as to find her son, who was abducted and driven into depravity by relatives. Pretty daring, all of it, as you can see. The piece had roughly the same fate as *Henriette Maréchal:* at the first performance there was both whistling and applause; the second went better, without too much commotion and with a decent reception. For him it is only a matter of money, nothing more. He has just finished a really good novel, *Thérèse Raquin.* It has already appeared in *L'Artiste,* a Parisian illustrated magazine, and will soon be published as a book. Zola promises to send me a copy immediately. He is firmly resolved to work hard for the theater, though he risks having precisely as little success as the brothers Goncourt. I am urging him strongly to do so. That way, he could quickly earn his living, which would be wonderful. Paul and he are hoping to return to Paris soon, and then I will be alone again.

By 1868, the situation appears to have changed. In Aix, they were even naming a street after Zola:

> Paul's living is assured, and Zola writes that he is now convinced that he will always be able to support himself in the future – even without too much trouble. He has become rather talked about of late. He is being very shrewd. He has put pressure on the city fathers in Aix, who behaved very badly toward his father that time. He managed to annoy a number of people, so that today, finally, the city council renamed one of our city's boulevards the Boulevard Zola.[2]

Marion also related an amusing story about Zola and Alexis, one that shows Zola equally shrewd in support of his comrade:

> All of our friends are in Paris: Cézanne, Zola, Valabrègue. Cézanne is painting constantly. Zola published a new novel this year; *Madeleine Férat,* which is better than all of his earlier writing, a book I would gladly have written myself. A man who is jealous of his beloved wife's past; all observed with the tact and insight unique to us.... I have something new to tell you, which is rather widely known here. You remember Alexis, the young man from Aix with whom we spent a couple of days. The fellow is really quite gifted. Zola helped him achieve

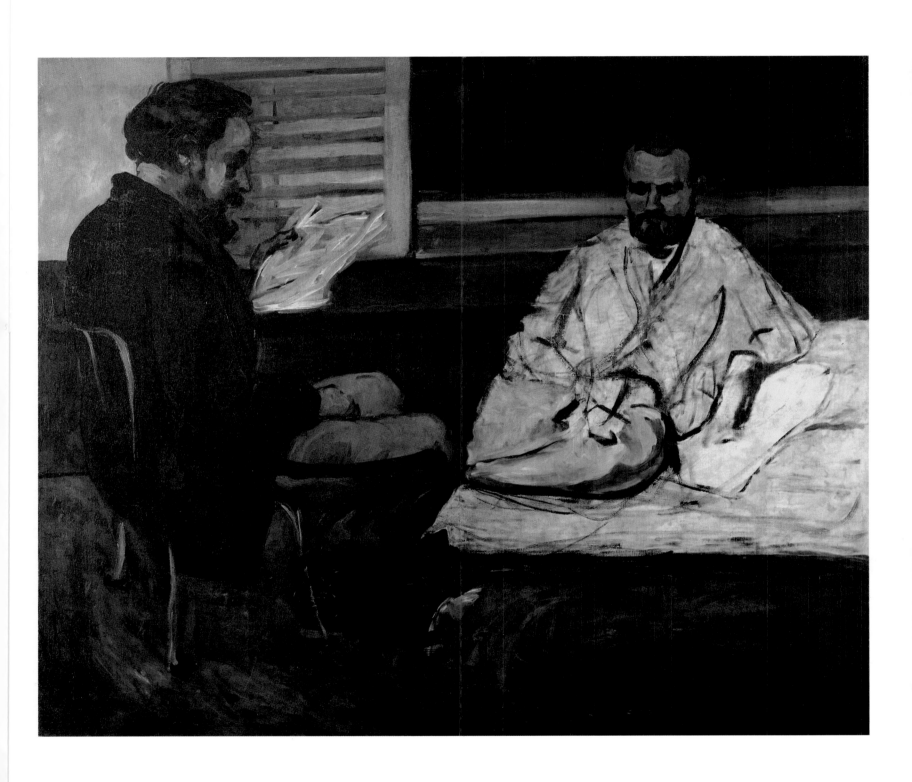

a most amusing and rewarding success.... Alexis wrote a series of poems with the title *Les vieilles plaies.* They show a subversive cleverness, ability, and spirit. Now, at this time the works of Baudelaire, who died a short time ago, are being reprinted. And suddenly Zola, who let one of his colleagues in on the deception, maintains that he has somewhere dug up some as yet unpublished pieces by Baudelaire, and publishes the Alexis poems. The whole thing worked splendidly. The Alexis verses have made the rounds of the Parisian press as well as that of the provinces. People saw in them the "magical power of the master," etc. etc. Then someone gave away the secret, the deception was exposed, and Alexis met with a genuine success.[3]

NOTES

1 See cat. no. 4, note 1. Courbet and Manet were not represented in the Salon in 1867, the year of the Paris World's Fair. Instead, they both hung a first retrospective in pavilions they paid for themselves (Rond-Point de l'Alma Champs-Élysées and Avenue de l'Alma), including 137 and 50 works, respectively.
2 See cat. no. 4, note 1.
3 Ibid.

PROVENANCE: Emile Zola, Paris-Médan; M. Helm, Le Vesinet; Paul Rosenberg, Paris; Wildenstein, Paris-London-New York.
BIBLIOGRAPHY: Gasquet 1930, illus.; Javorskaia 1935, illus. 4; Huyghe 1936, illus. 43; Rewald 1936, illus. 21; Venturi 1936, 23, 92f., no. 117, illus.; Barnes, Mazia 1939, 8, 14, **155**, 312, 403; Cogniat 1939, illus. 20; Rewald 1939, illus. 24; Dorival 1949, 35, illus. 26, 152; Schmidt 1952, 14; Cooper 1954, 346; Raynal 1954, **28**, 32; Gowing 1956, 186f.; Adhémar 1960, 288, illus. 5; Ratcliffe 1960, 8; Cézanne 1962, illus.; Chappuis 1962, 55f.; Andersen 1970, 5, 7, 37, 223, 226; Chappuis 1973, 82, no. 158, 98, no. 220, 99, no. 222; Newcastle 1973, 152; Elgar 1974, 35, 40, illus. 20; Schapiro 1974, **9**, 26; Sutton 1974, **101**; Venturi 1978, **15**; Adriani 1980, **14f.**; Cézanne 1988, **29**; Erpel 1988, illus.; Geist 1988, 220f., illus. 177; London 1988, 14, 55; Lewis 1989, 138f.; Gasquet 1991, **92**.
EXHIBITIONS: *Pictures of People, 1870–1930,* Knoedler Gallery, New York 1931, no. 5; *Modern French Painting,* Institute of Arts, Detroit 1931, no. 17, illus.; Philadelphia 1934, no. 2, *Modern French Painting,* Museum of Art, San Francisco 1935, no. 4, illus.; *Nineteenth Century Masterpieces,* Wildenstein Galleries, London 1935, no. 8, illus.; Paris 1936, no. 178; Lyon 1939, no. 8; Paris 1939, no. 5; London 1939, no. 8; New York 1947, no. 3, illus.; Chicago 1952, no. 14, illus.; London 1954, no. 6; Tokyo 1974, no. 6, illus.; Madrid 1984, no. 4, illus.; Tokyo 1986, no. 5, illus.; Ettore Camesasca, *Trésors du Musée de São Paulo,* Fondation Gianadda, Martigny 1988, **86ff.**; London 1988, 30, 64f. 156, 164f., no. 47, illus.

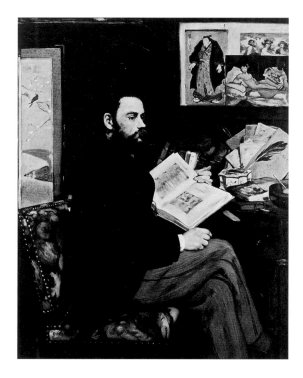

Illus. 1
Edouard Manet,
Portrait of Emile Zola, 1868.
Musée d'Orsay, Paris

Illus. 2
Edouard Manet,
The Balcony, 1868–69.
Musée d'Orsay, Paris

7 Turning Road in Provence, 1867–68
Route tournante en Provence

Venturi no. 53 (1867–70)
Oil on canvas, 36 1/2 x 28 1/2″ (92.4 x 72.5 cm).
The Montreal Museum of Fine Arts Collection,
Adaline van Horne Bequest (inv. no. 1945.872), Montreal

As early as February 1861, Zola had already expressed astonishment that Cézanne was painting outside in the middle of winter, sitting on the frozen ground with no thought of the cold. And the painter himself once referred in a humorous verse to a time in 1863 when the two of them had gone off "palette in hand to trace some fine landscape on canvas."[1] Yet, it was only in the late 1860s that his interest in landscape really began to bear fruit in the form of original compositions. At first these were all in smaller format, and betrayed the influence of Corot and Courbet as well as the Barbizon painters. Most are dark-toned landscapes painted with either broad brushes or a palette knife, set off against a strongly contrasting backdrop of light blue sky. Only toward the end of the decade did he begin to work in larger format and combine broader planes of color and shapes.

This decorative Provençal landscape, the first major landscape by Cézanne, is a decorative example of his work from the period. Under a blue sky with high clouds, a pine tree on the shoulder of a road rising steeply away from us towers up in front of dark foliage in the middle distance and a mountain ridge behind. Cézanne painted this harmonious composition either in the summer of 1867 or in 1868, when he stayed in Aix from May to December. He often worked in the environs of the city at that time in the company of the scientist Antoine Fortuné Marion (cf. cat. no. 4), who taught him to appreciate the geological formations of his Provençal homeland.

In October 1866, referring to a portrait sketch showing Marion and Antoine Valabrègue heading off in search of an interesting view,[2] Cézanne had definitely committed himself to plein air painting in a letter to Zola:

> You know, any picture done indoors, in the studio, never equals things done outdoors. In pictures of outdoor scenes, the contrast of figures to scenery is astonishing, and the landscape is magnificent. I see superb things and I must resolve to paint only out of doors. I've already mentioned to you a canvas I'm going to try. Its subject will be Marion and Valabrègue (in a landscape of course). The sketch Guillemet liked, the one I did from nature, makes everything else fall by the way and look bad. I truly believe all the "open air" pictures of the old masters' light were done by tricks, for to me none of them have the true, and above all, original look nature alone can give.[3]

The artist had realized that painstaking nature study alone could give his paintings a factualness that was missing in the wild figural scenes created of his own imagination (see cat. nos. 1, 2). He had to abandon impulsive fantasy in favor of careful analysis of what he saw.

Marion's letters to Heinrich Morstatt in Stuttgart from the summers of 1867 and 1868 also suggest how hard Cézanne was working to rein in his feelings and paint in a more traditional manner. In one we read: "Paul is here [in Aix] and painting. He is more himself than ever; but this year he is determined to achieve success as quickly as possible. He recently produced several very lovely portraits; no longer with the palette knife, but just as strong, and also with much greater technical skill and much more pleasing." In another: "Paul is convinced that he can retain his style of painting in broad strokes, and at the same time, manage to articulate details by means of deft

craftsmanship and precise observation. If he can, he will have achieved his goal, and his work will soon attain the level of perfection. I feel that time is not so far off. The most important thing for him now is to work." In yet another: "Cézanne is still working hard, and taking great pains to tame his temperament and subjugate it to the rules of sober observation. Once he reaches this goal, my friend, we will have strong, finished works to marvel at."[4]

NOTES

1 Cézanne 1984, 103.
2 *Les promeneurs*, Venturi 1936, no. 96.
3 Cézanne 1984, 116.
4 See cat. no. 4, note 1. Convinced that his work from nature was bearing fruit, in November 1868 Cézanne decided to produce a landscape for the next year's Salon in Paris: "I'm still doing a lot of work on a landscape of the banks of the Arc; it's still for the next Salon, will that be 1869?" Cézanne 1984, 129. He needn't have asked the question, for in 1869 the Salon jury rejected his entry once again.

PROVENANCE: Ambroise Vollard, Paris; Bernheim-Jeune, Paris; William van Horne, Montreal; Adaline van Horne, Montreal.
BIBLIOGRAPHY: Venturi 1936, 16, 78, no. 53, illus.; Schmidt 1952, 14.
EXHIBITIONS: *The Sir William van Horne Collection*, Art Association, Montreal 1933, no. 146b; New York 1959, no. 5, illus.; London 1988, 65, 142f., no. 36, illus.

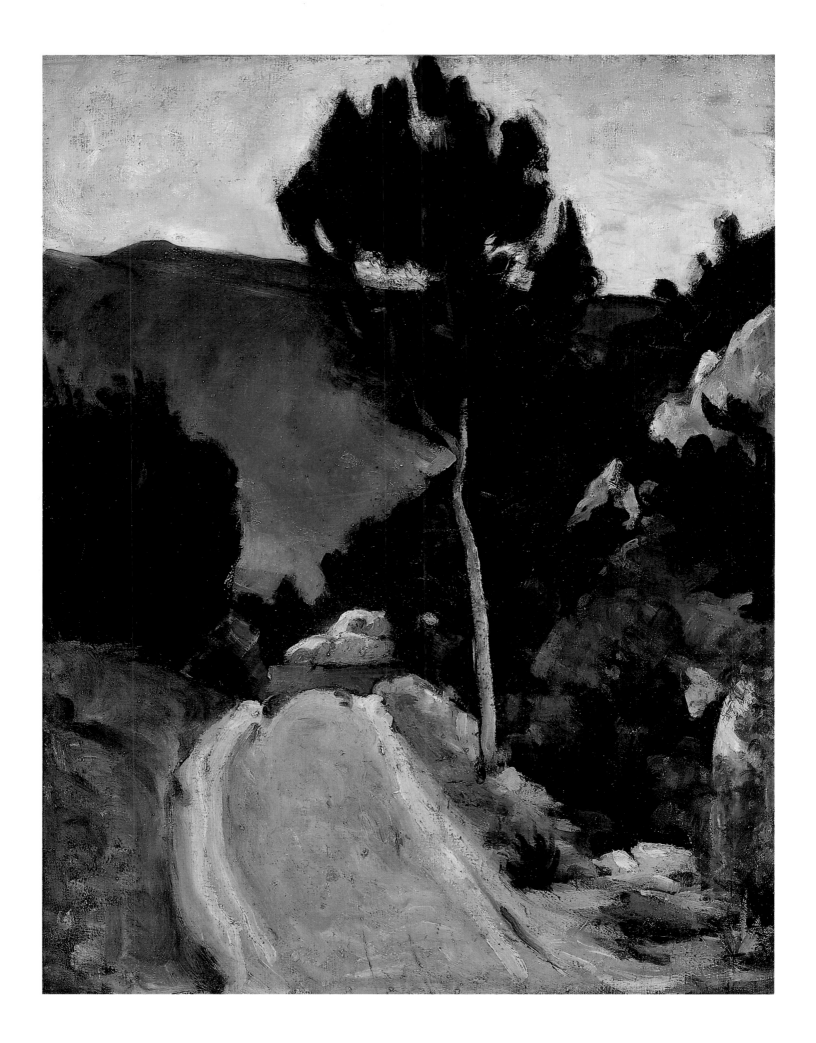

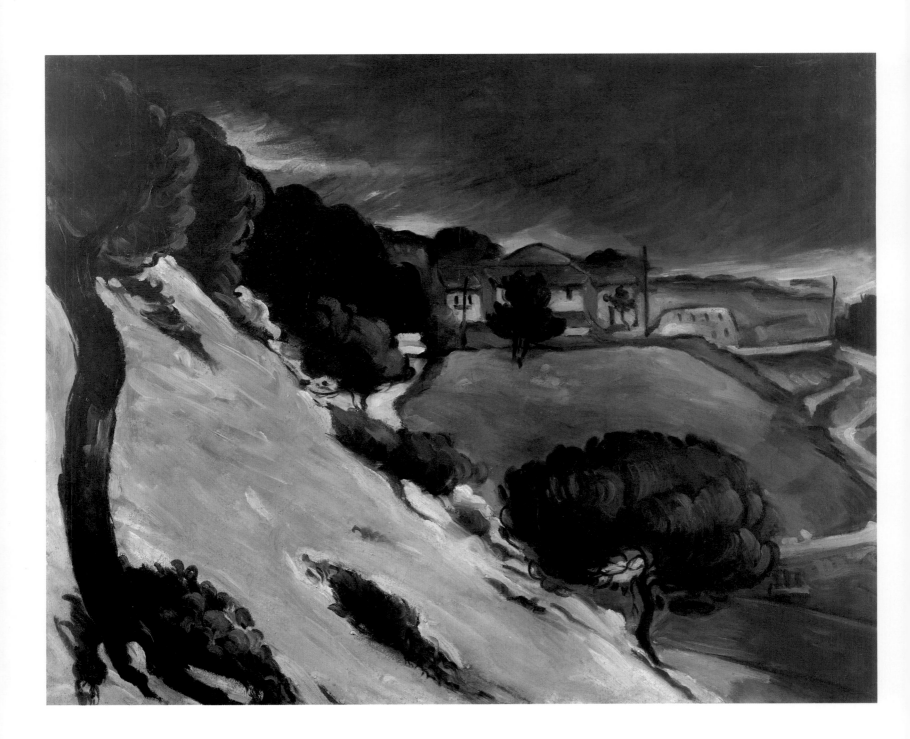

8 Melting Snow, L'Estaque, 1870–71
 La neige fondue à L'Estaque
 Venturi no. 51 (circa 1870)
 Oil on canvas, 28 3/4 x 36 1/4″ (72.5 x 92 cm).
 Private collection, Switzerland

Once Napoleon III had declared war on Prussia in July 1870, Cézanne felt obliged to leave Paris as quickly as possible for the South, so as to evade the mobilization. He first worked in Aix, then later in L'Estaque, on the coast some eighteen miles away. He had already stayed there with his family once in 1868 (see cat. nos. 19, 22, 23, 29, 72).[1] In that small industrial town, he hid from both his father's persecutions and those of the draft board. With him was Marie Hortense Fiquet, who had been his model in Paris since 1869 and would ultimately become his wife some seventeen years later (see cat. nos. 14, 37–44). Zola also stayed in L'Estaque briefly at this time. Untouched by chaotic political events, the defeat of the emperor, the proclamation of the Republic, the invasion of Prussian troops, France's capitulation, and the Commune, Cézanne spent his time there utterly concentrated on his work. After leaving L'Estaque in March 1871, he stayed in Aix for a time, then returned to Paris in the fall, once the political turmoil had settled. Later, when asked by the art dealer Ambroise Vollard how he and Zola had survived the war, Cézanne responded with extreme nonchalance: "During the war, I worked a lot on my painting in L'Estaque. Beyond that, I cannot tell you of a single unusual event from the years 1870–71. I divided my time between the landscape and my studio … I was stuck at the time on a landscape that I could make no progress with. So I stayed a while longer in Aix and worked on subject matter."[2]

From this laconic statement one can at least conclude that in L'Estaque the painter methodically continued his work outdoors (see cat. no. 7). He achieved a temporary triumph in the winter of 1870–71 with his picture *Melting Snow at L'Estaque*.[3] If one did not know who painted this landscape whipped by storm, one would tend to attribute it to one of the Fauvists or Expressionists. Painted in a single sitting, its massive forms are concentrated beneath the cold reflected light on the horizon. A steep slope lies buried under a precarious layer of snow. The only objects stemming this Baroque element of diagonal movement are a few pines, their branches contorted by the prevailing mistral. Wedged between the dirty, heavy white of the snow and the gloomy, menacing sky lies a hilly landscape enlivened by a few isolated red roofs. It is filled with expansive movement; one has the sense that its abruptly retreating slopes are being sucked into the distance. Although the painter had now clearly achieved a deftness in dealing with colors and spatial planes, this winter landscape is closer to the drama of the early figural pictures than to the concept of landscape as a complex of distinct structural relationships he would espouse in the future. There is still in this work something of the emphasis on emotion that marked his early period. All of the picture's elements have been placed in the service of a passionate spirit, but one now oriented primarily toward nature.

NOTES

1 According to Marion's letter to Morstatt from September 13, 1868, see cat. no. 4, note 1.
2 Vollard 1960, 21.
3 Although the snow-covered landscape was a frequent motif for the Impressionists, Cézanne only used it on one other occasion, in his *Neige fondante à Fontainebleau*, Venturi 1936, no. 336.

PROVENANCE: Ambroise Vollard, Paris; Bernheim-Jeune, Paris; Auguste Pellerin, Paris; Jean-Victor Pellerin, Paris; Wildenstein, Paris-London-New York; Arthur M. Kauffmann, London.
BIBLIOGRAPHY: Meier-Graefe 1910, 65; Vollard 1914, illus. 9; Meier-Graefe 1918, **99**; Coquiot 1919, 68; Meier-Graefe 1922, **114**; Klingsor 1923, 16; Rivière 1923, 199; Fry 1927, 22; Pfister 1927, illus. 23; Ors 1930,

73; Vollard 1931, **392**; Huyghe 1936, 167, illus. 41; Raynal 1936, 6, 57, 146, illus. 35; Venturi 1936, 16, 25, 77, no. 51, illus.; Novotny 1937, 17; Barnes, Mazia 1939, **159**, 312; Cogniat 1939, illus. 17; John Rewald, "Paul Cézanne: New Documents for the Years 1870–1871," *The Burlington Magazine* LXXIV, CDXXXIII (April 1939), **164**; Dorival 1949, 39, 41, 48, 61, illus. 27, 152; Guerry 1950, 39ff., 156ff.; Schmidt 1952, 14f.; Cooper 1954, 346; Raynal 1954, **26**, 101; Badt 1956, 199, 202, 232, 263; Neumeyer 1958, 54; *Sammlung Emil G. Bührle,* Zurich 1958, 127, **229**; Ratcliffe 1960, 9; Vollard 1960, 22; Reff 1962 (*Stroke*), 226; Leonhard 1966, 118, **123**; Andersen 1970, 121, 194; Cherpin 1972, **18**; Brion 1973, 22, 29; Elgar 1974, 36, 47f., illus. 24; Schapiro 1974, **38f.**; Barskaya 1975, **26f.**; Rewald 1975, 167; Wadley 1975, 28, illus. 26; New York 1977, 73; Paris 1978, 16; Venturi 1978, **54f.**, 59; Arrouye 1982, 43, 79; Rewald 1986, **90**; Cézanne 1988, **51**; London 1988, 60, 65, **166**; Lewis 1989, 196f., illus. XV; Krumrine 1992, 586.
EXHIBITIONS: *L'Impressionnisme,* Palais des Beaux-Arts, Brussels 1935, no. 11; Paris 1936, no. 13; Lyon 1939, no. 9, illus. 3; London 1939, no. 11; New York 1947, no. 4, illus.; Chicago 1952, no. 13, illus.; Hamburg 1963, no. 3, illus. 11; *Meisterwerke der Sammlung Emil G. Bührle, Zürich,* National Gallery of Art, Washington 1990 – Museum of Fine Arts, Montreal-Museum of Art, Yokohama-Royal Academy of Arts, London 1991, no. 38, illus.

9 Road Through a Wood, 1870–71
Route de forêt

Not in Venturi
Oil on canvas, 21 1/4 x 25 1/2" (53.8 x 64.9 cm).
Städtische Galerie im Städelschen Kunstinstitut
(inv. no. SG 458), Frankfurt am Main

From the beginning, Cézanne's catholic view of landscape included spacious, open panoramas as well as smaller scenes set deep in the woods. Here, in contrast to the gripping pathos of *Melting Snow at L'Estaque* (cat. no. 8), the painter was content with the unpretentious subject of an outcropping of rock in a stand of pines, with a forest road widening toward the foreground. This setting, also near L'Estaque, focuses on a massive cliff thrust into the picture like a curtain of stone. Its color, ranging from pure white to intermediate tones of gray and beige, stands in strong contrast to the green underlaid with black of the conifers. Rhythmic horizontal bands of shadow clarify the direction of the sunlight and interrupt the vanishing lines of the perspective. The picture's immediacy of perception and graceful, arresting brushstrokes indicate that Cézanne was increasingly surrendering himself to nature; that careful observation of natural phenomena was edging aside the concern for meaning so apparent in the works of his earliest years.

PROVENANCE: Ambroise Vollard, Paris.
BIBLIOGRAPHY: Vollard 1931, **395**; Hans Joachim Ziemke, *Die Gemälde des 19. Jahrhunderts* (Catalogue of the paintings in the Städelsches Kunstinstitut), Frankfurt am Main 1972, text volume 58f., plate volume, illus. 267; Rewald 1986, **90**.
EXHIBITIONS: *Vom Abbild zum Sinnbild,* Städelsches Kunstinstitut, Frankfurt am Main 1931, no. 19.

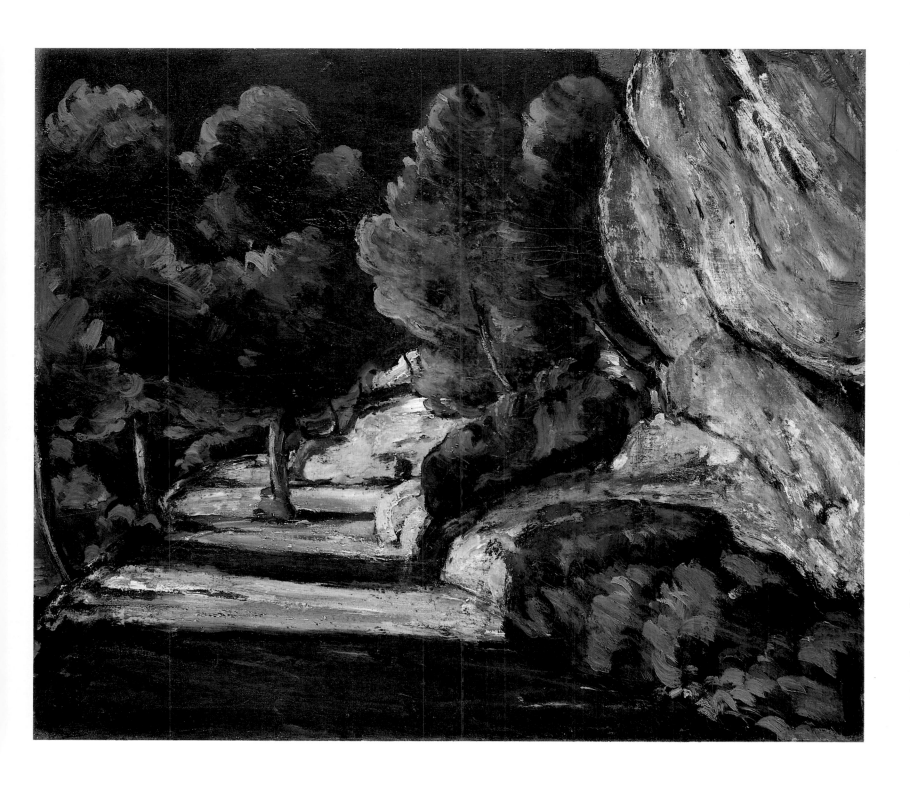

10 Female Bathers Surprised by a Voyeur, circa 1870
 Baigneuses surprises par un passant les observant

Not in Venturi
Oil on canvas, 12 7/8 x 15 3/4″ (32.8 x 40 cm),
composition 12 1/2 x 13 3/4″ (31.5 x 35 cm).
Private collection. Courtesy of the Galerie Jean-Claude Bellier, Paris

In this composition, we see the first appearance of a subject that would occupy
Cézanne repeatedly from the late seventies onward – that of a group of bathers
(see cat. nos. 33, 34, 79–83). While later versions drop the thematic and formal
contrasts so as to better suggest the unity of nature and figure, here the theme is still
infused with an element of conflict typical of his early work. He has not yet abandoned
the confrontation of the sexes in favor of formally disciplined groups of bathers
strictly segregated by gender. The definitive separation of male and female figures so
decisive for Cézanne has not yet occurred. The polarity of the sexes still echoes the
polarity between figures and nature. The four nudes modeled in light pink against the
deep blue of the background are captured at the very moment they become aware
that they are being spied upon by a stranger hidden behind the trunk of a tree at the
left edge of the picture.[1]
 Only recently it was suggested that this scene, placed in front of a theatrical
landscape view, was meant to represent the grotto of Venus from Wagner's *Tannhäuser*.[2]
Given Cézanne's enthusiasm for Wagner, one could certainly see the figure on the
right as the goddess herself, and those facing her to the left as the Three Graces.[3] Yet,
the figure of the voyeur and the treatment of the landscape, rather more pathetic than
romantic, argue against such an interpretation. It is more reasonable to compare this
work with Cézanne's *Temptation of Saint Anthony* (Stiftung Sammlung E. G. Bührle,
Zurich). There, too, we find four voluptuous female nudes confronted by an "intrusive"
male figure in the background on the left, in a setting characterized by similarly
contrasting colors. In both cases, the erotic aspect plays a central role, certainly no
surprise when one recognizes the artist's obsession with sex and his consequent
self-consciousness in the presence of all things feminine. The care with which he
developed the pale, nude figures out of the darkness with a broad brush is a clear
indication of it. One cannot overlook the fact that there is ample precedent for such a
grouping of nudes next to a pool of water in the iconography of religion and myth.[4] As
protagonists in a profane depiction of temptation, they even call to mind the Judgment
of Paris – the mythological correlative of temptation.

NOTES

1 In Cézanne's small painting *Trois baigneuses*, Venturi 1936, no. 266, as well in his signed watercolor
 studies Chappuis 1973, no. 368, and Rewald 1983, no. 62, the voyeur again figures as the disruptive
 counterfoil to female nudes; see also *La baignade*, Venturi 1936, nos. 272, 275.
2 Lewis 1989, 189ff.
3 See Cézanne 1984, 107–8, 126. In Marion's letters to Morstatt, see cat. no. 4, note 1, there are repeated
 references to their own enthusiasm for Wagner and that of their friends; see also the picture title
 L'ouverture du Tannhäuser, Venturi 1936, no. 90.
4 The seated figure on the left was repeated in similar form roughly five years later, Venturi 1936, no. 256,
 but otherwise these nudes were not further exploited either as a group or as single figures.

PROVENANCE: Dr. Paul Fernand Gachet, Auvers-sur-Oise; Paul Gachet, Auvers-sur-Oise; Wildenstein,
Paris-London-New York.
BIBLIOGRAPHY: Rewald 1986, 87 (with a strip of canvas on the right that was probably originally folded
under and is not part of the composition); London 1988, 32; Lewis 1989, 173, 185f., 189ff., 195, 200, illus. 13.
EXHIBITIONS: Basel 1989, 110, illus. 73, 167, 311, no. 6.

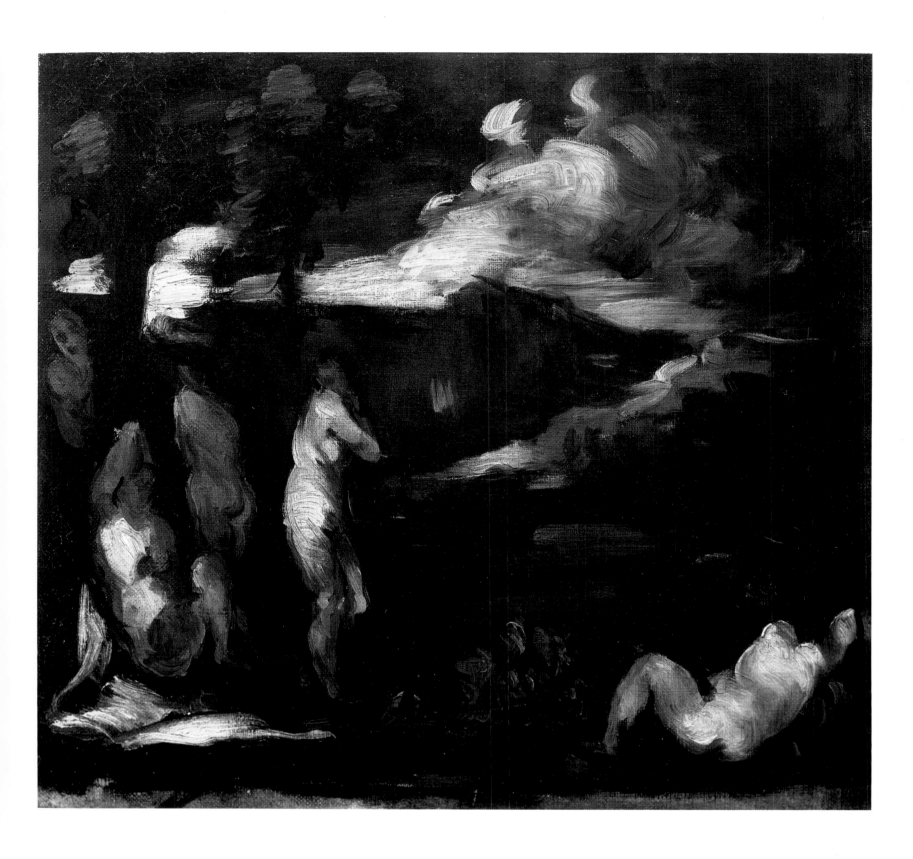

11 Afternoon in Naples (with a black servant), 1875–77
L'après-midi à Naples (avec servante noire)

Venturi no. 224 (1872–75)
Oil on canvas, 14 5/8 x 17 3/4″ (37 x 45 cm).
Australian National Gallery (inv. no. 85.460), Canberra

Of particular importance to Cézanne was a subject that intrigued him for several years and occupied him up until this last painted version, one having to do with the joy of sex and alcohol. As early as 1867, he tried to challenge the jury of the Paris Salon (see cat. nos. 2, 4) with two paintings he had taken there on a handcart. They bore the strange titles – probably provided by Antoine Guillemet – *Afternoon in Naples* or *The Wine Grog* (see illus. 1).[1] Their explicit subject matter can only have constituted a major affront. Though he was rejected as usual – in that year, Pissarro, Guillemet, Renoir, Bazille, Sisley, and Monet were also victims of the jury's strict criteria – with his outrageous behavior, Cézanne at least succeeded in inciting a certain Arnold Mortier to write a malicious article about him in the periodical *Europe*, portions of which were reprinted in *Le Figaro*:

> I have heard of two rejected paintings done by M. Sésame [*sic*] (nothing to do with *The Arabian Nights*), the same man who, in 1863, caused general mirth in the Salon des Refusés – always! – by a canvas depicting two pigs' feet in the form of a cross. This time M. Sésame has sent to the exhibition two compositions that, though queer, are nevertheless just as worthy of exclusion from the Salon. These compositions are entitled: *The Wine Grog*. One of them depicts a naked man whom a very dressed-up woman has just brought a wine grog; the other portrays a nude woman and a man dressed as a *lazzarone*: in this one the grog is spilt.[2]

Emile Zola, though never fully capable of understanding all that his friend Cézanne wished to express, nonetheless pounced on the inaccuracy of these descriptions. On April 12, 1867, he published in *Le Figaro* a sharp rejoinder:

> My dear colleague: Be good enough, I beg you, to insert these few lines of correction. They concern one of my boyhood friends, a young painter whose strong and individual talent I extremely respect.... M. Paul Césanne's [*sic*] in excellent and numerous company, has indeed had two canvases rejected this year: *The Wine Grog*, and *Intoxication*. M. Arnold Mortier has seen fit to be amused by these pictures and describe them with flights of imagination that do him great credit. I know that all this is just a pleasant joke, which one must not worry about. But I have never been able to understand this particular kind of criticism, which consists of ridiculing and condemning what one has not even seen. I insist at least on saying that M. Arnold Mortier's descriptions are inaccurate.[3]

In contrast to the version of the theme that occasioned this exchange (see illus. 1), the painting presented here, created years later as the result of numerous intervening studies,[4] is more balanced in its figural arrangement and its definition of space. Also, its colors are more subtle, ranging from the extreme whiteness of the bedsheet to the dark flesh tone of the exotic servant woman, who may well have been borrowed from Delacroix's painting *The Women of Algiers* (1834, Musée du Louvre, Paris). The whole structure of the painting takes on a lively interest, thanks not only to the juxtaposition of black and white, but also the complementary colors red and green, orange and blue.

Nothing has changed with respect to the provocative content of the picture, however, which still managed to flout all aesthetic and moral standards. The viewer is invited to look past a raised purple curtain, reflected on the right in a standing mirror, at a highly intimate scene. A couple lounges on a bed in a compromising pose, while a servant dressed in only a red loincloth rushes in with a "love potion" on a tray. A pitcher and glasses stand in a wall niche (see cat. no. 62). Neither the intrusion of the servant nor the viewer's indiscretion manage to jar the two out of their offensive languor.[5]

Cézanne's work with Pissarro in the early seventies had helped to discipline his tendency toward violent expression (see cat. no. 16), yet he could still not abandon, at least in terms of subject matter, what had moved him in previous years. The picture's images continue to be drawn from Manet's *Olympia* (illus. 2). That painting of a nude young girl lounging suggestively on her bed in the attendance of a black servantwoman and a cat arching its back had been the art scandal of 1865. Critics lost no time in branding the girl a courtesan. Anyone wishing to stand up for the much-maligned Manet and his deliberate provocations, and build on them, first had to tackle the ignorance of public opinion. Cézanne and Zola each did so in his own way, the highly articulate Zola soon diverting the desired publicity to himself (see cat. no. 6). In his series of pictures on the subject of *Afternoon in Naples*, Cézanne was fired by the hope that by taking Manet's painterly and iconographic innovations a step further, and presenting the public with illustrations of even more debased sensuality, he might achieve a comparable *succès de scandale*. Manet had merely exposed the tawdriness of a provincial beauty who knew how to get what she wanted. Cézanne went him one further by adding to the figures taken over from that painting a nude male, leaving no doubt as to the nature of their surroundings or the intentions of the guest. He was determined to confront his viewers, jaded as they were by the tastelessness they

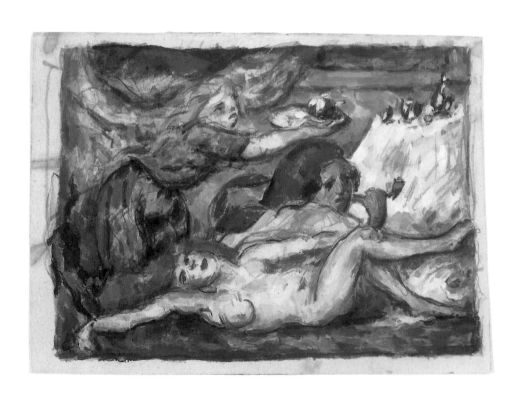

Illus. 1
Paul Cézanne,
The Wine Grog, 1866–67,
gouache. Private collection, Stuttgart

70

witnessed every day, with images of such shocking lewdness, stripped of the mantle of mythology, religion, or history, that they could no longer dismiss them as mere moralizing allegory. Even Manet was moved to ask Guillemet what on earth he saw in such filthy painting, revealing what he really thought of the creator of *Afternoon in Naples*.[6]

NOTES

1 The two paintings have not survived. However the gouache shown here, Rewald 1983, no. 34, gives us a relatively accurate idea of the motif in its original form.
2 Rewald 1986, 69.
3 Ibid.
4 Venturi 1936, nos. 112, 223; Rewald 1983, no. 35; Chappuis 1973, nos. 180, 275–80, 284–86, 460, 461.
5 The painting can be traced back to a watercolor study from circa 1871, Rewald 1983, no. 35, in which the couple is joined by a black cat with its tail erect. The cat has traditionally been thought of as an incarnation of the Devil, and a symbol of sexual aggression. Of a color that is the opposite of light, it attests to the mysterious workings of the rebellious life force. Although the cat plays a prominent role in most draft versions of the scene, it was left out of the final painted one.
6 Vollard 1960, 22.

PROVENANCE: Ambroise Vollard, Paris; Bernheim-Jeune, Paris; August Pellerin, Paris; Jean-Victor Pellerin, Paris; Wildenstein, Paris-London-New York.
BIBLIOGRAPHY: Vollard 1924, 36f.; Ors 1936, illus. 42; Raynal 1936, illus. 18; Venturi 1936, 91, 115, no. 224, 239, 291, **350**; Cogniat 1939, illus. 30; Rewald 1939, 447, illus. 42; Dorival 1949, 50, illus. 49, 156; Guerry 1950, 186; Schmidt 1952, 25; Badt 1956, 71, 226, 240; Berthold 1958, 58; Neumeyer 1958, 22, 36; Reff 1958, 72; Chappuis 1962, 53, 62f.; Reff 1962, 113; Reff 1963, 151; Lichtenstein 1964, 59, illus. 11; Schapiro 1968, 51f.; Elgar 1974, 41f., illus. 21; Adriani 1978, 79, 311; Adriani 1981, 259f.; Rewald 90, no. 34, 92, no. 35; Rewald 1986, **68**; Lewis 1989, 75; Krumrine 1992, 586.
EXHIBITIONS: London 1988, 21, 33, 45, 52, 61f., 124f., no. 27, illus., 204; Basel 1989, 100, 102, illus. 66, 105, 312, no. 27.

Illus. 2
Edouard Manet,
Olympia, 1863.
Musée d'Orsay, Paris

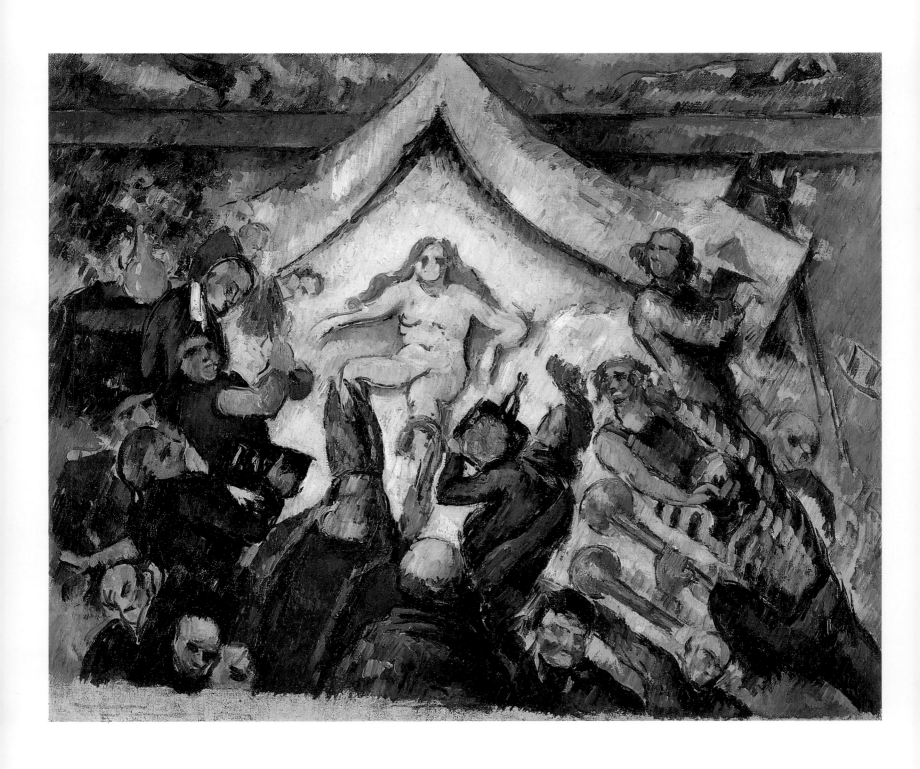

12 The Eternal Feminine, 1875–77
L'éternel féminin

Venturi no. 247 (1875–77)
Oil on canvas, 17 1/8 x 21″ (43.2 x 53.3 cm).
Collection of the J. Paul Getty Museum, Malibu, California

This painting, also known as *The Triumph of Women*, with its ironic glorification of the female nude, is one of the artist's last variations on the early theme of the confrontation of the sexes (see cat. nos. 1, 2, 10, 11). The eternal feminine, bathed in harsh light, looks down upon the world of men at her feet. A cult object, she sits enthroned on a mountainous bed, in a pose that seems to be a parody of sexual submissiveness. We see her receiving the adulation of those in thrall to her caprices in a public space. Above a high balustrade, the scene appears to open out onto a view of landscape. With its suggestion of collective desire, an imposing baldachin as an indication of majesty, and its repeated use of blue gray, scarlet, and yellow gold, the idolatrous scene takes on the air of a *sacra conversazione*, heaven having been reduced to the equilateral triangle of the canopy. Exposed to the inconsiderate stares of the crowd of men, the prostitute, scorned precisely because she has been so used, gets back at the *grands corrupteurs* who exploit her and the social class to which she belongs. By depicting this woman as both idol and demon, victim and victimizer, Cézanne betrays something of his own ambivalent attitude, part fascination and part loathing. It was not for nothing that he depicted the female as a godless object of worship, a figure with bloodshot eyes set apart from the world of the male.

His panorama of that world, meant to be a representative cross section (see cat. no. 63), is arranged by classes, types, and professions. On the center axis of the painting, directly below the brazen nude, we see the head and shoulders of a figure turned away from us. With his massive head, bald except for a fringe of hair, he appears to be a portrait of Cézanne himself.[1] Flanking this pivotal figure are two distinct sorts of men: artists of various kinds to the right, the established professions to the left. The former are introduced on the upper right by a painter brandishing his brush and palette before his easel. He has already begun to immortalize the beauty seated beneath the canopy. Next come a magician with his wand and flying top hat, a pair of acrobats in blue-and-white-striped tights, and musicians trumpeting a fanfare. A chef tends to the woman's physical needs, proffering wine and yellow fruit on a tray. Each of these practitioners of the liberal arts – also representative of the senses – pays homage to the plump leveler in his own way, using his own particular talents. Ranged across from them are representatives of the bourgeois establishment. The most prominent of them is a bishop dressed in splendid vestments, his mitre and crosier clearly visible. He is surely not in attendance out of concern for the spiritual well-being of his lost sheep. He is followed in turn by secular dignitaries, leaders from the realms of jurisprudence, the military, and finance. The first of these is backed up by obedient, gray-suited civil servants; the military officer wears a bicorne and epaulettes; the indispensable financier holds out a sackful of gold. Cézanne, having himself been forced to choose, like Hercules at the crossroads,[2] between security and risk, the law and the life of a painter, appears to be only a passive presence, standing back from the circle of worshippers. He identifies neither with one side nor the other. Doubtless he had resigned himself to the role of a mere spectator. The captivating beauty is hopelessly beyond his grasp. Like her, the *peintre-voyeur* only appears to be the center of society. In truth, they had both come to be considered social dynamite in the nineteenth century, respectively homme and femme fatale outside all decent society. The cult of the artist at that time was, as fickle as that of the courtesan; both

could only function within their own spheres of expertise, so long as they satisfied the demands of their generous patrons.

Zola's notes relating to his bestseller *Nana*, published in 1879–80, serve as illuminating commentary on Cézanne's various interpretations of this subject matter.[3] The novelist not only sheds light on the polarity between male and female, between the artist and society, but also makes the boudoir the meeting place of prestige and intellect, of political power and bohemianism. He writes about his heroine, the perfidious "mouche d'or" to whose "toute puissance de son sexe" all Paris is in thrall:

> Nana becomes an elemental force, a ferment of destruction, but not intentionally; it is only by virtue of her sex and her female smell that she destroys everything that comes close to her.... Ass in its absolute sway ... on an altar, to which everyone brings offerings. This book must be the epic of ass, and its moral that ass forces everyone to dance around it.... This is the philosophical substance: a whole society rushes after ass. A pack trailing a bitch that is not in heat and makes fun of the hounds who pursue her. A poem of male carnality, the great lever that sets the world in motion. There is only ass and religion. I have to show Nana as the focal point, as the idol at whose feet all men fling themselves, for whatever motives and with whatever personalities ... I will assemble a number of men who represent the whole of society.[4]

While these notes are roughly contemporary, the roots of Cézanne's pictorial idea lie further back in time. Among others, one might point out the engraving of an unknown Antwerp mannerist (illus. 1) showing a group of artists – in this case fools, musicians, and jugglers – dancing around a Dame World brandishing the symbols of vanity. There is also ample precedent for the motif of the elevated single figure above an unruly mob in the popular graphics of nineteenth-century France. One finds it used to glorify the French Republic, for example, in the naive style of political illustration (illus. 2), or to deplore, in caricature, the excessive power of certain journalists of the day (illus. 3). In the elaboration of his pictorial idea, Cézanne may also have borrowed from Delacroix and his *Samson and Delilah* (1849–56, Reinhart Collection, Winterthur)

Illus. 1
Antwerp master,
The Dance Around Dame World, circa 1600,
copper engraving

Illus. 2
Allegory of the French Republic, 1848,
lithograph from *Le Charivari*

Illus. 3
Grandville,
The Levee of the Great Journalist, 1846,
woodcut

and from Courbet's allegory of the times, *The Studio* (1854–55, Musée d'Orsay, Paris). Delacroix had shown the biblical hero succumbing to the "weaker sex" at the foot of a love bed crowned by a vast canopy. In the Courbet painting, we see not only the same combination of a self-portrait and a nude surrounded by a group of figures, but also a possible precedent for Cézanne's division of his worshippers into two opposing camps. According to Courbet's own statement, the figures on the right side of his ambitious cosmos are "friends, colleagues, art lovers," while those on the left are "ordinary folk, the people, misery, poverty, wealth, the exploited, the exploiters, the people who make their living from death."[5]

NOTES

1 Cézanne's half profile is clearly identifiable in a watercolor study, Rewald 1983, no. 57.
2 As a young man, the artist had dealt with the Hercules theme. See Cézanne 1984, 32, 82.
3 See the variants in watercolor and drawing, Rewald 1983, nos. 139, 385, Chappuis 1973, nos. 257, 258, 317.
4 Werner Hofmann, *Nana, Mythos und Wirklichkeit*. Cologne 1973, 58.
5 Klaus Herding, *Realismus als Widerspruch. Die Wirklichkeit in Courbets Malerei*, Frankfurt am Main 1978, 24.

PROVENANCE: Ambroise Vollard, Paris; Bernheim-Jeune, Paris; Auguste Pellerin, Paris; Jean-Victor Pellerin, Paris; Wildenstein, Paris-London-New York; Harold Hecht, Beverly Hills.
BIBLIOGRAPHY: Coquiot 1919, 212f.; Rivière 1923, 204; Fry 1927, 80, illus. 49; Raynal 1936, illus. 22; Rewald 1936, illus. 22; Venturi 1936, 17, 37, 120, no 247, 250, 252, 295; Barnes, Mazia 1939, 180, 324; Dorival 1949, 48, illus. VI, 177; Guerry 1950, 24f., 41, 120; Schmidt 1952, 25; Badt 1956, 71, 77, 215, 226; Chappuis 1962, 66; Reff 1962, 113f., 119, 122; Reff 1962 (*Stroke*), 217, 219, 221ff.; Lichtenstein 1964, 58f., illus. 7, 66; Schapiro 1968, 49, 51, illus. 18, 53; Cherpin 1972, 56; Max Dellis, "Note relative au tableau 'L'éternel féminin' de Cézanne," in *Arts et Livres de Provence* 81 (1972), 7ff.; Brion 1973, 31; Chappuis 1973, 105, no. 258, 142, no. 464; Newcastle 1973, 151; Elgar 1974, 46, 66, illus. 34; Lichtenstein 1975, 126; Adriani 1978, 312; Adriani 1980, illus. 4, 51ff.; Krumrine 1980, 115, 122; Adriani 1981, 262; Arrouye 1982, 55; Rewald 1983, 97, no. 57, 118, no. 139, 179, no. 385; Rewald 1986, 115; Geist 1988, 132f., illus. 116; London 1988, 29, 53; Aix-en-Provence 1990, 84, illus. 30, 200, illus. 179; Wayne V. Andersen, "Cézanne's L'éternel féminin and the Miracle of her restored Vision," in *The Journal of Art* III (December 1990), 43f.; Krumrine 1992, 586f., illus. 10, 591f., 594.
EXHIBITIONS: Paris 1895; Paris 1907, no. 5; Berlin 1909, no. 24; *L'Impressionnisme*, Palais des Beaux-Arts, Brussels 1935, no. 10; Paris 1936, no. 37; London 1939, no. 16; New York 1947, no. 13, illus.; Chicago 1952, no. 23; New York 1959, no. 11, illus.; Basel 1989, 16, 39, 78, 83f., illus. 49, 92ff., 96, 137, 159, 190, 208, 218, 257, 262, 313, no. 29.

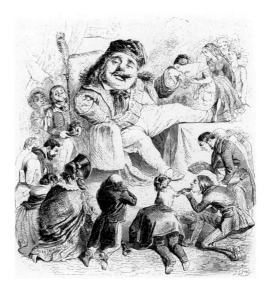

13 Self-Portrait with Rose Background, circa 1875
 Portrait de l'artiste au fond rose

Venturi no. 286 (1873–76)
Oil on canvas, 26 x 21 5/8″ (66 x 55 cm).
Private collection

This work showing the artist in front of a patterned rose background is Cézanne's most important self-portrait from his first decade of painting. Eye-to-eye self-scrutiny was of special interest to him throughout his life, and here for the first time, he brought it to perfection (see cat. nos. 36, 67). He expended a great deal of effort on self-portraiture in the years between 1872 and 1877, the very period in which he was closest to the Impressionists, who had little interest in the genre.[1] Clearly, Pissarro felt a sense of reponsibility toward the younger man in their years of working together, so that Cézanne's decided need to assert himself – he was always one to hold his own ground – survived undiminished (see cat. no. 16).

Here, he chose to execute a bust portrait of himself, the traditional portrait presentation since the early Renaissance. The man he shows us is extremely reserved, one who has experienced loneliness in all of its forms and has, accordingly, developed his ideas on his own. This was a period in which Cézanne, disturbed by his continuing lack of success, began to seal himself off so as to concentrate on the few things he found to be within his reach. His self-portrait, given over entirely to the authority of color as the most important constructive element, reveals a complex personality that has never known the simple certainty of self-confidence. The so evident self-control is rooted in resignation, the creative power in constant self-doubt. The assurance of this figure, filled with energy and inner conflict, is solely a question of form created with color; it is not dependent on an impressive pose, as was still the case in the highly sophisticated self-portraits of Delacroix, Courbet, or Manet.

The massive bust is topped by a round head turned to fix the viewer with a penetrating gaze. Fringed with a beard and what was left of his hair,[2] the head holds its own against the background wall patterned like fieldstone masonry. Half in the light, half in shadow, the facial features are built up in small brushstrokes reflecting the wealth of colors in the rest of the painting: the blue-black tinged with violet of the hair and the coat; the touch of cinnabar on the collar; the mixture of rose, gray, and beige in the pattern of the wall. The proportions are so appropriate to the three-dimensional strength of this body that – were there not flesh tones in the background tying it to the foreground of the painting – one might be tempted to compare the picture to Florentine sculptured busts from the Renaissance, or to Giacometti bust forms. Its background decor anticipates an essential element in the later portraits of Matisse, who probably knew this work from the former Pellerin Collection.

No one has ever managed to capture in words the phenomenon of color in Cézanne as well as Rainer Maria Rilke. On October 23, 1907, after visiting the exhibition of fifty-six works in the Grand Palais commemorating the first anniversary of the painter's death, the poet wrote to his wife about this portrait:

> For a moment, it seemed easier to talk about the *Self-Portrait*: it is earlier, apparently [than the *Hortense Fiquet in a Striped Skirt,* cat. no. 14, described just before], it does not run through the whole available palette, it appears to stay in the middle of it between orange, ocher, red lake, and violet purple, and to go in the coat and hair to the depth of a moist violet brown that is set off by a wall in gray and a pale copper. On closer inspection, however, one discovers in this picture, too, a subtle presence of light green and luscious blue that bring out the

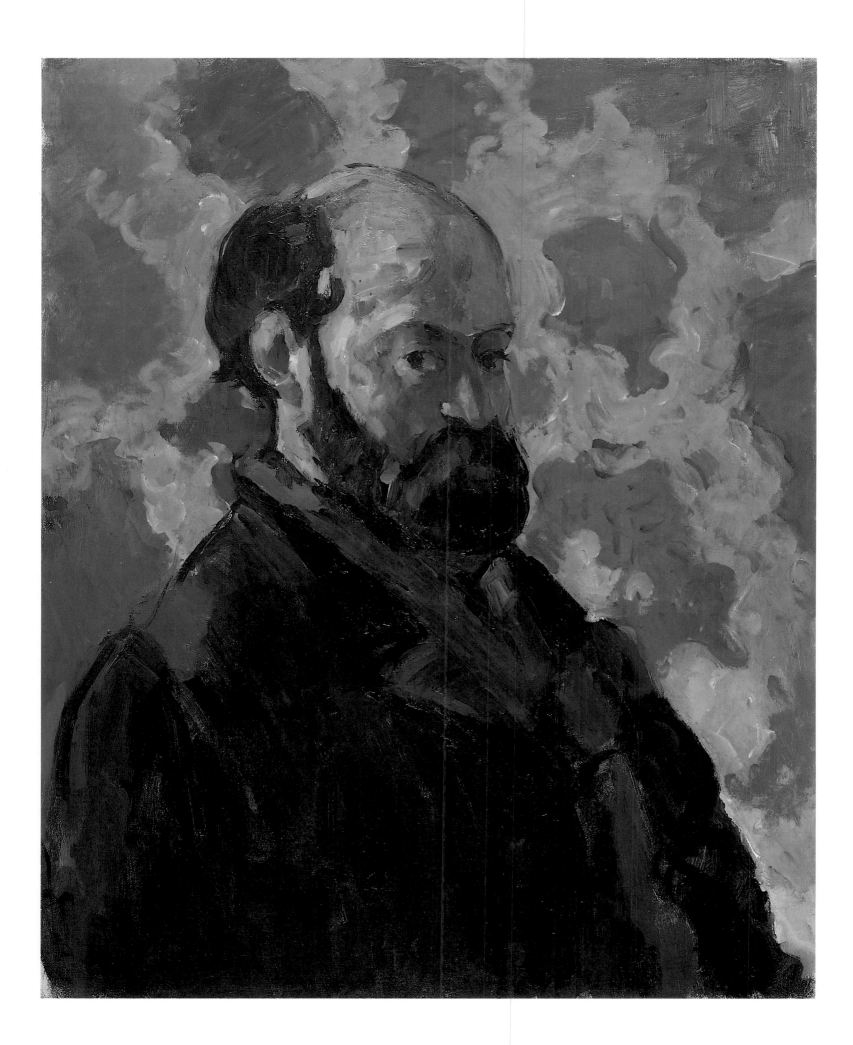

reddish tones and define the highlights. Meanwhile, the subject itself is perfectly comprehensible, and the words that feel so wretched talking about painterly details would only too gladly come into their own telling what is depicted, with which their proper realm begins, and describing what is there. It is a man seen from the right in profile turned forty-five degrees to the front, gazing at us. His thick, dark hair is bunched together at the back of his head and stops above the ears in such a way that the whole line of his cranium is exposed; it is drawn with eminent assurance, hard and yet round, from the temple downward in one piece, and its solidity is still apparent even in those spots where, absorbed into form and surface, it becomes only the outermost of thousands of outlines. The powerful structure of this skull embossed from within is again visible in the ledge of the eyebrows; from there down, however, the face hangs, the densely bearded chin thrust forward toward the bottom as though by a shoe tree; hangs as if every feature were suspended separately, in an amazing progression, and at the same time, there is that expression of gaping wonder that, reduced to its most primitive, children and peasants can fall into – only the blind stupidity of their abandon has been replaced with an animal attentiveness that maintains in the eyes, uninterrupted by lids, a constant, practical wakefulness. And it is almost touching the way he confirms how great and incorruptible this practicality of his seeing really was by presenting himself, without remotely explaining his expression or condescending to it, with such gentle objectivity, with the trust and the concern for simple facts of a dog who sees himself in the mirror and thinks: *there's another dog.* So long ... for now. Perhaps you can see him a little from all of this, the old master to whom one might well apply the words he himself used to describe Pissarro: *humble* and *colossal.* Today is the anniversary of his death....

On the following day, Rilke continued:

I said *gray* yesterday, when describing the background of the *Self-Portrait,* a light copper overlaid with a diagonal pattern in gray. I should have said: a strange, metallic white, aluminum or some such, for gray, actual gray, is never found in Cézanne's pictures. It did not stand up as a color to his immensely painterly eye: he got to the bottom of it, and found it there to be violet or blue or reddish or green. He is especially fond of seeing violet (a color that has never before been explored so fully and in so many variations) where we would expect only gray, and would be perfectly satisified with it. He does not give in, but rather draws out the violet that is as though turned under it, just as many evenings do, autumn evenings especially, which speak to the graying of the façades as violet so that it answers them in all the tones from a light, tentative lilac to the heavy violet of Finnish granite.[3]

NOTES

1 See the self-portraits, Venturi 1936, nos. 287–90.
2 Cézanne grew bald as a young man. It had been a long time since he could write, as he did in 1864, that "my hair and beard are more abundant than my talent" (Cézanne 1984, 105), or since August 28, 1867, when Marion was able to report to Morstatt: "This year he looks magnificent with his light, incredibly long hair and his revolutionary beard." See cat. no. 4, note 1.
3 Rilke 1977, 40f.

PROVENANCE: Auguste Pellerin, Paris; René Lecomte, Paris.
BIBLIOGRAPHY: Meier-Graefe 1910, frontispiece; Burger 1913, illus. 69; Meier-Graefe 1918, **110**; Meier-Graefe 1922, **131**; Rivière 1933, **73**; Venturi 1936, 36, 127, no. 286; Barnes, Mazia 1939, **204**, 339; Dorival 1949, illus. 44, 155; Cooper 1954, 346f.; Badt 1956, 142; Gowing 1956, 187, 192; Leonhard 1966, 141, **143**; Andersen 1970, 15, illus. 14; New York 1977, 75; Rilke 1977, 40f.; Paris 1978, 17; Gasquet 1991, **84**.
EXHIBITIONS: Paris 1907, no. 22; *Modern French Art,* Grosvenor House, London 1914; Paris 1936, no. 47, illus. 2; Chicago 1952, no. 39, illus.; Paris 1954, no. 33, illus. 14; Basel 1983, no. 8, illus.; Basel 1989, 104, illus. 68, 312, no. 17.

14 Hortense Fiquet in a Striped Skirt, 1877–78

Hortense Fiquet à la jupe rayée

Venturi no. 292 (circa 1877)
Oil on canvas, 28 1/2 x 22" (72.5 x 56 cm).
Museum of Fine Arts,
Bequest of Robert Treat Paine II (inv. no. 44.776), Boston

Cézanne had no more commissions for portraits than he did for landscapes or still lifes. He therefore confined himself to portrait subjects that quite literally appealed to him, a circle of people he knew and for whom he felt a definite personal fondness, whether rooted in shared recollections, in love, or in friendship. Unlike the portraitists of the Salon – or Manet, Renoir, Degas, or Toulouse-Lautrec for that matter – who tended to choose their sitters from high society, Cézanne concentrated on the few people close to him.

The most important of these was Hortense Fiquet (born 1850), the daughter of a bank clerk from Saligny, in the Jura, whom the painter had come to know as a model in 1869. They soon began living together, first in Paris and then in L'Estaque. She was eleven years younger than he, and for years. fearing that his modest monthly allowance could be withdrawn, Cézanne did everything he could to prevent his father from learning about their liaison. Their son Paul was born on January 4, 1872, but it was not until April 1886 – shortly before Cézanne's father's death – that the couple legalized their union by marriage.

Although they had little enough to say to each other, Hortense Fiquet repeatedly served the painter as a model (see cat. nos. 37–44). (While painted years before their marriage, the title sometimes identifies the sitter as Madame Cézanne; the work has also been called *Madame Cézanne in a Red Armchair*.) She was evidently extremely patient, and could get through the tiring sittings in silence and without moving. She was a congenial subject for him, one to which he could apply his now fully developed painterly style. There are far more portraits of her than of anyone else, twenty-seven in fact, the last of them dating from the early 1890s. Only one other painting shows her sewing in this same tassled chair, in front of the same olive-green wallpaper.[1] The wallpaper, with its pattern of blue motifs, can also be seen in various still lifes.[2] It apparently hung in the Paris apartment at 67, rue de L'Ouest, where the painter and his family spent the better part of 1877 and the first two months of 1878.

With this portrait, Cézanne returned to the large format he had employed in early portraits of his father and his friend Emperaire. both of whom are also shown facing the viewer and enthroned in upholstered chairs as symbols of bourgeois achievement.[3] The carmine red of this armchair takes on added weight to the right, so as to balance the slight tilt of the relaxed figure. Its vibrant color serves to separate the tones of her dress and those of the background, which are attuned to each other. The striking red also tends to ennoble the rather crude planes of this face, with vacant eyes gazing into the distance. The plump curve of the back of the chair is repeated in the shape of the woman's pleated skirt puffed out by her knees – a skirt with exquisitely painted greens that might have graced a Velásquez portrait of the Infanta.

Rilke was the first to write at length about this portrait (see cat. no. 13), and his description of it has never been surpassed. He wrote of it to his wife on October 22 and 23, 1907, at the close of the Cézanne memorial exhibition in the Salon d'Automne:

Already, though I stood before it so often transfixed and unflinching, the superb color combinations of the woman in the red armchair are fading beyond recall as hopelessly as a number composed of many digits. And yet, I fixed it in my mind. Digit by digit. The knowledge that it exists has become a lift to my spirit

that I still feel in my sleep; my very blood can describe it, but telling passes somewhere outside it and is not invited in. Did I write you about it? – A low, red, fully upholstered chair has been placed in front of a earthy green wall in which there are occasional repeats of a cobalt-blue pattern (a cross with the center cut out); its puffy round back curves forward and down into armrests (closed off like the sleeve of a man who has lost an arm). The left-hand armrest and the tassle drenched with cinnabar that hangs from it no longer have the wall behind them, but rather a wide strip of baseboard in greenish blue, against which they strike a loud contrast. Seated in this red armchair, a personality in itself, is a woman resting her hands in the lap of a dress with wide vertical stripes, most delicately rendered with discreet small patches of greenish yellow and yellowish green up to the edge of the blue-green jacket, which is held together in front by a blue silk tie shot with green reflections. In the brightness of her face the proximity of all these colors is exploited for simple modeling; even the brown of her hair piled in curves above her temples and the flat brown in her eyes have to speak up against their surroundings. It is as though each spot had knowledge of every other. So much do they collaborate; so much is there of adaptation and denial; so much does each concern itself in its own way with balance, and create it, as the whole picture ultimately holds reality in balance. For if one says it is a red armchair (and it is the first and most definitive red armchair in all of painting), it is only because it has within it a sum of color experience that, however it happens, bolsters its redness and confirms it. To come to its most blatant expression, it is painted very heavily around the light face, so that a kind of waxy layer results. And yet the color does not overwhelm the object, which appears so perfectly translated into its painterly equivalent that its bourgeois reality, no matter how perfectly captured and factual, surrenders all heaviness for an ultimate existence in a picture. Everything, as I already wrote you, has become a matter of colors among themselves. One is considerate of the other, maintains itself against it, reflects on itself.... So much for today ... you see how difficult it becomes when one wants to get quite close to the facts....

The next day he continued:

I had to wonder last night whether my attempt at describing the woman in the red armchair was able to give you any sense of it? I am not even confident of having captured the relationship between its values. Words seemed shut out more than ever, and yet, it must be possible to use them convincingly, if only one could look at such a picture the way one looks at nature – then it would have to be somehow fully expressible as a fact of existence.[4]

NOTES

1 *Hortense Fiquet cousant*, Venturi 1936, no. 291.
2 Venturi 1936, nos. 209, 210, 212-14.
3 *Portrait de Louis-Auguste Cézanne*, Venturi 1936, no. 91, *Portrait d'Achille Emperaire*, Venturi 1936, no. 88.
4 Rilke 1977, 38ff.

PROVENANCE: Ambroise Vollard, Paris; Egisto Fabbri, Florence; Paul Rosenberg, Paris; Samuel Courtauld, London; Robert Treat Paine, Boston.
BIBLIOGRAPHY: Meier-Graefe 1918, **135**; Meier-Graefe 1922, **165**; Faure 1923, illus. 14; Rivière 1923, 204; Fry 1927, illus. 21; Javorskaia 1935, illus. 14; Mack 1935, illus. 16; Ors 1936, illus. 6; Venturi 1936, 36, 112, 128f., no. 292; Mack 1938, illus.; Barnes, Mazia 1939, **209**, 338; Dorival 1949, illus. 45, 155; James M. Carpenter, "Cézanne and Tradition," in *The Art Bulletin* XXXIII (September 1951), 180; Raynal 1954, **49**; Badt 1956, 142; Cooper 1956, 449; Gowing 1956, 188; Reff 1958, 154; Andersen 1967, 138f.; Andersen 1970, 16, illus. 15, 19f., 152; Elderfield 1971, **52f.**; Murphy 1971, 55, **105**; Elgar 1974, 72; Rewald 1975, **160f.**; Wadley 1975, 99, illus. 88; Rilke 1977, 38ff., illus. 4; Arrouye 1982, 71; Frank 1986, illus.; Rewald 1986, **120**; Kirsch 1987, 21ff., 25f.; Cézanne 1988, **92**; Geist 1988, 134f., illus. 117, 136ff.; Rewald 1989, 25, 30.
EXHIBITIONS: Paris 1910, no. 18; Venice 1920, no. 7, illus.; Philadelphia 1934, no. 14, illus.; Paris 1936, no. 46, illus. 4; Washington 1971, no. 5.

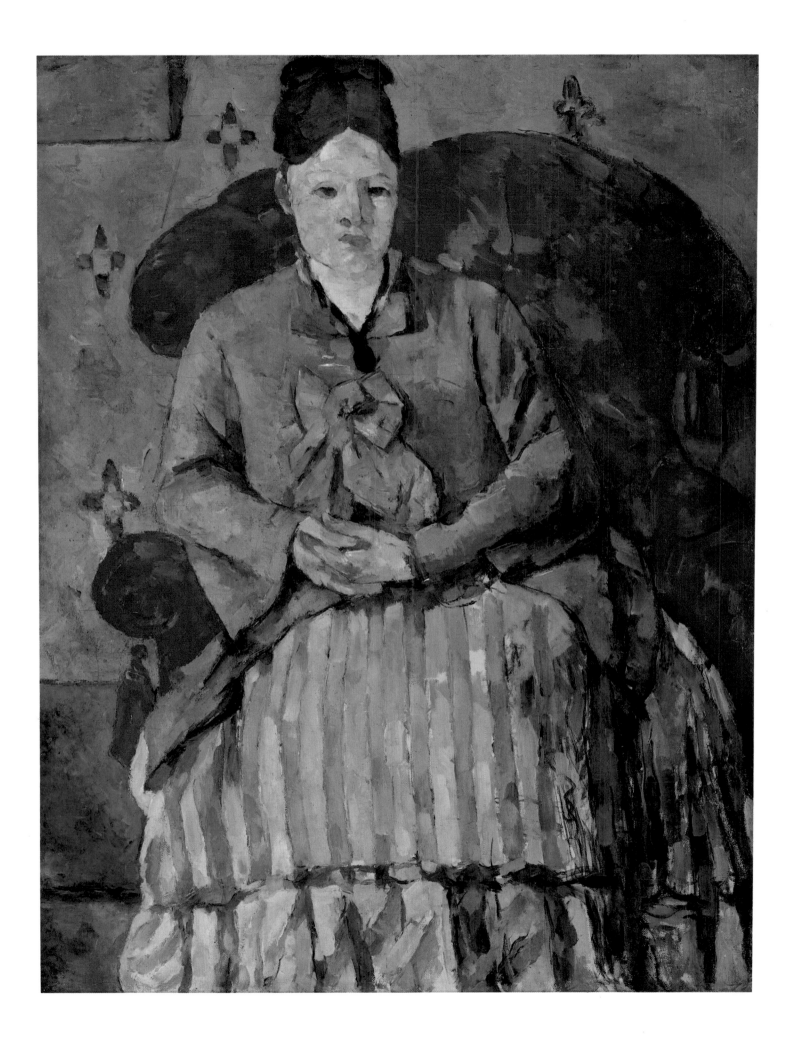

15 Victor Chocquet Seated, circa 1877
Victor Chocquet assis

Venturi no. 373 (1879–82)
Oil on canvas, 18 x 15″ (45.7 x 38.1 cm).
Signed, lower right
Columbus Museum of Art, Howald Fund (inv. no. 50.24),
Columbus, Ohio

Victor Chocquet (1821–1891) is here portrayed as the dedicated collector he was, in an appropriate setting, surrounded by expensive furnishings, carpets, and splendidly framed paintings. With the exception of a likeness of the art critic Gustave Geffroy,[1] the Chocquet portrait is the only Cézanne portrait in which one can immediately deduce the special interests of the subject from such details. Its otherwise perfectly ordinary space has been filled with objects the sitter has collected with great discernment. Yet, the portrait of the proud collector surrounded by his pictures in his Paris home at 198, rue de Rivoli, is by no means commanding. He has settled in a small armchair covered in a purple red and placed at an angle to the center of the space, sitting in a perfectly casual position as he turns from the diagonal to face the viewer directly. The pose belies the elegant formality of his surroundings, and in much the same way, the sitter's brown house slippers – which could have been painted by Van Gogh – provide an ironic comment on the sumptuous combination of blue, purple red, and yellow gold. The fine-boned figure, dressed in a blue-gray suit, white shirt, and stockings, presents a lively interplay of verticals and interlocking diagonals, light and shadow – the light falling in from the left, and in its subtle application helps to define the picture space. The feet, emphasized by the white stockings, are closer to the viewer than the head, which is nearly cut off by the upper edge of the painting. The sense of space it creates is enhanced by the presence of a dark blue baseboard separating the violet olive of the wallpaper with its pattern of red teardrop shapes from the abstract design of the carpet. To judge from this baseboard, the wall to the right appears to be farther back than the one behind the Baroque writing table on the left. It is because of the artist's careful attention to details such as these that the overall arrangement of the painting seems so well thought out. The part and the whole are as inseparably interwoven as the sitter's fingers.

Cézanne had met Chocquet through Renoir in 1875. At that time, he was still chief inspector in the Paris customs department, but in 1877, he retired in order to devote himself full-time to his real passion, collecting paintings by contemporary artists. He was by no means well off; his pension gave him an income of only a little over three hundred francs a month. He had first concentrated on Delacroix but had soon discovered the Impressionists, above all Renoir, who later recalled: "As soon as I got to know Mr. Chocquet, I thought to myself: *He must buy a Cézanne!* I took him to Père Tanguy's [a seller of artists' supplies in the rue Clauzel who, having taken pictures from Cézanne in lieu of payment for materials, became the first dealer in his works], where he selected a small study with nudes. He was enchanted with his acquisition, and exclaimed on the way home: 'How comfortable this will be between a Delacroix and a Courbet!' "[2] This was just the first of many such purchases by the collector; he would ultimately own no fewer than thirty-five Cézannes.[3] He became a fervent admirer of the artist, and it was doubtless at his request that Cézanne signed many of the pictures Chocquet owned in red (see cat. nos. 16, 19).

For the third Impressionist exhibition in April 1877, Cézanne borrowed several works from Chocquet, among them a small portrait he had painted of him in about 1876.[4] The work's strong colors attracted only ridicule from the public and the

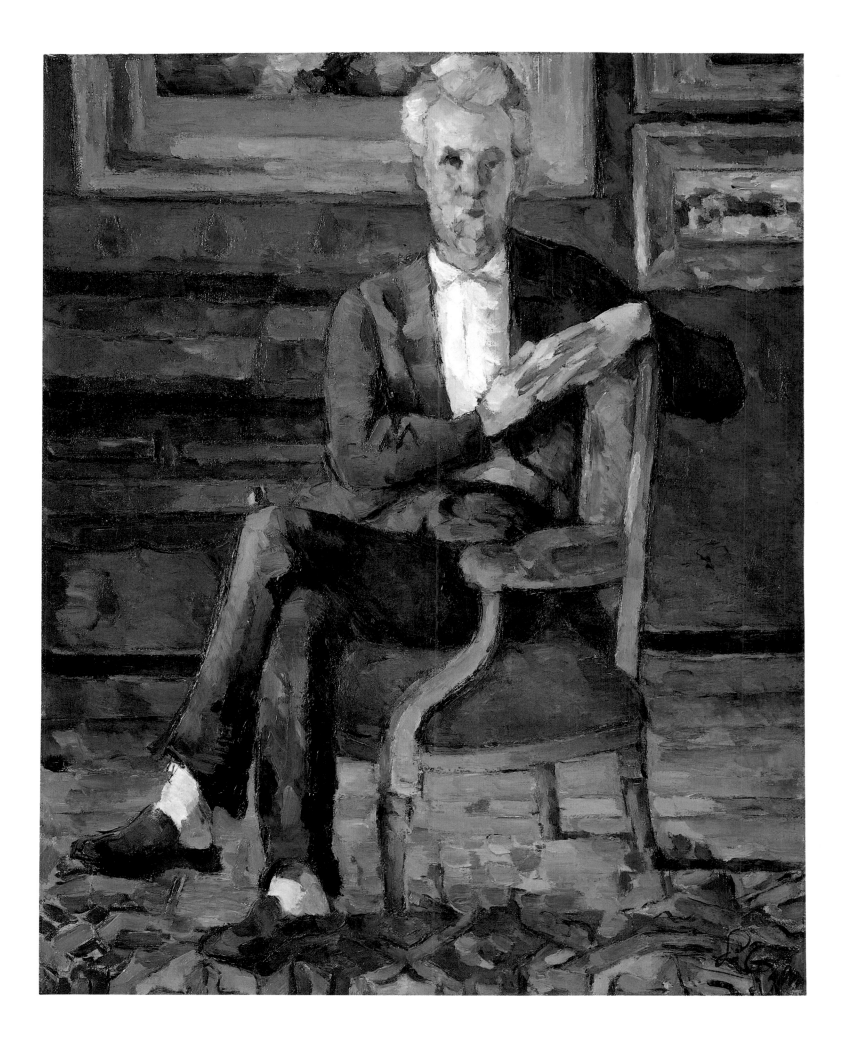

newspaper critics. Yet Chocquet refused to be discouraged. He was indefatigable in his efforts to convince visitors to the exhibition of Cézanne's ability.

The art critic Théodore Duret later wrote of him:

> He was worth seeing. He became a sort of apostle. One after another he took the visitors whom he knew or even approached others to try and make them share his admiration and his pleasure. It was an ungrateful role.... He got nothing but smiles or mockery. M. Chocquet was not discouraged. I remember having seen him try thus to persuade well-known critics and hostile artists who had come simply to run the show down. This gave Chocquet a reputation, and whenever he appeared people liked to attack him on his favorite subject. He was always ready. He always had the right word when it was a question of his painter friends. He was particularly indefatigable on the subject of Cézanne, whom he placed on the very highest level.... Many were amused at Chocquet's enthusiasm, which they considered something like a gentle insanity....[5]

Aside from this portrait of the seated Chocquet, which Cézanne probably painted of his patron in 1877, the year of the Impressionist exhibition, there is also a bust portrait later purchased by Degas (illus. 1), which repeats a section of the full-figure composition. Notable in both portraits is the way the upper body and head face directly to the front, with the interlaced hands forming a strong diagonal. Cézanne borrowed this arrangement from Renoir, who had portrayed the delicate-featured Chocquet in front of a Delacroix painting (illus. 2). In that work the slight tilt of the head and a gaze that is open and trusting characterize the independent sitter as a sentimental, especially sensitive personality. By contrast, Cézanne imposed on him a closed, aloof seriousness. He gazes down at the viewer appraisingly from behind the barriers of the chair back and his arms and hands. Cézanne's passionate application of sharply contrasting colors has nothing in common with the finely detailed portrait by Renoir.

Although Cézanne was perfectly capable of revealing his fondness for his subject in his painting, his attempt to communicate it in a letter to Chocquet years later seems somewhat stilted and forced: "since Delacroix has been the intermediary between yourself and me,[6] I will just say this: how I would have liked to possess the intellectual balance so notable in you and that enables you to attain the goals you set. Your fine letter... is evidence of a fine equilibrium in your way of life. And since I was struck by that serenity, I'm mentioning it to you. Fate did not provide me with similar fare, it's my only regret where earthly matters are concerned."[7]

Victor Chocquet died in 1891. On July 1, 1899, after the death of his widow, the childless couple's effects were auctioned off in the Galerie Georges Petit. Included in the sale were over thirty works by Cézanne, twenty-three by Delacroix, five by Manet, ten each by Monet and Renoir, as well as seventeenth-century furnishings, porcelain, jewelry, clocks, silver, and bronzes. Pissarro had alerted his son to the importance of the auction a month before: "A major artistic event is coming up: now that both père Chocquet and his widow have died, his collection is going to be auctioned off. Included in it are thirty-two first-rate Cézannes, Monets, Renoirs, and a single picture of mine. The Cézannes will fetch quite high prices, and have already been estimated at from four to five thousand francs."[8] It is true that this sale marked the first time that Cézanne's works fetched reasonable market prices – though they were still far below those paid for works by Manet, Monet, or Renoir.

NOTES

1 Venturi 1936, no. 692.
2 John Rewald, "Chocquet and Cézanne," in *Gazette des Beaux Arts* LXXIV, 111 (1969), 39. It was probably the small painting *Trois baigneuses*, Venturi 1936, no. 266.
3 Among others, Venturi 1936, nos. 133, 149, 156, 168 (cat. no. 19), 171, 173, 181, 182, 196, 197, 207, 216, 243 (cat. no. 16), 250, 266, 273, 320, 323, 396, 400, 442, 443, 445, 447, 464, 552, 583, 584, 617.
4 Venturi 1936, no. 283; see also the Chocquet portraits painted later from a photograph, Venturi 1936, nos. 532, 562, and the portrait drawings Chappuis 1973, nos. 394, 395, 398.
5 Rewald 1986, 112f.
6 Cézanne documented their common admiration for Delacroix in his *Apothéose de Delacroix* (cat. no. 63), in which he included Chocquet as the only non-artist.
7 Cézanne 1984, 224.
8 Pissarro 1953, 387.

PROVENANCE: Victor Chocquet, Paris, Chocquet auction, Galerie Georges Petit, Paris, July 5, 1899, no. 490; Durand-Ruel, Paris-New York; L. P. Bliss, New York; Museum of Modern Art, New York; Paul Rosenberg, New York; Marius de Zayas, Stamford; Paul Rosenberg, New York.
BIBLIOGRAPHY: Vollard 1914, 45, illus. 15, illus. 44; Meier-Graefe 1918, 108; Vollard 1919, 60; Meier-Graefe 1922, 128; Rivière 1923, 204; Pfister 1927, illus. 32; Jules Joets, "Les Impressionnistes et Chocquet," in *L'Amour de l'Art* 16, 4 (April 1935), 120; Paris 1936, 77; Venturi 1936, 58, 146, no. 373, illus.; Barnes, Mazia 1939, 26, 63, 193, 407; Dorival 1949, illus. XI, 179; Cooper 1954, 347; Badt 1956, 117, 144; Gowing 1956, 188; Ratcliffe 1960, 12; Vollard 1960, 26; Loran 1963, 85, 91; Andersen 1967, 139; Rewald 1969, 52, illus. 11, 53, 59, 75, 87; Andersen 1970, 20, illus. 16; Murphy 1971, 70f., 99; Schapiro 1974, 27, 50f.; Wadley 1975, 41, illus. 35 Wechsler 1975, illus. 5; New York 1977, 46; Kirsch 1987, 23; Erpel 1988, illus.; Geist 1988, 59f., illus. 51; Rewald 1989, 83, 128, 152.
EXHIBITIONS: Berlin 1900, no. 8; Paris 1904, no. 23; *A Selection from the Pictures by Boudin, Cézanne ...*, Grafton Gallery, London 1905, no. 42; Paris 1920, no. 7; Paris 1924; New York 1929, no. 9, illus.; *The Collection of the late Miss L. P. Bliss*, The Museum of Modern Art, New York 1931-Addison Gallery of American Art, Andover-John Herron Art Institute, Indianapolis 1932, no. 6; London 1954, no. 18, illus. 10; Aix-en-Provence 1956, no. 17, illus.; The Hague 1956, no. 21a; Zurich 1956, no. 41, illus. 16; Munich 1956, no. 29, illus.; Cologne 1956, no. 11, illus.; Aix-en-Provence 1961, no. 6, illus. 4; Vienna 1961, no. 15, illus. 10; *One Hundred Years of Impressionism. A Tribute to Durand-Ruel*, Wildenstein Galleries, New York 1970, no. 58, illus.; Washington 1971, no. 6, illus.; Tokyo 1974, no. 16, illus.; *Paris Cafes. Their Role in the Birth of Modern Art*, Wildenstein Galleries, New York 1985, 60.

Illus. 1
Paul Cézanne,
Portrait of Victor Chocquet,
1877, Virginia
Museum of Fine Arts,
Richmond

Illus. 2
Pierre Auguste Renoir,
Portrait of Victor Chocquet,
1875, Fogg Art Museum,
Harvard University,
Cambridge, Massachusetts

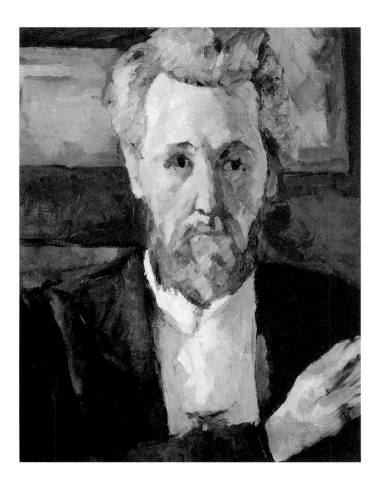

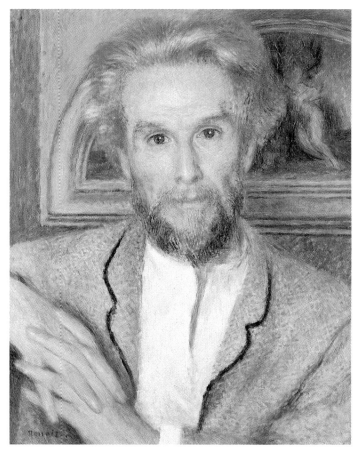

16 The Fishermen–July Day, circa 1875
 Les pêcheurs–journée de juillet

Venturi no. 243 (1873–75)
Oil on canvas, 26 x 32″ (66 x 81.3 cm).
Signed, lower right
Private collection, on permanent loan to
The Metropolitan Museum of Art, New York

Having determined that his greatest chance of success lay in painting from nature, Cézanne arranged to study with the one painter most experienced in the art of landscape, Camille Pissarro. Pissarro served as spokesman for the heterogeneous group of artists coming to be known as Impressionists, a term of disdain applied to them on the occasion of their first collaborative exhibition in 1874. Cézanne's conviction that an Impressionist might help him to clarify his own thinking may have to do with the fact that Pissarro had already been instructing his younger colleague in the patient study of nature for some time. On his return from London in 1871, after the war, Pissarro had settled in Pontoise, northwest of Paris in the valley of the Oise. On his advice, Cézanne had moved there himself in the fall of 1872, with Hortense Fiquet and their infant son, Paul, born on January 4 of that year. At the end of 1872, the young family took up residence in nearby Auvers-sur-Oise, remaining there until the spring of 1874.

Cézanne hoped that Pissarro could help him improve his technique and dampen the confessional nature of his work. Working alongside him in the countryside, the younger man learned to function as an impartial observer, something he had not managed heretofore, owing to his strong desire to interpret what he saw. Under the guidance of his understanding mentor, he gained lasting insights into the essential laws of nature. Pissarro must be credited with having encouraged Cézanne to work with a bright palette based on the three basic colors red, blue, and yellow, and to apply his pigments in thin layers. Over the course of the 1870s, we can see the latter's massive, dark colors giving way to progressively brighter tones *à l'impressionniste*. Pissarro was also responsible for his increasing use of richly differentiated color sequences in the modeling of forms and figures instead of simple contour lines, always keeping an eye on the painting as a whole. Cézanne's willingness to accept advice from Pissarro, whom he considered his only teacher, suggests that he had come to question his own identity and recognize the need for help and guidance. The "humble and colossal Pissarro" was the perfect person to turn to.[1] Thanks to his influence, Cézanne managed to tone down his excessive emphasis on content, forms, and colors, and to concentrate – no less passionately – on nature.

Much as Cézanne was to gain from his work with the older painter, learning to adapt his technique to the specific natural motif, he did not become one of the so-called Impressionists. To be sure, he exhibited with them in their first show in 1874 and again in their third in 1877, identifying himself with their unpopular goals. One can nevertheless see from *The Fishermen*, a painting whose subject matter is certainly one frequently encountered in the Impressionists, how very much he differs from that fraternity as represented, for example, by Pissarro, Monet, Sisley, or Renoir. At first glance, the work strikes one as a typical Impressionist painting, one that communicates something of the warm fellowship these painters enjoyed in Pontoise or Auvers. A brilliant summer day has drawn various groups of people to the banks of a river, and a sailboat has come close to shore while its crew of fishermen work on their nets. Two children fling themselves about on the grass as a pair of women, dressed as though they had stepped from the pages of a fashion journal,[2] wave at their partners lounging under the trees on a strip of land across from them.[3] A man in black top hat

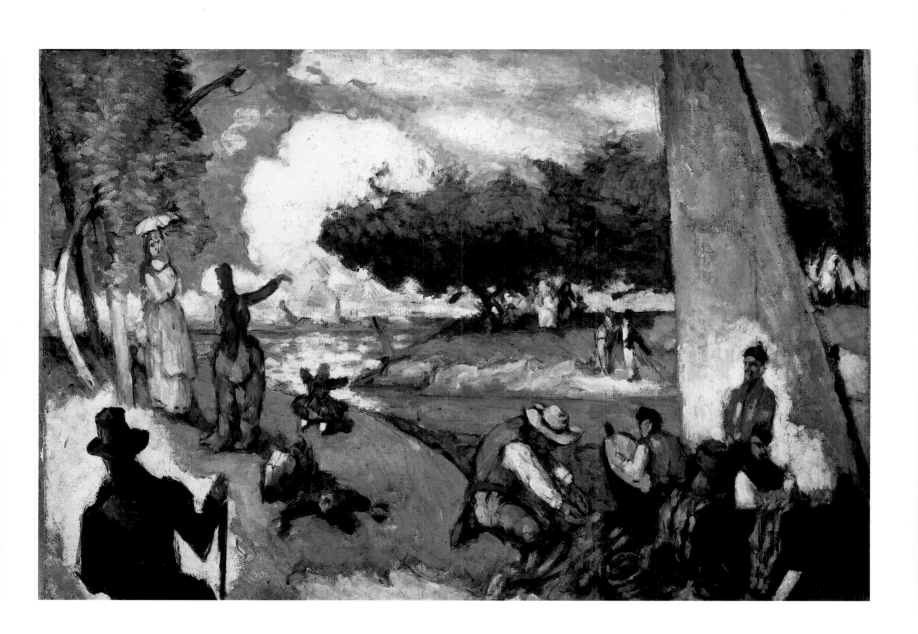

and tailcoat, uninvolved in these goings-on, appears to be eager to leave a scene that may represent the world of Impressionism.

Though there are obvious echoes of Impressionist style in this landscape peopled by fashionable figures,[4] the painting deviates from Impressionist practices in a number of important ways. One notes, for example, that Cézanne continues to be rooted in the pre-Impressionist tradition of form. The Impressionists tended to dissolve form, but here, the small, rhythmic brushstrokes still follow the shapes of objects and figures, betraying the distinct influence of Delacroix, who advocated "making things solid." Moreover, the viewer is left in some doubt about the actual content of the picture, which is also known under the title *Fantastic Scene – Sunday Afternoon*. Apparently, Cézanne here set out to realize in the Impressionist manner a scene he had observed years before (illus. 1), one that appealed to his fixation on the opposition of the sexes, thanks to its shocking juxtaposition – inspired by Manet's *Déjeuner sur l'Herbe* (1863, Musée d'Orsay, Paris) – of fully dressed men and female nudes. Yet, his promenade lacks much of the naturalness and simple joy of life that the Impressionists managed to capture in the form of the contemporary idyll or pastoral. In its solemnity, Cézanne's painting has more in common with Seurat's Pointillist *Un Dimanche à la Grande Jatte* from a decade later (1884–86, Art Institute of Chicago). It has none of the lightheartedness attached to such occasions by the Impressionists. Its figural groupings, clearly segregated by social class – laborers absorbed in their work on the one hand, the bourgeoisie in its Sunday best on the other – pay no attention to one another. They resemble marionettes manipulated by the hand of the artist. The only striking connection appears to be between the figure in the boat on the right, accented by his red clothing, and the one seen from the back on the left. Both are placed against strangely bright backgrounds, and seem to have some significance apart from the others. Certain details suggest that the serious figure on the left was meant to be the artist himself, no longer wishing to be a witness to this intermezzo devoted to modern life and its doings.[5] Just who his odd counterpart on the boat might be is unclear.

The Fishermen was probably painted sometime between the first collaborative exhibition of the Impressionists in 1874, at which Cézanne showed three works, and their third group show in 1877. It was one of sixteen paintings that Cézanne contributed to the 1877 exhibition. It found its way into the well-known collection of Victor Chocquet (see cat. no. 15), and was auctioned off on July 1, 1899, after the death of the collector's widow, for 2,350 francs.[6] By way of the Paris gallery owners Hessel and Bernheim-Jeune, it then came into the possession of the Berlin art dealer Paul Cassirer. In January 1908, Hugo von Tschudi bought the painting for the National-galerie in Berlin (see cat. nos. 25, 55), but the kaiser protested, and he was forced to return it. It was finally bought in early 1909 by the German Impressionist Max Liebermann, one of the first to collect the works of his French colleagues. Liebermann wrote about his purchase to Gustav Pauli, the director of the Kunsthalle in Bremen, on January 27, 1909: "I bought the Cézanne with the white sail – the picture was with Tschudi for a year up until his retirement. You see: I am trying to improve my taste, squandering my hard-earned money in the process. The picture is perhaps too much decoration and somewhat too little nature, almost Venetian, but it is charming and knocks everything else dead."[7]

NOTES

1 Cézanne 1984, 311.
2 See Cézanne's paintings after prints from magazines like *L'Illustrations des Dames* or *La Mode illustrée,*
 Venturi 1936, nos. 24, 119 120.
3 See the pencil studies Chappuis 1973, nos. 320, 321.
4 See his other landscapes including contemporary figures, Venturi 1936, nos. 104, 107, 115, 116, 230–32, 234,
 242, 249, 251, 377, 1517.
5 Cézanne appears as a half figure in a similar way in his *Apothéose de Delacroix* (cat. no. 63). The artist as
 observer figures also in the sketch for an amorous scene, Chappuis 1973, no. 323.
6 Rivière 1923, 233, no. 22.
7 *Max Liebermann in seiner Zeit,* Nationalgalerie Berlin 1979–Haus der Kunst, Munich 1980, 68f.
 Liebermann also owned another Cézanne painting: *Prairie et ferme de Jas de Bouffan,* Venturi 1936,
 no. 466.

PROVENANCE: Victor Chocquet, Paris: Chocquet auction, Galerie Georges Petit, Paris, July 1–4, 1899,
no. 22; Josse Hessel, Paris; Bernheim-Jeune, Paris; Paul Cassirer, Berlin; Nationalgalerie, Berlin; Paul
Cassirer, Berlin; Max Liebermann, Berlin; Mrs. Kurt Rietzler, New York.
BIBLIOGRAPHY: Meier-Graefe 1904, **65**; Maier-Graefe 1910, **17**; Bernheim-Jeune 1914, illus. 10; Vollard
1914, 34, illus. 8; Meier-Graefe 1918, **74**; Coquiot 1919, 68; Meier-Graefe 1922, 74, **115**; Rivière 1923, 199,
233; Pfister 1927, illus. 24; Javorskaia 1935, illus. 7; Venturi 1936, 37f., 119, no. 243, **298**; Guerry 1950, 27;
Reff 1959 (*Enigma*), 29, illus. 11; Ratcliffe 1960, 12; Chappuis 1962, 15, **61**; Reff 1962 (*Stroke*), 220f., 225;
Loran 1963, 57; Andersen 1967, 137; Rewald 1969, 47, illus. 9, 49, 75, 83; Andersen 1970, 138; Chappuis
1973, 117, nos. 320, 321, 122, no. 353; Rewald 1975, 158f.; Adriani 1978, 339; Rewald 1983, 102, no. 68;
Rewald 1986, **111**; Kirsch 1987, 25; Basel 1989, 288, **294**; Lewis 1989, 204f., illus. XVII; Rewald 1989, 6.
EXHIBITIONS: *3ᵉ Exposition de peinture,* 6 rue le Pelletier, Paris 1877; Galerie Paul Cassirer, Berlin 1904;
XV. Ausstellung der Berliner Sezession, Berlin 1908, no. 38; Berlin 1909, no. 27; Berlin 1921, no. 3, illus.;
Basel 1936, no. 12, illus.; New York 1947, no. 7, illus.; Chicago 1952, no. 33, illus.; New York 1959, no. 10,
illus.; Tokyo 1974, no. 9, illus.

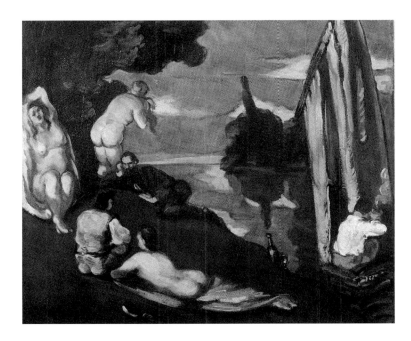

Illus. 1
Paul Cézanne,
Idyll (Pastoral),
circa 1870.
Musée d'Orsay, Paris

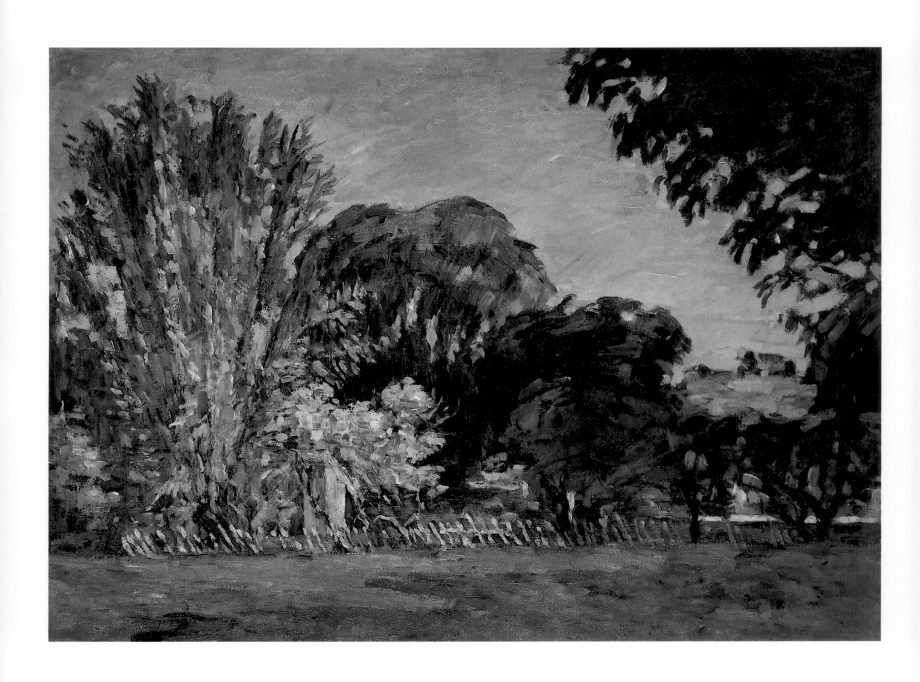

17 Trees at Jas de Bouffan, 1875–76
 Arbres au Jas de Bouffan

Venturi no. 161 (1875–76)
Oil on canvas, 21 3/4 x 29" (55.5 x 73.5 cm).
Mr. and Mrs. Thomas Kramer, Miami Beach, Florida

Jas de Bouffan – the House of the Winds – was an estate some two kilometers west of
Aix that served for decades as Cézanne's chief residence (see cat. nos. 20, 48, 49). His
father, having become a wealthy man as a hatmaker and co-owner of a bank, bought
the thirty-seven-acre property as a country place in 1859. It comprised a Baroque
manor house, a small farmstead, and a park with old trees. It was an ideal home for
the artist, a place where he could live and work in absolute privacy, remote from the
bustle of urban life. Protected from the curious gazes of passersby, he could
concentrate on his subject in utter peace. The number of paintings, watercolors, and
drawings that can be associated with the estate, offering glimpses of the manor house,
the farmstead with its low wall, the imposing chestnut trees, the stone pool, or the
greenhouse, is accordingly quite large.

To judge from the intense colors of the present landscape, its many shades of
green, its occasional accents in reddish brown, and its blossoming yellow shrubbery
beneath a cloudless sky, we are seeing the park on a radiant day in early summer. The
painter had set up his easel in the shade of a tree – its branches hang down into the
picture on the right – so as to record on canvas the line of a windblown fence, a
wooden shack behind it, bushes and trees, and a hill in the distance. It was not a
particularly promising subject, but the intensity with which the painter has rendered it
reveals that Pissarro's teaching had left its traces (see cat. no. 16). The older painter had
helped Cézanne to gain control over his inner turmoil, leaving him free to observe
what was before him with precision, to experience the great variety of nature and
articulate it in the very colors presented him.

PROVENANCE: Paul Cassirer, Berlin; Marianne von Friedländer-Fuld, Berlin-Paris; Morris Gutman, New
York; John L. Loeb, New York; Knoedler, New York; M. Lespagnol, Paris; Sotheby's auction, London,
December 2, 1986, no. 27; Wildenstein, Paris-London-New York; Sotheby's auction, London, June 26, 1990,
no. 5.
BIBLIOGRAPHY: Meier-Graefe 1918, 101; Meier-Graefe 1922, 119; Rivière 1923, 200; Venturi 1936, 102,
no. 161, illus.
EXHIBITIONS: Summer Loan Exhibitions, The Metropolitan Museum of Art, New York 1963, 1966, 1968,
nos. 10, 27, 31; Tokyo 1974, no. 10, illus.; Nature as Scene. French Landscape Painting from Poussin to
Bonnard, Wildenstein Galleries, New York 1975, no. 13.

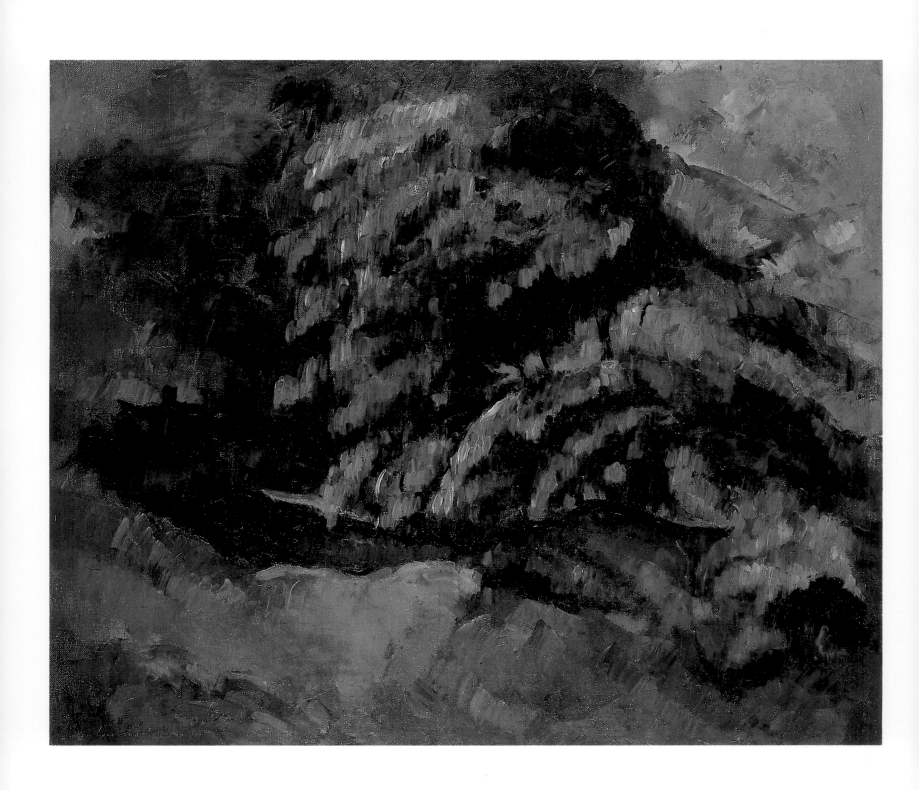

18 Wood, 1875–76
 Sous-bois

Venturi no. 1525 (1875–76)
Oil on canvas, 21 1/4 x 25 5/8″ (54 x 65 cm).
Yoshii Gallery, Tokyo

In his later years, after he had withdrawn to the solitude of the countryside around Aix-en-Provence, Cézanne was especially drawn to simple motifs like this one, a glimpse of the forest floor illuminated by only a few rays of sunlight. Although there are no comparable paintings from the 1870s, the style of the present work suggests that it was executed in the middle of that decade. In those years the painter often chose to work with a dark green that could be made to glow by mixing it with generous amounts of yellow, and he was beginning to organize his brushwork in short, parallel strokes so as to produce a uniform rhythm.

PROVENANCE: Ambroise Vollard, Paris.
BIBLIOGRAPHY: Venturi 1936, 333, no. 1525, illus.
EXHIBITIONS: Tokyo 1986, no. 15, illus.

19 The Sea at L'Estaque, 1876
 La mer à L'Estaque

Venturi no. 168 (1876)
Oil on canvas, 16 1/2 x 23 1/4″ (42 x 59 cm).
Signed, lower right
Fondation Rau pour le Tiers-Monde, Zurich

Cézanne painted this view of the Bay of Marseilles from the slopes of L'Estaque for the collector Victor Chocquet (see cat. no. 15). We know that it dates from the summer of 1876, when the painter worked in the South until the end of August,[1] for he speaks of it in a letter to Pissarro from July 2 of that year:

I have to tell you that your letter caught up with me at L'Estaque on the coast, I haven't been in Aix for a month now. I've begun two small subjects showing the sea for Monsieur Chocquet, who had spoken to me about it. It's like a playing card. Red roofs against the blue sea. If the weather improves, I might be able to finish them. In the event, I've done nothing yet. But one could settle on subjects that would require months of work, since the vegetation here doesn't evolve. Olive trees and pines retain their leaves. The sun here is so vivid that it seems to me that objects are always outlined, not only white or black, but blue, red, brown, violet. I may be wrong, but it seems to me that it is the limit of modeling. How happy our gentle landscape painters from Auvers would be here. As soon as I can, I am going to spend at least a month here, because it begs for canvases of at least two meters.[2]

Though he never did follow up on this last proposal, the passage is of considerable interest. For one thing, it tells us that Cézanne had recognized how much the light of his homeland tended to reduce objects to simple surfaces, and that modeling of forms by means of shading had to be abandoned in favor of rich sequences of color observed on the objects themselves. For another, he explains that the vegetation of the South appealed to him especially because it permitted him to work for months on a given motif. In his assumption that the landscape painters of the North would have liked it there as much as he did, however, he was probably mistaken. His Impressionist colleagues failed to appreciate the hard light of the Mediterranean. Even Renoir, who painted in L'Estaque and Aix-en-Provence in 1882 and 1889, failed to do it justice. Cézanne himself often worked in L'Estaque between 1870 and 1885, the town in which Braque, following his footsteps a generation later, would create the first Cubist landscapes.

In 1877, Cézanne borrowed this particular L'Estaque painting from Victor Chocquet for the third Impressionist exhibition, where he was represented by seventeen works. At the auction of the Chocquet collection in 1889, the landscape was sold, under the title *La méditerranée*, for fifteen hundred francs.[3]

It is amazing to see the change in style between the first of Cézanne's paintings of L'Estaque (cat. no. 8) and the present one executed only six years later – which would be followed by a whole series of similarly spacious views (cat. nos. 23, 29, 72). In between lay his collaboration with Pissarro and intense study of Impressionist concerns (see cat. no. 16). In place of that overcast, gloomy winter landscape, we now see a much more clearly structured panorama flooded with the transparent light of the South. The red-tiled roofs provide effective contrast to the green of the trees, while the ocher of the soil and the houses sets off the rich blue of the bay and the lighter blue sky aglow with low sunlight. For his various views of L'Estaque, as for his depiction of the Château Noir painted after 1900 (see cat. nos. 8, 23, 72, 95, 96), Cézanne, who weighted all of these landscapes horizontally, employed boldly intersecting diagonals as a means of organizing his picture space, a method introduced in the early Baroque.

Zola had frequently visited L'Estaque with Cézanne, and in one of his novellas he tried to suggest the beauty of the spot:

> A village just outside of Marseilles, in the center of a valley of rocks that close the bay.... The country is superb. The arms of rock stretch out on either side of the gulf, while the islands, extending in width, seem to bar the horizon, and the sea is but a vast basin, a lake of brilliant blue when the weather is fine. At the foot of the mountains the houses of Marseilles are seen on different levels of the low hills; when the air is clear, one can see, from L'Estaque, the gray Joliette breakwater and the thin masts of the vessels in port. Behind this may be seen, high on a hill surrounded by trees, the white chapel of Notre-Dame de la Garde. The coastline becomes rounded near Marseilles and is scooped out in wide indentations before reaching L'Estaque; it is bordered with factories that sometimes let out high plumes of smoke. When the sun falls perpendicularly to the horizon, the sea, almost black, seems to sleep between the promontories of rocks whose whiteness is relieved by yellow and brown. The pines dot the red earth with green. It is a vast panorama, a corner of the Orient rising up in the blinding vibration of the day.[4]

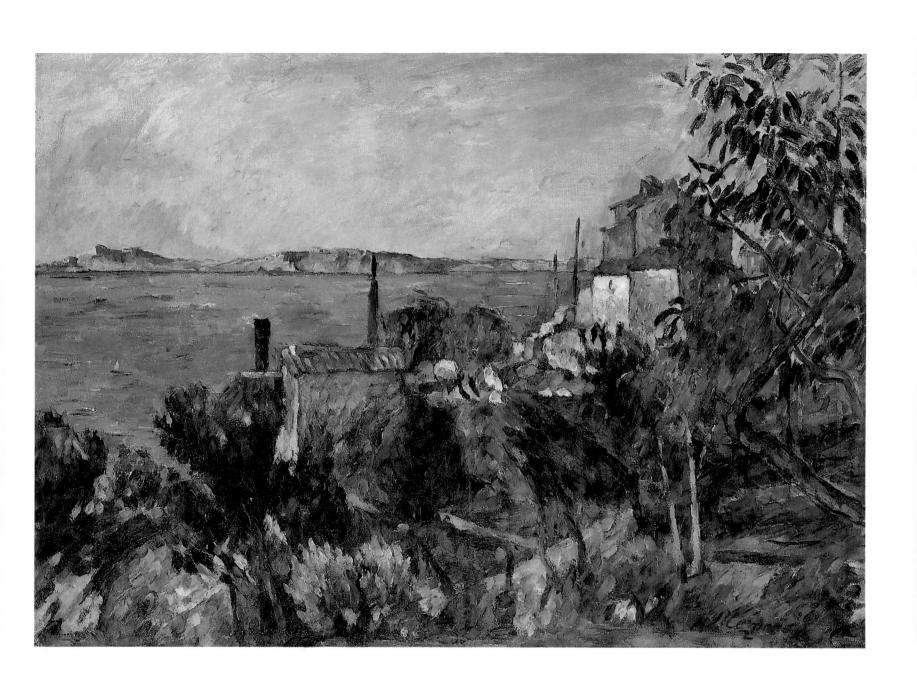

NOTES

1 A similar watercolor view, Rewald 1983, no. 117, was produced on a later visit to L'Estaque in connection
 with the painting Venturi 1936, no. 408 and the drawings Chappuis 1973, nos. 705, 783.
2 Cézanne 1984, 154. As early as 1874, the artist had asked his parents to raise his monthly allowance so
 that he could work regularly in the South: "I am asking Papa to give me 200 francs a month, which will
 enable me to make a real visit to Aix, and it would make me extremely happy to work in the Midi where
 the scenery offers so many opportunities for my painting. I am really begging Papa to be kind enough to
 grant my request, and I believe, I shall be able to succeed with the studies I want to do in the Midi."
 Ibid., 145.
3 Rivière 1923, 232, no. 2.
4 Rewald 1986, 93.

PROVENANCE: Victor Chocquet, Paris; Chocquet auction, Galerie Georges Petit, Paris, July 1-4, 1899,
no. 2; Bernheim-Jeune, Paris; Gaston Bernheim de Villers, Paris; Sam Salz, New York; Mrs. Richard J.
Bernhard, New York; Wildenstein, Paris-London-New York; Sotheby's auction, London, June 30, 1981, no. 8.
BIBLIOGRAPHY: Bernheim-Jeune 1914, illus. 39; Rivière 1923, 232; Venturi 1936, 53, 103, no. 168, illus.;
Novotny 1938, 193; Dorival 1949, 61, illus. 35, 153; Cooper 1954, 346; Gowing 1956, 187; Ratcliffe 1960, 12;
Reff 1962 (Stroke), 215, 220, 222; Andersen 1967, 139; Rewald 1969, 45, illus. 8, 50, 82; Elgar 1974, 71;
Adriani 1981, 265.
EXHIBITIONS: 3e Exposition de peinture, 6 rue le Pelletier, Paris 1877; Paris 1926, no. 57; Paris 1936,
no. 35, illus.; Paintings from Private Collections, The Metropolitan Museum of Art, New York 1960, no. 8;
The New Painting. Impressionism 1874-1886, National Gallery of Art, Washington 1986-de Young
Memorial Museum, San Francisco 1986, no. 17.

20 The Pool at the Jas de Bouffan, 1876-78
Le bassin du Jas de Bouffan

Venturi no. 417 (1882-85)
Oil on canvas, 28 7/8 x 23 3/4" (73.5 x 60.5 cm).
Albright-Knox Art Gallery, Fellows for Life Fund, 1927
(inv. no. 27:17), Buffalo, New York

In the park at Jas de Bouffan (see cat. nos. 17, 48, 49) there was a stone pool adorned
with sculptures that served as a subject for the painter, always from a different angle,
for nearly three decades.[1] In the present painting, the truncated triangle of the pool,
with its reflections of the surrounding chestnut trees, is echoed in the simpler angled
shapes of the sections of lawn at the bottom and in the background. Venturi suspected
that this picture was painted in the early 1880s, but on stylistic grounds that dating
must be revised.[2] The painter's use of pigment-laden brushstrokes in parallel diagonal
rows for the foliage and horizontal ones for the surface of the water, the masonry, and
other level surfaces suggests a dating in the second half of the 1870s. Moreover, the
chestnuts in leaf at the edge of the pool place the work in either 1876 or 1878, the only
two years in which Cézanne worked in Aix at the time of year they imply.

NOTES

1 See the paintings, watercolors, and drawings Venturi 1936, nos. 40, 160, 164, 166, 167, 484, 648, Rewald
 1983, nos. 20, 155, 256, 396, Chappuis 1973, nos. 763, 885, 891.
2 The dating in Venturi's catalogue raisonné may be the result of some confusion between nos. 417
 and 484.

PROVENANCE: Paul Cézanne fils, Paris; Josse Hessel, Paris; Bernheim-Jeune, Paris; Percy Moore Turner,
London; Ehrich Galleries, New York.
BIBLIOGRAPHY: Venturi 1936, 155, no. 417, illus.; Novotny 1938, 193; Andrew C. Ritchie, Paintings and
Sculpture, Albright-Knox Art Gallery, Buffalo 1949, 66.
EXHIBITIONS: Paris 1907, no. 26; Art Gallery, Toronto 1927; New York 1928, no. 12; Fine Arts Academy,
Buffalo 1928, no. 4, illus.; Philadelphia 1934, no. 12; San Francisco 1937, no. 14, illus.; New York 1947, no. 24,
illus.; The Art of Cézanne, Institute of Arts, Minneapolis 1950; New York 1959, no. 24, illus.; Aix-en-
Provence 1961, no. 49; Vienna 1961, no. 111; Washington 1971, no. 7, illus.

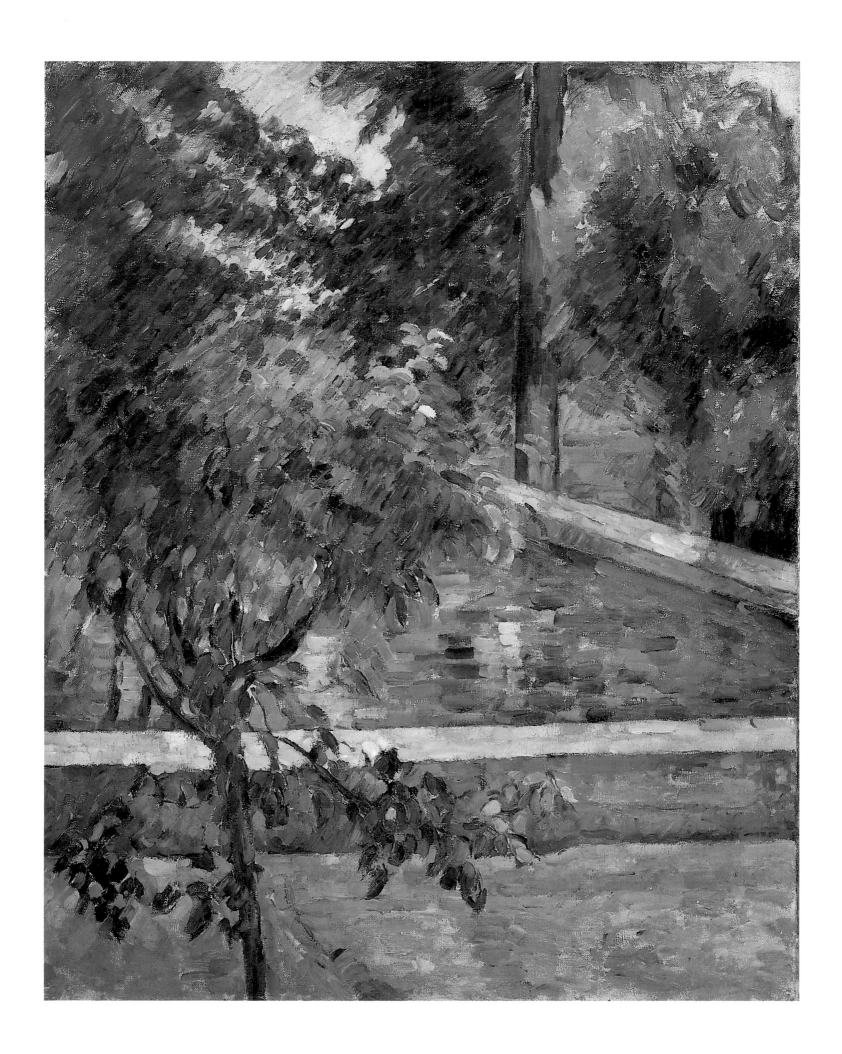

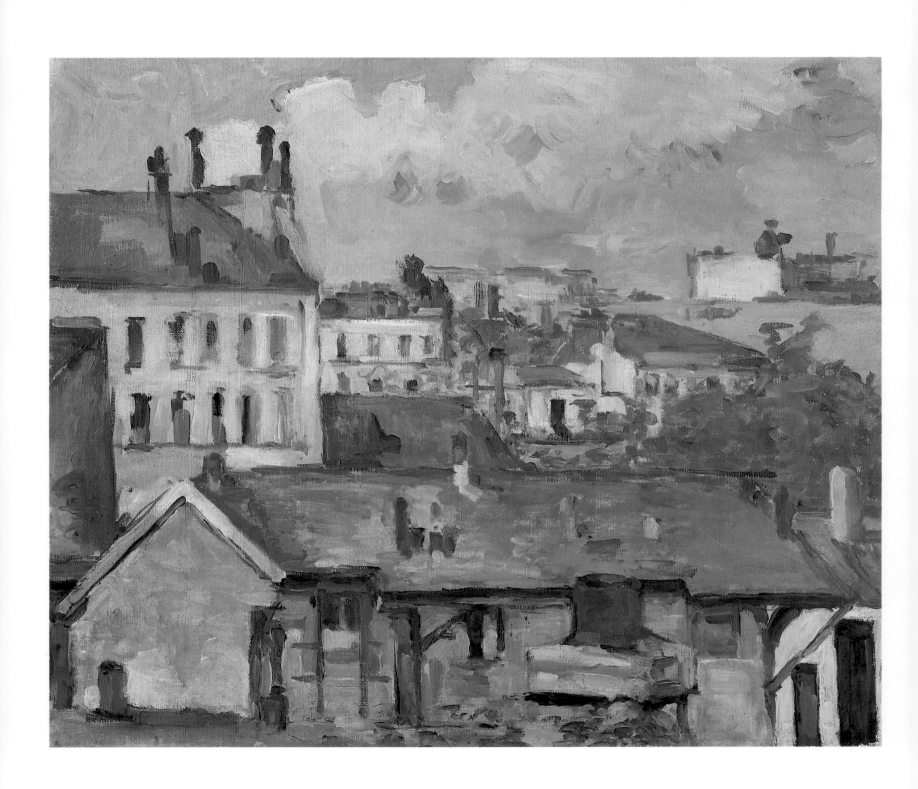

21 Rooftops, 1877

Les toits

Venturi no. 1515 (circa 1877)
Oil on canvas, 19 5/8 x 23 5/8" (50 x 60 cm).
Private collection

Roof landscapes in large cities were a favorite motif of the Impressionists, but Cézanne appears to have painted only two. We are able to identify the scene in one of them (illus. 1), and assign it a date accordingly. That work shows the view, with the spire of Notre-Dame-des-Champs on the far left, from the seventh-floor studio at no. 32, rue de L'Ouest. Cézanne lived there from March 1880 to April 1881, and again from March to October of the following year. The strictly orthogonal arrangement of the work also indicates that it was produced in the early 1880s, and not, as Venturi suggests, between 1874 and 1877.

Unfortunately, the second of these paintings does not provide such helpful clues. Compared to the one from the early 1880s, the present picture is more Impressionistic in concept. Its sunny palette and sketchy, fluid brushwork, its serene presentation of a colorful conglomerate of architecture and occasional treetops beneath a sky whose tones recur throughout as blue-gray shadows – all of this shows us a painter exploiting Impressionist formulas. If one assumes that this is indeed a view of Paris, and the architecture suggests that it is, then it seems likely that the work was painted in 1877, a year which Cézanne spent mostly in Paris. The years just before and after 1877 saw him mainly in Aix and L'Estaque.

PROVENANCE: Bernheim-Jeune, Paris; Arthur Hahnloser, Winterthur.
BIBLIOGRAPHY: Ors 1930, illus.; Venturi 1936, 331, no. 1515, illus.; Geist 1988, 131, illus. 114; *du* 1989, **63**.
EXHIBITIONS: Basel 1936, no. 147; *Hauptwerke der Sammlung Hahnloser*, Museum, Lucerne 1940, no. 15, illus.; The Hague 1956, no. 16, illus.; Zurich 1956, no. 31, illus. 9; Munich 1956, no. 22, illus.; Cologne 1956, no. 9, illus.

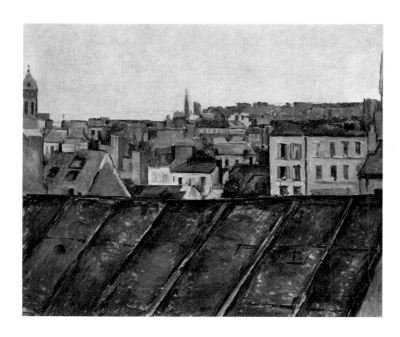

Illus. 1
Paul Cézanne, *Paris Rooftops*, 1882.
Private collection

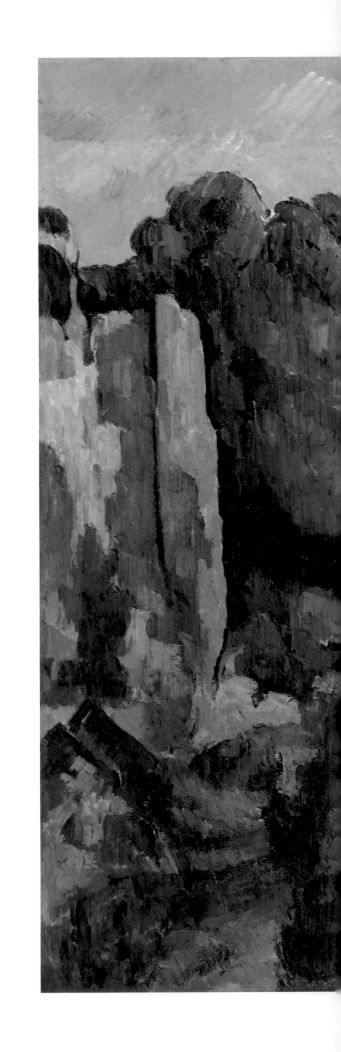

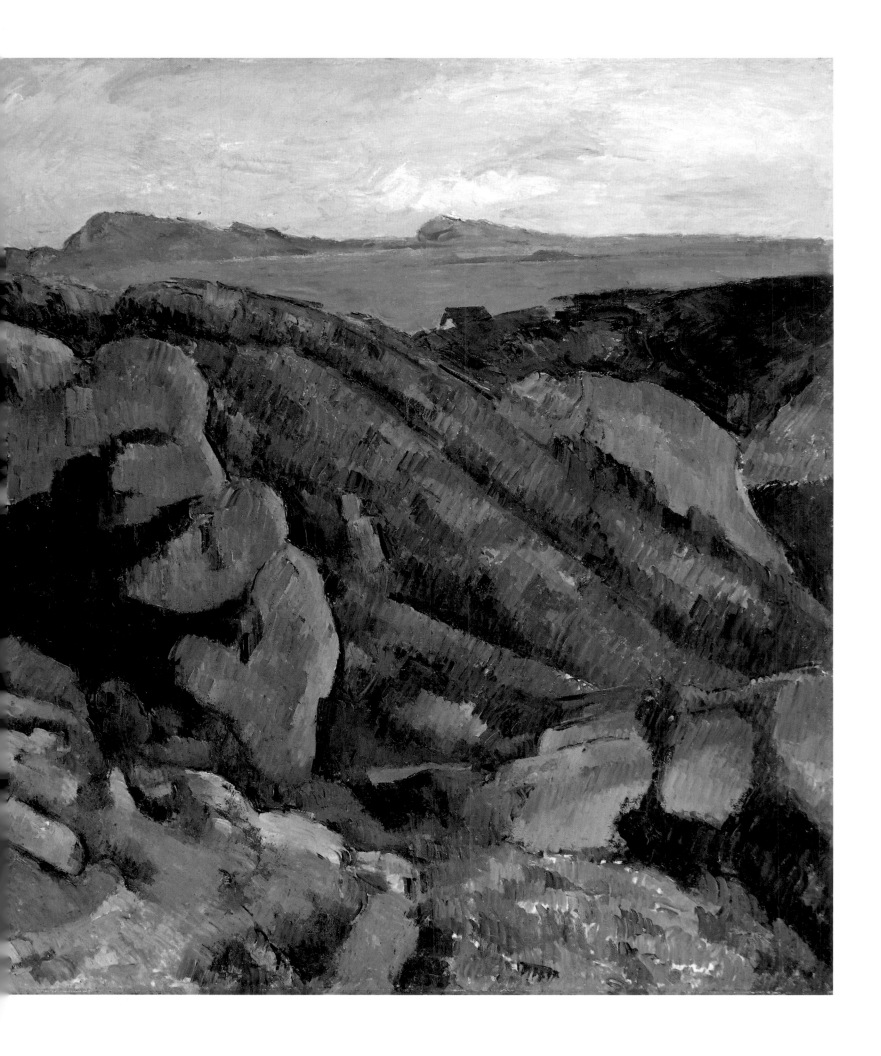

22 Rocks at L'Estaque, 1878–79
Rochers à L'Estaque

Venturi no. 404 (1882–85)
Oil on canvas, 28 3/4 x 35 7/8" (73 x 91 cm).
Museu de Arte de São Paulo

Having discovered in the early 1870s the charms of L'Estaque, a town southwest of Aix on the Bay of Marseilles (see cat. no. 8), Cézanne went back to work there for extended periods in 1876 (see cat. no. 19), 1878 and the beginning of 1879 (see cat. no. 23), and in 1883 (see cat. no. 29). Zola also visited the town on several occasions, and wrote the following description of its picturesque surroundings:

> But L'Estaque does not only offer access to the sea. The village, its back against the mountains, is traversed by roads that disappear in the midst of a chaos of jagged rocks.... Nothing equals the wild majesty of these gorges hollowed out between the hills, narrow paths twisting at the bottom of an abyss, arid slopes covered with pines and with walls the color of rust and blood.... Then, again paths full of brambles, impenetrable thickets, piles of stones, dried-up streams, all the surprises of a walk through the desert. High up, above the black border of the pines is placed the endless band of the blue silk of the sky.... When this dried-out country gets thoroughly wet, it takes on colors ... of great violence: the red earth bleeds, the pines have an emerald reflection, the rocks are bright with the whiteness of fresh laundry.[1]

In a reply to Zola written on December 19, 1878, Cézanne offered a considerably more sober commentary on the beauty of the L'Estaque countryside: "As you say, there are some very beautiful views here. The thing is to capture them, not likely for me, having begun to look at nature a bit late; which, however, doesn't keep it from holding my full interest."[2]

The painter does manage to reveal the same enthusiasm in *Rocks at L'Estaque*. The massive boulders tumbled about by gigantic forces appear to have brought the surface of the sea out of balance, for it tilts to the left. Its blue expanse, with the forward island of the Château d'If and mountains in the distance, lies under a misty sky. Below it, the landscape is raw and wild. Only a single house perches just over the ridge as a sign of civilization.[3] The red earth, the gleaming white of the blocks of stone, the looming boulders like clenched fists in front of the wooded slopes – everything betrays a vision still indebted to the pathos-laden landscapes of Courbet. This despite the self-discipline evidenced by the artist's painstakingly regular brushwork.

NOTES

1 Rewald 1986, 93.
2 Cézanne 1984, 175.
3 Two pencil sketches – probably later, Chappuis 1973, nos. 809, 810 – show this coastal landscape from a different angle.

PROVENANCE: Georges Dumesnil, Aix-en-Provence; Bernheim-Jeune, Paris; Count Harry Kessler, Paris-Weimar; Durand-Ruel, Paris-New York; Paul Cassirer, Berlin; Prince Matsukata, Tokyo; Wildenstein, Paris-London-New York.
BIBLIOGRAPHY: Gasquet 1921, **92**; Meier-Graefe 1922, **150**; Faure 1923, illus. 40; Venturi 1936, 53, 153, no. 404, illus.; Guerry 1950, 84f.; Cooper 1954, 378; Gowing 1956, 189f.; Reff 1958, 47; Reff 1959, 172; Brion 1973, 38, 43; Chappuis 1973, 204, no. 809, 205, no. 810, 263, no. 1155; Newcastle 1973, 10; Elgar 1974, 98f., illus. 55; Cézanne 1988, 54, **128**.
EXHIBITIONS: Tokyo 1986, no. 20, illus.; Ettore Camesasca, *Trésors du Musée de São Paulo*, Fondation Pierre Gianadda, Martigny 1988, 92ff., illus.

23 The Sea at L'Estaque, 1878–79
La mer à L'Estaque

Venturi no. 425 (1883–86)
Oil on canvas, 28 3/4 x 36 1/4" (73 x 92 cm).
Musée Picasso, Donation Picasso (inv. no. RF 1973–59), Paris

From July 1878 to March 1879, Cézanne worked mainly in the small industrial town of L'Estaque on the Bay of Marseilles (see cat. nos. 8, 19, 22, 29, 72). This landscape, composed according to classical principles, doubtless dates from that period. Picasso acquired the work in the 1940s (see also cat. no. 96).[1] Our gaze is drawn in from a road running at a diagonal across the foreground to several trees, a steep hillside lying in the sunlight, and various structures rendered with Cubist simplicity. A tall chimney towering up against the blue wall of the surface of the sea checks the movement of the slope. The sky lifts abruptly above a high horizon line. Cézanne's use of trees and branches as a connecting foil in the manner of Baroque landscape painters reveals a lingering insecurity in dealing with the depth of his motif, and Venturi therefore dated this work to the mid 1880s. From a spot farther down the hill, Cézanne painted two additional versions of the landscape in small format, with and without framing elements.[2]

NOTES

1 Also in his collection were the paintings Venturi 1936, nos. 385, 795 (cat. no. 96), and the watercolor Rewald 1983, no. 580.
2 Venturi 1936, nos. 427, 426.

PROVENANCE: Paul Cézanne *fils*, Paris; Pablo Picasso, Paris.
BIBLIOGRAPHY: Rivière 1923, 210; Venturi 1936, 156, no. 425, illus.; Novotny 1938, 22, 193; Dorival 1949, 61f., 66, 84, illus. 79, 161; *Donation Picasso. La collection personnelle de Picasso*, Paris 1978, no. 5, illus.; Geist 1988, 125f., illus. 108.
EXHIBITIONS: Paris 1929, no. 3; *Exhibition of Modern French Painting*, Galerie Bignou, New York 1935; Lyon 1939, no. 29, illus. 11; Edinburgh 1990, no. 36, illus.

Illus. 1
Paul Cézanne,
Buildings in L'Estaque, 1882–83, drawing.
Private collection, Stuttgart

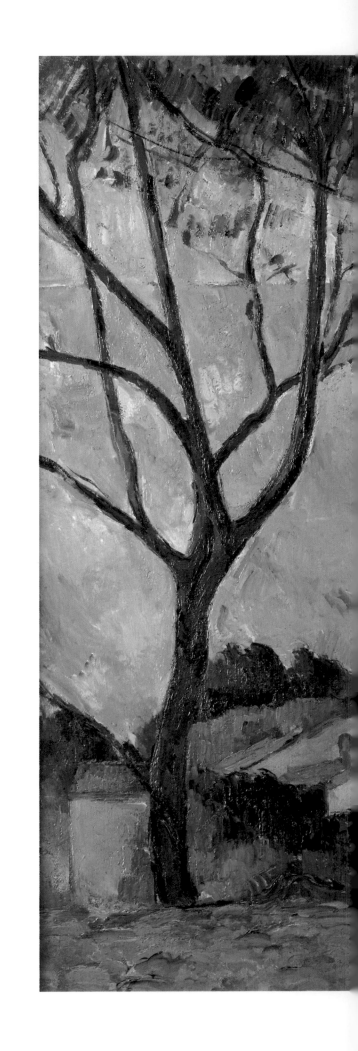

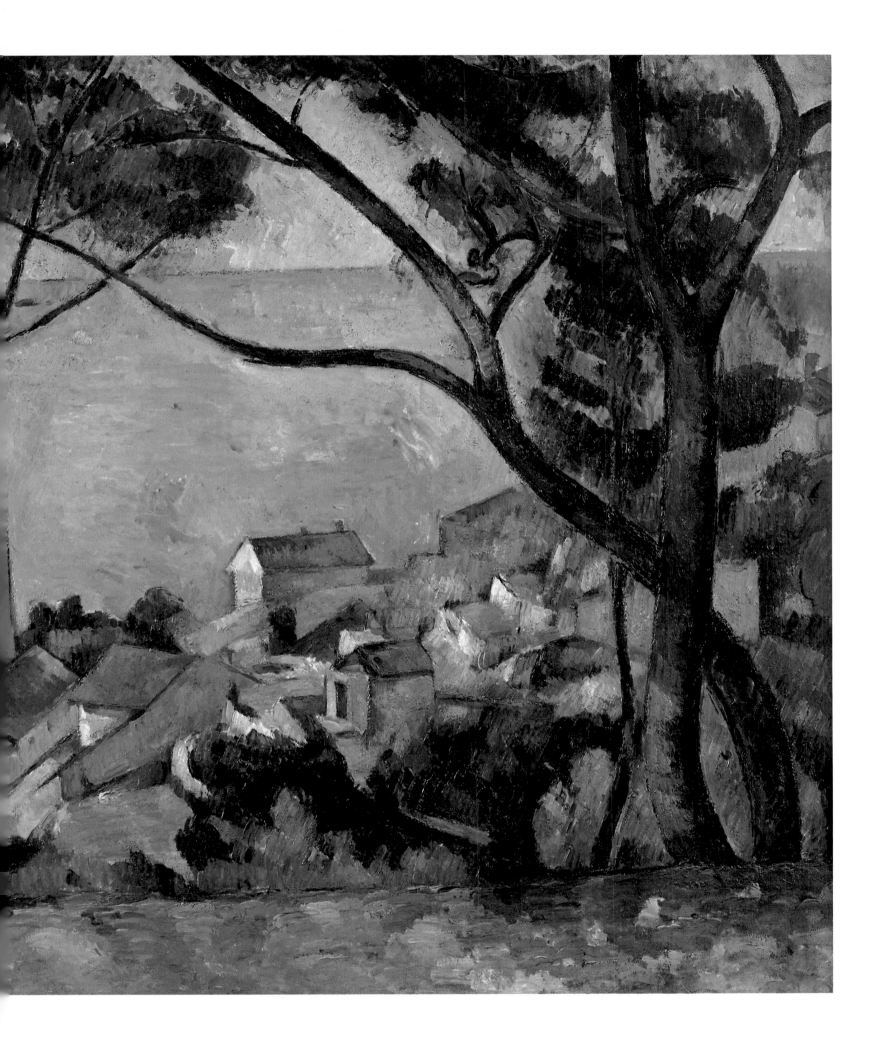

24 Abandoned House at Le Tholonet, 1878–79
La maison abandonnée au Tholonet

Venturi no. 659 (1892–94)
Oil on canvas, 19 3/4 x 23 3/4" (50.2 x 60.3 cm).
Stephen Hahn Collection, New York

This depiction of a farmstead once bustling with life but now abandoned to silence and decay is filled with tension. As opposed to the landscape, the obtrusively close, bleak building – with its boarded-up openings and an enclosing wall on shaky ground – communicates a mysterious unrest. The stark architecture takes on an almost magical significance. The Surrealist André Breton rightly described this as a possible crime scene.[1] This structure built on a steep slope appears to be not long for this world. There is nothing to secure the forbidding walls against the hillside. The brittle masonry is no match for the relentless forces of nature; it will soon be covered with the undergrowth of the advancing forest.

The intensity of the colors and the thin application of pigment would appear to date this ominous picture of surrender to nature to the late 1870s, when Cézanne was staying in Aix and certainly visited the tiny village of Le Tholonet. *La maison abandonnée* was included in the two most important exhibitions of Cézanne's paintings held in Paris while the artist was still alive, an indication that he always considered it one of his masterpieces. It was shown in the first Cézanne retrospective in the Galerie Ambroise Vollard in 1895, and in 1904, it was one of the thirty paintings exhibited in a special Cézanne room in the Salon d'Automne.

NOTES

1 André Breton, *L'Amour fou*. Paris 1937, 155ff.

PROVENANCE: Eugène Blot, Paris; first Blot auction, Hôtel Drouot, Paris, May 9–10, 1900, no. 19; second Blot auction, Hôtel Drouot, Paris, May 10, 1906, no. 17; Auguste Pellerin, Paris; Ambroise Vollard, Paris; Ralph M. Coe, Cleveland; Sotheby's auction, London, November 23, 1960, no. 41; Christie's auction, New York, May 19, 1981, no. 307; Sotheby's auction, New York, May 14, 1985, no. 30A.
BIBLIOGRAPHY: Meier-Graefe 1910, **59**; Burger 1913, 108, illus. 97; Vollard 1914, 58, illus. 20, 44; Meier-Graefe 1918, **145**; Vollard 1919, 78; Meier-Graefe 1922, **176**; Klingsor 1923, illus. 15; Rivière 1923, 215, 234; Ors 1930, illus. 11; Novotny 1932, 295f.; Mack 1935, 341; Venturi 1936, 206, no. 659, illus.; Novotny 1937, illus. 68; Mack 1938, 290; Novotny 1938, 52, 87; Cogniat 1939, illus. 80; Ratcliffe 1960, 17; Vollard 1960, 34; Brion 1973, **65**; New York 1977, **25**; Rewald 1989, 50.
EXHIBITIONS: Paris 1895; Paris 1904, no. 17; New York 1928, no. 17; *The Twentieth Anniversary Exhibition*, Museum of Art, Cleveland 1936, no. 253; *Cézanne and Gauguin*, Museum of Art, Toledo, Ohio, 1936, no. 25; New York 1947, no. 54; New York 1959, no. 40, illus.; *Impressionisten*, Galerie Beyeler, Basel 1967, no. 4.

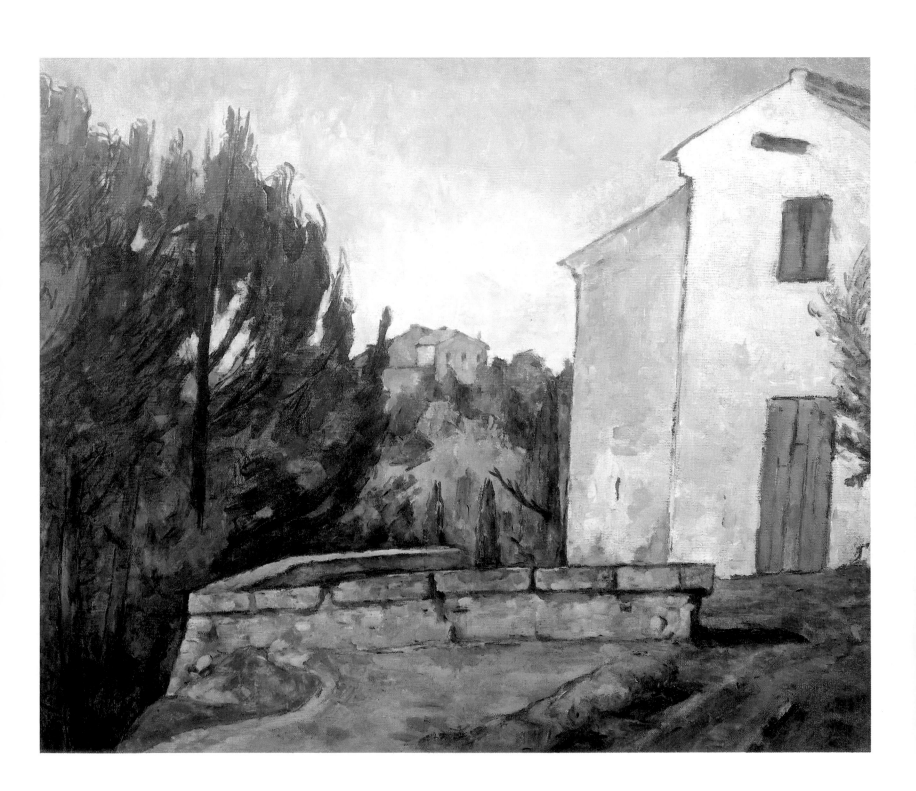

25 Mill on the Couleuvre, at Pontoise, 1881
Moulin sur la Couleuvre, à Pontoise

Venturi no. 324 (1879–82)
Oil on canvas, 28 3/4 x 36 1/4″ (73 x 92 cm).
Staatliche Museen zu Berlin,
Nationalgalerie (inv. no. A I 606), Berlin

Early in 1890, Cézanne had an opportunity to exhibit his work outside of France. Octave Maus, the secretary of the avant-garde Belgian art association Les Vingt, invited him, along with Renoir, Sisley, Toulouse-Lautrec, Van Gogh, and others, to show some of his paintings in Brussels. Cézanne hesitated at first, then convinced that he would be in "good company," accepted the invitation with pleasure.[1] He chose to exhibit three works. The first was this landscape, which he had given in payment to Julien Tanguy, to whom he was deeply in debt for his art supplies.[2] Tanguy had then sold it to the journalist Robert de Bonnières, the painter Jacques-Emile Blanche serving as an intermediary. The painter also submitted an early masterpiece from the collection of Victor Chocquet (see cat. no. 15), the *Cottage in Auvers-sur-Oise,*[3] and a study of bathers. He wrote Octave Maus on December 21, 1889:

> I got in touch with Tanguy to find out which of my studies he had sold to Monsieur de Bonnières. He was unable to tell me exactly. Therefore, I would ask that you enter that canvas as *'Etude de Paysage.'* On the other hand, since your request took me unawares, I have got in touch with Monsieur Chocquet, who is not in Paris at present, and who immediately made available to me *'Une chaumière à Auvers-sur-Oise.'* However, this canvas is unframed, since the frame ordered by Monsieur Chocquet (carved wood) is not yet ready. If you should have some old frame to put on it, you would ease my mind. It's a regular size 15. Lastly, I am sending you a canvas, *'Esquisse de Baigneuses,'* whose frame I shall have delivered to Monsieur Petit.[4]

It is possible that on this occasion – one on which he would be competing with younger colleagues – Cézanne deliberately chose the two important landscape pictures from 1872–73 and 1881 as a means of documenting his friendship with Camille Pissarro and his admiration for him. As we have seen, his work with Pissarro in Pontoise and Auvers-sur-Oise between 1872 and the spring of 1874 had led to a fundamental change in his style, causing him to lighten his palette and adopt a more regular brushstroke. It was thanks to the gentle influence of Pissarro, almost ten years his senior, that he learned to experience nature with the combination of subjectivity and dispassionate understanding that allowed him to produce such successful paintings (see cat. no. 16).

Cézanne stayed in Pontoise with Pissarro again from the beginning of May to the end of October 1881 (see cat. nos. 26, 27), residing at 31, quai du Pothuis. "Since our arrival," he wrote to Chocquet on May 16, "we are reveling in all the atmospheric changes the sky has been kind enough to accord us." And four days later, he wrote to Zola: "Of course, as you say, my stay in Pontoise will not stop me from coming to see you, on the contrary, I'm determined to come to Médan by shank's mare. I do not feel that that task is beneath me [it is roughly nine and a half miles from Pontoise to Zola's country house in Médan]. I see Pissarro fairly frequently … I've begun several studies, in both cloudy and sunny weather. I hope that you soon get back to normal with your work, which is, in my opinion and in spite of all the alternatives, the sole refuge where one can experience inner contentment."[5]

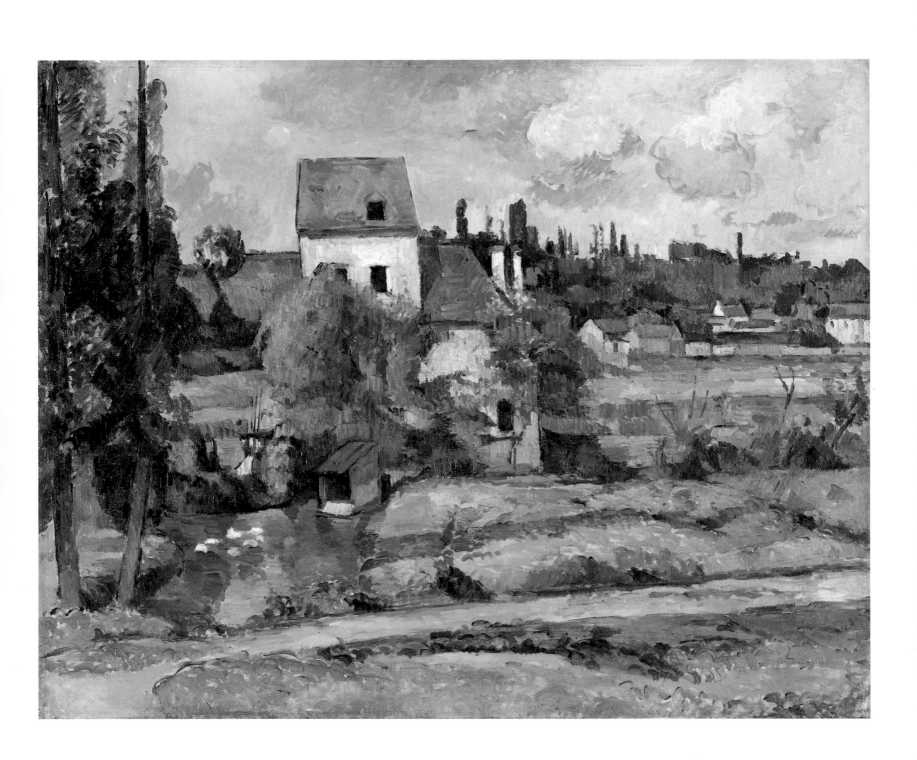

Among the landscapes he produced in Pontoise and Auvers in 1881, the one of the mill on the bank of the Couleuvre is unquestionably the most important. It reveals the degree to which the relationship between Pissarro and Cézanne had changed since 1874. Pissarro was now increasingly influenced by his pupil, who had meanwhile attained a degree of proficiency in the precise tectonic structuring of landscape forms to which he could add nothing more. He admitted as much in a letter to his son in 1895, on the occasion of the first Cézanne retrospective in the Galerie Vollard:

> An Article [about Cézanne] by Mauclair has appeared, which I am sending you. You will see how poorly informed he is – as are many of these critics who don't understand anything at all. He cannot appreciate that Cézanne has been subjected to influences like all the rest of us, and that this in no way detracts from his artistry. They do not realize that he was influenced at the beginning by Delacroix, by Courbet, by Manet, even by Legros – as all of us were. In Pontoise, he stood under my influence, as did I under his. You will recall the heated discussion between Zola and Béliard on this subject. They maintained that one invents painting oneself in all of its aspects, and that no one is original who resembles anyone else. In this exhibition of Cézanne's at Vollard's, the similarity of certain of his landscapes from Auvers and Pontoise to my own seems remarkable. But why not? We were always together, after all. One thing is certain, however. Each of us maintained the one thing that matters – feelings. And that is easy to prove.[6]

It is interesting to note that *Mill on the Couleuvre, at Pontoise* was the first Cézanne painting to be purchased by a museum. In 1897, the farsighted Hugo von Tschudi managed to buy it from Robert de Bonnières for the Nationalgalerie in Berlin (see cat. nos. 16, 55), despite the strictures of Wilhelm II, which in the same year led to the banishment of two of Cézanne's pictures from the collection, and ultimately brought about Tschudi's retirement in 1908 "for reasons of health." Immediately after assuming his post as museum director in 1896, Tschudi traveled to Paris with Max Liebermann in order to familiarize himself with the works of the Impressionists, mainly in the galleries of Durand-Ruel and Vollard,[7] and make some initial purchases. The Prussian State Art Commission was determined that only works by German artists be purchased with state funds. However, the new director was insistent that the collection become more international, and that the foundations of a museum of European stature be laid as soon as possible. His opponents organized themselves with equal determination. Thanks to their activities, an imperial decree of 1899 established that all new acquisitions required the monarch's consent. When Hugo von Tschudi resigned, he noted with a certain irony: "Berlin is not a particularly rich soil for artistic growth. The North German temperament, which strikes one as melancholy because of its broad moors of heather blue, still lakes, and sparse shoreline – yet produces blossoms of droll poetry – becomes sober, cold, skeptical, witty, and mocking in the bustle of the metropolis. It is an unartistic spirit, but in Menzel, it produced its artist nonetheless."[8]

NOTES

1 Cézanne 1984, 227.
2 See Cézanne's promissory note of March 4, 1878, and Tanguy's reminder of August 31, 1885, ibid., 161, 221.
3 The landscape Venturi 1936, no. 133 was later given the title *La maison du pendu, à Auvers.*
4 Cézanne 1984, 227–28.
5 Ibid., 198.
6 Pissarro 1953, 324.
7 Cézanne's dealer Ambroise Vollard wrote of Tschudi's 1896 visit in his reminiscences: "It is true, the director of the Berlin Nationalgalerie had just expressed a desire to buy the picture *Jas de Bouffan* [probably the painting *Prairie et ferme du Jas de Bouffan*, Venturi 1936, no. 466, ultimately bought by Max Liebermann]. I went to tell Cézanne, and took the opportunity to complain about the German emperor's prejudices against the Impressionists. 'He's right,' Cézanne replied, 'the Impressionists are a fraud; what we need is somebody who can paint like Poussin. He has everything.' Then he leaned toward me and whispered: 'Wilhelm is very powerful!' I soon had an opportunity, however, to discover that the German Kaiser and Cézanne were not in perfect agreement. When I mentioned the name Kaulbach, of whom it was said that Wilhelm often boasted, 'We too have a Delaroche,' Cézanne shouted: "The painting of a eunuch means nothing to me!' " Vollard 1960, 43.
8 Frank 1986, 200.

PROVENANCE: Julien Tanguy, Paris; Jacques-Emile Blanche, Paris; Robert de Bonnières, Paris.
BIBLIOGRAPHY: Meier-Graefe 1910, **60**; Burger 1913, illus. 38; Bernheim-Jeune 1914, illus. 34; Vollard 1914, 51; Meier-Graefe 1918, **131**; Gasquet 1921, 103; Meier-Graefe 1922, **160**; Rivière 1923, **207**; Pfister 1927, illus. 52; Gasquet 1930, 77; Javorskaia 1935, illus. 12; Rewald 1936, illus. 39, 40; Venturi 1936, 52, 135, no. 324, illus.; Novotny 1937, 19, illus. 31; Novotny 1938, 83, 110, 123, 129, 207; Dorival 1949, 55, illus. 56, 157; Gowing 1956, 189; Ratcliffe 1960, 19; Vollard 1960, 29; Feist 1963, illus. 29; Chappuis 1973, 215, no. 888; Elgar 1974, 86f., illus. 46, 93; Rewald 1975, 159; Rewald 1986, **97**; Basel 1989, 294; Rewald 1989, 156f., illus. 81.
EXHIBITIONS: *Les XX, VIi exposition annuelle*, Brussels 1890, no. 1; *Impressionisten-Ausstellung der Wiener Sezession*, Vienna 1903; Paris 1936, no. 50; Basel 1936, no. 30; *Works of Art from Museums in the German Democratic Republic*, State Hermitage Museum, Leningrad 1958, 33, illus.; *Schätze der Weltkultur von der Sowjetunion gerettet*, Berlin State Museums, Nationalgalerie, Berlin 1958, illus.; Aix-en-Provence 1961, no. 7, illus. 6; Vienna 1961, no. 19. illus. 13; *Francia Festök Delacroix-Tól Picassóig*, Szépmüvészeti Múzeum, Budapest 1965, 10, illus.; *Francouzské Malirstvi od Delacroix k Picassovi*, Národní Galerie v Praze, Prague 1965, no. 48, illus.

Illus. 1
The Mill on the
Couleuvre at Pontoise,
postcard circa 1900

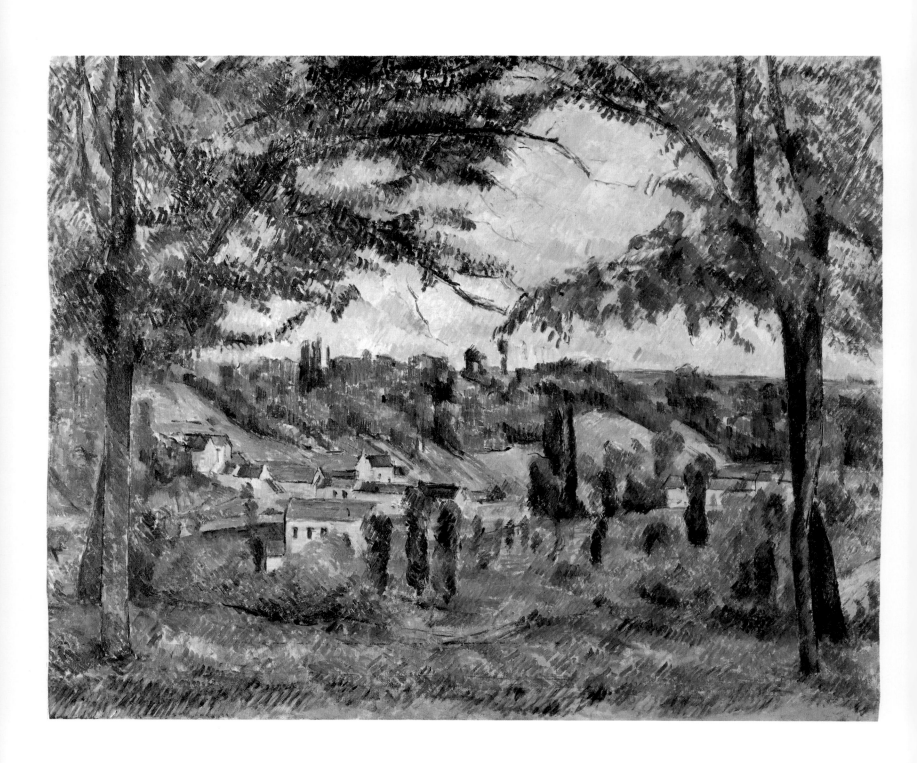

26 Landscape at Auvers-sur-Oise, circa 1881
Paysage à Auvers-sur-Oise

Venturi no. 317 (1879–82)
Oil on canvas, 28 1/4 x 36 1/4" (73 x 92 cm).
National Museum (inv. no. NM 1999), Stockholm

This landscape with its typical flavor of the Ile-de-France (see cat. nos. 25, 27) – slender rows of poplars, a valley floor dotted with light green meadows and an occasional cluster of buildings – exemplifies the approach the artist had worked out by about 1880. Determined to conquer the problem of form, he set out to force an orthogonal arrangement on the elements of his composition and adapt his spatial layers to the picture plane in such a way that they could be clearly appreciated. Aware that he was "too far from the norm" and "too far removed from the end in view, that is, the representation of nature,"[1] he tried both to balance his feeling for nature with an artificial pictorial structure and to fill that structure with life by means of color. In time he succeeded, for a growing sense of conformities visible in all of nature now allowed him to render objects without the awkwardness visible in his earlier work.

This picture space is developed by means of a succession of planes parallel to the surface, rather than by the traditional system of perspective. These planes extend across the entire width of the picture and lead us back to the line of the horizon, which lies almost precisely in the center. Cézanne has rendered this view of the Auvers-sur-Oise landscape with great warmth, as though he had just discovered it. The vertical thrust of the trees placed to the left and right on an elevated stage in the foreground repeats the line of the edges of the picture, and the same vertical emphasis recurs here and there in the distance. Foliage, which fills much of the upper half of the painting, betrays the artist's aversion to empty space and vast expanses of sky.[2] Both the organization of the painting by means of dominant verticals and horizontals and its execution in brushstrokes of uniform size and angle serve to define the relationship between the painted surface and the objects built upon it with color. In place of the impetuous, improvising brushwork we see in his work from the previous decade, Cézanne, reflecting his increasing powers of observation, now creates rows of patient, narrow strokes, most leading from the upper right to the lower left. At first glance, the repetition of these regular shapes across the picture surface appears to link him to Impressionism, but in fact, they reflect an altogether different concern, the revelation of form.

NOTES

1 Cézanne 1984, 165, 166.
2 See the watercolor study Rewald 1983, no. 80.

PROVENANCE: Bernheim-Jeune, Paris; Paul Cassirer, Berlin; Fritz Gurlitt, Berlin; Paul Cassirer, Berlin.
BIBLIOGRAPHY: Meier-Graefe 1918, 75, **130**; Meier-Graefe 1922, 75, **157**; Javorskaia 1935, illus. 17; Venturi 1936, 133, no. 317, illus.; S. Stömbom, *Nationalmusei Mästerverk*, Stockholm 1949, 27, **218ff.**; Rewald 1983, 105, no. 80.
EXHIBITIONS: *Cézanne till Picasso. Fransk Konst i svensk ägo.* Liljevalchs Konsthall, Stockholm 1954, no. 66, illus.; Madrid 1984, no. 24, illus.

27 Turning Road, circa 1881
La route tournante

Venturi no. 329 (1879–82)
Oil on canvas, 23 3/4 x 28 7/8″ (60.5 x 73.5 cm).
Museum of Fine Arts, Bequest of John T. Spaulding
(inv. no. 48.525), Boston

From 1879 to 1882, Cézanne worked mainly in Paris and environs. He lived in Melun from April 1879 to March 1880, and spent the months from May to October 1881 with Pissarro in Pontoise. He frequently journeyed to Médan, just under twenty-five miles from Paris, where Zola had managed to buy a country house with garden in 1878, largely thanks to the success of his novel *L'Assommoir*.

This picture of a curving road flanked by a wall with a jumble of farmhouses behind it may have been painted while Cézanne was staying in Pontoise in the summer of 1881 (see cat. nos. 25, 26). As late as September 1879, he had written to Zola from Melun about his struggle to find his way as a painter, complaining that nature presented him with his greatest problems.[1] One can assume that during his stay in Pontoise, Pissarro helped him to surmount those difficulties, for there is surely no trace of them in this richly structured composition.

In it one is particularly struck by the artist's disregard for the precise demands of perspective. The Impressionists had limited their use of perspective, but adhered to it as a structural principle, and Degas, Toulouse-Lautrec, Van Gogh, and Munch used it to sensational effect in creating spaces filled with action. Cézanne felt his vision constrained by such conventions, convinced that they limited one to only a single way of looking at things. To him, the linear perspective continuum needed to be tempered by precise observation. He would present every object from the angle most appropriate to it, as if it were within its own perspective. Without deviating to any essential degree from what he actually saw in nature, he quietly made the necessary corrections to that end. Here, for example, the inward pull of the road is suddenly broken off in the middle distance, and because of extreme distortions of points of view, one can find no overriding perspective to explain the jumble of houses. Instead, the space is structured mainly by intersecting vertical and horizontal axes.

This painting belonged to Théodore Duret, an art critic and friend of Zola's, and was sold at auction on March 19, 1894, for eight hundred francs. It was later acquired by Claude Monet, who owned a total of thirteen paintings by Cezanne (see cat. no. 95).[2]

NOTES

1 Cezanne 1984,182.
2 In addition to this one, Venturi 1936, nos. 100, 102, 295, 336, 492, 581, 599, 680, 733, 735, 765, 794 (cat. no. 95).

PROVENANCE: Théodore Duret, Paris; Duret auction, Galerie Georges Petit, Paris, March 19, 1894, no. 3; Paul-César Helleu, Paris; Claude Monet, Giverny; Michel Monet, Giverny; Paul Rosenberg, Paris-New York; Wildenstein, Paris-London-New York; John T. Spaulding, Boston.
BIBLIOGRAPHY: Rivière 1923, 232; Venturi 1936, 52, 136, no. 329, illus.; Novotny 1937, 19, illus. 33; Cogniat 1939, illus. 36; Guerry 1950, 52; Cooper 1954, 347, 378f.; Raynal 1954, **55**; Gowing 1956, 189; Andersen 1967, 139; Merete Bodelsen, "Early Impressionist Sales 1874–94 in the Light of Some Unpublished *procès-verbaux*," in *The Burlington Magazine* (June 1968), 345; Brion 1973, **39**; Venturi 1978, **82**; Cézanne 1988, **126**; Basel 1989, 302.
EXHIBITIONS: New York 1928, no. 14; *French Painting of the Nineteenth and Twentieth Centuries*, Fogg Art Museum, Cambridge, Massachusetts, 1929, no. 5, illus.; Chicago 1952, no. 42, illus.; London 1954, no. 26, illus. 3; New York 1959, no. 19, illus.; Tokyo 1974, no. 29, illus.

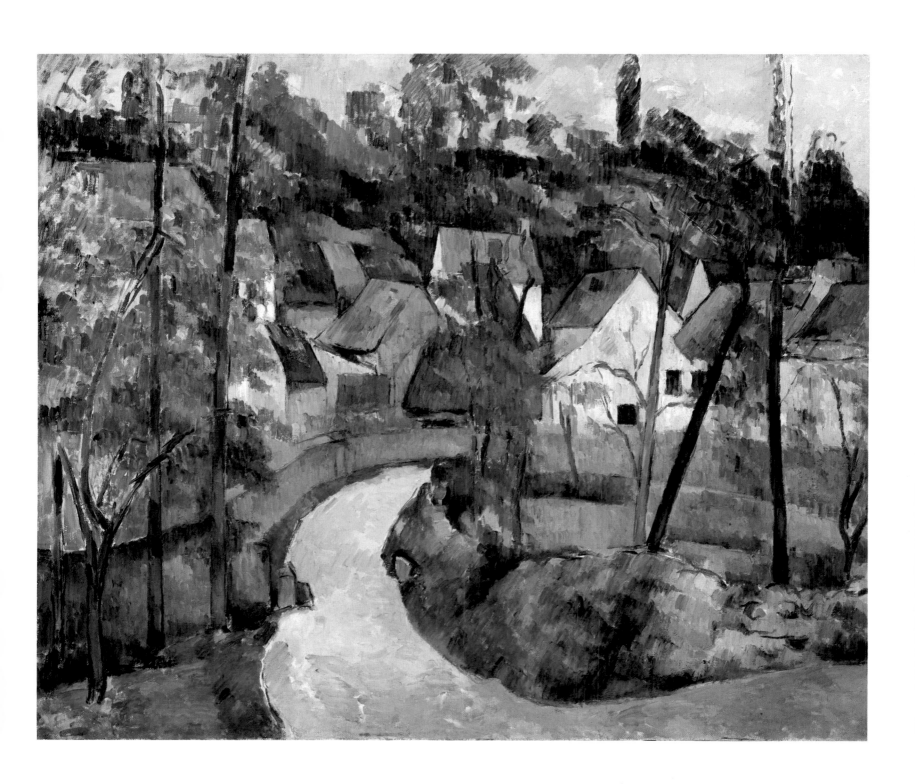

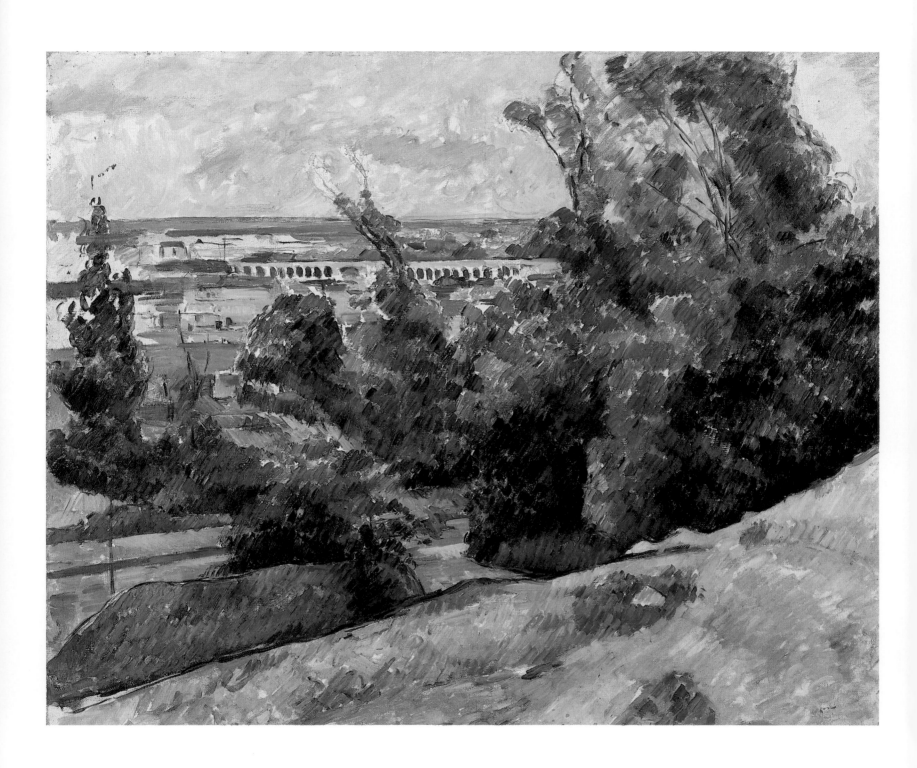

28 The Verdon Canal Aqueduct North of Aix-en-Provence, circa 1883
L'Aqueduc du canal de Verdon au nord d'Aix-en-Provence

Venturi no. 296 (1878–83)
Oil on canvas, 20 7/8 x 28 3/4" (59 x 73 cm).
Private collection, Switzerland

Borrowing from a compositional device familiar since the Baroque, Cézanne has here placed a tree-covered slope at a diagonal in front of a distant view clearly structured by horizontals and a few verticals. The space unfolds in successive planes from the foreground slope to the horizontal background, where we see as accents the arches of the long Aqueduc des Platanes as seen from the Chemin Noir. Three or four years later, the painter would use the arches of the Arc Valley viaduct as a similar accent in a view of the Mont Sainte-Victoire.[1] To prevent the sky from seeming too weighty, he covered part of it with the tops of the trees and further softened it by placing modified tones of the beige and brown of the foreground in the clouds. The pigment has been applied in such a way as to leave the canvas exposed in many spots, lending a lightness and transparency to the whole.

Cézanne painted mainly in Aix and environs in 1883 and 1884, and for southern landscapes as well, he now favored a brushwork style he had perfected in the North: rows of short strokes leading from the upper right to lower left (see cat. nos. 25, 26). He had found that these parallel strokes, almost identical in size, helped provide structure to his work. They first appeared between 1875 and 1877 (see cat. nos. 16–20), and became fully systematized after 1880.

Cézanne's chief concern with pictorial space was that it serve as a setting for objects formed by color. Qualities of the space itself, the changes of atmosphere and light captured so incomparably by the Impressionists, were of secondary importance to him. To register strong contrasts between palpable details and such subtleties as atmospheric changes, he would have had to give up his determination to treat the entire picture structure with the same intensity. For this reason, the painter chose to group his objects in the middle ground, leaving the foreground stripped of detail and drawing distant objects closer. Only in this middle ground did forms and colors seem to him to be fully expressive. Distributing his colors with a view to the rhythm of the entire surface was more important than reflecting the distortions of atmospheric perspective, which progressively rob objects of their form and color with the decreasing intensity of light.

NOTES

1 See the views Venturi 1936, nos. 452–55, 477.

PROVENANCE: Ambroise Vollard, Paris; Emile Hahnloser, Paris.
BIBLIOGRAPHY: Rivière 1923, 219; Venturi 1936, 130, no. 296, illus.; du 1989, **64**.
EXHIBITIONS: Basel 1936, no. 29; *La peinture française du XIXe siècle en Suisse*, Galerie Wildenstein, Paris 1938, no. 4, illus.; Lyons 1939, no. 20; London 1939, no. 27; *Europäische Kunst aus Berner Privatbesitz*, Kunstmuseum, Bern 1953 no. 15; Aix-en-Provence 1961, no. 8, illus. 5; Vienna 1961, no. 18.

29 The Railroad Bridge at L' Estaque, 1883
Le viaduc à L' Estaque

Venturi no. 402 (1882–85)
Oil on canvas, 21 1/4 x 26″ (54 x 66 cm).
Art Museum Ateneum, Collection Antell
(inv. no. AII 906), Helsinki

Cézanne was well aware that when working in his native South, whose clear forms were less affected by atmospheric and seasonal changes, he constantly had to revise the notions about light that he had developed in the North. He continued to construct his pictures almost always out of elementary contrasts, as he had since about 1880, but within that formula, we find him experimenting with increasingly free stylization.

Cézanne was attracted to the present motif not by the opportunity it presented to glorify the technical advances of rail transport, but rather by the architecture of the bridge and the way it is imbedded in the summery green of the landscape.[1] Despite its somewhat schematic structure, the picture creates an impression of inevitability, thanks to the precisely calculated balance between the downward slant of the tracks and the rising line of the roofs. Its foreground and background subject matter are worked in identical colors, and are compressed into a space in the middle distance. The dominant colors are shadings of complementaries green and red, ocher and blue. Natural forms with a slight suggestion of movement combine with rigid architectural shapes to form a unified whole.

The railroad bridge was probably not far from the painter's house in L'Estaque, which he described to Zola on May 24, 1883: "I shan't be returning to Paris before next year; I've rented a small house with garden in L'Estaque just above the station, and at the foot of the hill, with the pine-clad rocks just behind me. I'm still busy with my painting. Here there are fine views, but that doesn't necessarily make subjects. Nevertheless, when the sun sets and you're on high ground there's a beautiful distant panorama of Marseilles and the islands, the whole enveloped in the evening light with a very decorative effect [see cat. nos. 19, 22, 23]."[2]

NOTES

1 See the preliminary drawing Chappuis 1973, no. 790, and also the *Mountain Landscape with Railroad Bridge*, Venturi 1936, no. 401.
2 Cézanne 1984, 209–10.

PROVENANCE: Ambroise Vollard, Paris; Count Harry Kessler, Paris-Weimar; Ambroise Vollard, Paris.
BIBLIOGRAPHY: Vollard 1914, illus. 1; Rivière 1923, 209; Bernard 1925, **101**; Venturi 1936, 152, no. 402, illus.; Novotny 1937, illus. 38; Cooper 1954, 378f., illus. 16; Gowing 1956, 187, 189; Reff 1958, 47; Reff 1959, 172; Feist 1963, illus. 23; Chappuis 1973, 202, no. 790; Wadley 1975, frontispiece.
EXHIBITIONS: Paris 1907; *Manet and the Post-Impressionists*, Grafton Galleries, London 1910–11, no. 63; Berlin 1921, no. 9; London 1954, no. 31, illus. 4; Aix-en-Provence 1956, no. 24; The Hague 1956, no. 25; Zurich 1956, no. 44, illus. 19; Munich 1956, no. 32, illus.; Cologne 1956, no. 17, illus.; Vienna 1961, no. 21, illus. 14; Liège 1982, no. 13, illus.; Madrid 1984, no. 28, illus.; Edinburgh 1990, no. 37, illus.

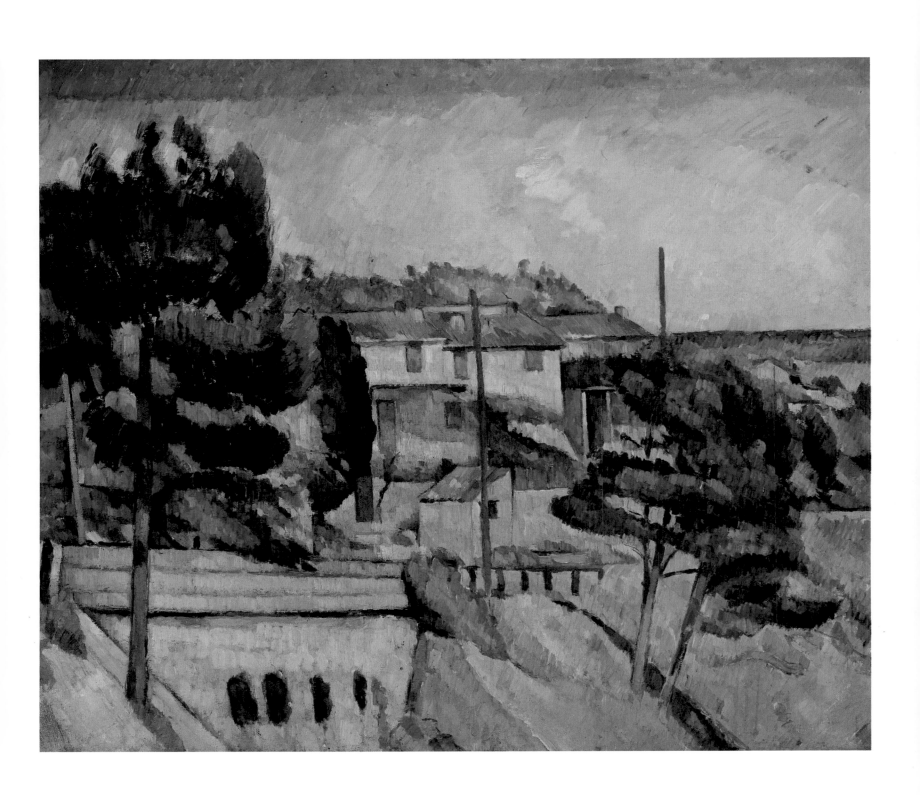

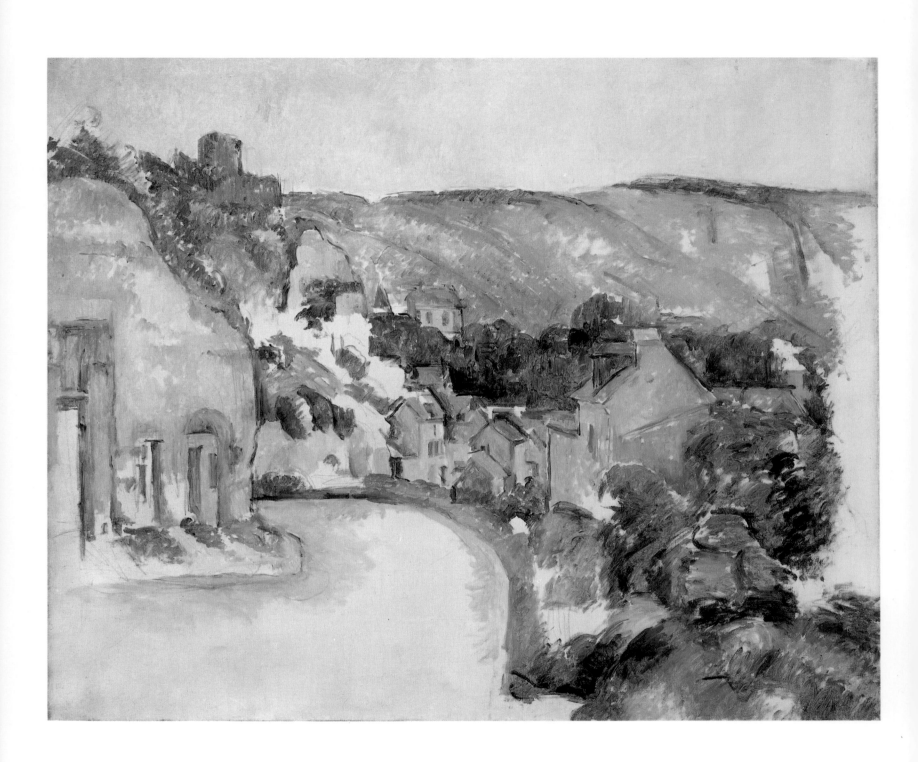

30 A Turn in the Road at La Roche-Guyon, 1885
Route tournante à La Roche-Guyon

Venturi no. 441 (1885)
Oil on canvas, 25 3/8 x 31 1/2" (64.2 x 80 cm).
Smith College Museum of Art, Purchased 1932,
Northampton, Massachusetts

From June 15 to July 11, 1885, Cézanne and his family visited Renoir in the picturesque village La Roche-Guyon on the Seine near Paris. As he had with Pissarro, Cézanne also went off painting with Renoir a number of times. For example, they worked side by side in early 1882 in L'Estaque, and in the summer of 1889 in Aix, where Renoir had rented the farm Bellevue from Cézanne's brother-in-law. Cézanne later spoke most unflatteringly of his colleague, whose landscapes did not appeal to him. He complained that there was still something "mother-of-pearl-like" about the work of the onetime porcelain painter, that his vision was "fuzzy."[1] Renoir, however, was a great admirer of Cézanne. He owned four of his paintings, including *A Turn in the Road at La Roche-Guyon*.[2] It is assumed that Cézanne left this painting with his host as a bread-and-butter gift.[3] It remained unfinished in a number of spots, and a few lines of the preliminary drawing are still visible on the empty canvas. The artist painted the colors only in thinned pigments with swift brushstrokes, but this was enough for Renoir, who once maintained that Cézanne needed merely to place two spots of color on a canvas to create perfection.[4]

NOTES

1 Gasquet 1930, 114.
2 The others were Venturi 1936, nos. 135, 308, 380.
3 Paul Cézanne *fils*, wrote the following certificate on December 28, 1931: "Tableau peint par mon père et donné à Renoir."
4 Gasquet 1930, 75.

PROVENANCE: Pierre Auguste Renoir, Cagnes; Maurice Renou, Paris; Stephan Bourgeois, New York.
BIBLIOGRAPHY: Rewald 1936, illus. 52; Venturi 1936, 160, no. 441, illus.; Novotny 1938, 21, 33, 52, 208, illus. 22; Rewald 1939, illus. 54; Gowing 1956, 190; Ratcliffe 1960, 16; Loran 1963, 25, 27, 31, **46**, 88, 105, 131; Venturi 1978, 83; C. Lloyd, "Reflections on La Roche-Guyon and the Impressionists," in *Gazette des Beaux-Arts* (January 1985), illus. 9; Charles Chetham, et al., *A Guide to the Collections, Smith College Museum of Art*, Northampton, Massachusetts, 1986, no. 85, illus.; Rewald 1986, 157; Basel 1989, 283.
EXHIBITIONS: *A Century of Progress*, Art Institute of Chicago 1933, no. 316, illus.; Philadelphia 1934, no. 29, illus.; *Cézanne and Gauguin*, Museum of Art, Toledo, Ohio, 1936, no. 24, illus.; San Francisco 1937, no. 17, illus.; New York 1942, no. 6, illus.; New York 1947, no. 30; New York 1959, no. 26, illus.; *Highlights from the Smith College Museum of Art*, IBM Gallery of Science and Art, New York 1990.

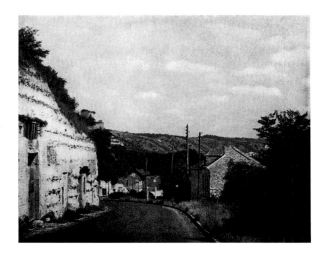

Illus. 1
La Roche-Guyon, photograph

31 Gardanne, 1885–86

Venturi no. 431 (1885–86)
Oil on canvas, 36 1/4 x 29 3/8" (92 x 74.5 cm).
The Brooklyn Museum, Ella C. Woodward and A. T. White Memorial Funds
(inv. no. 23.105), Brooklyn

In all of Cézanne's painting, there are only two architectural motifs he executed in vertical format: the mountain town Gardanne, which he pictured in two views in 1885–86,[1] and the houses and church in Montigny-sur-Loing, which he painted years later, in 1898.[2]

Cézanne settled his family in Gardanne, about eleven miles southeast of Aix, in August 1885, and they stayed there until May 1886. At first this meant that he had to commute from Aix to Gardanne and back every day,[3] but toward the end of this period, he managed to live in Gardanne as well. Two events of considerable importance occurred during those months. The first was his break with Zola, his boyhood friend and closest confidant for more than three decades. On April 4, 1886, Cézanne wrote Zola from Gardanne, thanking him very formally for sending a copy of his newest autobiographical novel, *L'Œuvre*, in whose main character, an artist who destroys himself, he was forced to discover his own features: "My dear Emile, I have just received the copy of *L'Œuvre* you were kind enough to send me. I thank the author of the *Rougon-Macquart* for this fine memorial and ask his permission to allow me to shake his hand, remembering years gone by. Ever yours for old times' sake."[4] The other notable event was Cézanne's marriage, on April 28, 1886, to Hortense Fiquet, the mother of his son, Paul, born in 1872. The influence of his eighty-eight-year-old father had finally been overcome.

There is no trace of any of this in the crystalline clarity of the landscapes Cézanne undertook in Gardanne and its environs.[5] The composition shown here, culminating in the church at the top of the town, once again relies on the color harmony of a red tending toward purple and a cobalt green derived from blue and yellow, accompanied by a light ocher. The picture is unfinished, and this is part of its charm. It permits us to see how the painter worked, patiently moving from left to right, a method he would continue to use through the two decades remaining until his death. The network of buildings curving like a protective wall around the church on the summit is relatively complete, while the trees in the foreground and the narrow strip of sky are nearly untouched (see cat. no. 30). In these areas, one can note the type of preliminary sketch he had employed since the mid 1880s, one that would have disappeared as the work was completed. Applied in pencil or in pigments thinned with turpentine, such sketches served to indicate the overall structure of a work and fix the shadows. Had the painting been completed, its foreground foliage and patches of green around the church might well have overpowered the inorganic element, the simplified solid forms of the architecture. The swirling brushstrokes of the trees would have dominated, rather than the flat red and ocher surfaces of the buildings. As it is, we see in the interlocking vertical and horizontal shapes what Cézanne contributed to Braque and Picasso and their Cubist interpretations of landscape.

But Cézanne never allowed the works of man to appear to dominate over nature, or rigid geometry over organic growth. On May 11, 1886, he wrote the collector Victor Chocquet (see cat. no. 15) from Gardanne, complaining that he was not very busy because of stretches of bad weather. But he then added: "The sky and the infinite elements of nature still attract me and provide me with the opportunity to take pleasure in looking ... green being one of the gayest of colors and most pleasing to the eye. Lastly, I can tell you that I am still busying myself with painting, and that this

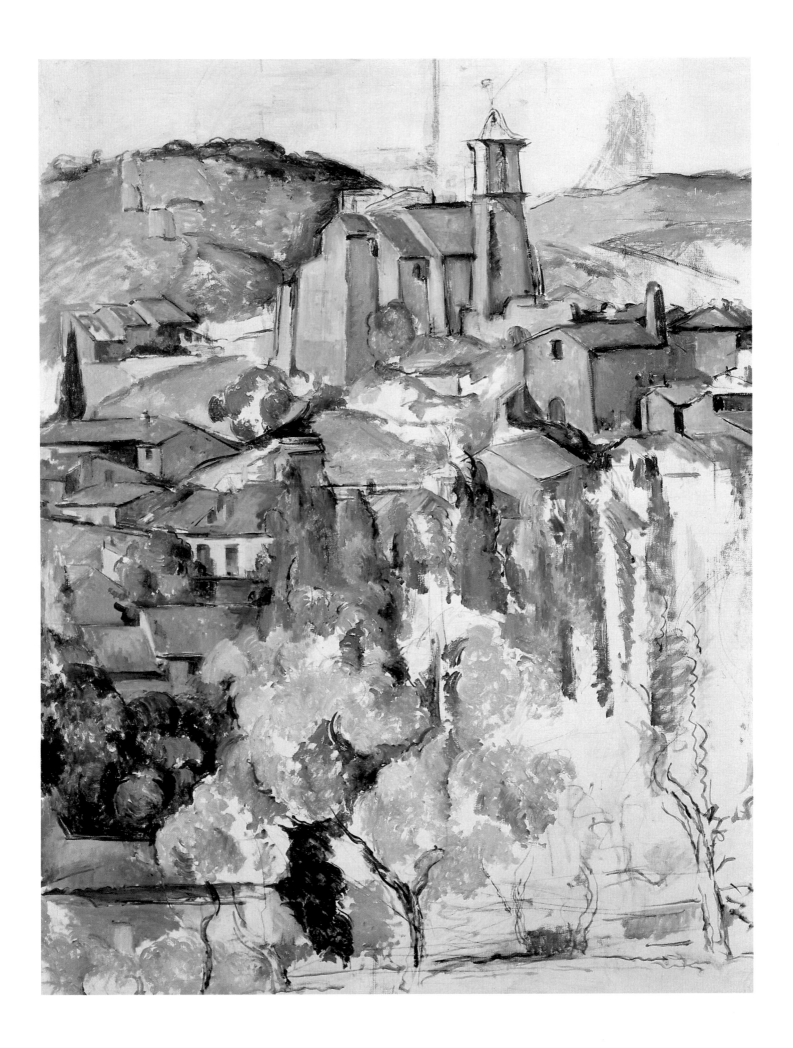

region offers treasures to be gleaned and has not yet found an interpreter worthy of the riches it offers."[6]

NOTES

1 Venturi 1936, no. 432; see also the horizontal-format depictions Venturi 1936, no. 430, Rewald 1983, no. 248, and Chappuis 1973, no. 902.
2 Venturi 1936, no. 1531.
3 See also the letters to Zola from August 20 and 25, 1885, Cézanne 1984, 220–21.
4 Ibid, 223.
5 Venturi 1936, nos. 430–37.
6 Cézanne 1984, 223–24.

PROVENANCE: Durand-Ruel, Paris-New York; Hans Wendland, Paris; Hôtel Drouot auction, Paris, February 24, 1922, no. 209.
BIBLIOGRAPHY: Klingsor 1923, illus. 28; Mack 1935, illus. 27; Rewald 1936, illus. 54; Venturi 1936, 158, no. 431, illus.; Novotny 1937, 19, illus. 42; Novotny 1938, 34, 43, 46, 205; Dorival 1949, 66, illus. XV, 180; Cooper 1954, 379; Ratcliffe 1960, 17; Cézanne 1962, illus.; Leonhard 1966, 133; Murphy 1971, 126, **148f.**; Elgar 1974, 104, 106, illus. 59; Schapiro 1974, frontispiece; Rewald 1983, 145, no. 248, 168, no. 343.
EXHIBITIONS: Philadelphia 1934, no. 15, illus.; New York 1947, no. 31; Aix-en-Provence 1961, no. 10; Vienna 1961, no. 24.

32 Mont Sainte-Victoire, Seen from Gardanne, 1885–86
La montagne Sainte-Victoire, vue de Gardanne

Venturi no. 434 (1885–86)
Oil on canvas, 28 7/8 x 36 3/8" (73.3 x 92.5 cm).
Museum of Art (inv. no. 87-OF-002), Yokohama

The essence and lesson of this barren landscape painting is how color alone can provide structure. Diagonal patches of orange-ocher and pink, violet and turquoise, stacked one behind the other, are set off and held together by tones of green. They draw the eye into the distance to a flat mountain ridge that, viewed from Gardanne (see cat. no. 31) or the hamlet of Meyreuil, is scarcely recognizable as the massif of the Mont Sainte-Victoire. Its more familiar silhouette is the face it presents to the west (see cat. nos. 89–92), not, as here, to the south.

PROVENANCE: Ambroise Vollard, Paris; Heinrich Thannhauser, Munich-Berlin (?); Eberhard von Bodenhausen, Berlin; Hugo Perls, Berlin; Georg Hirschland, Essen-New York; Sam Salz, New York; Sotheby Parke Bernet auction, New York, November 5, 1981, no. 208; Ernst Beyeler, Basel.
BIBLIOGRAPHY: Venturi 1936, 159, no. 434, illus.; Rewald 1983, 168, no. 341.
EXHIBITIONS: Cologne 1912, no. 140; New York 1947, no. 33; New York 1952, no. 6, illus.; Aix-en-Provence 1956, no. 49, illus.; Basel 1983, no. 21, illus.

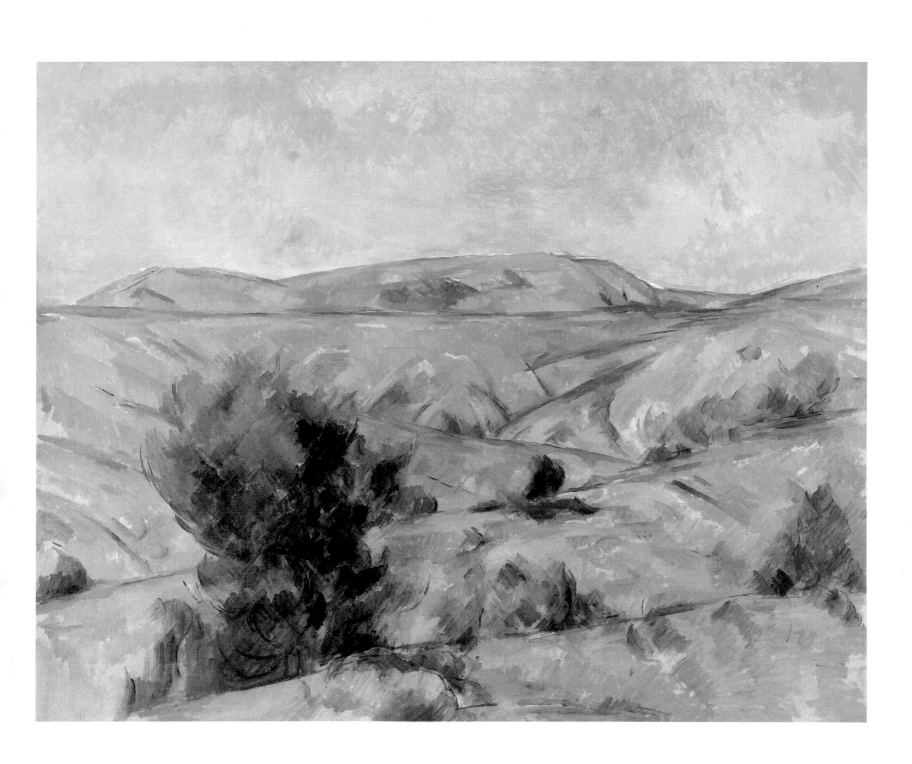

33 Five Male Bathers, circa 1880
Cinq baigneurs

Venturi no. 389 (1879–82)
Oil on canvas, 13 5/8 x 15″ (34.6 x 38.1 cm).
The Detroit Institute of Arts,
Bequest of Robert H. Tannahill (inv. no. 70.162), Detroit

Cézanne first became fascinated with the subject of bathers in the mid 1870s, as discussed earlier (see cat. no. 10). His highest ambition was to produce figural works, to restore narrative painting based on the human form to the high esteem it had enjoyed in the era of Giorgione, Titian, or Rubens. To the end of his life, he struggled to find a way of depicting figures at one with nature, paintings that would also show his subjects at ease with one another, enjoying simple human contact – the lack of which he himself had suffered so greatly (see cat. nos. 34, 79–83). Though he harbored none of the romantic yearning for the past that led the Classicists to try to outdo it and the Historicists to imitate it in every detail, Cézanne nevertheless sought to link himself to painting in the grand tradition.

His depictions of bathers were wholly invented, and to produce them, the plein-air painter was forced back to his studio. They were ultimately inspired by his boyhood memories of swimming on the banks of the Arc with his friends. Once the "Inseparables" went their separate ways after all in 1858, they frequently reminded each other of the joys of their childhood in Aix-en-Provence. The correspondence between Cézanne and Zola, for example, contains repeated allusions to them.[1] Cézanne's first paintings of boys bathing from about 1875 have the telltale silhouette of Mont Sainte-Victoire in the background.[2] With that indication of a specific setting, Cézanne paid homage to the actual experience that inspired him, yet he did everything he could to establish that what he was depicting was only a remote ideal from a lost time secretly remembered. From the beginning, he hoped to present through his bathers more than a mere description of experience. One might infer that his extreme formalism and his conscientious separation of the sexes in these paintings indicates a desire to distance himself from erotic fantasies, but that is only partially true. In his depiction of bathers, whether male or female, Cézanne sought to transcend reality with images that were immediately comprehensible while being secular correlatives to mythological and religious masterworks he so admired in the collections of the Louvre.

Since a more naturalistic portrayal would have compromised such an objective, the painter chose to rely on academic studies, feeling that in combination they might provide a reasonable suggestion of nature. It was perfectly logical for him to refer to the countless figure drawings he had done in Paris over the years, either from models in the Académie Suisse, or by copying famous paintings in the Louvre, or working from casts in the Musée de Sculpture Comparée du Trocadéro. It was through them that he had become familiar with the art of antiquity, the Renaissance, and the Baroque.[3] Already at one remove from nature, they could be readily incorporated in invented contexts. Cézanne had no interest in reproducing such figures literally; but by alluding to specific prototypes, he felt he could link his own sense of ideal form to important concepts from the past. And of course, by using his own earlier studies, he had no need of models – a major consideration since it would have been impossible to pose models out of doors in Paris, not to mention Aix. He confessed as late as 1904: "I've always made use of these drawings. They are by no means ideal, but I have no choice at my age."[4]

It took considerable effort to fit such heterogeneous figures with fixed poses and gestures into viable compositions, as is evident in this example of five male figures from the first generation of his paintings of bathers. Its arrangement, often repeated

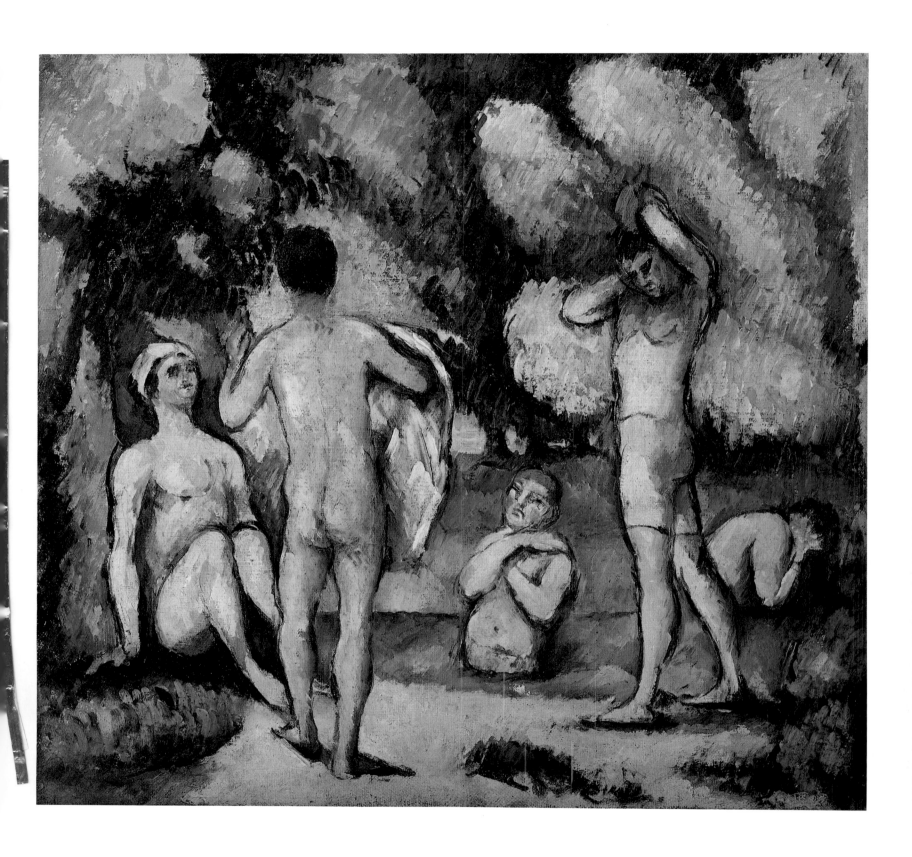

with minor variations up until his late period (see cat. nos. 79, 80),[5] can be traced back to a small study from about 1875.[6] The main figures in the picture are the two standing ones, which serve here and in all similar compositions as crucial vertical axes. The one seen from behind, with somewhat atypical proportions, is based on an ancient marble statue in the Louvre, the so-called *Roman Orator*.[7] The other was perhaps originally a life study, for with his raised arms he reflects a typical model's pose.[8] With their classical contraposto stance, both retain the look of statues, and it was unavoidable that they would dominate the composition. They also reveal Cézanne's focus on the structure of the human form and his relative lack of interest in sequences of movement and their analysis, the chief concerns of Degas, for example, or Toulouse-Lautrec. A third figural type is the seated nude bracing himself with his right arm.[9] In Cézanne's bathers, we usually find the last figure on the left in such a pose. The remaining figures are variously distributed through the composition, either standing in the water in the center or crouching on the bank on the right. This basic friezelike pattern of alternating standing and seated figures was at times enriched by the addition of still other figures, and in the late works more animated ones, but remained essentially constant.

NOTES

1 In 1858, Cézanne even went so far as to send his friend in Paris some doggerel verses recalling those happy times: Cézanne 1962, 16, 24; see also 14, 68.
2 *Les baigneurs au repos*, Venturi 1936, nos. 273, 274, 276.
3 There are sixty-three Cézanne drawings from antique sculptures alone, thirty-five from sculptures by Puget, and twenty-nine after paintings by Rubens.
4 Bernard 1982, 80.
5 See the compositions Venturi 1936, nos. 388, 390, 541, 580–82, 585, 587–91, 724, 727, 729, Rewald 1983, nos. 125, 130, 132, 494, 495, Chappuis 1973, nos. 418, 423.
6 *Les cinq baigneurs*, Venturi 1936, no. 268.
7 See the figure studies Venturi 1936, nos. 393, 394, Rewald 1983, nos. 127, 128, Chappuis 1973 nos. 418–30, 432, 684.
8 See the figure studies Venturi 1936, nos. 263, 392, 395, Rewald 1983, nos. 119, 120, 131, 133, Chappuis 1973, nos. 419, 436, 437, 439–43, 1217.
9 See the figure studies Venturi 1936, no. 260, Rewald 1983, no. 123, Chappuis 1973 nos. 418, 420–22, 425, 431–33, 684, 995.

PROVENANCE: Ambroise Vollard, Paris; Egisto Fabbri, Florence; Paul Guillaume, Paris; Robert H. Tannahill, Detroit.
BIBLIOGRAPHY: Raynal 1936, **128**; Venturi 1936, 149, no. 389, **151**; Dorival 1949, 78, illus. 69, 159; Berthold 1958, 39, 59, illus. 44; Reff 1958, 46, 111; Chappuis 1962, 115; Schapiro 1968, 52; Cherpin 1972, 67; Adriani 1978, 342f.; Krumrine 1980, 122; Adriani 1981, 286f.; Shiff 1984, 16f., illus. 35, 191; Rewald 1986, **141**; Geist 1988, 234f., illus. 194; Rewald 1989, 25, 30, 51, illus. 26; Krumrine 1992, 591f., illus. 15, 594f.
EXHIBITIONS: Venice 1920, no. 12; Basel 1989, 168, 179, illus. 146, 313, no. 31.

34 Female Bathers Before a Tent, 1883–85
Baigneuses devant la tente
Venturi no. 543 (1883–85)
Oil on canvas, 25 x 31 7/8" (63.5 x 81 cm).
Staatsgalerie (inv. no. 2550), Stuttgart

Cézanne generally created his portraits and still lifes, and certainly his landscapes,
which constitute the majority of his paintings, in long-drawn-out sessions directly
before his subject. The figural scenes of his early period, however, and his numerous
subsequent paintings of bathers, which together make up only a scant 20 percent of
his œuvre, were wholly the products of his imagination. The bathers, drawing on a
repertoire of figure studies on hand, are artistic inventions constructed solely according
to the laws of color, form, and space (see cat. nos. 33, 79–83).

In his paintings of bathers, strictly segregated by sex, Cézanne formalized his
renunciation of the confused sensuality that dominates his early work (see cat. nos. 1, 2,
10–12). It would be incorrect to explain his separation of the sexes as a bow to
bourgeois sensibilities, especially since he produced his first paintings of segregated
bathers at a time, in the mid 1870s, when he obviously felt no compunctions in that
regard. By creating this special genre, he deliberately moved away from extreme
situations laden with tension, in favor of veiled symbols of an internalized,
unproblematic sensuality for which Giorgione, Titian, Poussin, and Rubens had
provided a precedent long before. Courbet, Daumier, and Manet – not to mention
Baudelaire, Flaubert, and Zola – had encouraged the young Cézanne to see people as
the products of their times, prey to the processes of civilization. As he grew older,
however, the painter, too late for myth, sought to recapture with the invented
self-assurance of his bathers something of the grandeur that had characterized figural
compositions up until the age of Goya. To him, the great works of the past exhibited a
correspondence between idea, decor, and meaning, between actual experience and
pictorial concept. Somewhat earlier, Courbet had trivialized the ideal of bathers in a
landscape in his own invented *Bathers* (1853, Musée Fabre, Montpellier), and Daumier
had perverted it in his depictions of crowded bodies in municipal bathing
establishments. Cézanne was determined to rehabilitate the subject in pictures with a
timeless validity. It was from him, in turn, that Picasso, the most imaginative artist of a

Illus. 1
Paul Cézanne,
Female Bathers, 1874–75.
The Metropolitan Museum
of Art, New York

Illus. 2
Cover of the first Cézanne
monograph, Munich 1910

129

new generation, drew inspiration for his own variations on the theme, from *Les Demoiselles d' Avignon* (1907, The Museum of Modern Art, New York) to an amusingly conflated ensemble, *The Bathers* (1956, Staatsgalerie, Stuttgart).

Cézanne's first experiments in his new genre resulted in whole series of compositions, and he continued to come back to it for over three decades, yet in all of these works the present composition, with nudes arrayed in front of a tentlike structure, remains unique. There is only the suggestion of something vaguely similar in his very earliest picture of female bathers (illus. 1). It would also be possible, of course, to link this hanging spread out to form a pyramid-shaped shelter to the one in *The Eternal Feminine* (cat. no. 12), an ironically grandiose setting for the display of a nude's seductive charms (see also cat. no. 35).[1] The six nudes in *Bathers Before a Tent* exhibit little of that sensuality, to be sure; their bodies are solid, almost more masculine than feminine. It is unclear what they represent. The beauty of these figures, all of which clearly presented the artist with problems, is somehow alien. Oddly enough, these bodies in their natural state, frozen as they are in traditional model poses, appear quite unnatural. It was doubtless their exemplary stylization that led Franz Marc to use them, in a drawing made from a reproduction of the painting, on the cover of Julius Meier-Graefe's *Paul Cézanne*, the first monograph on the artist, published in Munich in 1910 (illus. 2).

This painting was included in the first Cézanne exhibition at Vollard's in 1895. Its figures, each taken out of a different context, are regularly placed in the space of the landscape, and this is what gives it an air of artificiality. Although Cézanne repeatedly made note of the addresses of models, he cannot have had much opportunity to employ them (see cat. no. 76). Hortense Fiquet, who was working as a model when he first met her, later posed for him occasionally, as did his son, Paul, but he was often away from them for long periods of time. Because he was shy, and also owing to provincial conventions, he was forced to rely on either reproductions or the nude studies he had done years before in drawing school in Aix and at the Académie Suisse in Paris (see cat. no. 33). Although far from ideal, at least these provided him with ideas for artificial figures largely inspired in any case by art history.[2]

NOTES

1 See also the painting *Une moderne Olympia,* Venturi 1936, no. 106.
2 For example, the pose of the nude standing in front of the tent is virtually identical to that of the one in the painting *La toilette,* Venturi 1936, no. 254, which can be traced back to Delacroix. The early model studies Chappuis 1973, nos. 201–3 could have served as inspiration for the seated figure to the left.

PROVENANCE: Ambroise Vollard, Paris; Auguste Pellerin, Paris; Paul Rosenberg, Paris; Klas Fahreus, Lidingön; Walther Halvorsen, Oslo; Ragnar Moltzau, Oslo.
BIBLIOGRAPHY: Meier-Graefe 1904, **493**; Meier-Graefe 1910, **29**; Vollard 1914, 59, illus. 30, illus. 45, illus. 47; Meier-Graefe 1918, 75, **113**; Meier-Graefe 1922, 75, **134**; Faure 1923, illus. 54; Rivière 1923, 207; Salmon 1923, 32ff., illus. 5; Venturi 1936, 181, no. 543, illus.; Mack 1938, 290; Dorival 1949, 98, illus. 164, 175; Guerry 1950, 112; Berthold 1958, 38, illus. 37; Reff 1958, 111; Reff 1959 (*Enigma*), 68; Vollard 1960, 34; Feist 1963, illus. 26; Peter Beye, Kurt Löcher, *Katalog der Staatsgalerie Stuttgart, Neue Meister,* Stuttgart 1968, 40f., illus. 32; Elgar 1974, 241; Krumrine 1980, 118, **120**; Lewis 1989, **21**.
EXHIBITIONS: Paris 1895; Paris 1904; London 1925, no. 12, illus.; *Exposition des grands maîtres du XIXe siècle,* Galerie Paul Rosenberg, Paris 1931, no. 5; Zurich 1956, no. 50, illus. 25; Munich 1956, no. 37, illus.; Basel 1989, 128, illus. 92, 132, 241, 296, 314, no. 45.

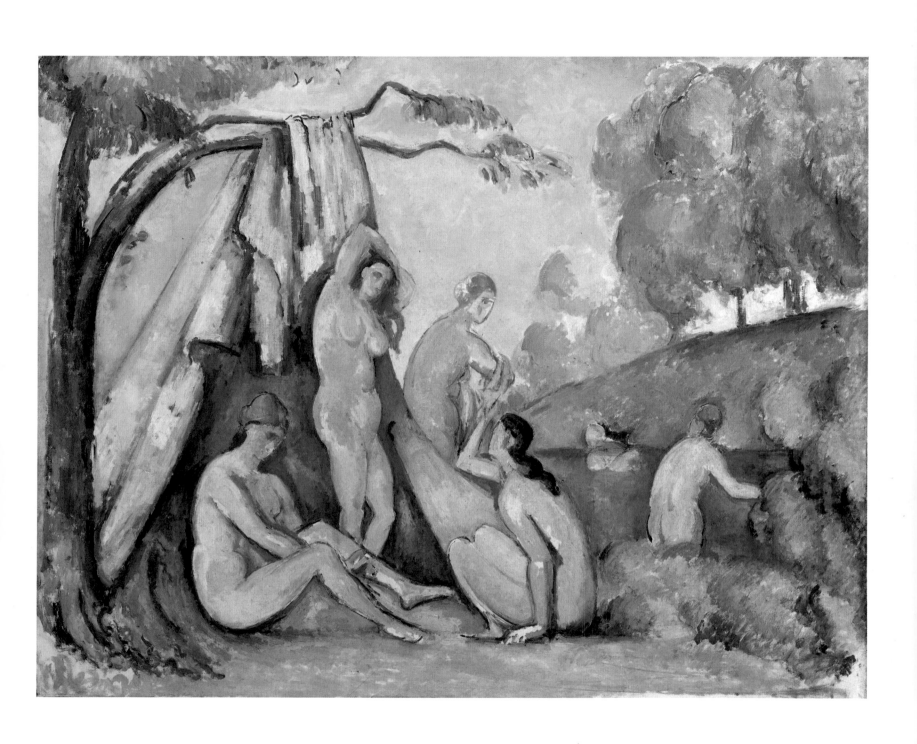

35 Reclining Nude, 1886-90
Femme nue couchée

Venturi no. 551 (1886-90)
Oil on canvas (stretched on pasteboard), 17 3/8 x 24 3/8″ (44 x 62 cm).
Von der Heydt-Museum (inv. no. G 1143), Wuppertal

This unfinished painting represents two separate undertakings. What first strikes the eye is a female nude, her charms provocatively exposed to view, stretched out on a blue divan under a sketchily indicated drapery (see cat. nos. 12, 34). Her head, framed by long locks of blond hair, inclines to the left, echoing the line of her raised right arm. On the continuation of that line we suddenly find two pears on a white cloth. The canvas had clearly been turned upside down when these were painted.

This nude has a history. From Cézanne's early years there is a sketch for a picture of a nude holding a mirror that prefigures the overall arrangement of the present composition and pose.[1] A drawing from the late 1870s includes a nude in an almost identical pose, this time with a champagne glass in her right hand. Finally, another sketch combines the now-familiar nude with the head of a swan.[2] These two drawings, doubtless executed after some unknown pattern, served as studies for a painting of Leda and her lover Zeus in the form of swan, the latter rather dramatically indicating his intentions (illus. 1). It seems clear enough that *Reclining Nude,* somewhat more generous in its format than the one of Leda, was also originally intended – that is before the upper-left-hand corner was painted over – to represent Zeus's visit to his beloved. The curving line of the swan's neck is still preserved in the folds of the tablecloth, and the pink stripe running through the cloth, visible in other still lifes as well (cat. nos. 53, 58), appears to follow the line of the swan's wing.[3]

The two parts of the picture have virtually nothing to do with each other.[4] As in the case of an earlier painting previously discussed (cat. no. 3), they are what remains of two distinct projects, the ultimate format of the still life remaining somewhat unclear. The rather clumsily masked seam curving across the canvas reveals that at some point the painter cut out the corner of the picture containing the still life, then later restored it to its original position (see cat. no. 60).

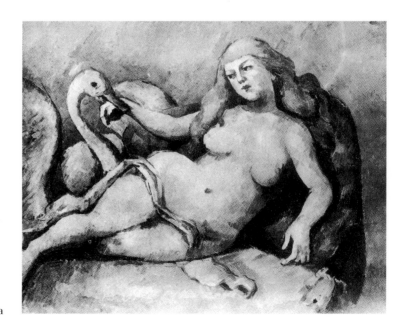

Illus. 1
Paul Cézanne,
Leda and the Swan, 1886.
The Barnes Foundation, Merion, Pennsylvania

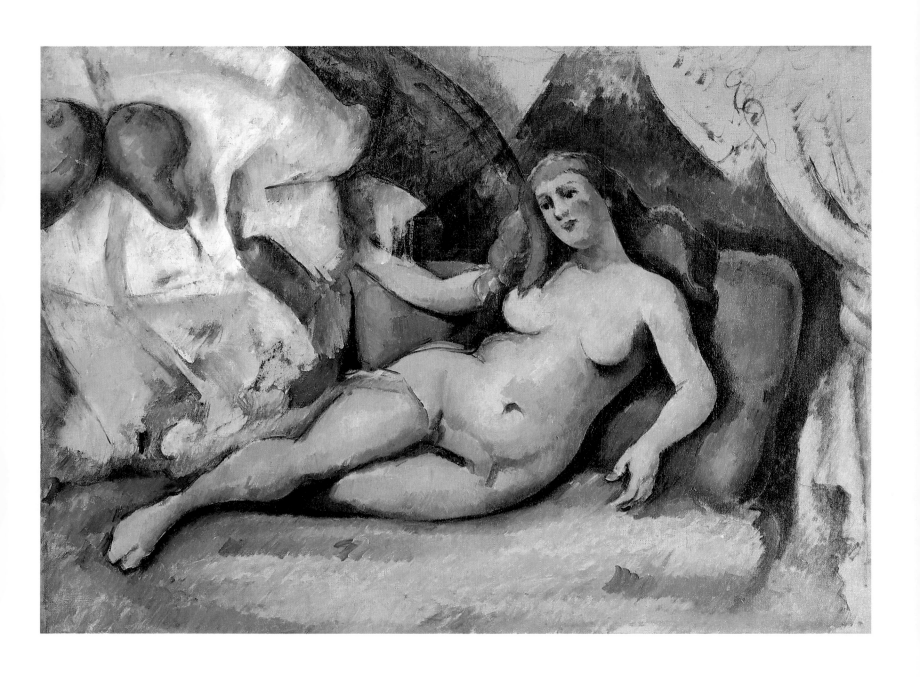

1 *Femme au miroir*, Venturi 1936, no. 111.
2 Chappuis 1973, nos. 483, 484.
3 In the reminiscences of the Paris art dealer Ambroise Vollard, which are not altogether trustworthy, we read that Cézanne produced a Leda and the Swan "after an engraving" as early as 1868. "The idea for his composition came to him by way of the famous Courbet painting *La femme au perroquet*. When Cézanne first saw that picture he exclaimed: 'And I will paint a woman with a swan!' He painted another nude woman in the same pose, but without the bird and less archaic in form, ten years later as an illustration for *Nana*." Vollard 1960, 20.
4 Schapiro 1982, 24, argues that the fruits do go together with the erotic figure as parts of a "planned whole," but his claim is unconvincing.

PROVENANCE: Ambroise Vollard, Paris; Heinrich Thannhauser, Munich-Berlin-Lucerne; Eduard von der Heydt, Ascona.
BIBLIOGRAPHY: Vollard 1914, 31, illus. 5; Ors 1936, illus. 48; Venturi 1936, 183, no. 551, illus.; Reff 1958, 115; Loran 1963, 58; Theodore Reff, "Cézanne and Hercules," in *The Art Bulletin* XLVIII, 1 (March 1966), 35; Schapiro 1968, 39f., 45, illus. 14, 51; Andersen 1970, 161; Chappuis 1973, 147, no. 483; Sutton 1974, **103**; Geist 1975, 16; Adriani 1978, 340; Krumrine 1980, 177; Arrouye 1982, **63**.
EXHIBITIONS: *Les maîtres du siècle passé*, Galerie Paul Rosenberg, Paris 1922, no. 8; Berlin 1927, no. 19, illus.; *Vom Abbild zum Sinnbild*, Städelsches Kunstinstitut, Frankfurt am Main 1931, no. 22; *Frauenbildnisse und Frauenbilder des XIX. und XX. Jahrhunderts*, Kunstmuseum, Lucerne 1937, no. 16; Tokyo 1974, no. 37, illus.; *Von Marées bis Picasso. Meisterwerke aus dem Von der Heydt-Museum Wuppertal*, Monte Verità, Ascona 1986 – Kunstmuseum, Bern 1986, 46f., illus.

36 Self-Portrait with Turquoise-Green Background, circa 1885
Portrait de l'artiste au fond turquoise-vert

Venturi no. 1519 (1883–87)
Oil on canvas, 21 5/8 s 18 1/4" (55.1 x 46.4 cm).
The Carnegie Museum of Art, Acquired through the generosity of the
Sarah Mellon Scaife family, 1968 (inv. no. 68.11), Pittsburgh

For a long time, it was unclear who this man standing behind the back of an upholstered chair (?) was meant to be. Venturi, unwilling to commit himself, titled the work simply *Portrait d'homme*. Only in 1938 did it become clear that it is in fact a self-portrait, painted in about 1885 from a photograph taken in 1872.[1] None of the twenty-four self-portraits listed in Venturi's catalogue raisonné[2] show him facing front like this in half-figure. With but one exception, in which the painter is posed in front of his easel with a palette in his hand,[3] they are all bust portraits, with the head turned one way or the other to face the viewer (see cat. nos. 13, 67).

The fact that Cézanne was working from a photograph portrait may explain the discrepancy in size between the head and the somewhat delicate body. Despite this discrepancy, the axial figure seems altogether monumental. The strong background color, enriched by slight variations in tone, is neutral enough to lend a certain grandeur to the somewhat reserved pose, but reveals nothing about the subject, who fixes the viewer with deep-set eyes. The hands

Illus. 1
Paul Cézanne,
photograph 1872

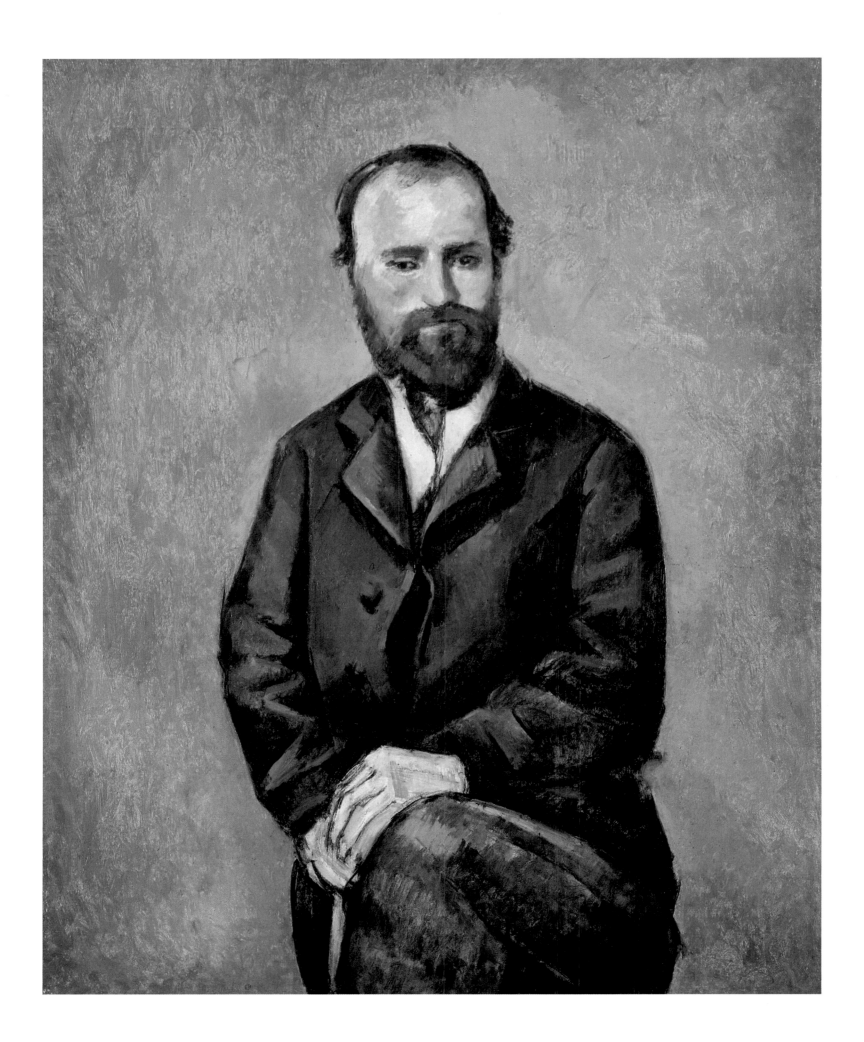

are the only part of the painting left unfinished; they are only sketched in with black crayon covered with a layer of mainly white paint.

NOTES

1 Novotny 1938, 101, illus. 48, illus. 49. Cézanne's first self-portrait, from the early 1860s, Venturi 1936, no. 18, was also painted from a photograph. Apparently, he did not yet have the patience to pose too long in front of a mirror.
2 Venturi 1936, nos. 18, 21, 23, 81, 280, 284, 286 (cat. no. 13), 287–90, 365–68, 371, 372, 514–18, 578, 579 (cat. no. 67), 693.
3 Venturi 1936, no. 516.

PROVENANCE: Bernheim-Jeune, Paris; Gottfried Tanner, Zurich; Rudolf Staechelin, Basel; Wildenstein, Paris-London-New York.
BIBLIOGRAPHY: Raynal 1936, illus. 73; Venturi 1936, 331, no. 1519, illus.; Novotny 1938, 101, illus. 48; Brion 1973, 78; *Catalogue of Paintings Collection, Museum of Art, Carnegie Institute*, Pittsburgh 1973, 36f., illus. 46; Rewald 1989, 290, 298f., illus. 150.
EXHIBITIONS: New York 1916; *Französische Meister des XIX. Jahrhunderts und van Gogh*, Kunsthalle, Bern 1934, no. 5; *Sammlung Rudolf Staechelin*, Kunstmuseum, Basel 1956, no. 22, illus.; *Impressionisten*, Galerie Beyeler, Basel 1967, no. 3, illus.; Liège 1982, no. 17, illus.

37 Hortense Fiquet in a Striped Dress, 1883–85
Hortense Fiquet en robe rayée
Venturi no. 229 (1872–77)
Oil on canvas, 22 3/8 x 18 1/2″ (56.8 x 47 cm).
Museum of Art (inv. no. 87-OF-001), Yokohama

The artist's wife looks quite young in this painting, and accordingly, Venturi may be correct in dating this portrait to the 1870s (see cat. no. 14). Yet, the subtle differentiation in the application of color and clear handling of form in this bust portrait in three-quarter profile to the left argue against such an early date, suggesting that the work may have been created some ten years later (see cat. nos. 38–44). The classical harmony of black, white, and crimson lends a vividness to the flesh tones against a turquoise-gray background that is reminiscent of Spanish Baroque portraits.[1]

NOTES

1 The small portrait Venturi 1936, no. 228, also shows Hortense Fiquet in a dark striped dress against a red chair back.

PROVENANCE: Ambroise Vollard, Paris; John Quinn, New York; Cornelius J. Sullivan, New York; Sullivan auction, Parke-Bernet, New York, December 6–7, 1939, no. 181; Walter P. Chrysler, Provincetown; Sotheby's auction, London, July 1, 1959, no. 14; Ernst Beyeler, Basel; G. David Thompson, Pittsburgh; Wildenstein, Paris-London-New York; Algur H. Meadows, Dallas; Sotheby's auction, London, December 2, 1986, no. 34.
BIBLIOGRAPHY: Vollard 1914, 59, illus. 39; Faure 1923, illus. 12; Rivière 1923, **123**; Bernard 1925, **124**; Faure 1926, illus. 12; Pfister 1927, illus. 35; Venturi 1936, 116, no. 229, illus.; Vollard 1960, 34; Feist 1963, illus. 13; Brion 1973, **27ff.**; Chappuis 1973, 154, no. 520, 195, no. 736, 200, no. 774; Philadelphia 1983, 32; Rewald 1989, 130, 133, 165, 173, 192, 198, 212, illus. XI, 263, 306, 317, 327.
EXHIBITIONS: Paris 1895; *Salon d'Automne*, Paris 1905, no. 323; *Armory Show*, New York-Chicago-Boston 1913, no. 580; *Impressionist and Post-Impressionist Paintings*, The Metropolitan Museum of Art, New York 1921, no. 7, illus.; New York 1928, no. 24; New York 1929, no. 5, illus.; *La femme*, Galerie Beyeler, Basel 1960, no. 2, illus.; *Faces from the World of Impressionism*, Wildenstein Galleries, New York 1972, no. 17, illus.; Tokyo 1974, no. 33, illus.; *Dallas Collects. Impressionist and Early Modern Masters*, Museum of Fine Arts, Dallas 1978, no. 19, illus.

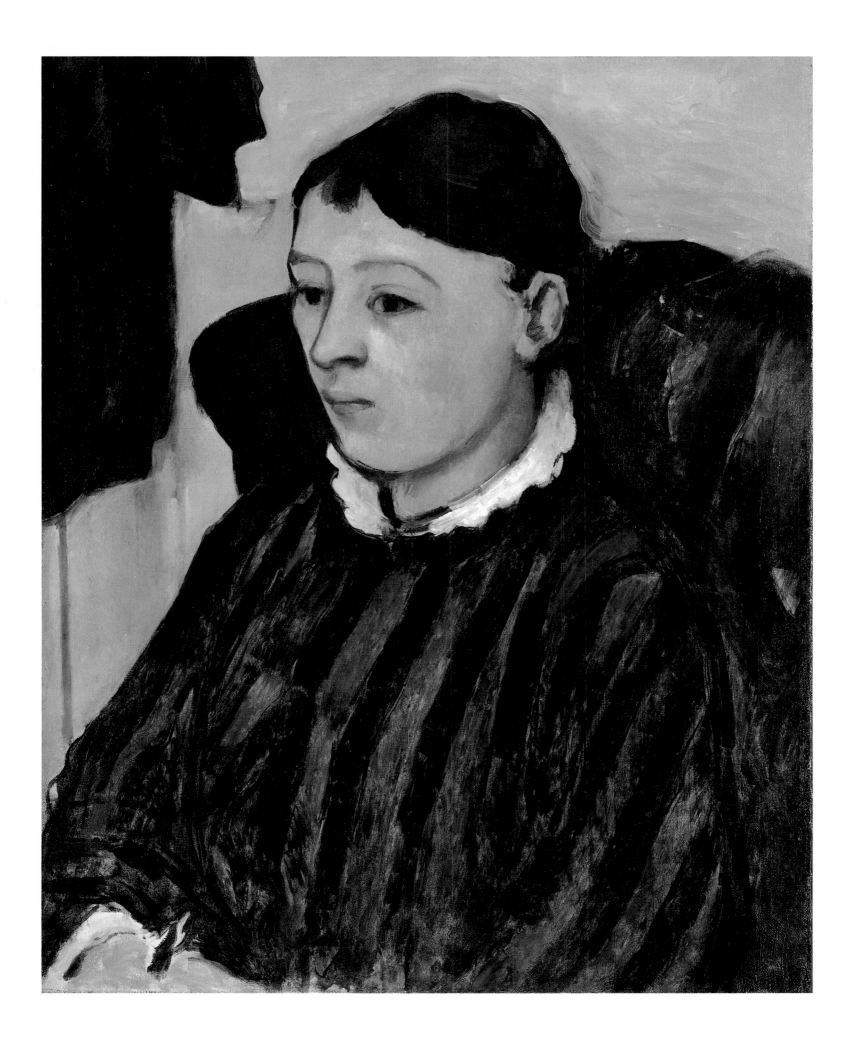

38 Madame Cézanne in Blue, circa 1886
Madame Cézanne en bleu

Venturi no. 529 (1885–87)
Oil on canvas, 29 x 24" (73.6 x 61 cm).
The Museum of Fine Arts,
The Robert Lee Blaffer Memorial Collection, Houston

Most of Cézanne's portraits, especially those of his wife Hortense (see cat. nos. 14, 37, 39–44), are to some extent self-portraits, for he has infused them with much of his own temperament. This is true whether his sitters were close relatives, friends, or simply people available to him as models. Almost all of them have something of the reserve, the desire for distance, the seriousness and loneliness of the artist. As external reflections of his own humanity, his sitters remained strangers who are not to be approached too closely. They all appear to be people who are ultimately turned inward on themselves. Expansive in neither their gaze nor their gestures, Cézanne's portraits seem self-contained to the point of blindness, and his solid pictorial structures and monumental treatment of forms only serve to underscore this impression. It is not because of their size that his portraits appear monumental, but rather because of their spiritual weight as expressed in forms created with color. Without falling back on any of the traditional formulas, the portraitist Cézanne managed to lend his motionless subjects a tremendous dignity.

The tension and movement in these paintings are solely a matter of color and form; they in no way depend on the personalities or expressions of their subjects. In *Madame Cézanne in Blue,* the seemingly rigid frontality of the sitter placed against a half-open door (?) is enlivened by the slight leftward tilt of the picture axis, which runs down from the top throught the middle of her face and along the trim on her jacket. The right-angle panels of the door provide deliberate contrast to the wealth of curved forms on the left in the wallpaper design and elaborate bracket of a buffet the artist had already used in a mid-seventies still life.[1] The sitter's head appears at the junction between the two zones, its flesh tone standing midway between the cool radiance of the light blue door and the darker warmth of the wallpaper and wood furniture. The painter has chosen to omit the sitter's hands, so that there is little to distinguish her heavy, statuesque torso from the solid volumetric forms of the background.

NOTES

1 *Le buffet,* Venturi 1936, no. 208.

PROVENANCE: Ambroise Vollard, Paris; Walther Halvorsen, Oslo; Heinrich Thannhauser, Munich-Berlin-Lucerne; Etienne Bignou, Paris; Knoedler, New York.
BIBLIOGRAPHY: Ors 1936, illus. 4; Venturi 1936, 58, 178, no. 529, illus.; Philadelphia 1983, 20; Kirsch 1987, 24; Cézanne 1988, 77.
EXHIBITIONS: London 1925; Berlin 1927, no. 23, illus.; Knoedler Galleries, New York 1930, no. 2, illus.; Knoedler Galleries, New York 1931; Fine Arts Society, Wilmington 1931; Institute of Arts, Detroit 1931, no. 16; Lyons 1939, no. 31, illus.; Paris 1939, no. 14; Chicago 1952, no. 67, illus.; Washington 1971, no. 11, illus.; Liège 1982, no. 18, illus.

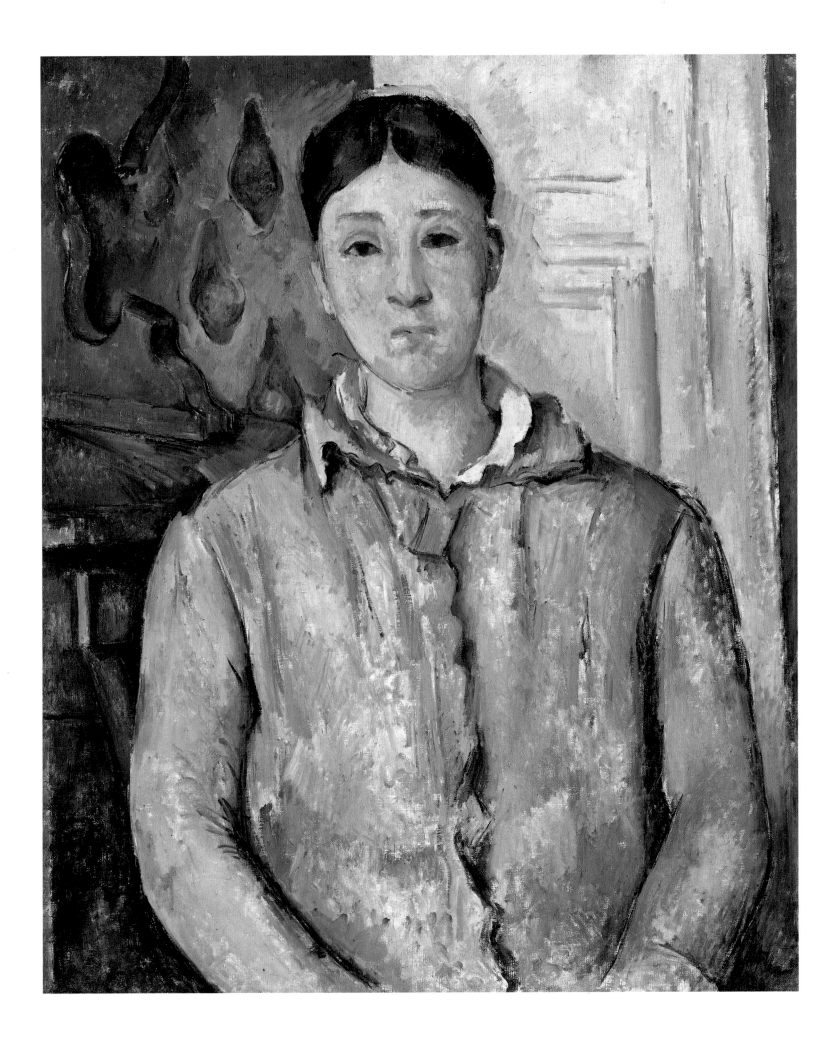

39 Madame Cézanne, circa 1886

Venturi no. 528 (1885–87)
Oil on canvas, 39 3/8 x 22″ (100.1 x 81.3 cm).
The Detroit Institute of Arts,
Bequest of Robert H. Tannahill (inv. no. 70.160), Detroit

Compared to the previous portrait (cat. no. 38), with its striking color contrasts in form, this painting is more restrained. It includes the sitter's hands and hips as well as her upper body. Her simple costume is similar (or the same?), however, as is her somewhat tilted pose. Born in 1850, the artist's wife is about thirty-six years old in both paintings. This portrait was also painted in the same room as the previous one; note the olive wallpaper with its teardrop pattern and the red accent of the narrow baseboard, but this time, Madame Cézanne poses in front of a drapery, so that the buffet is no longer visible on the left.

Although the color structure of the present work is very different from the previous painting, with much more delicate nuances, the color relationships presented in spirited brushwork tie the figure more closely to the surface of the painting. Even so, the similarities mentioned above suggest that the two portraits were made at about the same time. The present one appears in the background, as a loose canvas casually pinned to the wall, in a painting called *The Smoker* from about 1891 (Venturi no. 688; State Hermitage Museum, St. Petersburg), but this does not prove that the portrait was painted later than the preceding one. The couple's long-postponed marriage on April 28, 1886, in Aix-en-Provence, must have meant that Hortense was increasingly available to sit for the painter in the later 1880s, for Cézanne took frequent advantage of her experience as a model in this period (see cat. nos. 38, 40–44).

In his "Thoughts on Cézanne," written in 1926, Robert Walser remarked that the artist was much more concerned with formal questions and decisions than content:

> One wants to bear in mind how odd it was that he looked at his wife as though she were a piece of fruit on the tablecloth. To him his wife's outline, her contours, were the same quite simple ones, hence all the more complicated, that he found in flowers, glasses, plates, knives, forks, tablecloths, fruits, coffee cups, and coffeepots. A pat of butter was just as full of meaning for him as the gentle swellings he could make out in his wife's dress. I know I am not expressing myself well, but would like to think that the reader will understand me all the same, or perhaps on account of this lack of polish, in which light effects glisten, even better, more profoundly, although I object to carelessness in principle, obviously I feel one can rightly claim that he made the fullest possible use, almost tirelessly, of the suppleness and compliancy of his hands.[1]

NOTES

1 "Das Tor zur Moderne. Paul Cézanne in Schweizer Sammlungen," in *du* (September 9, 1989), 56.

PROVENANCE: Ambroise Vollard, Paris; Auguste Pellerin, Paris; Barnes Foundation, Merion, Pennsylvania; Etienne Bignou, Paris; Knoedler, New York; Robert H. Tannahill, Detroit.
BIBLIOGRAPHY: Vollard 1914, illus. 45; Rivière 1923, 229; Javorskaia 1935, illus. 25; Venturi 1936, 58, 178, no. 528, **213**; Barnes, Mazia 1939, 79ff., 414; New York 1977, **18f.**; Philadelphia 1983, X; Shiff 1984, 191, 193, illus. 41, 212, illus. 51; *100 Masterworks from the Detroit Institute of Arts*, New York 1985, **122f.**; Kirsch 1987, 24; Cézanne 1988, **93**; Rewald 1989, 263.
EXHIBITIONS: Paris 1904, no. 3; *A Nineteenth Century Selection of French Paintings*, Galerie Bignou, New York 1935, no. 2, illus.; *Chefs-d'œuvre des Musées des Etats-Unis de Giorgione à Picasso*, Musée Marmottan, Paris 1976, illus. 27.

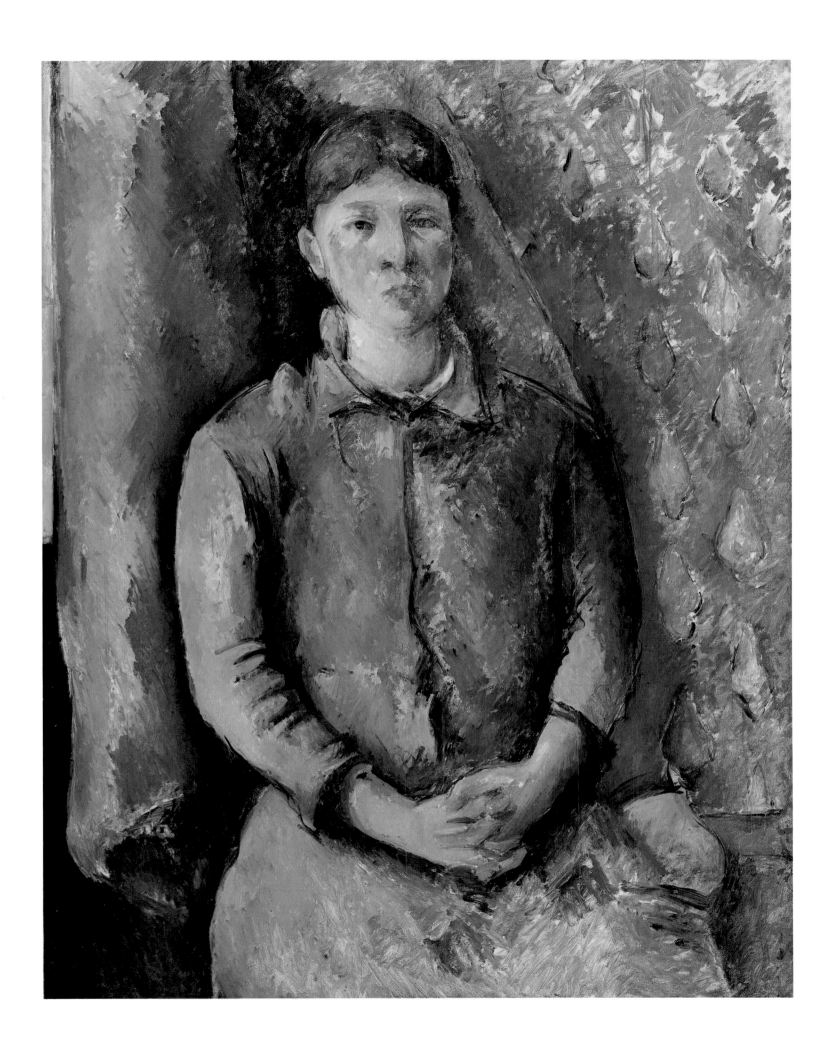

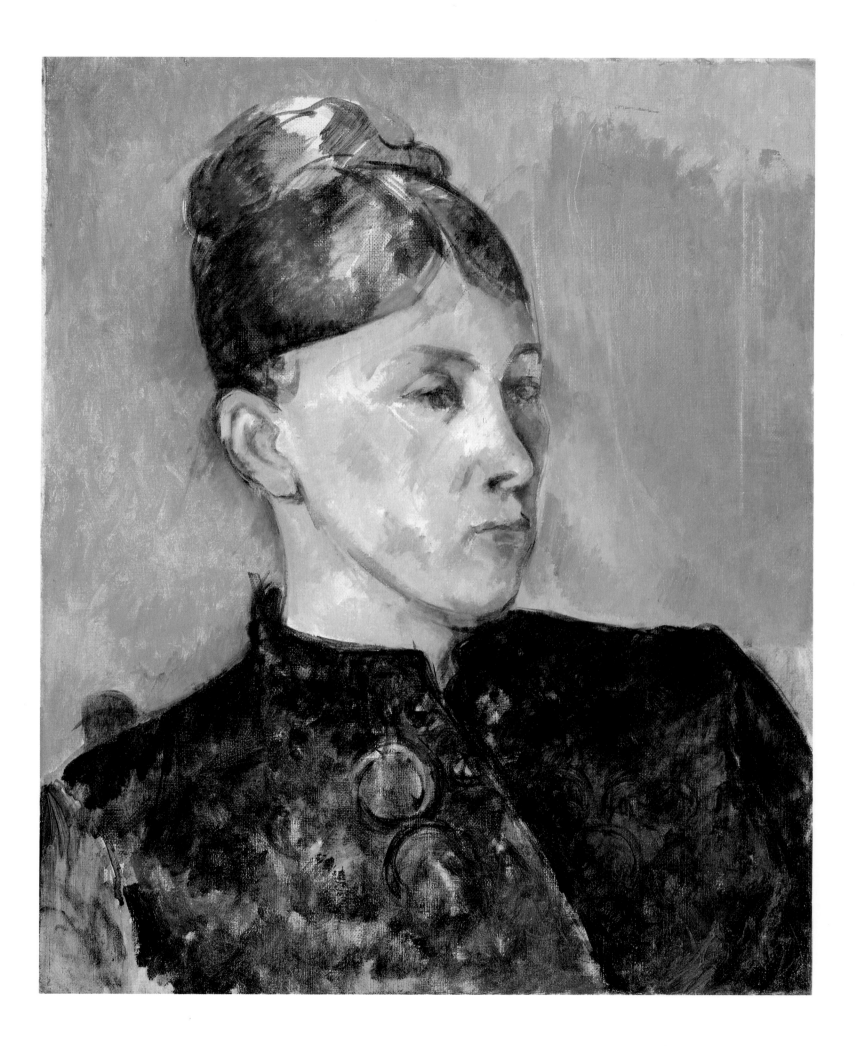

40 Madame Cézanne, 1886–87

Venturi no. 521 (circa 1885)
Oil on canvas, 18 1/2 x 15 1/4″ (46.8 x 38.9 cm).
Philadelphia Museum of Art, The Samuel S. White III and
Vera White Collection (inv. no. 67.30.17), Philadelphia

Of all twentieth-century artists, Henri Matisse was surely Cézanne's greatest admirer.
He owned five of his paintings and eight watercolor landscapes.[1] This portrait, which
he bought from Ambroise Vollard, is an excellent example of the painterly freedom
and decorative simplification of form that Matisse so respected in Cézanne. The two
artists were identical in their determination to adapt their subject to the spirit of the
picture, using its objects in their construction, but building them out of pure colors.
Both sought to harmonize existence with absolute clarity of consiousness.

The sitter's features have hardened somewhat; they appear more angular here
than in earlier portraits (see cat. nos. 14, 37–39).[2] Her head is turned in three-quarter
profile, and to give it a greater three-dimensionality, Cézanne painted over the
background, first applied in regular brushstrokes, with patches of solid blue and
turquoise. Behind the richly differentiated black dress with its swirl pattern we can see
what was probably part of the chair back.

NOTES

1 In addition to the present one, Venturi 1936, nos. 381, 530, 613, 786, Rewald 1983, nos. 256, 316, 323, 340,
415, 416, 541.
2 See also the frontal portrait Venturi 1936, no. 520.

PROVENANCE: Ambroise Vollard, Paris; Henri Matisse, Nice; Paul Rosenberg, Paris; Reid & Lefevre,
London; Samuel S. White, Ardmore, Pennsylvania.
BIBLIOGRAPHY: Gasquet 1930, illus.; Rewald 1936, illus. 58; Venturi 1936, 58, 176, no. 521, illus.; Novotny
1937, illus. 57; Rewald 1939, illus. 60; Dorival 1949, 70, illus. 109, 166; Guerry 1950, 95; Raynal 1954, 72;
Ratcliffe 1960, 17; Vollard 1960, illus. 6; Leonhard 1966, 120; Murphy 1971, 98; Chappuis 1973, 207, no. 827;
Elgar 1974, 105; New York 1977, 58; Adriani 1978, 324; Venturi 1978, 105; Cézanne 1988, 168;
Basel 1989, 303.
EXHIBITIONS: *Les maîtres du siècle passé*, Galerie Paul Rosenberg, Paris 1922, no. 12; *Loan Exhibition of
Masterpieces of French Art of the 19th Century*, Thomas Agnew Galleries, Manchester 1923, no. 13; New
York 1928, no. 23; Philadelphia 1934, no. 44; New York 1942, no. 13, illus.; New York 1947, no. 37, illus.;
Masterpieces of Philadelphia Private Collections, Museum of Art, Philadelphia 1947, no. 23; Chicago 1952,
no. 44, illus.; Philadelphia 1983, XIV, 26, 28f., no. 13, illus.

41 Madame Cézanne in Red, 1888–90
Madame Cézanne en rouge

Venturi no. 570 (1890–94)
Oil on canvas, 45 7/8 x 35 1/4″ (116.5 x 89.5 cm).
The Metropolitan Museum of Art, The Mr. and Mrs. Henry Ittleson Jr.
Purchase Fund, 1962 (inv. no. 62.45), New York

The three portraits of the artist's wife in a red dress (see also cat. nos. 42, 43), first shown together in the Tübingen exhibition, constitute a high point in the Cézanne œuvre. Though representing different points of view, these portraits, each of which is highly expressive in itself, were produced in the same spirit within a relatively brief period between 1888 and the spring of 1890. In retrospect, it would appear that Cézanne first painted the present portrait with its elaborate setting, then the intermediate half-figure version (cat. no. 42), and finally the considerably reduced one (cat. no. 43). Yet, it is perfectly possible that he produced them in the opposite order, progressing from the monumental experiment with the figure alone to its presentation in a tailor-made setting. Although it is impossible to determine the order in which they were done, it is certain that the works were produced in the period mentioned above (but see later copy, cat. 42, illus. 1). In 1888, Cézanne and his family moved into an upper-middle-class apartment on the fifth floor of the building at 15, quai d'Anjou on the Ile Saint-Louis. Having inherited a considerable estate on the death of his father in October 1886, the artist could now afford a somewhat more comfortable way of life. Among the telltale features of this apartment, which he occupied until the move to the Avenue d'Orléans in the spring of 1890, were a large mirror above the fireplace, which extended somewhat beyond the ends of the mantelpiece, and a blue wall set off from a lighter-colored wainscoting by a deep-red stripe.

Sometime between 1888 and 1890, then, Madame Cézanne posed in front of this particular wall (see cat. nos. 42, 45) for the most imposing portrait, not only in its size, but also in its decor and color, that her husband ever conceived. The fireplace, the tongs, and the corner of the mirror on the left edge of the painting are balanced on the right by a sumptuously patterned drapery that Cézanne also used after 1888 as an elegant touch in several other well-appointed portraits and in several still lifes from his late period (see cat. no. 88).[1] The framing verticals serve to balance the angular distortions to which the sitter appears to have been subjected. Like her, the back of her chair tilts to the right, as does the chair rail and the wide strip of wine red above it. It is unclear just how the verticals and horizontals of the mirror and the fireplace, conforming to the lines of the picture frame, fit in with the wall set at an angle.

Yet, none of these questions, all of them arising from our habit of seeing things in perspective, seem to matter once one falls under the spell of the figure dressed in carmine red set off with delightful patches of blue and backed by yellow gold. Rarely has the familiar been portrayed with less familiarity. The more intimately Cézanne knew his sitters, the less he sought to characterize them. One is especially struck by his reluctance to clearly define a face with details of physiognomy in his numerous portraits of Hortense (see cat. nos. 14, 37–40, 42–44). Always bearing in mind the picture as a whole, he thought it illogical to devote more attention to her eyes and mouth than to an arm, or for that matter, to a chair, which could be just as expressive as the body resting on it. To him, the sitter's nature was adequately expressed in the lethargic reserve of her pose, in her proportions, in her clothing, or the rose placed in her hand. Any strong emotion would have given her face too much movement, would have exposed rather than veiled, and made the oval of her head appear less hermetic than the other shapes. This is why Cézanne suppressed the personality of this models, whose patience while holding a given pose for long hours must have been enormous.

144

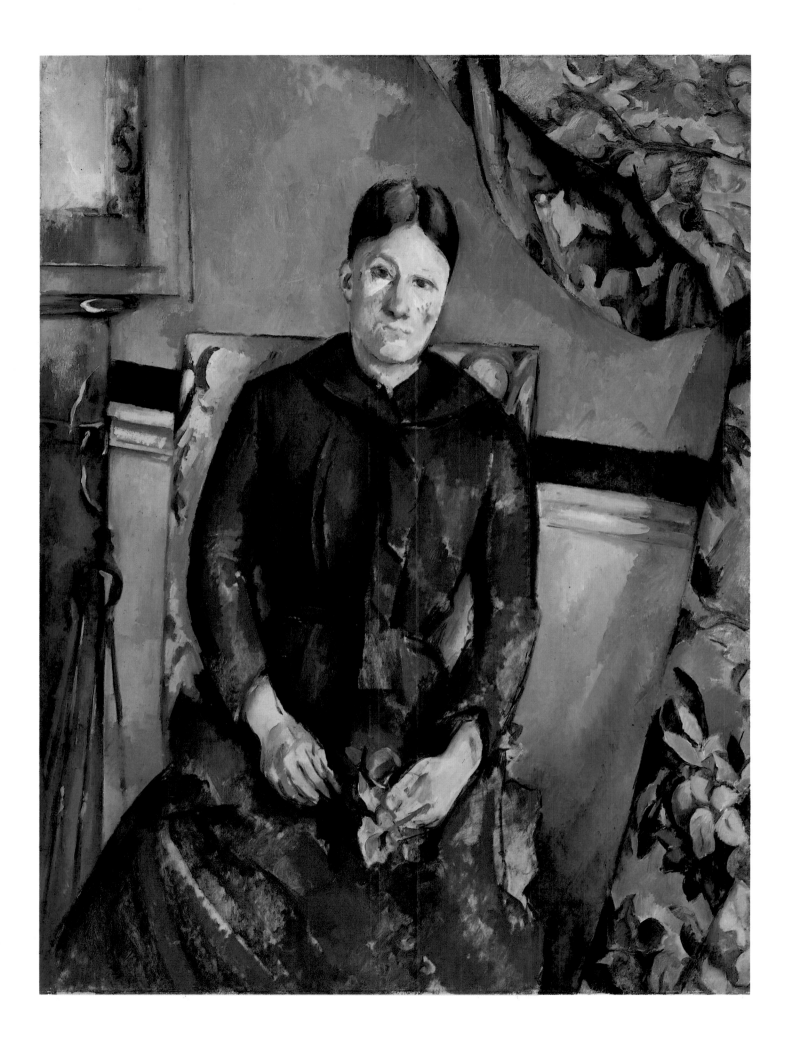

For all of the seeming candor of their arrangment, there are in fact no portraits more uncommunicative than these. For all their remoteness, there are no more circumspect souls than the ones Cézanne laid claim to for his compositions. All activity is denied them, they are not even permitted to display any curiosity, for the artist was too well aware of the relativity of any such behavior. The sole motivation for these solitary, unapproachable figures is a self-centered existence. Rilke, who surely saw the present portrait in the memorial exhibition in Paris in 1907, wrote of the "infinite impartiality, declining all involvement in the doings of others, that makes the people in Cézanne's portraits so objectionable and comical."[2] On this same subject, he had reported to his wife in an earlier letter:

> You have to see, some Sunday for instance, the people moving through the two galleries, amused, scornful, intrigued, annoyed, indignant. And when it comes time to sum up their impressions, they stand there, these monsieurs, these men of the world, in pathetic desperation, and you hear them declaiming: *il n'y a absolument rien, rien, rien.* And how pretty the ladies passing by think themselves; they recall how they caught a glimpse of themselves in the glass doors as they came in, to their full satisfaction, and conscious of their reflections, they arrange themselves for a moment, without looking, next to one of the touching portraits of Madame Cézanne, so as to exploit the hideousness of this kind of painting for a comparison so extremely favorable (as they assume) to themselves. And somebody told the old man in Aix that he was "famous." In his heart, however, he knew better, and didn't listen.[3]

NOTES

1 See the portraits and still lifes Venturi 1936, nos. 552, 679, 682, 697, 703, 731–34, 736, 738, 741 (cat. no. 88), 742, 745, 747.
2 Rilke 1977, 33.
3 Ibid., 30.

PROVENANCE: Ambroise Vollard, Paris; Bernheim-Jeune, Paris; Auguste Pellerin, Paris; Jean-Victor Pellerin, Paris; Henry Ittleson, New York.
BIBLIOGRAPHY: Meier-Graefe 1918, **167**; Coquiot 1919, **238**; Meier-Graefe 1922, **201**; Rivière 1923, 216; Fry 1927, 65f., illus. 34; Rivière 1933, **111**, 139; Mack 1935, illus. 17; Huyghe 1936, 44, illus. 28; Raynal 1936, 102, 146, illus. 70; Venturi 1936, 188, no. 570, illus.; Novotny 1937, 8, illus. 63; Novotny 1938, 87; Barnes, Mazia 1939, **217**, 373; Cogniat 1939, illus. 87; Guerry 1950, 35, 67, 76, illus. 20, 97, 103, 106, 110f., 116, **171ff.**; Badt 1956, 117; Ratcliffe 1960, 18; Loran 1963, 85, 91; Charles Sterling, Margaretta M. Salinger, *French Paintings. A Catalogue of the Collection of the Metropolitan Museum of Art*, New York 1966, **109ff.**; Andersen 1970, 43; Rewald 1975, 164, 166; New York 1977, 77; Paris 1978, **19**, 22; Rewald 1983, 26, 157, no. 296, 174 no. 375; Rewald 1986, 269; Kirsch 1987, 24; Cézanne 1988, **171**; London 1988, 65.
EXHIBITIONS: Paris 1907, no. 18; Berlin 1909, no. 10; Paris 1936, no. 76.

42 Madame Cézanne in a Yellow Chair, 1888–90
Madame Cézanne au fauteuil jaune

Venturi no. 572 (1890–94)
Oil on canvas, 31 7/8 x 25 5/8" (81 x 64.9 cm).
The Art Institute of Chicago,
Wilson L. Mead Fund (inv. no. 48.54), Chicago

So as to view his sitter from a different angle, the painter has here turned the yellow-patterned chair to the right next to the same wall, which now appears more turquoise than blue (see cat. nos. 41, 43). Madame Cézanne's gaze, centered in a masklike face, ignores the viewer and focuses instead on something in the distance. The simple combination of flat planes and the oval shapes of head and arms with their folded hands gives the portrait a sense of unshakable solidity and density. Its subject, rendered in precisely calculated forms, represents both a person and an idea. Her compact body, fixed on the surface, is wholly at the mercy of the puritanical stringency of the pictorial structure. The painter has corrected the slight tilt of the picture axis, determined by the pose, by placing the chair rail and the dark stripe above it higher on the left side than on the right (see cat. nos. 41, 45).

At some later point, Cézanne produced a copy of this portrait in the same format, but one in which the contrasts are more pronounced (illus. 1). Just why he did so is unclear. There are no other such copies in his entire œuvre.

PROVENANCE: Ambroise Vollard, Paris; Bernheim-Jeune, Paris; Paul Rosenberg, Paris; Alphonse Kann, Saint-Germain-en-Laye; Heinrich Thannhauser, Munich-Berlin-Lucerne.
BIBLIOGRAPHY: Vollard 1914, illus. 46; Meier-Graefe 1918, **166**; Meier-Graefe 1922, **200**; Salmon 1923, illus. 10; Pfister 1927, illus. 74; Javorskaia 1935, illus. 16; Ors 1936, illus. 5; Venturi 1936, 189, no. 572, illus.; Novotny 1938, 78; Barnes, Mazia 1939, **262**, 373; Cogniat 1939, illus. 73; Dorival 1949, illus. 113, 166; Théodore Rousseau, "Cézanne as an Old Master," in *Art News* 51, 2 (April 1952), **31**; *Paintings in the Art Institute of Chicago*, Chicago 1961, 73, **326**; Loran 1963, 85, 91; Andersen 1970, 43; Elderfield 1971, **52f.**; Murphy 1971, 55, **105**; Elgar 1974, 128, 148, 153, 158; Hülsewig 1981, 54, 61, illus. 16; Rewald 1983, 174, no. 375; Kirsch 1987, 23; Cézanne 1988, **170**.
EXHIBITIONS: New York 1928, no. 19; *Exposition des grands maîtres du XIXᵉ siècle*, Galerie Paul Rosenberg, Paris 1931, no. 7 Paris 1936, no. 75; Paris 1939 (Rosenberg), no. 26, illus.; Chicago 1952, no. 70, illus.; Washington 1971, no. 23, illus.

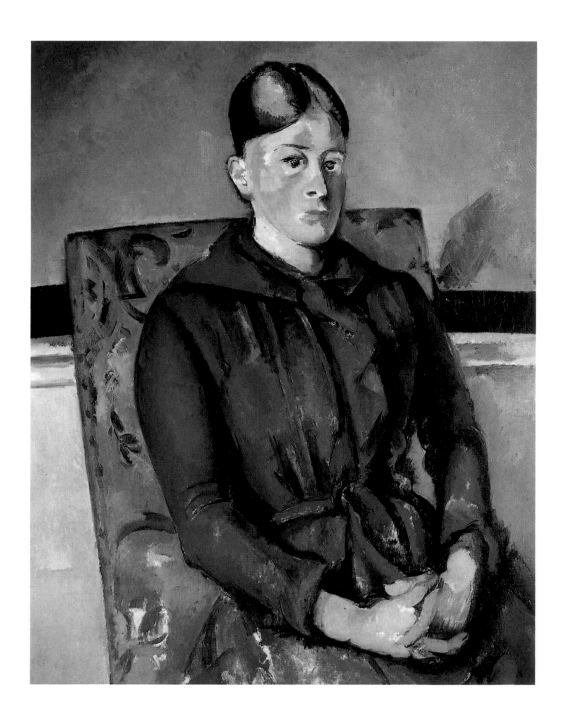

Illus. 1
Paul Cézanne, *Madame Cézanne in a Yellow Chair*, 1893–95. Private collection,
New York. © Photo Christie's, New York

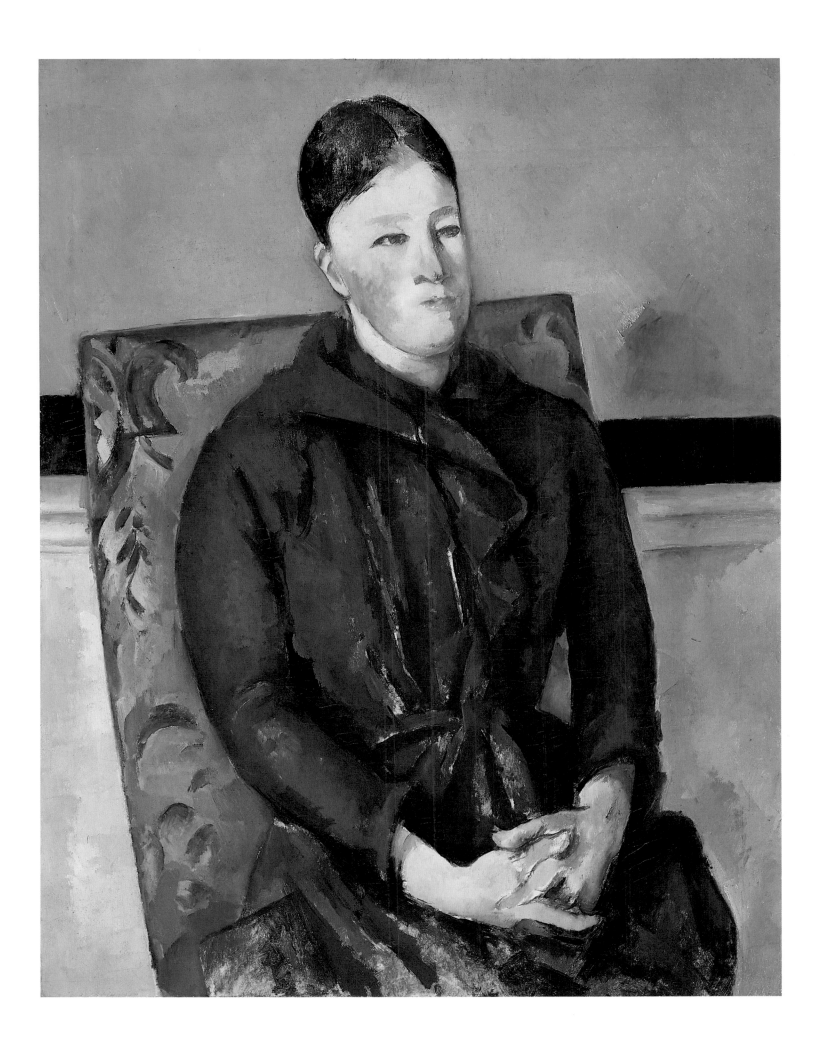

43 Madame Cézanne in Red, 1888–90
Madame Cézanne en rouge

Venturi no. 573 (1890–94)
Oil on canvas, 35 x 27 5/8" (89 x 70 cm).
Museu de Arte de São Paulo

In this painting, the artist's wife has been placed in front of a plain background, as though projected onto a canvas. All incidental details have been removed. The slight tilt of her body and the angular folds of her dress suggest an almost archaic composure; the relaxed position of her arms and the oval shape of her head only add to it. The definite poetry of the picture, most apparent in the inclusion of the flowers, suggests a quiet conversation taking place, one not so much between man and wife as between the painter and his subject.

Although the wall in the background has no distinguishing features, one can assume that this portrait of Madame Cézanne was produced in the couple's Paris apartment at 15, quai d'Anjou, between 1888 and 1890, as were those previously discussed (cat. nos. 41, 42). It has been suggested that this was merely a study in preparation for the largest of the three red-dress portraits (cat. no. 41), but its authoritative character and the care with which it was executed make it clear that the painting was an independent undertaking.

PROVENANCE: Ambroise Vollard, Paris; Bernheim-Jeune, Paris; Paul Cassirer, Berlin; Alfred Flechtheim, Berlin; Etienne Bignou, Paris; Paul Guillaume, Paris; Mrs. W. A. Clark, New York.
BIBLIOGRAPHY: Venturi 1936, 189, no. 573, illus.; Barnes, Mazia 1939, **251**, 381; Andersen 1970, 38, illus. 34, 43; Brion 1973, **50**; Elgar 1974, 157, illus. 92; Krumrine 1980, 121.
EXHIBITIONS: Cologne 1912, no. 145; Berlin 1921, no. 22, illus.; *Impressionisten,* Galerie Paul Cassirer, Berlin 1925, no. 10; *A Century of French Painting,* Knoedler Galleries, New York 1928, no. 27; Paris 1936, no. 84; New York 1947, no. 50; Tokyo 1986, no. 31, illus.; Ettore Camesasca, *Trésors du Musée de São Paulo,* Fondation Pierre Gianadda, Martigny 1988, 96ff., illus.

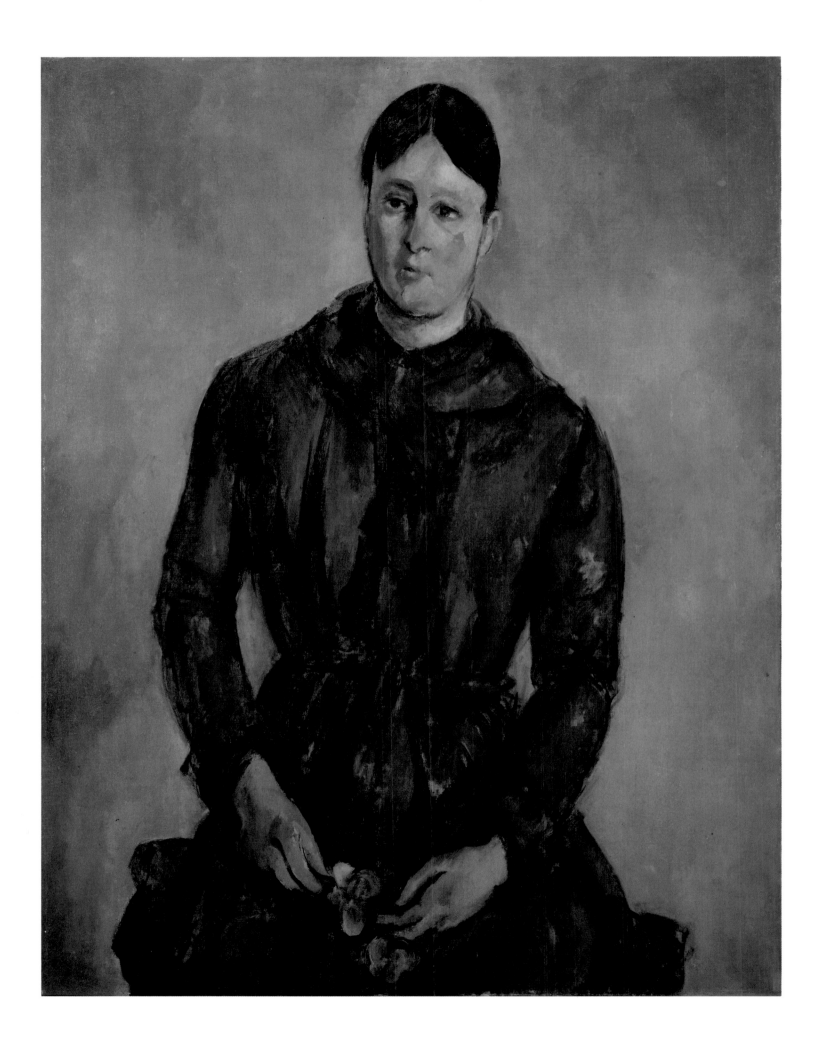

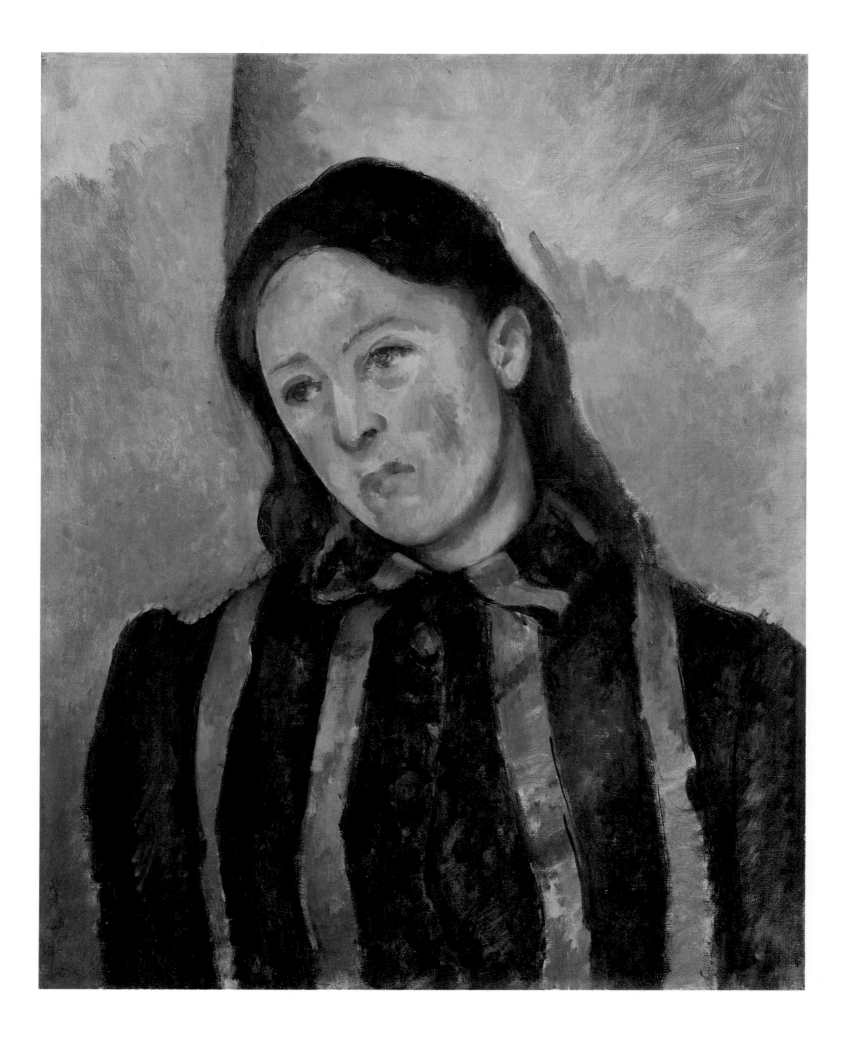

44 Madame Cézanne with Unbound Hair, 1890–92
Madame Cézanne aux cheveux dénoués

Venturi no. 527 (1883–87)
Oil on canvas, 24 5/8 x 20″ (61.9 x 50.8 cm).
Philadelphia Museum of Art,
The Henry P. McIlhenny Collection in Memory of Frances P. McIlhenny
(inv. no. 1986-026-001), Philadelphia

Cézanne had used his life's companion as a model since 1869 (see cat. nos. 14, 37–43), but in the early 1890s he seems to have lost interest in her as a subject. With this bust portrait his series of artfully composed paintings of Hortense Fiquet comes to a modest close. At the same time, this painting signals a new beginning, for in it one senses something of the pithy complacency of his late portraits. Here again the painter has given his sitter a submissive though dignified aura reminiscent of the tranquil faces of Piero della Francesca, but avoided any hint of too personal a portrayal. His high degree of abstraction left no room for psychological revelations, let alone comment on the personality exposed, as practiced most consistently by his contemporary Toulouse-Lautrec. Cézanne's straightforward composition harks back to the portrait tradition in France that stretches from the Clouets to Ingres, and prefigures the spare depiction of three-dimensional forms later employed so tastefully by Modigliani and Brancusi.[1]

The oval of the face framed by dark brown hair leans against a bare wall. A shadow indicating a corner runs down from the top on a tangent to the head, but the painter has wisely chosen not to extend it to the shoulder below. It would only have distracted us from the soft curves of the hair – here painted over somewhat – or of the facial features. The gray stripes in her dress (see cat. no. 37) lead upward to a face tilted to the side, its melancholy expression enlivened by touches of red. Earlier portraits of Madame Cézanne may have been more ambitious (see cat. nos. 41–43), but this one holds its own, thanks to its solemnity and its discreet use of color.

NOTES

1 Chaim Soutine records a somewhat confusing statement by Modigliani, who began studying Cézanne's portraits with great interest in 1907: "Cézanne's faces, like the beautiful statues of antiquity, do not see. Mine, on the other hand, do. They even see when I thought it better not to paint the pupils; even so, like the faces of Cézanne they do not express anything but a dumb harmony with life." *Amedeo Modigliani,* Kunstsammlung Nordrhein-Westfalen, Düsseldorf 1991 - Kunsthaus Zurich 1991, 27.

PROVENANCE: Ambroise Vollard, Paris; Walther Halvorsen, Oslo; Gottlieb Friedrich Reber, Barmen-Lausanne; Paul Rosenberg, Paris; Samuel Courtauld, London; Paul Rosenberg, New York; Henry P. McIlhenny, Philadelphia.
BIBLIOGRAPHY: Vollard 1914, illus. 46; Meier-Graefe 1918, illus.; Meier-Graefe 1922, **129**; Rivière 1923, 201; Pfister 1927, illus. 72; Venturi 1936, 178, no. 527, illus.; Novotny 1937, illus. 48; Barnes, Mazia 1939, 412; Cogniat 1939, illus. 67; Dorival 1949, illus. 111, 166; Guerry 1950, 95f., 102f.; Andersen 1970, 92; Brion 1973, 46; Schapiro 1974, **58f.**; New York 1977, **76**; Paris 1978, **18**; Hülsewig 1981, 61, illus. 21; Kirsch 1987, 23; Joseph J. Rishel, *The Henry P. McIlhenny Collection,* Philadelphia 1987, **42**; Cézanne 1988, **169**; London 1988, 30f.; Basel 1989, 258; Kosinski 1991, 521.
EXHIBITIONS: Paris 1904, no. 3; *Modern French Art,* School of Design, Rhode Island 1930; *Quelques œuvres importantes de Manet à van Gogh,* Galerie Durand-Ruel, Paris 1932, no. 5; Philadelphia 1934, no. 13; Paris 1936, no. 58; *Masterpieces of Philadelphia Private Collections,* Museum of Art, Philadelphia 1947, no. 21; *The Henry McIlhenny Collection,* The California Palace of the Legion of Honor, San Francisco 1962, no. 1, illus.; Philadelphia 1983, XVI, 26, 32, no. 15, illus.; Madrid 1984, no. 48, illus.

45 Boy in the Red Vest, 1888–90
Le garçon au gilet rouge
Venturi no. 681 (1890–95)
Oil on canvas, 31 1/2 x 25 3/8″ (80 x 64.5 cm).
Stiftung Sammlung E. G. Bührle, Zurich

With this famous painting (also known as *Boy in a Red Waistcoat*), whose popularity does nothing to lessen its importance and exquisite charm, Cézanne created what is probably his most beautiful contribution to European portraiture. It was shown in 1895, only a few years after it was executed, in the first Cézanne exhibition in the Paris gallery of the art dealer Vollard. At that time, it was praised by the influential critic Gustave Geffory, in the journal *La Vie Artistique,* as a work that "bears comparison with the loveliest figure pictures in all of painting." It is possible to date the work with relative accuracy, thanks to what it shows us of the setting: a section of the blue wall with light-colored wainscoting, chair rail, and a deep-red stripe that we associate with the Paris apartment at 15, quai d'Anjou (see cat. nos. 41, 42), which the Cézannes occupied from 1888 to the spring of 1890. While living in this apartment, the painter was extremely productive, creating a whole series of outstanding portraits.

This painting has something of the sensitive self-possesion of early-Renaissance Italian portraits. Its subject, dressed in the apparel of a peasant from Roman Campagna, was an Italian by the name of Michelangelo di Rosa. Cézanne immortalized the young man, with his shoulder-length hair and red-and-yellow vest, in a total of four paintings and two watercolors.[1] Here he placed him in front of a dark curtain and a cropped-off landscape painting hanging on the rear wall. Up to this time, Cézanne had relied on family members and friends as sitters for his portraits, but since his financial situation improved considerably following his father's death in 1886, he could now afford to hire professional models for long periods of time. It is worth noting that he used models exclusively for the 1890s series of paintings in which, borrowing from Dürer's popular *Melancholia* (see also cat. no. 77, illus. 1), he posed his sitters supporting their heads with one hand.[2]

Max Liebermann was the first to note that Cézanne's interest in this subject had nothing to do with the opportunity it provided to portray a handsome young face or register details of folk costume, but rather with its specific colors, which appear to take on form with each stroke of his brush. When someone pointed out that the right arm was too long, Liebermann retorted that no arm painted as beautifully as this could ever be long enough! To Cézanne, the extra length was necessary to give stability to the pose and balance the long curve of the back, and he proceeded to render its white sleeve with a spontaneity that might have done credit to a Frans Hals. As it happens, the apparent distortions and abrupt changes in size seem perfectly correct if one views them as though through the lens of a camera. Only a painter with an uncommonly sharp eye could have produced the balanced interplay of intersecting diagonals that forms the work's structure. A precisely calculated palette of vital tension contradicts the passivity of the youth with his dreamy gaze. The subdued tones close to the carmine red at the heart of the picture glow with touches of a bright ultramarine, ocher, and a deep moss green. The artist has nonchalantly placed strokes of delicate drawing next to broad patches of color, yet his brushwork never departs from a carefully calculated equilibrium. The entire composition attests to a harmonious blend of intellect and intuition.

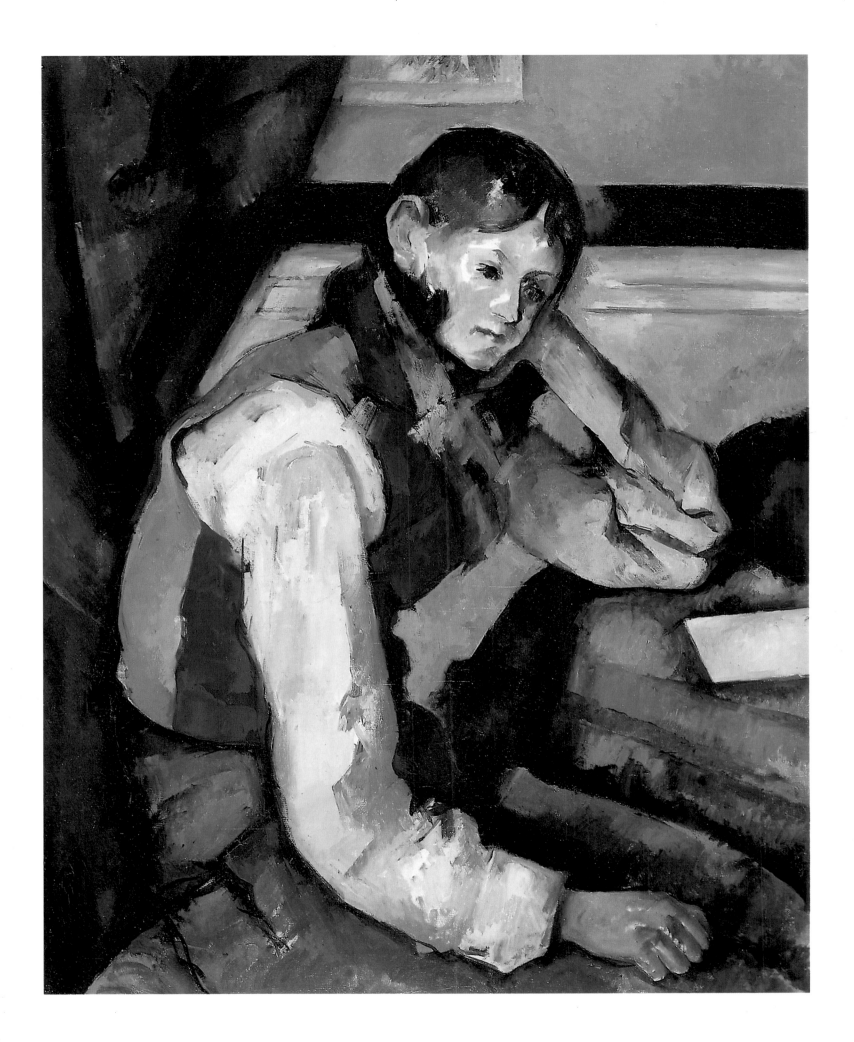

NOTES

1 They include, in addition to the present work, Venturi 1936, nos. 680, 682, 683, painted inside the apartment, and the watercolors Rewald 1983, nos. 375, 376, which may have been created outside in front of a backdrop of green foliage.

2 See also the portraits titled *Fumeur accoudé,* Venturi 1936 nos. 684, 868.

PROVENANCE: Marczell de Nemes, Budapest; de Nemes auction, Galerie Manzi-Joyant, Paris, July 18, 1913, no. 90; Gottlieb Friedrich Reber, Barmen-Lausanne.

BIBLIOGRAPHY: Meier-Graefe 1904, illus. 496; Meier-Graefe 1918, **75**; Meier-Graefe 1922, 75, **215**; Faure 1923, illus. 9; Rivière 1923, 216, 236; Pfister 1927, illus.; Ors 1930, 72, 75, illus. 14.; Rivière 1933, **79**; Venturi 1936, 61f., 211, no. 681, **276**; Novotny 1938, 77, 87, 98, 126, illus. 47; Cogniat 1939, illus. 83; Dorival 1949, 71f., 84, illus. 115, 167; Guerry 1950, 138, 201; Schmidt 1952, 28; Cooper 1954, 380; Raynal 1954, **94**; Badt 1956, 246; Neumeyer 1958, 48; Reff 1958, 26; *Sammlung Emil G. Bührle,* Zurich 1958, 132, **231**; Ratcliffe 1960, 22; Reff 1962, 117; Feist 1963, illus. 60; Lichtenstein 1964, 60; Murphy 1971, 99f.; Brion 1973, **54**; Chappuis 1973, 212, no. 871; Elgar 1974, 134, illus. 79; Wadley 1975, 53, illus. 46; New York 1977, 15, 17; Venturi 1978, **120**, **123**; Adriani 1981, 282; Hülsewig 1981, 55f., illus. 17; Rewald 1983, 174, no. 375; Rewald 1986, 269; *Stiftung Sammlung E. G. Bührle,* Zurich 1986, **148f.**; Cézanne 1988, **183**; *du* 1989, **44**; Kosinski 1991, 521.

EXHIBITIONS: Paris 1895; Berlin 1909, no. 38 (?); *Collection Marczell de Nemes,* Musée des Beaux-Arts, Budapest 1911 – Städtische Kunsthalle, Düsseldorf 1912, no. 117, illus.; Berlin 1921, no. 31, illus.; Berlin 1927, no. 22, illus.; Paris 1929, no. 34, illus.; Paris 1939 (Rosenberg), no. 30, illus.; Chicago 1952, no. 75, illus.; Aix-en-Provence 1956, no. 51, illus.; The Hague 1956, no. 38, illus.; Zurich 1956, no. 70, illus. 32; *Chefs-d'œuvre des collections suisses de Monet à Picasso,* Musée de l'Orangerie, Paris 1967, no. 92; *Meisterwerke der Sammlung Emil G. Bührle, Zurich,* National Gallery of Art, Washington 1990 – Museum of Fine Arts, Montreal – Museum of Art, Yokohama – Royal Academy of Arts, London 1991, no. 41, illus.

46 Mountains in Provence, 1886–90
Montagnes en Provence

Venturi no. 491 (1886–90)
Oil on canvas, 25 x 31 3/8″ (63.5 x 79.4 cm).
The Trustees of the National Gallery (inv. no. 4136), London

Cézanne had been taught to appreciate the geological peculiarities of his homeland by his friend Antoine Fortuné Marion (see cat. no. 4). He explored the landscape around Aix-en-Provence with that budding scientist and amateur painter between 1865 and 1868, and his remarkable ability to describe natural structures must have something to do with those youthful experiences. Without them, he surely would not have been able to reproduce the steep rock formations beside the road so convincingly in this view of a sun-bleached expanse of Provençal landscape.

This is the earliest of the quarry motifs that became one of the artist's favorite subjects in his last years, and consists of a simple rock outcropping overgrown with a few trees and bushes. The road, the geometric pattern of the fields, the hills, and the vaporous, empty sky are mere window dressing for the sake of the composition, meant to set off the layers of stone carved out of the landscape. The detailing of the boulders –rendered in umber, red-brown, and gray-violet and structured by dramatic variations of light and shadow – stands out in strong contrast to the simple road in the foreground and the soft curves of the hills behind. Nature tamed, in the cultivated land that man has made his own, becomes the background for a tumble of boulders created in a violent, primeval past.

There are no figures to serve as a scale against which to judge the actual size of these rocks. The painter has omitted all the atmospheric values that a space proceeding continuously into the distance would have provided, in favor of a surface structure only minimally affected by the laws of perspective. There is no lessening of clarity in this landscape, even in the farthest distance, no reduction in the solidity of forms. Indeed, a dark gray serves to bracket its upper and lower regions, its foreground and background. The obvious bunching together of nearer and more distant planes could be traced to the rigid perspectives that landscape photography had introduced to creative artists. Cézanne adopted the vision of the new optical devices only piecemeal, preferring to trust his own eye. He corrected it by placing foreground objects farther away from him, consigning them to an unreal, often incompletely developed in-between space. In doing so, he had to reduce the difference in size between objects in the foreground and those in the middle distance and background. The building in *Mountains in Provence,* for example, seems too large given its distance from the viewer.

PROVENANCE: Leicester Galleries, London; Courtauld Fund, London.
BIBLIOGRAPHY: Fry 1927, 60, illus. 28; Venturi 1936, 53, 170, no. 491, illus.; Novotny 1938, 105; Cooper 1954, 379; Raynal 1954, 82, 108; Cooper 1956, 449; Gowing 1956, 190; Martin Davies, *National Gallery Catalogues, French School, early 19th Century, Impressionists, Post-Impressionists,* London 1970, 18f.; Schapiro 1974, 14, 78f., illus.; Wadley 1975, 47, illus. 39; New York 1977, 23; Cézanne 1988, 55, 147; Erpel 1988, illus.
EXHIBITIONS: London 1925, no. 11; *19th Century French Paintings,* National Gallery, London 1942–43, no. 36; *Samuel Courtauld Memorial Exhibition,* Tate Gallery, London 1948, no. 9; London 1954, no. 38, illus. 5; *Impressionnistes de la collection Courtauld de Londres,* Musée de l'Orangerie, Paris 1955, no. 38.

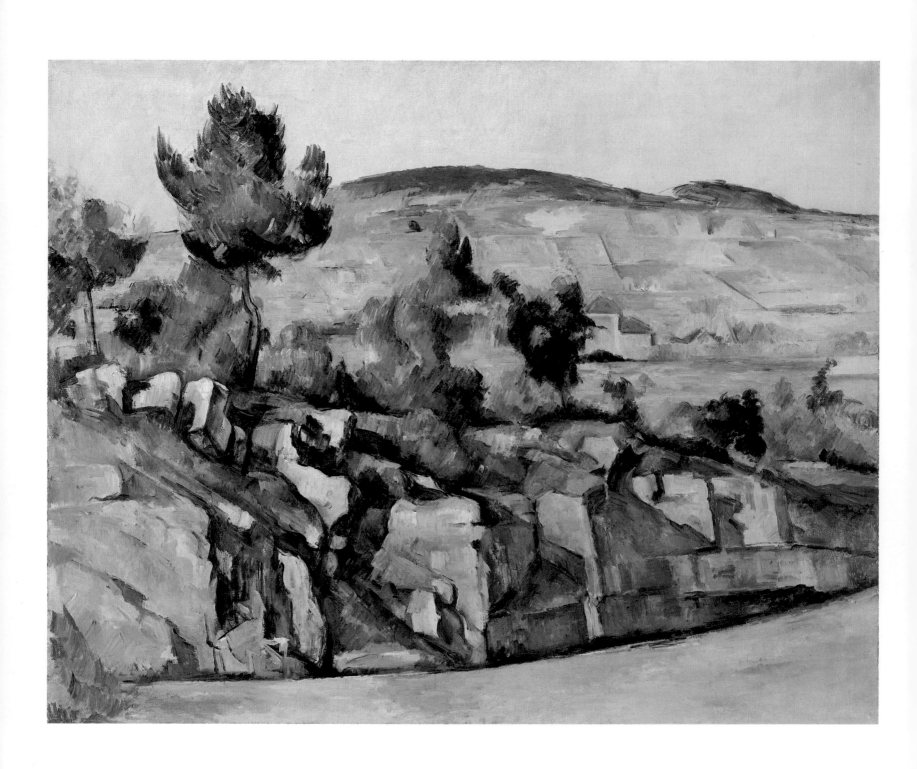

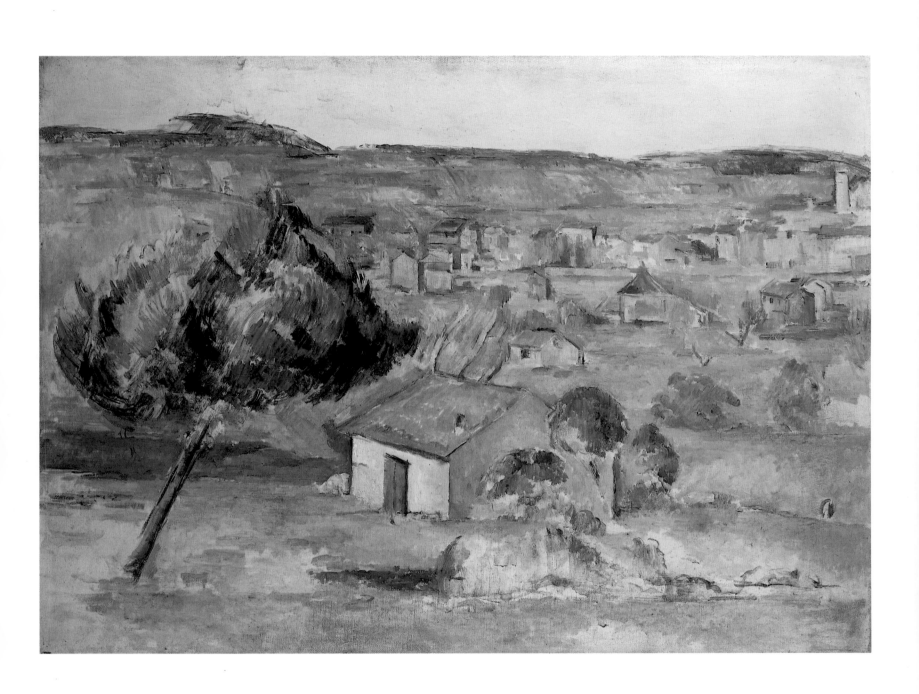

47 Plain in Provence, 1886–90
Plaine provençale

Venturi no. 302 (1878–83)
Oil on canvas, 23 x 31 7/8" (58.5 x 81 cm).
Private collection

Cézanne's spacious landscapes, most of them viewed from a high perspective, are unpopulated; nothing goes on in them. They present views devoid of the figural components that helped give specific tracts of landscape, from the Baroque to Impressionism, an appeal to the senses and emotions. Only rarely can one even identify the buildings Cézanne introduces to stabilize his pictures. The viewer is therefore forced into passivity, and can only appreciate these landscapes intellectually, for they have been emptied of anything familiar. Although there is light and shade, it tends to be generalized. One cannot make out any light sources or specific shafts of light serving to illuminate details. The time of day and even the season are indefinite, and the background has no trace of Romantic enticement. Flooded with light, but with neither the highlights nor the strong shadows one would expect under a blistering sun, the plain spread out between lines of hills lies before us silent and empty.

The green of a wind-bent pine and the red geometry of roofs serve to enliven a palette warmed by the sun. The intensity of this green is somewhat startling against the more reserved colors of the landscape, most of which appear in mid-range values. Its strength provides a balance to the great expanse of the cultivated plain. Each takes on some of the coloring of the other. There are no converging vanishing lines; instead, the objects are arranged in a series of parallel planes leading stepwise back into the distance.

Venturi chose to date this work between 1878 and 1883, but close examination tends to refute him. Its motif, its colors, its brushwork, and the manner in which it is composed place the *Plain in Provence* in close proximity to the previous landscape (cat. no. 46), which was probably painted in the late 1880s. Indeed, one could even argue that this landscape is a direct extension of that view, the almost identical dark ridge in the background serving as the link between them.

PROVENANCE: Ambroise Vollard, Paris; Arthur Hahnloser, Winterthur.
BIBLIOGRAPHY: Venturi 1936, 131, no. 302, illus.; Reff 1958, 79; Reff 1959, 172; Chappuis 1973, 199, no. 765.
EXHIBITIONS: *Französische Malerei*, Museum, Winterthur 1916; *La peinture française du XIXème siècle en Suisse*, Musée des Beaux Arts, Paris 1938, 5; *Hauptwerke der Sammlung Hahnloser*, Museum, Lucerne 1940, no. 31; Zurich 1956, no. 33; Munich 1956, no. 24, illus.; Madrid 1984, no. 21, illus.

48　House with Red Roof, circa 1887
Maison au toit rouge

Venturi no. 468 (1885–87)
Oil on canvas, 29 x 36 3/8″ (73.5 x 92.5 cm).
Private collection

This view of the main building and the approach through the park at Jas de Bouffan (see cat. nos. 17, 20, 49) is surely one of the most magnificent landscapes from Cézanne's maturity. In the last two decades of his life, the painter was motivated exclusively by his "stubborn faith in his own genius,"[1] and in 1887, when he spent the greater part of the year in Aix-en-Provence, he was able to work with absolute sovereignty and freedom. On this view of the Baroque manor house that once served as the residence of the governor of Provence, he lavished all that he had learned about painting and the subtle modulation of color. One could hardly imagine a more convincing depiction of the way shadows formed by the sunlight falling in from the left alternate with radiant strips of light into the middle distance, or a more masterful balancing of heavier forms with lighter ones, volumes with surfaces. Only rarely have inorganic and organic elements, architecture and luxuriant nature, been combined so harmoniously. All of them derive their fullness from a palette whose dominant tile red is embedded in the green of the foliage, whose sky blue is set off by the light ocher of the ground and the house. Never losing sight of the commanding formal relationships, the painter employed a color scale enriched with finely graduated passing tones.

　　　Every time Cézanne set out to describe a form, he was most concerned with tying it through color to its immediate context, and he frequently defied the realities of perspective in favor of balance in two dimensions; yet his views are always remarkably faithful to reality (illus. 1). In the early 1880s he had worked out a system of intersecting right-angle axes that threatened to overwhelm his compositions, causing them to appear too schematic. But here, the astonishing degree of tension and movement created by color relationships and by interlocking volumes and spaces

Illus. 1
Jas de Bouffan,
photograph circa
1940

161

makes it clear that he had avoided that danger. He had attained such a degree of flexibility in his delineation of forms that he could relate quite effortlessly, with powerful brushstrokes, spatial depth to the picture surface and light areas to areas of shadow – even accommodate the tilt of the architecture (see cat. no. 49).

Cézanne's father had bought Jas de Bouffan as a country house in 1859. The painter considered it his true home for four decades. When his mother died in November 1899, the estate was sold, allowing her holdings to be divided among her children. Jas de Bouffan has now been completely consumed by urban sprawl. With this picture Cézanne created his most beautiful memorial to the property.

NOTES

1 The phrase comes from Zola's novel *L'Œuvre*, whose hero was endowed with Cézanne's features. Emile Zola, *Das Werk*, Munich 1976, 376.

PROVENANCE: Ambroise Vollard, Paris; Paul Cassirer, Berlin; Margarete Oppenheim, Berlin; Paul Cassirer, Berlin; Georg Hirschland, Essen-New York.
BIBLIOGRAPHY: Meier-Graefe 1918, **128**; Meier-Graefe 1922, **156**; Venturi 1936, 166, no. 468, illus.; Loran 1963, 28, **51**, 105; Rewald 1986, **173**.
EXHIBITIONS: Berlin 1909, no. 15; *XIII. Jahrgang, VIII. Ausstellung,* Galerie Paul Cassirer, Berlin 1910–11, no. 2; *XVI. Jahrgang, II. Ausstellung,* Galerie Paul Cassirer, Berlin 1913, no. 31; Berlin 1921, no. 14, illus.; *Impressionisten,* Galerie Paul Cassirer, Berlin 1925, no. 6; Chicago 1952, no. 57, illus.; New York 1959, no. 32, illus.

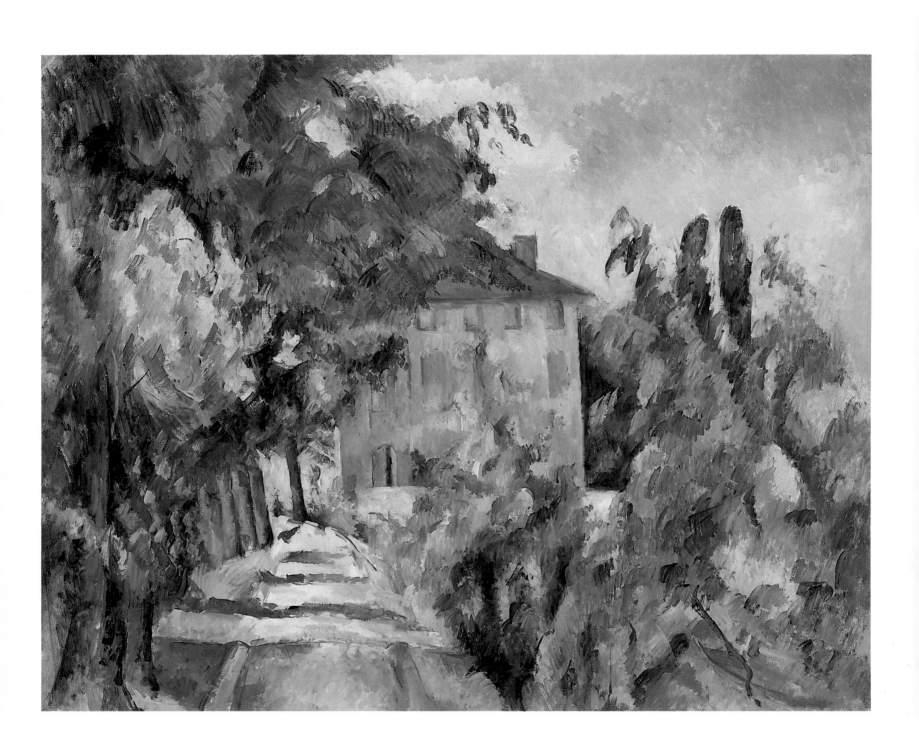

49 House and Farm at Jas de Bouffan, 1889–90
Maison et ferme du Jas de Bouffan

Venturi no. 460 (1885–87)
Oil on canvas, 23 3/4 x 29″ (60.5 x 73.5 cm)
Národni Galerie v Praze (inv. no. NG 03203), Prague

Because of the unusual prominence of architecture in this painting, the work has been cited again and again as proof that Cézanne was the "father" of Cubism. At first glance it does indeed appear that there might be some connection between the way Cézanne rendered architectural elements and the first city views set down by the Cubists. Yet, such superficial conclusions do justice to neither Cézanne nor his supposed heirs. In their insistence that the picture was an autonomous creation, the Cubists radically rejected factual details. Cézanne, on the other hand, though no less concerned for the integrity of his works, sought to incorporate architectural elements without essential changes. He did not simplify the forms or colors of actual objects; on the contrary, he attempted to reflect them in his picture in a variety of ways. His frequently quoted recommendation that one "deal with nature as cylinders, spheres, cones"[1] was not intended as a recipe for Cubism.

The given forms in *House and Farm* were the façade of the Jas de Bouffan with its tall windows, shutters, and attic floor on the left, the farm buildings and a garden wall thrust into the picture in a broad curve on the right. The wall served to screen the estate from the street (see cat. nos. 17, 20, 48). All of this had to be organized on the picture surface in separate spatial planes and convincingly tied together with matte, dusty colors.[2] By combining elements extending across the entire picture, such as the rolling lawn or the garden walls with others shifted to one side or the other of the picture axis – the house itself, the smaller and more intricate farm buildings, and the ridge of the hill above – the painter has produced a composition of unusually intriguing tension. Thanks to his careful weighting of its relatively large fields of color, it nonetheless functions as a balanced whole. The skill with which such a balance has been accomplished is but one of the features of this overall view of the Jas de Bouffan that suggest it was painted in about 1890.

NOTES

1 Cézanne 1984, 296.
2 See Venturi 1936, nos. 461–67, 476, Chappuis 1973, nos. 737, 880, 916.

PROVENANCE: Ambroise Vollard, Paris; Gottlieb Friedrich Reber, Barmen-Lausanne; Paul Rosenberg, Paris; Ambroise Vollard, Paris.
BIBLIOGRAPHY: Meier-Graefe 1918, **157**; Meier-Graefe 1922, **189**; Gasquet 1930, illus.; Venturi 1936, 54, 164, no. 460, illus.; Novotny 1938, 7, 17, 21, 36, 41, 52, 73, 87, 105, 198, illus. 26; Dorival 1949, 81, illus. 84, 162; Feist 1963, illus. 33; Loran 1963, 17f., 27, **52ff.**, 105, 131; Leonhard 1966, **16ff.**, 23, 29f.; Murphy 1971, **150f.**; Brion 1973, 41; Elgar 1974, 104, 107, illus. 60, 231; Barskaya 1975, **171**; Wadley 1975, 11, illus. 6; Arrouye 1982, **41**; Cézanne 1988, **209**; Erpel 1988, no. 13, illus.; Kosinski 1991, 521.
EXHIBITIONS: Berlin 1909, no. 34 (?); *Französische Kunst des 19. und 20. Jahrhunderts*, Gemeindehaus, Prague 1923, no. 143; Paris 1936, no. 60; Aix-en-Provence 1956, no. 37, illus.; The Hague 1956, no. 31; Zurich 1956, no. 58, illus. 27; Munich 1956, no. 41, illus.; Vienna 1961, no. 25, illus. 17; *Von Delacroix bis Picasso*, Nationalgalerie, Berlin 1965, no. 6; *Da Monet a Picasso*, Palazzo Pitti, Florence 1981, no. 6; *Impressionismo, Simbolismo, Cubismo*, Palazzo dei Conservatori, Rome 1988, no. 30.

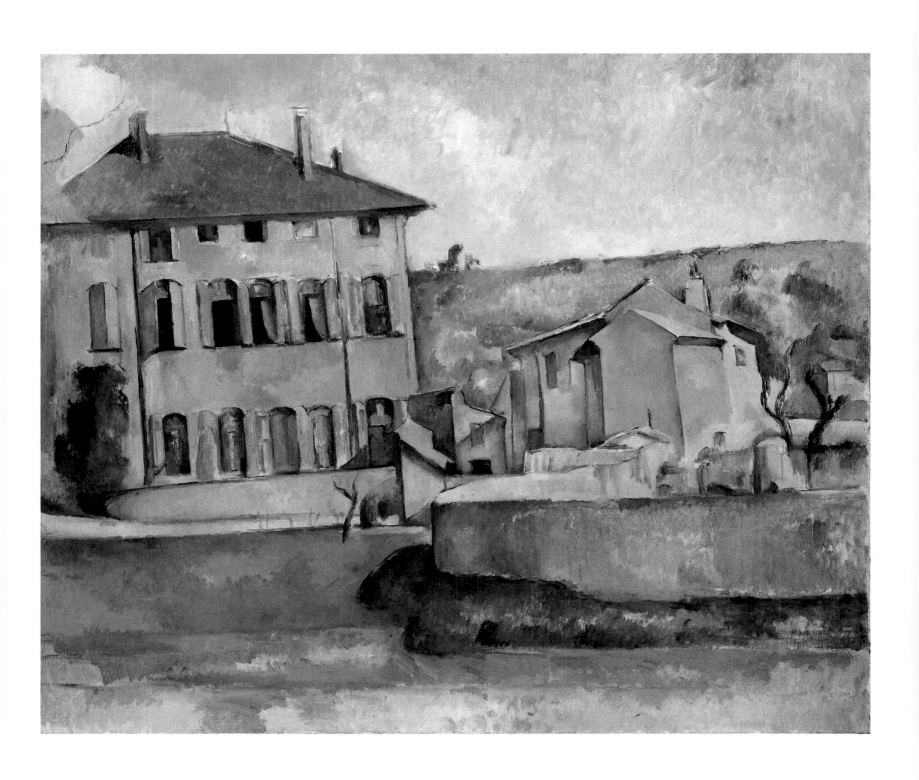

50 Landscape with Poplars, circa 1888
 Paysage aux peupliers

Venturi no. 633 (circa 1888)
Oil on canvas, 28 x 22 7/8″ (71 x 58 cm).
The Trustees of the National Gallery (inv. no. 6457), London

Cézanne spent most of 1888 in Paris and its environs. In the summer, he painted in Chantilly, north of the city on the Oise, then in Créteil and Alfort, on the bank of the Marne (see cat. nos. 51, 52). This landscape, with its view of a lush green meadow, trees, and farmhouses, may well have been produced on one of his outings during that summer. It makes amply clear that the painter, like the Impressionists, constructed his works out of nothing but manifestations of color. Unlike them, however, he did not choose to limit his vision to the effects of a specific moment. Seeking a more permanent record, he tried to develop strict rules by which he might create his whole picture out of color and, at the same time, register forms in detail.

Using his own unique method, relying on the strength of color, Cézanne hoped to get beyond Impressionism. He countered its fixation with the ephemeral moment with a more strictly systematic approach, building up individual objects and the picture as a whole with precisely balanced colors applied in rows of parallel vertical or diagonal brushstrokes. Here, the sky and the foreground are relatively uniform in color and in their brushwork, while the middle distance, with its trees, houses, walls, and the slope of a hill with accents in red, became a complex rhythmic structure.

PROVENANCE: Ambroise Vollard, Paris; Emil Heilbut, Berlin; Bruno and Paul Cassirer, Berlin; Bruno Cassirer, Berlin.
BIBLIOGRAPHY: Venturi 1936, 202, no. 633, illus.; Cooper 1954, 379; Gowing 1956, 190; Cézanne 1988, **295**.
EXHIBITIONS: Berlin 1900, no. 11; Berlin 1921, no. 19; Basel 1936, no. 45; London 1954, no. 42.

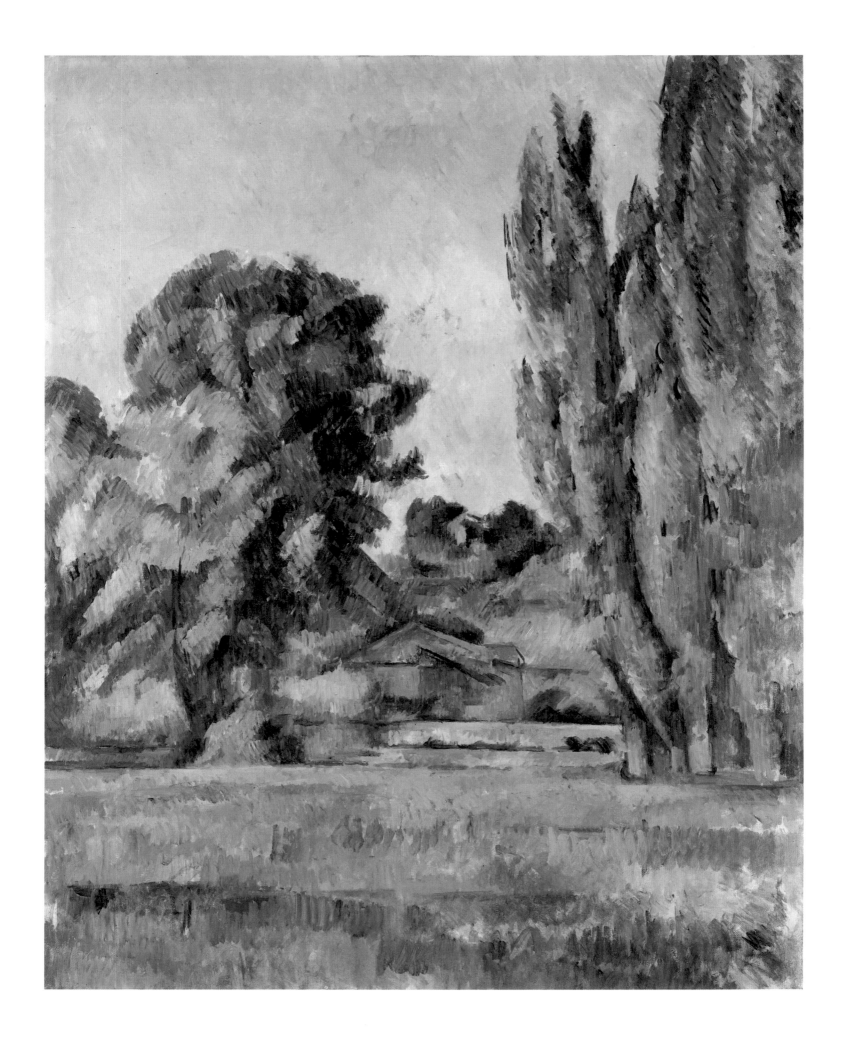

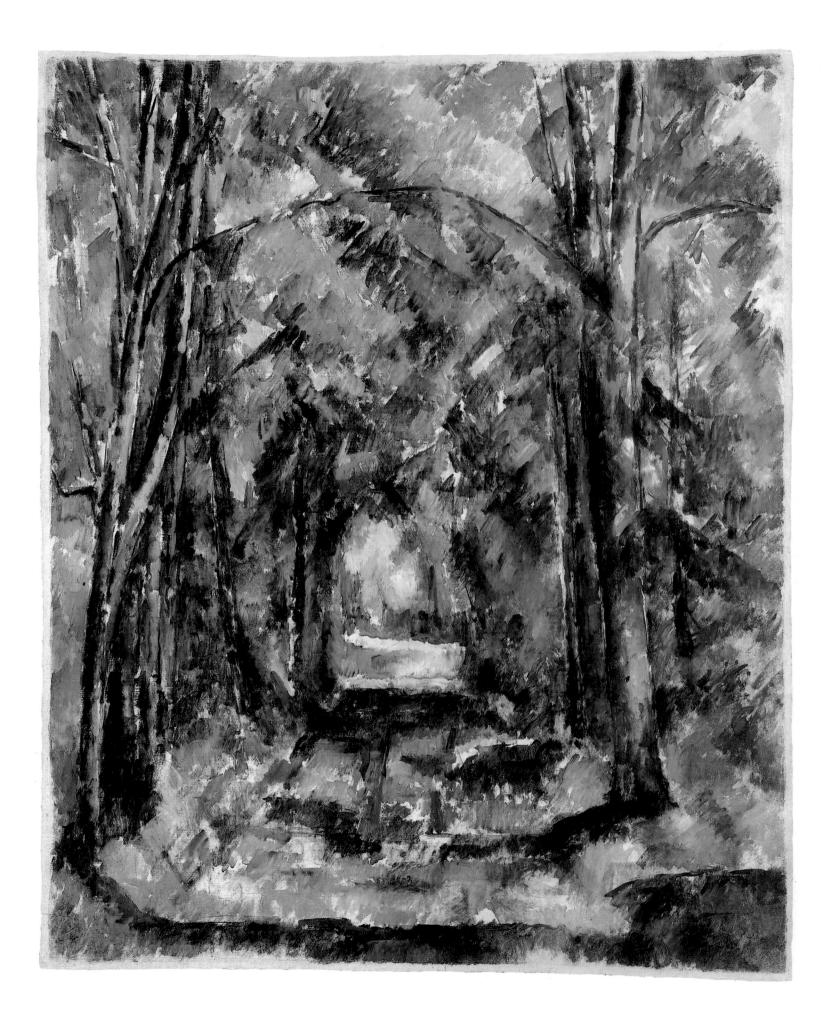

51 Tree-lined Path, Château de Chantilly, 1888
Allée au parc du Château de Chantilly

Venturi no. 628 (1888)
Oil on canvas, 32 1/4 x 26″ (82 x 66 cm).
Berggruen Collection, National Gallery, London

Paul Cézanne, Jr., recalled that his father spent five months at the Hotel Delacourt in Chantilly in 1888 (see cat. nos. 50. 52). This painting, two other similar views, and three watercolor studies survive from that period.[1]

Here, the path has become an almost abstract design of greenish tones. The volumes of the tree trunks, branches, and spaces between them only gradually emerge from a predetermined pattern of blue, yellow, and ocher brushwork. The tree-lined path comes to an end in a clearing shifted slightly off the picture axis. Its strong inward pull is diminished by horizontal layers of light, shadow, and intersecting planes in the spatial continuum. With a precisely fitted mosaic of color patches, the painter sought to balance the demands of the picture surface with those of the space itself. Each excited brushstroke and bit of hatching produced a network of interrelationships ever more tightly woven. Although it is not actually depicted, a sparkling light filtering through the foliage permeates the painting.

NOTES

1 Venturi 1936, nos. 626, 627; Rewald 1983, nos. 308–10; see also *L'allée des marronniers au Jas de Bouffan*, Venturi 1936, no. 649.

PROVENANCE: Ambroise Vollard, Paris; Paul Cassirer, Berlin; Leonie Katzenellenbogen, Berlin; Max Meirowsky, Berlin; Myriam von Rothschild, Vienna; André Weil, Paris; Nelson Harris, Chicago; Eugene V. Thaw, New York.
BIBLIOGRAPHY: Vollard 1914, 58, illus. 22; Meier-Graefe 1922, 75; Wedderkop 1922, illus.; Pfister 1927, illus. 94; Venturi 1936, 63, 200f., no. 628, **255**; Mack 1938 290; Novotny 1938, 21; Ratcliffe 1960, 18, 21; Vollard 1960, 34; Elderfield 1971, **54**, 57; New York 1977, **46f.**; Adriani 1981, 269; Rewald 1983, 160, no. 308; Rewald 1986, **193**; *du* 1989, **66**; Richard Kendall, *Van Gogh to Picasso. The Berggruen Collection at the National Gallery*, London 1991, 74, no. 18, illus.
EXHIBITIONS: Paris 1895; *Französische Malerei des XIX. Jahrhunderts*, Kunsthaus, Zurich 1933, no. 89; Washington 1971, no. 16, illus.

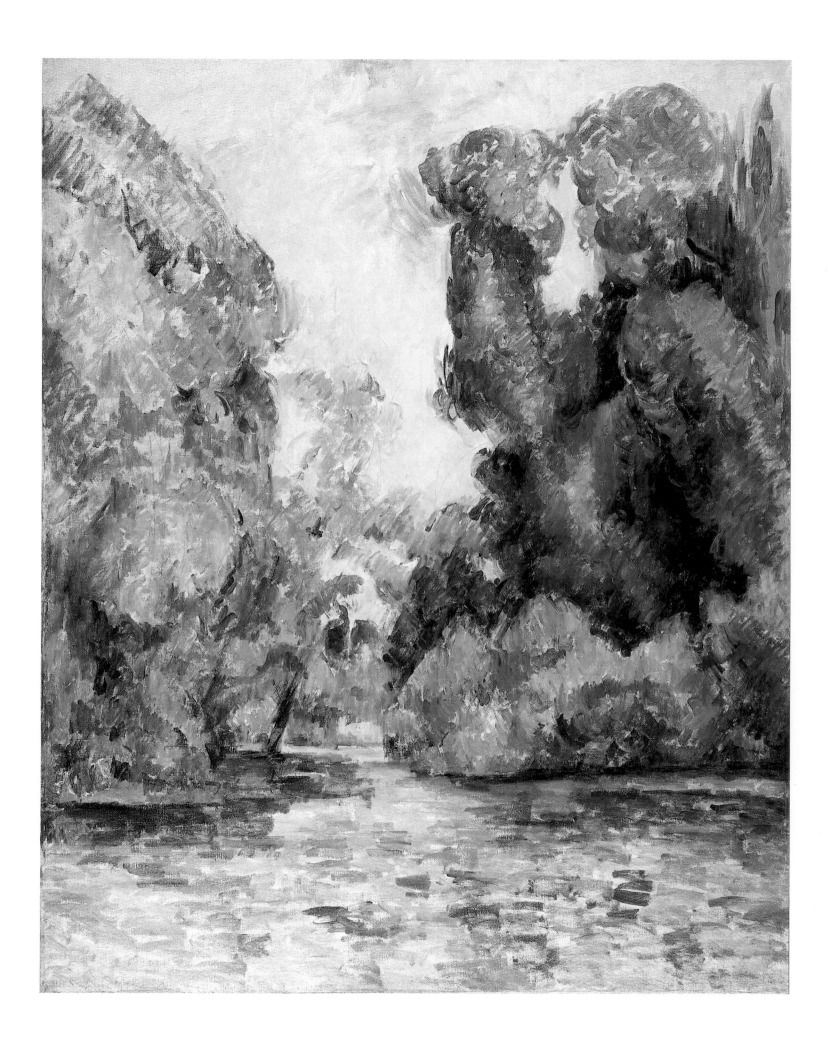

52 Water and Foliage, 1888
Eaux et feuillages

Venturi no. 638 (1888–90)
Oil on canvas, 29 1/2 x 24 3/4″ (75 x 63 cm).
Private collection, courtesy of Thomas Ammann Fine Art, Zurich

In almost all of Cézanne's landscapes there are buildings, not necessarily prominent, but nonetheless visible. In the early 1870s, at the very time his interest in landscape was being developed under the direction of Pissarro, architectural motifs embellished with views of landscape were particularly admired. This depiction of trees and water is one of Cézanne's very few woodland or rocky landscapes that have no architectural component (see cat. nos. 7, 9, 18, 32, 51, 74, 75). It is one of a series of river views that Cézanne painted in 1888, when he worked in the vicinity of Paris, setting up his easel either next to the Seine, the Oise, or on the banks of the Marne.[1] All of the paintings in this group are characterized by light brushstrokes and thin application of color. This vertical-format work is very freely painted, but loses nothing from its limited palette and relatively open brushwork. Cézanne continued to paint like a southerner even when he worked in the North, paying less attention to seasonal and atmospheric changes than to vivid juxtapositions of color resulting from a predominance of green and a somewhat diffuse blue gray.

NOTES

1 See the river landscapes Venturi 1936, nos. 629–32, 634, 635, 637, 639–41.

PROVENANCE: Julius Schmits, Elberfeld; Bachofen-Burckhardt, Basel.
BIBLIOGRAPHY: Venturi 1936, 63, 203, no. 638, illus.; Badt 1956, 130; Brion 1973, 79.

53 Still Life with Commode, 1883–87

Nature morte à la commode

Venturi no. 496 (1883–87)
Oil on canvas, 28 7/8 x 36 3/8″ (73.3 x 92.2 cm).
Bayerische Staatsgemäldesammlungen,
Neue Pinakothek (inv. no. 8647), Munich

This still life, which Hugo von Tschudi acquired for the Neue Staatsgalerie in Munich in 1912 (see cat. nos. 25, 55), is the first of a group of large-format compositions incorporating the "classical" repertory of objects met with again and again in paintings from Cézanne's middle and late periods.[1] The simple wooden table with a drawer, the stiff linen tablecloth, the fruit, the plate, and various containers still preserved in his atelier in Aix – a covered sugar bowl, a ginger jar, and an earthenware jar with a green glaze at the top – comprised the standard furnishings of Cézanne still lifes for decades (see cat. nos. 54, 55, 58, 59). They could hardly be more prosaic, but out of them, the painter created magnificent compositions of lapidary elegance. Cézanne set greater store by his still lifes than any other painter of his time, and Matisse and the Cubists would follow his example. In their formal complexity, his works in the genre are fully on a par with his landscapes, portraits, and figural compositions.

The painter Louis Le Bail, who called on Cézanne in 1898 at Pissarro's suggestion, recalled how the master set up a still life with peaches and a red-wine glass on a tablecloth: "The cloth was very slightly draped upon the table, with innate taste. Then Cézanne arranged the fruits, contrasting the tones one against the other, making the complementaries vibrate, the greens against the reds, the yellows against the blues, tipping, turning, balancing the fruits as he wanted them to be using coins of one or two sous for the purpose. He brought to this task the greatest care and many precautions; one guessed that it was a feast for the eye to him."[2]

From this description we learn how deliberate Cézanne was in the arrangement of his still lifes in his studio, gauging the form and weight of various objects before arranging them by color. Exposing them to the diffuse light of his studio, one that caused them to seem more three-dimensional than harsh sunlight, and arranging them in special ways, stacking them and/or leaning them one against the other, he took them out of their usual contexts. They are everyday objects, to be sure, whether manufactured or natural; they are meant either to serve a specific function or to be consumed. Yet, here they have no particular purpose, they have become abstract, they are no longer meant to be touched, smelled, or tasted. Cézanne thought of objects as being absolute in themselves, estranged from all utility. Separated from its intended function, even the most familiar object takes on a certain distance. When painting them, however, Cézanne felt obliged to depict only what he perceived to be their essential qualities.

The glacial white of the tablecloth, derived from tones of blue and green, sets off the orange red of the apples. All of the rest of the colors, which have been applied in thick layers, refer back to them: the brown of the commode, the muted ocher of the table, the beige and pink of the wallpaper on the left, and the complementary green of the glazed jar. The relationships between the various objects seem simple enough, the overall structure detailed and solid. Yet, if one tries to ignore the picture surface and reconstruct the actual space depicted, much becomes unclear. The commode appears to be standing at an angle to the wall, and the floor seems to tilt forward, causing one to wonder how the table can possibly rest on it. But this is only a result of our habit of looking at things with reference to traditional laws of perspective, and does not lead us anywhere. The logic of the composition itself forces us to abandon such objections. Cézanne sought to depict things as faithfully as he could, and to that end, he chose to

employ multiple points of view. Some details are seen from below, others as though from high above. Here he looks from one side, there from another. It is as though he wished to surround his objects and contain them. Here, the commode – its side forming an obtuse angle to the wall and its drawers tilting slightly upward – appears at eye level, while we look down onto the surface of the table from a considerable height. Further tension is created by the disorientation between the rectangular objects and the frame of the picture. The objects slope slightly downward to the left. In the interest of balance, the painter has even interrupted the line of the front edge of the table; it is lower on the left than on the right, as though the cloth masked a hidden seismic shift. To some degree, the painter's inclusion of a moving point of view in his creative process did guarantee a complete portrayal. In his exploration of the hidden relationships between the objects he had arranged, he obeyed his own dictum: "Penetrating what is before one and persevering in expressing oneself as logically as possible."[3] The Cubists borrowed the trick of seeing things from different points of view simultaneously, but failed to note in Cézanne's admonition that one "deal with nature as cylinders, spheres, cones,"[4] that he mentions only rounded forms, not rigid cubes.

NOTES

1 See the somewhat more closely cropped version of this still life, Venturi 1936, no. 497.
2 Rewald 1986, 228.
3 Cézanne 1984, 298.
4 Ibid., 296.

PROVENANCE: Denis Cochin, Paris; Durand-Ruel, Paris-New York; Bernheim-Jeune, Paris.
BIBLIOGRAPHY: Bernheim-Jeune 1914, illus. 26; Vollard 1914, illus. 1; Meier-Graefe 1918, **152**; Meier-Graefe 1922, **184**; Faure 1923, illus. 30; Klingsor 1923, illus. 16; Rivière 1923, 211; Pfister 1927, illus.; Rivière 1933, 134; Venturi 1936, 57, 172, no. 496, illus.; Novotny 1938, 33, illus. 23; Dorival 1949, 68 L. Dittmann, "Zur Kunst Cézannes," in *Festschrift Kurt Badt*, Berlin 1961, 204, illus. 2; Kurt Martin, *Die Tschudi-Spende*, Munich 1962, 16, 26, illus. 14; Feist 1963, illus. 41; Loran 1963, 77, 89; Schapiro 1968, 52; Chappuis 1973, 157, no. 539, 158, no. 546; Elgar 1974, 99, 101, illus. 56; Adriani 1981, 280; Cézanne 1988, 12, **103**; Gisela Hopp, Christoph Heilmann, Christian Lenz, et al., *Impressionisten, Post-Impressionisten und Symbolisten, ausländische Künstler*, Katalog der Bayerischen Staatsgemäldesammlungen, Neue Pinakothek, Munich 1990, **66ff.**
EXHIBITIONS: *Grosse Kunstausstellung*. Stuttgart 1913, no. 208; *Moderne französische Malerei*, Haus der Kunst, Munich 1947, no. 30b; *Impressionnistes et Romantiques français dans les musées allemands*, Musée de l'Orangerie, Paris 1951, no. 5, illus. Aix-en-Provence 1956, no. 38, illus.; The Hague 1956, no. 27, illus.; Zurich 1956, no. 51, illus. 21; Munich 1956, no. 38, illus.; Cologne 1956, no. 20, illus.; *Französische Malerei des 19. Jahrhunderts von David bis Cézanne*, Haus der Kunst, Munich 1964-65, no. 24, illus.

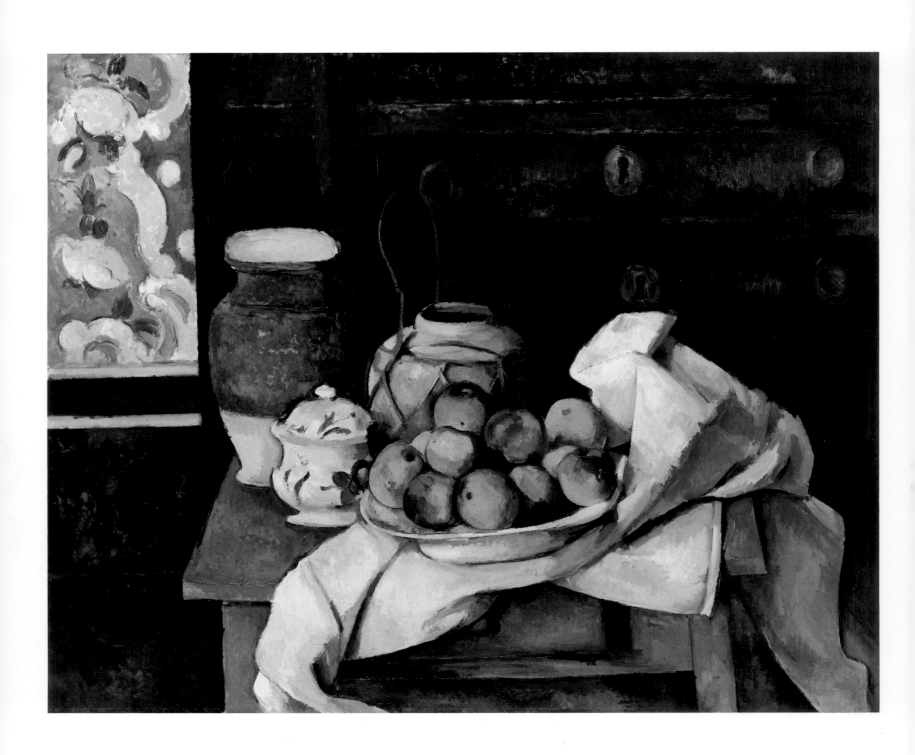

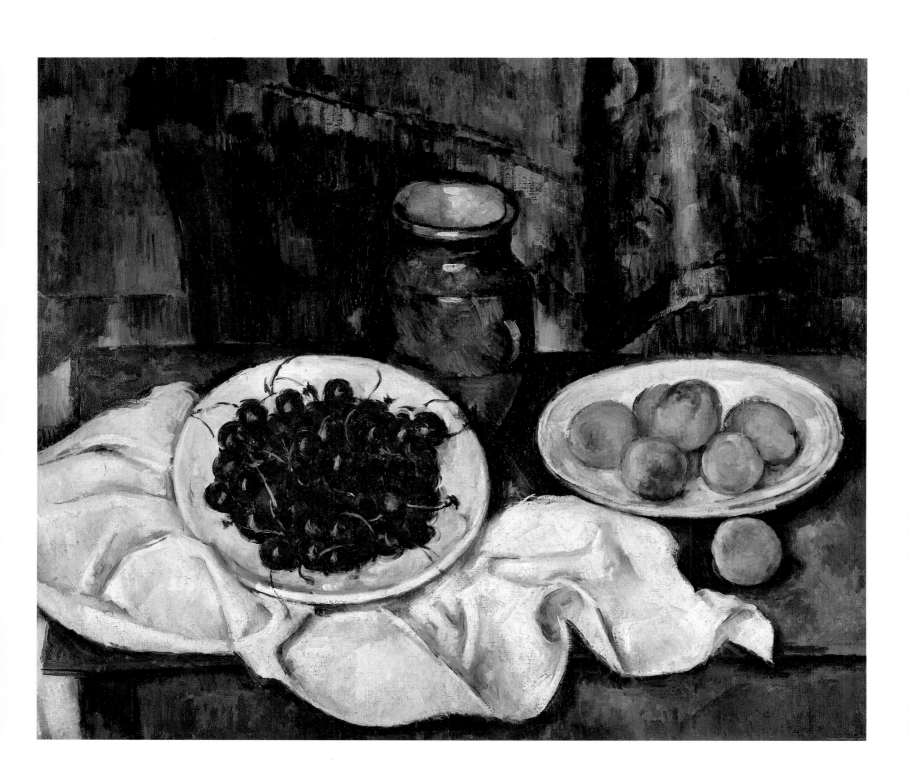

54 Still Life with Plate of Cherries, 1885–87
 Nature morte au plat de cerises

Venturi no. 498 (1883–87)
Oil on canvas, 22 7/8 x 27″ (58.1 x 68.9 cm).
Los Angeles County Museum of Art, Gift of the Adele R. Levy Fund
and Mr. and Mrs. Armand S. Deutsch (inv. no. M 61.1), Los Angeles

A typical Provençal olive jar (see cat. nos. 53, 58, 59) serves as the virtual backbone of
this picture. The top of it, glazed in dark green, forms a link to the shadowy blue-green
curtain behind it, while its earthier bottom third matches the crude surface of the
table on which the other familiar objects are seen from above. The center of the
painting falls precisely at the juncture between the jar's glazed and unglazed portions.
The objects of various colors are carefully arranged around this center.[1] To the left of it,
above the hard white of a crumpled napkin enhanced by blue shadows, is a plate of
cherries, tilted so far forward that it is a wonder they have not fallen to the floor.
Across from them are a few less prominent peaches in a bowl, one of which, for
compositional reasons, has fallen on the table. The color of their lovingly treated "flesh
tone" is picked up in the fringe and design of the curtain above. Its sumptuous
elegance contrasts sharply with the sober idiom of the still life, which represents
nothing but devoted study of simple things.

NOTES

1 In a drawing, Chappuis 1973, no. 632, the spatial relationship between the jar and the two bowls of fruit
 is laid out in detail.

PROVENANCE: Ambroise Vollard, Paris; Charles A. Loeser, Florence; M. Loeser-Calnan, Florence; David
M. Levy, New York; The Adele Rosenwald Levy Fund, New York.
BIBLIOGRAPHY: Venturi 1936, 172, no. 498, illus.; Cogniat 1939, illus. 62; Reff 1958, 47; Schapiro 1968, 52;
Murphy 1971, **135**; Brion 1973, 78; Chappuis 1973, 176, no. 632; Cézanne 1988, **102**; Rewald 1989, 52f., illus.
28, 82.
EXHIBITIONS: Venice 1920, no. 28; *Art in Our Time*, The Museum of Modern Art, New York 1939, no. 57,
illus.; New York 1959, no. 27, illus.; *Mrs. Adele R. Levy Collection*, The Museum of Modern Art, New York
1961, 19, illus.; Washington 1971, no. 13, illus.; Tokyo 1974, no. 36, illus.; *A Decade of Collecting 1965–1975*,
Los Angeles County Museum of Art 1975, no. 89; *Chefs-d'œuvre des Musées des Etats-Unis de Giorgione à
Picasso*, Musée Marmottan, Paris 1976, no. 31.

55 Still Life, Flowers and Fruit, 1888–90
 Nature morte, fleurs et fruits

Venturi no. 610 (1888–90)
Oil on canvas, 26 x 32 1/8″ (66 x 81.5 cm).
Staatliche Museen zu Berlin,
Nationalgalerie (inv. no. A I 965), Berlin

Cézanne has here added to the wooden table, the cloth, the fruit, and ginger jar of the
preceding, quite concentrated still lifes (cat. nos. 53, 54) a colorful bouquet of daisies,
carnations, and poppies that is almost Baroque in its richness. This is the only one of

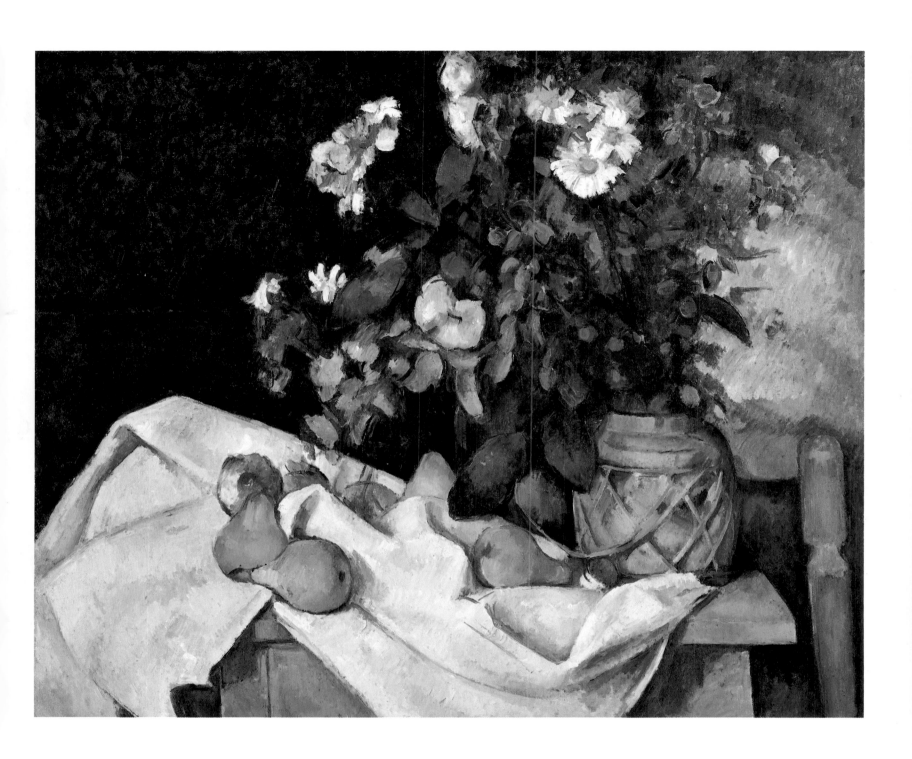

his larger, more ambitious still lifes to combines a vase of flowers with the already familiar components.[1] Cézanne often painted flowers in a vase, at times including a few pieces of fruit nearby, but nowhere in his other flower paintings is there anything like the decorative abundance displayed here.

One can almost imagine watching the painter at work as he carefully arranged the various objects: draping the cloth just so before placing the pears on it; drawing up a chair so that he could include the back of it as a stabilizing element; and turning the bouquet until it satisfied his sense of balance. Nothing is left to chance. The dark, empty background on the left, which sets off the cold splendor of the cloth, serves as a deliberate counterweight to the opulence of the right half of the picture. The forms of the pieces of fruit are motionless and self-contained, while the bouquet above them opens out in all directions. Together, they produce an incomparable harmony.

This still life has long been a showpiece in the collection of the Nationalgalerie in Berlin. It was acquired for the museum by Hugo von Tschudi in 1904. In 1897, Tschudi had bought Cézanne's *Mill on the Couleuvre, at Pontoise* (cat. no. 25), the first of the artist's paintings to be purchased for a museum (see cat. no. 16). The painter Maurice Denis visited Cézanne as late as 1906, and in his article on the master in the journal *L'Occident* in September 1907, he singled out these two paintings: "Cézanne's effect in the Berlin museum, for example, is very remarkable. No matter how much one delights in the *Serre* of Manet, the *Enfants Bérard* of Renoir, or the remarkable landscapes by Monet and Sisley, the presence of the Cézannes causes one to lump the Manets, Monets, Renoirs, and Sisleys – unjustly to be sure, but by force of contrast – with the whole of modern production, while the pictures by Cézanne appear to be works from another epoch, just as subtle, but stronger than the strongest products of the Impressionist School."[2]

NOTES

1 See the still life *Pot de géraniums et fruits,* Venturi 1936, no. 599.
2 Denis 1982, 205.

PROVENANCE: Bernheim-Jeune, Paris; Paul Cassirer, Berlin.
BIBLIOGRAPHY: Bernheim-Jeune 1914, illus. 18; Vollard 1914, illus. 1; Rivière 1923, 207; Bernard 1925, **148**; Gasquet 1930, 77; Venturi 1936, 57, 196f., no. 610, illus.; Novotny 1937, 14, illus. 75; Novotny 1938, 72; Cogniat 1939, illus. 86; Dorival 1949, 67; Guerry 1950, 70, 96; Feist 1963, illus. 57; Basel 1989, 294.
EXHIBITIONS: *L'Impressionnisme,* Palais des Beaux-Arts, Brussels 1935, no. 1; *Works of Art from Museums in the German Democratic Republic,* State Hermitage Museum, Leningrad 1958, 33, illus.; *Schätze der Weltkultur von der Sowjetunion gerettet,* Staatliche Museen zu Berlin, Nationalgalerie, Berlin 1958, illus.; *Francia Festök Delacroix-Tól Picassóig,* Szépmüvészeti Múzeum, Budapest 1965, 10, illus.; *Francouzské Malírstvi od Delacroix k Picassovi,* Národní Galerie v Praze, Prague 1965, no. 50, illus.; *50 Obras Maestras de Pintura de los Museos de Dresden y Berlin de la República Democrática Alemana,* Museo de San Carlos, Mexico City 1980, no. 11, color plate p. 33 (reversed); Madrid 1984, no. 36, illus.; Tokyo 1986, no. 24, illus.

56 Still Life, Milk Pitcher and Fruit on a Table, circa 1890
Nature morte, Pot au lait et fruits sur une table

Venturi no. 593 (1888–90)
Oil on canvas, 23 3/8 x 28 1/2" (59.5 x 72.5 cm).
Nasjonalgalleriet (inv. no. NG 942), Oslo

This is the simplest of Cézannes major still-life compositions, and for that very reason, one of the most beautiful. The glowing colors alone invest the spare arrangement with great dignity. The close warm yellows, oranges, and reds contrast effectively with the cooler blue, violet, and green of the background. The artist has strategically placed the obliging objects in such a way that each seems ideally situated. The painted porcelain pitcher looms up from the center of a wooden table into the blue of the wall, one wholly reminiscent of the nuanced color of a Cézanne sky.[1] A nosegay of violets represents a middle value between the deep indigo of the baseboard and the lightest patches of the turquoise-blue wall. Rainer Maria Rilke was struck by Cézanne's very special blue, one that derived from the eighteenth century and that "stripped Chardin of his pretention and is now, in Cézanne, no longer endowed with any secondary meaning." Rilke also suspected that Cézanne learned his matter-of-fact depiction of objects from Chardin: "Even his pieces of fruit are no longer thinking of dinnertime; they lie about on kitchen tables and could not care less whether somebody enjoys eating them. In Cézanne they become such self-contained objects, so indestructible in their single-minded existence that they stop being edible altogether."[2]

The center of the picture falls where the pitcher's handle – almost an afterthought – intersects with the surface of the table and the wide stripe of the baseboard begins its diagonal rise to the right. The steep angle of the floor and the placement of the table are calculated solely with regard to the picture surface. The element of tension that exists between the many rounded forms and the straight lines describing the relatively homogeneous surfaces of the floor, the table, and the wall is underscored by the emphasis on the angled baseboard. Its striking blue black is farthest removed, physically and in terms of color, from the blue-shadowed white of the plate. A more richly constructed second version of this still life in the Pushkin Museum in Moscow depicts an expanded view of the same space.[3]

NOTES

1 The pitcher is also the central object in the later still lifes Venturi 1936, nos. 735, 736, 750, Rewald 1983, nos. 571, 572; see also the pencil sketch Chappuis 1973, no. 540.
2 Rilke 1977, 20.
3 Venturi 1936, no. 619.

PROVENANCE: Auguste Pellerin, Paris; Bernheim-Jeune, Paris.
BIBLIOGRAPHY: Bernheim-Jeune 1914, illus. 22; Vollard 1914, illus. 1; Rivière 1923, **61**, 214; Venturi 1936, 57, 193, no. 593, illus.; Novotny 1937, illus. 55; Novotny 1938, 71; Raynal 1954, **84**; Gowing 1956, 191; Loran 1963, 93; Chappuis 1973, 157, no. 540; *Katalog over Utenlandsk Malerkunst,* Nasjonalgalleriet, Oslo 1973, 197f., no. 472, illus.; Barskaya 1975, **181**; New York 1977, 30; Arrouye 1982, **64f.**; Rewald 1983, 232, no. 571; Erpel 1988, no. 25, illus.
EXHIBITIONS: *L'Impressionnisme,* Palais des Beaux-Arts Brussels 1935, no. 2; Paris 1936, no. 67 Chicago 1952, no. 81, illus.; Madrid 1984, no. 27, illus.; Tokyo 1986, no. 25, illus.

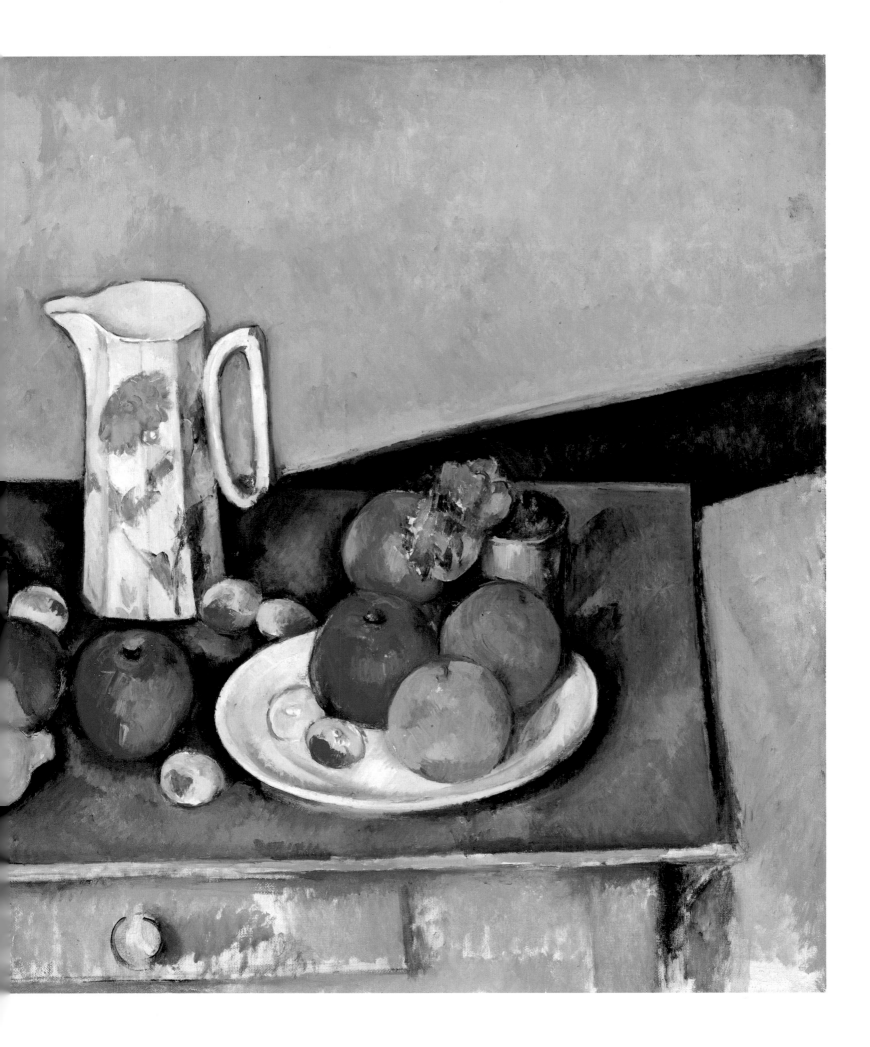

57 Still Life, Plate and Fruit, circa 1890
 Nature morte, assiette et fruits

Venturi no. 206 (1873-77)
Oil on canvas, 11 x 16″ (28 x 40.5 cm).
Thomas Gibson Fine Art Ltd., London

One would guess that Cézanne's sole reason for painting this study – handles of two fruit knives in the left foreground, fruits somewhat precariously arranged, and a blue-edged plate obviously propped up from underneath – was to experiment with color modulations in the modeling of the simplest objects, and to demonstrate the result against a dusky background. Venturi's early dating is untenable for stylistic reasons.

PROVENANCE: Ambroise Vollard, Paris; Count Harry Kessler, Weimar; Alfred Flechtheim, Berlin; Royan Middelton, Aberdeen; Paul Rosenberg, New York; Acquavella Galleries, New York; Heinz Berggruen, Paris.
BIBLIOGRAPHY: Ors 1936, illus. 31; Venturi 1936, 111, no. 206, illus.; Schapiro 1968, 52.
EXHIBITIONS: Berlin 1921, no. 39; *Renoir and the Post-Impressionists,* Reid & Lefèvre Gallery, London 1930; London 1954, no. 41, illus. 41; Tokyo 1974, no. 43, illus.; *XIX & XX Century Master Paintings,* Acquavella Galleries, New York 1982, 14f., illus.

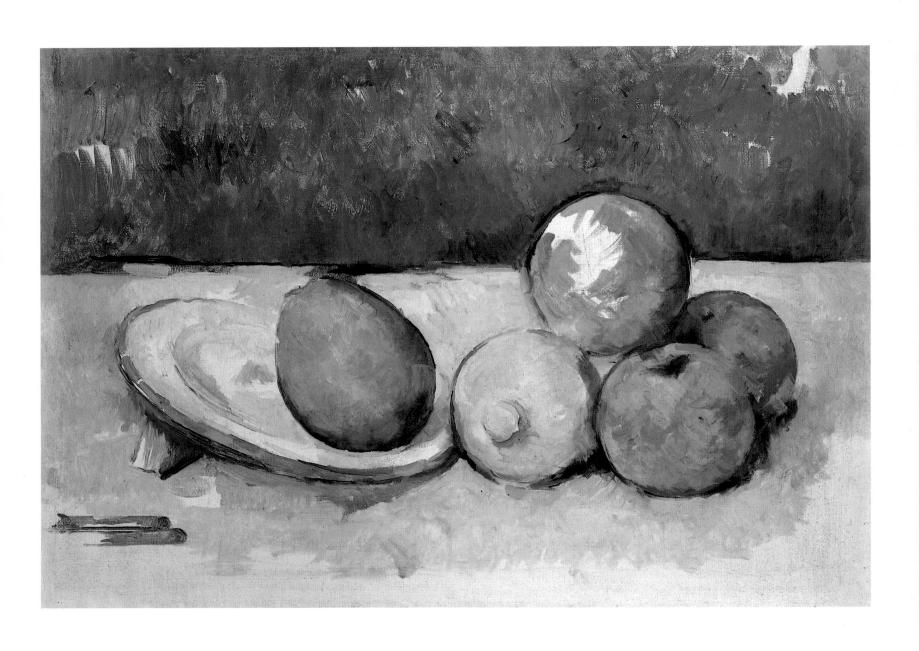

58 Still Life, Ginger Jar, Sugar Bowl, and Apples, 1893–94
Nature morte, pot de gingembre, sucrier, et pommes

Venturi no. 598 (1890–94)
Oil on canvas, 25 3/4 x 32 1/8″ (65.5 x 81.5 cm).
Private collection, on loan to the Kunsthaus Zurich

On November 4, 1907, on the train from Prague to Breslau, Rainer Maria Rilke wrote of an exhibition of French Impressionist and Post-Impressionist painting he had seen in Prague in the Pavillon Manès, the exhibition hall of the young Czech artist's union. After mentioning two early Cézannes,[1] he singled out this painting, then in the Hatvány Collection in Budapest and shown under the title *Still Life with Blue Rug*: "Between its bourgeois cotton blue and the wall, which is overlaid with a cloudlike light blue veil, a delicious, large, gray-glazed ginger jar, that is a different shape on the right than on the left. An earthy-green bottle of yellow Curaçao, and there is also a ceramic vase, the upper two-thirds of which have a green glaze. On the other side, on the blue rug, apples, some of which have rolled off of a porcelain plate, which has a bluish tinge. The red rolling into the blue seems as much the result of the picture's color processes as the contact between two Rodin nudes is the result of their plastic affinity."[2]

Rilke's observation that the ginger jar has a different shape on the right than it does on the left bears upon Cézanne's objective way of seeing, his utter surrender to visual impressions. If one side of a vessel seemed to be shaped differently because of the angle of the light, for example, he did not hesitate to register that difference. Here, the right side bulges out somewhat, while the left follows a more regular curve. Wholly without prejudice, the painter did not rely on his knowledge that an object was symmetrical; he simply reproduced what he saw before him. The reality of the object was thus made to conform to his subjective view of it, with whatever distortions that entailed. The viewer who takes the trouble to correct these discrepancies becomes aware that it is precisely these slight aberrations of line that allow us to see certain logical cross-references within the composition. It is left to us to correct any distortions and displacements, using our own knowledge – only partially conforming to what we really see – that plates are round and the necks of bottles vertical, that vessels and fruits tend to be symmetrical, and that the edge of a table is likely to continue in a straight line. At the same time, the viewer is called upon to believe any adjustments undertaken by the artist to make the elements of the picture fit together more logically, for it is the painter's precise observation of distortion in the forms of objects that serves to reveal their immutable essences.

The objects in question – a ginger jar, small sugar bowl, glazed olive jar, and a fruit plate on a white tablecloth with red stripe – are already familiar to us, and we can see them still today in the artist's studio in Aix (see cat. no. 53). But placed against the arabesque shapes on the blue rug, they all seem exotic and new (see cat. no. 59). With one later exception (cat. no. 88), this is the only Cézanne still life in which the objects are lined up along diagonals as opposed to the usual horizontal arrangement. As with several other compositions featuring the same blue rug (see cat. nos. 59, 60),[3] Cézanne probably did this painting in his studio at the Jas de Bouffan. The various objects, apparently used exclusively in Aix, and the blue-tinged wall, support that assumption. The latter, generally provided with a red-brown stripe above the wainscoting, served as the background for various still lifes and portraits (cat. nos. 64, 68), all of which were produced in the 1890s in Aix, more precisely at the Jas de Bouffan, which was sold in 1899.

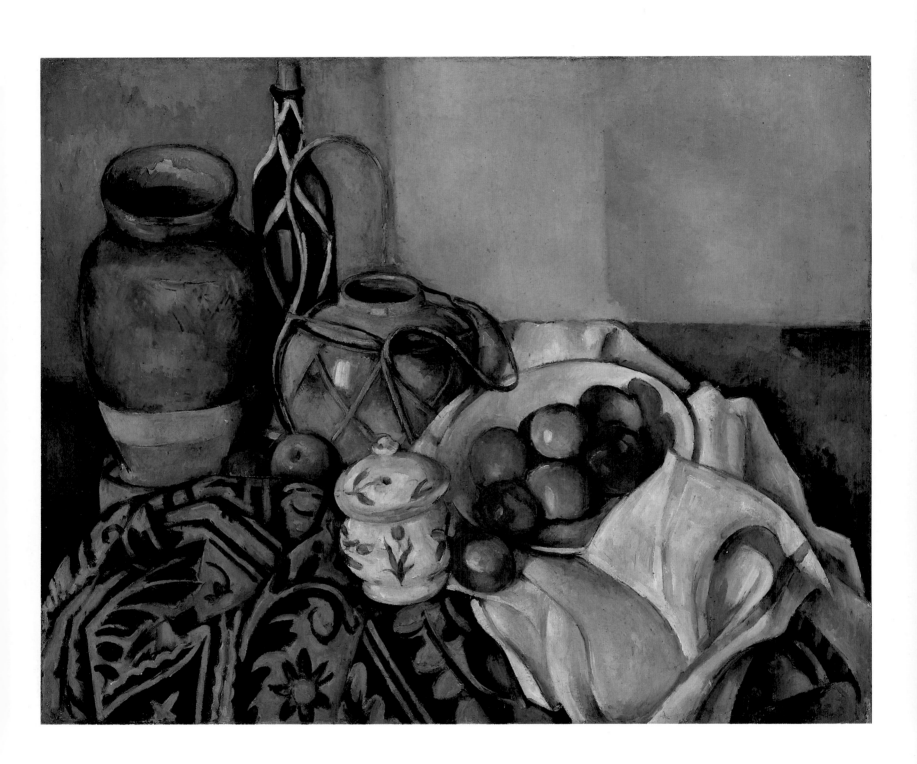

1 *Portrait de Valabrègue,* Venturi 1936, no. 126, and *Nature morte: Le pain et les œufs,* Venturi 1936, no. 59.
2 Rilke 1977, 45, 99.
3 Venturi 1936, nos. 499, 601, 611, 612, 622, 624, 625, 706, 707.
4 See the course of the wall in the still lifes and portraits Venturi 1936, nos. 502, 565, 625, 675, 704, 706, 730; see also the still Life not included in Venturi, *Still Life, Flowers in a Vase,* Rewald 1986, **165**, and the watercolor Rewald 1983, no. 289.

PROVENANCE: Franz von Hatvany, Budapest-Paris; Paul Cassirer, Berlin; Hugo Cassirer, Berlin.
BIBLIOGRAPHY: Vollard 1919, **92**; Venturi 1936, 57, 194, no. 598, illus.; Loran 1963, 76, 89; Chappuis 1973, 31; Rilke 1977, 45, illus. 9; Adriani 1981, 280; Rewald 1983, 134, no. 204, 230, no. 563; Rewald 1986, **210**; *du* 1989, **24**.
EXHIBITIONS: Cologne 1912, no. 129, illus. 19; Berlin 1921, no. 32.

59 Still Life, Ginger Jar and Eggplants, 1893–94
Nature morte, pot de gingembre et aubergines

Venturi no. 597 (1890–94)
Oil on canvas, 28 1/2 x 36 1/4″ (72.4 x 91.4 cm).
The Metropolitan Museum of Art,
Bequest of Stephen C. Clark, 1960 (inv. no. 61.101.4), New York

The same vessels are now joined by fresh fruits, a squash, and three eggplants in an arrangement even more sumptuous and studied than that of the previous still life (cat. no. 58). It is amazing to see how the artist continued to develop new picture ideas out of the same materials. The objects are now perched above the intricately patterned folds of the rug like buildings at the edge of a steep cliff. The rug develops a separate and mysterious relationship with the sharp point of tablecloth, whose white consists largely of turquoise and green, against which the mundane objects take on a ceremonial splendor. The focal point of the arrangement, apparently placed on a low pedestal given the height of the table in the background, is the ginger jar, and the remaining objects, ranging from orange to green, are grouped around it in a circle (see cat. nos. 53, 55, 58),[1] the narrow vertical of the rum bottle marking the center axis. The construction's great stability virtually demands that certain of its elements seem less secure, the plate for example, which is tilted at such an angle that it seems impossible that the pears have not rolled off of it. The smaller the forms, the more brilliant their colors. Their opulence precisely distinguishes between the textures of the glazed jar, the glass bottle, and the sensual fruit, tempting the viewer to reach out and touch them.

By their arrangement, these everyday objects suggest anything but an everyday situation. This magnificent painting is almost Baroque in feeling, not because of hidden meaning, but because of its wealth of invention, diversity of objects, and distinct color. It is remarkable because it produces such a monumental effect with the most ordinary of objects, because its varied brushwork relieves even the heaviest forms of all ponderousness, because of the way it harmonizes through color the jagged folds in the drapery with the rounded objects placed upon it.

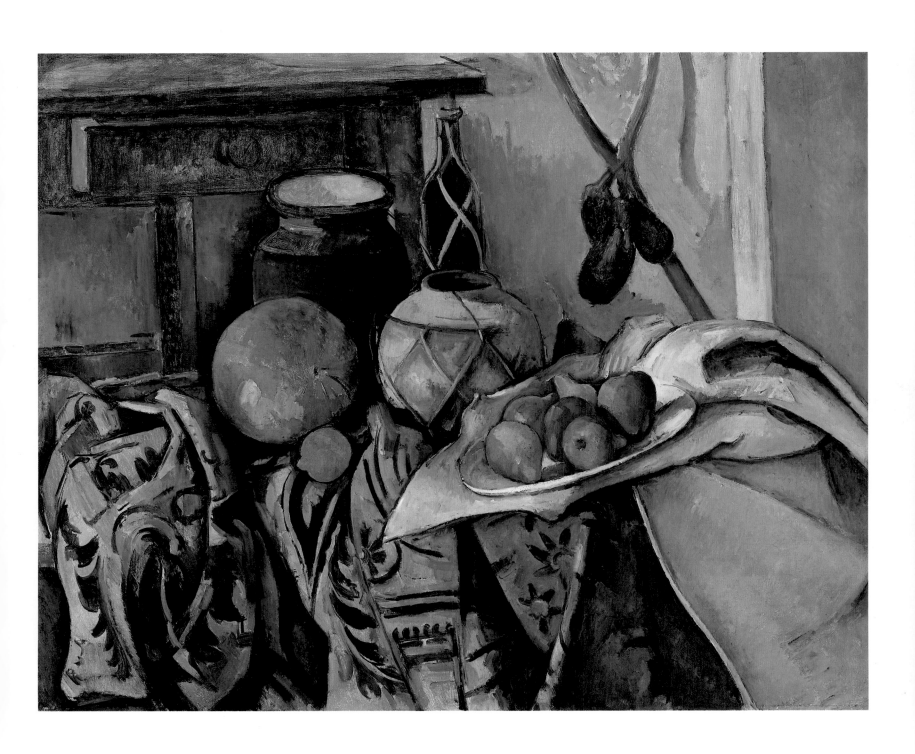

1 The ginger jar appears in the still lifes Venturi 1936, nos. 497, 594-96, 616, 733, 737, 738, Rewald 1983, nos. 289, 290.

PROVENANCE: Durand-Ruel, Paris-New York; H. O. Havemeyer, New York; Horace Havemeyer, New York; Knoedler, New York; Stephen C. Clark, New York.
BIBLIOGRAPHY: Venturi 1936, 57, 194, no. 597, illus.; Charles Sterling, Margaretta M. Salinger, *French Paintings. A Catalogue of the Collection of The Metropolitan Museum of Art,* New York 1966, **111f.**; Adriani 1981, 280; Rewald 1983, 134, no. 204, 230, no. 563; Rewald 1986, **210**; Cézanne 1988, **188**; Geist 1988, 23ff., illus. 25, illus. 26; Rewald 1989, 128.
EXHIBITIONS: *French Masterpieces of the late XIX Century,* Durand-Ruel Galleries, New York 1928, no. 4; *A Collector's Taste. Selections from the Collection of Mr. and Mrs. Stephen C. Clark,* Knoedler Galleries, New York 1954, no. 13; *Great French Paintings,* Art Institute of Chicago 1955, no. 4; *Paintings from Private Collections,* Museum of Modern Art, New York 1955; *Paintings from Private Collections,* The Metropolitan Museum of Art, New York 1958, no. 18.

60 Still Life, Pomegranate and Pears on a Plate, 1893-94
Nature morte, grenade et poires sur une assiette

Not in Venturi
Oil on canvas, 10 1/2 x 14″ (26.7 x 35.6 cm).
Stephen Hahn Collection, New York

The beautiful color in this painting, only a detail from a still life, comes from the natural colors of the fruits themselves.[1] The four objects rest on a plate whose luster reflects the blue of the adjacent rug (see cat. nos. 58, 59). For Cézanne, this was enough. It challenged him to refine his observation of reality and his skill at rendering what he saw. It also gave him a chance to demonstrate how color alone can create form. As Rainer Maria Rilke wrote in one of his letters from 1907: "Although it is his habit to use chrome yellow and flaming red on his lemons and apples without mixing them, he knows how to contain their loudness within the picture: It blares directly, as though into an ear, into a receptive blue, and from it receives a silent response, so that no one outside has to feel that he has been addressed or shouted at."[2]

The presence of the patterned rug and the somewhat arbitrary manner in which the pitcher has been cut off suggest that this small still life was originally part of a larger composition. Cézanne's art dealer Ambroise Vollard recalls pictures on which "Cézanne had painted over some of the pictures with small sketches of various subjects. He left it to Tanguy [the shopkeeper who for years accepted paintings in payment for art supplies] to cut them up. They were meant for those buyers who were unable to pay either forty or a hundred francs [the standard prices for paintings in the early nineties, depending on format]. Thus one would see Tanguy selling small 'motifs' with his scissors, while some Maecenas or other handed him a louis and made off with 'Three Apples' by Cézanne."[3] After Tanguy's death in 1893, Vollard must have

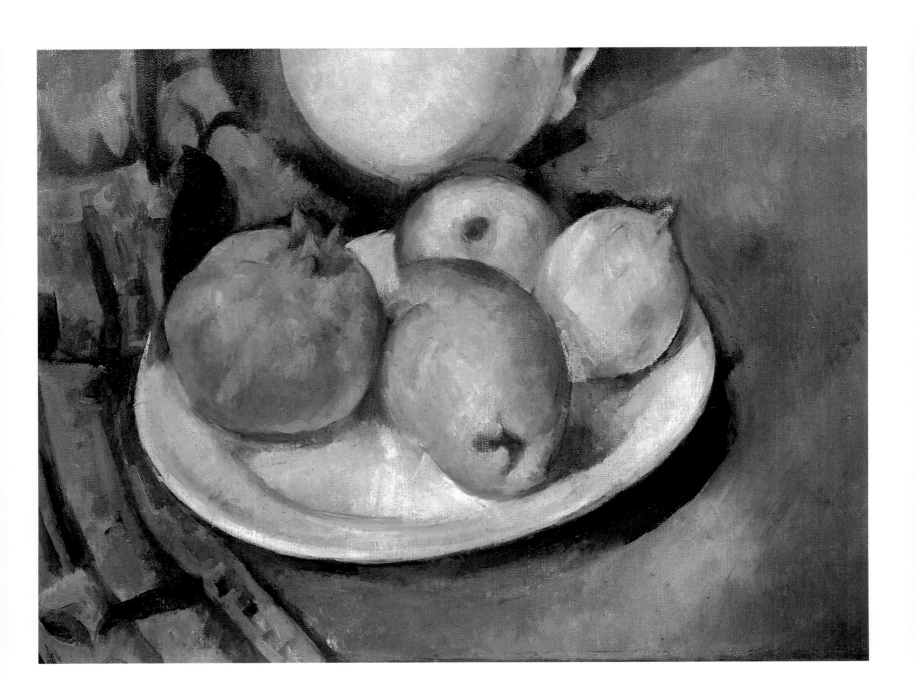

taken to using his scissors in a similar way (see cat. no. 35), especially once he was able to raise his prices considerably after the first Cézanne exhibition in the fall of 1895. Vollard sold this still life in March 1896 for two hundred francs. The buyer was Ludovic Halévy, famous as the librettist for most of Offenbach's operettas and for Bizet's *Carmen*. Halévy was a friend of Degas, and at this same time, Degas bought a tiny *Still Life with Pear and Lemon* at Vollard's.[4]

NOTES

1 See the still lifes Venturi 1936, nos. 611, 612.
2 Rilke 1977, 42.
3 Vollard 1960, 30.
4 Not in Venturi; see *Vente Collection Edgar Degas*, Galerie Georges Petit, Paris, March 26-27, 1918, no. 13. Degas also owned the small still life *Apples*, Venturi 1936, no. 190, as well as the paintings Venturi 1936, nos. 124, 339, 367, 375, 522, 544.

PROVENANCE: Ambroise Vollard, Paris; Ludovic Halévy, Paris; Daniel Halévy, Paris; Leon Halévy, Paris; Dominique Halévy, Paris.
BIBLIOGRAPHY: Rewald 1986, **165**.

61 Still Life with Jug, circa 1893
Nature morte à la cruche

Venturi no. 749 (1895–1900)
Oil on canvas, 20 7/8 x 28″ (53 x 71.1 cm).
The Trustees of the Tate Gallery,
Bequest of C. Frank Stoop, 1933 (inv. no. 4725), London

There are six still lifes similar to this one, with a water jug surrounded by various plates, porcelain bowls, and fruits, on a simple wooden table set parallel to the picture plane.[1] Venturi assigned various dates between 1885 and 1890 to these works, but it is my opinion, based on their style, that they were all painted at roughly the same time, between 1893 and 1895, in the studio at Aix. This is one of the paintings that permits us to reconstruct Cézanne's way of working (see cat. nos. 30, 31, 62, 69, 91). He first sketched the layout of the picture in a highly thinned blue gray. Having established the positions of the table, the stiffly folded cloth, the plate, a knife, the pieces of fruit, and the jug in front of a draped curtain (?), he could then proceed to place the first spots of color, upon which, with additional shading, he would eventually develop rounded shapes. Departing from the traditional practice of equating darkness and density with nearness and their progressive diminution with distance, Cézanne developed the varied color of an object from dark to the light, from back to front, from outside in, from cold to warm. In chromatical layers extending like the spectrum from the distant, cold colors violet, blue, and green to the close, warm tones yellow, orange, and red, he successively built up the round forms of the jar and the fruits from the background. As a result, the deepest layers, in terms of both color and space, are just as effective as the raised bright highlights. Concentrations of shadow, in part conforming to the edges of objects, are generally established by a deep blue, then

progress by way of most delicate gradations of green to lighter and lighter areas. The actual color of the object is found in those portions lying between the shaded sides turned away from the light and the highlights.

Delacroix and Pissarro had already made it clear that objects are not to be understood as shapes defined by mere lines, but rather as colored volumes rising up out of darkness into the light. Accordingly, the most important elements for establishing form were the "culmination points" lying closest to the eye, not the contours farthest away from the viewer. The latter, sharply defined and close together in outline drawing, fail to take into account the actual appearances of objects. Cézanne formulated his own approach to this problem in 1904: "In any future progress to be made nothing counts but nature, and an eye educated through contact with it. The more one looks and works, the more concentric it becomes. I mean, in an orange, an apple, a head, there is a culminating point; and that point is always – despite the terrible effect: light and shade, sensations of color – the one closest to our eyes the edges of objects flow toward a central point situated on our horizon."[2] In other words, this means that in every carefully studied form, whether round, curved, or flat, the point on which our gaze is concentrated appears clearest. The light culminates in these high spots, and from them the surface curves back into space. One of Cézanne's great creative achievements as a colorist was making color and form absolutely congruent, his forms attaining their greatest fullness where their color is richest.[3]

NOTES

1 Venturi 1936, nos. 499, 500, 601, 609, 612, 622; see also the pencil sketches Chappuis 1973, nos. 1079, 1080.
2 Cézanne 1984, 299.
3 Bernard 1982, 55.

PROVENANCE: Ambroise Vollard, Paris; C. Frank Stoop London.
BIBLIOGRAPHY: Venturi 1936, 226, no. 749, illus.; Cooper 1954, 380; Cooper 1956, 449; Gowing 1956, 191; Chappuis 1973, 248, no. 1079; New York 1977, 37, 340, illus. 151; Adriani 1981, 281; *Catalogue of the Tate Gallery, Collections of Modern Art*, London 1981, 104f.; Hülsewig 1981, 41, 72, 78, illus. 23; Cézanne 1988, 228.
EXHIBITIONS: London 1954; Basel 1983, no. 20, illus.; Madrid 1984, no. 44, illus.

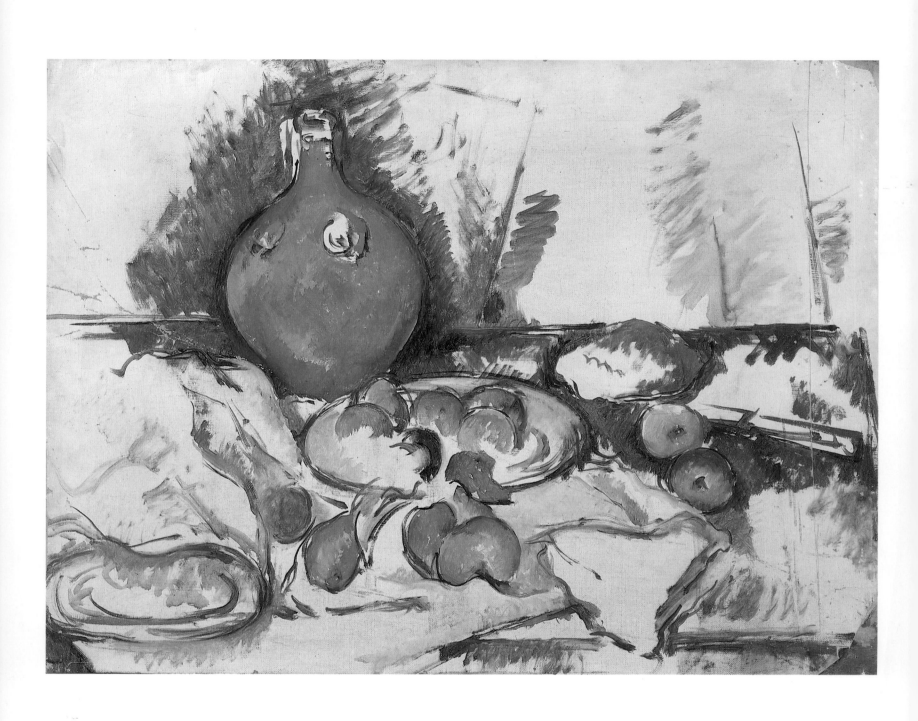

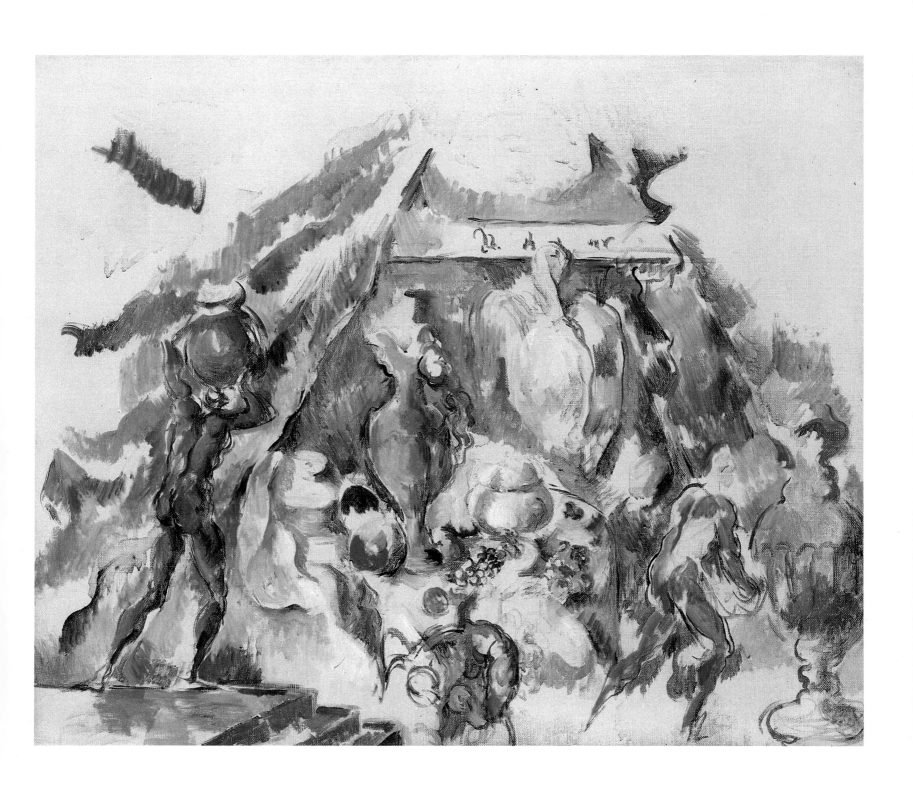

62 Banquet Preparation, 1890–95
La préparation du banquet

Venturi no. 586 (circa 1890)
Oil on canvas, 18 x 21 3/4″ (45.7 x 55.3 cm).
Acquavella Modern Art, New York

This scene is one of Cézanne's most remarkable inventions. Neither a still life, historical narrative, nor a genre painting, it is clearly from his late period stylistically, yet in subject matter more closely related to his earliest work.

As a young man, inspired by Flaubert's *Temptation of St. Anthony* and *Salammbô*, the artist had painted a debauched and exotic banqueting scene in which tall amphoras filled with wine stand about on tables draped in white (illus. 1). Now, nearly a quarter of a century later, we again discover a richly set table to which two dark-skinned nudes are carrying in still more delicacies. This later work has none of the lasciviousness of the one from his youth, but it is just as bold in its passionate interplay of colors, and just as vague in its depiction of space. The centerpiece is a huge gold ewer (see cat. no. 11), and a similar vessel in blue stands in the right foreground. The white-draped round table is further graced with displays of fruit and porcelain tureens. Green shadows at the back of the room serve to balance the abundance of red and blue on either side.

Large sections of the canvas have been left blank. There are only enough details to permit us to understand the general import of the work. It remains unclear, for example, whether there was to be a curtain on the right like the one drawn back on the left, or a view to outdoors similar to the one in two related still lifes from this same period.[1] It is also difficult to make out the configuration of the room, which we see from some indeterminate point of view. One enters it from the left foreground by way of a descending staircase, and it then extends at a lower level back as far as the white bird shape (?) with a molding above it. In front of a virtually Rococo drapery on the left, one of the figures balances a large jar on his head, while his partner on the right seems to be leaving. A third nude in the center, cut off by the bottom edge of the picture, is only suggested in a few outline strokes. He seems to be bowing to an imaginary public.

Illus. 1
Paul Cézanne,
The Orgy, 1866–68, gouache.
Private collection, Stuttgart

NOTES

1 Venturi 1936 no. 200, Rewald 1983, no. 294.

PROVENANCE: Ambroise Vollard, Paris; Galerie Pierre, Paris; Douglas Cooper, London; Paul Rosenberg, New York; Irene Mayer Selznick, New York; Sotheby's auction, London June 24, 1986, no. 20.
BIBLIOGRAPHY: Venturi 1936, 110, 192, no. 586, illus.; Neumeyer 1958, 51; Reff 1963, 152; New York 1977, **34f.**; Krumrine 1980, **116f.**; Rewald 1983, 156, no. 294; London 1988, **33**, 39; Basel 1989, 47f., illus. 24, 50, 144, 190, 214, 256, 262; Lewis 1989, **175f.**
EXHIBITIONS: Paris 1935; New York 1959, no. 36, illus.; *XIX & XX Century Master Paintings, Acquavella Galleries, New York 1983, no. 8, 19, illus.; Tokyo 1986, no. 29, illus.*

63 Delacroix's Apotheosis, circa 1894
Apothéose de Delacroix

Venturi no. 245 (1873–77)
Oil on canvas, 10 5/8 x 13 3/4″ (27 x 35 cm).
Musée d'Orsay (inv. no. RF 1982–38), dépôt de l'Etat 1984,
Musée Granet (inv. no. 84–7–1–7), Aix-en-Provence

As an artist, Eugène Delacroix, whose father, Talleyrand, played a major role in shaping the political fortunes of France in the beginning of the nineteenth century, unquestionably had the greatest influence on the French avant-garde in the latter half of the century.

Three generations of artists were indebted to him, beginning with Daumier and Corot, through the group that included Manet, Monet, Renoir, and Degas, to that of Redon and Van Gogh, who hailed Delacroix as a pioneer. It was he who taught them that the essential problem for the painter was to create a picture exclusively out of color. His accomplished dramaturgy, his generous choice of color in harmony with nature, and his somewhat improvisational style accorded with their own ideas of originality and artistic audacity. Cézanne, more than anyone else, stood under the spell of the "master" and his insistence on the primacy of color. In Delacroix he saw a painter who had managed to use color both for substance and for creating form. Cézanne owned two paintings by Delacroix as well as a watercolor and two lithographs. His studio in Aix was adorned by six reproductions of works by the older artist. Among his own drawings and paintings there are over twenty-five copies from Delacroix, chiefly dating from the 1860s and 1870s. He shared with Delacroix an admiration for the great Venetians, for Rubens, and for the sculptor Pierre Puget.

Although Cézanne had done his most intensive study of Delacroix during his early years in Paris, at the time of the exhibition of the master's works on paper in the Galerie Georges Petit in 1862 and the major retrospective in 1864, he continued to refer to Delacroix constantly even in his old age.[1] As late as a month before his death

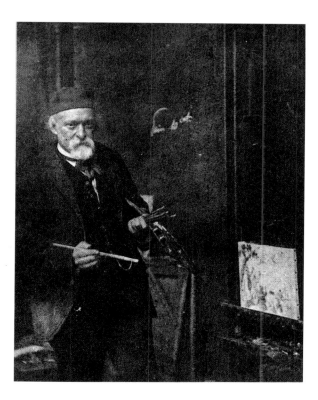

Illus. 1
Paul Cézanne in his Paris studio,
at work on *Delacroix's Apotheosis*.
Photograph, 1894

195

he announced that he was rereading "the appreciative things [Baudelaire] wrote about Delacroix's work."[2]

Cézanne meant to document his close affinity to Delacroix in a painting, *Delacroix's Apotheosis*, one he planned for decades but never finally realized. On May 12, 1904, the old painter wrote to Emile Bernard: "I don't know if my precarious health will ever enable me to realize my dream of creating [Delacroix's] apotheosis."[3] Ten years before, in 1894, Cézanne was photographed, brush in hand, in his Paris studio in Passage Dulac (illus. 1). On his easel, one can make out the small study, obviously unfinished, for the *Apotheosis*, which he happened to be working on just then. Although the motif goes back to a pen and pencil drawing from the second half of the 1870s, possibly worked in watercolor and expanded at a later date,[4] both its style and the documentation of the photograph suggest that the painting was done in about 1894. Cézanne could have been inspired to take up the subject again by the publication, in 1893, of Delacroix's *Journal*. The impetus may also have been the death in 1891 of the collector Chocquet (see cat. no. 15), who shared Cézanne's admiration for Delacroix.

Cézanne's monument to the artist took the form of a circle of "worshippers" watching as Delacroix is carried off into Baroque spheres of heaven, a composition similar to the one he had used in his ironic celebration of the Eternal Feminine (see cat. no. 12). In that earlier work, the artist himself appears as an outsider, while anonymous representatives of the Church and society pay tribute to the fair sex. Here, he is again seen from the back, in the center of the foreground, but this time he is among friends gathered to pay homage to Delacroix, and is an active participant. In the company of Pissarro, Monet, and Victor Chocquet, he appears as though on his way to work, with his paintbox on his back. Thanks to Emile Bernard, who sought out the artist in Aix-en-Provence in 1904, we know who most of the figures represent:

> He planned to paint an *Apothéose de Delacroix*, and showed me the sketch for it. The Romantic master was depicted just as he was being carried off to heaven by angels, one holding his brush, the other his palette. Below this was an open landscape in which Pissarro stood painting at his easel. To the right was Claude Monet, and in the foreground, Cézanne, seen from the back, with a large Barbizon hat on his head, a lance in his hand, and a game-bag at his side. On the left stood M. Chocquet, applauding the angels. In another spot, finally, a barking dog (the symbol of envy, according to Cézanne) represented the critics.[5]

NOTES

1 See Cézanne 1984, 103, 105, 224, 297.
2 Ibid., 326.
3 Ibid., 302.
4 Rewald 1983, no. 68; see the single studies Rewald 1983, no. 69, Chappuis 1973, nos. 174, 175, and the drawings after Rubens' *Apotheosis of Henri IV,* Chappuis 1973, no. 102, and Delacroix's *Entombment of Christ,* Chappuis 1973, no. 167.
5 Bernard 1982, 92.

PROVENANCE: Ambroise Vollard, Paris; Auguste Pellerin, Paris; Jean-Victor Pellerin, Paris.
BIBLIOGRAPHY: Rivière 1923, 204; Bernard 1925, 69; Huyghe 1936, 33; Venturi 1936, 119, no. 245, **250**; Novotny 1937, 14, 20, illus. 67; Badt 1956, 85, 215f., illus. 41; Berthold 1958, 35; Ratcliffe 1960, 21; Cézanne 1962, illus.; Chappuis 1962, 49f.; Lichtenstein 1964, 55, 57, 60, illus. 1; Andersen 1967, 137f., illus. 3; Schapiro 1968, 48f., 51, illus. 17; Rewald 1969, **70f.**, 89; Andersen 1970, 44; Murphy 1971, **83**; Chappuis 1973, 85, no. 174, 86, no. 175; Geist 1975, 16; Lichtenstein 1975, 126; Adriani 1978, 80, 309; Adriani 1981, 28; Bernard 1982, 92; Rewald 1983, 102f., nos. 68, 69; Coutagne 1984, **222ff.**; S. Gache-Patin, "Douze œuvres de Cézanne de l'ancienne collection Pellerin," in *La Revue du Louvre* 2, April 1984, 137; London 1988, 26, 31, 53; Aix-en-Provence 1990, 112, illus. 60.
EXHIBITIONS: Lyons 1939, no. 12; Madrid 1984, no. 12, illus.

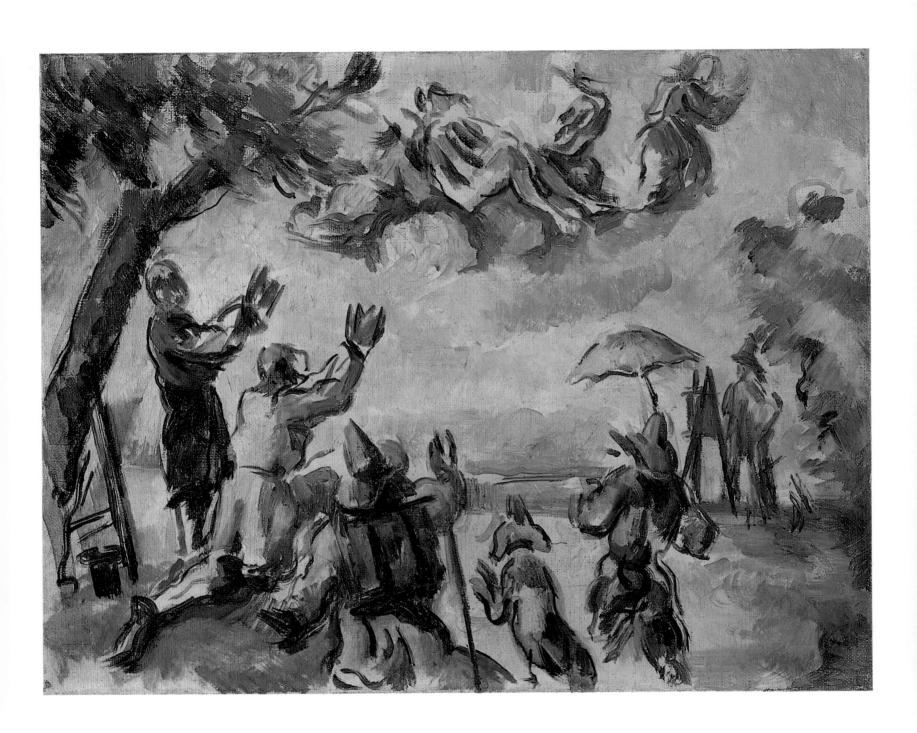

64 Peasant, circa 1891

Le paysan

Venturi no. 567 (1890–92)
Oil on canvas, 22 x 18 1/8" (56 x 46 cm).
Private collection

Once his wife and his grown son, Paul, ceased to be available as models, the painter was forced to look about for other sitters. He found them beginning in the fall of 1890 among the various farmhands and other local workmen engaged by his mother or his sister at the Jas de Bouffan, the family estate. For years, these men served him as welcome subjects, and he painted them with the same degree of attentiveness that he would have devoted to a stand of trees or the jar in a still life.

In 1891, five years after the painter's breach with Zola, the novelist commissioned Paul Alexis (see cat. nos. 5, 6) to write him from Aix in detail about how his longtime friend was doing:

> Fortunately, Cézanne, whom I am now seeing again, brings a breath of air and life into my socializing. He, at least, is vibrant, expansive and alive. He is furious with the Globe [Hortense Fiquet] who, after a year's stay in Paris punished him with five months in Switzerland and hotel food last summer ... the only bit of friendship he found was with a Prussian.... Nowadays, buttressed by his mother and sister – who loathe the lady in question – he feels himself able to stand firm. During the day, he paints in the Jas de Bouffan, where a laborer poses for him, and where I'll be going one of these days to see what he's up to. Finally, to complete the picture, he's been converted and is practicing.[1]

The model Alexis refers to may have been this young man, whose portrait, less profound in its expression than its structure, Cézanne infused with a dreamlike blue. This presentation of a simple man lost in thought has none of the social pathos of Courbet. The sitter is utterly passive; there is nothing on which to base any speculation about his character or occupation. His social position is irrelevant. This is neither a Millet decrying the exploited condition of the heroic peasant nor a Daumier commenting through caricature on his lowly station.

Specific wardrobe details might have revealed something more about the sitter, and for that reason, the painter has largely omitted them. He shows him in a simple white shirt and blue jacket in front of a plain blue wall, yet despite the absence of traditional social-class trappings, the picture of his reverie is filled with dignity. According to Venturi, this farmhand also served as the model for the figure on the right in the paintings of two men playing cards (cat. nos. 65, 66), produced between 1892 and 1895. He may also have posed for the various versions, painted in 1890–92, of a smoker leaning on his elbows – the *Fumeur accoudé.*[2]

On the occasion of a showing of Cézanne portraits in Paris in the Galerie Vollard, no less a luminary than Apollinaire, then working as an art critic, wrote in the journal *L'Intransigeant* on September 27, 1910, that a visit to the exhibition:

> ... will help one to appreciate something of the influence of the master of Aix on today's young painters.... In Cézanne, great simplicity is achieved deliberately. Painting from nature, he engaged the whole of his genius to turn Impressionism into an art of intellect and culture. All of this becomes clear in the expressive faces that M. Vollard has put on display. Some imprudent hand was foolish enough to varnish the pictures, which – we hope only temporarily – disturbs their overall harmony. But what an exquisite and powerful refinement

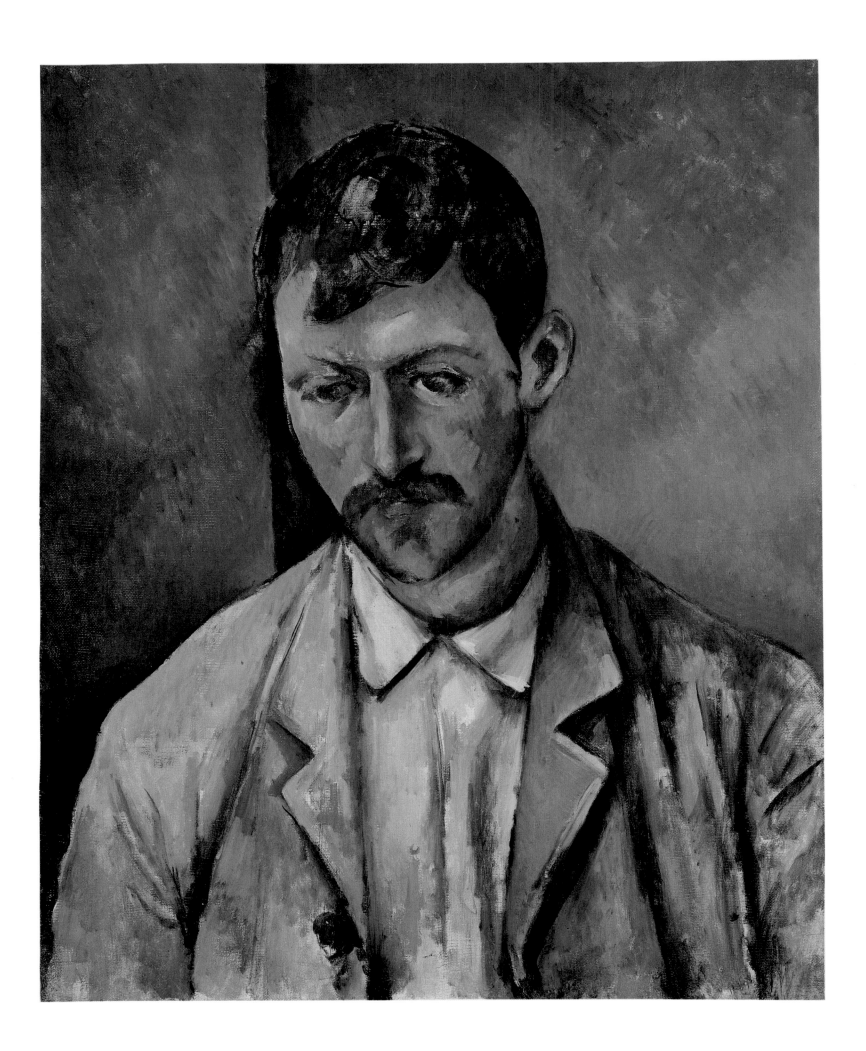

resides in these simple, austere portraits! As a provincial artist, Cézanne is sometimes lacking in charm. But even the most peasantlike of these faces possesses nobility. One can ascertain that he always transposed the humanity of his models into higher spheres.[3]

NOTES

1 Cézanne 1984, 231-32.
2 Venturi 1936, nos. 684, 686, 688.
3 Apollinaire 1989, 106.

PROVENANCE: Ambroise Vollard, Paris; Arthur Hahnloser, Winterthur.
BIBLIOGRAPHY: Venturi 1936, 187, no. 567; Novotny 1937, 8, illus. 60; Cogniat 1939, illus. 97; Dorival 1949, 71, 73, illus. 122, 168; Guerry 1950, 104; Feist 1963, illus. 51; Andersen 1970, 43; Elgar 1974, 136, 139, illus. 83, 218; Cézanne 1988, **180**.
EXHIBITIONS: Zurich 1956, no. 66, illus. 43; Munich 1956, no. 48, illus.; Cologne 1956, no. 24, illus.

65 Two Cardplayers, 1892–95
Deux joueurs de cartes

Venturi no. 557 (1890-1892)
Oil on canvas, 23 5/8 x 28 3/4″ (60 x 73 cm).
Courtauld Institute Galleries, London,
Courtauld Gift 1932

In 1890-92, Cézanne once again took up the idea of a group portrait (see the early double portraits, cat. nos. 5, 6) in two paintings of men playing cards.[1] He later decided to reduce that subject matter to only two cardplayers seated across a table from each other, instead of the original four or five. The process of working his way from the two more elaborate, detailed compositions to simplified versions took a long time, and involved a change of sitters. Of the three later versions (see also cat. no. 66), the one shown here is the freest, and although it is not the largest, it is the most monumental in its effect. Here the artist managed to integrate more fully what he initially conceived for the picture, making this the definitive expression of his cardplayer motif – an idea that probably first came to him in the fall of 1890.

Nothing is known about why Cézanne was so drawn to this subject, why he attached such importance to it that he went on to wrest from it five masterfully thought-out paintings. It is unlikely that he would have been inspired by the frequent appearance of cardplayers in Netherlandish and French paintings from the seventeenth century.[2] In those works, the focus was on the minutiae of everyday life, the pleasures of male companionship, or in some cases, human weakness, but Cézanne showed no interest in any of these. He certainly had no interest in advocating any uprising on behalf of the heroic peasant, like Millet, or railing at social conditions, like Daumier. The complacency displayed in the simple poses of these local farmers would have had no place in standard genre painting. The painter must have been inspired by a real situation, by watching an actual card game, but that is not what he painted.

Instead, he had the men come sit for him in his studio, where he could do studies of them. Once he had worked out the role of each of the figures within the composition,[3] he would proceed, in ongoing sittings, to execute composite paintings.

With the last of these pictures, Cézanne freed himself once and for all from the idea of narration. He was not concerned with what his two figures were doing, but solely in their poses and the way they related to the space in terms of color. They are two men playing cards, but more important, they are structural elements in a painting. Such details as the angle of their heads, their lowered gazes, the bracing of their arms, or the positions of their fingers are not determined by what they communicate so much as by how they relate to the composition as a whole. A dark palette suggests something of the stolid patience of these men, who ignore the world around them as they concentrate on their game. The dominant forms, the reddish brown table, the hands and faces, and the light green jacket of the man on the right, are the ones painted with the greatest care. The trace of carmine red in the background and the small burst of cinnabar hinting at the view into an undefined landscape serve to balance the foreground colors, and the stark white of the cards provides effective contrast to the deepest blue black of the wall.

The formal details have been calculated as carefully as these intense color relationships. For example, the drama converging on the table, as the central object in the picture, is plotted with precision. The bottle at its far end stands squarely on the vertical axis and marks the intersection of the diagonals of the men's gazes and their bent forearms. Its tilt is thwarted by the heavy weight of arms resting on it on the right, while for balance, the thighs of the man on the left had to be greatly elongated. This figure's rigid posture, underscored by the straight line of his chair back and the stiff form of his hat, contrasts with the altogether more relaxed, easy attitude of his partner. Through the mere choice of colors, the stronger of the two figures radiates warmth and an engaging openness, while the other one remains coolly reserved. Even such seemingly insignificant details as their faintly indicated jacket pockets add to the contrast. Cézanne has gone so far as to enlist their respective hat brims and chair backs to express the men's contrary temperaments. The result is an unpretentious picture of mutual acceptance. These quiet comments are in large part responsible for transforming a perfectly mundane activity into a great work of art.

NOTES

1 Venturi 1936, nos. 559, 560.
2 While it is true that the Musée Granet in Aix acquired an insignificant painting of cardplayers by Jan Horeman in 1860, and that the young Cézanne produced a drawing after some genre scene with cardplayers, Chappuis 1973, no. 36, neither reference has any bearing here.
3 For the figure on the left, usually identified as Père Alexandre, the gardener at the Jas de Bouffan, see the portrait studies Venturi 1936, no. 566, Rewald 1983, no. 378, and as a verso Chappuis 1973, no. 1095. The figure on the right appears in the watercolor Rewald 1983, no. 380, and in the drawing Chappuis 1973, no. 1094.

PROVENANCE: Ambroise Vollard, Paris; Julius Elias, Berlin; J. B. Stang, Oslo; Alfred Gold, Berlin; Samuel Courtauld, London.
BIBLIOGRAPHY: Meier-Graefe 1918, 75, **194**; Meier-Graefe 1922, 75, **236**; Rivière 1923, 218; Mack 1935, 317f., 373; Raynal 1936, illus. 26; Venturi 1936, 59, 185, no. 557, **275**; Dorival 1949, 73ff., illus. 126, 169; Guerry 1950, 196; Schmidt 1952, 27; Cooper 1954, 380; Douglas Cooper, *The Courtauld Collection*, London 1954, 88, illus. 10; Badt 1956, 65f., 93, illus. 11; Reff 1958, **93**; Loran 1963, 93; Andersen 1970, 37, 39, 43; Murphy 1971, 199f.; Chappuis 1973, 250, no. 1094; Newcastle 1973, 164; Elgar 1974, 136, 141, illus. 85; New York 1977, 17, 20; Adriani 1978, 89, 325; Theodore Reff, "Cézanne's 'Cardplayers' and Their Sources," in *Arts Magazine* 55, no. 3 (November 1980), 104ff.; Adriani 1981, 282; Rewald 1983, 175, no. 377, 176, no. 378, 177, no. 380; Basel 1989, 260; Krumrine 1992, 592.
EXHIBITIONS: Berlin 1909, no. 31 Prague 1929, no. 8; *French Art*, Royal Academy, London 1932, no. 392, illus.; London 1954, no. 52; *Impressionist & Post-Impressionist Masterpieces. The Courtauld Collection*, The Museum of Art, Cleveland 1987 – The Metropolitan Museum of Art, New York – The Kimbell Art Museum, Fort Worth – The Art Institute of Chicago – The Nelson Atkins Museum of Art, Kansas City 1988, no. 26, illus.

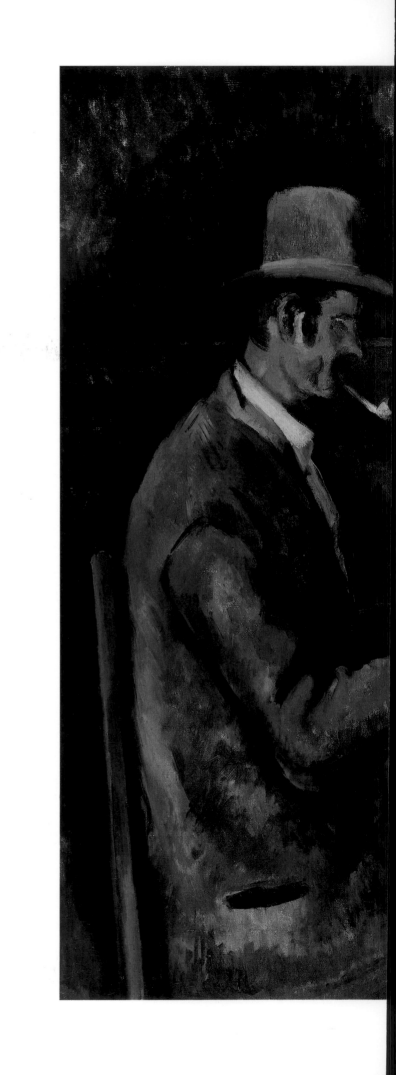

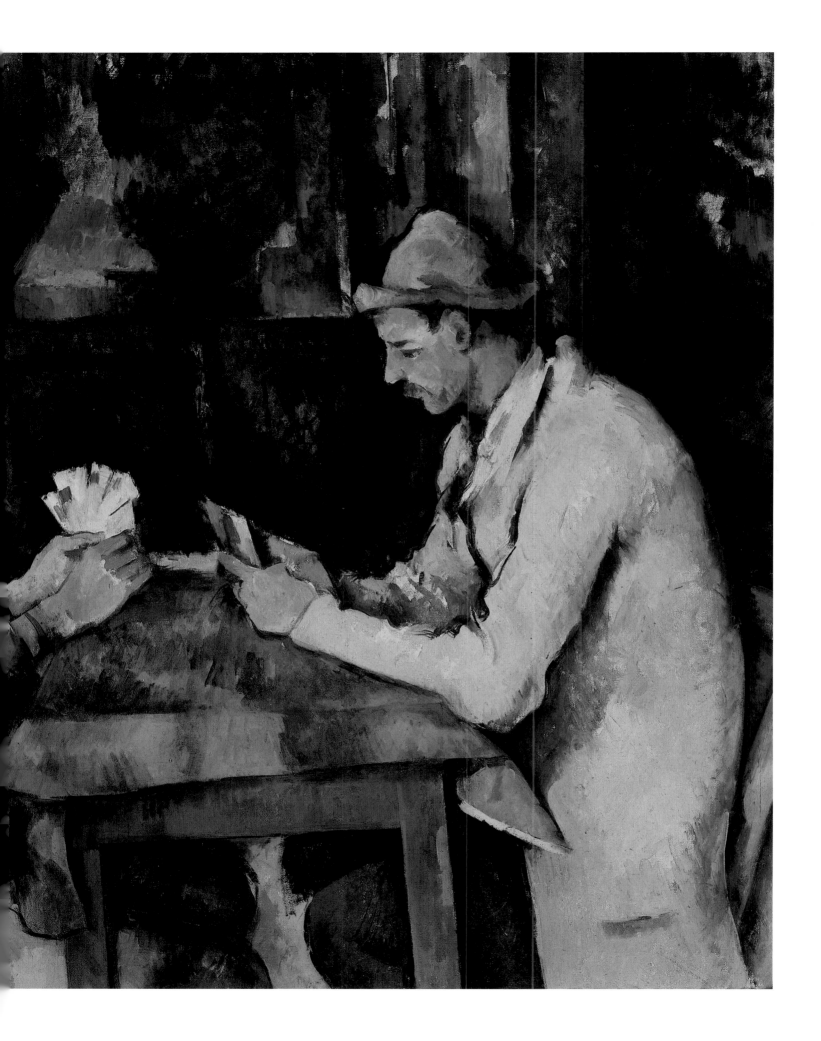

66 Two Cardplayers, 1892–95
Deux joueurs de cartes

Venturi no. 558 (1890–92)
Oil on canvas, 18 3/4 x 22 1/2" (47.5 x 57 cm).
Musée d'Orsay (inv. no. R.F. 1969), Paris

This version of the cardplayers is smaller than the previous one (cat. no. 65); it is cropped somewhat more closely, and in it, both men sit a bit more erect – even the hat worn by the one on the left is taller and straighter. The colors and the setting are essentially the same. The two are seated on what is possibly a veranda with a wooden balustrade and a view. The lighting is different, however, and we can assume that this is daylight in contrast to the third variant, which depicts the players in pale artificial light and leaves the view in darkness (illus. 1), the deep green of the landscape even finding its way into the shadows of the clothing.

Although there are no direct connections to Cézanne's earlier double portraits, it is clear that here he arrived at similar solutions to problems inherent to such works. He attempted only three such compositions; however, he always attached particular importance to these depictions of friendship. They include the two early portraits of Alexis reading to his friend Zola (cat. nos. 5, 6); the imposing, full-figure portrait of his son, Paul, and Louis Guillaume as Harlequin and Pierrot from 1888;[1] and finally, the various paintings of cardplayers, in which the artist reveals his close attachment to the people of his "hometown." Cézanne confessed to that attachment in a comment recorded by Jules Borély in 1902: "Today, everything we know is changing, but not for me; I live in the town of my childhood, and it is in the gaze of people of my own age that I look into the past. Above all, I love looking at people who have grown old without doing violence to tradition by adopting the rules of the times. I hate what these rules have done. Look at this café owner, sitting there in front of his door … what style!"[2]

NOTES

1 Venturi 1936, no. 552.
2 Borély 1982, 38.

PROVENANCE: Ambroise Vollard, Paris; Denis Cochin, Paris; Durand-Ruel, Paris-New York; Isaac de Camondo, Paris.
BIBLIOGRAPHY: Vollard 1914, illus. 1; Meier-Graefe 1922, 75; Rivière 1923, 218; Fry 1927, 69f., illus. 37; Ors 1936, **29**; Venturi 1936, 59, 185, no. 558, **275**; Novotny 1937, 8, 13f., 20, illus. 58; Cogniat 1939, illus. 76; Dorival 1949, 73ff., illus. 127, 169; Guerry 1950, 196; Schmidt 1952, 27; Cooper 1954, 380; Badt 1956, 65f., illus. 12; Gowing 1956, 191; Reff 1958, 93; Feist 1963, illus. 64; Loran 1963, 93; Andersen 1970, 37, 39, 43; Murphy 1971, 119f., 168; Brion 1973, **52f.**; Chappuis 1973, 250, no. 1094; Newcastle 1973, 164; Elgar 1974, 136, 142, illus. 86; Schapiro 1974, 16, **88f.**; Barskaya 1975, **35**; Wadley 1975, 56, illus. 49; Wechsler 1975, illus. 15; New York 1977, **17**, 20; Rilke 1977, illus. 8; Adriani 1978, **70**, 89, 325; Theodore Reff, "Cézanne's 'Cardplayers' and Their Sources," in *Arts Magazine* 55, no. 3 (November 1980), 104ff.; Adriani 1981, 282; Rewald 1983, 175, no. 377, 176, no. 378, 177, no. 380; Cézanne 1988, **178**; Erpel 1988, no. 20, illus.; Basel 1989, 260.
EXHIBITIONS: *Chefs-d'œuvre de la peinture,* Musée du Louvre, Paris 1945, no. 2; Aix-en-Provence 1953, no. 18, illus.; Paris 1954, no. 55, illus. 24; The Hague 1956, no. 35, illus.; Aix-en-Provence 1961, no. 12, illus. 8; Vienna 1961, no. 33, illus. 21; *Un siècle de peinture française 1850–1950,* Fondation Gulbenkian, Lisbon 1965, no. 22, illus.; Paris 1974, no. 44, illus.; Madrid 1984, no. 43, illus.

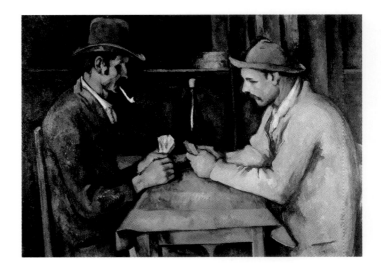

Illus. 1
Paul Cézanne, *Two Cardplayers,*
1892–95. Private collection

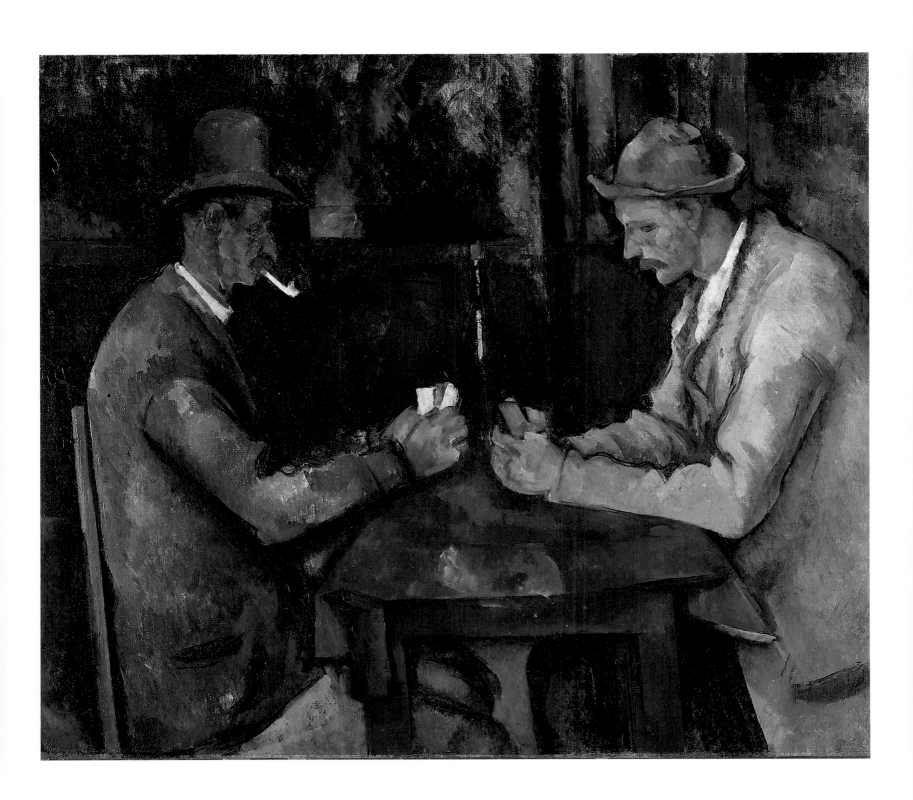

67 Self-Portrait with Soft Hat, circa 1894
Portrait de l'artiste, coiffé d'un chapeau mou

Venturi no. 579 (1890–94)
Oil on canvas, 23 5/8 x 19 5/8" (60.2 x 50.1 cm).
Bridgestone Museum of Art, Ishibashi Foundation, Tokyo

Of the twenty-three self-portraits he had produced before 1895 (see cat. nos. 13, 36), Cézanne selected for his first one-man show in the Galerie Vollard in Paris only the one shown here and another from about 1880.[1] Zola's onetime friend had long since been forgotten by the Parisian public, and apparently, he felt this bust portrait in three-quarter view to the right an appropriate way of reintroducing himself.[2] To judge from his apparent age and the gray hair, the painter would have been in his midfifties when he painted the work (see cat. no. 63, illus. 1). Accordingly, this portrait, based largely on shades of red, brown, and green, falls midway between the great *Self-portrait with Palette* from about 1890, in which his hair is still dark, and a closely related bust portrait from 1895.[3]

In November 1894, the American painter Mary Cassatt met Cézanne at Monet's in Giverny. Immediately afterward she described him, surely quite accurately, in a letter to a friend:

> He resembles the description of a southerner by Daudet. When I saw him for the first time, he struck me as a kind of brigand, with large, red bulging eyes, which gave him a ferocious air, further augmented by a pointed beard, almost gray, and a manner of speaking so violent he literally made the dishes rattle. I later discovered that I had let myself be deceived by appearances, for far from being ferocious, he has the sweetest possible temperament, like a child.... At first glimpse, his manners shocked me. He scrapes his soup plate and then tilts it and drains the last drops into his spoon; he picks up his cutlet in his fingers, tearing the meat from the bone. He eats with his knife, and with that instrument, which he firmly grasps at the beginning of the meal and doesn't relinquish until he rises from the table, he accompanies every gesture and movement of his hand. Yet, despite his total contempt for good manners, he displays toward us a politeness that none of the other men here could possibly equal.... Conversation at lunch and dinner is mainly about art and cooking. Cézanne is one of the most liberal artists I have ever seen. He begins each sentence with "For me, it's this way," but he acknowledges that others can be equally honest and truthful with regard to nature, according to their convictions. He does not think that everyone must see in the same way.[4]

NOTES

1 Venturi 1936, no. 368.
2 Vollard loaned this self-portrait for the famous Armory Show in New York and Chicago in 1913.
3 *Cézanne à la palette*, Venturi 1936, no. 516, and *Portrait de Paul Cézanne*, Venturi 1936, no. 578; see also the watercolor self-portrait Rewald 1983, no. 486.
4 Cézanne 1984, 239.

PROVENANCE: Ambroise Vollard, Paris
BIBLIOGRAPHY: Vollard 1914, 58, illus. 26; Meier-Graefe 1918, 188; Meier-Graefe 1922, 75, 228; Venturi 1936, 190, no. 579, illus.; Mack 1938, 290; Ratcliffe 1960, 21; Vollard 1960, 34; Feist 1963, illus. 50; *Bridgestone Gallery*, Tokyo 1965, no. 37, illus.; Andersen 1970, 39; Elgar 1974, 163, illus. 94; Rewald 1989, 202, illus. 103; *Masterworks, Paintings from the Bridgestone Museum of Art*, Tokyo 1990, 38f.
EXHIBITIONS: Paris 1895; Berlin 1909, no. 26; *Armory Show*, New York–Chicago–Boston 1913, no. 215; *Cézanne, Renoir*, Museum of Modern Art, Kamakura 1951, no. 5; *La Collection Ishibashi*, Musée National d'Art Moderne, Paris 1962, no. 8; Tokyo 1974, no. 61, illus.; Tokyo 1986, no. 34, illus.; Basel 1989, 166, illus. 132, 314, no. 52.

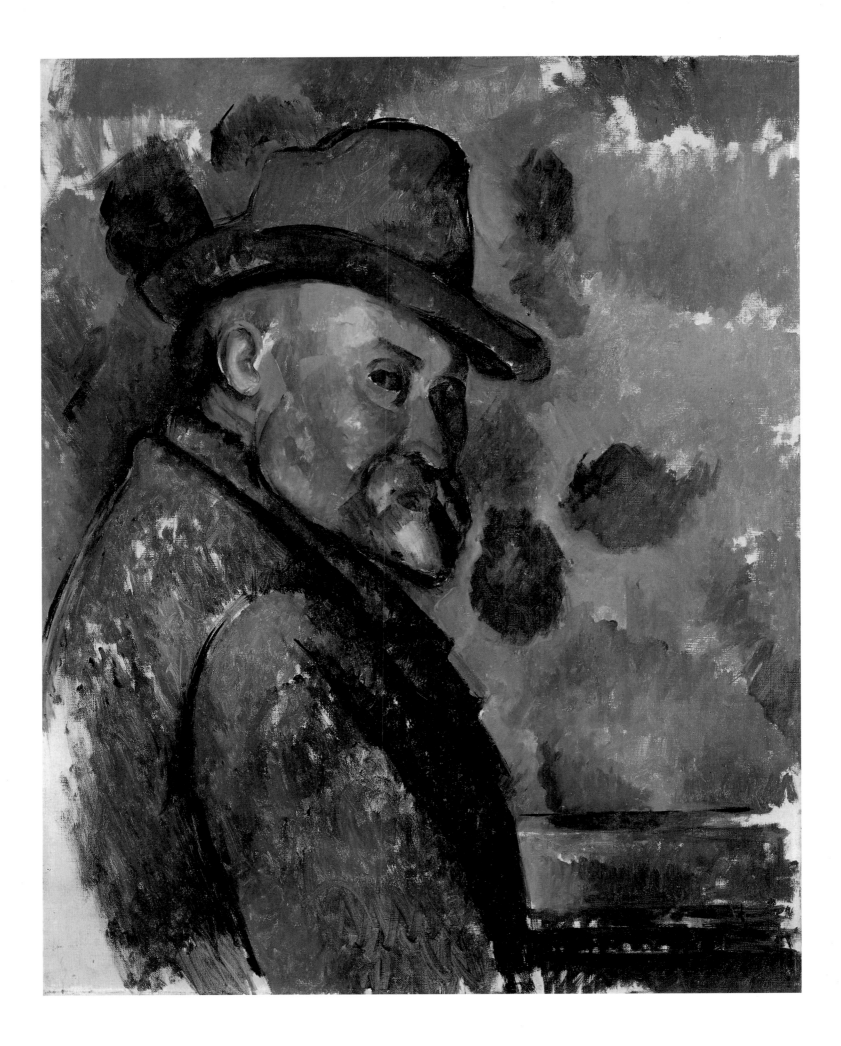

68 Joachim Gasquet, 1896

Venturi no. 694 (1896–97)
Oil on canvas, 25 7/8 x 21 3/8″ (65.5 x 54.5 cm).
Národní Galerie v Praze (inv. no. NG 03202), Prague

The writer Joachim Gasquet (1873–1921) was the son of Cézanne's schoolmate Henri Gasquet, who owned a bakery in Aix. He had a somewhat pompous style, and is chiefly remembered in Provence as an outspoken regionalist. Cézanne had become acquainted with him in the spring of 1896, and found his right-wing political views perfectly congenial. Gasquet's obvious admiration for him seems to have flattered the older man, who wrote countless letters to him between April 1896 and July 1904.[1] Gasquet's wrote his reminiscences of the painter in 1912–13, and these were published as a biography in 1921. A chauvinistic mix of fact and speculation, they are hardly reliable as scholarly source material.

Cézanne also executed a portrait of Gasquet's father (illus. 1), and there is no reason to question Gasquet's recollection of the painter's studio at the Jas de Bouffan at that time:

> Cézanne was in the process of finishing the portrait of my father. I attended the sittings. The studio was bare. Its only furnishings were his easel, the small table that held his paints, the chair my father sat on, and the stove. Cézanne worked standing up.... In one corner, leaning against the base of the wall, was a pile of canvases. A uniform soft light, blue from being reflected off the walls. On a light-colored wooden shelf, two or three plaster casts and some books.... Most of the time Cézanne, though holding his brush and palette in his hand, studied my father's face, examining it thoroughly. He did not paint. From time to time, a trembling placement of the brush, a stroke of thin pigment, a lively blue outlining an expression, revealing and confirming an evanescent character trait.... The next day, I found registered on the canvas the penetrating observations made the day before. On that day, an afternoon at the end of winter, you could feel spring in the air all around the Jas.[2]

Cézanne completed his portrait of Henri Gasquet in the spring of 1896, just before he undertook the one of his son Joachim. The latter's wife later recalled: "When the Henri Gasquet portrait was finished, it was placed in a corner facing the wall, and Cézanne chose to do one of my husband."[3] From Joachim Gasquet himself we learn that he sat for Cézanne only five or six times:

> I thought that he had given up the picture. Later, I discovered that he had spent roughly sixty sessions on it, that he was always thinking of his painting when he would give me a penetrating look during our conversations, and that he worked on it after I had left. He wanted to reveal life itself in one's features, the pulse in one's speech, and without my knowing it he brought me to the point of disclosing my innermost self to him.... It was customary for him, by the way, to paint on a portrait after the sitter had gone.... During numerous sittings, Cézanne would seem to make but a few brushstrokes, but he was constantly boring into his model with his eyes ... I emphasize that, since it has often been claimed that Cézanne was only able to paint directly before the model, and never worked in any other way. He had a memory for colors and lines like almost no one else. With a modesty like that of Flaubert, he stubbornly forced himself to observe the smallest facets of reality, harnessed his own ardor in

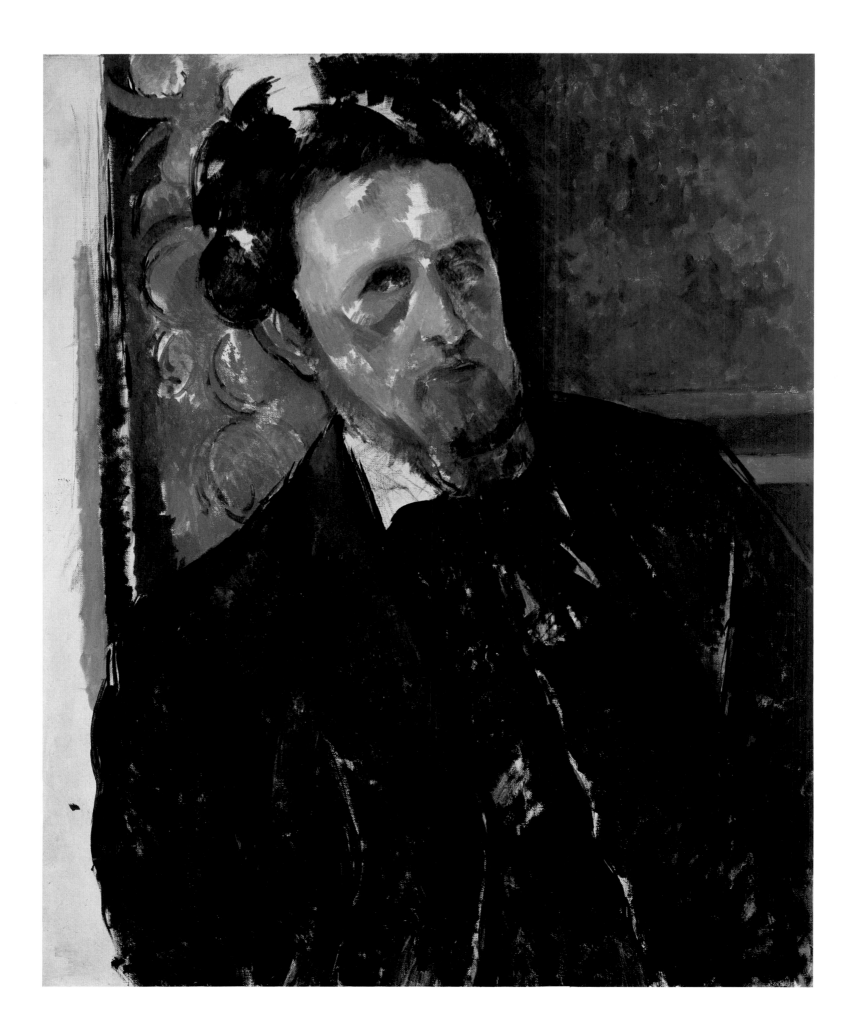

direct depiction of nature.... That, I believe, is the source of the seeming austerity that masks the human tenderness in his loveliest pictures.[4]

In his portrait of Joachim Gasquet, Cézanne employed the conventional bust form, but placed it at a most unconventional angle. A letter of Cézanne's to Gasquet from May 21, 1896, may allude to the work: "Being obliged to return to town early this evening, I cannot be at the Jas de Bouffan.... So until tomorrow, Friday, if you can, at the usual time."[5] This was surely a reference to one of the scheduled sittings for the portrait in his studio at the Jas de Bouffan. These had to be interrupted when Cézanne left at the beginning of June to take the cure in Vichy, then spend the summer in Talloires on Lake Annecy (see cat. no. 69),[6] and the fall and winter in Paris. Since the sittings were obviously not resumed, the picture remained unfinished in his studio. On the head especially, as the most three-dimensional form, and in the adjacent curtain, the color has been laid on very thin, so that the preliminary drawing shows through. The blue light of the studio noticed by the sitter sets the tone, and places the work, one of the most fascinating portraits from Cézanne's late years, among the large series of "blue" paintings created in his studio at the Jas de Bouffan (see cat. nos. 55, 58, 59, 64).

NOTES

1 In one from April 30, 1896, he noted: "All my life I've worked in order to be able to earn my living, but I thought that one could do good painting without attracting attention to one's private life. Of course, an artist attempts to elevate himself intellectually as much as he can, but the man must stay in the background. The pleasure must stay in the work.... I might as well be dead, for that matter. You are young, and I can understand that you want to get ahead. As for me, however, the only thing I can do in my situation is to fade away, and were it not that I have an enormous affection for the contours of my countryside, I wouldn't be here." Cézanne 1984, 249–50.
2 Gasquet 1930, 145.
3 New York 1977, 387.
4 Gasquet 1930, 68.
5 Cézanne 1984, 250.
6 From there, the painter wrote Gasquet on July 21, 1896, in a style somewhat resembling that of the addressee: "I recommend myself to you and your good thoughts, so that the links that keep me attached to our old native soil, so vibrant, so harsh and so reverberant with light that your eyelids squint and your vessels of sensation are enchanted, will never break and set me loose as it were from the land where I felt, even without realizing it, so much." Cézanne 1984, 252.

PROVENANCE: Ambroise Vollard, Paris.
BIBLIOGRAPHY: Gasquet 1921, **91**; Meier-Graefe 1922, **249**; Rivière 1923, 221; Gasquet 1930, 68; Mack 1935, illus. 40; Venturi 1936, 214, no. 694, illus.; Novotny 1937, illus. 79, illus. 80; Mack 1938, illus.; Dorival 1949, 96, illus. 155, 173; Cooper 1954, 380; John Rewald, *Cézanne, Geffroy et Gasquet suivi de souvenirs sur Cézanne de Louis Aurenche*, Paris 1959, illus. 3; Ratcliffe 1960, 22; Cézanne 1962, illus., 230; Feist 1963, illus. 61; Leonhard 1966, **50ff.**; Andersen 1970, 39; Brion 1973, **14**; Elgar 1974, 171, illus. 97, 180, 218; New York 1977, 14, 29, 210, illus. 2, 387; Venturi 1978, **41**; Hülsewig 1981, 41, 56f., 72, illus. 18; Cézanne 1988, **301**; Gasquet 1991, frontispiece.
EXHIBITIONS: Paris 1920, no. 13, illus.; *Französische Kunst des 19. und 20. Jahrhunderts*, Gemeindehaus, Prague 1923, no. 142; Paris 1936, no. 104; Aix-en-Provence 1956, no. 53, illus.; The Hague 1956, no. 44; Zurich 1956, no. 75, illus. 37; Munich 1956, no. 58, illus.; Vienna 1961, no. 36; *Le portrait en Provence de Puget à Cézanne*, Musée Cantini, Marseilles 1961, no. 4; Paris 1978, 67ff., no. 2, illus., 240; *European Art from the Collection of the National Gallery in Prague II*, Takashimaya Nihonbashi, Tokyo 1982, no. 14; *Modern Treasures from the National Gallery in Prague*, The Solomon R. Guggenheim Museum, New York 1988, no. 3, illus.; *Impressionismo in Europa*, Casa di Rispamio, Bologna 1990, no. 23.

Illus. 1
Paul Cézanne, *Portrait of Henri Gasquet*, 1896.
The MacNay Art Institute, San Antonio, Texas

69 Child with Straw Hat, 1896
L'enfant au chapeau de paille

Venturi no. 698 (1896)
Oil on canvas, 31 7/8 x 25 5/8″ (81 x 65 cm)
Galerie Yoshii, Tokyo

Venturi notes that this picture of a boy wearing a straw hat was painted during Cézanne's stay in Talloires on Lake Annecy in July and August of 1896. His assertion is confirmed in that the verso of a watercolor study for the child's portrait presents a view of the lake.[1]

Cézanne's only stay abroad had been a very unhappy visit to French Switzerland in the summer of 1890. This second and last summer vacation trip six years later, in the Haute-Savoie region of France, does not appear to have been any more successful: "I have left our Provence for a while," he reported to Joachim Gasquet (see cat. no. 68) on July 21 from Talloires. "After considerable shilly-shallying, my family, in whose hands I find myself at the moment, has persuaded me to settle temporarily where I now find myself. It's a temperate climate. The surrounding hills are high enough. The lake, which is narrowed here by two channels, seems made for the linear exercises of young misses. It's the same old nature, of course, but more as we have been taught to see it in the sketchbooks of young lady tourists."[2] Two days later he described his situation with a similar detachment to the Aix sculptor Philippe Solari: "When I was at Aix, I had the feeling I would be better off somewhere else, now that I'm here, I miss Aix. For me, life has begun to be deathly monotonous. To overcome my boredom, I am painting, it's not greatly amusing, but the lake, with the high hills around it is very fine, they tell me they're two thousand meters high, it's not our countryside, but all right as far as it goes. However, when you've been born there, that's it – nothing else can compare."[3]

Since the mountain landscape with the lake apparently did not particularly appeal to Cézanne – though he did produce his famous view of it, the *Lac d'Annecy*[4] – and neither his wife nor his son, Paul, were eager to detract from their own amusements by sitting for portraits, he had to make do with a small boy as a model

Illus. 1
Paul Cézanne,
Child with Straw Hat, 1896.
Los Angeles County Museum of Art

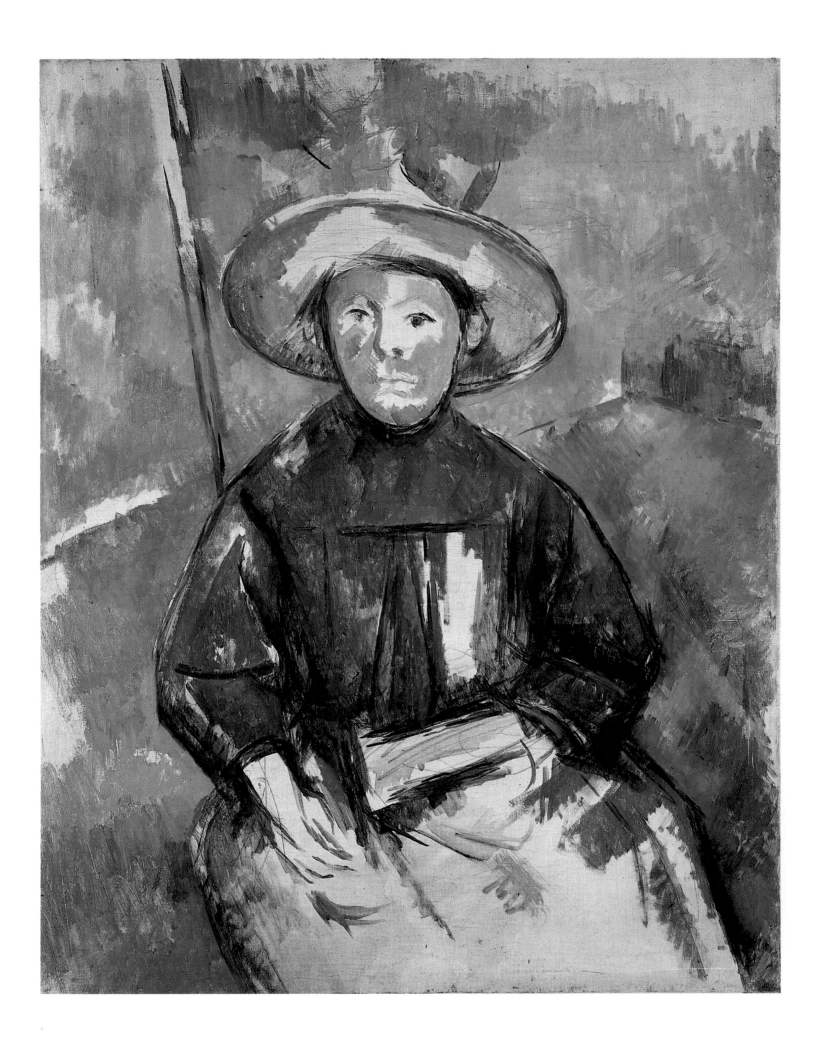

(illus. 1). The patience of this child posed in his smock on a lawn must have been limited. This would explain why the painting was only blocked out and provided with its first thin layers of color. Apparently, Cézanne then took the canvas with him from Talloires to Paris, where it waited in vain to be completed. Finally, at the urging of Cézanne's son, the painting was placed in the hands of the art dealer Ambroise Vollard for safekeeping. The painter had absolute faith in Vollard after the successful exhibition he had mounted the year before. This work is one of the very few portraits Cézanne painted outdoors.

NOTES

1 Rewald 1983, nos. 482 (recto), 468 (verso); see also the portrait studies Rewald 1983, nos. 480, 481, 483; Chappuis 1973, no. 1985.
2 Cézanne 1984, 251.
3 Ibid., 252-53.
4 Venturi 1936, no. 762.

PROVENANCE: Ambroise Vollard, Paris.
BIBLIOGRAPHY: Venturi 1936, 215, no. 698, 277, **326**; Ratcliffe 1960, 23; Andersen 1970, 43, 236; Newcastle 1973, 168.
EXHIBITIONS: Basel 1983, no. 25, illus.

70 Arc River Plain, 1892–95
La plaine de L' Arc

Venturi no. 472 (1885–87)
Oil on canvas, 32 1/4 x 26″ (82 x 66 cm).
The Carnegie Museum of Art, Acquired through the generosity of the
Sarah Mellon Scaife family, 1966 (inv. no. 66.4), Pittsburgh

Despite the improvement in Cézanne's fortunes following the death of his father, which might have permitted him a more comfortable way of life with extensive travel, the artist remained committed to his modest rhythm of work and the motifs of his homeland that he had always preferred. The subjects within easy reach of Aix – the country roads, forests, river, hills, and mountains – were scenery enough. His habit of presenting large expanses of landscape through a screen of trees, thereby connecting the close at hand to the remote distance, is especially apparent in two wonderful vistas: the Bay of Marseilles from L'Estaque (see cat. no. 72), and the broad plain of the Arc Valley (see cat. no. 71). With the exception of these two examples, each the last of its kind, most of these views through trees were painted in about the mid 1880s.[1] In them the inclusion of the sea or the profile of the Mont Sainte-Victoire was meant to heighten the effect. However, this tall-format *Arc River Plain,* very freely executed, is less picturesque, and certainly dates from a later period than suggested by Venturi. Above the sunburned earth, the green pine needles gleam against an ethereal blue sky in such a way as to perfectly capture the sparkling atmosphere of a Provençal landscape in summer.

NOTES

1 Venturi 1936, nos. 406, 425 (cat. no. 23), 427, 452–55, 459, 477.

PROVENANCE: Dikran Khan Kelekian, Paris-New York; Kelekian auction, American Art Association, New York, January 30-31, 1922, no. 148; John Quinn, New York; Paul Cassirer, Berlin; Max Silberberg, Breslau; S[imon] and S[ilberberg] auction, Galerie Georges Petit, Paris, June 9, 1932, no. 12; Etienne Bignou, Paris; C. Suydam Cutting, Mine Mount; Brady Foundation, New York; Wildenstein, Paris-London-New York.
BIBLIOGRAPHY: Venturi 1936, 166f., no. 472, illus.; Novotny 1937, illus. 46; Brion 1973, 78; *Catalogue of Paintings Collection, Museum of Art, Carnegie Institute,* Pittsburgh 1973, 37, illus. 45; Rewald 1989, 320f., illus. 166, 327, 330, 341.
EXHIBITIONS: *Französische Kunst des XIX. und XX. Jahrhunderts,* Kunsthaus, Zurich 1917, no. 28; *Paintings by Modern French Masters,* Brooklyn Museum, New York 1921, no. 25; New York 1935; New York 1947, no. 29; *From the Collection of Mrs. C. Suydam Cutting, Paintings, Drawing, Prints,* Museum, Newark 1954, no. 6; *Masterpieces of Impressionist and Post-Impressionist Painting,* National Gallery of Art, Washington 1959, no. 29.

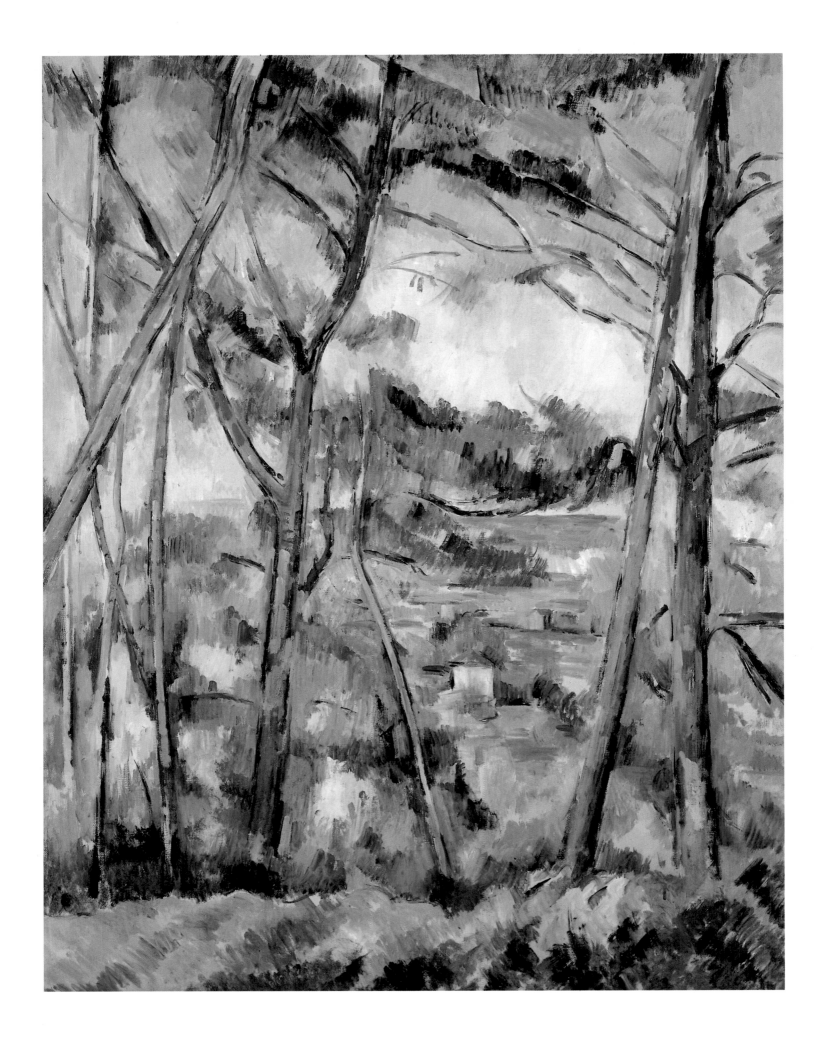

71 Large Pine and Red Earth, circa 1895
 Grand pin et terres rouges
 Venturi no. 458 (1885–87)
 Oil on canvas, 28 3/8 x 35 7/8" (72 x 91 cm).
 State Hermitage Museum (inv.no. 8963.01), St. Petersburg

This motif of a single, monumental tree with a powerful trunk and a wide-spreading
network of delicate branches is found in two paintings that Venturi dated to 1885–87.
He was surely correct about one of them, in which the thin colors and the smaller
brushstrokes are fully consistent with the artist's style in the mideighties (illus. 1). Its
counterpart, however, from the famous Morosow Collection in Moscow, presents a very
different style. Once again, the painter had set up his easel in front of this large pine
above the Arc Valley near the farm called Bellevue, which his sister Rose had
purchased in early December 1886. He now stood a bit farther to the right, so that the
tree comes to stand to the left of the center axis. The pattern of the branches remains
much the same. The trunk and branches have become somewhat thicker, quite
possibly thanks to ten years of new growth. The undergrowth is also denser, obscuring
much of the view of the valley. The colors have now been applied in generous broad
strokes, and reveal an astonishing degree of stylization conforming to the overall
structure of the composition. Yet, the painter has masterfully attended to certain
realistic details: the complicated structure of the top of the tree, its intersecting
branches, the scars on its trunk.[1]

NOTES

1 Three watercolors, Rewald 1983, nos. 285–87, may have been done for the sole purpose of clarifying the
 paths of these branches.

 PROVENANCE: Ambroise Vollard, Paris; Ivan Morosow, Moscow; Museum of Modern Western Art,
 Moscow.
 BIBLIOGRAPHY: Venturi 1936, 55, 163, no. 458, illus.; Novotny 1937, illus. 44; Feist 1963, illus. 69;
 Newcastle 1973, 164; Elgar 1974, 186, illus. 108; Barskaya 1975, 36ff., illus. 17, **182**; New York 1977, **23f.**;
 Adriani 1981, 270; Rewald 1983, 153f., nos. 285–87, 169, no. 349; Frank 1986, illus.
 EXHIBITIONS: *Masterpieces of Modern Painting from the Soviet Union*, Museum of Modern Art, Tokyo
 1966 – Museum of Modern Art, Kyoto 1967, no. 58; *Capolavori impressionisti e postimpressionisti dai musei
 sovietici*, Collection Thyssen-Bornemisza, Lugano 1983, no. 30, illus.; *Da Cézanne a Picasso. 42 capolavori
 dai musei sovietici*, Musei Capitolini, Rome 1985 – Museo Correr, Venice 1985, no. 36, illus.

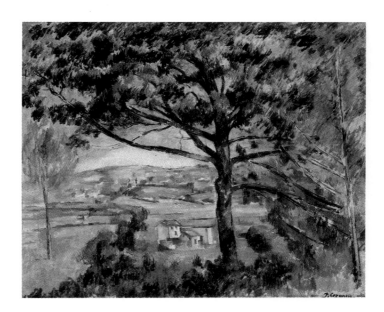

Illus. 1
Paul Cézanne,
Large Pine and Red Earth, 1885.
Private collection

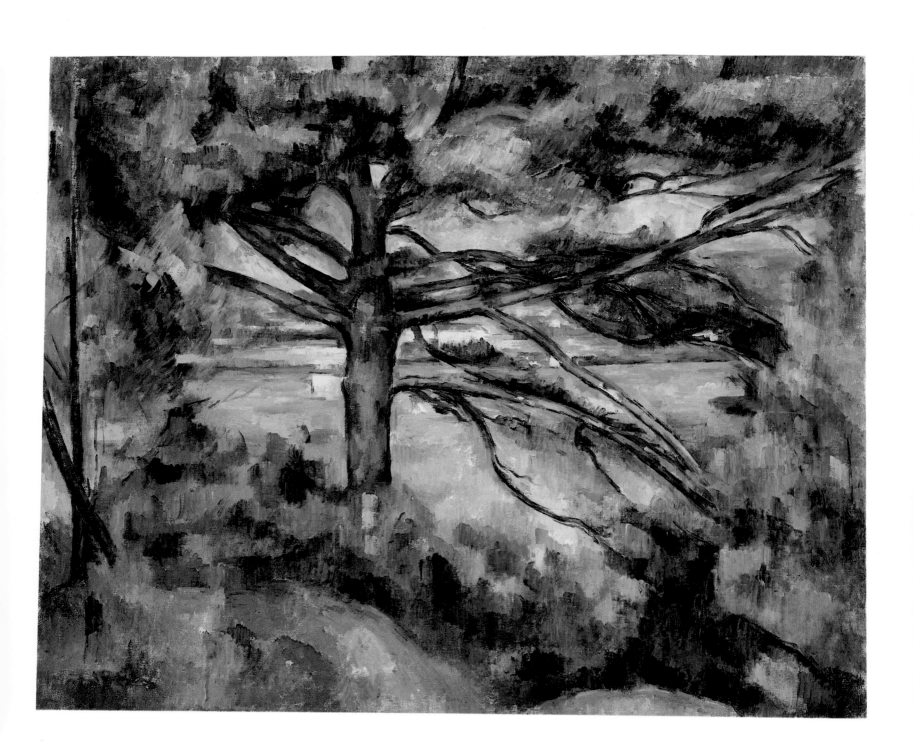

72 The Sea at L'Estaque, 1895–98
La mer à L'Estaque

Venturi no. 770 (1898–1900)
Oil on canvas, 39 3/8 x 31 7/8″ (100 x 81 cm).
Staatliche Kunsthalle (inv. no. 2450), Karlsruhe

In a letter Cézanne wrote to his boyhood friend Henri Gasquet on June 3, 1899, the artist nostalgically recalled that "the vibrations of those feelings set in motion by the lovely Provençal sun have not completely died out for us, [of] our memories of our past youth, the horizons, landscapes and unforgettable outlines that have left so many deep impressions upon us."[1] While this late landscape of trees and rocks records the forms and colors the painter actually saw at his easel, its exquisite harmonies are rooted in those old memories.

Venturi lists some twenty views of the bay at L'Estaque. If one compares the first of them (cat. no. 19) with this one, the last, one notes that the fundamental structural principles of these landscapes remained constant over two decades. Whether Cézanne chose to work in a horizontal or a vertical format, there is always a diagonal leading into the space of the picture, beyond which there is an abrupt leap to the more remote features of the landscape. Over time, this diagonal became steeper and steeper, leaving room for only a relatively narrow strip of sky above the sea. The charming glimpses of red-tiled roofs, three-dimensional shaded areas of deep green, and the blue of the water and sky at the top maintain the same intensity of color despite the distance. The varied curves of the pine trunks braced against the prevailing mistral are highly expressive in themselves – not unlike Van Gogh's cypresses – and they also soften the predominance of verticals.

Cézanne apparently decided to be content with this last view of L'Estaque and never return, more than likely because he could not bear to see what relentless industrialization was doing to the landscape. He registered something of his dismay in a letter to his niece on September 1, 1902: "I remember Establon and the once so picturesque shores of L'Estaque very well. Unfortunately, what we call progress is nothing but the invasion of bipeds, who won't stop until they have transformed the whole thing into hideous quays with gas lamp standards and – even worse – electric light. What kind of times are we living in!"[2]

NOTES

1 Cézanne 1984, 268.
2 Ibid., 285.

PROVENANCE: Ambroise Vollard, Paris; Paul Cassirer, Berlin; Alexander Lewin, Guben-New York; Alix Kurz, New York; Feilchenfeldt, Zurich.
BIBLIOGRAPHY: Faure 1923, illus. 47; Venturi 1936, 230f., no. 770, illus.; Guerry 1950, 130; Badt 1956, 35, 242, illus. 44; Feist 1963, illus. 68; Badt 1971, **14f.**; Jan Lauts, Werner Zimmermann, *Staatliche Kunsthalle Karlsruhe. Katalog Neuere Meister,* Karlsruhe 1971, **40f.**
EXHIBITIONS: *Centennale de l'art française 1812–1912,* Hermitage, St. Petersburg 1912, no. 588e; Paris 1920, no. 11, illus.; *Schilderijen van Delacroix tot Cézanne en Vincent van Gogh,* Museum Boymans, Rotterdam 1933, no. 3, illus.; Vienna 1961, no. 37, illus. 23.

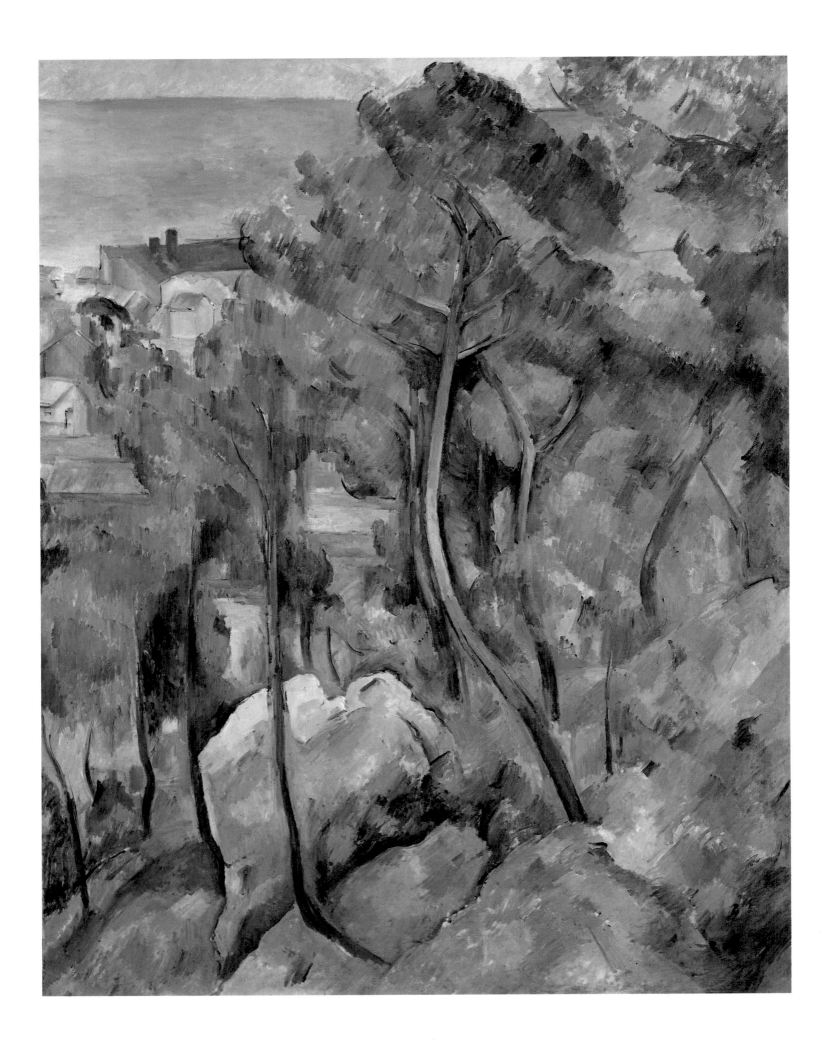

73 Village Behind Trees, 1898
Village derrière les arbres

Venturi no. 438 (circa 1885)
Oil on canvas, 26 x 32 1/4" (66 x 82 cm).
Kunsthalle (inv. no. 373.1918/1), Bremen

The Cézanne biographer Georges Rivière mentions in his monograph from 1923 a landscape with a village behind trees that was painted in 1898 in Marines.[1] His son-in-law Paul Cézanne *fils,* is supposed to have given him his information. The painting shown here is the only landscape from the artist's late period that would fit his description. The only comparable views of the region around Auvers-sur-Oise and Pontoise date from the 1870s.[2] In 1898, Cézanne sojourned in the vicinity of those two towns, the landscape in which he had so often met with Pissarro (see cat. nos. 25–27). This was his last visit. In the summer, he worked in Montgeroult and Marines to the north of Pontoise, in Marlotte, on the edge of the forest of Fontainebleau, and in nearby Montigny-sur-Loing.

Venturi assumed that this painting dated from about 1885, and depicted a landscape in Provence. Its style also tends to refute that assumption. The strong juxtaposition of a rich orange ocher and bluish green argue for the late period, as do the complexity of the artist's conception of space and of his development of surface relationships. Behind a row of trees edging a horizontal road we glimpse a village nestled in a hollow. Some fields stretch back to the horizon, which is hidden behind the treetops. The broad patches of the ocher and orange tones that also serve to set off the verticals of the tree trunks move back in parallel planes from the suggestion of the road to the far distance, and balance the soaring color ensembles of Prussian blue, violet, delicate and emerald greens, cinnabar, and olive set off against the sky.

Remarkably, the Bremen Gallery Society purchased this landscape for the enormous sum of ninety-five thousand gold marks in 1918, at a time when opponents of the purchase insisted that it represented the culture of Germany's "arch enemy." That the society chose to proceed with the acquisition is a credit to the tolerance of its members and of its director, Emil Waldmann.

NOTES

1 Rivière 1923, 222.
2 See the landscapes *Auvers à travers les arbres,* Venturi 1936, no. 151, and *Le mur d'enceinte,* Venturi 1936, no. 158.

PROVENANCE: Bernheim-Jeune, Paris; Herbert Kullmann, Manchester; Kullmann auction, Hôtel Drouot, Paris, May 16, 1914, no. 2; Bernheim-Jeune, Paris; Paul Cassirer, Berlin; Sally Falk, Mannheim; Paul Cassirer, Berlin.
BIBLIOGRAPHY: Meier-Graefe 1918, **187**; Emil Waldmann, *Die Bremer Kunsthalle,* Berlin 1919, **48f.**; Meier-Graefe 1922, **226**; Rivière 1923, 222; Venturi 1936, 159, no. 438, illus.; Brion 1973, **44**; Gerhard Gerkens, Ursula Heiderich, *Katalog der Gemälde des 19. und 20. Jahrhunderts in der Kunsthalle Bremen,* Bremen 1973, 54, illus. 606; Rewald 1983, 199 (no. 460).
EXHIBITIONS: *XVIII. Jahrgang, II. Ausstellung,* Galerie Paul Cassirer, Berlin 1915, no. 53; Philadelphia 1934, no. 19; The Hague 1956, no. 22; Zurich 1956, no. 49, illus. 22; Cologne 1956, no. 26, illus.; *Französische Malerei des 19. Jahrhunderts von David bis Cézanne,* Haus der Kunst, Munich 1965, no. 27, illus.; New York 1977, 205, 280, illus. 77, 391f., no. 20, 409; Paris 1978, 164f., no. 62, illus. 242; Tokyo 1986, no. 35, illus.

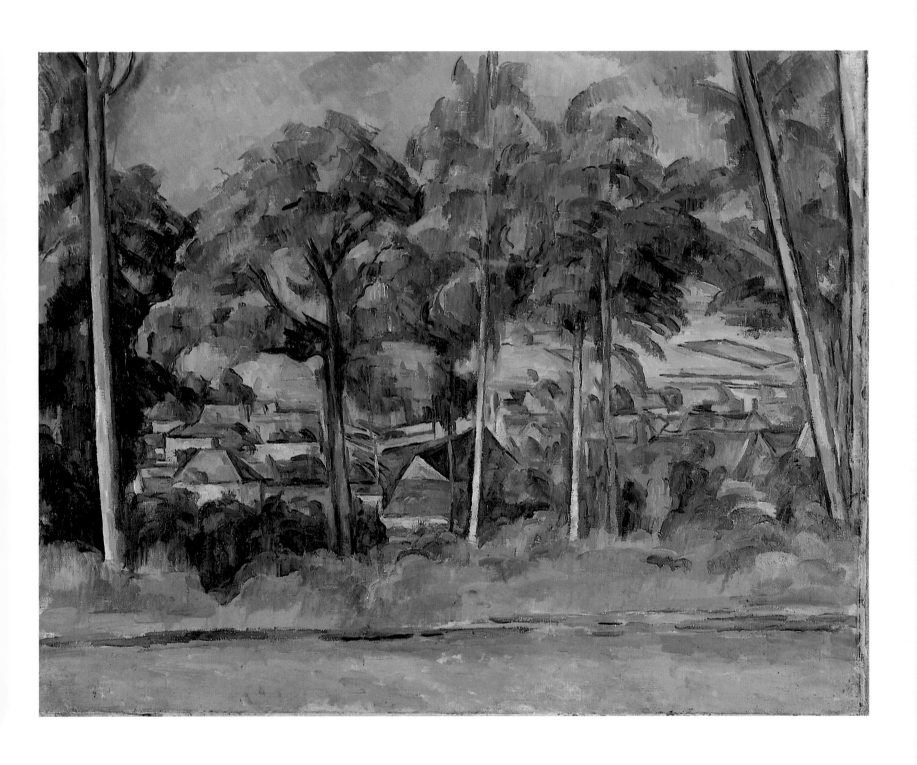

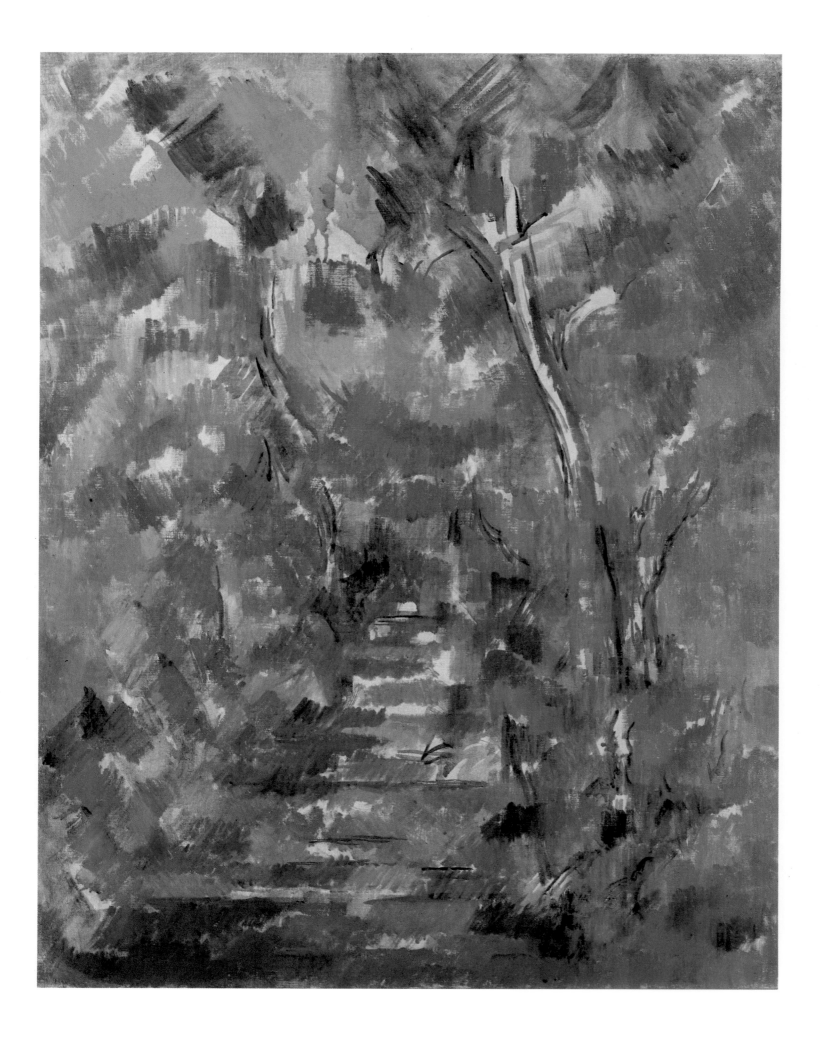

74 The Road from Mas Jolie to Château Noir, 1898–1900
Chemin du Mas Jolie au Château Noir

Venturi no. 1527 (1895–1900)
Oil on canvas, 31 3/8 x 25 3/8" (79.5 x 64.5 cm).
Beyeler Collection, Basel

After a long stay in Paris, Cézanne returned in the fall of 1899 to Aix-en-Provence, there to spend most of the remaining seven years of his life. The Jas de Bouffan, his home for decades, had to be sold in November of that year to settle his mother's estate. The painter immediately tried to buy – without success – a property halfway between Aix and Le Tholonet that boasted a nec-Gothic complex of buildings known as Château Noir. At this time, he often worked in the vicinity (see cat. nos. 95, 96) on the Tholonet road, which leads due east out of Aix toward Mont Sainte-Victoire. He had walked this road in search of subjects for paintings since his youth.

In this instance, he was drawn by neither the scenic mountain massif nor the only slightly less picturesque Château Noir, but rather by a forest road he happened to notice in passing. His painting of this lonely spot, protected from the gazes of the curious and far from the traffic of the main roads, was in part a testimonial to an area he had known since his childhood. The motif also presented a challenge, demanding that he utilize his powers of imagination to the utmost. The task of translating its unimposing view of a road leading back into the distance onto canvas became for him an exercise in pure painting. Deliberately including the white of the canvas in his color decisions, he proceeded to create a dense texture of brushstrokes that offers only a suggestion of the reality before him. Its colors, ranging from a dark slate gray to lighter and lighter shades of blue, green, and ocher, are made to stand equally for foreground and background, undergrowth and treetops. A lustrous blue serves as both underpainting for additional treetops and a suggestion of the gleaming sky above.

Comparing this work with *Tree-lined Path, Chantilly* (cat. no. 51) from roughly ten years before, we see something of the distance the artist had put behind him in the 1890s. He now could entrust the picture concept even more exclusively to the rhythms of color, and was intent on tying the space even more closely to the surface in tightly interlocking color patterns.

PROVENANCE: Ambroise Vollard, Paris; G. David Thompson, Pittsburgh; Sotheby's auction, London, April 26, 1967, no. 26.
BIBLIOGRAPHY: Venturi 1936, 333, no. 1527, illus.; Wadley 1975, 80, illus. 74; Rilke 1977, illus. 12; *du* 1989, 73.
EXHIBITIONS: *Thompson Collection*, Kunsthaus, Zurich 1960 – The Solomon R. Guggenheim Museum, New York 1960, no. 19, illus.; New York 1977, 46, 72, 205, 275, illus. 72, 389, no. 9; Paris 1978, 160ff., no. 60, illus., 242; Basel 1983, no. 23, illus.; *Coleccion Beyeler* (ed. Reinhold Hohl), Centro de Arte Reina Sofia, Madrid 1989, 35ff., illus.; Aix-en-Provence 1990, no. 35, 317, illus. 246.

75 Stream Through a Wood, 1898–1900
 Eau courante en sous-bois
 Venturi no. 783 (1898–1900)
 Oil on canvas, 23 1/4 x 31 7/8″ (59.1 x 81 cm).
 The Cleveland Museum of Art,
 Bequest of Leonard C. Hanna, Jr. (inv. no. 58.20), Cleveland

At first glance, this choice of motif seems perfectly arbitrary: a wealth of foliage
spotted by sunlight, a suggestion of meadow, and the broad blue of a stream winding
through the underbrush and washing against the spit of land upon which the painter
had placed his easel. The landscape is certainly proof of the degree to which
Impressionism continued to influence even Cézanne's late work. True to his own
convictions, the painter has managed to stabilize this atmospheric tapestry of earth,
foliage, sky, and their reflections in the water by means of delicate, diagonal
correlations between the dark color masses of lower left and the glimpses of blue sky
at upper right, and by turning vegetation into a solid vault of branches and leaves.

PROVENANCE: Ambroise Vollard, Paris; Galerie Heinemann, Munich; Thomas Metcalf, Boston.
BIBLIOGRAPHY: Venturi 1936, 233, no. 783, illus.; Badt 1956, 242; New York 1977, 26, 273, illus. 70.
EXHIBITIONS: New York 1952, no. 9, illus.; Tokyo 1974, no. 49, illus.

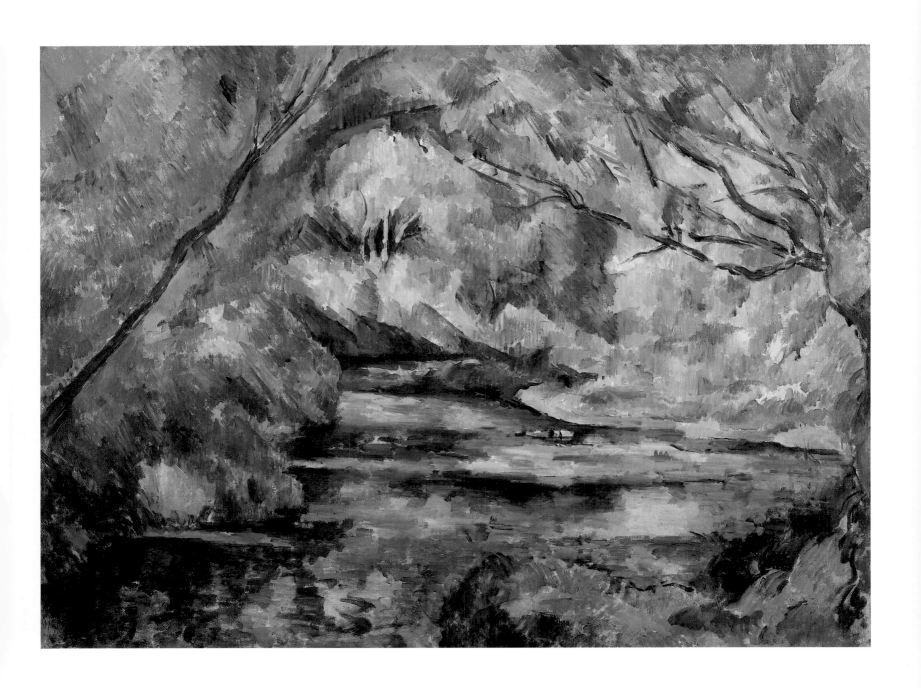

76 Standing Nude, 1898–99
Femme nue debout

Venturi no. 710 (circa 1895)
Oil on canvas, 36 1/2 x 28″ (92.8 x 71.1 cm).
Private collection

This is the only large-format, full-figure standing female nude in all of Cézanne's work.[1] The only painting that might be thought of as a male counterpart to it is the *Large Bather* posed as though walking in front of an open landscape (illus. 1), which was painted after a photograph of a model. Neither figure appears in any of the compositions of bathers. The cool blue atmosphere of that earlier work is here supplanted by the warm reddish browns of an interior. The vertical figure occupies the axis of the picture, while the wall behind her, blank except for a picture that is partly visible in the upper right, is structured by horizontals. Her full-blooded flesh tones are attuned to the darker lower section of the wall. Her feet, firmly anchored as the supports for a heavy body stretched taut by the raised arms, might have been modeled by Giacometti. Motionless and self-contained, she maintains a pose twisted forward from the diagonal, her weight thrown onto her left leg. Yet, she displays none of the natural ease that characterizes the roughly contemporary female nudes at their toilets in the paintings of Degas. Cézanne's figure is far from the classical ideal, but somehow evokes it nonetheless. No longer young and not particularly attractive, she exudes a certain melancholy. Her coarseness and coloring anticipate the statuesque Fauvist nudes of Matisse, and Picasso's early Cubist ones from the following decade.

In his biography of Cézanne published in 1923, Georges Rivière lists this work from the Pellerin Collection in Paris, and claims that a certain Marie-Louise served as the model for it in 1898.[2] Venturi questioned that assertion, and dated the nude to 1895, proposing that it represents the artist's wife. Not only is it highly unlikely that Hortense did any posing for him after 1892 (see cat. no. 44), but Rivière doubtless had his information directly from his son-in-law Paul Cézanne *fils*. Furthermore, the brown wall we see here is identical to the one in the portrait of Cézanne's dealer Ambroise Vollard (cat. no. 78, illus. 1), and that work we know to have been painted in 1899 in Cézanne's Paris studio at 15, rue Hégésippe-Moreau. The painter rented the space in Montmartre from the summer of 1898 to the fall of 1899. In Vollard's sometimes rather fanciful reminiscences, there is the story that one day, to his great astonishment, Cézanne announced that he was going to paint a nude woman at the same time he was doing Vollard's portrait:" 'But Monsieur Cézanne,' I cried, 'a naked woman?' 'Oh, Monsieur Vollard, I'll use some dried-up old frump!' He did find one of the sort he had in mind, and used her for a nude and two portraits. Cézanne confessed to me that he was much less happy with this 'camel' than he was with me. 'Working with a female model is very difficult,' he explained. 'Moreover, a sitting costs me a lot of money; it comes to nearly four francs, twenty centimes more than in the years before 1870.' "[3]

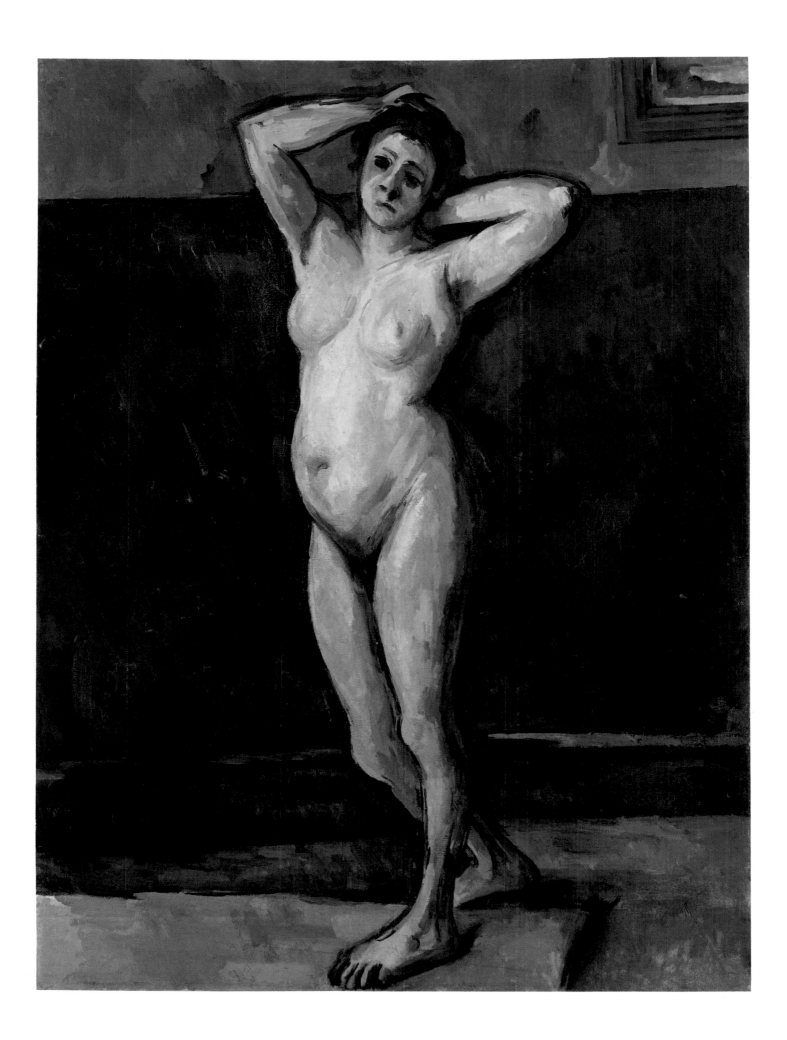

NOTES

1 See the watercolor study Rewald 1983, no. 387.
2 Rivière 1923, 222.
3 Vollard 1960, 52. According to Vollard, "The studio in the rue Hégésippe-Moreau was even more simply furnished than the one in Aix. A few Forain reproductions cut out of the newspapers formed the basis of the master's Paris collection ... I regret that it was I who suggested he hang a few of his own works on the walls. He hung some ten or so of his watercolors; but one day, unable to get the effect he wanted in a still life, he tore down the watercolors with much cursing and swearing and threw them in the stove. I saw the flames leap up; chastened, the painter then returned to his palette." Ibid., 49f. One should note that the picture-in-a-picture motif behind the nude on the right does not appear to be either a Forain reproduction or a watercolor by Cézanne.

PROVENANCE: Ambroise Vollard, Paris; Auguste Pellerin, Paris; Jean-Victor Pellerin, Paris.
BIBLIOGRAPHY: Rivière 1923, 222; Larguier 1925, **80**; Fry 1927, 80, illus. 48; Ors 1936, illus. 12; Venturi 1936, 218, no. 710, **276**; Barnes, Mazia 1939, 387, 417; Berthold 1958, 38, illus. 38; Reff 1958, 111; Reff 1959 (*Enigma*), 29; Ratcliffe 1960, 26; Waldfogel 1962, 203; Andersen 1970, 92; Brion 1973, **79**; Paris 1974, 151; New York 1977, 39, 372, illus. 190; Theodore Reff, "Cézanne's Late Bather Paintings," in *Arts Magazine* LII, 2 (October 1977), 117f.; Rewald 1983, 179f., no. 387; Geist 1988, 117f., illus. 98; Basel 1989, 266; Krumrine 1992, 594.
EXHIBITIONS: New York 1947, no. 58, illus.; *Six Masters of Post-Impressionism*, Wildenstein Galleries, New York 1948, no. 8; *Les Fauves*, Museum of Modern Art, New York 1952-53, no. 2; *Figures nues d'école française depuis les maîtres de Fontainebleau*, Galerie Charpentier, Paris 1953, no. 33, illus.; *Nude in Painting*, Wildenstein Galleries, New York 1956, no. 35, illus.; New York 1959, no. 47, illus.; Tokyo 1974, no. 44, illus.; Paris 1978, 221ff., no. 97, illus., 242.

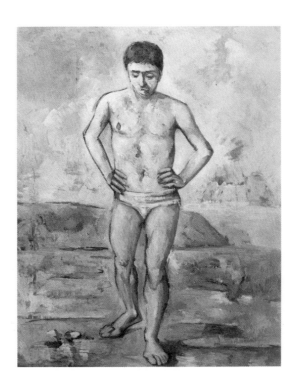

Illus. 1
Paul Cézanne,
Large Bather, 1885-87.
Museum of Modern Art, New York

77 Woman in Blue, 1900–1902
Dame en bleu

Venturi no. 705 (1900–1904)
Oil on canvas, 34 3/4 x 28 3/8" (88.5 x 72 cm).
State Hermitage Museum (inv. no. 8990.01), St. Petersburg

After Cézanne built his spacious new studio on the Chemin des Lauves outside Aix in the late summer of 1902, the only sitters he used for portraits were his gardener Vallier and various farmers (see cat. no. 78). Accordingly, this depiction of a woman wearing a stylish dress and hat and sunk in thought may well be his last female portrait. Similar in style to the portrait of a young Italian woman (illus. 1), it must date from the period between 1900 and 1902, when the artist had to make do with a small attic studio in his Aix apartment at 23, rue Boulegon. A Madame Brémond kept house for him there until his death, and it is altogether possible that she is the woman here immortalized in one of his rooms in the rue Boulegon. The woman who appears in another portrait wearing the same blue dress and hat (illus. 2) seems older and somewhat heftier, and whether or not that one is also his housekeeper is uncertain.

Making such identifications is difficult because Cézanne revealed essentially no interest in capturing either the particular physical characteristics of his sitters or their personalities. He also did without many of the representative props employed by celebrated portraitists of his time. In this instance, his setting is a cramped, unidentifiable space containing a table draped with a patterned cloth, a dark curtain (?), and a wardrobe. From these it is impossible to draw any conclusions about the sitter's social position, her age, or her class, despite the hint of style in her apparel. Thanks to their timeless qualities and seeming submission to anonymity, the people in Cézanne's portraits seem more foreign to us than those of Manet, Degas, or Toulouse-Lautrec. These contemporaries created an image of the modern cosmopolitan that continues to be valid today, and finds an echo in the cynical society pieces of Warhol. While some of their portraits were revealing to the point

Illus. 1
Paul Cézanne,
*Young Italian Woman
Leaning on Her Elbow*, 1900.
Private collection

Illus. 2
Paul Cézanne,
*Seated Woman in a
Blue Dress*, 1900–1902.
The Phillips Collection, Washington

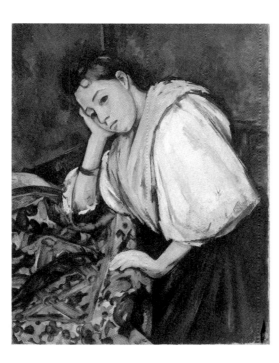

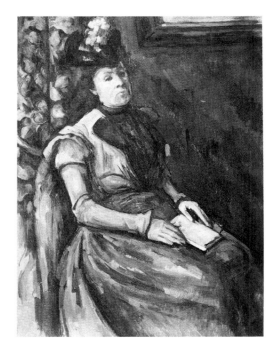

of indiscretion, Cézanne's were veiled in stylizations whose formalism, occasionally forced, is filled with life by the unlimited potency of color. The way he used green highlights to give this dress a radiant blue, at the same time drawing on the green of the foreground and background, the way he carefully structured the wealth of forms, and relationships between them, reveals that the spiritual substance of his portraits derives from their complexes of color and form, and that he was far more concerned with the solidity of a human body and translating its vitality into three dimensions than with traits of character.

PROVENANCE: Ambroise Vollard, Paris; Sergei Shchukin, Moscow; Museum for Modern Western Art, Moscow.
BIBLIOGRAPHY: Venturi 1936, 217, no. 705, illus.; Dorival 1949, 96; Cooper 1954, 380; Barskaya 1975, illus. 21, **186**; Rewald 1983, 232, no. 571; Frank 1986, illus.
EXHIBITIONS: London 1925, no. 14, illus.; New York 1977, 22, 64f., illus., 102, 204, 227, illus. 19, 388, 402, no. 54; Paris 1978, 85ff., no. 11, illus., 240; *Impressionisten und Post-Impressionisten aus sowjetischen Museen II*, Collection Thyssen-Bornemisza, Lugano 1987, no. 19, illus.

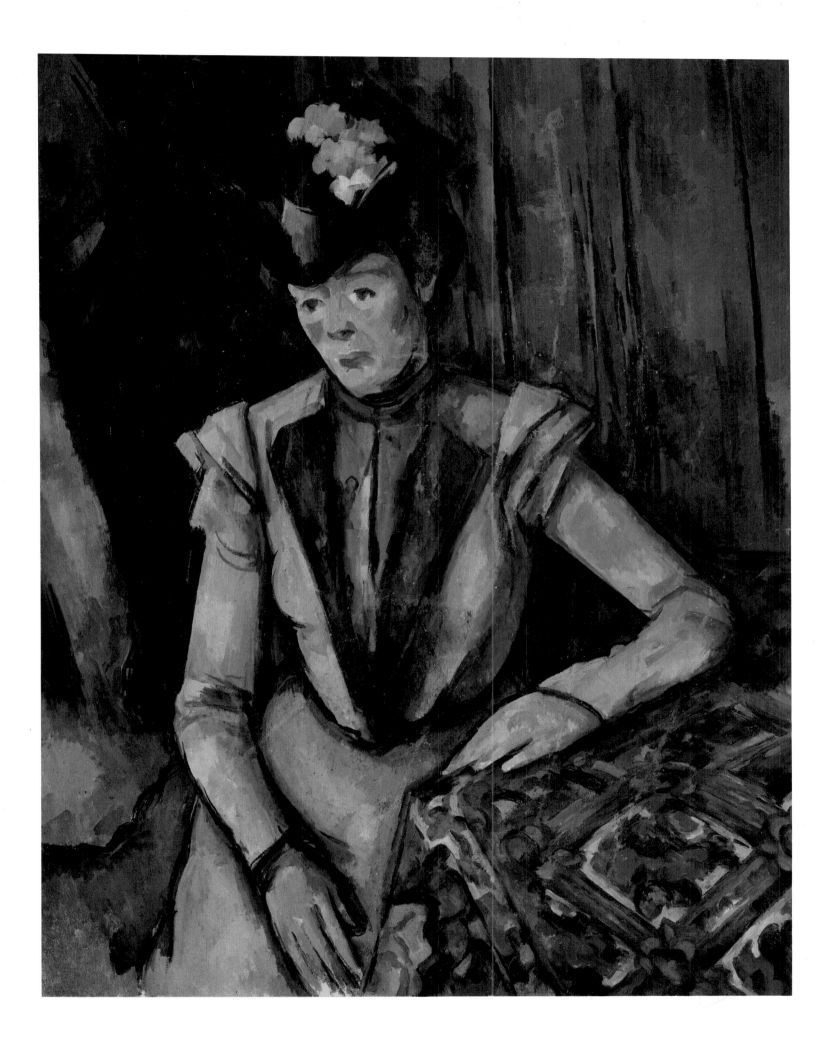

78 Seated Peasant, 1902–1904
Paysan assis

Venturi no. 712 (1900–1904)
Oil on canvas, 36 1/2 x 29 1/8″ (92.7 x 73.7 cm).
National Gallery of Canada (inv. no. NGC 5769), Ottawa

In addition to this one, Cézanne painted three other portraits of male models seated facing the viewer with their legs crossed and their feet cut off by the bottom of the frame. One of these is the likeness of the art dealer Ambroise Vollard (illus. 1), executed in Paris in 1899; the others present two peasants who sat for the artist in Aix in the 1890s. Although the highly stylized drawing and distribution of shadows in this portrait of a farmer in his Sunday best seem particularly close to those of the Vollard portrait, and one notes the presence of the ocher-colored platform used for the standing nude (see cat. no. 76), the work was certainly painted somewhat later. Behind the figure we see the wall arrangement – green above with brown wainscoting and a wide baseboard – found in some of Cézanne's last paintings and watercolors. Apparently this wall, against which a portfolio of drawings leans, was part of the new studio on the Chemin des Lauves. Cézanne moved into it in September 1902, and it served as his primary workplace until his death in 1906.[1] One sees the same green background, with different brownish tones for the wainscoting and baseboard, in various still lifes (see cat. no. 86),[2] and especially in the three portraits of the gardener Vallier from 1905–6.[3] The latter were long assumed – mistakenly – to have been painted outdoors on the studio terrace. There, the pigment is applied in impasto, as though the painter were constructing his painting with a trowel. Here, we find uniformly thinner layers of color, and we can therefore assume that the work was done soon after the completion of the Lauves studio, and not during the artist's last two years.

To find such a powerful, quiet evocation of an old man's detachment and reconciliation to his fate one has to turn to the late work of Titian or Rembrandt. In his discussion of his own tedious portrait sittings (illus. 1), Vollard tells us what patience Cézanne required from his models, how fussy he was with his painting, and how pointless it was to argue about just when a painting was actually finished according to the artist's own conception:

> The sittings lasted from eight to eleven-thirty in the morning. ... Each afternoon, Cézanne went to the Louvre or the Trocadero to make drawings after the masters. It often happened that he would stop in at my place for a moment about five, and announce with a beaming expression: "Monsieur Vollard, I bring you good news; I am relatively satisfied with the study I did today; if tomorrow's weather is light gray, I think our sitting will go well." Very few people saw Cézanne at work; he could not abide having people watching over his shoulder. For those who never saw him paint, it is difficult to imagine how slow and laborious his work could be on certain days. In my portrait, there are two little spots on the hand where the canvas is bare. I pointed this out to Cézanne. "If my sitting in the Louvre is good this afternoon," he responded, "I may be able to find the right color with which to cover the white spots tomorrow morning. You understand, Monsieur Vollard, that if I were to cover them with just anything, I would be forced to start the painting all over again from here!" When you consider that I had a hundred and fifteen sittings, you can understand that the prospect of starting the picture again from the beginning made me shudder! ... After a hundred and fifteen sittings, Cézanne stopped work on my portrait and returned to Aix. "I am not dissatisfied with the shirtfront," he told me as he departed.[4]

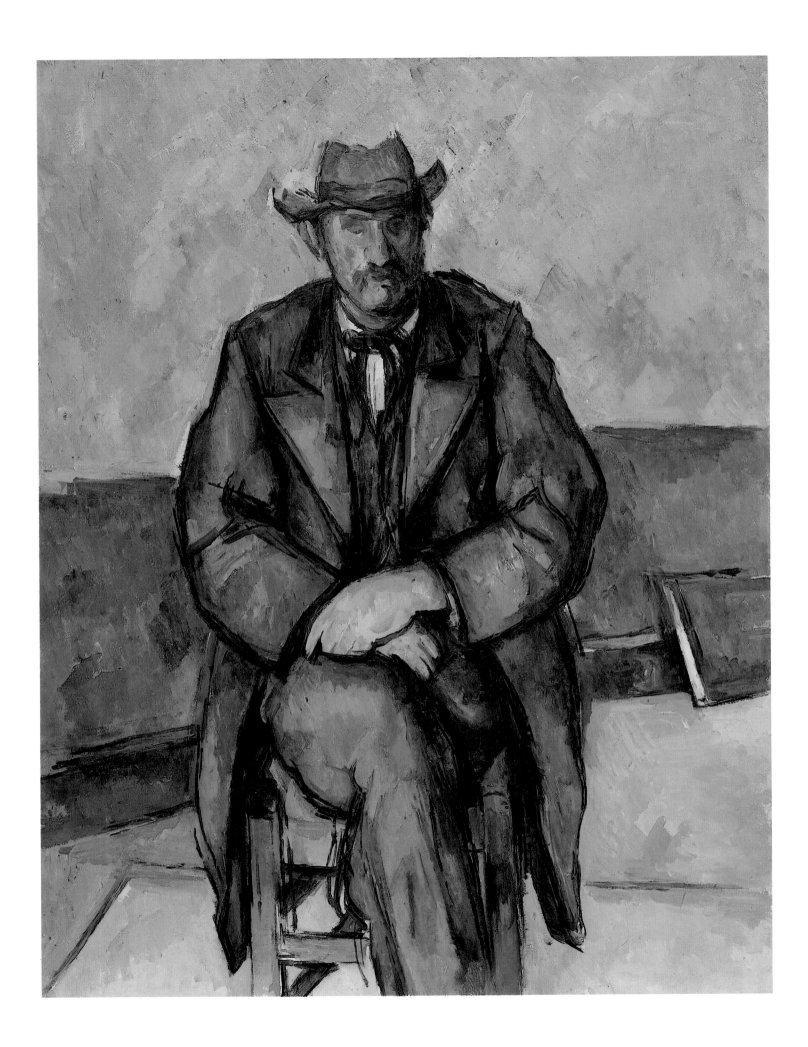

Since Vollard was one of the few permitted to observe the painter at work over an extended period of time, thanks to his seemingly endless sittings, his report is also of interest with respect to the painter's technique:

> In his painting Cézanne used very soft brushes that looked as though made of marten or polecat. After each stroke, he would rinse them in a brush-holder filled with turpentine. However many brushes he had, he would use them all in the course of a sitting.... Cézanne's way of working explains why his paintings are so permanent. Because he did not apply thick layers of pigment, but rather thin washes of color one on top of the other almost as in watercolor painting, the paint dried immediately, and there was no danger of the pigment shifting, which causes cracks when it fails to dry.[5]

NOTES

1 Since he required a more spacious studio, especially for the large-format paintings of bathers he had started working on (see cat. nos. 81–83), Cézanne determined to build one, and to that end he bought a piece of property on the Chemin des Lauves in the hills north of Aix in November 1901. In the following year, a two-story structure was erected on the site to the artist's specifications. Almost the whole upper floor was given over to a studio, with a wall of windows to the north. He had never thought of using his studio as a showplace for large figural compositions and still-life arrangements as the Impressionists did, but he did require access to natural light even for his studio compositions, and accordingly, a high opening was left in the north wall through which he could easily slide out the huge bather canvases. The room was furnished with only a few objects retrieved from the Jas de Bouffan: his easel, a commode, a low table, and various props used in his still lifes. Among the latter were two small plaster casts (see cat. no. 3), some glasses, various old bottles, several skulls, a blue ginger jar, assorted plates, an olive jar, and a rug patterned in brown, dark green, and red. Reproductions of especially admired works by Rubens, Delacroix, Signorelli, Couture, and Forain adorned the walls.
2 Rewald 1983, nos. 571, 572, 611; Rewald's dating of 1900–1906 thus needs to be shortened to 1902–6.
3 Venturi 1936, nos. 716, 717; there is also the version (42 3/8 x 29 3/8"; 107.4 x 74.5 cm) in the National Gallery of Art, Washington, which is not listed in Venturi.
4 Vollard 1960, 49ff., 56.
5 Ibid., 53.

PROVENANCE: Ambroise Vollard, Paris.
BIBLIOGRAPHY: Venturi 1936, 218, no. 712, illus.; Badt 1956, 130, 246; Feist 1963, illus. 74; Andersen 1970, 43; J. S. Boggs, *The National Gallery of Canada,* Toronto 1971, 41, illus. 52; Sutton 1974, **100f.**; New York 1977, 21; J. S. Boggs, "The Prophetic Paintings of Cézanne," in *Artscanada* XXXV, 1 (1978), 38; *Masterpieces of Impressionism and Post-Impressionism. The Annenberg Collection,* Philadelphia 1989, 81, illus., 179.
EXHIBITIONS: *Paintings from the Vollard Collection,* National Gallery of Canada, Ottawa 1950, no. 4, illus.; *French Impressionists,* Art Gallery, Vancouver 1953, no. 46; *European Masters,* Art Gallery, Toronto 1954, no. 67, illus.; The Hague 1956, no. 49; Zurich 1956, no. 80, illus. 42; Munich 1956, no. 62, illus.; Cologne 1956, no. 30, illus.; Tokyo 1974, no. 60, illus.; Madrid 1984, no. 53, illus.

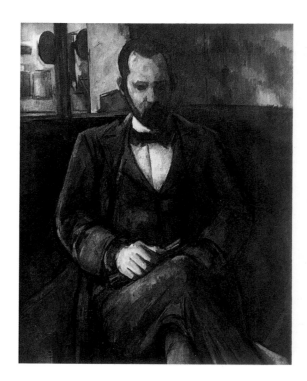

Illus. 1
Paul Cézanne,
Portrait of Ambroise Vollard, 1899.
Musée du Petit Palais, Paris

79 Seven Male Bathers, 1896–97
 Sept baigneurs
 Venturi no. 387 (1879–82)
 Oil on canvas, 14 3/4 x 17 7/8" (37.5 x 45.5 cm).
 Beyeler Collection, Basel

This composition appears to be finished despite its sketchy drawing. It is a typical example of the artist's habitual arrangement of male bathers in a friezelike pattern, where standing figures alternate with lower ones crouched on the shore or in the water.[1] These groups of figures, generally quite similar, never represent any particular narrative that the viewer can discern. The men do not relate to one another; their appearance together is altogether arbitrary, the result of artistic decision on the part of the artist. In the "original version" with five bathers (see cat. no. 33), the figures were quite distinct individuals, based on their respective models. But here, that is no longer the case. Two more seated bathers have now been added, and although all of the figures were first introduced as specific entities and not as interrelated groupings, they have now lost much of their individuality as the artist has become more concerned with the overall structure of the painting (see cat nos. 80–83).

A certain tension results from the fact that the figures are seen close at hand while their surroundings are only vaguely suggested, but this may be explained by the specific purpose the painting was to serve. Of course, the style of the work alone argues against Venturi's dating of it to 1879–1882; moreover, it is likely that Cézanne produced this painting as the pattern for the so-called *Small Bathers* (illus. 1), a lithograph commissioned by the art dealer Ambroise Vollard. During Cézanne's stay in Paris from the fall of 1896 to April 1897, when he lived in Montmartre, he created the lithograph under the guidance of the printer Auguste Clot. It appeared in 1897 in Vollard's second album titled *Les Peintres Graveurs*. It lacks the figure half immersed in the water on the right, but on the canvas one can see that Cézanne started to paint over that figure with layers of a light brown. One of the main arguments in support of linking the painting to the lithograph is that Cézanne would have needed such a

Illus. 1
Paul Cézanne,
Small Bathers, 1896–97, lithograph.
The Art Institute of Chicago

pattern to establish the outlines of the figures. Outlines were altogether foreign to his method, but in the unfamiliar medium of lithography he would be required to draw them, either on transfer paper or directly on the stone. It is unlikely that he would have felt confident in setting them down freehand, whether on stone or paper, without reference to a previous work. We also know that for a second lithograph done at the same time, *The Large Bathers*,[2] Cézanne used as his pattern the painting *Les baigneurs au repos,* then over two decades old.[3]

NOTES

1 See the compositions of bathers Venturi 1936, nos. 541, 590, as well as the figure studies Rewald 1983, nos. 124, 125, 133, 494, 495, Chappuis 1973, nos. 440, 524, 526, 528, 962, 1066, 1218.
2 Venturi 1936, no. 1157.
3 Venturi 1936, no. 276.

PROVENANCE: Ambroise Vollard, Paris; Bernheim-Jeune, Paris; Heinrich Thannhauser, Munich-Berlin; Werner Dücker, Düsseldorf; Margarete Oppenheim, Berlin; Oppenheim auction, Julius Böhler, Munich, May 18, 1936, no. 1226; Sotheby's auction, London, July 2, 1975, no. 58.
BIBLIOGRAPHY: Meier-Graefe 1910, **34**; Meier-Graefe 1918, **190**; Meier-Graefe 1922, **230**; Pfister 1927, illus. 108; Raynal 1936, illus. 100; Venturi 1936, 149, no. 387, 279, **287**; Ratcliffe 1960, 24; Melvin Waldfogel, "Caillebotte, Vollard and Cézanne's 'Baigneurs au repos,'" in *Gazette des Beaux-Arts* LXV, 107 (1965), 120; Schapiro 1968, 52; Cherpin 1972, 48, 67; Adriani 1978, 342; Adriani 1981, 286f.; Hülsewig 1981, 21, illus. 1, 41; Rewald 1983, 116, no. 13, 208, no. 495; Cézanne 1988, **263**; Teboul 1988, 88f., illus. 52; *du* 1989, **33f.**; Krumrine 1992, 595.
EXHIBITIONS: New York 1977, 41, 123, illus. 126f., 205, 382, illus. 202, 398, no. 36; Paris 1978, 228, no. 101, 230f., illus., 243; Liège 1982, no. 27, illus.; Basel 1983, no. 22, illus.; Madrid 1984, no. 51, illus.; Tokyo 1986, no. 37, illus.; Basel 1989, 183, 190, 192, illus. 162, 315, no. 65; *Coleccion Beyeler* (text and catalogue by Reinhold Hohl), Centro de Arte Reina Sofia, Madrid 1989, 32ff., illus.

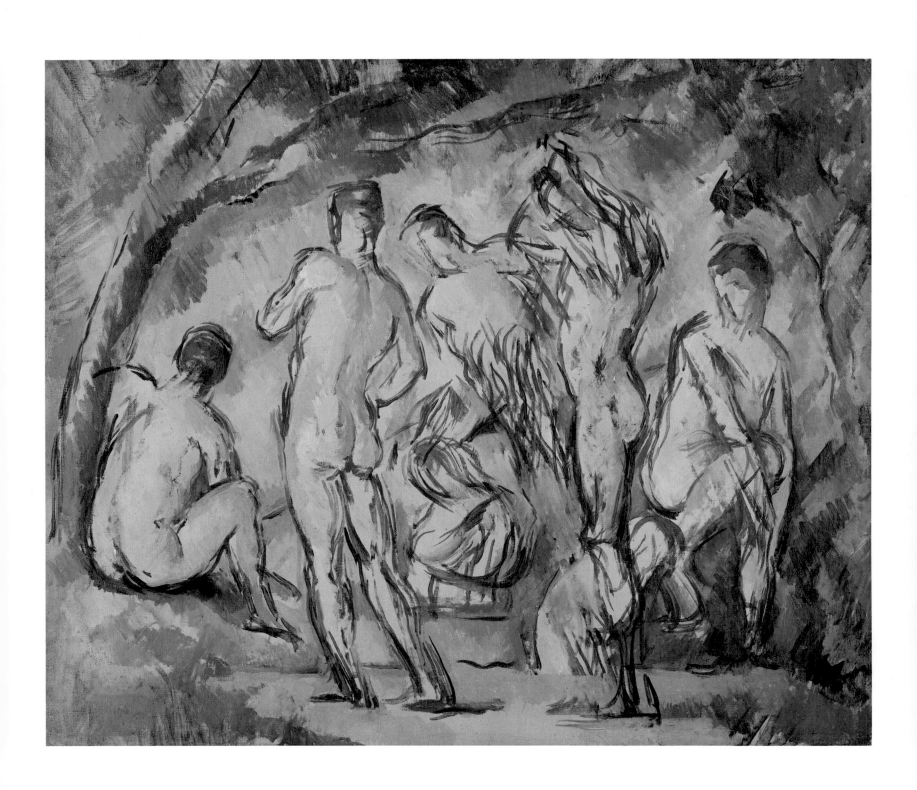

80 Five Male Bathers, 1900–1904
Cinq baigneurs

Not in Venturi
Oil on canvas, 16 5/8 x 21 5/8″ (42.2 x 55 cm).
Stephen Hahn Collection, New York

This painting, with an especially open grouping of figures, is the last one Cézanne did of male bathers. The five figures extracted from the repertory of the previous versions (cat. nos. 33, 79) are only loosely arranged. Thanks to the unifying force of color, however, they do not appear to be mere recapitulations of the earlier work. It was his mastery of color that allowed the painter to free himself from the original patterns for each of the figures, and to place them in a natural setting in such a way that the grouping becomes altogether believable, some clearly behind the other. As in his late watercolors, these men at ease in the landscape with the dense vegetation behind them are subjected to an all-encompassing painterly rhythm. The short, narrow curves of color, at times braced by perpendicular ones, seem like reverberations of the body contours and their shadow lines. Placed against the brightness of the canvas, the convex color outlines separate the figures from the surface, while at the same time transforming it in its light-filled three-dimensionality through concave inner contours. After the turn of the century, Cézanne was most committed to his three powerful paintings of female bathers (see cat. nos. 81–83), yet here, in his last presentation of their male counterparts, he summed up his skills as a painter.

PROVENANCE: Ambroise Vollard, Paris; Julius Schmits, Elberfeld; Wildenstein, Paris-London-New York; Henry Ittleson, New York; Acquavella Galleries, New York.
BIBLIOGRAPHY: Reff 1959 (*Enigma*), 26f., illus. 1, 68.
EXHIBITIONS: New York 1977, 383, illus. 203, 398, no. 37; Paris 1978, 231ff., no. 102, illus., 243.

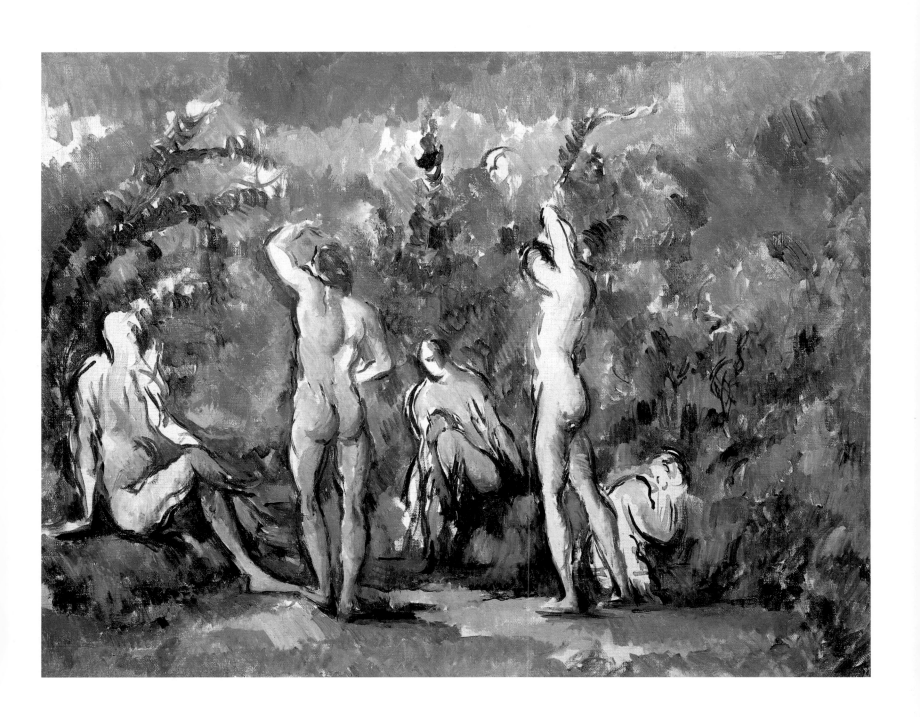

81 Eight Female Bathers, 1895–96
Huit baigneuses

Venturi no. 540 (1883–87)
Oil on canvas, 11 x 17 3/8″ (28 x 44 cm).
Signed, lower left
Musée d'Orsay (inv. no. RF 1982–39), dépôt de l'Etat 1984,
Musée Granet (inv. no. 84-7-1-8-), Aix-en-Provence

This composition of female bathers is the only painting Cézanne supplied with a dedication. According to Venturi, the inscription on the back of the frame was definitely written by the artist himself. It reads: "Hommage respectueux de l'auteur à la Reine des Félibriges. P. Cézanne, 5 mai 1896." The "queen of the Félibriges" was Marie Gasquet, the wife of the writer Joachim Gasquet (see cat. no. 68). Cézanne had become acquainted with the newly married couple in Aix in the spring of 1896, and beginning in April of that year maintained a lively correspondence with the writer.[1] A passionate local booster, Gasquet belonged to a writer's organization called "Félibrige," which had been founded in the middle of the century and promoted the preservation of the Provençal language.

That the composition dates from the midnineties, and not the decade before as Venturi conjectured, is borne out by its close relationship to *The Large Bathers* (illus. 1) begun in 1895. Its arrangement of eight female nudes in two pyramidal groupings linked by a dog lying in the foreground was repeated in the larger version, but in a more stylized form. Eight separate figure studies drawn over the previous two decades[2] represent preliminary stages of the composition, which was then realized in the form of a painting beginning in 1895.[3]

NOTES

1 Cézanne also gave Gasquet the large-format painting *La montagne Sainte-Victoire au grand pin,* Venturi 1936, no. 454, and *La vieille au chapelet,* Venturi 1936, no. 702.
2 Chappuis 1973, nos. 371, 511, 649, 650, 969, 971, 1104, 1134.
3 See the painted version Venturi 1936, no. 539 as well as the watercolor Rewald 1983, no. 603.

PROVENANCE: Marie Gasquet, Aix-en-Provence; Auguste Pellerin, Paris; Jean-Victor Pellerin, Paris.
BIBLIOGRAPHY: Gasquet 1921, illus.; Rivière 1923, 220; Gasquet 1930, illus.; Venturi 1936, 180f., no. 540, illus.; Chappuis 1973, 126, no. 371, 153, no. 511, 226, nos. 969, 971, 252, no. 1104; New York 1977, **39**, 52; Rewald 1983, 244, no. 603; Coutagne 1984, **226ff.**; S. Gache-Patin, "Douze œuvres de Cézanne de l'ancienne collection Pellerin," in *La Revue du Louvre* (April 2, 1984), 131; Aix-en-Provence 1990, 217, illus. 193.
EXHIBITIONS: Madrid 1984, no. 29, illus.; Basel 1989, 167, 207, 221, illus. 184, 315, no. 61.

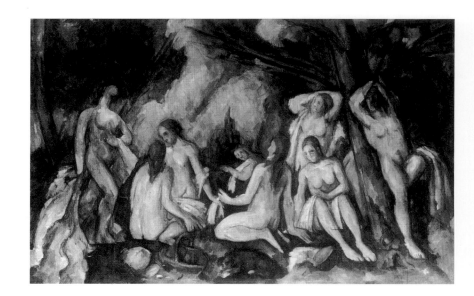

Illus. 1
Paul Cézanne,
The Large Bathers, 1895–1906.
The Barnes Foundation, Merion, Pennsylvania

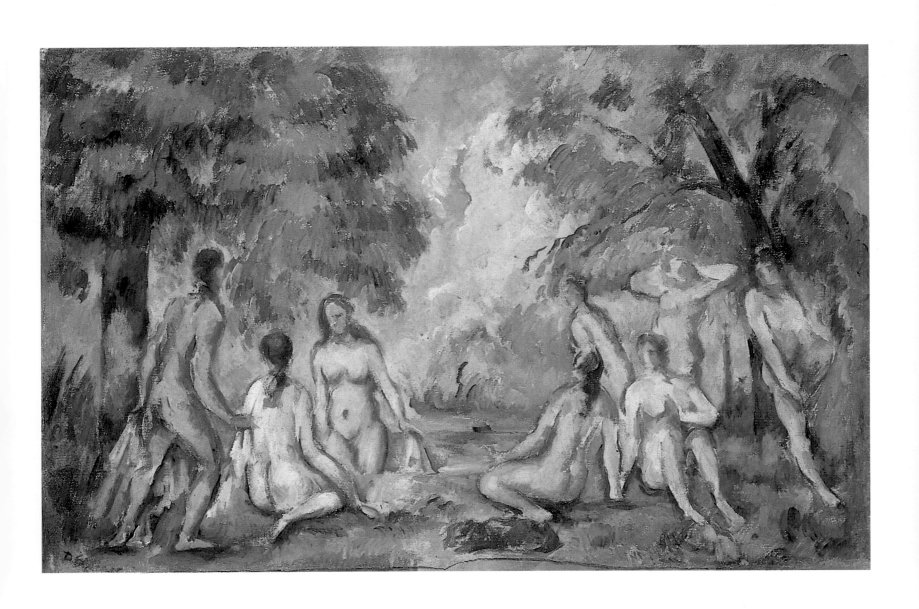

82 Nine Female Bathers, 1902–5
Neuf baigneuses

Venturi no. 723 (1900–1905)
Oil on canvas, 11 3/8 x 14 1/8″ (29 x 36 cm).
Private collection

Here, the figures selected are no longer as derivative of the earlier nude patterns (see cat. nos. 33, 34), and these are wholly subsumed by a pervasive blue atmosphere, a feature typical of nearly all the late paintings of bathers. This atmosphere serves to distance the figures and their self-absorbed activities from everyday experience in much the same way that it lifts the objects in the painter's "blue" still lifes (see cat. nos. 55, 58, 59) out of their banality.

Cézanne's greatest ambition was to create important figural paintings, not landscapes, and in both the first and the last decades of his painting career, he devoted himself especially to such compositions. From the midnineties up until his death in 1906, he was preoccupied with three monumental works presenting female bathers. This beautifully painted scene is directly related to those larger canvases, a variant in which he freely summarized what he hoped to realize in their considerably more fixed arrangements. Its distribution of figures and treatment of space link it most closely to the painting *The Large Bathers* (illus. 1), which may have been undertaken only after the completion of the artist's studio on the Chemin des Lauves in September 1902.[1] Yet, the spirit of this work is altogether different from that of the larger one. Here, the rhythmic brushwork displays a vitality and spontaneity that is almost Rococo in feeling, quite unlike the colossal stylization on the large canvas.[2] The figures are here arranged in two distinct groupings, whereas in the more ambitious version, they form an almost solid wall. The painter then adopted the clearly separated groups and the glimpse of water between them in the last of his monumental paintings, executed in 1906 (cat. no. 83, illus. 1). There, he inserted an additional crouched figure in profile behind the dominant one lying on her stomach.

These inventions, in no way related to genre pictures and with no hint of narrative content, have something of the primeval about them. They provide us with a vision of a classless, anonymous human condition remote from the pressures of everyday life. Like all nudes in art, whether in antiquity or the Rococo, Cézanne's figures celebrate our human commonality. At home in the nurturing setting of nature,

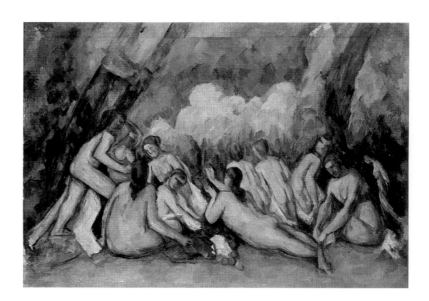

Illus. 1
Paul Cézanne,
The Large Bathers, 1902–6.
National Gallery, London

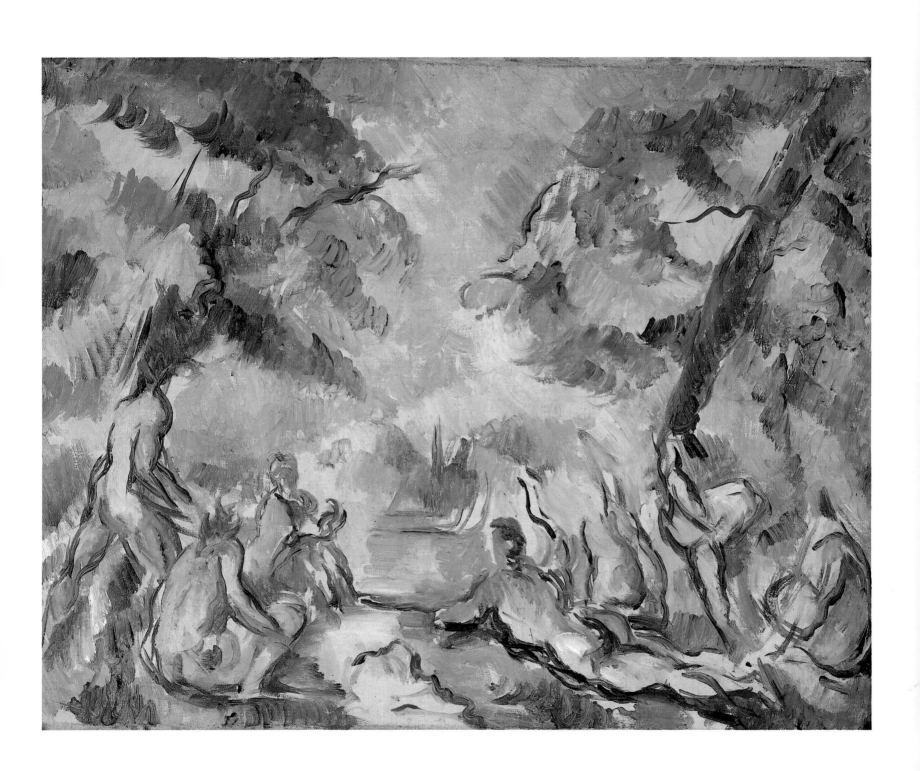

they are blissfully free of any clues that might link them to a specific time and place. At the beginning of his career, Cézanne was determined to use his art to illuminate his times (see cat. nos. 2, 11, 12); now, nearing the end of it, he was equally determined to shed all contemporary references. While some of his more violent early works can be seen as a rejection of his sheltered childhood and youth, his complacent bathers from his late years reveal a yearning to be accepted among supportive, like-minded spirits.

NOTES

1 There cannot have been room in either his attic studio in Aix or the one in Paris to permit him to work simultaneously on two canvases, Venturi 1936, nos. 720, 721, of such huge dimensions. For that reason, it is likely that this one was only begun after his new quarters were finally ready in late 1902.
2 See the watercolor study of the same name, Rewald 1983, no. 602, the painted version with more figures, Venturi 1936, no. 722, and the figure study Chappuis 1973, no. 1104. The larger version, Venturi 1936, no. 1523, remained a mere sketch.

PROVENANCE: Ambroise Vollard, Paris; Alphonse Kann, Saint-Germain-en-Laye.
BIBLIOGRAPHY: Meier-Graefe 1910, **35**; Meier-Graefe 1918, **191**; Meier-Graefe 1922, **231**; Venturi 1936, 221, no. 723, illus.; Novotny 1938, 130; Guerry 1950, 143; Badt 1956, 118, 247, illus. 45; Neumeyer 1959, 9, illus. 6; Reff 1960, 173; Badt 1971, 47, **50**; Krumrine 1980, 122; Teboul 1988, 91, illus. 55; Krumrine 1992, 590f., 593, 595.
EXHIBITIONS: Zurich 1956, no. 81, illus. 44; New York 1977, 40f., 205, 374, illus. 192, 399, no. 39; Basel 1983, no. 24; Tokyo 1986, no. 38, illus.; Basel 1989, 208, 214, 228, illus. 194, 315, no. 69.

83 Draft of the Large Bathers, 1904–6
Ebauche des grandes baigneuses

Venturi no. 725 (1898–1905)
Oil on canvas, 29 x 36 3/8″ (73.5 x 92.5 cm).
Private collection

This composition is one of Cézanne's last figural paintings (see cat. no. 82). It is closely related to the largest of the paintings known as *The Large Bathers* (illus. 1), which was probably not begun until 1906. Its title, established by Venturi, does not do it full justice. It, too, is ambitious in format, and, of all of the works Cézanne produced in his many years of preoccupation with the subject of bathers, in this work he attained the greatest degree of freedom. Moreover, its similarities to the last of the three *Large Bathers* are limited. They include the relationship between the figural groupings and the overall picture space, the way the trees curving upward from either side form a pointed arch above, and a view of the far shore across the water. These are outweighed by the differences in color and by the very different arrangement of the figures on the banks and in the water. Unusual features of this picture, found elsewhere only in a corresponding watercolor,[1] are the clear view of a line of mountains in the background and the way the water reaches into the foreground down to the bottom edge. All of this indicates that this is an independent conception, one in which the artist sought to exchange the highly formalized weighting of the larger canvas with an unencumbered, ethereal harmony of man and nature.

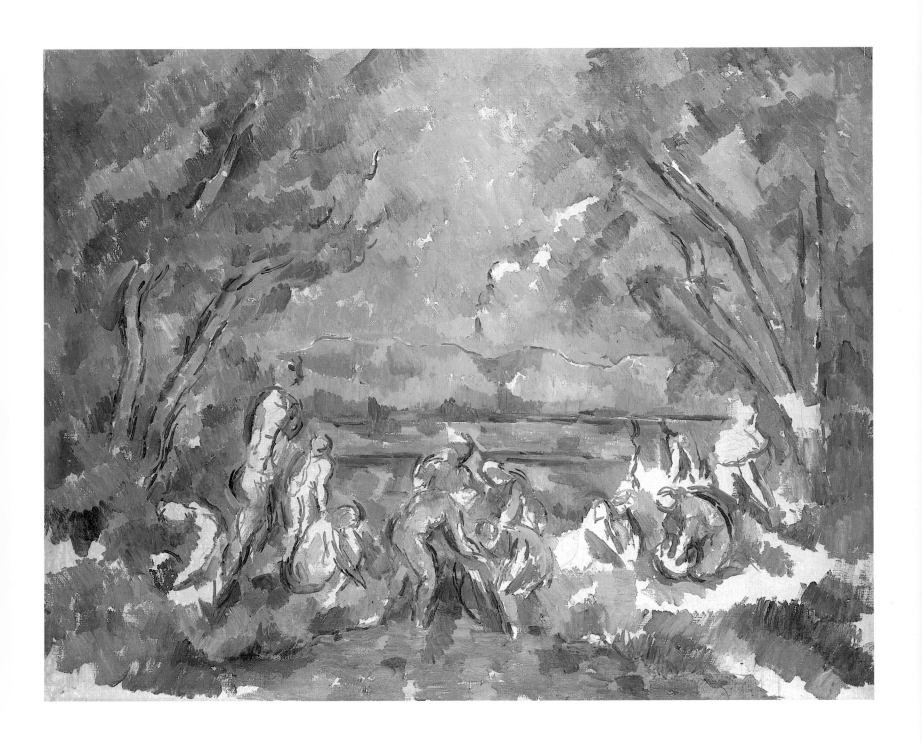

With this late work Cézanne achieved the freest possible brushwork, largely independent of the objects depicted and leaving large spaces open to the imagination. His curving single strokes and denser clusters of color have only the most casual reference to outlines and only hint at specific forms. What we see here may be in part the fruit of the painter's years of drawing Baroque portrait busts in the Louvre. The sky and water, mountains, trees, and the somewhat mysterious doings of the figures have all been embraced and unified by the reserved beauty of an omnipresent blue. Near the figures especially, there are sections unworked, where the canvas shows through with traces of preliminary drawing, but one tends to overlook it and focus on the exquisite blue, the least sensual but most spiritual of colors.

The initial severity of these compositions, with four or five female nudes forced into pyramidal arrangements in front of a curtain of trees, was now gone. Increasingly, the artist had developed looser, almost ornamental arrangements of the figures. But never before had he integrated them so naturally into the brilliant blue space of the vision of landscape. His convincing marriage of figures and landscape was meant to represent neither a contemporary swimming party nor some idyll from a past – despite the claim by one interpreter that Cézanne was here illustrating the discovery of Moses in the bulrushes. Implicit in his bathers is the artist's yearning for harmony in a century that had lost its way. And groping to find his own way, Cézanne strives here to satisfy the age-old desire to reconcile reality with the ideal.

NOTES

1 Rewald 1983, no. 607.

PROVENANCE: Ambroise Vollard, Paris; Paul Cézanne *fils*, Paris.
BIBLIOGRAPHY: Venturi 1936, 221, no. 725, illus.; Badt 1956, 247; Neumeyer 1959, 9, illus. 7; Reff 1960, 173; Waldfogel 1962, 204; Cherpin 1972, **57**; Sutton 1974, **104f.**; Geist 1975, **12**; Adriani 1981, 287; Rewald 1983, 245, no. 607; Cézanne 1988, **266**; Teboul 1988, 81, illus. 47; Krumrine 1992, 586.
EXHIBITIONS: Paris 1929, no. 43; Paris 1936, no. 106; Aix-en-Provence 1956, no. 63, illus.; The Hague 1956, no. 46, illus.; Zurich 1956, no. 82, illus. 39; Munich 1956, no. 63, illus.; Cologne 1956, no. 31, illus.; Aix-en-Provence 1961, no. 19, illus. 14; Vienna 1961, no. 42, illus. 28; Hamburg 1963, no. 13, illus. 55; Tokyo 1974, no. 55; New York 1977, 40, 205, 368, illus. 186, 399, no. 41; Paris 1978, 233, no. 104, 235f., illus., 243; Basel 1989, 233, illus. 199, 278, 280, 316, no. 72.

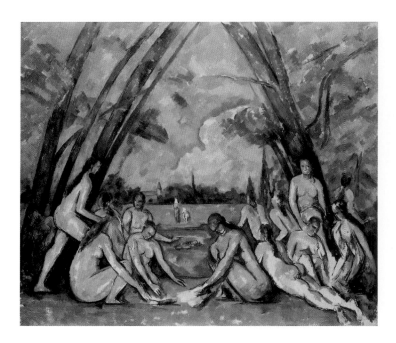

Illus. 1
Paul Cézanne,
The Large Bathers, 1906.
Philadelphia Museum of Art,
W. P. Wilstach Collection

84 Still Life, Plate of Pears, 1895–1900
 Nature morte, assiette de poires

Venturi no. 744 (1895–1900)
Oil on canvas, 15 x 18 1/8″ (38 x 46 cm).
Wallraf-Richartz-Museum (inv. no. WRM 3189), Cologne

Each of Cézanne's more than one hundred seventy still lifes is in a certain sense a portrait of the artist himself, for of course, in his selection and arrangement of objects he was fond of, it was he who created the reality represented. Yet, one rarely finds in them any of the typical paraphernalia of his profession. There are only six such instances, where one finds a stretched canvas leaning against a wall, a palette that has been set aside, or the cast of a figure used in drawing exercises.[1] The still life shown here, with its plate of fruit and its chiffon shimmering in silken white, is one of them. For we note that the objects have been arranged on a wooden slab supported by sawhorses, a type of drawing table commonly found in artists' studios in this period. The divergent angles of the table edge and the wall stripe in the same color conspire with the diagonal lines of the sawhorses to give the picture an unusual dynamism.

NOTES

1 See the still lifes Venturi 1936, nos. 357, 594, 622, 623, 706, 707.

PROVENANCE: Ambroise Vollard, Paris; Paul Cassirer, Berlin; Hugo Cassirer, Berlin; Lotte Fürstenberg, Berlin; Sotheby's auction, London, December 6, 1961, no. 78; Feilchenfeldt, Zurich.
BIBLIOGRAPHY: Venturi 1936, 226, no. 744, illus.; Dorival 1949, illus. 150, 173.
EXHIBITIONS: Berlin 1921, no. 37.

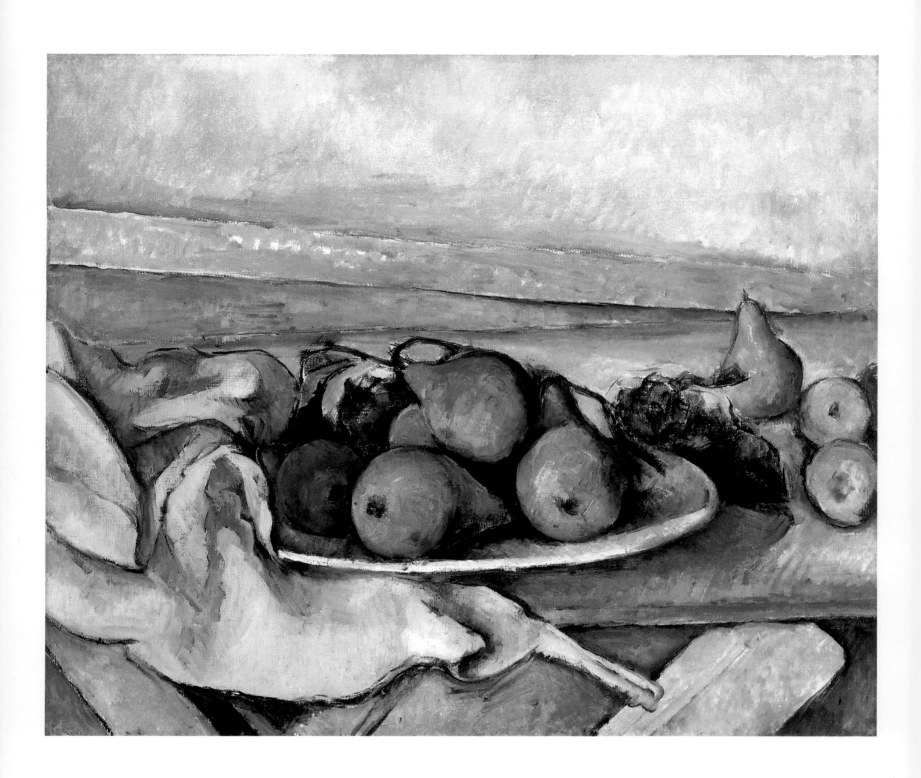

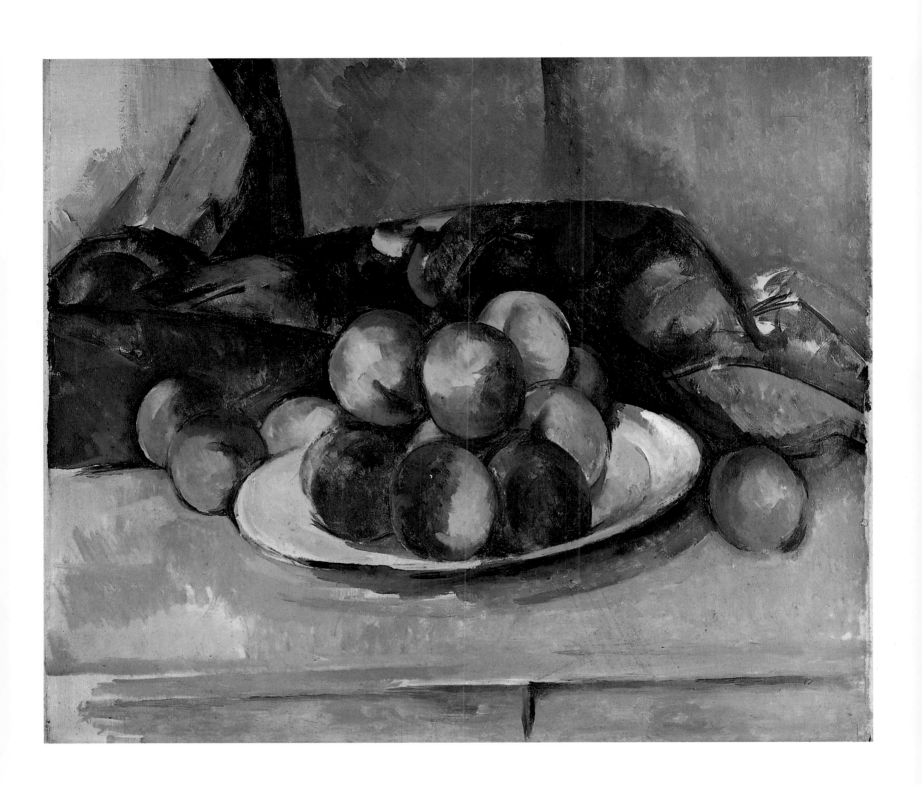

85 Still Life, Plate of Peaches, 1895–1900
 Nature morte, assiette de pêches
 Venturi no. 743 (1895–1900)
 Oil on canvas, 15 x 18 1/8″ (38 x 46 cm).
 Private collection, on loan to the Kunsthaus Zurich

Before undertaking the exquisite still life compositions of his last decade, which surpassed all of his earlier ones in size and in their Baroque abundance, the artist first had to experiment with more modest arrangements in smaller format (see cat. no. 84). In these he continued to perfect his skill at creating three-dimensional forms and capturing their individual essence with nothing but color. In large part thanks to his countless cross-references between colors, such very unrelated objects as an ocher-colored tabletop, a tilted porcelain plate, and a group of wonderfully painted peaches ennobled by the colorful cloth draped above them (see cat. nos. 77, 86, 88) seem perfectly at home with each other. The color makes their juxtaposition seem altogether natural, even though they were certainly not "found" to be arranged in this way. It is not the objects themselves or their exquisitely rendered textures that make Cézanne's still lifes so sumptuous, but the manner in which these very simple arrangements, most of them centered on fruit, have been translated into incomparably evocative painting.

PROVENANCE: Ambroise Vollard, Paris; Paul Cassirer, Berlin; Hugo Cassirer, Berlin; Lotte Fürstenberg, Berlin.
BIBLIOGRAPHY: Venturi 1936, 226, no. 743, illus.; New York 1977, 339, illus. 150.
EXHIBITIONS: Berlin 1921, no. 38.

86 Three Skulls on an Oriental Rug, 1898–1905
Trois crânes sur un tapis d'orient

Venturi no. 759 (1904)
Oil on canvas, 21 1/4 x 25 1/4″ (54 x 64 cm).
Kunstmuseum (inv. no. C.80.2), Solothurn

Since his studio at 23, rue Boulegon, was not large enough, Cézanne had a new studio structure built on a hill north of the city in 1902, moving into it in September of that year. From Emile Bernard's reminiscences of his stay in Aix-en-Provence and visits to Cézanne in February 1904, we learn among other things that the painter was working on this still life with skulls in the new studio:

> After lunch, we went to see the studio outside of town, and this time, Cézanne finally led me into his actual workroom to see his paintings. It was a large space painted in a calcimine gray, with north light falling in through a window at chest height.... He was working on a painting of three skulls on an Oriental rug. For a month he had been painting on it every morning from six to ten-thirty. His routine was as follows: He would get up early, no matter the season, and set out for his studio, where he worked from six until half past ten. Then he would return to Aix for lunch. Immediately afterward, he would leave again to work on his motif or his landscape until five in the afternoon. He then would eat his evening meal and immediately go to bed. Several times I saw him so tired from his work that he was unable to either converse with me or even listen to what I was saying.... "What I'm missing," he told me in front of these three death's heads, "is the realization. Perhaps I'll get there, but I am old, and it is perfectly possible that I will die without having attained this highest goal: Realization! Like the Venetians!" I saw him in this way through the entire month I spent in Aix, working away at the picture with the three death's heads, which I think of as his testament. The painting changed form and color almost every day, and yet, the first time I stepped into Cézanne's studio, one could have removed it from his easel as a finished work. Truly, his manner of working was a kind of meditation with brush in hand.[1]

Bernard's report gives us a fascinating glimpse of Cézanne's paintstaking method. In this painting, three skulls appear in front of a dark green wall. They have been placed in the folds of a carpet he often used in his late period (see cat. nos. 77, 85, 88). The painter has rendered them in the thick colors characteristic of some of the late portraits as well, built up with repeated new layers of darker pigment. In juxtaposing the colorful floral design of the rug with the almost abstract pattern consisting of the eye-sockets and nasal cavities of the skulls, Cézanne deliberately linked an affirmation of life to the consciousness of death.[2] Although we can see in the painting the signs of protracted struggle and repeated overpainting, Bernard relates that by the time he visited Aix a second time in the spring of 1905, Cézanne had abandoned work on it, and that it was then tacked to the wall of the studio.[3] Ambroise Vollard also recalled having seen the painting in 1905, on the occasion of his last visit with the painter: "At the end of the year 1905 I went to Aix.... On his easel stood a still life that he had begun several years before; it pictured skulls on an Oriental rug. 'How wonderful it is to paint a skull! Just look, Monsieur Vollard.' He had the highest hopes for this work. 'You must understand, I am close to realization!' Then after a pause: 'In Paris, now, do they like what I'm doing? Oh, if only Zola were here now, now that I'm making my breakthrough.'"[4]

Vollard's indication that Cézanne had begun the still life with skulls a number of years before is confirmed by a comment by Rivière to the effect that the still life arranged on a carpet, *Trois têtes de mort,* was executed in Paris in the studio in the rue Hégésippe-Moreau in about 1898 (see cat. no. 76).[5] It is altogether probable, and the compact layers of colors suggest as much, that Cézanne had begun the still life at that time and then, in a constant desire to improve it, continued to occupy himself with it until 1905. Vollard also commented that it frequently took the painter years to finish certain paintings: "If Cézanne abandoned a study, it was almost always with the hope of finishing it later. That explains how landscapes that had already been 'consigned' were often reworked in the following year or even two or three years later, which by no means troubled him, by the way; for to him, painting from nature was not merely copying the subject, but realizing what he perceived in observing it."[6] And the painter himself spoke of this in the postscript to a letter from July 8, 1902: "I had a study that I began two years ago; I had hoped to pursue it."[7]

NOTES

1 Bernard 1982, 78f.
2 This is even more apparent in the watercolor version of the still life, Rewald 1983, no. 611.
3 Bernard 1982, 102.
4 Vollard 1960, 74, 76.
5 Rivière 1923, 222.
6 Vollard 1960, 56.
7 Cézanne 1984, 284.

PROVENANCE: Ambroise Vollard, Paris; Gertrud Müller, Solothurn; Dübi-Müller-Stiftung, Solothurn.
BIBLIOGRAPHY: Vollard 1914, 148; Rivière 1923, 222; Bernard 1925, 25f.; Graber 1932, **96**; Venturi 1936, 57, 228, no. 759, illus.; Novotny 1938, 117, 132; Schmidt 1952, 12; Reff 1958, 57; Ratcliffe 1960, 29, 31; Vollard 1960, 74, 76; Reff 1962, 114; Schapiro 1968, 53; New York 1977, 33, 36, 51, 102, 344, illus. 155, 393, 396, 408; Adriani 1978, 85; Adriani 1981, 280; *Dübi-Müller-Stiftung, Josef-Müller-Stiftung,* Solothurn 1981, **94f.**; Bernard 1982, 78f.; Rewald 1983, 140, no. 232, 232, no. 571, 247, nos. 612, 613; *du* 1989, **26**.
EXHIBITIONS: Paris 1936, no. 110; *Europäische Meister,* Kunstmuseum, Winterthur 1955, no. 33; The Hague 1956, no. 50; Zurich 1956, no. 83.

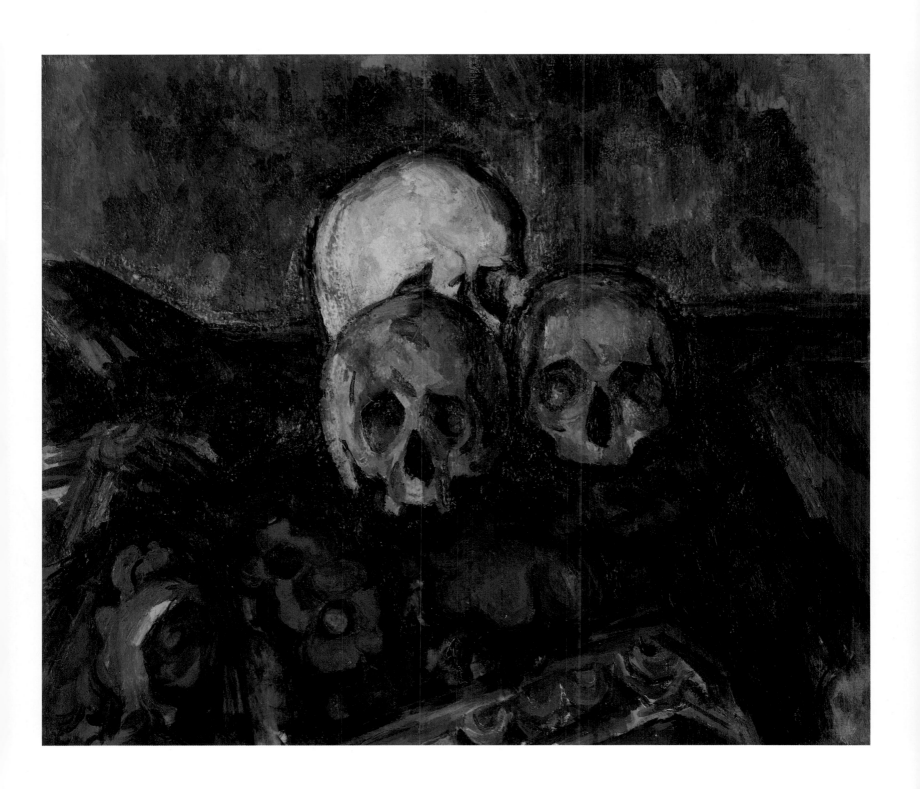

87 Pyramid of Skulls, circa 1901
Pyramide de crânes

Venturi no. 753 (circa 1900)
Oil on canvas, 14 5/8 x 17 7/8" (37 x 45.5 cm).
Private collection

In no other painting did Cézanne place his objects so close to the viewer as in this exceptional group portrait of four skulls, a macabre evocation of death virtually filling the picture space. He was just as scrupulous in his arrangement of these gruesome relics of life in a pale light as he was in placing plump fresh fruits on tablecloths. His resulting monument to mortality is the ultimate still life, for since the Baroque, the genre has illustrated human interests: man's activities, his material or decorative needs, his tastes, his symbols, his moral concepts.

Cézanne was a contemplative, and there had always been traces of a kind of melancholy rebelliousness about him (see cat. nos. 3, 4). In his old age, increasingly, his imagination was sparked by his moods and emotions. Out of the sense of his own mortality and isolation, in several extraordinary paintings he took up the elegiac notion of the memento mori, one that had been discovered for art by Poussin. His own efforts in the genre served to inspire later artists, from Picasso to Warhol (illus. 1, 2). Cézanne had always accorded particular importance to the still life, considered only a subordinate genre by many of his contemporaries. It is thanks to his large quantity of still lifes that the Cubists were drawn to the genre.

In his *Pyramid of Skulls,* he expressed something of the tragic sense of death (see cat. no. 86)[1] that is touched upon in his letters as early as 1896: "I might as well be dead," or "For me, life has begun to be deathly monotonous," and in another passage: "As for me, I'm old. I won't have time to express myself." Similar sentiments color his letters from 1899 and 1901: "For the nonce, I am still seeking a way to express those confused feelings that we bring with us into the world. If I die, it will all be over, but that doesn't matter," and finally, "If isolation tempers the strong, it is a stumbling-block for the hesitant. I must admit that it is always sad to turn one's back on life, as long as we are here on earth."[2]

After the sale of the Jas de Bouffan in November 1899, the artist rented an apartment in Aix-en-Provence at 23, rue Boulegon, where he set up a small studio in the attic. The archeologist Jules Borély, who visited him there in July 1902, recalled: "I left Cézanne after spending another half an hour with him in his cold house. In his room, on a narrow table in the center, I noticed three human skulls set across from one another, three lovely, polished pieces of ivory. He spoke of a very beautiful study that he had somewhere in his attic. I asked to see it. He looked for the key to the attic room, but in vain, for the servant-girl had lost it."[3] The painting in question could have been either the *Pyramid of Skulls,* the still life *Three Skulls on an Oriental Rug* (cat. no. 86), or a still life depicting three skulls in a row on a table.[4] When Cézanne moved into his new studio outside of town, he took the skulls with him, and one can still see them there today.

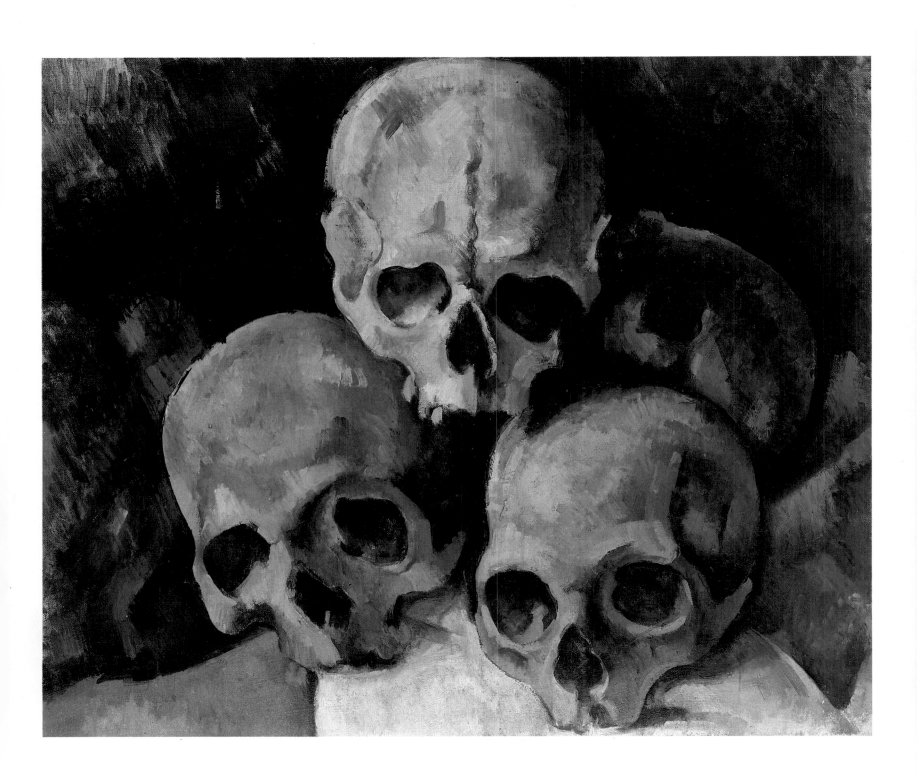

NOTES

1 See the melancholy portrait *Jeune homme à la tête de mort*, Venturi 1936, no. 679, as well as the still lifes
 with skulls Venturi 1936, nos. 751, 758, 1567, and the *Still Life with Death's Head and Candlestick*,
 Staatsgalerie Stuttgart, which is not in Venturi. Compare also the watercolors and drawings Rewald 1983,
 nos. 231, 232, 611–13 and Chappuis 1973, nos. 1214, 1215.
2 Cézanne 1984, 250, 252, 255, 268, 272.
3 Borély 1982, 39.
4 Venturi 1936, no. 1567.

PROVENANCE: Ambroise Vollard, Paris.
BIBLIOGRAPHY: Venturi 1936, 227, no. 753, illus.; Novotny 1938, 117; Schapiro 1968, 53; Sutton 1974, **105**;
Adriani 1978, 85; Adriani 1981, 280; Rewald 1986, **264**; Cézanne 1988, 251; Erpel 1988, illus.
EXHIBITIONS: Zurich 1956, no. 79; Aix-en-Provence 1961, no. 16, illus. 12; Vienna 1961, no. 38, illus. 25;
Tokyo 1974, no. 50, illus.; New York 1977, 36, 205, 346, illus. 157, 396, no. 30; Paris 1978, 112f., no. 25, illus.
241.

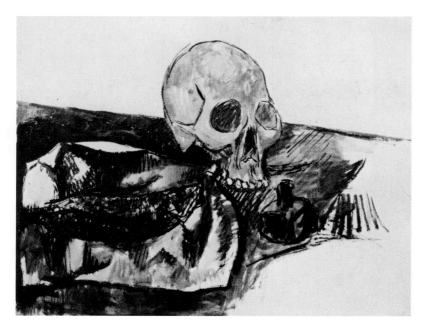

Illus. 1
Pablo Picasso, *Still Life with Fish, Skull, and Ink Bottle*, 1907, ink drawing.
Musée Picasso, Paris, © 1995 VG Bild-Kunst, Bonn

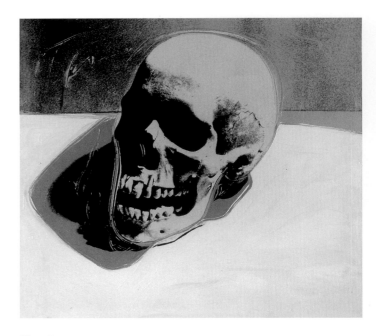

Illus. 2
Andy Warhol, *Skull*, 1972.
Sammlung Fröhlich, Stuttgart, © 1995 Ars, New York

88　Still Life, Floral Curtain, and Fruit, 1904–6
Nature morte, rideau à fleurs, et fruits

Venturi no. 741 (1900–1906)
Oil on canvas, 28 3/4 x 36 1/4" (73 x 92 cm).
Private collection

Looking back at modernism from our postmodern vantage point, this grandiose late Cézanne still life seems so modern as to put into the shade much of what the twentieth century has so self-importantly extolled as artistic innovation. It demonstrates beyond all question that color constitutes the essence of a painting. The boldness of its combination of strong, lapidary brushwork and freedom in the treatment of objects are those of the "perfected genius," to borrow a phrase from Zola. Never shown in any of the major Cézanne exhibitions, the work is the most magnificent example of his late style, one that balanced the passion latent in his work from the beginning with ravishing painterly effects.

The objects, familiar from his decades of work with them, have become Cézanne's metaphors for a perception of reality settled between euphoric affirmation and despairing resignation. They include the patterned curtain that had graced several especially fine portraits since the late 1880s (see cat. no. 41)[1] but appears in Cézanne's late style only as a Baroque element in still lifes[2]; the obligatory wooden table; a rug with a design in red and green (see cat. nos. 77, 85, 86)[3]; several pieces of fruit gleaming against a white plate; a goblet; and a glaring white napkin. All of them, rendered in deep, radiant colors, have been highly stylized. The painting's powerful energy even lends dignity to the single apple placed on the corner of the table for balance. Against the coolness of the wall, whose green and blue tones are laid on in diagonal hachures, the warm fabrics plunge down at a diagonal onto the table and a chair drawn up to it on the left (?) like a cascade. Never before had Cézanne captured with such excitement the dramatic dialogue between color and form, light and dark, cold and warm color values. This still life set a standard for generations of artists to follow.

NOTES

1　See the large-format portraits *Mardi gras*, Venturi 1936, no. 552, *Jeune homme à la tête de mort*, Venturi 1936, no. 679, *Garçon au gilet rouge*, Venturi 1936, no. 682, and *Homme assis*, Venturi 1936, no. 697.
2　See the still lifes Venturi 1936, nos. 731–34, 736, 738, 739, 742, 745, 747, Rewald 1983, no. 296.
3　This rug was also used in portraits and still lifes from the late period: Venturi 1936, nos. 701, 703, 757, Rewald 1983, nos. 571, 572, 611, 612.

PROVENANCE: Josse Bernheim-Jeune, Paris; Bernheim-Jeune, Paris.
BIBLIOGRAPHY: Bernheim-Jeune 1914, illus. 52; Rivière 1923, 221; Raynal 1936, illus. 90; Venturi 1936, 57, 225, no. 741, illus.; Dorival 1949, 95, illus. 152, 173; Guerry 1950, 135; Andersen 1967, 139; Elgar 1974, 221, 225f.; New York 1977, 35, 80, 355, illus. 167; Paris 1978, 21; Rewald 1983, 26.
EXHIBITIONS: Paris 1914, no. 21; *L'Impressionnisme*, Palais des Beaux-Arts, Brussels 1935, no. 4; *Quelques toiles importantes de collections particulières du XIXᵉ et XXᵉ siècle*, Galerie Durand-Ruel, Paris 1945, no. 6; *Voici des fruits, des fleurs, des feuilles et des branches…*, Galerie Bernheim-Jeune, Paris 1957, no. 10; *Cézanne, aquarelliste et peintre*, Galerie Bernheim-Jeune-Dauberville, Paris 1960, no. 30; *La douce France*, Nationalmuseum, Stockholm 1964, no. 52; *Aquarelles de Cézanne*, Galerie Bernheim-Jeune, Paris 1971, no. 27.

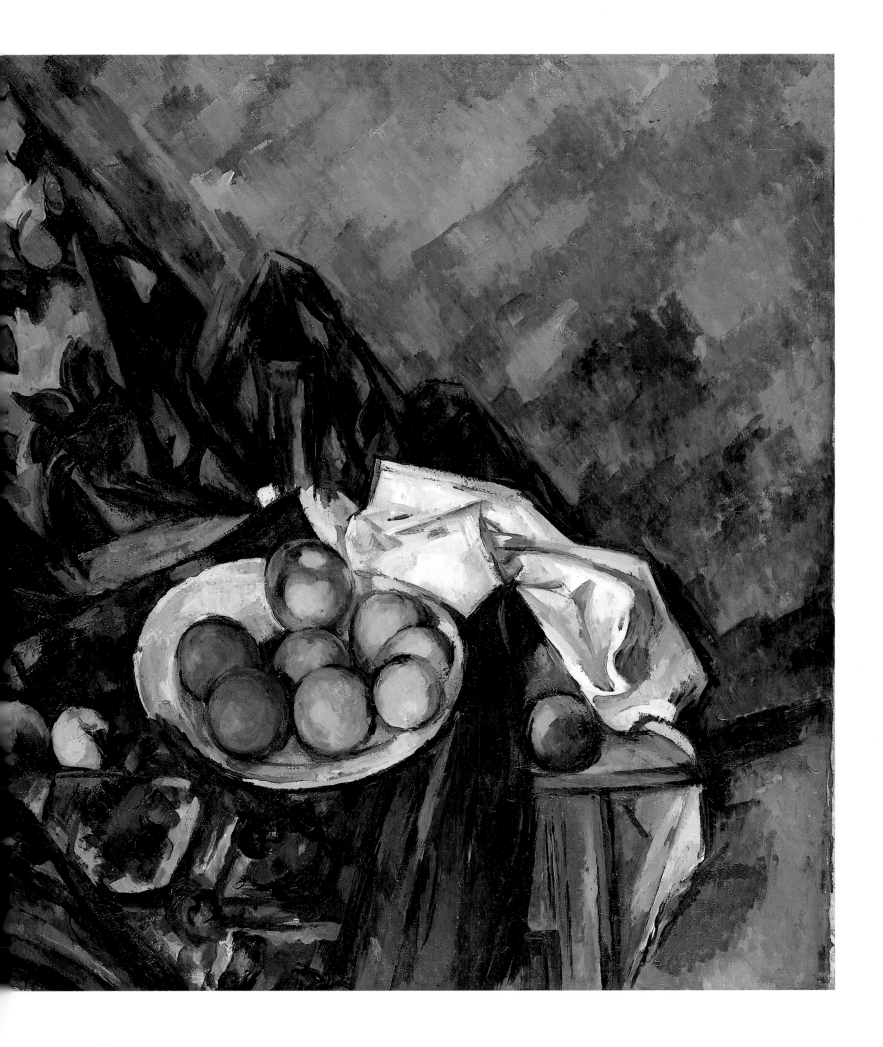

89 Mont Sainte-Victoire, 1900–2
La montagne Sainte-Victoire

Venturi no. 661 (1890–94)
Oil on canvas, 21 1/2 x 25 1/2″ (54.6 x 64.8 cm).
National Gallery of Scotland, Edinburgh

Cézanne's sister Rose Conil had bought the Montbriand estate west of Aix, and up into his old age, the artist frequently walked its hills and those of the neighboring farm Bellevue. From there he could look out across the valley of the Arc (see cat. no. 71) to Mont Sainte-Victoire, rising to the east, as Rilke wrote, "indescribably with all its thousand troubles.... There he would sit for hours, occupied with finding and registering the 'planes' (about which he speaks again and again, remarkably enough in the same terms as Rodin)."[1] Though he had hiked the mountain in his youth, Cézanne only began to paint this "absolutely stunning view"[2] extensively beginning in the mid 1880s. The paintings he did of it (see cat. nos. 90–92) join those of L'Estaque (see cat. nos. 8, 19, 22, 23, 72) as the only spacious panoramas in his entire œuvre. Its west face looming above the city, often painted from the road leading from the Jas de Bouffan to Montbriand, presents a gently rising north slope and a steeper descent on the south. Combined with the slopes of Mont du Cengle on the right and the railroad viaduct in the valley below, it provided the painter with an endlessly fascinating motif.

One of the last of his views of the mountain rising above the expanse of the Arc Valley and calmed by its strong horizontals was this landscape pervaded by a chill blue. The leafless branches on the left tell us that he painted it in winter. Because he worked from an elevated vantage point, high above the ocher-colored fields, the painter and his mountain become virtual partners. And it was *his* mountain, for in his over thirty-five views of it, he was the first to give it an unmistakable physiognomy. Despite the distance, the planes and outlines of Mont Sainte-Victoire are as clearly defined as the branches just in front of the viewer, which repeat the mountain silhouette upside down. Their blue serves as a bridge between the foreground and the symmetrical background, in which the imposing massif, utterly weightless, basks in the blue of the sky. A very few linear perspective effects create the illusion of a picture space, into which a delicate web of lines has been cast. Many patches are left without color, suggesting transparency on the one hand, and on the other, solid forms receiving the full glare of Provençal sunlight. One has the impression that the painting was constructed around these bare patches, that they lift up in three dimensions to assume physical shape, to become recognizable as solid matter. It is in large part thanks to them that the picture manages to convey a sense of both solidity and vast, sweeping space.

NOTES

1 Rilke 1977, 23. See the views Venturi 1936, nos. 452–57, 477, 488, 662.
2 Cézanne 1984, 164. The motif makes its first monumental appearance in about 1870 in the landscape *La tranchée,* Venturi 1936, no. 50; aside from this, the mountain appeared only as a backdrop in a few of the early figural scenes, see cat. no. 1 and Venturi 1936, nos. 273, 274, 276.

PROVENANCE: Ambroise Vollard, Paris; Reid & Lefevre, London; Stanley W. Sykes, Cambridge; Arthur Tooth, London; Alexander Maitland, Edinburgh.
BIBLIOGRAPHY: Venturi 1936, 207, no. 661, illus.; Badt 1956, 130; Chappuis 1973, 214, no. 886; Paris 1974, 96; New York 1977, 26, 48, 308, illus. 115; Arrouye 1982, **95**; Cézanne 1988, **206**.
EXHIBITIONS: Paris 1978, 186ff., no. 80, illus., 242; Madrid 1984, no. 42, illus.; Aix-en-Provence 1990, 205, illus. 184, no. 40; Edinburgh 1990, no. 60, illus.

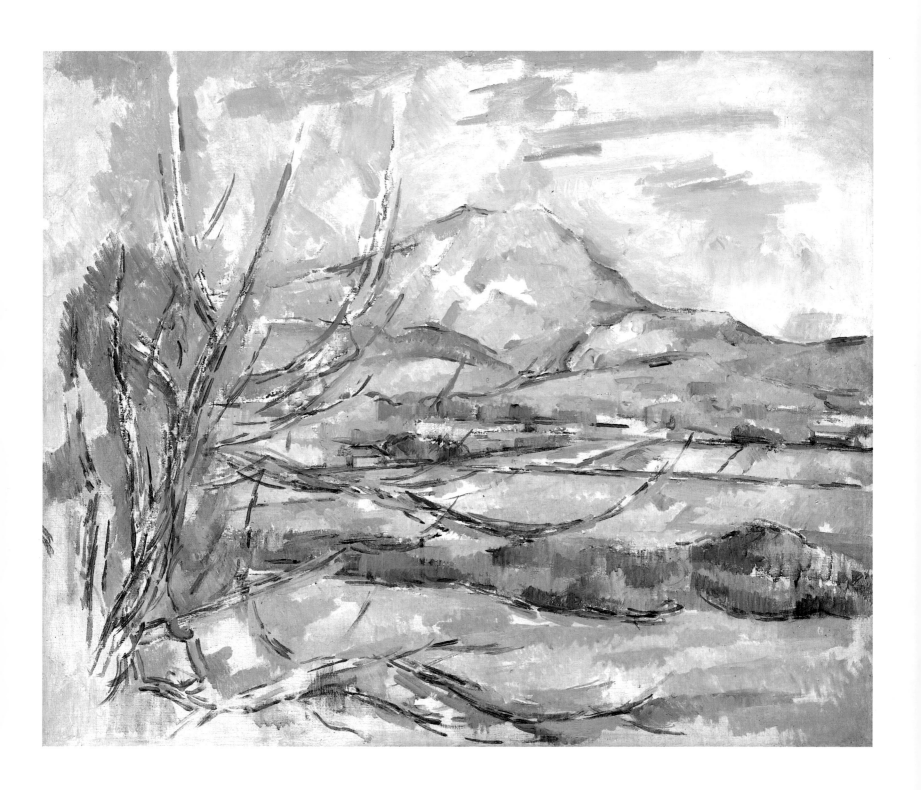

90 Mont Sainte-Victoire Seen from Les Lauves, 1904–6
La montagne Sainte-Victoire vue des Lauves

Venturi no. 800 (1904–6)
Oil on canvas, 29 1/8 x 32 1/8″ (73.8 x 81.5 cm).
The Nelson-Atkins Museum of Art, Nelson Fund (inv. no. 38–6),
Kansas City, Missouri

Once Cézanne built his new studio in 1902 on the Chemin des Lauves (see cat. no. 78),
in an area north of Aix that he had not particularly frequented before, he found
himself presented with new views of the city with the hills of the Chaîne de l'Etoile
and Mont Sainte-Victoire in the distance. His various depictions of the remote,
formidable mountain attest to his inexhaustible formal inventiveness (see cat. nos. 91,
92).[1] Most of the early panoramas presented either the profile of the limestone peak
rising to the east of Aix balanced by the broad expanse of the Arc Valley (cat. no. 89),
or a view showing the whole breadth of its southern face (cat. no. 32). In the 1890s,
Cézanne depicted it most often as seen from the Tholonet road, from the Bibémus
Quarry, or from the village of Saint-Marc, making the mountain seem relatively close.
Only in his last years, between 1902 and 1906, did Mont Sainte-Victoire as viewed
from the Chemin des Lauves or the Plateau d'Entremont become the monumental
centerpiece in an incomparably visionary landscape that we see here.

With no framing elements in the foreground, the picture presents the peak as
though placed upon a giant platform, rising up from its darker foothills toward the
light. The platform, the second of the three horizontal picture zones, is made up of an
interlocking grid of color forms, largely overlapping rectangles. Across its depth, dotted
with only a few suggestions of buildings, it presents an amazing wealth of
intermediary tones. Its function is to serve as a link between the green of the
foreground with its olive trees, somewhat carelessly applied, and the blue of the
conical mountain looming up against the sky. It is a dizzying conglomerate of
hatching, shading, and jabs of color, yet the overall structure of the landscape is
altogether defined. The mountain lifts like a solitary crystal above the heavily
burdened space of the plain below.

It is clear that Cézanne felt obliged to be true to nature, but he also had
obligations to the picture, whose two dimensions had to be acknowledged just as fully
as the three-dimensionality of space. His chief concern was how to relate spatial
dimensions, volumes, and surface details appropriately through color, and his solution
in this landscape is what makes it especially worth studying. Recognizing that one
perceives colors first, only later connecting them with known objects, qualities, and
spatial associations, the painter modified the atmospheric space he saw before him
into a picture space dominated by horizontals, layered out of "taches colorées." Warm
colors specific to the foreground sometimes recur in the background; conversely, cool
ones are brought forward. Layer by layer, the eye is led into the distance. It is solely
the construct of colors created through patient observation – suggestive of space, yet
never compromising the picture surface – that clarifies the correlations between spatial
depth and surface relationships. One of Cézanne's pioneering innovations was to
liberate color from the constraints imposed on it for centuries by the demands of
central perspective. Just as he rejected obtrusive lighting effects, using neither dramatic
shadows nor backlighting, he distanced himself from rigid perspective conventions. In
so doing, he by no means discounted what he saw, but rather reinterpreted it in terms
of the specific character of the picture surface. He was perfectly respectful of the effects
that could be achieved with linear perspective, lighting, and outlining, but color
relationships always came first. Speaking of Mont Sainte-Victoire in about 1896, the
painter confessed to his use of "flat," scarcely converging perspectives: "It is quite a

distance away from us, it is massive enough in itself. At the Academy, to be sure, they teach the laws of perspective. I discovered it on my own after long exertions, and I have painted in planes, for I don't paint anything that I don't see."[2] Cézanne also explained his views on this subject to the collector Karl Ernst Osthaus, who visited him in Aix on April 13, 1906:

> He could only show me a few unimportant pictures and studies that the rapacity of the art dealers had left with him. He gathered them together from various corners of the house. They showed masses of shrubbery, rocks, and mountains stacked behind one another. Clouds hung above. The main thing in a picture, he explained, was getting the depth. The color has to express every advance into the distance. How a painter handles that is what lets you know how good he is. While he was talking, he traced with his fingers the boundary lines of the layers in his pictures. He showed me precisely how successful he had been at suggesting depth and where the painting failed to do so. Here the color has remained only color, and has not become an expression of distance. His presentation was so convincing and spirited that I could not recall having ever had my eye trained so much in so short a time.[3]

NOTES

1 See also the views Venturi 1936, nos. 798, 799, 801, 803, 804, 1529, as well as a tall-format work (32 3/4 x 25 5/8"; 83.8 x 65 cm), in the estate of Henry Fearlman, New York, which is not listed in Venturi.
2 Jean Royère, "Paul Cézanne – Erinnerungen," in *Kunst und Künstler* X (1912), 485.
3 Osthaus 1982, 123.

PROVENANCE: Ambroise Vollard, Paris; William Rockhill-Nelson, Kansas City.
BIBLIOGRAPHY: Venturi 1936, 64, 235, no. 800, illus.; Novotny 1938, 12, 204; Badt 1956, 125, 242; Loran 1963, 105; Brion 1973, 81; Barskaya 1975, **190**; Wechsler 1975, illus. 22; Rewald 1986, **248**; Boehm 1988, 140; Teboul 1988, 50, illus. 29; Aix-en-Provence 1990, 285, illus. 231.
EXHIBITIONS: New York 1947, no. 67, illus.; New York 1959, no. 55, illus.; New York 1977, 27, 67, 95, 205, 313, illus. 120, 405, no. 61; Liège 1982, no. 26, illus.

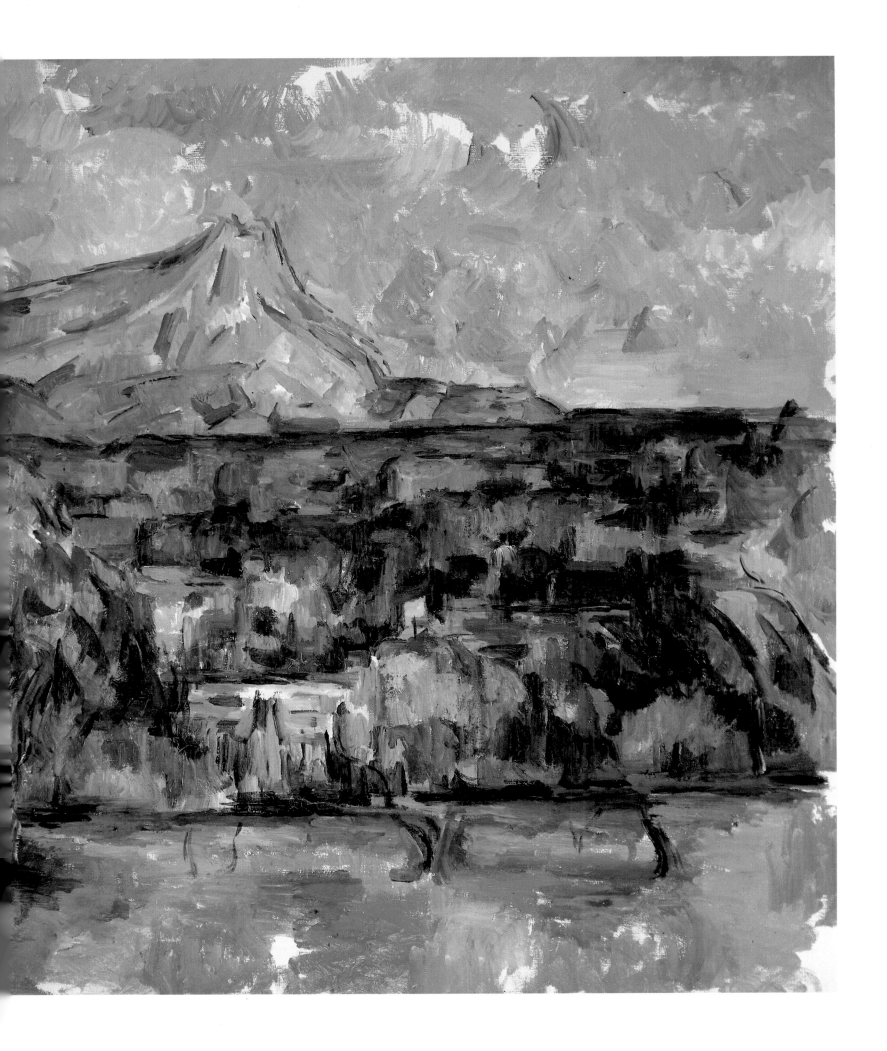

91 Mont Sainte-Victoire Seen from Les Lauves, 1904–6
La montagne Sainte-Victoire vue des Lauves

Not in Venturi
Oil on canvas, 21 1/4 x 28 3/4″ (54 x 73 cm).
Private collection, Switzerland

This landscape study is a miraculous piece of unfinished painting (see cat. nos. 90, 92). It does little more than fix the basic structures of the vaguely suggested mountain peak and the layers of space. Starting from the shadows, it ties the depth to the picture surface in a delicate mosaic of colors made up of horizontals and short vertical shapes. In works like this it is essential to note how brilliantly the aging artist transferred the knowledge and experience he had gained as a watercolorist to the medium of oils. Here, for example, he thinned some of the blue, green, and gray tones with so much turpentine that he managed to achieve with them the transparency and blending of watercolors. It also appears that he deliberately left portions of the canvas free of color in much the same way he might have treated the paper in watercolor, where "highest" and "lowest" brightnesses, that is to say bright white and obviously background white, though identical in appearance, fulfilled separate functions. For example, with a few strokes he lifted the familiar form of the mountain from the neutral background white of the canvas, which stands simultaneously for the inner forms of the mountain that are highest and most brightly illuminated. The one is thus a ground white, while the other, at the far end of the scale, indicates areas of greatest brightness. To bracket foreground and background even more closely, in watercolor painting as well, he created generous transitions from the ground to high white that only reveal their original component of white on closer analysis. The different functions of white, distinguishable only thanks to the colors placed between them, cease to be clear in those areas where it is almost impossible to separate them. From Gestalt psychology we know that a white surrounded by color appears brighter and more three-dimensional than one that is unbounded and seemingly more distant from our gaze. When the light flows undisturbed into the ground, and separate picture planes blend into each other, there is no way we can orient ourselves.

PROVENANCE: Ernst Beyeler, Basel.
BIBLIOGRAPHY: Fritz Novotny, *Paul Cézanne*, London-Cologne 1971, no. 48, illus.; Elgar 1974, 216f., illus. 126; Hülsewig 1981, 21, 41, illus. 1; Arrouye 1982, illus. (jacket); *du* 1989, **60**; Aix-en-Provence 1990, 30, illus. 5.
EXHIBITIONS: *Autour de l'Impressionnisme*, Galerie Beyeler, Basel 1966, no. 69, illus.; *Manet, Degas, Monet, Cézanne, Bonnard*, Galerie Beyeler, Basel 1977, no. 16, illus.; New York 1977, 68, 95, 110, illus. 116, 320, illus. 127, 406, no. 63; Paris 1978, 33, 203, no. 89, 205, illus. 242; Basel 1983, no. 26, illus.

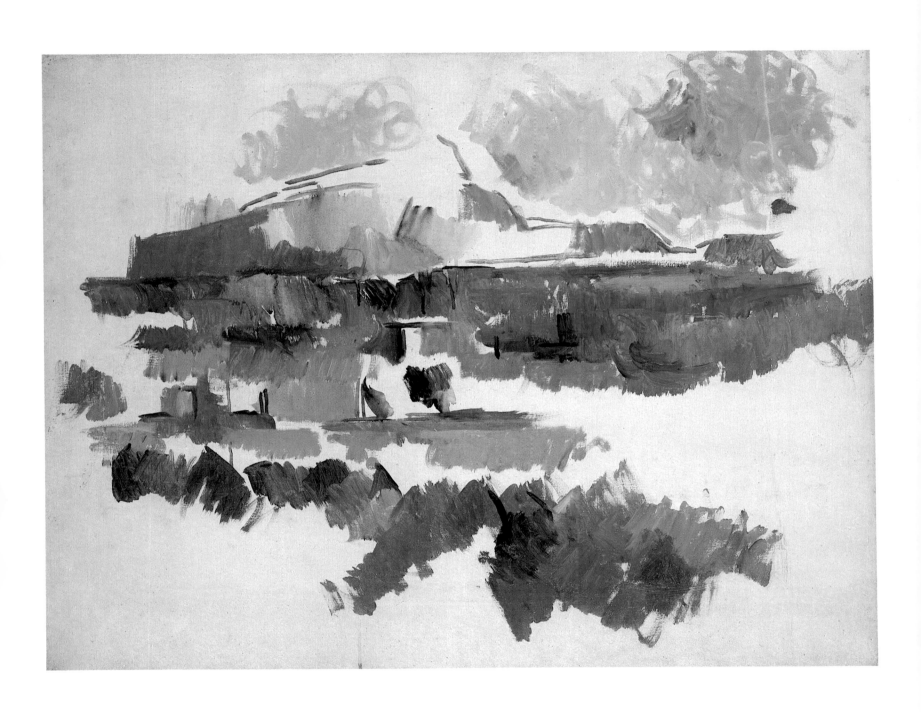

92 Mont Sainte-Victoire Seen from Les Lauves, 1904–6

La montagne Sainte-Victoire vue des Lauves

Venturi no. 802 (1904–6)
Oil on canvas, 26 x 32 1/8″ (66 x 81.5 cm).
Private collection, Switzerland

Never before had the rugged profile of Mont Sainte-Victoire loomed so abruptly above the lavish breadth of the landscape as it does in this view from the Chemin des Lauves (see cat. nos. 90, 91). The mountain silhouette rises into the sky like a monument from a gigantic base of steplike plateaus, and, in fact, the peak serves as a monument of sorts, for it was on this plain that Marius defeated the Teutones. From his low vantage point the painter simplified the structure of the landscape as much as possible, reducing it to the plain, the mountain, and the sky. It is unlikely that Cézanne was familiar with Hokusai's views of Mount Fuji, which appeared in Paris in 1883, but the Japanese artist's woodcuts display a similar degree of abstraction.

The weight of the solitary peak is set above a landscape in which sunlit fields and buildings alternate with dark strips of shadow. The illuminated areas almost seem to mirror the irregular triangle of the mountain. In reality, of course, the mountain is not the dramatic presence that it is here, in part owing to the fact that Cézanne tended to ignore conventions of central perspective and depicted distant objects as lying nearer than they appear. More important to him was structuring the depth in such a way as to preserve clarity and consistency undiminished even in the remotest distance. The eye should be able to understand every feature of the painting, no matter how far away. For Cézanne, there are no distances so great that objects found in them should have appeared less distinct. It is thanks to that consistency in rendering, his substitution of the finite for the infinite, that gives this landscape space its tranquillity. The axis of our gaze leads upward across its expanse to that central point where the horizontal dividing the mountain from the plain dips briefly then moves on.

The depth of feeling that caused Cézanne to be such a revolutionary in his early work reveals itself once again in ravishing eruptions of color found in late paintings like this one. Here, emotion is matched by a supreme ability to condense colors into clearly structured pictures full of sound and fury.[1] In this image of his homeland the painter expressed in concentrated form what he had felt for this landscape since his childhood. Now, after years of struggle, we see him certain of having emerged triumphant as a painter.

NOTES

1 Cézanne, who could translate the "divine comedy" of nature into one of art, was never able to express in words the things he felt when facing monumental landscape. We see him trying to do so in a tortured letter to Emile Bernard from April 15, 1904: "Allow me to reiterate what I said to you here: Deal with nature as cylinders, spheres, cones, all placed in perspective so that each aspect of an object or a plane goes toward a central point. Lines parallel to the horizon give a feeling of expanse, either of a section of nature or, if you prefer, of the spectacle the *Pater Omnipotens Aeterne Deus* offers to our eyes. Lines perpendicular to that horizon give depth. Now, for us men nature consists more of depth than of surface, whence the need to introduce into our vibrations of light, represented by reds and yellows, a sufficient amount of shades of blue to make the air felt." Cézanne 1984, 296.

PROVENANCE: Ambroise Vollard, Paris; William Rockhill-Nelson, Kansas City; Rosengart, Lucerne.
BIBLIOGRAPHY: Venturi 1936, 64, 236, no. 802, illus.; Novotny 1937, 8, 10, 20f., illus. 83; Novotny 1938, 204; Dorival 1949, illus. 145, 172; Raynal 1954, **119**; Badt 1956, 125, 242; *Sammlung Emil G. Bührle*, Zurich 1958, illus. XIV, 134; Loran 1963, 105; Murphy 1971, 146, **156f.**; Wadley 1975, 77, illus. 71; New York 1977, 27f., **67**, **98**, 316, illus. 123; Hülsewig 1981, illus. 5; Boehm 1988, 43, 46, illus. 8, 90, 140; Aix-en-Provence 1990, 42, illus. 8.
EXHIBITIONS: Paris 1929, no. 41; Basel 1936, no. 58, illus.; Lyons 1939, no. 39; *Ausländische Kunst in Zürich*, Kunsthaus, Zurich 1943, no. 540; *Europäische Kunst, 13.–20. Jahrhundert*, Kunsthaus, Zurich 1950,

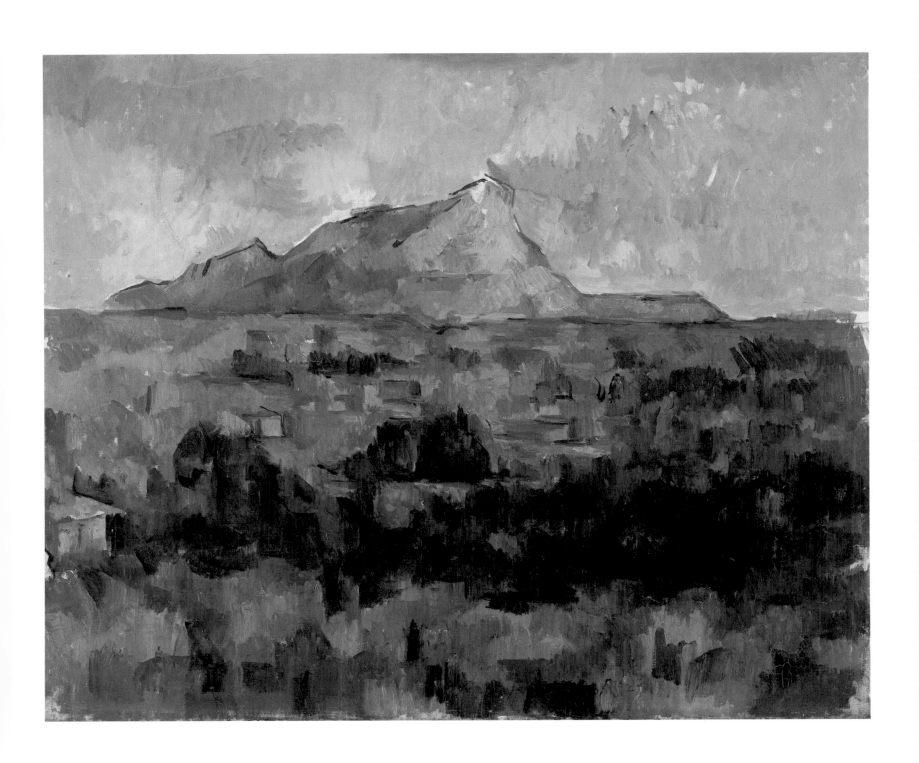

26; *P. Cézanne, 28 Malerier*, Kunstnerforbundet, Oslo 1954, no. 28; *Masterworks from the Collection of Emil G. Bührle, Zurich*, National Gallery of Art, Washington 1990 – Museum of Fine Arts, Montreal – Museum of Art, Yokohama – Royal Academy of Arts, London 1991, no. 44, illus.

93 Riverside, 1904–5
Paysage au cours d'eau

Venturi no. 1533 (1900–1906)
Oil on canvas, 25 3/4 x 31 7/8″ (65.5 x 81 cm).
Private collection

It can be argued that none of Cézanne's paintings were ever finished in the sense of accurately reflecting what he himself imagined. Moreover, there are many works he conceptualized to the end but never completed, abandoning them in a preliminary stage. Nevertheless, in such work the painting can still be regarded as reaching toward an ultimate perfection. The aging painter could afford to keep his vision of things more open than ever before. He said as much in a letter he wrote on October 23, 1905: "Now, old as I am, nearly seventy, I find that the sensations of color that light gives create abstractions that don't allow me to cover my canvas or follow the outlines of objects when the points of contact are tenuous, delicate; thus my image or picture is incomplete."[1]

Cézanne may not have been able to put into words what had happened to his painting, but the canvases themselves are perfectly eloquent. His vision of nature was now wholly consistent with his insight into the nature of the picture. Within a palette that was actually quite limited, he was able to achieve a wealth of color effects, to orchestrate both resounding chords and the most delicate harmonies. His brushwork was now so self-assured that his colors, far from defining concrete realities, appear to follow an abstract logic of their own. Out of the most varied individual colors, generally applied with a broad brush, he succeeded in creating resonances of extreme delicacy along with formal relationships that strike us as exceedingly abstract. Only after repeated study does one begin to make out the landscape captured in these colors: a few buildings next to what appears to be a river on the left, above them clouds in a deep blue sky, on the right, above a masonry wall, a row of shaded trees, and toward the foreground, a flat space mostly overgrown with green.[2] Cézanne worked in the forest of Fontainebleau in the summer of 1904 and again briefly in July 1905. This landscape may well have been one of the fruits of that last summer sojourn in the vicinity of Paris, one that he then likely left with his dealer Vollard before heading home (see cat. no. 94).

Although the statements attributed to Cézanne by the writer Joachim Gasquet hardly have the ring of the painter's own speech, they do indicate what were his major concerns in his late years:

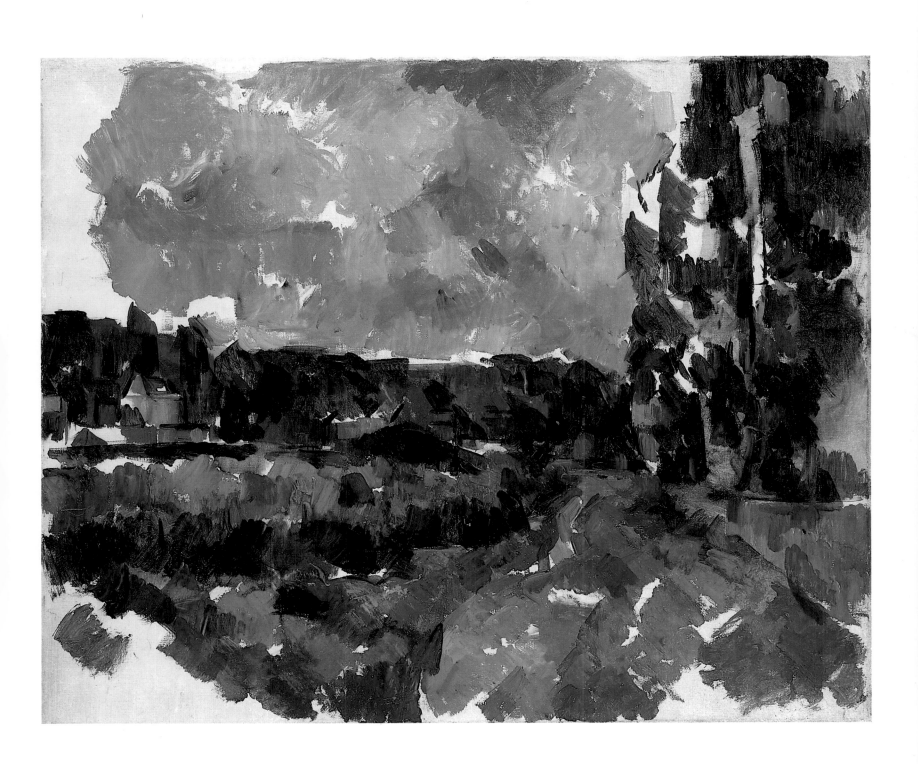

I have captured my motif (He clasps his hands.) A motif, you see, is like this. (He repeats his movement, separating his hands, stretching his ten fingers wide apart, then slowly, slowly bringing them together and clasping them again, pressing them together, tighter, forcing them to crush each other.) There, that's what you need to accomplish. If I reach too high or too low, all is lost. There mustn't be a single stitch too loose, any hole through which the excitement, the light, the truth can slip through. I develop the whole picture uniformly, you understand, in its entirety.... After that, I pull her [nature's] erring hands together ... taking from the right, from the left, here, there, everywhere, her tones, her colors, her gradations, I hold them fast, I bring them together ... they form lines. They become objects, rocks, trees, without my thinking about it. They take on weight, they have a color value. If this weight, this color value in my picture, in my perception corresponds to the planes, the patches that I have, that are there before our eyes, then my picture clasps its hands. It doesn't totter. It doesn't reach too high, not too low. It is truthful, it is tight, it is full.... But if I feel the slightest digression, the slightest weakness, especially if one day I project too much into it, if I get carried away by a theory today that contradicts the one from yesterday, if I think while painting, if I put myself in the way, *Bang!* ... everything is ruined.[3]

NOTES

1 Cézanne 1984, 313.
2 See the painting *Paysage au cours d'eau,* Venturi 1936, no. 769, and the watercolor *La Seine aux environs de Paris,* Rewald 1983, no. 627.
3 Gasquet 1930, 100.

PROVENANCE: Ambroise Vollard, Paris; Christian de Galéa, Paris; Heinz Berggruen, Paris.
BIBLIOGRAPHY: Venturi 1936, 334, no. 1533, illus.; New York 1977, 49, 281, illus. 78.
EXHIBITIONS: *Het Fransk Landschaaf van Poussin tot Cézanne,* Rijksmuseum, Amsterdam 1951, no. 13; Tokyo 1974, no. 58.

94 Riverbanks, 1904–5
Bords d'une rivière

Venturi no. 771 (circa 1900)
Oil on canvas, 25 1/4 x 31 7/8″ (65 x 81 cm).
Private collection, Switzerland

This river landscape is constructed like a wall pieced together out of colored blocks of stone. Almost nowhere else in Cézanne's landscapes is so much space accorded to the depth of the sky. Its blue shot through with green is reflected in a stream flowing past the summer-browned ocher of grainfields on its banks. Somewhere in the vicinity of Paris, either in the summer of 1904 or 1905 (see cat. no. 93), the painter singled out this seemingly unpromising motif and transformed it in his picture into an exquisitely wrought tapestry of browns, greens, and blues.

PROVENANCE: Ambroise Vollard, Paris.
BIBLIOGRAPHY: Venturi 1936, 231, no. 771, illus.; Badt 1956, 242; *du* 1989, 77.
EXHIBITIONS: Basel 1983, no. 27, illus.

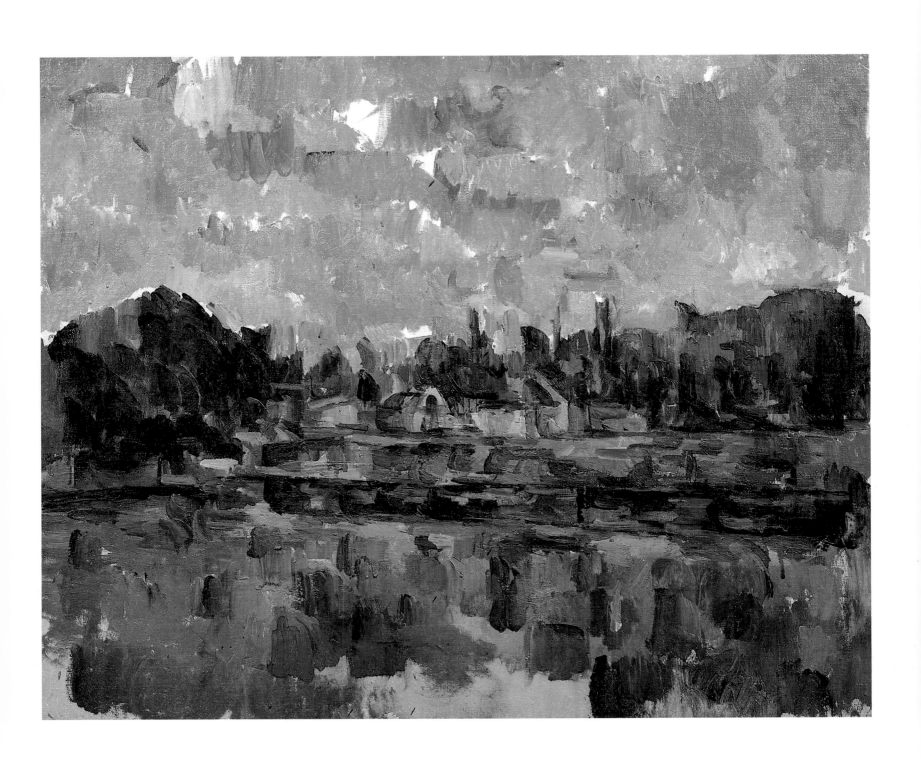

95 The Château Noir, 1904–6
Le Château Noir

Venturi no. 794 (1904–6)
Oil on canvas, 28 7/8 x 36 3/4" (73.6 x 93.2 cm).
The Museum of Modern Art,
Gift of Mrs. David M. Levy, 1957, New York

To the elderly Cézanne, attractive views to the south of Aix like those of the houses at
L'Estaque (see cat. nos. 8, 19, 23, 72) or the mountain village of Gardanne (see cat. no.
31) had lost their appeal. He now preferred working to the north and east of the city,
on the road leading to the hamlet of Le Tholonet. In that area, then unspoiled, he
could enjoy splendid views of Mont Sainte-Victoire; in addition, there were two
intriguing estates, La Maison Maria and above it Le Château Noir. The latter, a
neo-Gothic folly built for a coal merchant in the second half of the nineteenth century,
provided the landscape with a touch of mystery and romance. He painted most of his
pictures of the château (see cat. no. 96) and had also tried to buy the unfinished
structure, only after the Jas de Bouffan had been sold, in 1899.[1]

To obtain this west view of the château, partially obscured by tall pines and
shrubbery, with the Mont du Cengle dark blue foothills to the right above its terrace,
Cézanne had to stand near the path connecting La Maison Maria to Le Château Noir.[2]
The touch of ocher in the lower left corner of the picture, required as a counterweight
to the broad green diagonal of the trees, indicates a portion of the road itself. The
masonry of the building is also rendered in ocher, and its façade is further enlivened
by several windows with pointed arches and a dark brown wooden door at almost the
exact center of the picture.

Leaving behind the lighter palette of the 1880s, in his late years Cézanne
preferred more urgent colors of an intensity once again more indebted to Delacroix.
The complementary contrasts between the brightest and darkest of them, rendered in
strong, rhythmic brushwork with relatively large amounts of pigment, again became
most important to him. Proceeding from blue and yellow or orange-ocher and deep
violet, Cézanne constructed sequences of color that could either escalate to the
powerful contrast of red and blue or come to rest in the juxtaposition of purple and
emerald green. He also made use of the fact that the three primary colors, red, yellow,
and blue, seem especially intense when placed next to the secondary colors mixed
from them – red juxtaposed to orange or violet, yellow to orange or green, blue to
violet or green. Henri Matisse referred to the painter's brilliant manipulation of such
relationships in 1908: "Cézanne used blue to bring out his yellow, but he used it, like
everything else, with a degree of discrimination unmatched by anyone else."[3]

In the intense emotion in the face of nature that Cézanne registered in his old
age, we still glimpse some of the passion that led him to be so self-assertive in his
early years. Although the mature paintings are much more layered with feeling than
those that preceded them, they attain a matter-of-factness that comes closest to that of
nature. Leaving behind him the more complex structures of his earlier years, he now
developed pictorial ideas in which his emotions and artistic judgment, his expressive
will and experience with his medium, his perceptions and logic, could come together
in gorgeous instrumentations of color. Claude Monet – whom Cézanne greatly
admired – must have been moved by the magnitude of this blending of architecture
and nature when he bought this masterpiece. One of no fewer than thirteen Cézanne
paintings in his collection (see cat. no. 27), it hung for a long time in Monet's bedroom
at Giverny. Monet's comment when he proudly showed the work to George
Clemenceau was brief and to the point: "Yes, Cézanne, he is the greatest of us all!"[4]

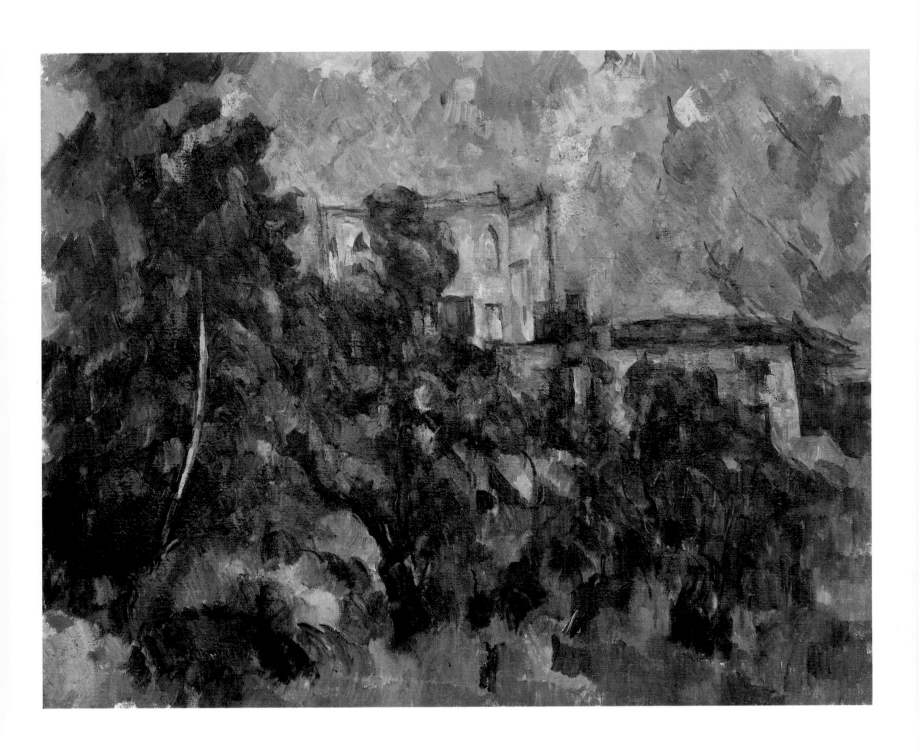

NOTES

1 See Venturi 1936, nos. 667, 765, 796, 797.
2 See the watercolor copy Rewald 1983, no. 636.
3 Matisse 1982, 89.
4 M. Georges-Michel, *De Renoir à Picasso*, Paris 1954, 24.

PROVENANCE: Claude Monet, Giverny; Paul Rosenberg, Paris-New York; David M. Levy, New York.
BIBLIOGRAPHY: Raynal 1936, illus.; Venturi 1936, 64, 234f., no. 794, illus.; Novotny 1938, 114, 195; Dorival 1949, 92, 94, 101, illus 141, 171; Guerry 1950, 129; Badt 1956, 126, 242; Neumeyer 1958, 61; Badt 1971, 40, 42; Elgar 1974, 193, illus. 113; Schapiro 1974, 122f.; Barskaya 1975, 189; Hülsewig 1981, illus. 9; Philadelphia 1983, XVI; Rewald 1983, 183, no. 394, 255, no. 636; Cézanne 1988, 286; Basel 1989, 283, 288, 302.
EXHIBITIONS: Paris 1936, no. 111, illus. 30; Paris 1939 (Rosenberg), no. 34, illus.; New York 1942, no. 23, illus.; Chicago 1952, no. 117, illus.; New York 1977, 36, 86, 204, 264, illus. 60, 401f., no. 51; Paris 1978, 147f., no. 52, illus., 241; Basel 1983, no. 29, illus.; Aix-en-Provence 1990, 34, illus. 7, no. 29.

96 The Château Noir, 1904–6
Le Château Noir

Venturi no. 795 (1904–6)
Oil on canvas, 29 1/8 x 37″ (74 x 94 cm).
Musée Picasso, Donation Picasso (inv. no. RF 1973–60), Paris

It is hardly surprising that Cézanne's dealer Ambroise Vollard, knowing that the counterpart to this painting (cat. no. 95) hung in the collection of none other than Monet, should have held this work back for such a prominent buyer as Picasso. The transaction must have taken place before 1936, for in Venturi's catalogue raisonné, the painting is already listed as being in Picasso's collection. Although both Monet and Picasso had assembled collections of the highest quality, there is no question but that their respective views of the west wing of the Château Noir were their most important acquisitions. For both versions Cézanne used the same vantage point on the path between La Maison Maria and the château. Here, he turned his easel slightly more to the right, so that the foothills of the Plateau de Maurély and the Mont du Cengle are more clearly recognizable in the background. While he stood at essentially the same spot, the color effects he developed in his two paintings are very different. The Picasso version, with only thin layers of color, seems more muted, flatter, and as a result altogether more homogenous. André Malraux provides a simple explanation for this in connection with a Japanese picture scroll from the twelfth or thirteenth century: "In the west a matte painting means a fresco.... The only place I have found the essential quality of this picture scroll is in *Le Château Noir* from the Picasso Collection. Vollard, who was always scrupulous in his dealings with Cézanne, had refrained from varnishing it."[1]

NOTES

1 André Malraux, *La Tête d'obsidienne*, Paris 1974, 191.

PROVENANCE: Ambroise Vollard, Paris; Pablo Picasso, Paris.
BIBLIOGRAPHY: Venturi 1936, 64, 235, no. 795, illus.; Novotny 1938, 114, 195; Badt 1956, 242; Neumeyer 1958, 61; *Donation Picasso. La collection personelle de Picasso*, Paris 1978, no. 6, illus.; Rewald 1983, 255, no. 636; Basel 1989, 293, 303.
EXHIBITIONS: New York 1977, 28, 36, 86, 90, illus., 204, 259, illus., 263, illus. 59, 402, no. 52; Paris 1978, 237, no. 53 bis, illus.; Aix-en-Provence 1990, 184, illus. 166, no. 30, 334, illus. 266.

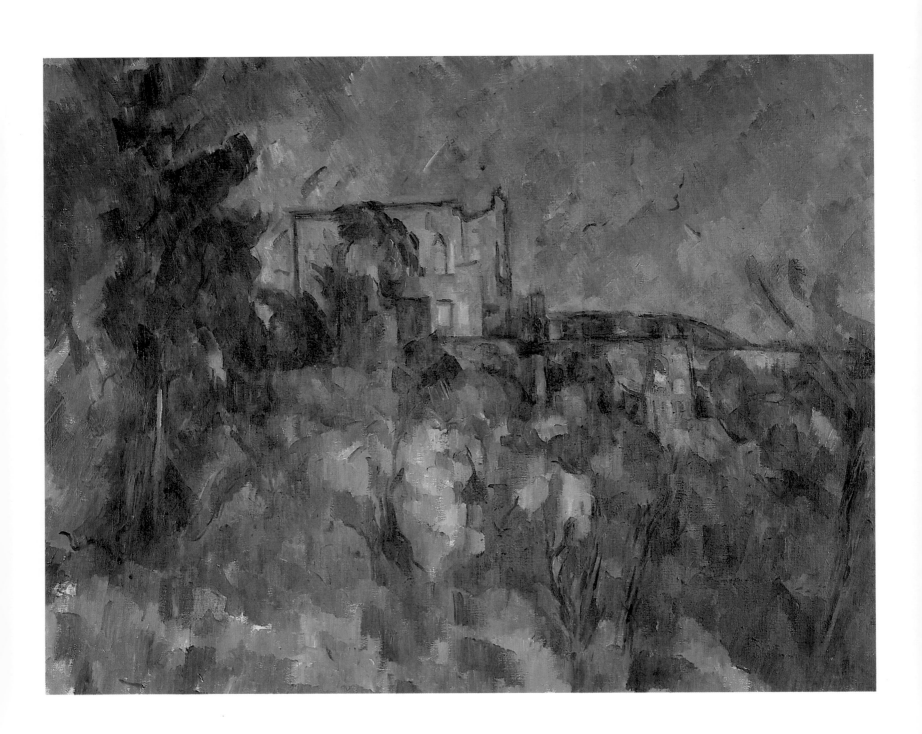

97 Jourdan's Cottage, 1906
Le cabanon de Jourdan
Venturi no. 805 (1906)
Oil on canvas, 25 5/8 x 31 7/8″ (65 x 81 cm).
Galleria Nazionale d'Arte Moderna, Rome

A merchant by the name of Jourdan had sizable real-estate holdings northeast of Aix in the vicinity of Beauregard, and toward the end of Cézanne's life, he often chose to paint there in the extremely hot months of summer and early fall. On July 24, 1906, he wrote his son that he had gotten a ride "out again to the Jourdans,"[1] and in his next-to-last letter to him, on October 13, he tells about working in the vicinity of Beauregard:

> The banks of the river have grown a bit chilly, I've abandoned them and am going higher up around Beauregard where the path is quite steep, very picturesque but wide open to the Mistral. At the moment, I'm going on foot with just a bag of watercolors, putting off painting in oil until I've found somewhere to leave my gear. In the old days you could do that for thirty francs a year. One is exploited on all sides.... The weather is stormy and very changeable. With my nerves so weakened, only oil painting keeps me going. And I must continue. Thus, I have to work from nature. Any sketches or canvases I would do would have to be constructions [from nature] based on the means, feelings and approaches suggested by the model. But I'm always saying the same thing. Could you get me a small amount of almond loaf?[2]

According to tradition, this depiction of Jourdan's stone cottage surrounded by cypresses, with its pointed chimney and a door that brings down the blue of the sky into the middle of a glowing orange ocher, was the last landscape painting Cézanne worked on *sur le motif*.[3] With it, Cézanne closed the circle of locations around the city of Aix that he had relied on through his painting career. It had begun with the Jas de Bouffan, Bellevue, and Montbriand in the southwest; then it extended to the south and southwest to include various spots on the banks of the Arc and in the vicinity of the villages Meyreuil and Gardanne. To the east, the painter followed the Route du Tholonet or the old road to the Bibémus Quarry and the coffer-dam built by Zola's father. Now, at the last, he favored motifs to the north and northeast, midway toward Vauvenargues, where Picasso, the greatest genius among his successors, would one day be laid to rest at the foot of Mont Sainte-Victoire.

Cézanne died on October 23, 1906, as nearly as he might have wished to, at his easel. On the fifteenth, while working in the vicinity of Beauregard, possibly on this picture of the Jourdan house, he suffered an attack of faintness during a violent storm.[4] The painter's sister Marie notified her nephew Paul in Paris of the situation five days later: "Your father has been ill.... He was out in the rain for several hours on Monday; they brought him back on a laundry cart, and two men had to carry him up to his bed. The next day, as soon as it was light enough, he went out to the garden [of the Lauves studio] to work on a portrait of Vallier under the linden tree; he came back nearly dead."[5]

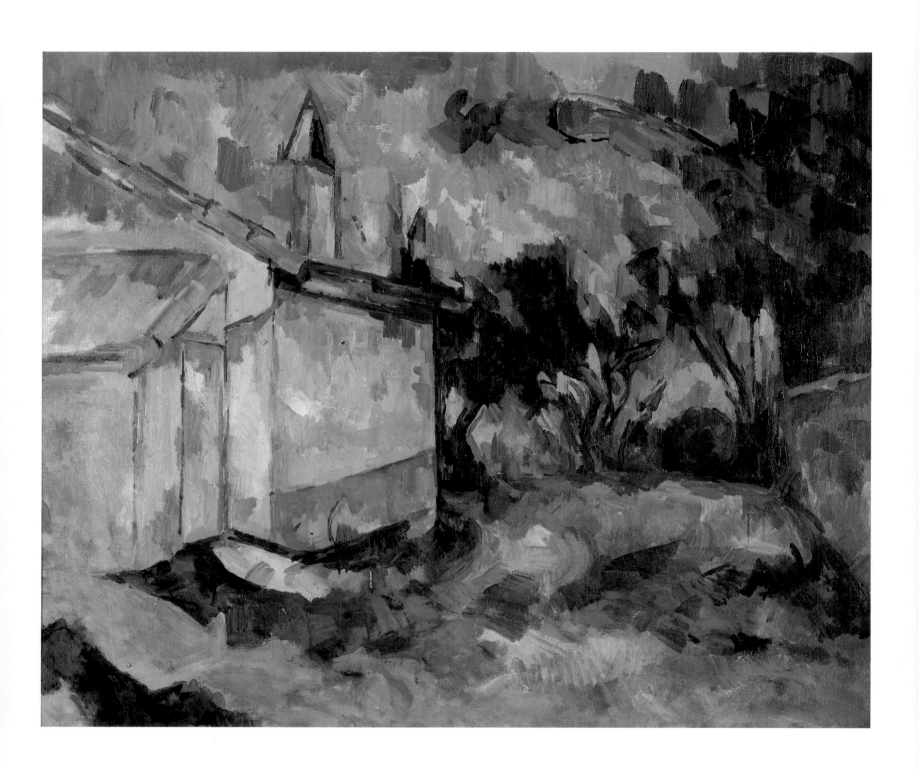

NOTES

1 Cézanne 1984, 316.
2 Ibid., 327-28.
3 See the watercolor Rewald 1983, no. 645, which is altogether different in color. In the watercolor with the same cropping, one can make out neither the wall in the right foreground nor a "typical Provençal fountain in the form of a beehive" in the background, which Rewald claims to see in the painting. More clearly than in the painting, however, one can see a gutter along the roof in front that drains into a small basin to the right of the cottage.
4 As late as the morning of October 15, he wrote his son in Paris: "You are right when you say this is the real country. I'm still working, with difficulty but at least something is coming. It's important I think. Feelings being at the bottom of what I'm doing, I believe I'm impenetrable. Everything happens so terribly quickly. I'm not doing too badly. I take care of myself and eat well. Please order me two dozen *émeloncile* brushes, like those we ordered last year ... I repeat, I eat well, and a bit of moral satisfaction – but only work can provide that – would be good for me. All my compatriots are asses compared to me ... I think the young painters far more intelligent than the others, the elders see in me only a dangerous rival." Cézanne 1984, 328.
5 Ibid., p. 329. It was probably the portrait Venturi 1936, no. 718.

PROVENANCE: Paul Cézanne *fils*, Paris.
BIBLIOGRAPHY: Rivière 1923, illus. p. 225; Venturi 1936, 64, 236, no. 805, illus.; Raynal 1954, 113, **121**; Badt 1956, 242; Gowing 1956, 192; Ratcliffe 1960, 32; Loran 1963, 105; Leonhard 1966, 10; Brion 1973, 65, **71**; Elgar 1974, 231, illus. 137; Geist 1975, 16; Adriani 1981, 278; Arrouye 1982, 53; Rewald 1983, 260, no. 645.
EXHIBITIONS: Lyons 1939, no. 40; Paris 1939, no. 20; London 1939, no. 45; Chicago 1952, no. 128, illus.; Aix-en-Provence 1953, no. 24; Zurich 1956, no. 207; New York 1977, 29, 69, 105, 116, 205, 286, illus. 83, 403, no. 56; Paris 1978, 38, 45, 168ff., no. 65, illus. 242.

Paul Cézanne on the Chemin des Lauves,
photograph by Emile Bernard, 1904

Selected Bibliography

Sources cited in plate bibliographies in abbreviated form are in the listing below, which consists mainly of books and articles on Cézanne published since 1936, excluding numerous illustrated volumes and text compilations, especially those that have appeared since 1970. An extensive bibliography of the pre-1936 literature may be found in the catalogue raisonné Venturi 1936, 365ff.

Adhémar 1960	Jean Adhémar, "Le cabinet de travail de Zola," in *Gazette des Beaux-Arts*, November 1960, 285ff.
Adriani 1978	Götz Adriani, *Paul Cézanne, Zeichnungen*, Cologne 1978 (in conjunction with the exhibition *Paul Cézanne, Zeichnungen*, Kunsthalle, Tübingen 1978).
Adriani 1980	Götz Adriani, *Paul Cézanne, "Der Liebeskampf," Aspekt zum Frühwerk Cézannes*, Munich-Zurich 1980.
Adriani 1981	Götz Adriani, *Paul Cézanne, Aquarelle*, Cologne 1981 (in conjunction with the exhibition *Paul Cézanne, Aquarelle*, Kunsthalle, Tübingen 1982).
Andersen 1967	Wayne Andersen, "Cézanne, Tanguy, Choquet," in *The Art Bulletin* XLIX, 2 (June 1967), 137ff.
Andersen 1970	Wayne Andersen, *Cézanne's Portrait Drawings*, Cambridge (Mass.)-London 1970.
Apollinaire 1989	*Apollinaire zur Kunst, Texte und Kritiken 1905–1918*, edited by Hajo Düchting, Cologne 1989.
Arrouye 1982	Jean Arrouye, *La Provence de Cézanne*, Aix-en-Provence 1982.
Badt 1956	Kurt Badt, *Die Kunst Cézannes*, Munich 1956.
Badt 1971	Kurt Badt, *Das Spätwerk Cézannes*, Constance 1971.
Barnes, Mazia 1939	Albert C. Barnes, Violette de Mazia, *The Art of Cézanne*, Merion (Pa.) 1939.
Barskaya 1975	A. Barskaya, *Paul Cézanne*, Leningrad 1975.
Bernard 1925	Emile Bernard, *Sur Paul Cézanne*, Paris 1925.
Bernard 1982	Emile Bernard, "Paul Cézanne 1904" and "Erinnerungen an Paul Cézanne," in *Gespräche mit Cézanne*, edited by Michael Doran, Zurich 1982, 47ff., 69ff.
Bernheim-Jeune 1914	*Album Cézanne*, edited by Bernheim-Jeune, Paris 1914.
Berthold 1958	Gertrude Berthold, *Cézanne und die alten Meister*, Stuttgart 1958.
Boehm 1988	Gottfried Boehm, *Paul Cézanne, Montagne Sainte-Victoire*, Frankfurt am Main 1988.
Borély 1982	Jules Borély, "Cézanne in Aix," in *Gespräche mit Cézanne*, edited by Michael Doran, Zurich 1982, 34ff.
Brion 1973	Marcel Brion, *Paul Cézanne*, Munich 1973.
Brion-Guerry 1961	Liliane Brion-Guerry, "Esthétique du portrait cézannien," in *Revue d'esthétique* 14 (1961), 1ff.
Burger 1913	Fritz Burger, *Cézanne und Hodler*, Munich 1913.
Cézanne 1962	Paul Cézanne, *Briefe*, edited by John Rewald, Zurich 1962 (original French edition, Paris 1937).
Cézanne 1984	*Paul Cézanne, Letters*, Revised and Augmented Edition, edited by John Rewald, translated by Seymour Hacker. New York 1984.
Cézanne 1988	*Cézanne by Himself*, edited by Richard Kendall, London-Sydney 1988.

Chappuis 1962 Adrien Chappuis, *Le dessins de Paul Cézanne au Cabinet des Estampes du Musée des Beaux-Arts de Bâle*, text and plate volumes, Olten-Lausanne 1962.

Chappuis 1973 Adrien Chappuis, *The Drawings of Paul Cézanne, a Catalogue Raisonné*, text and plate volumes, London 1973.

Cherpin 1972 Jean Cherpin, "L'Œuvre gravé de Cézanne," in *Arts et Livres de Provence* 82 (1972).

Cogniat 1939 Raymond Cogniat, *Cézanne*, Paris 1939.

Cooper 1954 Douglas Cooper, "Two Cézanne Exhibitions, I-II," in *The Burlington Magazine* XCVI, 620-21 (November–December 1954), 344ff., 378ff.

Coquiot 1919 Gustave Coquiot, *Paul Cézanne*, Paris 1919.

Coutagne 1984 Denis Coutagne, *Cézanne au Musée d'Aix*, Aix-en-Provence 1984.

Denis 1982 Maurice Denis, "Cézanne," in *Gespräche mit Cézanne*, edited by Michael Doran, Zurich 1982, 202ff.

Dorival 1949 Bernard Dorival, *Cézanne* Hamburg 1949.

du 1989 "Das Tor zur Moderne. Paul Cézanne in Schweizer Sammlungen," in *du* 9 (September 1989), 16ff.

Elderfield 1971 John Elderfield, "Drawing in Cézanne," in *Artforum* (June 1971), 51ff.

Elgar 1974 Frank Elgar, *Cézanne*, London 1974.

Erpel 1988 Fritz Erpel, *Paul Cézanne*, Berlin 1988.

Faure 1923 Elie Faure, *P. Cézanne*, Paris 1923.

Feist 1963 Peter H. Feist, *Paul Cézanne*, Leipzig 1963.

Frank 1986 Paul Frank, *Cézanne*, Reinbek 1986.

Franz 1956 H. G. Franz, "Cézanne und die Abkehr vom Impressionismus," in *Forschungen und Fortschritte* 30 (1956), 50ff., 82ff.

Fry 1927 Roger Fry, *Cézanne, a Study of his Development*, London-New York 1927.

Gasquet 1921 Joachim Gasquet, *Cézanne*, Paris 1921.

Gasquet 1930 Joachim Gasquet, *Cézanne*, Berlin 1930.

Gasquet 1991 *Joachim Gasquet's Cézanne*, London 1991.

Geist 1975 Sidney Geist, "The Secret Life of Paul Cézanne," in *Art International* XIX, 9 (November 1975), 7ff.

Geist 1988 Sidney Geist, *Interpreting Cézanne*, Cambridge (Mass.)-London 1988.

Gowing 1956 Lawrence Gowing, "Notes on the Development of Cézanne," in *The Burlington Magazine* XCVIII, 639 (June 1956), 185ff.

Graber 1932 Hans Graber, *Paul Cézanne, Briefe, Erinnerungen*, Basel 1932.

Guerry 1950 Liliane Guerry, *Cézanne et l'expression de l'espace*, Paris 1950.

Hamilton 1956 G. H. Hamilton, "Cézanne, Bergson and the Image of Time," in *College of Art* 16 (1956), 2ff.

Hülsewig 1981 Jutta Hülsewig, *Das Bildnis in der Kunst Paul Cézannes*, Bochum 1981.

Huyghe 1936 René Huyghe, "Cézanne et son œuvre," in *L'Amour de l'Art* (May 1936).

Javorskaia 1935 Nina Javorskaia, *Cézanne*, Moscow-Milan 1935.

Kirsch 1987 Bob Kirsch, "Paul Cézanne, 'Jeune fille au piano' and Some Portraits of His Wife," in *Gazette des Beaux-Arts* (July–August 1987), 21ff.

Klingsor 1923 Tristan L. Klingsor, *Cézanne*, Paris 1923.

Kosinski 1991 Dorothy Kosinski "G. F. Reber, Collector of Cubism," in *The Burlington Magazine* CXXXIII, 1061 (August 1991), 521.

Krumrine 1980 — Mary Louise Krumrine, "Cézanne's Bathers, Form and Content," in *Arts Magazine* (May 1980), 115ff.

Krumrine 1992 — Mary Louise Krumrine, "Cézanne's 'Restricted Power,' Further Reflections on the 'Bathers,' in *The Burlington Magazine* CXXXIV, 1074 (September 1992), 586ff.

Larguier 1925 — Léo Larguier, *Le dimanche avec Paul Cézanne*, Paris 1925.

Lehel 1923 — François Lehel, *Cézanne*, Budapest 1923.

Leonhard 1966 — Kurt Leonhard, *Paul Cézanne*, Reinbek 1966.

Lewis 1989 — Mary Tompkins Lewis, *Cézanne's Early Imagery*, Berkeley 1989.

Lichtenstein 1964 — Sara Lichtenstein, "Cézanne and Delacroix," in *The Art Bulletin* XLVI, 1 (March 1964), 55ff.

Lichtenstein 1975 — Sara Lichtenstein, "Cézanne's Copies and Variants after Delacroix," in *Apollo* (February 1975), 116ff.

Loran 1963 — Erle Loran, *Cézanne's Composition*, Berkeley 1963.

Mack 1935 — Gerstle Mack, *Paul Cézanne*, New York-London 1935.

Mack 1938 — Gerstle Mack, *La vie de Paul Cézanne*, Paris 1938.

Matisse 1982 — Henri Matisse, *Über Kunst*, edited by Jack D. Flam, Zurich 1982.

Meier-Graefe 1904 — Julius Meier-Graefe, *Entwicklungsgeschichte der modernen Kunst*, Stuttgart 1904.

Meier-Graefe 1910 — Julius Meier-Graefe, *Paul Cézanne*, Munich 1910.

Meier-Graefe 1918 — Julius Meier-Graefe, *Cézanne und sein Kreis*, Munich 1918.

Meier-Graefe 1922 — Julius Meier-Graefe, *Cézanne und sein Kreis*, Munich 1922.

Murphy 1971 — Richard W. Murphy, *Cézanne und seine Zeit 1839–1906*, 1971.

Neumeyer 1958 — Alfred Neumeyer, *Cézanne Drawings*, New York-London 1958.

Neumeyer 1959 — Alfred Neumeyer, *Die Badenden*, Stuttgart 1959.

Novotny 1932 — Fritz Novotny, "Das Problem des Menschen Cézanne im Verhältnis zu seiner Kunst," in *Zeitschrift für Ästhetik und allgemeine Kunstwissenschaft* 26, 3 (1932), 268ff.

Novotny 1937 — Fritz Novotny, *Cézanne*, Vienna 1937.

Novotny 1938 — Fritz Novotny, *Cézanne und das Ende der wissenschaftlichen Perspektive*, Vienna 1938.

Ors 1936 — Eugenio d'Ors, *Paul Cézanne*, New York 1936.

Osthaus 1982 — Karl Ernst Osthaus, "Ein Besuch bei Cézanne 1906," in *Gespräche mit Cézanne*, edited by Michael Doran, Zurich 1982, 122ff.

Perruchot 1956 — Henri Perruchot, *Cézanne*, Esslingen 1956.

Pfister 1927 — Kurt Pfister, *Cézanne, Gestalt, Werk, Mythos*, Potsdam 1927.

Pissarro 1953 — Camille Pissarro, *Briefe an seinen Sohn Lucien*, edited by John Rewald, Erlenbach-Zurich 1953.

Ratcliffe 1960 — Robert William Ratcliffe, *Cézanne's Working Methods and Their Theoretical Background* (unpublished dissertation, Courtauld Institute of Art, University of London), 1960.

Raynal 1936 — Maurice Raynal, *Cézanne*, Paris 1936.

Raynal 1954 — Maurice Raynal, *Cézanne*, Geneva 1954.

Reff 1958 — Theodore Franklin Reff, *Studies in the Drawings of Cézanne* (dissertation, Harvard University, Cambridge), 1958.

Reff 1959 — Theodore Reff, "Cézanne's Drawings, 1875–85," in *The Burlington Magazine* CI, 674 (May 1959), 171ff.

Reff 1959 (*Enigma*) — Theodore Reff, "Cézanne, the Enigma of the Nude," in *Art News* LVIII, 7 (November 1959), 26ff., 68.

Reff 1960 — Theodore Reff, "Cézanne and Poussin," in *Journal of the Warburg and Courtauld Institutes* 23 (1960), 150ff.

Reff 1962 — Theodore Reff, "Cézanne, Flaubert, St. Anthony, and the Queen of Sheba," in *The Art Bulletin* XLIV (June 1962), 113ff.

Reff 1962 (*Stroke*)	Theodore Reff, "Cézanne's Constructive Stroke," in *The Art Quarterly* XXV. 3 (Fall 1962), 214ff.
Reff 1963	Theodore Reff, "Cézanne's Dream of Hannibal," in *The Art Bulletin* XLV, 2 (June 1963) 148ff.
Reff 1983	Theodore Reff, "Cézanne, the Severed Head and the Skull," in *Arts* (October 1983). 90ff.
Rewald 1936	John Rewald, *Cézanne et Zola*, Paris 1936.
Rewald 1939	John Rewald, *Cézanne, sa vie, son œuvre, son amitié pour Zola*, Paris 1939.
Rewald 1969	John Rewald, "Chocquet and Cézanne," in *Gazette des Beaux-Arts* LXXIV, 111 (July–August 1969), 33ff.
Rewald 1975	John Rewald, "Some Entries for a New Catalogue Raisonné of Cézanne's Paintings," in *Gazette des Beaux-Arts* CXXXIV, 117 (September 1975), 157ff.
Rewald 1983	John Rewald, *Paul Cézanne, the Watercolours*, London 1983.
Rewald 1986	John Rewald, *Cézanne, a Biography* (originally published in 1936), New York 1986.
Rewald 1989	John Rewald, *Cézanne and America*, Princeton 1989.
Rilke 1977	Rainer Maria Rilke, *Briefe über Cézanne*, edited by Clara Rilke, Frankfurt am Main 1977.
Rivière 1923	Georges Rivière, *Le maître Paul Cézanne*, Paris 1923.
Rivière 1933	Georges Rivière, *Cézanne, le peintre solitaire*, Paris 1933.
Rousseau 1953	Theodore Rousseau, *Paul Cézanne*, New York 1953.
Salmon 1923	André Salmon, *Cézanne*, Paris 1923.
Schapiro 1968	Meyer Schapiro, "The Apples of Cézanne, an Essay on the Meaning of Still-life," in *Art News Annual* XXXIV (1968), 35ff.
Schapiro 1974	Meyer Schapiro, *Paul Cézanne*, Cologne 1974.
Schmidt 1952	Georg Schmidt, *Aquarelle von Paul Cézanne*, Basel 1952.
Shiff 1984	Richard Shiff, *Cézanne and the End of Impressionism*, Chicago-London 1984.
Strauss 1980	Ernst Strauss, "Nachbetrachtungen zur Pariser Cézanne-Retrospektive 1978," in *Kunstchronik* XXXIII, 7–8 (July–August 1980), 246ff. and 281ff.
Sutton 1974	Denys Sutton, "The Paradoxes of Cézanne," in *Apollo* (August 1974), 98ff.
Teboul 1988	Jacques Teboul, *Les Victoires de Cézanne*, Paris 1988.
Venturi 1936	Lionello Venturi, *Cézanne, son art, son œuvre*, text and plate volumes, Paris 1936.
Venturi 1978	Lionello Venturi, *Cézanne*, Geneva 1978.
Vollard 1914	Ambroise Vollard, *Paul Cézanne*, Paris 1914.
Vollard 1919	Ambroise Vollard, *Paul Cézanne*, Paris 1919.
Vollard 1924	Ambroise Vollard, *Paul Cézanne, his Life and Art*, London 1924.
Vollard 1931	Ambroise Vollard, "Souvenirs sur Cézanne," in *Cahiers d'Art* 9–10 (1931), 386ff.
Vollard 1960	Ambroise Vollard, *Paul Cézanne*, Zurich 1960.
Wadley 1975	Nicholas Wadley, *Cézanne and His Art*, London 1975.
Waldfogel 1961	Melvin Waldfogel *The Bathers of Paul Cézanne* (unpublished dissertation, Harvard University, Cambridge), 1961.
Waldfogel 1962	Waldfogel, "A Problem in Cézanne's 'Grandes Baigneuses,'" in *The Burlington Magazine* CIV, 710 (May 1962), 200ff.
Wechsler 1975	Judith Wechsler, *Cézanne in Perspective*, Englewood Cliffs 1975.
Wedderkop 1922	H. von Wedderkop, *Paul Cézanne*, Leipzig 1922.
Williams 1953	F. Williams, "Cézanne and French Phenomenology," in *The Journal of Aesthetics and Art Criticism* 12 (1953), 481ff.

Exhibitions and Catalogues

Aix-en-Provence 1953	*Cézanne, peintures, aquarelles, dessins* (text by Jean Leymarie), Pavillon de Vendôme, Aix-en-Provence 1953 – Nice 1953.
Aix-en-Provence 1956	*Exposition pour commémorer le cinquantenaire de la mort de Cézanne* (text by Lionello Venturi, Fritz Novotny), Pavillon de Vendôme, Aix-en-Provence 1956.
Aix-en-Provence 1961	*Paul Cézanne* (text by Fritz Novotny), Pavillon de Vendôme, Aix-en-Provence 1961.
Aix-en-Provence 1990	*Sainte-Victoire, Cézanne* (text by Denis Coutagne, Jean Arrouye, et al.), Musée Granet – Pavillon de Vendôme, Aix-en-Provence 1990.
Basel 1936	*Paul Cézanne*, Kunsthalle, Basel 1936.
Basel 1983	*Paul Cézanne*, Galerie Beyeler, Basel 1983.
Basel 1989	*Paul Cézanne. Die Badenden* (text by Mary Louise Krumrine, Gottfried Boehm, Christian Geelhaar), Kunstmuseum, Basel 1989.
Berlin 1900	*III. Jahrgang der Kunst-Ausstellungen*, Galerie Bruno und Paul Cassirer, Berlin 1900.
Berlin 1909	*XII. Jahrgang – III. Ausstellung*, Galerie Paul Cassirer, Berlin 1909.
Berlin 1921	*Paul Cézannes Werke in deutschem Privatbesitz*, Galerie Paul Cassirer, Berlin 1921.
Berlin 1927	*Erste Sonderausstellung in Berlin*, Galerie Thannhauser, Berlin 1927.
Chicago 1952	*Cézanne, Paintings, Watercolors, and Drawings* (text and catalogue by Theodore Rousseau, Patrick T. Malone), The Art Institute of Chicago 1952 – The Metropolitan Museum of Art, New York 1952.
Cologne 1912	*Internationale Kunstausstellung des Sonderbundes*, Cologne 1912.
Cologne 1956	*Cézanne*, Wallraf-Richartz-Museum, Cologne 1956.
Edinburgh 1990	*Cézanne and Poussin, the Classical Vision of Landscape* (text by Richard Verdi), National Gallery of Scotland, Edinburgh 1990.
Hamburg 1963	*Cézanne, Gauguin, Van Gogh, Seurat, Wegbereiter der modernen Malerei* (text by Hans Platte), Kunstverein, Hamburg 1963.
Liège 1982	*Cézanne*, Musée Saint-Georges, Liège 1982.
London 1925	*Paul Cézanne*, The Leicester Galleries, London 1925.
London 1933	*French Painting of the 19th Century, Ingres to Cézanne*, Reid & Lefèvre Gallery, London 1933.
London 1935	*Cézanne*, Reid & Lefèvre Gallery, London 1935.
London 1939	*Homage to Paul Cézanne* (text by John Rewald), Wildenstein Galleries, London 1939.
London 1954	*Cézanne* (text by Lawrence Gowing), Tate Gallery, London 1954.
London 1988	*Cézanne, the Early Years 1859–1872* (text by Götz Adriani, Lawrence Gowing, Mary Louise Krumrine, Mary Tompkins Lewis, Sylvie Patin, John Rewald, catalogue by Lawrence Gowing), Royal Academy of Arts, London 1988 – Musée d'Orsay, Paris – National Gallery of Art, Washington 1989.
Lyons 1939	*Centenaire de Cézanne* (text by Joseph Billiet), Palais Saint-Pierre, Lyons 1939.
Madrid 1984	*Paul Cézanne* (text by John Rewald, Jean Cassou, et al.), Museo Español de Arte Contemporaneo, Madrid 1984.

Munich 1956	*Paul Cézanne* (text by Fritz Novotny), Haus der Kunst, Munich 1956.
Newcastle 1973	*Watercolour and Pencil Drawings by Cézanne* (text by Lawrence Gowing, catalogue by Robert William Ratcliffe), Laing Art Gallery, Newcastle 1973 – Hayward Gallery, London 1973.
New York 1916	*Cézanne*, Montross Gallery, New York 1916.
New York 1919	*Cézanne*, Arden Galleries, New York 1919.
New York 1921	*Cézanne, Redon and others*, Museum of French Art, New York 1921.
New York 1928	*Paul Cézanne*, Wildenstein Galleries, New York 1928.
New York 1929	*Cézanne, Gauguin, Seurat, Van Gogh*, Museum of Modern Art, New York 1929.
New York 1935	*Cézanne and the Impressionists*, Galerie Bignou, New York 1935.
New York 1942	*Cézanne* (text by Lionello Venturi), Galerie Paul Rosenberg, New York 1942.
New York 1947	*Paul Cézanne 1839–1906* (catalogue by Vladimir Visson, Daniel Wildenstein), Wildenstein Galleries, New York 1947.
New York 1952	*Cézanne, Rarely Shown Works* (text by Karl-Ernst Osthaus), Fine Arts Associates, New York 1952.
New York 1959	*Cézanne* (text by Meyer Schapiro, catalogue by Daniel Wildenstein, Georges Wildenstein), Wildenstein Galleries, New York 1959.
New York 1977	*Cézanne, the Late Work* (text by Theodore Reff, Lawrence Gowing, Liliane Brion-Guerry, John Rewald, Fritz Novotny, Geneviève Monnier, Douglas Druick, George Heard Hamilton, William Rubin, catalogue by John Rewald), Museum of Modern Art, New York 1977 – Museum of Fine Arts, Houston 1978 (a comprehensive plate section of the catalogue includes works not actually exhibited).
Paris 1895	*Paul Cézanne*, Galerie Ambroise Vollard, Paris 1895.
Paris 1904	*Salon d'Automne*, Petit Palais, Paris 1904.
Paris 1907	*Salon d'Automne*, Grand Palais, Paris 1907.
Paris 1910	*Cézanne*, Galerie Bernheim-Jeune, Paris 1910.
Paris 1914	*Cézanne*, Galerie Bernheim-Jeune, Paris 1914.
Paris 1920	*Cézanne* (text by Octave Mirbeau), Galerie Bernheim-Jeune, Paris 1920.
Paris 1924	*Cézanne*, Galerie Bernheim-Jeune, Paris 1924.
Paris 1926	*Paul Cézanne*, Galerie Bernheim-Jeune, Paris 1926.
Paris 1929	*Cézanne 1839–1906* (text by Ambroise Vollard, catalogue by Roger Gaucheron), Galerie Pigalle, Paris 1929.
Paris 1930	*Cent ans de peinture française*, Galerie Georges Petit, Paris 1930.
Paris 1935	*Aquarelles et Baignades de Cézanne*, Galerie Renou et Colle, Paris 1935.
Paris 1936	*Cézanne* (texts by Jacques-Emile Blanche, Paul Jamot, catalogue by Charles Sterling), Musée de L'Orangerie, Paris 1936.
Paris 1939	*Paul Cézanne, centenaire du peintre indépendant* (text by Maurice Denis), Musée de L'Orangerie, Paris 1939.
Paris 1939 (*Rosenberg*)	*Cézanne* (text by Tabarant), Galerie Paul Rosenberg, Paris 1939.
Paris 1954	*Hommage à Cézanne* (text by Germain Bazin), Orangerie des Tuileries, Paris 1954.
Paris 1960	*Cézanne, aquarelliste et peintre*, Galerie Bernheim-Jeune, Paris 1960.
Paris 1974	*Cézanne dans les musées nationaux* (text by Maurice Merleau-Ponty), Orangerie des Tuileries, Paris 1974.

Paris 1978 *Cézanne, les dernières années, 1895–1906* (text by William
 Rubin, Liliane Brion-Guerry, John Rewald, Geneviève Monnier,
 catalogue by John Rewald), Grand Palais, Paris 1978 (reduced
 version of the 1977 New York exhibition).

Philadelphia 1934 *Works of Cézanne*, Pennsylvania Museum of Art, Philadelphia
 1934.

Philadelphia 1983 *Cézanne in Philadelphia Collections* (text and catalogue by
 Joseph J. Rishel), Museum of Art, Philadelphia 1983.

San Francisco 1937 *Paul Cézanne* (text by G. L. Cann Morley, Gerstle Mack),
 Museum of Art, San Francisco 1937.

The Hague 1956 *Paul Cézanne* (text by Fritz Novotny), Gemeentemuseum, The
 Hague 1956.

Tokyo 1974 *Cézanne* (text by John Rewald, Denys Sutton, et al.), Museum of
 Western Art, Tokyo 1974 – Museum of the City of Kyoto – Cultural
 Center, Fukuoka 1974.

Tokyo 1986 *Paul Cézanne* (text and catalogue by Ronald Pickvance), Isetan
 Museum of Art, Tokyo 1986 – The Hyogo Prefectural Museum of
 Modern Art, Kobe – The Aichi Prefectural Art Gallery, Nagoya
 1986.

Venice 1920 *XII. Esposizione internazionale d'arte della Città di Venezia.
 Mostra individuale di P. Cézanne*, Venice 1920.

Vienna 1961 *Paul Cézanne* (text by Fritz Novotny, catalogue by Klaus Demus),
 Österreichische Galerie, Vienna 1961.

Washington 1971 *Cézanne, an Exhibition in Honor of the Fiftieth Anniversary of the
 Phillips Collection* (text by John Rewald, Duncan Phillips), The
 Phillips Collection, Washington 1971 – The Art Institute of
 Chicago – Museum of Fine Arts, Boston 1971.

Zurich 1956 *Paul Cézanne* (text by Gotthard Jedlicka), Kunsthaus, Zurich
 1956.

Chronology

1839 Born on January 19 in Aix-en-Provence at 28, rue de l'Opéra, the eldest son of Louis-Auguste Cézanne (1798–1886) and Anne-Elisabeth-Honorine Aubert (1814–1897).

1844 Cézanne's parents marry on January 29.

1848 His father, having acquired a certain amount of wealth through the sale and export of felt hats, founds the Bank Cézanne and Cabassol in Aix on June 1.

1849 Begins schooling at the Ecole de Saint-Joseph, where he remains until 1852.

1852 Begins attending the highly traditional Collège Bourbon, where he befriends Emile Zola (1840–1902), newly moved to Aix from Paris. Continues his studies there until 1858.

1857 Begins classes in the Ecole Spéciale et Gratuite de Dessin (Free Municipal School for Drawing), which he continues to attend until 1862.

1858 Zola moves to Paris with his mother in February. The two friends begin an active correspondence. On his second try, Cézanne passes his graduation examination in November.

1859 Follows his father's wishes and enrolls as a law student in the university at Aix. Now a wealthy banker, his father buys the estate Le Jas de Bouffan (House of Winds) two kilometers west of Aix. Purchases his son's exemption from military service by paying a substitute.

1860 Cézanne forced to continue study of law, though he dreams of becoming a painter.

1861 Breaks off his law studies. Arrives in Paris on April 22 with allowance from his father. At Zola's recommendation, attends the Académie Suisse, led by the elderly Père Suisse, where he is able to work from a model. Becomes acquainted with Camille Pissarro (1830–1903). Returns to Aix in September to help out in his father's bank.

1862 Applies to the Ecole des Beaux-Arts in Paris in the fall, but is not accepted.

1863 Continues his studies working with models at the Académie Suisse. A Cézanne still life is exhibited in the Salon des Refusés.

1864 Produces copies of paintings by Eugène Delacroix and Nicolas Poussin at the Louvre. The first of his almost annual rejections by the jury of the Salon exhibition.

1865 His stay in Paris interrupted by a summer trip to Aix. Zola dedicates his first novel, *La confession de Claude*, to his two friends from Aix, Cézanne and Baptistin Baille (1841–1918).

1866 After being rejected once again by the Salon jury, sends a letter of protest to the Surintendant de Beaux-Arts, demanding a Salon des Refusés. Zola also lays himself open to criticism by publishing a negative report on the Salon in *L'Evénement*. The two friends spend the month of July in Bennecourt.

1867 Cézanne mainly in Paris.

1868 Works in the South from May to December, chiefly at the Jas de Bouffan.

1869 In Paris, early in the year, meets his future wife, Hortense Fiquet, then nineteen, who is working as a model.

1870 On May 31, Cézanne serves as a witness at Zola's wedding. Before the outbreak of the Franco-Prussian War on July 18, leaves the capital with Hortense Fiquet to take up residence in L'Estaque, on the Mediterranean coast.

1871 Unaffected by tumultuous events in Paris – the dissolution of the Empire and establishment of the Republic, the siege and surrender, the rule of the Commune and its suppression – Cézanne stays in L'Estaque until March, devoting himself to his studies.

1872	On January 4, his son, Paul, born to Hortense Fiquet. In the fall, he follows Pissarro's advice and moves with Hortense and his infant son to Pontoise, northwest of Paris. Close association with Pissarro. Toward the end of the year, the young family moves to Auvers-sur-Oise, home of the art-loving physician Paul Fernand Gachet (1828–1909).
1873	Produces a few engravings in Auvers with help from Dr. Gachet.
1874	Returns to Paris in the spring. Shows three of his paintings in the first group exhibition of the so-called Impressionists, held between April 15 and May 15 in the atelier of the photographer Nadar under the title *Société anonyme des artistes, peintres, sculpteurs, graveurs*.
1875	Through Pierre-Auguste Renoir (1841–1919), meets the collector Victor Chocquet (1821–1891), who had just purchased from Julien Tanguy one of the paintings Cézanne had given him in payment for art supplies.
1876	Mainly in Aix and L'Estaque.
1877	Spends the better part of the year in Paris and environs. Contributes fourteen paintings and three watercolors to the third Impressionist exhibition, held in a rented apartment in the rue Le Peletier. The critic Georges Rivière is the first and only critic to write a positive review of his work.
1878	Despite fallings-out with his father, from whom he continues to keep the existence of his life's companion and young son a secret, works mainly in Aix and L'Estaque. Zola, who had purchased a country house in Médan, supports him with regular allowance.
1879	Lives from April to December in Melun, near Paris.
1880	In March, moves from Melun back to Paris, where – with the exception of a summer stay with Zola in Médan – he stays until April 1881.
1881	Again works with Pissarro from May to October in Pontoise, where he meets Paul Gauguin (1848–1903).
1882	In the spring, works with Renoir in Aix and L'Estaque. From March to October in Paris. Thanks to the assistance of Antoine Guillemet (1843–1918), who recommends him as his "pupil," has a portrait accepted by the Salon. After visits to Zola in Médan and Chocquet in Hattenville, meets Pissarro in the vicinity of Pontoise.
1883	Works mostly in Aix and L'Estaque. Claude Monet (1840–1926) and Renoir look him up there in December.
1884	Works in Aix and L'Estaque.
1885	Interrupts his stay in the South for a visit in June and July with Renoir in La Roche-Guyon.
1886	Lives with his family in Gardanne, south of Aix. Zola's novel *L'Œuvre* appears in March. Cézanne recognizes himself in the novel's hero, an artist who fails to live up to his promise. Extremely hurt, he breaks off all contact with his boyhood friend. Marries Hortense Fiquet on April 28. His father dies on October 23, leaving him a considerable fortune.
1887	Lives mostly in Aix.
1888	Renoir visits in L'Estaque in January, and together they return to Paris. Works in Chantilly, Alfort, and other nearby towns.
1889	Spends the second half of the year mainly in Aix.
1890	Back in Paris, is invited to exhibit some of his works in Brussels with the group Les Vingt. Summer holiday with his family in French Switzerland, then back to Aix. First signs of diabetes.
1891	Lives at his mother's in the Jas de Bouffan, while his wife and son are housed elsewhere in Aix. Professes Catholicism.
1892	Aix and Paris. Works in the forest of Fontainebleau and temporarily acquires a house in the village of Marlotte. The painter Emile Bernard (1868–1941) publishes an article on Cézanne in the series *Hommes d'aujourd'hui*.

1893	Lives alternately in Aix, Paris, and Marlotte.
1894	Sojourns in Aix, Paris, and Giverny, where he spends the autumn with Monet. Death of Tanguy and auction of his estate, Cézanne paintings fetching from forty-five to over two hundred francs. The young art dealer Ambroise Vollard (1865–1939) among the buyers.
1895	Spends the first half of the year in Paris, the second in Aix. Vollard presents· the first Cézanne exhibition, in his gallery in the rue Laffitte, from November to mid December.
1896	In Aix from January to June. Zola also there for several days, but the old friends do not meet. Following a cure in Vichy, summer holiday in July and August in Talloires on Lake d'Annecy.
1897	From June on, back in Aix, where he frequently paints in nearby Le Tholonet and at the Bibémus Quarry. His mother dies on October 25. Cézanne is uncomprehending of Zola's bold behavior in the Dreyfus Affair. The National-galerie in Berlin purchases a Cézanne painting, the first museum to do so. The artist fears that French museums will therefore have nothing to do with him.
1898	The first part of the year in Aix, then in the summer settles in Paris for his last extended stay in the capital.
1899	Returns to Aix in the fall. At the insistence of his brother-in-law, the estate Jas de Bouffan is sold on November 25. Cézanne rents an apartment in Aix at 23, rue Boulegon. Vollard reports to Gauguin in Tahiti that he has bought all the pictures in Cézanne's Paris studio.
1900	In October, the Paris art dealer Durand-Ruel deposits with his Berlin colleague Paul Cassirer twelve Cézanne paintings for a first exhibition in Germany, but they are returned to Paris unsold.
1901	On November 18, buys a piece of land north of Aix on the Chemin des Lauves, where he intends to build a small studio.
1902	A local architect by the name of Mourgues erects the studio, and by September the artist is able to move in. Writes his last will on September 26, naming his son as his sole heir. Zola dies in Paris on September 29, and Cézanne is deeply saddened.
1903	At the auction of Zola's estate on March 7, ten Cézanne works are sold for an average price of fifteen hundred francs.
1904	Visit from the young painter Emile Bernard in February. Journey to Paris on the occasion of an exhibition of thirty of his works in the Salon d'Automne, and brief sojourn in the vicinity of Fontainebleau.
1905	In the summer, yet another trip north to work in the forest of Fontainebleau.
1906	In January, visits from Maurice Denis (1870–1943) and Ker-Xavier Roussel (1867–1944). Cézanne dies in Aix at 23, rue Boulegon, on October 23.

Ambroise Vollard in his Paris office,
photograph circa 1930

Walter Feilchenfeldt

The Early Reception of Cézanne's Work, with Emphasis on Its History in Germany

Tanguy and Vollard: Their Role in France

A little over one hundred years ago, a young man from La Réunion, a French colony in the West Indies, stepped off a boat in Marseilles planning to seek his fortune. His name was Ambroise Vollard, and he hoped to study law in Montpellier. As it happened, he ended up in Paris, where he became an art dealer. In 1893, he opened a gallery in the rue Laffitte, the heart of the market in contemporary art, and in the course of the following years became the leading Paris dealer in Post-Impressionist art.

Vollard relates that it was Pissarro who called his attention to Cézanne, and that he saw his first painting by the artist in the shop window of the legendary Père Tanguy. It was a small landscape that he bought for roughly 200 francs.[1]

Tanguy's shop was a meeting place for artists of that time. Gauguin, Cézanne, Van Gogh, Guillaumin, and Emile Bernard were some of the painters who bought their paints, canvases, and stretchers there, leaving pictures in lieu of payment when they were short of cash – which was usually the case. His generosity and, best of all, his patience were of great help to all of them. From the correspondence between Cézanne and Tanguy, we learn that in 1878, the painter owed the shop a sum of 2,174 francs, and that by 1885, his debt had grown to 4,015 francs.[2] Tanguy had Cézanne's pictures as security. He kept a key to the painter's studio in the Boulevard Montparnasse, where great stacks of paintings were stored that were only rarely shown.

Gauguin bought two Cézanne paintings from Tanguy in 1883, for 120 francs.[3] Théodore Duret, the art critic and collector, had also bought his Cézannes there. At that time, the standard prices were 40 francs for small ones, 100 for large. In 1894, Duret sold his three Cézannes at auction, along with the rest of his important collection. The sales were listed in the auction records as follows:

[Cat. No.] [Title]	[Size, cm]	[Price/Buyer]	[Venturi No.]
3 *Route* [Road]	59:71	800 f-s. [to] Helleu	[329]*
4 *Nature morte* [Still Life]	47:59	660 f-s. [to] Abbé Gauguin	[346]
5 *La moisson* [The Harvest]	43:54	650 f-s. [to] Chabrier	[249]

* Numbers given here and with the abbreviation *V.* elsewhere in this article designate numbers in Lionello Venturi's catalogue raisonné of the paintings: *Cézanne, son art, son œuvre*, Paris 1936.

Another Cézanne collector was Armand Comte Doria, who is thought to have been the first person ever to buy a painting by Cézanne. He had bought the *House of the Hanged* (V. 133) at the first Impressionist exhibition in 1874, which he later traded to Victor Chocquet for the picture *Melting Snow in Fontainebleau* (V. 336). At the auction of the Doria Collection in 1899, the latter painting fetched the enormous sum of 6,750 francs. When the hammer fell, there was suddenly a great commotion in the hall, for it was suspected that the winning bid was somehow faked. Accordingly, the buyer stood up and identified himself: It was Claude Monet, at that time the most famous and highly respected of living Impressionists.[4]

The picture *House of the Hanged* (V. 133) was purchased at the Chocquet auction in 1899 by Isaac de Camondo. Along with the rest of his collection, including three

other Cézannes – the painting *Two Cardplayers* (V. 558, cat. no. 66) and two still lifes (V. 732 and V. 512) – it was left to the French State in 1911, with the proviso that the entire collection be shown in galleries in the Louvre set aside for it for fifty years.[5]

On the death of his father, Cézanne suddenly found himself free of money worries. He moved back to the south of France, to Aix-en-Provence, there to devote himself totally to his art. He was reputed to be difficult and unapproachable, which only served to stimulate Vollard's interest.[6] The art dealer was fully aware of Cézanne's importance; moreover, he saw that with the exception of Père Tanguy, the painter was without anyone to represent his interests. Vollard therefore made up his mind at this point to become Cézanne's dealer.

Julien Tanguy died in 1894. In June of that year, an auction was held in the Hôtel Drouot for the benefit of his widow. Organized by Octave Mirbeau, the sale consisted both of works that had belonged to Tanguy and of others donated by artists and friends to help support Tanguy's widow out of gratitude to her deceased husband.

Six Cézannes were sold in that auction, the record listed as follows[7]:

[Title]	[Size, cm]	[Price/Buyer]
Les Dunes [The Dunes]	55:46	frs. 95 [to] Volat
Village [Village]	46:55	frs. 175 [to] Volat
Coin de Village [Village Corner]	45:54	frs. 215 [to] Volat
Le Pont [The Bridge]	60:73	frs. 170 [to] Volat
Le Pont (toile crevée) [The Bridge] [unstretched canvas]	60:72	frs. 102 [to] Malcoud
Ferme [Farm]	60:73	frs. 145 [to] Murat

Vollard bought no fewer than nine paintings at this sale. As he writes in his reminiscences, he spent a total of 1,212 francs, thereby overspending his budget and overdrawing his credit several times over.[5] The fact that his name appears in the sale record as *Volat* makes it clear that he was at that time still unknown to the auctioneer. In addition to four of the six Cézannes, he purchased, according to "procès verbal," a landscape by Pissarro, a Gauguin, a Guillaumin, and a picture catalogued simply as "Vincent," depicting a pair of shoes.[9]

Vollard used his purchase of the four Cézanne paintings as an opportunity to make contact with the painter and present him with his proposals. He was assisted in his undertaking by Cézanne's son Paul, who supported his intentions and agreed to serve as intermediary between dealer and artist. Terms were agreed upon, and it is said that shortly afterward Vollard received more than one hundred and fifty rolled canvases from Cézanne.

This association led to the first major Cézanne exhibition, held in December 1895 at Vollard's gallery in the rue Laffitte. The show amounted to a breakthrough for both the artist and his dealer. There was no catalogue of the exhibition, but Vollard later identified over twenty-three of the paintings, listing them in his monograph on Cézanne published in 1914.[10]

Soon afterward, it became apparent who the early Cézanne collectors were. The two Americans living in Florence, Charles Loeser and Egisto Fabbri, bought Cézannes from Vollard from 1895 on. By 1899, Fabbri already had sixteen in his collection. H. O. Havemeyer, the most important collector of Impressionist art in America, bought his first Cézanne at Vollard's in 1898.[11]

The most important collector in this period was the Dutchman Cornelis Hoogendijk, who, according to Vollard appeared in the shop one day and in a single visit purchased over thirty Cézanne paintings. The relevant passage in Vollard's reminiscences provides us with a glimpse of the dealer at work. It appears that Hoogendijk bought all the paintings that Vollard recommended, without hesitating or bargaining.[12] Hoogendijk was splendidly served, for it was a stunning selection. Two of the pictures in the group – an early landscape (V. 58) and a flower painting (V. 752) – were sold with the rest of the Hoogendijk Collection in Amsterdam on May

21, 1912. The others were sold in 1918 through Paul Rosenberg, working in collaboration with Durand-Ruel, to Albert Barnes in Philadelphia, and to French buyers.

The name Auguste Pellerin, the greatest French collector of Cézannes, first appears in Vollard's account books in 1898. Unlike the other collectors mentioned, he also bought works from the artist's early years, assembling a collection unmatched in its comprehensiveness.

Hugo von Tschudi Fosters German Interest

The first group of Impressionist paintings to be seen in a Berlin collection belonged to Carl and Felicie Bernstein. They had moved to Berlin from Paris in about 1875, taking an apartment in the Tiergarten quarter. In 1882 the couple bought about ten paintings, notably three masterpieces by Edouard Manet, at that time the most admired Impressionist both in France and abroad. In 1883, the Bernstein Collection was shown at Gurlitt's, together with a selection of Impressionist pictures from the Galerie Durand-Ruel. There were no Cézannes in the exhibition.

The artist Max Liebermann, a collector of French Impressionists who had begun making regular trips to Paris as early as the 1870s, was also most enamored of Manet. Only two Cézannes found their way into his collection: *The Fishermen – July Day* (V. 243, cat. no. 16) and a landscape (V. 466).

The art historian and museum director Hugo von Tschudi also did much to foster an appreciation of French Impressionism in Germany. First employed as assistant to Wilhelm von Bode in the Berlin Gemäldegalerie der Alten Meister, in 1896, he became the director of the Nationalgalerie, the modern museum. Shortly after taking up his post, he set out with his friend Max Liebermann on a buying trip to Paris. He came back with Manet's *In the Winter Garden* and Monet's *Church of St. Germain l'Auxerrois*, two pictures that may still be seen in Berlin's Nationalgalerie. In Paris a year later, he bought a major work from Cézanne's constructive period, *Mill on the Couleuvre, at Pontoise* (V. 324, cat. no. 25). Cézanne had painted it in 1881, while working with Pissarro in Pontoise. It had formerly belonged to the journalist and novelist Robert de Bonnières. His purchase occasioned an article in the Paris journal *Revue Blanche* in June 1897:

> In recent days, we've been forced to note an important fact in the history of contemporary French art. The Berlin museum has just acquired a major landscape by Cézanne. The price was not especially high, but that is irrelevant [according to Meier-Graefe it was 1,500 francs]. Is it not enough that in the year 1897 a foreign institution has acquired a picture that none of the museums in this country would have wanted, not even as a gift?
> Naturally, you will agree with me that the officials who govern us, like the majority of the public on whom they depend, have no appreciation for the works of Cézanne, do not even pretend to. But one is justifiably amazed that they – if only for the historical education of the masses – take so little notice of a man who is venerated by Renoir, Degas, Monet, Pissarro, Sisley, Gauguin, and many younger talents.[13]

The controversy evident in these lines had been fanned a year before, in 1896, when the painter and collector Gustave Caillebotte had given his collection to the nation, but the national museums had accepted only thirty-eight pictures, refusing twenty-nine. Only two of his five Cézannes had been accepted, *Farmstead in Auvers* (V. 326) and *Landscape at L'Estaque* (V. 428).

In any case, a first Cézanne had now gone to Berlin, a picture perfectly classical in concept and one that was unlikely to arouse any controversy. A year later, however, at the very time the Cassirers opened their Berlin gallery, there began to be definite protests against the acquisition of French art. The trend was initiated by mediocre German artists, but found strong support in Kaiser Wilhelm II, who reserved a veto right on acquisitions for the Nationalgalerie. It culminated in 1909, with Hugo von

Tschudi's dismissal as director of that museum. He was immediately employed at the Königliche Pinakothek in Munich.

The First Cézannes in the Bruno and Paul Cassirer Gallery

In the winter of 1898, the cousins Bruno and Paul Cassirer opened a gallery at Viktoriastrasse 35 in Berlin, in rooms newly decorated by Henry van de Velde. Their first exhibition presented works by Max Liebermann, Edgar Degas, and Constantin Meunier. The two dissolved their partnership in 1901. Paul took over the gallery and the office of secretary to the Berlin Secession; Bruno kept the publishing business, and as the publisher of the journal *Kunst und Künstler*, would become an important figure in the city's cultural life.

Paul Cassirer spoke flawless French and felt at home in Paris. He became a familiar figure in the city's galleries. He had especially close business connections with the art houses Durand-Ruel and Bernheim-Jeune, but regularly negotiated transactions with Vollard as well. From the surviving records that are most complete, those of the firm Durand-Ruel, we learn that on October 18, 1900, twelve Cézanne paintings were sent to Paul Cassirer in Berlin. They were returned on January 9, 1901.[14]

Two newspaper reviews have been the only evidence of an exhibition at Cassirer's including works by Cézanne as early as November 1900. Recently, however, a catalogue of the exhibition came to light, and from it we learn that Cézanne was represented in the group show by thirteen pictures, while there were eighteen by the Berlin painters Corinth, eleven by Leistikov, seven by Klimsch, and two by D. Y. Cameron from Glasgow.[15] The Cézanne pictures bore the following titles:

1	*Still Life, Apples*	8	*Portrait of Monsieur C., Seated*
2	*Still Life*	9	*Undergrowth*
3	*A Meadow*	10	*Carnival*
4	*Portrait of Monsieur C.*	11	*Summer Landscape*
5	*Small Houses in Antwerp*	12	*Apples on a Table*
6	*Country Road*	13	*Harlequin*
7	*Flowers in a Vase*		

The brief unsigned foreword to the catalogue read as follows:

The exhibition of such an unknown and unusual painter calls for some words of orientation. After having played a role in the beginning of the Impressionist movement, Cézanne, who shared Manet's aspirations and is a contemporary of Claude Monet's, disappeared from the scene altogether. He was subsequently known by only a few devotées. His name only found currency in larger circles when Zola, his boyhood friend, dedicated to him his famous volume of critiques of painters, *Mon salon*. From time to time, one sees him in the vicinity of Paris, sitting in the landscape before his canvas; he lives in seclusion and avoids contact with his earlier acquaintances. His art, though nearly forgotten for many years – Muther doesn't even mention his name – has been finding increasing numbers of admirers in recent years in France, and one now occasionally sees his pictures. The Impressionist hall at the Paris World's Fair contains some of his landscapes. In Germany, Cézanne is completely unknown. The present exhibition is his first. The brief essay that Huysmans devoted to him in his critical collection *Certains* in 1894 may give some idea of how his friends think about his merits and his flaws.
In full light, in porcelain dishes or on white tablecloths, pears and apples, brutal and crude as though built up with a trowel and blended with the thumb, from close up a savage masonry of cinnabar and yellow, green and blue, but from the proper distance wonderful ripe and juicy fruits appropriate to the show-windows at Chvet's [*sic*; a large Parisian fruit store].
And realities never seen heretofore become apparent, strange and yet real shades of color, spots that are uniquely right, nuances of the cloths that are created by the shadows cast by the round fruits and are absorbed into lovely gradations of blue, that is what makes these pictures works of perfection when one compares them to ordinary still lifes with their asphalt shadows standing in front of unrecognizable backgrounds.
Then again there are the plein-air studies, starts arrested in their first stages, sketches whose freshness is ruined by overpainting, childlike and barbaric designs, and finally stupendous blunders; houses that tilt to one side as though drunk; fruits in tottering bowls; female bathers described with insane outlines, yet – a feast for the eyes – painted with the furor of a Delacroix, yet without the refinement of his vision

Paul Cassirer, photograph circa 1920

and without the suppleness of his hand, as though howling in a frenzy of swirling colors on the all too heavy canvas, which threatens to explode.

And finally, an explorer of color who influenced the Impressionist movement more than Manet, an artist with a diseased retina who with his most extreme visual perception discovered the beginnings of a new art. There you have this much too forgotten painter – Cézanne.

Since 1877, when he showed sixteen pictures, he has not been exhibited. At that time the absolute sincerity of his art served as amusement for the rabble for some time.

The exhibition list includes two portraits of a Monsieur C. These were likenesses of Victor Chocquet.

Chocquet had been chief inspector in the customs office, and was a passionate collector of the Impressionists. On the advice of Renoir, he too went to Père Tanguy's to see the Cézannes. Cézanne and Chocquet became great friends, in part because of their mutual admiration for Delacroix. Cézanne painted five portraits of Chocquet, one of which was shown in Paris in 1877.

In the 1880s, Chocquet's was the largest collection of Cézannes. The late John Rewald (1912-1994) determined that it included thirty-six or thirty-seven pictures. At that time, Caillebotte owned but five, as did de Bellio, a Rumanian collector living in Paris.[16] The Chocquet collection was sold at auction after the death of his wife – Victor Chocquet died in 1891, his wife in 1899.

In his article "Chocquet and Cézanne," Rewald identified the paintings in the Chocquet auction and also the three Cézanne watercolors shown in the Impressionist exhibition in 1877. In the process, he established that these watercolors also belonged to Chocquet at the time.[17]

Everything seems to indicate that all of the Cézannes shown in 1877 were from Chocquet's collection.[18] It is certainly logical that Chocquet would have made them available for the exhibition. Moreover, it happens that fourteen of the sixteen Cézannes in the exhibition are signed, something unusual for the artist but characteristic of the paintings owned by Chocquet. Chocquet's name appeared nowhere in the exhibition, and Rewald concludes that this was probably at Chocquet's request, for he would not have wished to upset Monet and Renoir, each represented in his collection with a mere eleven (!) paintings, with his obvious preference for Cézanne.[19] Meier-Graefe described the auction of Chocquet's estate as follows:

> The great triumph for him [Cézanne] was the sale of his friend Chocquet in the summer of 1899 at [Georges] Petit's. On three hot afternoons in the middle of the dead season, when normally there isn't a cat left in Paris, people were scrambling for the best pieces collected by a man only yesterday branded as an eccentric.[20]

Asked by Monet to do something for Cézanne at last, Durand-Ruel ended up being the major buyer at the sale. He bought at least seventeen paintings.[21] Of the thirteen pictures shown at Cassirer's in 1900, eight can clearly be identified as works purchased by Durand-Ruel at the Chocquet auction. Two of the others, both still lifes, had been acquired through Durand-Ruel's branch in New York.

Where did the remaining three pictures come from? In Vollard's account books, there is the record of a sale of three Cézannes for 6,000 francs on April 14, 1900, to a certain Heilbut. This could have been Emil Heilbut, a friend of Bruno Cassirer's and later editor-in-chief of *Kunst und Künstler*, working on behalf of the gallery. It is possible to identify the three pictures from Vollard's stock books.[22] Cassirer's exhibition was thus made up of the following pictures:

Nos. 1–10 Pictures on commission from Durand-Ruel.
Nos. 11–13 Pictures owned by Bruno and Paul Cassirer, purchased by Emil Heilbut from Ambroise Vollard in April 1900.

In the catalogues of the Cassirer firm, works from the gallery's own holdings are generally listed last; as a rule, some of the pictures exhibited were owned by the gallery itself. English titles are direct translations

from the German as it appeared in gallery records, and may not always match the English and French titles used today, which in some cases have undergone changes through the years.

[Cat. No.]	[Title]	[Venturi No.]
1	*Still Life, Apples*	unidentified
2	*Still Life*	[337 or 338]
	Both these pictures had been taken over on February 21, 1894, from the New York branch of Durand-Ruel. They had formerly belonged to Miss Sara Hallowell, who had bought them from Targuy.	
3	*A Meadow*	[442]
	Un pré, Chocquet auction no. 10, to Durand-Ruel	
4	*Portrait of Monsieur C.*	[562]
5	*Small Houses in Antwerp* [sic]	[156]
	Les petites maisons à Auvers, Chocquet auction no. 15, to Durand-Ruel. A secretary, unfamiliar with the material, had obviously misread the handwritten *Auvers* for *Anvers*.	
6	*Country Road*	[158]
	La route, Chocquet auction no. 14, to Durand-Ruel	
7	*Flowers in a Vase*	[181]
	Fleurs dans un vase, Chocquet auction no. 20, to Durand-Ruel	
8	*Portrait of Monsieur C., Seated*	[373] cat. no. 15
9	*Undergrowth*	[173]
	Un coin de bois, Chocquet auction no. 9, to Durand-Ruel	
10	*Carnival*	[552]
	Mardi gras, Chocquet auction no. 1, to Durand-Ruel	
11	*Summer Landscape*	[633] cat. no. 48
12	*Apples on a Table*	[502]
13	*Harlequin*	[555]
	Jayne Warman, John Rewald's assistant and now collaborator with this writer on the completion of John Rewald's Cézanne catalogue raisonné, identifies this picture as V. 553; V. 555 as having turned up in the 1912 exhibition of the Reber Collection, then disappearing until the Sotheby auction on November 29, 1988, only to disappear again. Not included in the catalogue, but mentioned in the review by H[ans] R[osenhagen] are the two paintings:	
–	*Vase with Tulips*	[617]
–	*Fleurs et fruits*, Chocquet auction no. 13, to Durand-Ruel.	

Cassirer's exhibition was reviewed in the *Kunstchronik*. Corinth and Leistikov were discussed at length, while considerably less was said about Cézanne:

> One of the older generation is also represented here, a comrade-in-arms of Manet and the others, the Frenchman Paul Cézanne. A short introduction to his works is provided in the catalogue, and rightly so. There is a quote from a Huysmans essay, full of warm admiration for the artist. But even this commendation is not enough to make such daubs enjoyable. In truth, *Country Road* and *Undergrowth* are not without charming color perspective, and even in the tasteless and artless portraits and harlequin pictures, and especially in the still lifes, one gets the sense of an unquestionably strong feeling for color, a painterly eye. Even so, one still has to derive *Kunst* [art] from *Können* [ability]; mere feeling alone and absolute sincerity are not enough. Therefore, these effusions of color teeming with bizarre mistakes in drawing do not deserve to be seriously considered works of art.[23]

And the well-known critic Hans Rosenhagen wrote in *Die Kunst*:

> Of the artists deserving credit for the development of the Impressionist idea in French painting, Paul Cézanne is one of the most important; but it appears the time is not yet ripe for the recognition of his merits as a painter and pioneer. The thirteen pictures of his presented by Bruno and Paul Cassirer in their gallery delight those in the know, who recognize Cézanne as the greatest painter among the successors of Manet. But his work is flatly rejected by the public, which takes exception to certain distortions in the drawing of his figural pictures. Yet, Cézanne is an artist through and through. How wonderfully true and beautiful are the colors of his landscapes; how marvelous this broad Impressionistic painting; how exquisite the harmony of the strongest tones in his scenic work, his harlequin pictures; his still lifes with apples; his *Vase with Tulips!*[24]

The reviewer was correct in observing that the time was not yet ripe. As an art dealer, Paul Cassirer clearly came to the appropriate conclusions, and for several years, there was no further mention of Cézanne in Berlin.

The New Century: Paris Exhibitions and Meier-Graefe's Writings

In the early years of the twentieth century, Neo-Impressionism became quite fashionable among Germany's more knowledgeable collectors. Count Harry Kessler, who had published the art journal *Pan* between 1895 and 1900, a friend of Liebermann's and the art patron who had introduced Meier-Graefe to the Parisian art world, was one of the major champions of Seurat and his circle. In this period, he bought three Cézannes from Vollard. They were *Still Life, Plate and Fruit* (V. 206, cat. no. 57), acquired on February 2, 1902, and the two landscapes *The Railroad Bridge at L'Estaque* (V. 402, cat. no. 29) and *Landscape in Provence* (V. 403), which he bought in December of the same year.[25]

Cézanne was not represented in the first exhibition of the Berlin Secession to include international artists, in the spring of 1901. However, in the Impressionist exhibition of the Vienna Secession in 1903, seven of his pictures were shown. The catalogue does not list them, but a review of the show assures us that they were included. On that occasion, Emil Heilbut [H] wrote an extensive article for *Kunst und Künstler*, in which he dealt with each of the artists in a brief paragraph. Among the paintings illustrated in that article are Cézanne's *Carnival* (V. 552) and *Still Life* (V. 341).[26]

The Galerie Bernheim-Jeune was expanded in 1904. The sons of Alexandre Bernheim-Jeune, Josse and Gaston, were more interested in contemporary art, and wished to specialize in it. With that in mind they opened a second shop, with Félix Fénéon serving first as an advisor and ultimately as director. Fénéon was mainly interested in Seurat and the Neo-Impressionists, though he championed all contemporary art.

In the fall of 1904, thirty paintings by Cézanne were shown at the Salon d'Automne in the Petit Palais. They were all from the inventories of art dealers, twenty-three belonging to Vollard, two to Blot, and five to Durand-Ruel.

The year 1904 also saw the publication of Julius Meier-Graefe's *Entwicklungsgeschichte der modernen Kunst* (History of the development of modern art). The author had spent a great deal of time in Paris in the 1890s, becoming thoroughly familiar with the art scene. His first book on Impressionism, *Manet und sein Kreis* (Manet and his circle), had appeared in 1902, but it was this new work, in three volumes and with a six-page article on Cézanne, that led Germany to be more receptive to the French artists. In it, the author emphasized the myth that had grown up around Cézanne, for that was typical of his style. He called Cézanne a revolutionary.[27]

> "He was extremely reserved; no one in the younger generation has seen him; artists who are totally indebted to him have never exchanged a word with him. Occasionally people wonder whether he ever lived at all. . . . He is said to reside in Aix."

But Meier-Graefe also wrote things about Cézanne's art that were quite astonishing for that early date:

> In all of this one is astonished by something quite different, something that remains puzzling, indeed from afar sometimes appears to be pure madness. It is a magnification, though one does not rightly know what is being magnified. All art is overstatement in one way or another, but what is here so striking is that the meaning of it is hidden. . . .
> His still lifes are confusingly similar. How often has he painted the ridiculously crumpled napkin with the plate, the jar, and the fruit. . . .
> A Cézanne apple like this is as accomplished as a costume by Velásquez, with an assured matter-of-factness that is unshakable. . . .
> His nudes look like lumps of chopped flesh. In them all anatomy appears to have been ignored, this is simply flesh, thick and ungainly, and nevertheless it is living, only one never thinks of taking hold of it with one's hands; one wants to soak it up with one's eyes. . . .

Meier-Graefe understood Cézanne's importance at a time when hardly anyone knew who the painter was, even though he was still alive.

> One can never see Provence again without thinking of Cézanne; he paints it with a true fanaticism, one that invents a unique way of painting so as to capture its unique features. It stands before us in a perfect likeness, one feels one can recognize hundreds of details in these pictures …

And regarding Cézanne's method of painting he said:

> In Cézanne, the great variety with which he places his small brushstrokes defies all systems, yet remains systematic in the highest sense.…

Meier-Graefe's book appeared in English in 1908, and in a completely revised and rewritten second edition published by Piper in 1914, which is now much better known. It had a great influence on art appreciation in the early twentieth century. Everyone interested in art read Meier-Graefe's brilliant and provocative observations with profit and pleasure.

In the spring of 1904, even before the Salon d'Automne, Cézanne's name again turned up in a Berlin review. This time it was in a brief notice in *Kunst und Künstler:*

> There is an exhibition at Paul Cassirer's of the difficult, wonderfully powerful artist Cézanne.[28]

This must have been a major show, or Hans Rosenhagen would not have written about it and the artist at such length in *Die Kunst für Alle*[29]:

> We are indebted to the Paris Centennial for the rediscovery of Cézanne. His works in the Impressionist gallery let us know how powerful he is. Manet seemed elegant by comparison, Monet decadent, Sisley sweet, and Pissarro almost weak. People began to grasp his greatness, and becoming more closely acquainted with his work one could see that he was the actual pioneer of the Manet circle, that his influence on today's younger generation of artists is quite extraordinary, and only just beginning. A large number of modern artists, with Vuillard and Bonnard in the forefront, are attempting to make his austere art more palatable, more comprehensible to the public. Since isolated pictures of his have been shown repeatedly in the Salon Cassirer and rejected decisively by the public and most of the critics, it seemed that one ought to at least try to make Cézanne's importance clear to lovers of art with a more extensive exhibition. A large collection of his works is now on view in the Salon Paul Cassirer, one that presents a complete survey of the artist's development. Many of the works exhibited are from private collections.… Cézanne's pictures are almost monumentally decorative, and for all their external crudity, quite superior expressions of taste. His colors are as strong and glowing as can be, yet his pictures never shout. Here he has a spring landscape with blue air, blue water, and a white sail, green grass and trees, and brightly clad people who are fantastically poorly drawn. The similarity to Böcklin is astounding; but the Frenchman is infinitely superior to the Swiss master in culture. Despite this, that he emerges from the hand of the Creator with pure, unspoiled, untainted senses that one perceives him to be a creative nature in the Goethean sense in every way, in his taste as well as his manner of guiding his brush, is the best evidence of his greatness. The recognition of this by more than merely a few may be closer at hand than one thinks.

As far as we know, there was no catalogue for this exhibition. The few pictures mentioned in the reviews give no clue as to who the main supplier was or how the exhibition came about.

The First Cézanne Sales in Germany: From Tschudi to Osthaus

From this point on, Cézanne's name does appear with regularity in Cassirer's account books. One of the first entries records the sale of the *Still Life, Flowers and Fruit* (V. 610, cat. no. 55) on April 2, 1904. The work had been purchased from Bernheim-Jeune for 9,000 francs and sold to Hugo von Tschudi on behalf of the Nationalgalerie Berlin for 10,000 francs. On June 1, 1904, three more Cézannes were bought from Bernheim-Jeune. They were three landscapes with the French titles *Paysage*, *Déchargeurs* (Stevedores) and *Paysage*, and may have been lent by Bernheim-Jeune for the exhibition just mentioned and purchased from it. We may assume that the majority of exhibited

works consisted of loans from Bernheim-Jeune. One of the landscapes (V. 318) was bought by the Dresden collector and dealer Rothermundt; the collector Victor von Mutzenbecher, then living in Hamburg, bought the *Stevedores* (V. 242); and a Lieutenant Colonel Kuthe of Berlin bought a landscape that has not been identified, one that Cassirer bought back in 1913.

Paul Cassirer acquired more Cézannes in the years 1904 and 1905 from both Bernheim-Jeune and Vollard, and names like Max Linde from Lübeck and Theodor Behrens from Hamburg appear in his account books as buyers.

In 1905, Julius Stern bought the picture *Vase with Tulips* (V. 618), which Cassirer had just purchased from Vollard. The legendary and somewhat questionable Prince de Wagram acquired three still lifes from Cassirer in this period, all of which were probably bought back later by Bernheim-Jeune. It was said that, in 1907, when the prince was still only twenty-eight, he owned no fewer than twenty-eight Cézannes.[30]

Also at this time, Durand-Ruel organized an Impressionist exhibition in London, one that included ten Cézannes from his own stock.[31] For the most part, these were pictures exhibited at Cassirer's five years earlier.

Oddly enough, there is not a single mention of Cézanne in Cassirer's records for 1906, the year the artist died. In that year, Karl Ernst Osthaus, the great art patron from Hagen, journeyed to Aix to visit Cézanne. Contrary to all expectations, the painter received him quite warmly and courteously, and showed him his pictures. On his way home, Osthaus bought at Vollard's the *Bibémus Quarry* (V. 767) and *Buildings at Bellevue with Dovecote* (V. 651) for his own private museum.

Immediately after Cézanne's death, his widow Hortense and his son Paul sold most of the artist's remaining paintings to Vollard. The sale included twenty-seven oils and 187 watercolors. The asking price of 275,000 francs was more than Vollard could raise, so he was forced to go into partnership on the purchase with Bernheim-Jeune.[32] Shortly after this transaction, in June 1907, the Galerie Bernheim-Jeune mounted an exhibition of seventy-nine Cézanne watercolors. Cassirer presented the exhibition on a smaller scale in Berlin in September of that year, as did the Galerie Emil Richter, Dresden, in April 1908.[33]

The Paris Salon d'Automne in 1907 included forty-nine Cézanne paintings and seven watercolors. Twenty-five of the paintings belonged to the greatest of all Cézanne collectors, the industrialist Auguste Pellerin; five paintings and the seven watercolors to the painter's son; seven paintings to the collector Maurice Gangnat; and one each to the painter Eugène Boch and the art dealer Aubry. The remaining ten were probably the property of Vollard and Bernheim-Jeune.

In the letters he wrote between October 5 and November 4 of that year, Rainer Maria Rilke repeatedly spoke of the Cézanne room at the Salon d'Automne, where he ran into Meier-Graefe and Count Kessler. He wrote to his wife Clara:

Actually, in two or three well-chosen Cézannes one can see all of his pictures, and surely somewhere, at Cassirer's for example, we could have gained a much better understanding than I now seem to have, but for everything one needs a long, long time.[34]

In that year, Cassirer purchased a landscape from Vollard, *Allée in the Park of the Château Chantilly* (V. 627), which his brother bought from him. He also bought three pictures from Bernheim-Jeune: *Curving Road* (V. 330), later acquired by the Hamburg collector Theodor Behrens; *Still Life with Apples* (V. 600), which Bernheim-Jeune bought back a year later; and *The Fishermen – July Day* (V. 243, cat. no. 16), also known as *Fantastic Scene* or *Bourgeois Afternoon*. According to the account book, Cassirer sold the last of these on January 4, 1908, to Hugo von Tschudi for the Nationalgalerie in Berlin. Tschudi never managed to gain approval for this purchase, however, and the sale was ultimately canceled. The painting was shown in the spring of 1908 at the exhibition of the Berlin Secession, but Cassirer took it back on August 21. On January 26, 1909, he sold it to Max Liebermann, who left it to his heirs.

The year 1909 saw another important Cézanne exhibition at Cassirer's. From November 27 to December 10, the gallery displayed forty-two paintings.[35] Sixteen were from private German collections. Eighteen are documented as having come from Vollard. Only one picture from the early period, *Still Life with Bread and Eggs* (V. 59), was sold at the exhibition, to an otherwise unknown collector, Dr. Walter Lewinstein from Schoeneberg. In 1915, Cassirer bought it back through the dealer Wolfgang Gurlitt, and sold it to his brother Hugo.

Meanwhile, Hugo von Tschudi had become the director of the Königliche Pinakothek in Munich. In 1909, he had bought an important El Greco from Bernheim-Jeune, *The Disrobing of Christ*, and with it, instead of a price reduction, one of Cézanne's most important early paintings, *Railway Cut in Aix* (V. 50), which he was thus able to incorporate in his museum collection. This picture was shown in the Berlin Secession exhibition in spring 1910, and illustrated in its catalogue.

The Great Years Before World War I and Beyond: From the Sonderbund Exhibition to the 1921 Cézanne Retrospective at Paul Cassirer's

On October 2, 1910, Cassirer purchased from Théodore Duret one of Cézanne's most important landscapes, *The Plain at Bellevue* (V. 450), and sold it to the Bremen collector Mrs. Adele Wolde. This picture, which still bore the designation "Wolde Collection" when shown at Cassirer's as late as 1921, was sold at the time of the worldwide financial crash and is now in the Barnes Foundation in Merion, a suburb of Philadelphia.

At the end of 1910, twenty Cézanne paintings, all of them from the Paris art market, were shown at London's Grafton Gallery in the exhibition *Manet and the Post-Impressionists*.

Thanks to the Sonderbund exhibition in Cologne, crucial not only for Germany but for the whole world, 1912 became the most important year for the breakthrough of modern art. Paul Cassirer served on the exhibition's planning committee; the show ran from May to September.

Of the twenty-six Cézannes included in that exhibition, fourteen were borrowed from German private collections. Among the collectors named in the catalogue were Bernhard Koehler of Berlin, with three pictures, one of which, a portrait of Madame Cézanne (V. 577), he had bought at Vollard's in Paris in the company of Franz Marc; Tilla Durieux, Paul Cassirer's wife; Hugo Cassirer and Julius Stern of Berlin; Leonhard Tietz of Cologne; and Frau Georg Wolde of Bremen. The art dealer Alfred Flechtheim was listed as the owner of three paintings and a watercolor.[36] The Cassirer account books note fourteen Cézanne purchases in 1912, including four from Bernheim-Jeune and six from Vollard.

Other German collectors gradually specialized in Cézanne. The first of these was the industrialist Gottlieb Friedrich Reber from Barmen. Eleven paintings from his collection were shown at Cassirer's in January 1913, and fourteen in Darmstadt in May 1913.[37] From Vollard's records it is clear that some of the pictures shown in these two exhibitions had just previously been purchased. In fact, it is unclear whether the pictures actually belonged to Reber.

In an article on the collection in *Kunst und Künstler* in 1913, occasioned by the Cassirer showing, it was mentioned that Reber began collecting in 1910, and that his collection was a jumble, ranging from fifteenth-century objects to Manets and Cézannes. Eight Cézanne paintings were specifically named: *Still Life with Sugar Jar, Quinces, Lemons, and Pears* (V. 624); *Harlequin* (V. 555); *Young Man Seated at a Table in Front of a Skull* (V. 679); *Man with Crossed Arms* (V. 689); *The Peasant* (V. 687); *Male Bathers* (V. 580); *Lutteurs amoureux* (Fighting Lovers; V. 380); and *House in Park*

(V. 635).[38] After visiting the collector in his new home in Lausanne in 1931, Meier-Graefe related:

> He has exchanged most of his Cézannes for pictures by Picasso, essentially repeating what Pellerin did years before when he sold his priceless Manet collection in order to pounce exclusively on Cézanne. It is said of Pellerin that he was motivated by financial considerations, and followed Vollard's advice. Rumor has it that Reber did much the same, and not only have people accused him of speculation, they have also called him a poor speculator because he traded one Cézanne for ten Picassos. In terms of the market, he was probably being smart. It is impossible to tell as yet with the same assurance as in the case of Pellerin, who made an enormous profit. However, all of this aside, Reber's transaction is as much a piece of art history as was the earlier exchange of Manets for Cézanne.[39]

The Paris art dealer Paul Rosenberg sold a number of important Cézannes that-according to Venturi-Reber is supposed to have owned: *Mont Sainte-Victoire with Large Pine* (V. 455); *House and Farm at Jas de Bouffan* (V. 460, cat. no. 49); *Undergrowth* (V. 788); *Still Life* (V. 742); *Peasants* (V. 687), and two versions of bathers (V. 541 and V. 580).

Reber was one of the first so-called *marchands-amateurs*, a collector who was always perfectly prepared to sell. The painting he kept for the longest time was the *Young Philosopher* (V. 679), the small version of the *Boy in the Red Vest* (V. 683). Pinched for cash, he finally sold it on the Paris art market to Barnes. His pride and joy, however, was the large version of *Boy in the Red Vest* (V. 681, cat. no. 45) – mentioned by Meier-Graefe in 1931 in his article on Reber – which was acquired by Emil Georg Bührle only after the war, in 1948.

Egisto Fabbri's *Boy in the Red Vest* (V. 682) had also come from a German collection. The Berlin banker Jakob Goldschmidt purchased the picture through Paul Rosenberg in 1937, and took it with him to America. It was one of seven pictures in the legendary Sotheby auction of the Jakob Goldschmidt estate in London in 1958, where Paul Mellon managed to buy it.

Another Cézanne collector was a Swiss living in Dresden, Oskar Schmitz, who was joint owner of an export business in Le Havre. Articles about him and his collection appeared in *Kunst und Künstler* in 1909/10 and again in 1920/21.[40] His six Cézannes, a portrait (V. 72), a still life (V. 338), and four landscapes (V. nos. 328, 401, 410, and 411), were mentioned only in the later article. This could mean that he only acquired them after 1910, although he had lived in Paris until 1903 and been acquainted with Durand-Ruel.

Germany's most important Cézanne collector was Margarete Oppenheim in Berlin. She owned ten important paintings and three watercolors by her much admired artist. In 1913, she sold three Cézanne landscapes at Cassirer's, all of which had come from Vollard: in February, *In the Plain at Bellevue* (V. 448); in November, *The Outskirts of Gardanne* (V. 436) and *House with Red Roof* (V. 468, cat. no. 48). These last two pictures were exhibited at Cassirer's in November and December 1913 along with four others.[41] The same collector also owned a sketch of bathers (V. 257) and *Seven Male Bathers* (V. 387, cat. no. 79) as well as four additional landscapes: *Village and Sea at L'Estaque* (V. 294), *Outskirts of Marseilles* (V. 407), *The Bent Tree* (V. 420), and *Buildings at Bellevue with Dovecote* (V. 652). Her pictures were sold by the Cassirer firm after 1930. Three paintings (V. nos. 407, 652, 387) and the three watercolors were offered for sale at auction along with the furnishings of the Margarete Oppenheim collection at Julius Böhler's in Munich on May 18, 1936. By that time the firm Paul Cassirer, Berlin, no longer existed. Only the *Seven Male Bathers* (V. 387, cat. no. 79) found a buyer.

The Cassirer account books list purchases from Vollard and Bernheim-Jeune even in 1916. These paintings must have already been in Berlin before the beginning of the war, and only now found buyers. One of them, *Grounds of the Jas de Bouffan* (V. 466), was bought by Max Liebermann. Another was *The Murder* (V. 121, cat. no. 2), owned for a short time by the Mannheim industrialist Sally Falk, then sold through Cassirer to Julius Elias.

These wartime sales of pictures sent to Cassirer on consignment by his Paris colleagues led to an irreparable falling-out between the dealer and his French business partners. Since the German currency obtained for these pictures turned out to be worthless after the war, his Paris counterparts felt they had been swindled, and broke off contact completely with Cassirer. Moreover, being a German, he was now a political enemy, and hence no longer received in Paris after the war. This not only affected his business, but hurt him deeply.

In 1917, an additional landscape, *Village Street* (V. 141), was acquired from Josse Hessel, the cousin of the Bernheim-Jeunes.

In 1921, the Cassirer gallery exhibited forty-two Cézanne pictures from German private collections. They were the property of twenty different collectors.[42] In the years to follow, all but one of them, *Stevedores* or *The Seine at Bercy* (V. 242), have left Germany. This picture from the collection of Theodor Behrens was sold in 1924 to the Kunsthalle Hamburg, where it may still be seen today.

Between the Wars: Exodus of Art Collections from Germany

During World War I, the Paul Cassirer firm had begun to specialize in auctions, which it held in Berlin in collaboration with the Munich auction house Hugo Helbing.

The first such sale, on May 22, 1916, included the collection of the banker Julius Stern, who had purchased *Vase with Tulips* (V. 618) from Cassirer in 1905. This picture, no. 8 in the sale, was sold to the Mannheim industrialist Sally Falk for 40,000 marks.[43] The entire Falk Collection was acquired by Paul Cassirer only two years later, and according to the account books, *Vase with Tulips* was sold on April 20, 1918, to Frau F. Schütte of Bremen. This is the last transaction concerning a work by Cézanne recorded in the Cassirer account books until after Paul Cassirer's death.

Also in 1916, the Moderne Galerie in Munich (Heinrich Thannhauser) issued a 168-page inventory catalogue including works from Goya to Picasso. Heinrich Thannhauser had left his partner Brakl in 1909 to devote himself more fully to modern art. His son Justin Thannhauser, born in 1892 and fascinated by all things French, had joined the firm in 1911. In 1913, the younger Thannhauser had organized an exhibition of twenty Cézannes.[44] The inventory catalogue from 1916 listed four Cézanne paintings: *Still Life with Peaches* (V. 12), *Portrait of Madame Cézanne* (V. 571), *Still Life with Fruit* (V. 210), and *Portrait of a Man* (V. 20). Three supplementary volumes included the additional paintings *Portrait of Madame Cézanne* (V. 522), *Hagar* (V. 708), *Auvers sur Oise* (V. 141), *Mountain Landscape* (V. 48), and *Rocky Landscape* (not in Venturi). Only one work, *Hagar* (V. 708), found a German buyer. The important paintings from this group were sold only many years later in America.

Numerous collectors were forced to sell their paintings during the inflation of the early twenties, but by the end of the decade, Germany was enjoying an economic upswing, and as a result, Berlin became a major stronghold in the art market. The dealers Marcel Goldschmidt from Frankfurt, Justin Thannhauser from Munich, and Alfred Flechtheim from Düsseldorf all opened branches in Berlin. Alfred Gold and Hugo Perls founded new galleries in the city in order to deal in nineteenth-century French masters, now quite generally sought after.

Following Paul Cassirer's death in January 1926, the co-owners Dr. Walther Feilchenfeldt (the writer's father) and Dr. Grete Ring took over the business. Both had joined the firm in 1919.

In June 1929, Feilchenfeldt acquired the collection of the Paris publisher Paul Gallimard for Cassirer's. In October of that year, the American stock-market crashed, and with it, the art market collapsed as well. It became impossible to sell paintings. Gallimard's Cézanne still life *Cup, Glass, and Fruit* (V. 186), for example, sat unsold for six years, until the banker Siegfried Kramarsky finally bought it in November 1936.

After the Nazis seized power in 1933, art collectors and art dealers of Jewish descent were faced with the problem of how to secure their property, unaware at the time that not only their incomes but even their very lives were threatened. This meant seeking ways to take their collections out of the country.

Feilchenfeldt and Grete Ring decided to liquidate the Berlin firm, which was duly registered on March 31, 1935. Feilchenfeldt went to Amsterdam, where a Cassirer branch had been established in the 1920s, under the direction of Dr. Helmuth Lütjens. Grete Ring opened a new firm, Paul Cassirer Ltd., in London.

Feilchenfeldt had already established good connections in Switzerland, and when he heard that the director of the Zurich Kunsthaus, Dr. Wartmann, was planning an exhibition of nineteenth-century French paintings for the spring of 1933, he offered his assistance. The majority of the 103 works exhibited came from Germany. Feilchenfeldt had procured thirty-seven of them, seventeen of which belonged to the Paul Cassirer firm.[45] Thirteen Cézannes were included in the Zurich show. They were owned by Oskar Schmitz, Bruno Cassirer, and Estella Katzenellenbogen. Oskar Schmitz had moved to Switzerland in 1931, and had shown his collection in Basel and Zurich.

Bern followed in February 1934 with the exhibition *Französische Meister des 19. Jahrhunderts und Van Gogh* (French Masters of the Nineteenth Century and Van Gogh), with seven works by Cézanne. Three of these paintings (nos. 3–5) came from the Staechelin Collection in Basel; Feilchenfeldt had brought the other four (nos. 6–9) from Germany.[46]

Once these Swiss exhibitions had closed, it was necessary to secure ways of avoiding the return of these pictures to Germany. The Museum Boymans in Rotterdam saw an opportunity to mount an exhibition of nineteenth-century French art containing some eighty-five paintings. The main works from the Gallimard Collection were thus shipped to Holland, where they would be safe for the time being. These included the still life *Cup, Glass, and Fruit* (V. 186), the *Still Life with Commode* (V. 497) belonging to the publisher Samuel Fischer, and two pictures from the Dr. Alexander Lewin Collection in Guben, *The Sea at L'Estaque* (V. 770; cat. no. 72) and *Four Bathers* (V. 726).[47]

The Gemeentemuseum in The Hague also became an understanding partner, accepting pictures and storing them for their homeless owners. One notes for example that in his catalogue raisonné of 1936, Venturi lists the paintings of the Hugo Cassirer-Fürstenberg family as being on permanent loan to the Gemeentemuseum.[48] With the help of Justin Thannhauser, these works were sent in April 1939 to Montevideo, where they were kept until they could be reclaimed in New York after the war. Thannhauser sold the early *Still Life with Bread and Eggs* (V. 59) to a Cincinnati collector, and the *Still Life with Pitcher and Various Fruits* (V. 615) to the New York collector Harry Bakwin.

Feilchenfeldt's best friend and client was the writer Erich Maria Remarque, who had surfaced as a buyer in the early thirties, at the depth of the Depression. One of Remarque's purchases was Cézanne's landscape *In the Plain at Bellevue* (V. 448), from the Margarete Oppenheim Collection. Driven out of Germany for his political stance rather than for racist reasons, Remarque emigrated first to Switzerland, then shortly before the war to America.

Many artworks were removed from German museums after being branded "degenerate." Feilchenfeldt refused to have anything to do with buying or selling any work so stigmatized. Siegfried Kramarsky, a German banker from Hamburg who had been living in Amsterdam since the twenties and managed to emigrate to America in time, felt quite differently. Among the paintings he purchased at this time was Cézanne's *Bibémus Quarry* (V. 767), one of 145 works confiscated from the Museum Folkwang in Essen on August 27, 1937.[49]

This picture, originally purchased in France by Karl Ernst Osthaus in 1906, was the one work most sorely missed by the museum, a fact stressed by Paul Vogt in his history of the Essen Museum written at a time when the picture was still in America.

On January 1, 1948, Walther Feilchenfeldt opened a gallery under his own name in Zurich. His wife, Marianne Feilchenfeldt, kept the firm going after his death in 1953, and it was she who contributed especially to the story of Cézanne's reception in Germany by selling four of the artist's paintings to German museums between 1959 and 1964.

The first was *The Sea at L'Estaque* (V. 770, cat. no. 72), formerly from the collection of Dr. Alexander Lewin from Guben, later New York. Jan Lauts bought the picture from her for the Kunsthalle Karlsruhe in March 1959, with special funds from the cultural ministry of Baden-Württemberg.

In June 1965, Gert von der Osten bought two paintings from her for the Wallraf-Richartz-Museum in Cologne. These were *In the Plain at Bellevue* (V. 448), which had formerly belonged to Erich Maria Remarque, and *Still Life, Plate of Pears* (V. 744, cat. no. 84), formerly in the collection of Hugo Cassirer.

Marianne Feilchenfeldt's most important transaction, however, was the return of Cézanne's *Bibémus Quarry* (V. 767) to the Museum Folkwang in Essen. After owning the painting for twenty-seven years, the Kramarskys had offered it for sale in December 1964. The Folkwang's director, Paul Vogt, managed to raise the money for it with the help of a West German radio station.[50]

Two more German museums acquired Cézannes after World War II. The Stuttgart Staatsgalerie bought *Still Life with Skull and Candlestick* (not in Venturi) from a private Paris collection in 1955, and *Female Bathers Before a Tent* (V. 543, cat. no. 34) from the Moltzau Collection in 1960. In 1964, as a bequest from Von der Heydt, the Von der Heydt-Museum in Wuppertal acquired *Reclining Nude* (V. 551, cat. no. 35) and *Portrait of the Artist's Son Paul* (V. 536). Already in its collection was the landscape *Hermitage in Pontoise* (V. 176), a gift from Julius Schmits of Elberfeld in 1912.

Today, there are twenty-one Cézannes in German museums (not including the picture *View of Auvers Through the Trees* (V. 151), from the Kaiser-Friedrich-Museum in Magdeburg; that painting was supposedly destroyed by fire. Some scholars continue to hope this picture might yet resurface). The paintings are as follows:

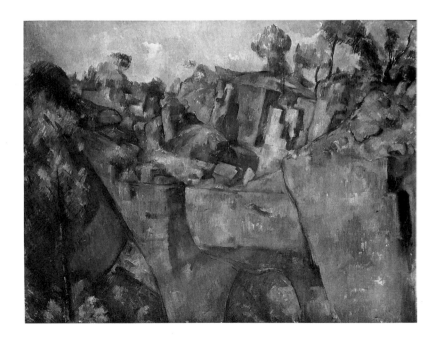

Paul Cézanne, *Bibémus Quarry*, circa 1895.
Museum Folkwang, Essen

Acquisition Date	Title/City/Museum	Venturi No.
1897	*Mill on the Couleuvre, at Pontoise* Berlin, Nationalgalerie	324, cat. no. 25
1904	*Still Life, Flowers and Fruit* Berlin, Nationalgalerie	610, cat. no. 55
1906	*Still Life with Jug and Bottle* Berlin, Nationalgalerie	71
1906	*Bibémus Quarry* Essen, Museum Folkwang (confiscated and sold in 1937)	767
1906	*Buildings at Bellevue with Dovecote* Essen, Museum Folkwang	651
1909	*Railway Cut in Aix* Munich, Neue Pinakothek	50
1910	*The Smoker* Mannheim, Städtische Kunsthalle	684
1912	*Self-Portrait* *Still Life with Commode* Munich, Neue Pinakothek	284 496, cat. no. 53
1912	*Hermitage in Pontoise* Wuppertal, Von der Heydt-Museum	176
1918	*Village Behind Trees* Bremen, Kunsthalle	438, cat. no. 73
1924	*The Seine at Bercy* Hamburg, Kunsthalle	242
1929	*Road Through a Wood* Frankfurt, Städtische Galerie	not in Venturi, cat. no. 9
1955	*Still Life with Skull and Candlestick* Stuttgart, Staatsgalerie	not in Venturi
1959	*The Sea at L'Estaque* Karlsruhe, Kunsthalle	770, cat. no. 72
1960	*Female Bathers Before a Tent* Stuttgart, Staatsgalerie	543, cat. no. 34
1964	*Bibémus Quarry* Essen, Museum Folkwang	767
1964	*Reclining Nude* *Portrait of the Artist's Son Paul* Wuppertal, Von der Heydt-Museum	551, cat. no. 35 536
1965	*In the Plain at Bellevue* *Still Life, Plate of Pears* Cologne, Wallraf-Richartz-Museum	448 744, cat. no. 84

 Essentially, the German museums have three people to thank for their Cézanne holdings: Hugo von Tschudi, who acquired six of the paintings, three of which are now in Berlin, three in Munich; Karl Ernst Osthaus, who bought his two pictures in Paris while the artist was still alive; and Paul Cassirer, who brought the six pictures to Germany that are now in the museums in Mannheim, Bremen, Hamburg, Karlsruhe, and Cologne. Cézanne never attained the popularity that Van Gogh enjoyed in Germany, but for Paul Cassirer, he was the greatest. When asked in 1911 why he "speculated" in French art rather than German, Cassirer composed a written reply:

 Because I love Manet;

 because I saw Monet, Sisley, and Pissarro as strong artists;

 because I recognized Daumier and Renoir as geniuses,

 Degas as one of the greatest masters,

 Cézanne as the representative of a philosophy of life.[51]

Time has proved him correct.

Acknowledgments

We note with sorrow the death of John Rewald (1912–1994) as this English edition was prepared for publication. A preeminent Cézanne scholar, Rewald is cited extensively in this book, and his works were indispensable to research for it.

At the time this text was written in 1992, John Rewald and his assistant, Jayne Warman, were preparing the new catalogue raisonné of the paintings of Paul Cézanne. I am grateful for their help in connection with this essay. I also thank Titia Hoffmeister, Gerrard White, and Roland Dorn for information and suggestions, and all of my friends who gave their support.

NOTES

1 A. Vollard, "Souvenirs sur Cézanne [25e Anniversaire de la mort de Cézanne]," in *Cahiers d'Art* 14 (1931), 386.

2 *Paul Cézanne, Letters*, Revised and Augmented Edition, edited by John Rewald, translated by Seymour Hacker, New York 1984. Cézanne to Julien Tanguy, March 4, 1878, 161; Julien Tanguy to Cézanne, August 31, 1885, 221.

3 M. Bodelsen, "Early Impressionist Sales 1874-94," in *The Burlington Magazine* (June 1968), 335, and "Gauguin's Cézannes," in *The Burlington Magazine* (May 1962), 204-11.

4 J. Rewald, "Chocquet and Cézanne," in *Studies in Impressionism*, New York 1985, 162. This article first appeared in *Gazette des Beaux-Arts* LXXIV (1969), 33ff. Here and in the following the revised version from 1985 is cited.

5 G. Migeon, "Isaac de Camondo," in *Musée National du Louvre, Catalogue de la Collection Isaac de Camondo*, Paris 1922.

6 J. Meier-Graefe, "Handel und Händler," in *Kunst und Künstler* 11 (1912/13), 205.

7 M. Bodelsen, "Early Impressionist Sales 1874-94," in *The Burlington Magazine* (June 1968), 348.

8 A. Vollard, *Erinnerungen eines Kunsthändlers*, Zurich 1957 32.

9 Vincent van Gogh, *Shoes*, Baltimore Museum of art (Cone Collection).

10 A. Vollard, *Paul Cézanne*, Paris 1914, 58.

11 J. Rewald, *Cézanne and America*, New York 1989, 21-30.

12 A. Vollard, *Erinnerungen eines Kunsthändlers*, Zurich 1957 131.

13 Anonymous, *Revue Blanche* (June 15, 1897).

14 J. Rewald, *Paul Cézanne*, Cologne 1986, 270, and J. Rewald, *Cézanne and America*, New York 1989, 49, note 7. According to a list by Durand-Ruel, made available to me by John Rewald and Jayne Warman, the twelve pictures were: V. nos. 156, 158, 181, 373, 522, 617, 173, 337, 338, 442, 562, and *Pommes* (Apples; unidentified either by Rewald or Durand-Ruel). Of these, the first six were not for sale.

15 Exhibition catalogue: Berlin, Bruno and Paul Cassirer, *III. Jahrgang der Kunstausstellungen*, Winter 1900/01. This catalogue was discovered by Titia Hoffmeister, who graciously allowed me to use it.

16 J. Rewald, "Chocquet and Cézanne," in *Studies in Impressionism*, New York 1985, 181, note 30.

17 Ibid., 167.

18 3ᵉ Exposition de peinture, 6 rue le Peletier, Paris, 1877, Paul Cézanne: [Venturi No.]

17–19	*Nature Morte* [Still Life]	[196]
17–19	*Nature Morte*	[197]
17–19	*Nature Morte*	[207]
20–21	*Etude de fleurs* [Floral Study]	[181]
20–21	*Etude de fleurs*	[182]
22–25	*Paysage, étude d'après nature* [Landscape, study from nature]	[158]
22–25	*Paysage, étude d'après nature*	[168]
22–25	*Paysage, étude d'après nature*	[171]
22–25	*Paysage, étude d'après nature*	[173]
26	*Les Baigneurs, étude, projet de tableau* [Bathers, study for painting]	[273]
27	*Un Tigre, d'après Delacroix* [Tiger, after Delacroix]	[250]
28	*Figure de femme* [Woman's Face]	[?]
29	*Tête d'homme* [Man's Head]	[283]
30–31	Aquarelle, *Impression d'après nature* [Watercolor, Impression from Nature]	[RWC 10]*
30–31	Aquarelle, *Impression d'après nature*	[RWC 17]*
32	Aquarelle, *Fleurs* [Flowers]	[RWC 8]*

In addition to the catalogue: *Scène fantastique* [Fantastic Scene] [243]

* J. Rewald, *Paul Cézanne, The Watercolors*, London 1983, hereinafter, RWC. My identifications are based on the assumption that all of the Cézanne works belonged to Victor Chocquet.

19 J. Rewald, "Chocquet and Cézanne," in *Studies in Impressionism*, New York 1985, 182, note 47.

20 J. Meier-Graefe, *Entwicklungsgeschichte der modernen Kunst*, Stuttgart 1904, 166.

21 The seventeen works bought by Durand-Ruel in the Chocquet auction were: V. nos. 145, 156, 158, 171, 173, 181, 182, 196, 197, 207, 266, 320, 369, 400, 442, 552, 617.

22 *Summer Landscape* (V. 633) AV stock no. 3773: "Huile; sur un terrain vert deux massifs d'arbres, au milieu comme un monticule rougeatre et verdoyant [Oil, landscape] 73:60"
Apples on a Table (V. 502) AV stock no. 3361: "Peinture à l'huile; representant deux assiettes une petite avec des fruits d'une harmonie verte; et une grand harmonie rouge [Oil, still life] 54:60"

Harlequin (V. 555) AV stock no. 3908: "Huile; Harlequin tenant sa batte [Oil, figure] 62:46"
The Vollard stock books (AV) were graciously provided to me by John Rewald and Gerrard White.

23 p. w. [Paul Warncke], "Sammlungen und Ausstellungen," in *Kunstchronik*, new series 12 (November 29, 1900), 105f.
The articles in *Kunstchronik* and *Die Kunst für Alle* dealing with exhibitions at Cassirer's were graciously made available to me by Roland Dorn.

24 h. r. [Hans Rosenhagen], "Aus Berliner Kunstsalons," in *Die Kunst* 3 (1900/01), 193.

25 B. v. Bismarck, "Harry Graf Kessler und die französische Kunst," in *Zeitschrift des Deutschen Vereins für Kunstwissenschaft*, Berlin 1988, 60, note 36.

26 H [E. Heilbut], "Die Impressionistenaustellung der Wiener Sezession," in *Kunst und Künstler* 1 (1902/3), 189f.

27 J. Meier-Graefe, *Entwicklungsgeschichte der modernen Kunst*, Stuttgart 1904, 165-70.

28 h [E. Heilbut], "Chronik," in *Kunst und Künstler* 2 (1903/4), 378.

29 H. Rosenhagen, "Von Ausstellungen und Sammlungen," in *Die Kunst für Alle* (May-June 1904), 401.
This review was graciously made available to me by John Rewald and Jayne Warman.

30 A. Distel, "Wagram," in *Petit Larousse de la Peinture*, Paris 1979, 1960.

31 J. Rewald, *Cézanne and America*, New York 1989, 134.

32 J. Rewald, *Cézanne*, Cologne 1986, 264f., and J. Rewald, *Cézanne Watercolours*, London 1983, 39f.

33 Ibid., 469.

34 Rainer Maria Rilke, *Briefe*, Frankfurt am Main 1985-87. Letter to Clara Rilke, October 10, 1907.

35 Exhibition catalogue: Berlin, Paul Cassirer, *XII. Jahrgang, 3. Ausstellung*, November 27-December 10, 1909. Forty-two paintings by Cézanne:

[Cat. No.]	[Title]	[Venturi No.]
1	*Village Beneath Trees*	[406]
2	*L'Estague [sic]*	[?]
3	*Still Life*	[59]
4	*Woman Sewing (Madame Cézanne)*	[291]
5	*Rooftops*	[175]
6	*Still Life (Fruit)*	[615]
7	*Landscape*	[?]
8	*Landscape*	[?]
9	*Portrait: Valabrègue*	[126]
10	*Portrait: Madame Cézanne*	[570]
11	*Landscape*	[667?]
12	*Peasant Reading a Newspaper*	[25]
13	*Woman with Crinoline Indoors*	[24]
14	*Chestnut Trees*	[462]
15	*Landscape*	[468]
16	*Landscape*	[635]
17	*Plein-air Portrait: Madame Cézanne*	[569]
18	*Portrait: Valabrègue*	[127]
19	*Still Life with Bread*	[59]
20	*Landscape with Small Houses*	[448]
21	*Still Life with Clock*	[69]
22	*Landscape, Auvers*	[178]
23	*Landscape*	[414?]
24	*Study for Zola's "Nana"*	[247]
25	*Landscape, Auvers*	[?]
26	*Self-Portrait*	[579]
27	*Sunday in Summer* (private collection)	[243]
28	*Tulips* (private collection)	[618]
29	*Self-Portrait*	[290]
30	*From the Outskirts of Marseille* (private collection)	[407]
31	*Cardplayers* (private collection)	[557]
32	*Still Life*	[?]
33	*Landscape* (private collection)	[455?]
34	*Landscape* (private collection)	[460?]
35	*Still Life* (private collection)	[624?]
36	*Still Life* (private collection)	[?]
37	*Still Life* (private collection)	[?]
38	*Young Man in the Red Vest* (private collection)	[681?]
39	*Still Life* (private collection)	[495?]
40	*Still Life* (private collection)	[345?]
41	*Sainte-Victoire at Marseilles* (private collection)	[664?]
42	*Portrait of Madame Cézanne* (private collection)	[577?]

Numbers 1-8 were works that had been on consignment at Cassirer's for some time; nos. 9-26 a shipment from Vollard especially for this exhibition, listed in a letter from Vollard to Cassirer from November 11, 1909; nos. 33-35 possibly belonged to Gottlieb Friedrich Reber; nos. 36-38 to Marcel von Nemes; nos. 39-42 to Bernhard Koehler.

36 Exhibition catalogue: Cologne, Sonderbund, May 25-September 30, 1912. Twenty-four paintings and two watercolors by Cézanne:

[Cat. No.]	[Title, Owner]	[Venturi No.]
126	*Still Life, Fruit with Glass and Porcelain Plate*. Leonhard Tietz, Cologne	[351?]
127	*View of Pontoise*. A. Bonger, Amsterdam	[307]

128 *Fruit on a Plate*. Bernhard Koehler, Berlin [345]
129 *Still Life with Apples, Table with Blue and White Cloth*.
Baron Franz von Hatvany, Budapest-Paris, illus. [598]
130 *Still Life, Fruit and Pitcher on a White Tablecloth*. Dr. Hugo Cassirer, Berlin [615]
131 *Tulips*. Bank Director Julius Stern, Berlin [618]
132 *Madame Cézanne*. Bernhard Koehler [577]
133 *Bouquet of Flowers in a Green Jar*. A.Bonger [511]
134 *Bouquet of Roses in a Brown Jar*. A. Bonger [358]
135 *Trees and Meadow with View of Houses on a Hill* [651]
136 *Tree-Lined Path with View of Roofs*. Dr. Hugo Cassirer [627]
137 *House in Foliage*. Frau Georg Wolde, Bremen, illus. [450]
138 *View Down a Park Allee* [626]
139 *Rocky Slope with Shrubbery* [775]
140 *Mountain Landscape in Provence*. Dr. Eberhard Baron von Bodenhausen, Essen [434]
141 *Sainte-Victoire near Aix*. Bernhard Koehler, illus. [664]
142 *Seated Man with Book* [697]
143 *Boy in a Hat with an Open Book* [678]
144 *Man with Crossed Arms*. Tilla Durieux-Cassirer, Berlin, illus. [685]
145 *Woman in Red Dress*. Alfred Flechtheim, Düsseldorf [573]
146 *Peasant with Red Neckerchief* [687]
147 *Landscape*. Elsa Tischner-von Durant, Freising [427]
148 *Head of a Boy*. Alfred Flechtheim, Düsseldorf [536]
149 *Head of a Woman*. Alfred Flechtheim [533]
150 *Peaches* (watercolor). Victor Mössinger, Frankfurt [RWC 293]
151 *Flowers in a Green Jar* (watercolor). Alfred Flechtheim [RWC 374]
37 Exhibition catalogue: Berlin, Paul Cassirer, *XV. Jahrgang, 3. Ausstellung-Sammlung Reber*, January 1913.
Eleven paintings by Cézanne:

[Cat. No.] [Title]		[Size, cm]	[Venturi No.]
19	*Still Life with Apples*	[49: 40]	[?]
20	*Still Life with Pears*	[46: 60]	[624]
21	*Large Still Life*	[72:100]	[742]
22	*Still Life*	[watercolor; 47:63]	[RWC 552/572?]
23	*Landscape*	[80: 64]	[635]
24	*Lutteurs amoureux* [Fighting Lovers]	[37: 45]	[380]
25	*Large Nudes*	[60: 81]	[580]
26	*Harlequin*	[61: 46]	[555]
27	*The Young Philosopher*	[103: 98]	[679]
28	*Portrait of a Carter*	[80: 64]	[687]
29	*Man with Crossed Arms*	[92: 72]	[689]

The dimensions are taken from the exhibition catalogue of the Reber Collection in Darmstadt.

38 E. Waldmann, "Die Sammlung Reber," in *Kunst und Künstler* 11 (1912/13), 441-51.

39 E. Meier-Graefe, "Die Sammlung Reber," in *Kunstschreiberei-Essays und Kunstkritik*, Leipzig 1987, 210.

40 P. Fechter, "Die Sammlung Schmitz," in *Kunst und Künstler* 8 (1909/10), 15-25, and
"Die Sammlung Rothermundt," in *Kunst und Künstler* 8 (1909/10), 346-55; K. Scheffler, "Die
Sammlung Oskar Schmitz in Dresden," in *Kunst und Künstler* 19 (1920/21), 178-190.

41 Exhibition catalogue: Berlin, Paul Cassirer, *XVI. Jahrgang, 2. Ausstellung*, November 1-December 1913.
Six paintings by Cézanne:

[Cat. No.] [Title]		[Venturi No.]
30	*The Château Noir*	[667]
31	*House with a Red Roof*	[468]
32	*View of a Town*	[411]
33	*Undergrowth*, illus.	[332]
34	*The Provence House*	[436]
35	*Landscape*	[401]

42 Exhibition catalogue, Berlin, Paul Cassirer, *Cézannes Werke in deutschem Privatbesitz*,
November-December 1921:

Owner/City	Cassirer Nos.	Venturi Nos.
Theodor Behrens, Hamburg	77, 16, 17	330, 290, 242
Alfred Cassirer, Berlin	10	194
Bruno Cassirer, Berlin	19, 34, 35	633, 323, 596
Hugo Cassirer, Berlin	4, 11', 12, 25, 32, 37, 38	59, none, 627, 412, 595, 744, 743
Paul Cassirer, Berlin	6, 21, 22, 24	175, 667, 573, 775?
Dr. Julius Elias, Berlin	1	121
Samy Fischer, Berlin	33	497
Alfred Flechtheim, Berlin	8, 23	274, 533
Jacobi, Berlin	41	420
Count Harry Kessler, Berlin	9, 39	402, 206
Max Liebermann, Berlin	3, 29	243, 466
Franz von Mendelssohn-Bartholdy, Berlin	18	669
Henry Newman, Hamburg	26, 27	467, 163
Margarete Oppenheim, Berlin	13, 14, 15, 20, 30	294, 468, 407 448, 436

Emil Orlik, Berlin	42	507?
Hugo Perls, Berlin	2	108
Friedrich Gottlieb Reber, Barmen	31, 36	681, 580
Baron von Simolin, Berlin	5	708
Frau Georg Wolde, Bremen	28	450
Wolff Collection, Hamburg	40	332

* *Still Life with Cauliflower*

43 R. Dorn, *Sammlung Falk*, unpublished manuscript, February 16, 1991, text p. 2, documentation (Cézanne) pp. 5-7.

44 Wilhelm Hausenstein, *Katalog der Modernen Galerie Heinrich Thannhauser*, Munich 1916, XII.

45 Exhibition catalogue: Zurich, Kunsthaus, *Französische Maler des XIX. Jahrhunderts*, May 14-August 6, 1933. Thirteen paintings by Cézanne:

[Cat. No.] [Title]		[Size, cm]	[Venturi No.]
77	*The Monk*	54:64.5 illustrated	[72]
78	*Rocky Landscape*	55:46.5	[401]
79	*Curving Road*	46:55	[328]
80	*Fruit in a Goblet and Cup*	46:32.5	[187]
81	*Landscape in the Rain*, signed	54.5:46	[323]
82	*Bathers*	47:38.5	[274]
83	*L'Estaque*	81.5:65.5	[411]
84	*Still Life with Fruit, Ocher Background*	73:60	[59]
85	*Still Life with Fruit, Blue-Gray Background*	61:50	[615]
86	*Landscape*	92:73	[471]
87	*Still Life with Melons*	61.5:46.5	[596]
88	*Landscape, View of a Small Town*		[410]
89	*Undergrowth*		[628]

46 Exhibition catalogue: Bern, Kunsthalle, *Französische Meister des 19. Jahrhunderts und Van Gogh*, February 18-April 2, 1934. Seven paintings by Cézanne:

3	*Village Houses Behind Trees*		[146]
4	*Still Life with Apples and a Glass*	32:40	[339]
5	*Self-Portrait*	55:47	[1519]
6	*Still Life with Apples, Cup, and Glass*	41:55	[186]
7	*Still Life with Ginger Jar and Apples*	65:81	[497]
8	*Landscape*	73:92	[471]
9	*Amor*	57:25	[711]

47 Exhibition catalogue: Rotterdam, Museum Boymans, *Schilderijen van Delacroix tot Cézanne en Vincent van Gogh*, December 20, 1933-January 21, 1934. Six paintings by Cézanne:

1	*Still Life with Apples*	41:55 illus.	[186]
2	*Still Life with Ginger Jar*	65:81 illus.	[497]
3	*The Sea at L'Estaque*	79:78 illus.	[770]
4	*Female Bathers*	72:92 illus.	[726]
5	*Landscape*	73:92	[471]
6	*Amor*	57:25	[711]

48 Reinhold Cassirer, the eighty-four-year-old son of Paul's brother Hugo, recalled for me how he and his cousin, a painter, smuggled the pictures from the collection that were not exhibited in Zurich across the border into Holland in July 1933. The two young men simply took the paintings with them, wrapped in packing paper, in two compartments in a sleeping-car from Berlin. When the German customs officials turned up and asked what was in the packages, he replied they were paintings by his cousin, who was asleep in the next compartment. Satisfied, the officials responded with a brisk „Heil Hitler" and disappeared.

49 E. Göpel, "Die Irrwege des Essener Cézanne" and "Ein Bild kehrt zurück," *Süddeutsche Zeitung*, December 23, 1964.

50 P. Vogt, "Entartete Kunst," in *Das Museum Folkwang*, Cologne 1965, 72-142; revised and enlarged edition, Cologne 1983, 81-163 and 168.

51 P. Cassirer, "Kunst und Kunsthandel," in *Pan* 1 (May 16, 1911), 467.

Index

This index refers to names in texts and notes, but not to those in provenance, bibliography, and exhibitions given with each catalogue entry.

Abbate, Niccolo dell' 39; Illus. p. 39
Alexandre, Père 201
Alexis, Paul 52 ff., 55-58, 198, 204; Illus. p. 53, 57
Apollinaire, Guillaume 30, 35, 198, 200
Aubert, Anne-Elisabeth-Honorine see Cézanne
Aubry 302

Baille, Baptistin 289
Bakwin, Harry 306
Barnes, Albert 295, 304
Barr, Alfred 51
Batle, Louis Le 172
Baudelaire, Charles 35, 58, 129, 196
Bazille, Jean-Frédéric 68
Beckmann, Max 9, 31, 35
Beethoven, Ludwig van 48
Behrens, Theodor 302, 305, 311
Béliard, Edouard 110
Bellio, de 298
Bernard, Emile 18, 23, 25, 26, 30, 34, 35, 128, 191, 196, 251, 252, 268, 281, 290, 293; Illus. p. 29, 281
Bernheim-Jeune 28, 30, 31, 88, 296, 300, 301, 302, 303, 304, 305; Illus. p. 317
Bernheim-Jeune, Josse and Gaston 300
Bernstein, Carl and Felicie 295
Bismarck, B. von 310
Bizet, Georges 190
Blanche, Jacques-Emile 108
Blot, Eugène 300
Boch, Eugène 302
Bode, Wilhelm von 295
Bodelsen, Merete 35, 309
Bodenhausen, Eberhard Freiherr von 311
Böcklin, Arnold 301
Böhler, Julius 304
Bonger, A. 310, 311
Bonnard, Emile 32
Bonnières, Robert de 108, 110, 295
Borély, Jules 34, 204, 256
Brakl 305
Brancusi, Constantin 153
Braque, Georges 9, 28, 30, 94, 122
Brassaï, Gyula H. 35
Brémond, Madame 229
Breton, André 106
Bührle, Emil Georg 304

Caillebotte, Gustave 295, 298
Cameron, D. Y. 296
Camoin, Charles 18
Camondo, Isaac de 293, 309
Caravaggio 42, 48; Illus. p. 44
Cassatt, Mary 206
Cassirer, Alfred 311

Cassirer, Bruno 296, 293, 299, 306, 309, 311
Cassirer, Hugo 302, 303, 307, 310, 311, 312
Cassirer, Paul 8, 31, 82, 291, 295, 296, 298, 299, 301, 302, 303, 304, 305, 308, 309, 310, 311, 312; Illus. p. 297
Cassirer, Reinhold 312
Cassirer-Fürstenberg 306
Cézanne, Anne (Anne-Elisabeth-Honorine Aubert) 96, 162, 198, 289, 290, 291
Cézanne, Hortense (Marie Hortense Fiquet) 63, 76, 79 f., 86, 122, 130, 136-153, 211, 213, 226, 289, 290, 302, 303, 310; Illus. p. 81, 137, 139, 141, 142, 145, 148, 149, 151, 152, 198
Cézanne, Louis-Auguste 79, 80, 96, 122, 162, 289, 290, 294
Cézanne, Marie 198, 278
Cézanne, Paul fils 15, 22, 52, 79, 86, 121, 122, 130, 169, 198, 204, 213, 220, 226, 278, 280, 290, 291, 294, 302
Cézanne, Rose see Conil
Chappuis, Adrien 34, 40, 47, 54, 71, 75, 85, 89, 94, 96, 102, 118, 124, 128, 130, 134, 164, 176, 179, 191, 196, 201, 213, 240, 244, 256
Charbonnier, Georges 35
Chardin, Jean-Baptiste-Siméon 179
Chocquet, Caroline 88 298
Chocquet, Victor 27, 82-85, 88, 93, 94, 108, 122, 196, 290, 293, 298, 299, 309; Illus. p. 83, 85
Clémenceau, Georges 274
Clot, Auguste 235
Clouet, François 153
Conil, Maxime 291
Conil, Paule 34, 218
Conil, Rose 216, 260
Corinth, Lovis 296, 299
Corot, Jean-Baptiste-Camille 59, 195
Courbet, Gustave 15, 16, 32, 48, 50, 55, 58, 59, 75, 76, 82, 110, 129, 134, 198
Couture, Thomas 234

Daubigny, Charles 50
Daudet, Alphonse 206
Daumier, Honoré 16, 39, 129, 130, 195, 198, 200, 308
Degas, Edgar 16, 17, 26 27, 28, 31, 79, 84, 114, 128, 190, 195, 226, 229, 295, 296, 308
Delacroix, Eugène 22, 32, 55, 68, 74, 76, 82, 84, 85, 89, 110, 130, 191, 195, 196, 234, 274, 289, 296, 312
Delaroche 111
Denis, Maurice 17, 25, 34, 178, 291

Distel, A. 310
Doria, Armand Comte 293
Dorn, Roland 309, 310 312
Duchamp, Marcel 9, 30, 35
Dürer, Albrecht 154
Durand-Ruel, Paul 110 291, 294, 295, 296, 298, 299, 300, 304, 309
Duret, Théodore 27, 84, 114, 293, 303
Durieux, Tilla 303, 311

Elder, Marc 34
Elias, Julius 304, 311
Emperaire, Achille 79

Fabbri, Egisto 294, 304
Falk, Sally 304, 305, 311
Fechter, P. 311
Feilchenfeldt, Marianne 307
Feilchenfeldt, Walther 305, 306, 307
Fénéon, Félix 300
Fiquet, Marie Hortense see Cézanne
Fischer, Samuel 306, 311
Flaubert, Gustave 15, 34, 129, 194, 208
Flechtheim, Alfred 45, 303, 305, 311
Forain, Jean-Louis 228, 234
Francesca, Piero della 153
Frank, Paul 35, 111

Gachet, Paul Fernand 27, 34, 290
Gallimard, Paul 305
Gangnat, Maurice 302
Gasquet, Henri 208, 210, 218; Illus. p. 210
Gasquet, Joachim 45, 47, 121, 208-210, 211, 240, 270, 272; Illus. p. 209
Gasquet, Marie 240
Gauguin, Paul 16, 26, 28, 290, 291, 293, 294, 295
Geffroy, Gustave 27, 35, 82, 154
Georges-Michel, M. 276
Géricault, Théodore 32
Giacometti, Alberto 9, 32, 35, 76, 226
Giorgione 126, 129
Göpel, E. 312
Goethe, Johann Wolfgang von 301
Gogh, Vincent van 16, 26, 82, 108, 114, 195, 218, 293, 306, 308, 309, 312
Gold, Alfred 305
Goldschmidt, Jakob 304
Goldschmidt, Marcel 305
Goncourt, brothers 56
Goya, Francisco 32, 305
Grandville 74; Illus. p. 75
Greco, El 31, 32
Guillaume, Louis 52, 204
Guillaumin, Armand 293, 294

Guillemet, Antoine 50, 68, 71, 290
Gurlitt, Wolfgang 295, 303

Halévy, Ludovic 190
Hallowell, Sara 299
Hals, Frans 154
Hatvány, Franz Baron von 184, 311
Hausenstein, Wilhelm 312
Havemeyer, H. O. 294
Heilbut, Emil 298, 300, 310
Helbing, Hugo 305
Herding, Klaus 75
Hessel, Josse 88, 305
Heydt, Eduard von der 307
Hoffmeister, Titia 309
Hofmann, Werner 75
Hogendijk, Cornelis 294
Hokusai, Katsushika 268
Horemans, Jan 201
Huysmans, Joris Carl 27, 35, 296, 299

Ingres, Jean Auguste Dominique 153

Jacobi, collector 311
Johns, Jasper 9, 28, 33, 35
Jourdan 278

Kandinsky, Wassily 9, 31, 35
Katzenellenbogen, Estella 306
Kaulbach, Wilhelm von 111
Kessler, Harry, Count 300, 302, 310, 311
Kirkeby, Per 32, 35
Klee, Felix 35
Klee, Paul 9, 31
Klimsch, Fritz 296
Koehler, Bernhard 303, 310, 311
Kramarsky, Siegfried 305, 306, 307
Kramer, Thomas 91

Lankheit, Klaus 35
Lassaigne, Jacques 35
Lauts, Jan 307
Le Bail, Louis 172
Legros, Alphonse 110
Leistikow, Walter 296, 299
Lenin, Wladimir I. 32
Leonardo da Vinci 35
Lewin, Alexander 306, 307
Lewinstein, Walter 303
Liebermann, Max 9, 31, 32, 88, 89, 110, 111, 154, 295, 296, 300, 302, 304, 311
Linde, Max 302
Lissitzky, El 32, 35
Lissitzky-Küppers, Sophie 35
Loeser, Charles 294
Lord, James 35
Lütjens, Helmuth 306

Macke, August 31
Maillol, Aristide 32
Malcoud 294
Malevich, Kasimir 30, 35
Malraux, André 276
Mandelstam, Ossip 35
Manet, Edouard 15, 16, 17, 31, 42, 48, 50, 55, 56, 58, 70, 71, 76, 79, 84, 88, 110, 129, 178, 195, 229, 295, 296, 298, 299, 301, 303, 304, 308; Illus. p. 58, 71

Marc, Franz 31, 130, 303
Marion, Antoine Fortuné 48, 50, 51, 54, 55, 56, 59 f., 63, 66, 78, 157
Marius 268
Masson, André 26
Matisse, Henri 9, 14, 28, 32, 76, 140, 172, 226, 274, 276; · Illus. p. 30
Mauclair 110
Maus, Octave 108
Meier-Graefe, Julius 8, 129, 130, 295, 298, 300, 301, 302, 304, 309, 311
Mellon, Paul 304
Mendelssohn-Bartholdy, Franz von 311
Menzel, Adolph 110
Meunier, Constantin 296
Michelangelo 47; Illus. p. 45
Michelangelo di Rosa 154
Migeon, G. 309
Millet, Jean-François 198, 200
Mirbeau, Octave 294
Modersohn-Becker, Paula 31
Modigliani, Amedeo 153
Mössinger, Victor 311
Moltzau, collection 307
Mondrian, Piet 9, 30
Monet, Claude 9, 15, 16, 26, 27, 28, 32, 34, 68, 84, 86, 114, 178, 195, 196, 206, 274, 276, 290, 291, 293, 295, 296, 298, 301, 308
Morosov, Iwan 32, 216
Morstatt, Heinrich 48, 50, 51, 54, 55, 56, 59, 63, 66, 78
Mortier, Arnold 68
Mourgues 291
Munch, Edvard 114
Murat 294
Muther 296
Mutzenbecher, Victor von 302

Nakov, A. B. 35
Napoleon III. 63
Nemes, Marcel von 310
Newman, Henry 311
Novalis 244
Novotny, Fritz 136

Oller, Francisco 27
Oppenheim, Margarete 304, 306, 311
Orlik, Emil 312
Osten, Gert von der 307
Osthaus, Karl Ernst 263, 302, 306, 308
Ovid 39

Parmelin, Hélène 34
Pascal, Blaise 30
Pauli, Gustav 88
Pearlman, Henry 263
Pellerin, Auguste 76, 226, 295, 302, 304
Penck, A. R. 33
Perls, Hugo 305, 312
Petit, Georges 84, 108, 195, 298
Picasso, Pablo 9, 28, 30, 32, 34, 42, 103, 122, 129 f., 254, 276, 304, 305; Illus. p. 256
Pillep, Rudolf 35
Pissarro, Camille 15, 16, 17, 25, 26, 27, 28, 35, 42, 68, 70, 76, 78, 84,

85, 86, 91, 93, 94, 108, 110, 114, 171, 172, 191, 196, 220, 289, 290, 293, 294, 295, 301, 308; Illus. p. 20, 21
Pissarro, Lucien 27, 84, 110
Pollaiuolo, Antonio del 39
Poussin, Nicolas 111, 129, 254, 289
Puget, Pierre 128, 195

Reber, Gottlieb Friedrich 303, 304, 312
Redon, Odilon 195
Remarque, Erich Maria 306, 307
Rembrandt van Rijn 50, 232
Renoir, Auguste 9, 26, 27, 28, 32, 68, 79, 82, 84, 85, 86, 94, 108, 178, 195, 290, 295, 298, 308; Illus. p. 85
Rewald, John 34, 38, 40, 71, 75, 85, 94, 96, 102, 103, 113, 124, 128, 156, 169, 173, 179, 188, 194, 196, 201, 206, 213, 216, 228, 236, 244, 246, 252, 256, 257, 272, 278, 298, 309, 310
Ribera, Jusepe 48, 51
Richter, Emil 302
Rilke, Clara 76, 79, 146, 302
Rilke, Rainer Maria 22, 23, 31, 34, 76 f., 78, 79 f., 146, 179, 184, 186, 188, 190, 260, 302, 310
Ring, Grete 305, 306
Rivière, Georges 35, 89, 96, 220, 226, 252, 290
Rodin, Auguste 184, 260
Rosenberg, Paul 295, 304
Rosenhagen, Hans 299, 301, 310
Rothermundt 302
Roussel, Ker-Xavier 291; Illus. p. 13
Royère, Jean 263
Rubens, Peter Paul 18, 126, 128, 129, 195, 196, 234

Sabartes, Jaime 34
Schapiro, Meyer 134
Schmits, Julius 307
Schmitz, Oskar 304, 306
Shchukin, Sergei 32
Schütte, F. 305
Seurat, Georges 16, 88, 300
Signorelli, Luca 31, 234
Simolin, Baron von 312
Sisley, Alfred 68, 86, 108, 178, 186, 295, 301, 308
Solari, Philippe 211
Soutine, Chaim 153
Stern, Julius 302, 303, 305, 311
Suisse, Père 289
Szczesny, Stefan 35

Talleyrand, Charles Maurice de 195
Tanguy, Père Julien 26, 27, 29, 35, 82, 108, 110, 188, 290, 291, 293, 294, 298, 299, 309
Tanguy, Mrs. 294
Thannhauser, Heinrich 305
Thannhauser, Justin 305, 306
Tietz, Leonhard 303, 310
Tintoretto 31, 34, 39
Tischner-von Durant, Elsa 311
Tizian 126, 129, 195, 232

Toulouse-Lautrec, Henri de 17,
 26, 79, 108, 114, 128, 153, 229
Tschudi, Hugo von 31, 88, 110,
 111, 172, 178, 295 f., 301, 302, 303,
 308

Ulbach, Louis 44

Valabrègue, Antony 50, 51, 54,
 56, 59, 310
Vallier 229, 232, 278, 280
Vélazquez, Diego 79, 300
Velde, Henry van de 296
Venturi, Lionello 38, 40, 80, 85,
 89, 96, 103, 110, 114, 117, 121,
 124, 128, 134, 136, 138, 140, 146,
 156, 160, 164, 169, 171, 173, 178,
 182, 186, 188, 190, 191, 194, 198,
 200, 201, 206, 211, 213, 214,

216, 218, 220, 226, 234, 235,
 240, 244, 247, 256, 257 260,
 263, 276, 280, 304, 305, 306,
 307, 309
Verlaine, Paul 45
Veronese, Paolo 18
Vogt, Paul 306, 312
Vollard, Ambroise 26, 27, 28, 30,
 34, 35, 63, 71, 106, 110, 111, 130,
 134, 140, 154, 188, 190, 198, 206,
 213, 226, 228, 232, 234 235, 251,
 252, 270, 276, 291, 293 294,
 295, 296, 298, 300, 302, 303,
 304, 309, 310; Illus. p. 234, 292
Vuillard, Edouard 301

Wagner, Richard 48, 66
Wagram, Prince de 302
Waldmann, Emil 220, 311

Walser, Robert 140
Warhol, Andy 230, 254;
 Illus. p. 256
Warman, Jayne 38, 299, 309, 310
Wartmann, Dr. 306
Westhoff, Clara see Rilke
White, Gerrard 309, 310
Wilhelm II. 110, 111, 295
Wolde, Adele 303
Wolde, Georg 303, 312
Wolff, collection 312

Zola, Emile 9, 15, 26, 27, 34, 39,
 42, 44, 48, 51, 52 ff., 55-58, 59,
 63, 68, 70, 74, 94, 102, 108, 110,
 114, 118, 122, 124, 126, 128, 162,
 198, 204, 251, 257, 278, 289, 290,
 291, 296, 310; Illus. p. 53, 57, 58
Zurbarán, Francisco de 48, 51

Photograph Credits

We thank those listed below for furnishing reproductions of the paintings and illustrations noted. Many photographs were graciously provided by lenders of works owned by them; other photos are from the archives of the author and publisher. Photo sources cited previously in these pages are not listed here.

The Art Institute of Chicago
 Illus., p. 235
Ashmolean Museum, Oxford
 (Pissarro Archives) Illus., p. 5
The Baltimore Museum of Art
 Illus., p. 30
Bibliothèque Nationale, Paris
 Illus., p. 281
Bildarchiv Preussischer Kulturbesitz, Berlin (photo Klaus Göken)
 Cat. nos. 25, 55
The Central Art Archives, Helsinki
 Cat. no. 29
Ursula Edelmann, Frankfurt am Main
 Cat. no. 9
Walter Feilchenfeldt Collection, Zurich
 Illus., pp. 297, 307
Chauderon, Lausanne
 Illus., p. 204
Giraudon, Paris
 Illus., pp. 39, 44, 45 (left), 71
Bruno Hartinger, Munich
 Cat. nos. 48, 93
Gerhard Howald, Kirchlindach-Bern
 Cat. nos. 28, 64
H. Humm, Brüttisellen
 Cat. nos. 82, 83, 87
Kunsthaus Zurich
 Cat. nos. 58, 85
The Metropolitan Museum of Art, New York
 Illus., p. 129 (left); (photo Malcolm Varon), cat. no. 16
Musée Granet, Aix-en-Provence (photo Bernard Terlay)
 Cat. nos. 63, 81
Museu de Arte, São Paulo (photo Luiz Hossaka)
 Cat. nos. 6, 22, 43
The Museum of Modern Art, New York
 Illus., p. 228
National Gallery, London
 Illus., p. 242
Philadelphia Museum of Art
 Illus., p. 246
The Phillips Collection, Washington
 Illus., p. 229 (right)
Rodo Pissarro Collection
 Illus., p. 111
Réunion des Musées Nationaux, service photographique, Paris
 Cat. nos. 23, 66, 96
Rheinisches Bildarchiv, Cologne
 Cat. no. 84
Peter Schälchli, Zurich
 Cat. no. 19
Giuseppe Schiavinotto, Rome
 Cat. no. 97
Schweizerisches Institut für Kunstwissenschaft, Zurich
 Cat. no. 86
Steiner-Jaeggli, Winterthur
 Cat. nos. 21, 47
Virginia Museum of Fine Art, Richmond
 Illus., p. 85 (left)
Zindman/Fremont, New York
 Illus., p. 256 (right)

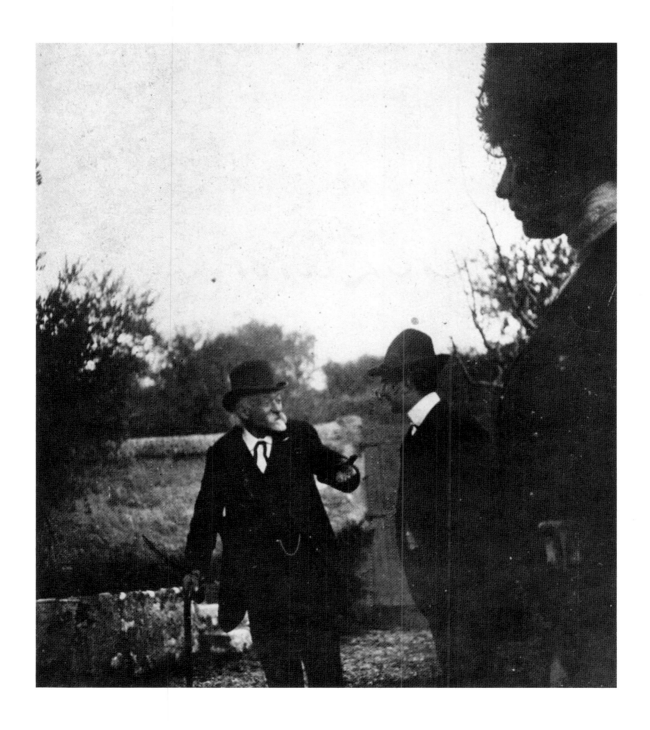

Paul Cézanne and Gaston Bernheim de Villers,
photograph by Josse Bernheim-Jeune, 1904